FIRST CATALOGUE PRODUCED IN 1929

Cards illustrated on front cover are from the series:

John Player & Sons Cricketers Caricatures by 'Rip' 1926

John Player & Sons Film Stars 3rd Series 1938

Ogdens Ltd Motor Races 1931

ISBN 0 903790 78 5

Published by THE LONDON CIGARETTE CARD COMPANY LTD Sutton Road, Somerton, Somerset, England TA11 6QP

Telephone: 01458-273452 Fax: 01458-273515

International Calls: Telephone: 011 44 1458-273452

Fax: 011 44 1458-273515

HOW TO USE THE CATALOGUE

This catalogue is published in four sections. Section 1 covers the cigarette card issues of British Tobacco Manufacturers for the home market together with certain export series (indicated by 'export' in brackets). Section 2 deals with cards issued outside the United Kingdom. Section 3 covers reprinted series and section 4 illustrations.

In each section manufacturers are featured in alphabetical order, and the issues of each firm are catalogued alphabetically within suitable sub-divisions, such as, in Section 1, 'Pre-1919 Issues', 'Post-1920 Issues', 'Silks', 'Miscellaneous' and, in Section 2, 'With Brand Name', 'Without Brand Name', 'Silks', etc. Where a brand name but no maker's name is shown on the card, reference should be made to the appropriate Index of Brands. Anonymous series, that is those with printed backs but no brand or maker's name, are listed under the firms to which the issue has been attributed. Anonymous British issues are also listed at the end of Section 1.

Information is given in the columns from left to right as follows:

Size

- (a) British issues and reprints series: the code letter refers to the size of the card as indicated in the chart on page x. A number 1 or 2 after the letter means that the card is slightly larger or smaller than shown.
- (b) Foreign issues: the absence of a code letter indicates that the series is of standard size. A code letter 'L' defines the card as being large (about 80 × 62 mm). Other codes are 'K' = smaller than standard, 'M' = between standard and large, and 'EL' = larger than large.

Printing

- (a) British issues and reprint series: the code indicates the printing on the front of the card. 'BW' = black-and-white; 'C' = coloured; 'CP' = colour photograph; 'P' = photograph; 'U' = uncoloured (monochrome).
- (b) Foreign issues: the letter 'P' is used to show that a series consists of photographs.

Number in Set

This figure gives the number of cards in the series. A question mark alongside shows the exact number is unknown.

Title and Date

Where a series title is printed on the cards, this is used in the catalogue. For cards which do not exhibit a series title, an 'adopted' title is shown (indicated by an asterisk in the British section). Where a firm issued more than one series with the same title, these are distinguished by the addition of 'Set 1', 'Set 2', etc. or a code letter. The date of issue, where known, is shown in brackets, otherwise an approximate date is shown prefixed by 'C'.

Reference Code

- (a) British issues: un-numbered series, series issued by more than one manufacturer, and different series of the same title issued by a single firm, have been given an 'H' or 'Ha' number cross-referencing to Handbooks Parts I and II respectively, which provide further information. In some cases it might be necessary to follow the 'H' number through to Handbook Part II and also the World Tobacco Indexes (i.e. H.189 in Handbook Part I, Ha.189 in Handbook Part II, and XI/H.189 in World Index).
- (b) Foreign issues: 'RB18' followed by a number refers to the BAT and Tobacco War reference book. 'WI' and 'WII' refer to World Tobacco Index Part I and Part II respectively. A reference number following a Wills series relates to the Wills Reference Book (details of these publications will be found on page iv).

Prices

The last two columns show the London Cigarette Card Company's selling prices for odd cards and complete sets in very good condition. Where no price is shown, this does not necessarily mean that the Company are permanently unable to supply, and if you require items in this category please request a quotation enclosing a self-addressed envelope either with an International Reply Coupon or ready-stamped for posting in Britain.

HOW TO ORDER CARDS

Availability

We have the world's largest stocks of cigarette cards and the chances are that we will be able to supply your requirements for most series at the prices shown in the catalogue. However, certain odd cards, particularly from rarer series, may not be available in top condition and in such cases it is helpful if you indicate whether cards of a lower standard are acceptable at reduced prices. If a complete set is not in stock, we may be able to offer a part set, with one or two cards missing, at the appropriate fraction of full catalogue price. In some instances we can supply sets on request in fair to good condition at half catalogue price. If in doubt, please write for a quotation, enclosing a stamped, self-addressed envelope.

End Numbers

When ordering 'end' numbers, for example Nos. 1 and 50 of a set of fifty, please note that the following applies. For series catalogued up to £1 per card, end cards are charged at treble price. For series catalogued from £1 to £3 per card, end cards are charged at £3 per card. And for series catalogued at more than £3 per card there is no additional charge for end numbers.

Postage

Inland second class post is included in all prices quoted. Overseas postage is charged at cost.

Ordering and Payment

Please ensure that your name and full address are clearly shown. State the maker's name and the set title required (with 'first series', 'second series', date of issue, etc. as appropriate). For odds, please list each individual number wanted. Make your crossed cheque or postal order payable to The London Cigarette Card Company Limited and enclose with order. Notes and coins should be registered. Overseas payments in currencies other than Sterling are acceptable, but allow £4 for bank conversion charges. Foreign remittances will be credited after conversion and deduction of bank charges. We accept Eurocard, Mastercard and Visa credit cards. Quote your card number and expiry date. Please allow 14 days for delivery. Send your order to:

The London Cigarette Card Co. Ltd.
Sutton Road, Somerton, Somerset TA11 6QP, England
Telephone: Somerton (01458) 273452

Answering Machine For the convenience of customers, an answering machine is in operation to receive orders when the office is closed. Just leave your order, name and address with credit card number and expiry date, and it will be dealt with as soon as possible. Please note that we can only deal with odds orders and general enquiries in office hours. Telephone number: (01458) 273452 (international 011 44 1458 273452).

Fax Machine Our fax machine is on 24 hours a day to receive orders. Just place your order stating your name, address, credit card number and expiry date. The fax number is (01458) 273515 (international 011 44 1458 273515).

Remember that your cards will look their best when displayed in one of our albums, for which please see page viii. Value Added Tax where applicable is included in all prices shown, at the current rate of 17½%.

Showroom

At our Showroom in separate premises in West Street, Somerton, some 2,500 different sets are displayed for sale, together with a large selection of framed cards, albums and books, as well as framing kits and mounting boards. For further information about the Showroom, including opening times, please see back cover. Odd cards for collectors' wants lists are not stocked at the Showroom, but are available from our headquarters in Sutton Road on Mondays to Fridays from 9.30am to 1pm and 2pm to 4.30pm.

Guarantee

In the unlikely event that you, the collector, are not satisfied with the cards supplied, we guarantee to replace them or refund your money, provided the goods are returned within 14 days of receipt. This guarantee does not affect your statutory rights.

CARTOPHILIC REFERENCE BOOKS

Handbook Part I (1888 to 1919). 172-page reference book (no prices) listing subjects of unnumbered series, etc. Illustrated, hardback. Covers British cigarette cards issued between 1888 and 1919, cross-referenced to the catalogue (964 cards illustrated)
Handbook Part II (1920 to 1940). 164-page reference book (no prices) listing subjects of unnumbered series, etc. Illustrated, hardback. Covers British cigarette cards issued between 1920 and 1940, and all silk issues, cross-referenced to the catalogue (906 cards illustrated) £12.00
World Tobacco Card Index and Handbook Part I. 701 pages and nearly 2,000 cards illustrated£23.50
World Tobacco Card Index Part II. Supplement to Index I, 452 pages with approximately 3,600 cards illustrated£15.50
World Tobacco Card Index Part III. Supplement to Index I and II, 504 pages with more than 650 cards illustrated
World Tobacco Card Index Part IV. Supplement to Index I, II and III, 688 pages, illustrated £18.50
World Tobacco Card Index Part V. Supplement to Index I, II, III, IV, 552 pages with approximately 1300 cards illustrated
The Card Issues of Abdulla/Adkin/Anstie. 20 pages
The Card Issues of Ardath Tobacco. 28 pages
Australian and New Zealand Card Issues. Over 300 pages with 600 cards illustrated £15.50
The Card Issues of BAT and Tobacco War. 336 pages with nearly 3,000 cards illustrated £12.50
The Card Issues of Churchman. 36 pages with 29 cards illustrated
The Card Issues of Faulkner. 12 pages
The Card Issues of Gallaher. 40 pages
The Card Issues of Hill. 28 pages
The Card Issues of Lambert & Butler. 32 pages with 25 cards illustrated
The Card Issues of Ogdens including Guinea Gold. 244 pages with 356 cards illustrated £12.50
The Card Issues of Godfrey Phillips. 40 pages with 225 cards illustrated
The Card Issues of John Player. 44 pages with 26 cards illustrated
The Card Issues of Taddy. 32 pages with 30 cards illustrated
The Card Issues of Wills. 200 pages with 559 cards illustrated
Guide Book No. 1, Ty-Phoo Tea Cards. 36 pages with 68 cards illustrated
Guide Book No. 2, F. & J. Smith Cards. 36 pages with 79 cards illustrated
Guide Book No. 3, A & BC Gum Cards. 44 pages with 29 cards illustrated (2nd edition 1994) £3.50
British Trade Card Index Part I. Pre-1945 issues, 216 pages with 423 cards illustrated £10.00
British Trade Card Index Part II. 1945-1968 issues, 232 pages with 274 cards illustrated £10.00
British Trade Card Index Part III. 1968-1986 issues, 400 pages with 480 cards illustrated £12.50
British Trade Card Index Part IV. 1986-1994 issues, 411 pages with 550 cards illustrated £20.00
Errors and Varieties in British Trade Cards. 36 pages with 33 cards illustrated
Directory of British Tobacco Issuers. 36 pages with 16 cards illustrated
Glossary of Cartophilic Terms. 40 pages with 27 cards illustrated
Brooke Bond Picture Cards — The First Forty Years. 72 pages with more than 100 colour
Illustrations £7.00

BOOKS FOR THE COLLECTOR

The Catalogue of Liebig Issues, 1999 Edition. Features around 1,500 different series (all except the earliest). This book lists each title with Fada reference, number in set, date of issue and price £3.00

FRAME YOUR CARDS

Cards displayed in frames are an eye-catching decorative feature and are ideal gifts for friends and family. Framing cards could not be easier with our special kits which give a really professional finish.

COMPLETE EMPTY FRAMES

Our frames are designed with glass on both sides so that the cards can be placed in the mount to display both fronts and backs without risk of damage. Complete kit includes wooden frame, mounting board, two sheets of glass, spring clips, etc., ready for wall display, stocked in the following sizes:

50 standard size cards	£35.00	25 large size cards	£35.00
25 standard size cards	£20.00	24 large size cards	£35.00
15 standard size cards	£16.00	20 large size cards	£32.00
10 standard size cards	£14.00	15 large size cards	£27.00
3 standard size cards	£6.50	12 large size cards	£20.00
1 standard size card	£6.50	6 large size cards	
		06.50	

1 postcard size card £6.50

MOUNTING BOARDS

Mounting boards can be purchased separately in green, black, brown or maroon as follows:

50 standard size cards	£4.25	25 large size cards	£4.25
25 standard size cards	£3.25	* 24 large size cards	£4.25
** 15 standard size cards	£2.50	* 20 large size cards	£4.25
10 standard size cards	£2.50	** 15 large size cards	£4.25
3 standard size cards	£2.00	** 12 large size cards	£3.25
1 standard size card	£2.00	6 large size cards	£2.25
		1 00 00	

1 postcard size card £2.00

* Available in black only

** Available only in green or black

POST FREE TO UK ADDRESSES, OR COLLECT FROM OUR SHOWROOM

THE MAGAZINE FOR CARD COLLECTORS OLD & NEW Save £s with up to 25% off our catalogue prices with

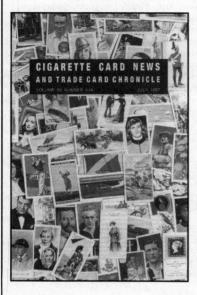

CIGARETTE CARD NEWS AND TRADE CARD CHRONICLE

Published monthly by post

Cigarette Card News was launched in 1933. The first issue cost twopence and comprised just 12 pages. It flourished and has been published continuously through peace-time and in war. In 1965 the title was changed to Cigarette Card News and Trade Card Chronicle in recognition of the growing importance of trade cards in the modern collecting world. Today's magazine maintains the traditions established in the 1930s whilst giving full coverage to all the latest new card series and developments in the hobby.

Join subscribers all over the world who find Cigarette Card News keeps them in touch with what's going on, and saves them money too!

Your subscription will cover 12 magazines posted monthly to your address

PLUS

- Save £s with Subscribers' Special Offers with up to 25% off the catalogue price of selected sets
- FREE monthly 400-lot auction catalogue. Postal bidding open to collectors from around the world. Lots to suit every collector and pocket (many lots under £10)
- FREE sample card with every issue
- Set of the Month with up to 25% off the catalogue price
- Details of new series available from stock

Inside the magazine itself you will find information about new card series, special commemorative features, interesting articles by expert contributors, research information by collectors and the compilers etc.

All this for just £17.00 a year (Europe £20.00, outside Europe £26.00) Individual specimen copies £1.40 each

We also supply **Special Magazine Binders** each designed to hold 12 copies in a choice of attractive blue or maroon covers with gold lettering.

Price £6.50 each

Available only from

THE LONDON CIGARETTE CARD CO. LTD., SUTTON ROAD, SOMERTON, SOMERSET, ENGLAND TA11 6QP

A 24-hour credit card order line is available on (01458) 273452 or send Fax (01458) 273515

AUCTIONS AND FAIRS

Saturday 2 January 1999 Postal Auction Saturday 6 February 1999 Postal Auction

Saturday 6 March 1999 at Langport Arms Hotel, Langport, Somerset

Saturday 3 April 1999 Postal Auction Saturday 1 May 1999 Postal Auction

Saturday 5 June 1999 at Eccleston Hotel, Victoria, London

Saturday 3 July 1999 Postal Auction
Saturday 7 August 1999 Postal Auction
Saturday 4 September 1999 Postal Auction
Postal Auction

Saturday 2 October 1999 at Langport Arms Hotel, Langport, Somerset

Saturday 6 November 1999 Postal Auction

Saturday 4 December 1999 at Eccleston Hotel, Victoria, London

Viewing from 10.00a.m. Auction begins 1.30p.m.

Auction catalogues available 4 weeks before date of sale free from the address below (automatically sent free to Cigarette Card News subscribers)

Also on display at the London & Somerset auctions over 2500 different sets for direct sale:

* Many hundreds of sets in mint condition from £1.50

* Selection of rare sets in top condition

* Wide range of sets in fair to good condition at half price

* Hundreds of pre-1918 odd cards and types individually priced

* The latest new issues and additions to stock

* Books, collectors' aids and albums

* Specific requirements brought for viewing if requested in advance

Free admission.

Everybody welcome.

Eccleston Hotel, Victoria, London:

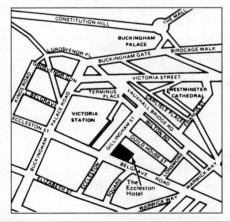

Langport Arms Hotel, Langport, Somerset:

From London: M3, A303 to junction with A37, then A372.

From the Midlands and North: M5 to junction 25, A378 to Langport.

From the South Coast: various routes to Yeovil, A37 to Ilchester, B3151 to A372 to Langport.

From the South West: M5 to junction 25, A378 to Langport.

From Bath/Bristol: use A367/A37 to junction with A303, A372 to Langport.

The Langport Arms Hotel is in the town centre adjacent to the main free car park

THE LONDON CIGARETTE CARD COMPANY LIMITED

SUTTON ROAD, SOMERTON, SOMERSET TA11 6QP, ENGLAND Telephone: (01458) 273452

Fax: (01458) 273515

LUXURY ALBUMS

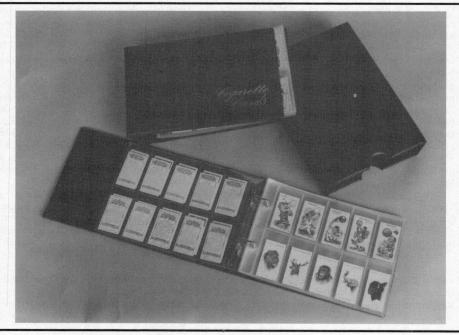

LUXURY BINDER WITH 30 LEAVES £9.00

MATCHING SLIP-CASE £3.50 (only supplied with binder) EXTRA LEAVES 15p EACH

BLACK CARD INTERLEAVES NOW AVAILABLE — 30 FOR £1.20

 ★

Full display, front and back, is given to your cards in top quality transparent leaves held in a luxurious binder. The leaves are made from a tough, clear optical film. Binders are available in a choice of blue or maroon covers (with matching slip-cases as an optional extra) and each is supplied complete with 30 leaves, of which various sizes are available as listed below.

Page		Pockets	Pocket size (mm)
Ref.	Suitable for	Per Page	wide × deep
A	Standard size cards	10	43 × 83
M	Medium size cards	8	55 × 83
D	Doncella/Grandee/Typhoo size cards	6	111×55
L	Large size cards	6	73×83
X	Extra large cards	4	111×83
P	Postcards	2	111×170
C	Cabinet size cards, booklets etc.	1	224×170
K	Miniature size cards	15	43×55

Remember to state which colour (blue or maroon) and which page reference/s you require.

Credit card ordering service (Visa, Mastercard, Eurocard) 24 hours a day, 7 days a week by telephone on (01458) 273452, by Fax on (01458) 273515 or by post from

THE LONDON CIGARETTE CARD CO. LTD, SUTTON ROAD, SOMERTON, SOMERSET, ENGLAND TA11 6QP

THE CIGARETTE CARD VIDEO

On 7 January 1993, history was made when the first ever television programme devoted entirely to cigarette cards was broadcast by HTV. And now you can buy the video, called 'Miniature Masterpieces'.

Introduced by the well-known west country personality Fred Wedlock, whose grandfather played football for Bristol City and who is featured in Ogden's 1905 series of Famous Footballers, the programme concentrates on the heyday of cigarette cards. In visits to the Wills' tobacco factory and the printers Mardon Son & Hall, we meet Eric Sampson, one of the artists who were employed in the top floor studios during the 1930s, and see some of his work. Text writer, Geoff Bennett, tells us about one of his mistakes which led to the issue of a corrected card, and we observe a modern artist, Eric Bottomley, at work on the recent series of Britain's Motoring History. Charlie Watkins, retired foreman printer at Mardons, shows us how cards were printed by chromolithography and letterpress. We see cards from many different periods — the Boer War, World War I, the 1920s and '30s, through to the famous Air Raid Precautions series, among the last to be printed by Mardons before their Caxton Works was destroyed in the blitz.

The cameras visit the London Cigarette Card Company in Somerton, and Frank Doggett demonstrates some of the more unusual cartophilic items such as silks, cards in metal frames and a record cigarette card which somehow the sound engineers actually manage to play. The film sound track cleverly uses music and historic recordings to recreate the essence of the period.

This fascinating tape was made by the production company Forum Television and plays for approximately 25 minutes. It is now available exclusively from the London Cigarette Card Company. For the technically minded, the tape is on the PAL standard (625 lines) and is suitable for playing in Great Britain and Europe (except France), Australia, New Zealand, South Africa and many other countries around the world, but not in the USA and Canada which are on the NTSC system. If in doubt, overseas collectors should seek advice. Normal copyright rules apply.

This is a unique opportunity to obtain a fascinating film which really does do justice to the subject — you will be impressed.

Price £10.50

☆ COLLECTORS' ACCESSORIES ☆

A neat and tidy way for you to deal with incomplete sets is to use our **numbered**, **printed** "wants" lists

30 adhesive lists numbered 1 to 50	75p	,
30 non-adhesive lists numbered 1 to 200	75p	,

The professional way to wrap sets for safe storage is with our translucent glascine wrapping strips

200 strips size 123×68 mm for standard size cards £2	.80
200 strips size 175×83 mm for large cards £3	.20
200 strips size 228 × 83mm for extra-large cards	.50

CARD SIZES (Applies to British issues only)

SECTION I

BRITISH CIGARETTE CARDS

INDEX OF BRANDS

The following is a list of the cases so far known where cards appear without the name of issuer, but inscribed with a brand name or other indication which is the collector's only clue to the identity of the issuer.

A INDEX OF BRANDS and initials found on British issues of cards or silks

Airmail Cigarettes — see Hill All Arms Cigarettes — see Carreras

BDV Cigarettes — see Godfrey Phillips Bandmaster Cigarettes — see Cohen, Weenen & Drapkin

Big Gun Cigarettes — see Sandorides Black Cat Cigarettes — see Carreras Blush of Day Cigarettes — see Robinson & Barnsdale

Borneo Queen Cigars — see B. Morris Broadway Novelties — see Teofani The Buffs — see Drapkin Bulldog Cigars — see Elliot

Cake Walk Cigarettes — see Pezaro
Caps The Lot — see Bewlay
Casket and Critic Cigarettes — see Pattreiouex
Castella Cigars — see W.D. & H.O. Wills
Chairman Cigarettes — see R.J. Lea
The Challenge Flat Brilliantes — see Gloag
Citamora Cigarettes — see Gloag
Club Member Cigarettes — see Pattreiouex
Club Mixture Tobaccos — see Continental
Cigarette Factory

Cohn Campbell Cigars — see Robinson & Barnsdale

Crowfoot Cigarettes — see Hill Cymax Cigarettes — see Coudens

Double Ace Cigarettes — see Ardath

Eldona Cigars — see Drapkin & Millhoff Erinmore Cigarettes — see Murray Explorer Cigars — see Drapkin & Millhoff The Favourite Magnums Cigarettes — see
Teofani
The Flor de Dindigul Cigar — see Bewlay
Forecasta — see B. Morris
Four Square — see Dobie
Fresher Cigarettes — see Challis

GP — see Godfrey Phillips
 Gainsborough Cigarettes — see Cohen Weenen
 Gala Cigarettes — issuers unknown, see under
 Miscellaneous

General Favourite Onyx — issuers unknown, see under Anonymous

Gibson Girl Virginia, Madrali Turkish and Hungarian — see Hill Gold Flake Cigarettes — see Hill

Gold Flake Cigarettes — see Hill Gold Flake, Honeydew and Navy Cut Medium

Cigarettes — see Hill

The Greys Cigarettes — see United Kingdom Tobacco Co.

Guards Cigarettes — see Carreras

Hawser, Epaulet and Honey Flake Cigarettes see Wholesale Tobacco Supply Syndicate Heart's Delight Cigarettes — see Pritchard & Burton

Imperial Tobacco Limited (Castella) — see W.D. & H.O. Wills

Jersey Lily Cigarettes — see Wm. Bradford Cigarette Job — see Societe Job Junior Member Cigarettes — see Pattreiouex

Kensitas Cigarettes — see J. Wix

Leon de Cuba Cigars — see Eldons Levant Favourites — see B. Morris Life Ray Cigarettes — see Carreras Lucana Cigarettes — see Sandorides

Manikin Cigars — see Freeman Matossian's Cigarettes — see Henley & Watkins Max Cigarettes — see A. & M. Wix Mayblossom Cigarettes — see Lambert & Butler Mills — see Amalgamated

New Orleans Tobacco - see J. & T. Hodge

Oracle Cigarettes — see Tetley

Pibroch Virginia — see Fryer
Pick-Me-Up Cigarettes — see Drapkin &
Millhoff
Pinnace — see Godfrey Phillips
Pioneer Cigarettes — see Richmond Cavendish
Polo Mild Cigarettes — see Murray
Private Seal Tobacco — see Godfrey Phillips

QV Cigars — see Webster

RS — see Robert Sinclair Reina Regenta Cigars — see B. Morris De Reszke Cigarettes — see Millhoff and Godfrey Phillips Ringers Cigarettes — see Edwards, Ringer & Bigg Roseland Cigarettes — see Glass

Senior Service Cigarettes — see Pattreiouex
Spinet Cigarettes or The Spinet House — see Hill
The Spotlight Tobaccos — see Hill
Star of the World Cigarettes — see JLS
State Express Cigarettes — see Ardath
Summit — see International Tobacco Co.
Sunripe Cigarettes — see Hill
Sunspot Cigarettes — see Theman
Sweet Alva Cigarettes — see Drapkin

TSS — see Tobacco Supply Syndicate
Tatley's Cigarettes — see Walker's Tobacco Co.
Three Bells Cigarettes — see J. & F. Bell
Tipsy Loo Cigarettes — see H.C. Lloyd
Topsy Cigarettes — see Richards & Ward
Trawler, Critic and King Lud Cigarettes — see
Pattreiouex
Turf Cigarettes — see Carreras

WTC — see Walker's Tobacco Co.

B INDEX OF INSCRIPTIONS found on British issues of cards

'The Cigarettes with which these Picture Cards are issued are manufactured in England and are Guaranteed Pure' — see Hill

'England expects that Every Man will do his duty — By Purchasing these Cigarettes you are supporting British labour' — issuers unknown, see Anonymous

'Issued with these Famous Cigarettes' - see Teofani

'Issued with these Fine Cigarettes' — see Teofani

'Issued with these High Grade Cigarettes' - see Teofani

'Issued with these Well-known Cigarettes' — see Teofani

'Issued with these World Famous Cigarettes' — see Teofani

'Presented with these well-known choice cigarettes' — see Teofani

'Smoke these cigarettes always' — see Teofani

'These Cigarettes are Guaranteed Best British Manufacture' — see Hill.

C INDEX OF OTHER INDICATIONS found on British Tobacco issues

THE B.I. Co. — see Burnstein Isaacs
Chantler & Co., Bury — see Lea
'Eagle, Cork' — see Lambkin
Agnes D. Eld, Dudley — see Lea
L. & Y. Tobacco Co. — see Lancs. and Yorks. Tobacco Manufacturing Co.
Orient Line Steamships — see Singleton & Cole
PO Box 5764, Johannesburg — see A. & M. Wix
S.C. Peacock Sales Co. — see Lea

	age Rei	ference	e Book (combined with Adkin & Anstie) available — £3.5			
Size	Print-			Handbook		Complete
	ing	in se		reference	per card	se
4			SUES POST-1920		02.60	
A	BW	50	Beauties of To-Day (1938)	Ha.514	£3.60	C25 00
4	C	25	British Butterflies (1935)	Ha.517-1	£1.00	£25.00
A	P	52	Cinema Stars Set 1 (c1933)	Ha.515-1B	£3.60	
42	U	30	Cinema Stars Set 2 (c1933)	Ha.515-2	£3.60	-
42	U	30	Cinema Stars Set 3 (c1933)		£3.60	
42	U	32	Cinema Stars Set 4 (c1933)	Ha.515-4	£2.20	£70.00
42	C	32	Cinema Stars Set 5 (c1933)		£2.20	£70.00
42	C	30	Cinema Stars Set 6 (c1933)		£3.60	
D	C	25	Feathered Friends (1935)		£1.00	£25.00
A2	C	50	Film Favourites (1934)	Ha.517-2	£3.60	
A	C	50	Film Stars (1934)		£8.00	
_	C	24	*Film Stars (128 × 89mm) (c1934)	Ha.517-3	£8.00	_
4	C	25	Old Favourites (1936) (Flowers)	Ha.517-4	80p	£20.00
A	C	40	Screen Stars (1939):			
			A Normal Abdulla back		£1.25	£50.00
			B 'Issued by the Successors to' back		£1.80	
42	C	50	Stage and Cinema Beauties (1935)	Ha.517-5	£3.60	
A	U	30	Stars of the Stage and Screen (c1934)		£3.60	
•						
В	MISCE	LLAN	NEOUS			
		? 4	Bridge Rule Cards (various sizes) (c1935)		£16.00	
	C	2	Commanders of the Allies $(127 \times 67 \text{mm})$ $(c1915)$		£60.00	-
	BW	3	Great War Gift Packings Cards (1916)		£50.00	
A	U	18	Message Cards (letters of the alphabet) (c1936)		£11.00	
					£11.00	
K2	U	18	Message Cards (letters of the alphabet) (c1936)		211.00	belt b
		K &	SON, Norwich—		211.00	605.00
AD	COC	K &	SON, Norwich—		£3.00	1-1-1-1-1
AD POS A1	COC 57-1920 U	CK & DISSU	SON, Norwich————————————————————————————————————			1-1-1-1-1
AD POS A1	COC 5T-1926 U	K & DISSU	Ancient Norwich (1928)			1-1-1-1-1
AD AD AD	COC GT-1920 U	K & DISSU 12	Ancient Norwich (1928)	.50		1-1-1-1-1
AD AD AD AD	OKIN Designer reference of the pre-19 of the	8K & DISSU 12 12 8 Serence 019 IS. 25	Ancient Norwich NE Ancient Norwich (1928) 11/12 Ancient Norwich (No. 6 missing) ONS, London book (combined with Abdulla & Anstie) available — £3. SUES *Actresses — French. Nd. 126-150 (c1898)	.50 H.1	£3.00	
AD A1 AD AD A	OKIN Dage ref PRE-19 BW C	& Solerence 019 IS. 25	Ancient Norwich NE Ancient Norwich (1928) 11/12 Ancient Norwich (No. 6 missing) ONS, London book (combined with Abdulla & Anstie) available — £3. SUES *Actresses — French. Nd. 126-150 (c1898) *Beauties 'PAC' (c1898)	.50 H.1	£3.00	
AD A1 AD AD A	OKIN Designer reference of the pre-19 of the	8K & DISSU 12 12 8 Serence 019 IS. 25	Ancient Norwich Ancient Norwich (1928)	.50 H.1 H.2	£3.00	£33.00
AD A1 AD AD A	OKIN Dage ref PRE-19 BW C	& Solerence 019 IS. 25	Ancient Norwich Norwich (1928) 11/12 Ancient Norwich (No. 6 missing) ONS, London book (combined with Abdulla & Anstie) available — £3. SUES *Actresses — French. Nd. 126-150 (c1898) *Beauties 'PAC' (c1898) Character Sketches: A Black printing on back (1901)	.50 H.1 H.2	£3.00 £140.00 £180.00	£33.00
AD AD AD AD AA AA2	OKIN OKIN Dage ref PRE-19 BW C C	& Solution 12	Ancient Norwich Norwich (1928) 11/12 Ancient Norwich (No. 6 missing) ONS, London book (combined with Abdulla & Anstie) available — £3. SUES *Actresses — French. Nd. 126-150 (c1898) *Beauties 'PAC' (c1898) Character Sketches: A Black printing on back (1901) B Green printing on back (1902)	H.1 H.2 H.3	£3.00 £140.00 £180.00	£33.00
AD AD AD AD AA AA2	OKIN Dage ref PRE-19 BW C	& Solerence 019 IS. 25	Ancient Norwich ME Ancient Norwich (1928) 11/12 Ancient Norwich (No. 6 missing) ONS, London be book (combined with Abdulla & Anstie) available — £3. SUES *Actresses — French. Nd. 126-150 (c1898) *Beauties 'PAC' (c1898) Character Sketches: A Black printing on back (1901) B Green printing on back (1902) A Living Picture (c1901):	.50 H.1 H.2	£3.00 £140.00 £180.00	£33.00
AD AD AD AD AA AA	OKIN OKIN Dage ref PRE-19 BW C C	& Solution 12	Ancient Norwich NE Ancient Norwich (1928) 11/12 Ancient Norwich (No. 6 missing) ONS, London be book (combined with Abdulla & Anstie) available — £3. SUES *Actresses — French. Nd. 126-150 (c1898) *Beauties 'PAC' (c1898) Character Sketches: A Black printing on back (1901) B Green printing on back (1902) A Living Picture (c1901): A 'Adkin & Sons' at top back	H.1 H.2 H.3	£3.00 £140.00 £180.00 £7.00	£33.00 - £85.00 £85.00
AD AD AD AD AA AA	OKIN OKIN Dage ref PRE-19 BW C C	& Solution 12	Ancient Norwich NE Ancient Norwich (1928) 11/12 Ancient Norwich (No. 6 missing) ONS, London book (combined with Abdulla & Anstie) available — £3. SUES *Actresses — French. Nd. 126-150 (c1898) *Beauties 'PAC' (c1898) Character Sketches: A Black printing on back (1901) B Green printing on back (1902) A Living Picture (c1901): A 'Adkin & Sons' at top back (i) crimson	H.1 H.2 H.3	£3.00 £140.00 £180.00 £7.00 £7.00	£85.00 £85.00 £85.00
AD AD AD AD AA AA	OKIN OKIN Dage ref PRE-19 BW C C	& Solution 12	Ancient Norwich Norwich (1928) 11/12 Ancient Norwich (No. 6 missing) Nons, London book (combined with Abdulla & Anstie) available — £3. SUES *Actresses — French. Nd. 126-150 (c1898) *Beauties 'PAC' (c1898) Character Sketches: A Black printing on back (1901) B Green printing on back (1902) A Living Picture (c1901): A 'Adkin & Sons' at top back (i) crimson (ii) scarlet	H.1 H.2 H.3	£3.00 £140.00 £180.00 £7.00 £7.00 £7.00	£85.00 £85.00 £85.00 £85.00
AD POS A1 AD A D A A2 A2	OKIN OAGE ref BW C C	EK & SI 12 12 12 12 12	Ancient Norwich Norwich (1928) 11/12 Ancient Norwich (No. 6 missing) Nons, London book (combined with Abdulla & Anstie) available — £3. SUES *Actresses — French. Nd. 126-150 (c1898) *Beauties 'PAC' (c1898) Character Sketches: A Black printing on back (1901) B Green printing on back (1902) A Living Picture (c1901): A 'Adkin & Sons' at top back (i) crimson (ii) scarlet B 'These cards are' at top back	H.1 H.2 H.3	£140.00 £180.00 £7.00 £7.00 £7.00 £7.00	£85.00 £85.00 £85.00 £85.00
AD POS A1 AD A AA2 A2	OKIN Designer ref PRE-19 BW C C C	EK & DISSU 12 12 & S General Control of the St. 25 15 12 12 25	Ancient Norwich NE Ancient Norwich (1928) 11/12 Ancient Norwich (No. 6 missing) DNS, London book (combined with Abdulla & Anstie) available — £3. SUES *Actresses — French. Nd. 126-150 (c1898) *Beauties 'PAC' (c1898) Character Sketches: A Black printing on back (1901) B Green printing on back (1902) A Living Picture (c1901): A 'Adkin & Sons' at top back (i) crimson (ii) scarlet B 'These cards are' at top back Notabilities (1915)	H.1 H.2 H.3 H.5	£3.00 £140.00 £180.00 £7.00 £7.00 £7.00 £7.00 £5.00	£85.00 £85.00 £85.00 £85.00
AD POS A1 AD A A2 A2 AA2	OKIN Dage ref PRE-19 BW C C BW C	EK & So ISSU 12 12 & S So reference 25 15 12 12 12	Ancient Norwich ME Ancient Norwich (1928) 11/12 Ancient Norwich (No. 6 missing) ONS, London be book (combined with Abdulla & Anstie) available — £3. SUES *Actresses — French. Nd. 126-150 (c1898) *Beauties 'PAC' (c1898) Character Sketches: A Black printing on back (1901) B Green printing on back (1902) A Living Picture (c1901): A 'Adkin & Sons' at top back (i) crimson (ii) scarlet B 'These cards are' at top back Notabilities (1915) Pretty Girl Series (Actresses) (c1897)	H.1 H.2 H.3 H.5	£140.00 £180.00 £7.00 £7.00 £7.00 £7.00	£85.00 £85.00 £85.00 £85.00
AD AD AD AD AA AA AA	OKIN Designer ref PRE-19 BW C C C	EK & DISSU 12 12 & S General Control of the St. 25 15 12 12 25	Ancient Norwich NE Ancient Norwich (1928) 11/12 Ancient Norwich (No. 6 missing) ONS, London book (combined with Abdulla & Anstie) available — £3. SUES *Actresses — French. Nd. 126-150 (c1898) *Beauties 'PAC' (c1898) Character Sketches: A Black printing on back (1901) B Green printing on back (1902) A Living Picture (c1901): A 'Adkin & Sons' at top back (i) crimson (ii) scarlet B 'These cards are' at top back Notabilities (1915) Pretty Girl Series (Actresses) (c1897) *Pretty Girl Series (RASH' (1897):	H.1 H.2 H.3 H.5	£3.00 £140.00 £180.00 £7.00 £7.00 £7.00 £5.00 £50.00	£85.00 £85.00 £85.00 £85.00
AD POS A1 AD A A2 A2 AA2	OKIN Dage ref PRE-19 BW C C BW C	EK & So ISSU 12 12 & S So reference 25 15 12 12 12	Ancient Norwich Norwich (1928) 11/12 Ancient Norwich (No. 6 missing) ONS, London book (combined with Abdulla & Anstie) available — £3. SUES *Actresses — French. Nd. 126-150 (c1898) *Beauties 'PAC' (c1898) Character Sketches: A Black printing on back (1901) B Green printing on back (1902) A Living Picture (c1901): A 'Adkin & Sons' at top back (i) crimson (ii) scarlet B 'These cards are' at top back Notabilities (1915) Pretty Girl Series (Actresses) (c1897) *Pretty Girl Series 'RASH' (1897): A Calendar back	H.1 H.2 H.3 H.5	£3.00 £140.00 £180.00 £7.00 £7.00 £7.00 £5.00 £50.00	£85.00 £85.00 £85.00 £85.00
AD AD AD AD AAAAAAAAAAAAAAAAAAAAAAAAAA	OKIN Dage ref PRE-19 BW C C BW C	EK & So ISSU 12 12 & S So reference 25 15 12 12 12	Ancient Norwich Norwich (1928) 11/12 Ancient Norwich (No. 6 missing) Nons, London book (combined with Abdulla & Anstie) available — £3. SUES *Actresses — French. Nd. 126-150 (c1898) *Beauties 'PAC' (c1898) Character Sketches: A Black printing on back (1901) B Green printing on back (1902) A Living Picture (c1901): A 'Adkin & Sons' at top back (i) crimson (ii) scarlet B 'These cards are' at top back Notabilities (1915) Pretty Girl Series (Actresses) (c1897) *Pretty Girl Series (RASH' (1897): A Calendar back B Advertisements back	H.1 H.2 H.3 H.5 H.6 H.7 H.8	£3.00 £140.00 £180.00 £7.00 £7.00 £7.00 £5.00 £50.00 £30.00	£85.00 £33.00 £85.00 £85.00 £85.00 £85.00
AD POS A1	OKIN Dage ref PRE-19 BW C C BW C	EK & So ISSU 12 12 & S So reference 25 15 12 12 12	Ancient Norwich Norwich (1928) 11/12 Ancient Norwich (No. 6 missing) ONS, London book (combined with Abdulla & Anstie) available — £3. SUES *Actresses — French. Nd. 126-150 (c1898) *Beauties 'PAC' (c1898) Character Sketches: A Black printing on back (1901) B Green printing on back (1902) A Living Picture (c1901): A 'Adkin & Sons' at top back (i) crimson (ii) scarlet B 'These cards are' at top back Notabilities (1915) Pretty Girl Series (Actresses) (c1897) *Pretty Girl Series 'RASH' (1897): A Calendar back	H.1 H.2 H.3 H.5 H.6 H.7 H.8	£3.00 £140.00 £180.00 £7.00 £7.00 £7.00 £5.00 £50.00	£85.00 £85.00 £85.00 £85.00

Size	Print-ing	Number in set	Handbook reference	Price per card	Complete
	BW			per cara	se
A	DW	Soldiers of the Queen (1899-1900): A Series of 50:	H.10		
		25 (a) Nos. 1-25 ' and exclusively with'		627.00	
		50 (b) Nos. 1-50 and variety ' and issued with'		£27.00	C225 00
		(-)		£4.50	£225.00
A	BW		TT 11	£4.50	01/0 0/
A	C		H.11		£160.00
A	BW			£16.00	
		25 War Trophies (1917)		£5.00	£125.00
A	C		*** 00		
A	C		H.80	£1.80	£90.00
		(1)22)	H.77	£1.60	£80.00
C 1		LLANEOUS			
	C	12 Character Sketches (premium issue) (c1901)		£80.00	-
	C	?4 *Games — by Tom Browne, postcard back (135 ×			
	-	85mm) (c1900)	H.4	£150.00	-
_	C	12 A Living Picture (premium issue) (c1900)		£80.00	-
	ATN	CWODTH H			
		SWORTH, Harrogate—			
	-1919 I				
D	C	30 *Army Pictures, Cartoons, etc (1916)	H.12	£75.00	
	DED	NE & BROMEE I			
		GE & BROMET, London—			
PRE	-1919 I	SSUES			
A	C	25 *Boer War and General Interest (c1900):	H.13		
		A 'Bridal Bouquet' and 'El Benecio' wording on			
		green leaf design back		£85.00	
		B 'La Optima' and 'Federation' wording on green		205.00	
		leaf design back		£85.00	
		C 'Bridal Bouquet' and 'El Benecio' wording on		203.00	
		brown leaf design back		£85.00	
DI	C		H.14	205.00	
		A 'Bridal Bouquet' and 'El Benecio'	11.17	£80.00	
		B 'La Optima' and 'Federation'		£80.00	
DI	C	30 *Proverbs (c1903)	Ц 15		
		20 Tioretos (C1903)	11.13	£80.00	
PH	ILLII	ALLMAN & CO. LTD, London	Latinth som		
		ISSUES			
A	C	50 Coronation Series (1953)			620.00
^	-	Pin-up Girls (1953):		60p	£30.00
A1	C				
AI	C	A First 12 subjects:			
		12 Ai Unnumbered, 'For men only'		£3.00	£36.00
		12 Aii Numbered, 'Ask for Allman always'		£3.00	£36.00
. 1		12 Aiii Unnumbered, 'Ask for Allman always'		£3.00	£36.00
A1	C	12 B Second 12 subjects		£3.50	_
A1	C	24 C Inscribed '1st series of 24'		£6.00	
	C	24 D Large size (75 × 68mm)		£3.50	
AM	ALG	AMATED TOBACCO CORPORATION LTD	('Mills' ('igarette	ac)
			(Willis (Igaretti	cs)——
4 F	C C	25 Famous British Ships 'Series No. 1' (75 × 48mm)			
	-	The series in th		15	62.00
	C	(1952)		15p	£3.00
		(1952)		15p	£3.00
		()		150	25.00

AMALGAMATED TOBACCO CORPORATION LTD ('Mills' Cigarettes) (continued)

Size	Print-ing	Num in se		Handbook reference	Price per card	Complete set
	C	50	History of Aviation (75 \times 48mm) (1952):			
_	C	50	A Nos. 1 to 16, 18 to 25 and 27		£1.80	
			B Nos. 17, 26 and 28 to 50		16p	£4.00
A	C	25	Kings of England (1954)		£1.40	£35.00
A	C	25	Propelled Weapons (1953)		15p	£3.00
	DEL L					
	EXPOR				25p	£7.50
A	C	25	Aircraft of the World (1958)		15p	£3.50
A	C	25 25	Aquarium Fish (1961)		15p	£3.50
A	C	25	Army Badges — Past and Present (1961)		60p	£15.00
A	C	25	British Coins and Costumes (1958)		24p	£6.00
A	C	25	British Locomotives (1961)		30p	£7.50
A	C	25	British Uniforms of the 19th Century (1957)		70p	£17.50
A	C	25	Butterflies and Moths (1957)		15p	£3.25
A	C	25	Cacti (1961)		32p	£8.00
A	C	25	Castles of Britain (1961)		£1.00	£25.00
A	C	25	Coins of the World (1961)		15p	£3.00
A	C	25	Communications (1961)		80p	£20.00
A	C	25	Dogs (1958)		60p	£15.00
A	C	25	Evolution of the Royal Navy (1957)		60p	£15.00
A	C	25	Football Clubs and Badges (1961)		£1.00	£25.00
A	C	25	Freshwater Fish (1958)		24p	£6.00
A	C	25	Guerriers à Travers les Ages (French text) (1961)		70p	£17.50
A	C	25	Historical Buildings (1959)		80p	£20.00
A	C	25	Histoire de l'Aviation, 1st series (French text) (1961) .		20p	£5.00
A	C	25	Histoire de l'Aviation, 2nd series (French text) (1962).		60p	£15.00
A	C	25	Holiday Resorts (1957)		15p	£2.75
A	C	25	Interesting Hobbies (1959)		40p	£10.00
A	C	25	Into Space (1958)		24p	£6.00
A	C	25	Les Autos Moderns (French text) (1961)		40p	£10.00
A	C	25	Medals of the World (1959)		20p	£5.00
A	C	25	Merchant Ships of the World (1961)		40p	£10.00
A	C	25	Merveilles Modernes (French text) (1961)		40p	£10.00
A	C	25	Miniature Cars and Scooters (1959)		£1.00	£25.00
A	C	25	Nature (1958)		15p	£2.75
A	C	25	Naval Battles (1959)		30p	£7.50
A	C	25	Ports of the World (1957)		15p	£2.75
A	C	25	Ships of the Royal Navy (1961)		30p	£7.50
A	C	25	Sports and Games (1958)		£1.00	£25.00
A	C	25	Tropical Birds (1959)		£1.00	223.00
A	C	25	Weapons of Defence (1961)		60p	£15.00
A	C	25	Wild Animals (1958)		20p	£5.00
	C	25	The Wild West (1960)		80p	£20.00
A	C	25	World Locomotives (1959)		60p	£15.00
A	C	23	world Locollouves (1939)		оор	215.00
TU	IE AN	CL	O-AMERICAN CIGARETTE MAKING	CO LTD	Londor	1
				CO. LID	London	
	E-1919			На 100	£180.00	
Α	C	20	Russo-Japanese War Series (1906)	па.100	£100.00	, talk ja ka
TOTAL	TE AN	CI	O CICADETTE MANUELCTUDING CO	Londo		
			O CIGARETTE MANUFACTURING CO	., Londoi	1———	
	PRE-19		SUES To iff Bufferer Society (1900)	Ш 16	£25.00	
A	C	36	Tariff Reform Series (1909)	п.10	125.00	_

Size	Print-			Handbook		Complete
	ing	in sei		reference	e per card	set
			book (combined with Abdulla & Adkin) available — £3.	50		
	PRE-19					
A	C	16	*British Empire Series (1904)		£11.00	£175.00
	C	8	Puzzles (26 × 70mm) (1902)		£110.00	-
_	C	5	Royal Mail (70 × 50mm) (1899)	H.19	£200.00	-
	POST-1					
A2	C	25	Aesop's Fables (1934)		£2.00	£50.00
A	BW	40	Nature Notes (1939)		£10.00	-
A	U	50	People of Africa (1926)		£3.00	£150.00
A	U	50	People of Asia (1926)		£3.00	£150.00
A	U	50	People of Europe (1925)		£3.00	£150.00
A2	BW	40	Places of Interest (1939):			
			A Varnished front		75p	£30.00
	-	50	B Unvarnished front		£1.50	£60.00
A	С	50	*Racing Series (1922): 1-25 — Racing Colours			
			1-25 — Racing Colours		£4.00	
	-		26-50 — Horses, Jockeys, Race-courses, etc		£5.00	
A	C	50	Scout Series (1923)		£2.40	£120.00
A2	C	10	Sectional Series:	Ha.519		
		10	Clifton Suspension Bridge (1938)		£2.50	£25.00
		10	Stonehenge (1936)		£2.50	£25.00
		10 20	The Victory (1936)		£2.50	£25.00
		20	Wells Cathedral (1935)		£2.00	£40.00
		10	Wilder Costs (1935)		£2.00	£40.00
A2	BW	40	Windsor Castle (1937)		£1.80	£18.00
A	U	50	Wessex (1938)		£1.25	£50.00
	SILKS.		The World's Wonders (1924)		£1.50	£75.00
		form a	nd length sizes are thus arbitrary.	ioted as the	silks were p	repared in
	C	?9	*Flags, large (width 95mm) (c1915)	He 405 1	£9.00	
	C	40	*Flags, small (width 42mm) (c1915)	Ha.495-1	£1.30	
		? 83	*Regimental Badges (width 32mm) (c1915)	Ha 405 2	Erom £1.30	
	C	. 65	*Royal Standard and Portraits (c1915):	На.495-2	From £1.20	1
		1	Royal Standard (width 61mm)	па.493-2		C15 00
		1	King George V:			£15.00
			(a) Large (width 71 mm), black frame			670.00
			(b) Large (width 71 mm), gold frame			£70.00
			(c) Small (width 15mm)		_	£60.00
		1	Queen Mary:		_	£70.00
			(a) Large (width 71 mm)			060.00
			(b) Small (width 35mm)			£60.00
		1	Lord French (width 71mm)			£75.00
		1	Lord Kitchener (width 71mm)			£85.00
		1	Lora Ruchener (wiain /1mm)			£20.00
H. /	ARCI	HER	& CO., London—			
PRE	-1919 1	SSUE	S			
C	C		*Actresses — Selection from 'FROGA A and B'			
			(c1900):	H.20		
		20	A 'Golden Returns' back		£50.00	_
		? 13	B 'M.F.H.' back		£60.00	_
C			*Beauties — 'CHOAB' (c1900):	H.21		
	U	50	A 'Bound to Win' front		£25.00	_
	C	? 5	B 'Golden Returns' back		£65.00	-
	C	?4	C 'M.F.H.' back		£65.00	<u>- 101</u>
C		20	*Prince of Wales Series (c1912)	TTOO	£25.00	

ARDATH TOBACCO CO. LTD, London

Size	Print-ing	Num in se		Handbook reference	Price per card	Complete set
28 r	age refe	rence	book available — £3.50			
			SUES. All export			
A	U U	30	Boucher Series (77 × 62mm) (c1915)		£2.60	
A1	U	40			£15.00	
AI			Franz Hals Series, Dutch back (c1916)			
A 1	U	30	Gainsborough Series (77 \times 62mm) (c1915)		£2.60	Marine 1770
A1	U	50	Great War Series (c1916)		£5.00	- 1 - 1 - - 1
A1	U	50	Great War Series 'B' (c1916)		£5.00	
A1	U	50	Great War Series 'C' (c1916)		£5.00	
-	U	25	A First 25 subjects		£15.00	_
_	U	25	B Second 25 subjects		£15.00	_
_	U	30	Raphael Series (77 × 62mm) (c1915)		£2.60	_
	U		Rembrandt Series (1914):			
		30	A Large size $(77 \times 62 \text{ mm})$, English back		£3.50	T
		40	B Large size $(77 \times 62 \text{mm})$, Dutch back		£16.00	
		30	C Extra-large size (101 × 62mm)		£5.00	- 10 Table
<u> </u>	U	30	Rubens Series $(77 \times 61 \text{ mm})$ (c1915):			
			A English 'State Express' back		£2.60	
			B English 'Winfred' back		£15.00	
			C Dutch back		£15.00	_
			D New Zealand 'State Express' back		£15.00	_
	U	30	Valasquez Series (c1915):		215.00	
1 5867	C	50	A Large size (77 × 62mm)		£3.50	
			B Extra-large size (101 × 62mm)		£5.00	
					25.00	
			ON-PHOTOGRAPHIC ISSUES	** ***		
A1	C	50	*Animals at the Zoo (export) (c1924):	Ha.520		
			A Back with descriptive text		£2.20	_
			B Back without description, 'Double Ace' issue		£15.00	_
A	C	96	Ardath Modern School Atlas (export) (c1935)		£1.30	
A	C	25	Big Game Hunting (export) (c1930):			
			A Back in blue		£3.00	_
			B Back in black		£12.00	_
A	U	50.	Britain's Defenders (1936)		70p	£35.00
	U	50	British Born Film Stars (export) (1934):		F	
A2	Ü	20	A Small size, back white semi-glossy		£1.40	_
A2			B Small size, back cream matt		£1.40	
AZ			C Medium size (67 × 53mm)		£2.50	
77	U		Camera Studies (c1939):		22.50	
	U	36			£1.00	£36.00
11-75		45				
1 1 20	0		B Large size $(79 \times 57 \text{mm})$		£1.00	£45.00
_	C	25	Champion Dogs (95 × 67mm) (1934)		£1.20	£30.00
A	C	50	Cricket, Tennis and Golf Celebrities (1935):		21.20	0.00.00
			A Home issue, grey back B Export issue, brownish-grey back, text		£1.20	£60.00
	**	25	revised		£1.80	£90.00
-	U	25	Dog Studies $(95 \times 68 \text{mm}) (1938) \dots$	** **	£3.20	£80.00
A	C	25	Eastern Proverbs (export) (c1930)	Ha.521	£1.40	£35.00
A	C	48	Empire Flying-Boat (sectional) (1938)		£1.50	£75.00
A	C	50	Empire Personalities (1937)		60p	£30.00
A	C	50	Famous Film Stars (1934)		80p	£40.00
A	C	50	Famous Footballers (1934)		£1.20	£60.00
A	C	25	Famous Scots (1935)		£1.20	£30.00
_	C	25	Fighting and Civil Aircraft (96 × 68mm) (1936)		£1.80	£45.00
			Figures of Speech (1936)			
A	C	50	rigures of Speech (1930)		70p	£35.00

ARDATH TOBACCO CO. LTD, London (continued)

111	DILL	1 10.	Breed ed. Erb, Ediddi (commucu)			
Size	Print-ing	Num in se		Handbook reference	Price per card	Complete set
_	C	25	Film, Stage and Radio Stars (96 × 68mm) (1935)		£1.20	£30.00
	C	50	From Screen and Stage $(96 \times 65 \text{mm}) (1936) \dots$		80p	£40.00
A	U	50	Life in the Services (1938):			
		-	A Home issue, adhesive		70p	£35.00
			B Export issue, non-adhesive		£1.20	£60.00
A	C	50	National Fitness (1938):		21.20	200.00
Λ	-	50	A Home issue, adhesive		50p	£25.00
			B Export issue, non-adhesive			£40.00
A	U	50		He 522	80p	
A	C	30	Our Empire (export) (c1937)	Ha.322	£1.20	£60.00
A	C	25	A Home issue Nos 1-25		90-	620.00
		25	P. Franct issue Nos 1-25		80p	£20.00
	**		B Export issue Nos 26-50		£1.80	
	U	100	Scenes from Big Films (export) (1935):		01.60	
A			A Small size, white back		£1.60	
A			B Small size, cream back		£1.60	_
_	_		C Medium Size (67 × 52mm)		£3.50	_
A	C	50	Silver Jubilee (1935)		70p	£35.00
A	C	50	Speed — Land, Sea and Air (1935):			
			A Home issue, 'Issued with State Express'		£1.20	£60.00
			B Export issue, Ardath name at base		£1.60	_
_	C	25	Speed — Land, Sea and Air $(95 \times 68 \text{mm}) (1938) \dots$		£1.20	£30.00
A	C	50	Sports Champions (1935):			
			A Home issue, 'State Express' at base		90p	£45.00
			B Export issue, 'Ardath' at base		£1.60	£80.00
A	C	50	Stamps — Rare and Interesting (1939)		£1.30	£65.00
A	C	50	Swimming, Diving and Life-Saving (1937) (export)	Ha.523	£1.40	_
A	C	50	Tennis (1937) (export)	Ha.524	£1.60	_
A	C	48	Trooping the Colour (sectional) (1939)		£1.80	£90.00
A	C	50	Who is This? (1936) (Film Stars)		£1.80	£90.00
	BW	24	World Views (No. 13 not issued) $(95 \times 68 \text{mm})$ (1937) .		32p	£8.00
A	C	50	Your Birthday Tells Your Fortune (1937)		60p	£30.00
C	POST-	1920 P	PHOTOGRAPHIC ISSUES			
A2	P	54	Beautiful English Women (1928) (export)		£3.00	<u> </u>
A2	P	35	Hand Shadows (c1930) (export)		£18.00	_
A2	CP	50	New Zealand Views (1928) (export)		£2.50	
H	P		Photocards — Numbered Series (1936)*:		22.00	
		110	'A' — Football Clubs of Lancashire		£1.10	£120.00
		110	'B' — Football Clubs of North East Counties		£1.10	£120.00
		110	'C' — Football Clubs of Yorkshire		£1.10	£120.00
		165	'D' — Football Clubs of Scotland		90p	£150.00
		110	'E' — Football Clubs of Midlands		£1.10	£120.00
		110	'F' — Football Clubs of London and Southern Counties			
		99	'Z' — General Interest (Sports):		90p	£100.00
		99			50	007.00
			Nos. 111-165		50p	£27.00
		11	Nos. 166-209 (Cricket etc)		50p	£22.00
		11	'A.s' (1), 'C.s' (2-3), 'E.s' (4-10), 'F.s' (11) — Football		00.00	005.60
**	D		Clubs (supplementary)		£3.20	£35.00
Н	P		Photocards — 'A Continuous Series of Topical Interest'	** ***		
		00	(1937):	Ha.525		
		22	Group A — Racehorses and Sports		65p	£14.00
		22	Group B — Coronation and Sports		-	£35.00
			21 Different (minus Walter Neusel)		70p	£14.00
		22	Group C — Lancashire Personalities		-	£42.00
			21 Different (minus Gracie Fields)		£1.00	£21.00
		22	Group D — Sports and Miscellaneous		£1.10	£24.00

ARDATH TOBACCO CO. LTD, London (continued)

Size	Print-ing	Num in se		Handbook reference	Price per card	Complete set
		22	Group E — Film Stars and Sports		£1.00	£22.00
		22	Group F — Film Stars and Sportsmen		£1.00	£22.00
		66	'G.S.' — Miscellaneous subjects (export)		£2.00	
H	P		Photocards — 'A Continuous Series of General			
			interest', with album offer (1938):	Ha.526		
		11	Group G — Australian Cricketers		£18.00	_
		22	Group H — Film, Radio and Sporting Stars		£1.00	£22.00
		22	Group I — Film Stars and Miscellaneous		£1.20	£26.00
	P		Photocards — 'A Continuous Series of General	11 505		
		22	Interest', without album offer — uncoloured (1938):	Ha.527	70	015.00
H		22	Group J — Film Stars and General Interest		70p	£15.00
п		22	Group K — Film, Radio and Sporting Stars: 1 With 'Kings' Clause		£1.00	£22.00
			2 Without 'Kings' Clause (export)		£1.00	£26.00
Н		44	Group L — Film Stars and Miscellaneous		60p	£26.00
11		45	Group M — Film Stars and Miscellaneous:		оор	220.00
C		73	1 Small size		80p	£36.00
_			2 Large size $(80 \times 69 \text{ mm})$, with 'Kings' Clause		80p	£36.00
			3 Large size (80×69 mm), without 'Kings' Clause		80p	£36.00
	P	45	Group N — Film, Stage and Radio Stars:		оор	
C			1 Small size		80p	£36.00
_			2 Large size (80 × 69mm)		80p	£36.00
Н	CP		Photocards — 'A Continuous Series of General			
			Interest', without album offer - Hand coloured			
			(export) (1938):	Ha.528		
		22	Group 1 — Views of the World		80p	£17.50
		22	Group 2 — Views of the World		80p	£17.50
		22	Group 3 — Views of the World		80p	£17.50
			Real Photographs:			
	P	45	Group O — 'A Continuous Series of General		14	
	_		Interest' — Films, Stage and Radio Stars (1939)	Ha.529	70p	£32.00
C	P	45	'1st Series of 45' — Film and Stage Stars (1939)		£1.00	- -
C	P	54	'2nd Series of 54' — Film and Stage Stars (1939)		£1.00	-
J2	P	18	'First Series' — Views (1937)		£2.20	
J2 J2	P P	18 18	'Second Series' — Film and Stage Stars (1937)		£2.20 £2.20	
J2	P	18	'Third Series' — Views (1937) 'Fourth Series' — Film and Stage Stars (1937)		£2.20	
J2	P	18	'Fifth Series' — Views (1938)		£2.20	1,400
J2	P	18	'Sixth Series' — Film and Stage Stars (1938)		£2.20	
H	P	44	'Series One' 'G.P.1' — Film Stars (export) (1939)		80p	£35.00
Н	P	44	'Series Two' 'G.P.2' — Film Stars (export) (1939)		27p	£12.00
Н	P	44	'Series Three' 'G.P.3' — Film Stars (export) (1939)		£2.20	_
H	CP	44	'Series Three' 'C.V.3' — Views (export) (1939)		80p	£35.00
H	CP	44	'Series Four' 'C.V.4' — Views (export) (1939)		27p	£12.00
J2	P	36	'Series Seven' — Film and Stage Stars (1938)		90p	
J2	Ρ.	54	'Series Eight' — Film and Stage Stars (1938)		60p	£32.00
1 250	P	54	'Series Nine' — Film and Stage Stars (1938):			100
H			A Medium size		60p	£32.00
J2	D	E 4	B Extra-large size		60p	£32.00
	P	54	'Series Ten' — Film and Stage Stars (1939):			022.00
J2			A Large size (80 × 69mm)		60p	£32.00
32	P	54			60p	£32.00
	r	34	'Series Eleven' — Film and Stage Stars (1939): A Large size (80 × 69mm)		60r	£32.00
J2			B Extra-large size		60p 90p	£32.00
32			2 ZAMA IMIGO SIZO		эор	

AR	DATH	I TO	BACCO CO. LTD, London (continued)			
Size	Print-ing	Num in se		Handbook reference	Price per card	Complete set
-	P	54	'Series Twelve' — Film and Stage Stars (80 × 69mm) (1939)		60p	£32.00
-	P	54	'Series Thirteen' — Film and Stage Stars (80×69 mm) (1939)		60p	£32.00
	P	36	'Of Famous Landmarks' (1939):		оор	202.00
			A Large size (80 × 69 mm), titled 'Real Photographs'		£2.75	1
	J2		B Extra-large size, titled 'Real Photographs of Famous Landmarks'		£1.50	£55.00
	P	36	'Of Modern Aircraft' (1939): A Large size (80 × 69mm)		£3.00	_
J2			B Extra-large size		£2.00	
D	MISCE	ELLAN	NEOUS			
-	C	30	Girls of All Nations (78 × 66mm) (c1916)		£15.00	_
		25	Historic Grand Slams (folders) (101 × 70mm) (c1935)		£20.00	-
J2	U	48	How to Recognise the Service Ranks (holed for			
			binding) (c1939)		£3.50	
			Industrial Propaganda Cards (c1942):			
H1	U	2	A Black fronts		£4.00	£8.00
H1	C	4	B Coloured fronts		£5.00	£20.00
J2	BW	11	C White fronts		£3.60	£40.00
J2	U	150	Information Slips (holed for binding) (1938)		£2.25	<u> </u>
J2	U	5	A Calendar — 'It all depends on me'		£2.50	£12.50
			B Greeting Card — 'It all depends on me'		£5.00	
_	C	24	C 'It all depends on me' $(80 \times 63 \text{mm}) \dots$		£1.25	£30.00
-	C	1	D Union Jack Folder (59 × 41mm)			£10.00
100	C	1	E 'On the Cotton Front' (80 × 63mm)		<u> </u>	£2.00
100	BW	1	F 'On the Kitchen Front' (70 × 55mm)		<u></u>	£2.00
J2	U	? 4	Wonderful Handicraft (c1935)		£18.00	
	E AS		CIATED TOBACCO MANUFACTURERS	LTD—	1 1 1 1 1 1 1 1	
C2	C	25	Cinema Stars (export) (c1926):	Ha.530		
			A 'Issued with Bond Street Turkish Cigarettes'		£25.00	
			B 'Issued with John Bull Virginia Cigarettes'		£25.00	
			C 'Issued with Club Virginia Cigarettes'		£25.00	
			D 'Issued with Heliopolis Turkish Cigarettes'		£25.00	<u> </u>
			E 'Issued with Sports Turkish Cigarettes'		£25.00	-
Α.	ATKI	INSC	ON, London—			
D	E-1919 . C	30	*Army Pictures, Cartoons, etc (c1916)	H.12	£75.00	124 5
437	TCC D	PDO'	ГНERS LTD, London————		30.2	
				er player and	7 8	
PRE D1	E-1919 . C	ISSUL 40	*Naval and Military Phrases (c1904)	H.14	£75.00	4 (C)1 .4
J.A	. BA	ILE	Y, Swansea—			11.11.11.11
ppi	2-1919	ICCIII	7			
D1		40	*Naval and Military Phrases (c1904)	H.14	£130.00	

Size	Print-	- Num in se		Handbook reference	Price per card	Complete set
				rejerence	per curu	sei
	E-1919			11.00		
A	BW	20	*Actresses — 'BLARM'(c1900):	H.23	625.00	
			A Long design back (64mm)		£25.00	-
			B Design altered and shortened (58mm)	****	£25.00	0050 00
A	BW	10	*Actresses — 'HAGGA' (c1900)		£25.00	£250.00
	BW		*Actresses 'Baker's 3-sizes' (c1900):	H.25	625.00	
A		25	Small cards		£25.00	1
		25	Medium cards (56 × 75mm)		£35.00	- 1 - 1 - 1 - 1 - 1 - 1 - 1 - 1 - 1 - 1
_	DIII	?9	Extra large cards (67 × 127mm)	11.06	£180.00	
C	BW	? 41	*Baker's Tobacconists' Shops (c1901):	H.26	0160.00	
			A 'Try our 3½d Tobaccos' back		£160.00	8 - S - 1 - 1 - 1 - 1 - 1 - 1 - 1 - 1 - 1
		25	B 'Cigar, Cigarette, etc. Manufacturers' back	11.27	£110.00	-
C	C	25	Beauties of All Nations (c1900):	H.27	C15 00	C275 00
			A 'Albert Baker & Co. (1898)' back		£15.00	£375.00
_	DIII		B 'A. Baker & Co' back	11.00	£10.00	£250.00
С.	BW	16	*British Royal Family (c1902)		£45.00	1 1 W 01
A1	$_{\rm BW}$	20	Cricketers Series (1901)		£250.00	_
A 1	C	25	*Star Girls (c1898)	H.30	£130.00	
RA	YLE	V &	HOLDSWORTH—			
	E-1919					
A	С	26	*International Signalling Code (c1910)		£140.00	, 4 - 4 <u>11.</u>
	-					
E.	C. BE	EST	ON, Wales—			
PRI	C. BE E-1919 C			H.12	£75.00	
PRI D	E-1919 C	ISSUE 30	*Army Pictures, Cartoons etc (c1916)	H.12	£75.00	-
PRI D	E-1919 C	ISSUE 30		H.12	£75.00	
PRI D BE	E-1919 C	ISSUE 30 ST SI	*Army Pictures, Cartoons etc (c1916)	H.12	£75.00	
PRI D BE	E-1919 C LFAS	ISSUE 30 ST SI	*Army Pictures, Cartoons etc (c1916)		£75.00	
PRI D BE	E-1919 C LFAS E-1919 C	ISSUE 30 ST SI ISSUE 1	*Army Pictures, Cartoons etc (c1916) HIPS STORES CO. LTD, Belfast— *Dickens' Characters (79 × 40mm) (c1895)			31 x
PRI D BE PRI J. o	E-1919 C LFAS E-1919 C & F. 1	ST SI ISSUE 1 BELI	*Army Pictures, Cartoons etc (c1916) HIPS STORES CO. LTD, Belfast *Dickens' Characters (79 × 40mm) (c1895)			/ 31 x
PRI BE PRI J. o	E-1919 C LFAS E-1919 C & F. 1	ST SI ISSUE 1 BELI ISSUE	*Army Pictures, Cartoons etc (c1916) HIPS STORES CO. LTD, Belfast *Dickens' Characters (79 × 40mm) (c1895) L LTD, Glasgow ES			4 3 1 ×
BE PRI	E-1919 C LFAS E-1919 C & F. 1	ST SI ISSUE 1 BELI	*Army Pictures, Cartoons etc (c1916)	H.31	£225.00	/ 38 1
PRI D BE PRI J. (E-1919 C LFAS E-1919 C & F. 1 E-1919 BW	ISSUE 30 ST SI ISSUE 1 BELI ISSUE 10	*Army Pictures, Cartoons etc (c1916)	H.31		7 387 1
PRI D BE PRI J. (E-1919 C LFAS E-1919 C & F. 1	ST SI ISSUE 1 BELI ISSUE	*Army Pictures, Cartoons etc (c1916) *HIPS STORES CO. LTD, Belfast *Dickens' Characters (79 × 40mm) (c1895) L LTD, Glasgow *S *Actresses — 'HAGGA' ('Three Bells Cigarettes) (c1900) *Beauties — Tobacco Leaf Back (c1898):	H.31	£225.00	
PRI D BE PRI J. (E-1919 C LFAS E-1919 C & F. 1 E-1919 BW	ISSUE 30 ST SI ISSUE 1 BELI ISSUE 10	*Army Pictures, Cartoons etc (c1916) HIPS STORES CO. LTD, Belfast *Dickens' Characters (79 × 40mm) (c1895) L LTD, Glasgow *S *Actresses — 'HAGGA' ('Three Bells Cigarettes) (c1900) *Beauties — Tobacco Leaf Back (c1898): A 'Bell's Scotia Cigarettes' back	H.31	£225.00 £70.00 £90.00	
PRID BE PRI J. 6 PRI A	E-1919 C LFAS E-1919 C & F. 1 E-1919 BW	ISSUE 30 ST SI ISSUE 1 BELI ISSUE 10 25	*Army Pictures, Cartoons etc (c1916)	H.31	£225.00 £70.00 £90.00 £90.00	
PRIDO BEE	E-1919 C LFAS E-1919 C & F. 1 E-1919 BW C	ISSUE 30 ST SI ISSUE 1 BELI ISSUE 10 25	*Army Pictures, Cartoons etc (c1916) *HIPS STORES CO. LTD, Belfast *Dickens' Characters (79 × 40mm) (c1895) *LTD, Glasgow ES *Actresses — 'HAGGA' ('Three Bells Cigarettes) (c1900) *Beauties — Tobacco Leaf Back (c1898): A 'Bell's Scotia Cigarettes' back	H.31	£225.00 £70.00 £90.00 £90.00 £35.00	
BE PRI	E-1919 C LFAS E-1919 C & F. 1 E-1919 BW C	ST SI ISSUE 1 1 1 1 1 1 1 1 1 1 1 1 1 1 1 1 1 1 1	*Army Pictures, Cartoons etc (c1916) *HIPS STORES CO. LTD, Belfast *Dickens' Characters (79 × 40mm) (c1895) *L LTD, Glasgow *S *Actresses — 'HAGGA' ('Three Bells Cigarettes) (c1900) *Beauties — Tobacco Leaf Back (c1898): A 'Bell's Scotia Cigarettes' back B 'Three Bells Cigarettes' back Colonial Series (c1901) *Footballers (c1902)	H.31 H.24 H.32	£225.00 £70.00 £90.00 £90.00 £35.00 £45.00	5200.00
BE PRI	E-1919 C LFAS E-1919 C & F. 1 E-1919 BW C	ISSUE 30 ST SI ISSUE 1 BELI ISSUE 10 25	*Army Pictures, Cartoons etc (c1916) *HIPS STORES CO. LTD, Belfast *Dickens' Characters (79 × 40mm) (c1895) *LTD, Glasgow ES *Actresses — 'HAGGA' ('Three Bells Cigarettes) (c1900) *Beauties — Tobacco Leaf Back (c1898): A 'Bell's Scotia Cigarettes' back	H.31 H.24 H.32	£225.00 £70.00 £90.00 £90.00 £35.00	£300.00
PRIDD BE PRIDA C AAAA	E-1919 C LFAS E-1919 C & F. I E-1919 BW C	ST SI ISSUE 1 1 1 1 1 1 1 1 1 1 1 1 1 1 1 1 1 1 1	*Army Pictures, Cartoons etc (c1916) *HIPS STORES CO. LTD, Belfast *Dickens' Characters (79 × 40mm) (c1895) *L LTD, Glasgow *S *Actresses — 'HAGGA' ('Three Bells Cigarettes) (c1900) *Beauties — Tobacco Leaf Back (c1898): A 'Bell's Scotia Cigarettes' back B 'Three Bells Cigarettes' back Colonial Series (c1901) *Footballers (c1902) Scottish Clan Series No. 1 (c1903)	H.31 H.24 H.32	£225.00 £70.00 £90.00 £90.00 £35.00 £45.00	£300.00
PRID BE PRI J. C A A A B.	E-1919 C LFAS E-1919 C & F. 1 E-1919 BW C	ST SI ISSUE 1 1 1 2 5 2 5 30 2 5 LWO	*Army Pictures, Cartoons etc (c1916) *HIPS STORES CO. LTD, Belfast *Dickens' Characters (79 × 40mm) (c1895) *L LTD, Glasgow *SS *Actresses — 'HAGGA' ('Three Bells Cigarettes) (c1900) *Beauties — Tobacco Leaf Back (c1898): A 'Bell's Scotia Cigarettes' back B 'Three Bells Cigarettes' back Colonial Series (c1901) *Footballers (c1902) Scottish Clan Series No. 1 (c1903)	H.31 H.24 H.32	£225.00 £70.00 £90.00 £90.00 £35.00 £45.00	£300.00
PRID BE PRI J. G A A A B PRI B B B B B B B B B B B B B	E-1919 C LFAS E-1919 C & F. I E-1919 BW C	ST SI ISSUE 1 1 1 2 5 2 5 30 2 5 LWO	*Army Pictures, Cartoons etc (c1916) *HIPS STORES CO. LTD, Belfast *Dickens' Characters (79 × 40mm) (c1895) *L LTD, Glasgow *SS *Actresses — 'HAGGA' ('Three Bells Cigarettes) (c1900) *Beauties — Tobacco Leaf Back (c1898): A 'Bell's Scotia Cigarettes' back B 'Three Bells Cigarettes' back Colonial Series (c1901) *Footballers (c1902) Scottish Clan Series No. 1 (c1903)	H.31 H.24 H.32	£225.00 £70.00 £90.00 £90.00 £35.00 £45.00	£300.00
PRID BE PRI J. G A A A A C B. PRI C	E-1919 C LFAS E-1919 C & F. 1 E-1919 BW C C BELLI E-1919 C	ST SI ISSUE 1 BELI ISSUE 10 25 25 25 25 LWO ISSUE 18	*Army Pictures, Cartoons etc (c1916) *HIPS STORES CO. LTD, Belfast *Dickens' Characters (79 × 40mm) (c1895) *L LTD, Glasgow *S *Actresses — 'HAGGA' ('Three Bells Cigarettes) (c1900) *Beauties — Tobacco Leaf Back (c1898): A 'Bell's Scotia Cigarettes' back B 'Three Bells Cigarettes' back Colonial Series (c1901) *Footballers (c1902) Scottish Clan Series No. 1 (c1903) OD, BRADFORD Motor Cycle Series (c1912)	H.31 H.24 H.32 H.33	£225.00 £70.00 £90.00 £90.00 £35.00 £45.00 £12.00	£300.00
PRID BE PRID J. G PRID A A A A A A A A A A A A A A A A A A	E-1919 C LFAS E-1919 C & F. I E-1919 BW C BELIE E-1919 C CHA	ST SI ISSUE 1 BELI ISSUE 10 25 25 25 25 LWO ISSUE 18	*Army Pictures, Cartoons etc (c1916) *HIPS STORES CO. LTD, Belfast *Dickens' Characters (79 × 40mm) (c1895) *L LTD, Glasgow *S *Actresses — 'HAGGA' ('Three Bells Cigarettes) (c1900) *Beauties — Tobacco Leaf Back (c1898): A 'Bell's Scotia Cigarettes' back B 'Three Bells Cigarettes' back Colonial Series (c1901) *Footballers (c1902) Scottish Clan Series No. 1 (c1903) OD, BRADFORD Motor Cycle Series (c1912) *BENSON LTD, Bristol—	H.31 H.24 H.32 H.33	£225.00 £70.00 £90.00 £90.00 £35.00 £45.00 £12.00	£300.00
PRID BE PRID J. G PRID A A A A A A A A A A A A A A A A A A	E-1919 C LFAS E-1919 C & F. I E-1919 BW C BELI E-1919 C CHAI	ISSUE 30 ST SI ISSUE 10 25 25 30 25 LWO ISSUE 18 RD E	*Army Pictures, Cartoons etc (c1916) *HIPS STORES CO. LTD, Belfast *Dickens' Characters (79 × 40mm) (c1895) *L LTD, Glasgow ES *Actresses — 'HAGGA' ('Three Bells Cigarettes) (c1900) *Beauties — Tobacco Leaf Back (c1898): A 'Bell's Scotia Cigarettes' back B 'Three Bells Cigarettes' back Colonial Series (c1901) *Footballers (c1902) Scottish Clan Series No. 1 (c1903) OD, BRADFORD Motor Cycle Series (c1912) BENSON LTD, Bristol—	H.31 H.24 H.32 H.33	£225.00 £70.00 £90.00 £90.00 £35.00 £45.00 £12.00	£300.00
PRID BE PRI J. C A A A A A A A A A A A A A A A A A A	E-1919 C LFAS E-1919 C & F. I E-1919 BW C BELIE E-1919 C CHA	ST SI ISSUE 1 BELI ISSUE 10 25 25 25 25 LWO ISSUE 18	*Army Pictures, Cartoons etc (c1916) *HIPS STORES CO. LTD, Belfast *Dickens' Characters (79 × 40mm) (c1895) *L LTD, Glasgow ES *Actresses — 'HAGGA' ('Three Bells Cigarettes) (c1900) *Beauties — Tobacco Leaf Back (c1898): A 'Bell's Scotia Cigarettes' back B 'Three Bells Cigarettes' back Colonial Series (c1901) *Footballers (c1902) Scottish Clan Series No. 1 (c1903) OD, BRADFORD Motor Cycle Series (c1912) BENSON LTD, Bristol E Old Bristol Series:	H.31 H.24 H.32 H.33	£70.00 £90.00 £90.00 £35.00 £45.00 £12.00	
PRID BE PRI J. C A A A A A A A A A A A A A A A A A A	E-1919 C LFAS E-1919 C & F. I E-1919 BW C BELI E-1919 C CHAI	ISSUE 30 ST SI ISSUE 10 25 25 30 25 LWO ISSUE 18 RD E	*Army Pictures, Cartoons etc (c1916) *HIPS STORES CO. LTD, Belfast *Dickens' Characters (79 × 40mm) (c1895) *L LTD, Glasgow ES *Actresses — 'HAGGA' ('Three Bells Cigarettes) (c1900) *Beauties — Tobacco Leaf Back (c1898): A 'Bell's Scotia Cigarettes' back B 'Three Bells Cigarettes' back Colonial Series (c1901) *Footballers (c1902) Scottish Clan Series No. 1 (c1903) OD, BRADFORD Motor Cycle Series (c1912) BENSON LTD, Bristol—	H.31 H.24 H.32 H.33	£225.00 £70.00 £90.00 £90.00 £35.00 £45.00 £12.00	£300.00

BE	NSO	N &	HEDGES, London		وأنسمت	
	Print-ing		ber	Handbook reference	Price per card	Complete set
POS	T-1940	ISSU	VE			
A2		1	Advertisement Card, The Original Shop (1973)		-	£2.00
FE	LIX	BER	LYN, Manchester—		100	44.0
PRE	E-1919	ISSIII	7			
	C	25	Golfing Series (Humorous) (c1910):			
A1			A Small size		£300.00	_
			B Post card size $(139 \times 87 \text{mm})$		£400.00	
BE	RRY	Lor	ndon		1904 (00	94-1795
D	E-1919 U	? 1		H.34	£140.00	a se i <u>L</u>
BE	WLA	Y &	CO. LTD, London			
	E-1919					
D1	U	13301	Rewlay's War Series (Generals, etc.) (c1915):	Ha.477		
		12	A 'Caps the Lot' Smoking Mixture		£11.00	A 4 1 6
		6	B Iry Bewlay's Caps the Lot Mixture		£11.00	sterio
		6	C Try Bewlay's 'Modern Man' Mixture		£11.00	
D1	U	25	Bewlay's War Series (Photogravure War Pictures)			
			(c1915):	H.35	011.00	
			A 'Modern Man' Mixtures etc		£11.00	
			B 'Modern Man' Cigarettes		£11.00 £11.00	
A	C	?6	C 'Two Great Favourites'* *Comic Advertisement Cards (1909)	H.36	£200.00	
W.	O. BI	GG	& CO., Bristol			
A	E-1919 C	37	*Flags of All Nations (c1904):	H.37		
Α	C	31	A 'Statue of Liberty' back, 4d oz	П.37	£7.00	
			B As A:— (a) altered to 4½d by hand		£7.00	
			(b) 4½d red seal over 4d		£7.50	
			C Panel design 'New York' Mixture		£7.50	<u> </u>
Α	C	50	Life on Board a Man of War (c1905)	H.38	£9.00	£450.00
IA	S. BI	GGS	& SONS, London—			
C	E-1919 C	26	*Actresses — 'FROGA A' 'Two Roses' in white			
-	C	20	(c1900)	H.20	£35.00	
C	C	25	*Actresses — 'FROGA A & B' 'Two Roses' in black			
A	C		(c1900)*Beauties, with frameline — 'CHOAB' (c1900):	H.20 H.21	£55.00	
A	C	25	A Blue typeset back	П.21	£65.00	
		?8	B Overprinted in black on Bradford cards		£60.00	
C	C	. 0	*Beauties, no framelines — selection 'BOCCA'		200.00	
			(c1900):	H.39		
		25	A Blue back		£65.00	
		25	B Black back		£65.00	
C	C	30	*Colonial Troops (c1901)	H.40	£30.00	_
C	C	30	*Flags and Flags with Soldiers (c1903)	H.41	£25.00	_
A1	C	25	*Star Girls (c1900)	H.30	£150.00	_

Size Print Number n set Price Price Complete net n set Price Price Price Price P	J. S. BILLINGHAM, Northampton			-
D C 30 *Army Pictures, Cartoons etc (c1916)	Size Print- Number			
D C 30 *Army Pictures, Cartoons etc (c1916)	PRF-1919 ISSUE		a slikelina	
POST-1920 ISSUE		H.12	£75.00	_
BLANKS CIGARETTES	R. BINNS, Halifax—		-	
BLANKS CIGARETTES				
### POST-1920 ISSUE A C 50 Keystrokes in Break-Building (c1935)	A U ? 6 *Halifax Footballers (c1924)	Ha.531	£100.00	7 4
THE BOCNAL TOBACCO CO., London— **POST-1920 ISSUES** A2 U 25 Luminous Silhouettes of Beauty and Charm (1938)	BLANKS CIGARETTES—			
### THE BOCNAL TOBACCO CO., London— **POST-1920 ISSUES** A2 U 25				
POST-1920 ISSUES	A C 50 Keystrokes in Break-Building (c1935)		£175.00	
A2 U 25 Luminous Silhouettes of Beauty and Charm (1938) £2.20 £55.00 A2 C 25 Proverbs Up-to-Date (1938) £2.20 £55.00 ALEXANDER BOGUSLAVSKY LTD, London POST-1920 ISSUES - C 12 Big Events on the Turf (133 × 70mm) (1924) £35.00 - A Back in black, white board £6.00 - B Back in green £6.00 - C Back in green £6.00 - B Back in green £6.00 - C Back in green £6.00 - C Back in green £6.00 - E40.00 - E40.00 - B Small size, captions 'sans serif' £3.00 £75.00 - C Large size £5.00 - R. & E. BOYD LTD, London POST-1920 ISSUES - U 25 Places of Interest (c1938): A Size 67 × 35mm £40.00 - B Size 71 × 55mm £40.00 - B Size 71 × 55mm £40.00 - WM. BRADFORD, Liverpool PRE-1919 ISSUES C C 50 *Beauties 'CHOAB' (c1900) Ha.488 £170.00 - DU ?7 Beauties 'GHOAB' (c1900) Ha.498 £170	THE BOCNAL TOBACCO CO., London—			
ALEXANDER BOGUSLAVSKY LTD, London POST-1920 ISSUES — C 12 Big Events on the Turf (133 × 70mm) (1924) £35.00 — A 2 C 25 Conan Doyle Characters (1923): — A Back in Dakek, white board £6.00 — — B Back in grey, cream board £6.00 — — C Back in green . £6.00 — — C Back in green . £6.00 — — C Back in green . £6.00 — A C 25 *Sports Records, Nd. 1-25 (1925) £1.40 £35.00 — C 25 Winners on the Turf (1925) £1.40 £35.00 — C 25 Winners on the Turf (1925): A A A Samall size, captions 'sans serif' £3.00 £75.00 B Small size, captions with 'serif' £4.00 — B C Large size £5.00 — R. & E. BOYD LTD, London— POST-1920 ISSUES — U 25 Places of Interest (c1938): A Size 67 × 35mm £40.00 — B Size 71 × 55mm £40.00 — WM. BRADFORD, Liverpool— PRE-1919 ISSUES C C 50 *Beauties 'CHOAB' (c1900) Ha.488 £170.00 — D U ?7 Beauties — 'Jersey Lily Cigarettes' (e1900) Ha.488 £170.00 — D U ?7 Beauties — 'Jersey Lily Cigarettes' (e1900) Ha.488 £170.00 — D U ?7 Beauties — 'Jersey Lily Cigarettes' (e1900) Ha.488 £170.00 — D U ?7 Beauties — 'Jersey Lily Cigarettes' (e1900) Ha.488 £170.00 — D U ?7 Beauties — 'Jersey Lily Cigarettes' (e1900) Ha.488 £170.00 — D U ?7 Beauties — 'Jersey Lily Cigarettes' (e1900) Ha.488 £170.00 — D U ?7 Beauties — 'Jersey Lily Cigarettes' (e1900) Ha.488 £170.00 — D U ?7 Beauties — 'Jersey Lily Cigarettes' (e1900) Ha.488 £170.00 — D U ?7 Beauties — 'Jersey Lily Cigarettes' (e1900) Ha.488 £170.00 — D U ?7 Beauties — 'Jersey Lily Cigarettes' (e1900) Ha.488 £170.00 — D U ?7 Beauties — 'Jersey Lily Cigarettes' (e1900) Ha.488 £170.00 — D U ?7 Beauties — 'Jersey Lily Cigarettes' (e1900) Ha.488 £170.00 — D U ?7 Beauties — 'Jersey Lily Cigarettes' (e1900) Ha.488 £170.00 — B Red Virginia £30.00 — C Sweet as the Rose £30.00 —	POST-1920 ISSUES			
### ALEXANDER BOGUSLAVSKY LTD, London ### POST-1920 ISSUES ### C 12 Big Events on the Turf (133 × 70mm) (1924) ### £35.00				
POST-1920 ISSUES — C 12 Big Events on the Turf (133 × 70mm) (1924) £35.00 — A2 C 25 Conan Doyle Characters (1923): — A Back in black, white board £6.00 — B Back in grey, cream board £6.00 — C Back in green £6.00 — A2 C 25 Mythological Gods and Goddesses (1924) £1.60 £40.00 — £35.00 £40.00 — £35.00 £35.00 £35.00 £35.00 £35.00 £35.00 £35.00 £35.00 £35.00 £35.00 £35.00 £35.00 £35.00 £35.00 £35.00 £75.00 £35.00 £75.00 £35.00 £75.00 £30.00 £75.00 £30.00 £75.00 £30.00 £75.00 £30.00 £75.00 £30.00 £75.00 £30.00 £75.00 £30.00 £75.00 £30.00 £75.00 £40.00 — £5.00 — R. & E. BOYD LTD, London E80.00 E90.00	A2 C 25 Proverbs Up-to-Date (1938)		£2.20	£55.00
— C 12 Big Events on the Turf (133 × 70mm) (1924)	ALEXANDER BOGUSLAVSKY LTD, London———	NAT CARACT		
A2 C 25 Conan Doyle Characters (1923): A Back in black, white board	POST-1920 ISSUES			
A Back in black, white board B Back in grey, cream board C Back in green C Back in green C Back in green A C 25 Mythological Gods and Goddesses (1924) A C 25 *Sports Records, Nd. 1-25 (1925) A C 25 Sports Records, Nd. 1-25 (1925) A C 25 Winners on the Turf (1925) A A Small size, captions 'sans serif' A Small size, captions with 'serif' B C Large size C Large size C Large size A Size 67 × 35mm A Size 67 × 35mm B Size 71 × 55mm C U 25 Wild Birds at Home (75 × 57mm) (c1938) B Size 71 × 55mm C U 25 Wild Birds at Home (75 × 57mm) (c1938) B Size 71 × 55mm C C So *Beauties 'CHOAB' (c1900) B C C So *Beauties - 'Jersey Lily Cigarettes' (c1900) B C C So *CO, London PRE-1919 ISSUES C C 30 *Colonial Troops (c1901): B Red Virginia A Golf Club Mixture B Red Virginia C Sweet as the Rose B Red Virginia C Sweet as the Rose B Size 67 × 350.00 C Sweet as the Rose B Red Virginia C Sweet as the Rose B Red Virginia C Sweet as the Rose B C So *Bacuties G So C So So C So C So C So C So C So C			£35.00	_
B Back in grey, cream board			06.00	
C Back in green				- -
A2 C 25 Mythological Gods and Goddesses (1924)				
A C 25 *Sports Records, Nd. 1-25 (1925)				£40.00
C 25 Winners on the Turf (1925): A A Small size, captions 'sans serif' £3.00 £75.00 A B Small size, captions with 'serif' £4.00 — B C Large size £5.00 — R. & E. BOYD LTD, London— POST-1920 ISSUES — U 25 Places of Interest (c1938): A Size 67 × 35mm £40.00 — B Size 71 × 55mm £40.00 — WM. BRADFORD, Liverpool— PRE-1919 ISSUES C C 50 *Beauties 'CHOAB' (c1900) Ha.626 £40.00 — D U ?7 Beauties—'Jersey Lily Cigarettes' (c1900) Ha.488 £170.00 — D2 BW 20 Boer War Cartoons (c1901) H.42 £85.00 — T. BRANKSTON & CO., London— PRE-1919 ISSUES C C 30 *Colonial Troops (c1901): H.40 A Golf Club Mixture £30.00 — B Red Virginia £30.00 — C Sweet as the Rose £30.00 —				£35.00
A A Small size, captions 'sans serif' £3.00 £75.00 A B Small size, captions with 'serif' £4.00 — B C Large size £5.00 — R. & E. BOYD LTD, London— POST-1920 ISSUES — U 25 Places of Interest (c1938): A Size 67 × 35mm £40.00 — B Size 71 × 55mm £40.00 — B Size 71 × 55mm £40.00 — WM. BRADFORD, Liverpool— PRE-1919 ISSUES C C 50 *Beauties 'CHOAB' (c1900) Ha.626 £40.00 — D U ?7 Beauties — 'Jersey Lily Cigarettes' (c1900) Ha.488 £170.00 — D2 BW 20 Boer War Cartoons (c1901) Ha.48 £85.00 — T. BRANKSTON & CO., London— PRE-1919 ISSUES C C 30 *Colonial Troops (c1901): H.40 A Golf Club Mixture £30.00 — B Red Virginia £30.00 — C Sweet as the Rose £30.00 —			£1.40	£35.00
A B Small size, captions with 'serif'	C 25 Winners on the Turf (1925):		c2 00	C75.00
B C Large size	A Small size, captions sans serif			£/3.00
POST-1920 ISSUES — U 25 Places of Interest (c1938): £40.00 — — B Size 67 × 35mm £40.00 — — U 25 Wild Birds at Home (75 × 57mm) (c1938) Ha.626 £40.00 — WM. BRADFORD, Liverpool PRE-1919 ISSUES C C 50 *Beauties 'CHOAB' (c1900) H.21 £27.00 — — D U ? 7 Beauties — 'Jersey Lily Cigarettes' (c1900) Ha.488 £170.00 — — D2 BW 20 Boer War Cartoons (c1901) H.42 £85.00 — — T. BRANKSTON & CO., London PRE-1919 ISSUES C C 30 *Colonial Troops (c1901): H.40 A Golf Club Mixture £30.00 — B Red Virginia £30.00 — C Sweet as the Rose £30.00 —				3 2
POST-1920 ISSUES — U 25 Places of Interest (c1938): £40.00 — — B Size 67 × 35mm £40.00 — — U 25 Wild Birds at Home (75 × 57mm) (c1938) Ha.626 £40.00 — WM. BRADFORD, Liverpool PRE-1919 ISSUES C C 50 *Beauties 'CHOAB' (c1900) H.21 £27.00 — — D U ? 7 Beauties — 'Jersey Lily Cigarettes' (c1900) Ha.488 £170.00 — — D2 BW 20 Boer War Cartoons (c1901) H.42 £85.00 — — T. BRANKSTON & CO., London PRE-1919 ISSUES C C 30 *Colonial Troops (c1901): H.40 A Golf Club Mixture £30.00 — B Red Virginia £30.00 — C Sweet as the Rose £30.00 —	R. & E. BOYD LTD, London			
— U 25 Places of Interest (c1938):	점심하다 그리고 보고 있었다. 그리고 그리고 있는 그리고 있는 그리고 있는 그리고 있는 그리고 있는 것이 없다.			
A Size 67 × 35mm				
			£40.00	_
WM. BRADFORD, Liverpool— PRE-1919 ISSUES C C 50 *Beauties 'CHOAB' (c1900) H.21 £27.00 — D U ? 7 Beauties — 'Jersey Lily Cigarettes' (c1900) Ha.488 £170.00 — D2 BW 20 Boer War Cartoons (c1901) H.42 £85.00 — T. BRANKSTON & CO., London— PRE-1919 ISSUES C C 30 *Colonial Troops (c1901): H.40 A Golf Club Mixture £30.00 — B Red Virginia £30.00 — C Sweet as the Rose £30.00 —				i va i
PRE-1919 ISSUES C C 50 *Beauties 'CHOAB' (c1900) H.21 £27.00 — D U ? 7 Beauties — 'Jersey Lily Cigarettes' (c1900) Ha.488 £170.00 — D2 BW 20 Boer War Cartoons (c1901) H.42 £85.00 — T. BRANKSTON & CO., London PRE-1919 ISSUES C C 30 *Colonial Troops (c1901): H.40	— U 25 Wild Birds at Home (75 × 57mm) (c1938)	Ha.626	£40.00	101.55
C C 50 *Beauties 'CHOAB' (c1900)	WM. BRADFORD, Liverpool			
C C 50 *Beauties 'CHOAB' (c1900)	PRE-1919 ISSUES			
D2 BW 20 Boer War Cartoons (c1901) H.42 £85.00 — T. BRANKSTON & CO., London PRE-1919 ISSUES C C 30 *Colonial Troops (c1901): H.40 A Golf Club Mixture £30.00 — B Red Virginia £30.00 — C Sweet as the Rose £30.00 —		H.21	£27.00	_
T. BRANKSTON & CO., London PRE-1919 ISSUES C C 30 *Colonial Troops (c1901): H.40 A Golf Club Mixture £30.00 — B Red Virginia £30.00 — C Sweet as the Rose £30.00 —				_
PRE-1919 ISSUES C C 30 *Colonial Troops (c1901): H.40 A Golf Club Mixture £30.00 — B Red Virginia £30.00 — C Sweet as the Rose £30.00 —	D2 BW 20 Boer War Cartoons (c1901)	H.42	£85.00	· ·
C C 30 *Colonial Troops (c1901): H.40 A Golf Club Mixture £30.00 — B Red Virginia £30.00 — C Sweet as the Rose £30.00 —	T. BRANKSTON & CO., London—	Theretaka y	-	
C C 30 *Colonial Troops (c1901): H.40 A Golf Club Mixture £30.00 — B Red Virginia £30.00 — C Sweet as the Rose £30.00 —	PRE-1919 ISSUES			
B Red Virginia	C C 30 *Colonial Troops (c1901):	H.40		
C Sweet as the Rose£30.00 —				_
A2 C 12 *Pretty Girl Series 'RASH' (c1900)				7
	A2 C 12 *Pretty Girl Series 'RASH' (c1900)	H.8		1 / 1

BR	IGHA	MA &	& CO., Reading—		the a say	
Size	Print-ing	Num in se		Handbook reference	Price per card	Complete set
	-1919					
B A	U	16 16	Down the Thames from Henley to Windsor (c1912)			-
_	BW	3	Reading Football Players (c1912)		£140.00 £15.00	£45.00
BR	ITAN	NIA	ANONYMOUS SOCIETY			
PRE	-1919	SSUE				
-	C	? 19	*Beauties and Scenes (60×40 mm) (c1914)	Ha.532	£75.00	
BR	ITISI	% H	COLONIAL TOBACCO CO., London—			
	-1919					
A1	C	25	*Armies of the World (c1900)	H.43	£100.00	- -
J.M	I. BR	OW	N, Derby—			
PRE	-1919	SSUE				
D	C	30	*Army Pictures, Cartoons etc (c1916)	H.12	£75.00	-
JO	HN B	RUN	MFIT, London—————			principle.
POS	T-1920	ISSU	E			
A	C	50	The Public Schools' Ties Series (Old Boys) (1925)		£3.00	£150.00
G.A	. BU	LLC	OUGH, Castleford—————			
PRE	-1919	SSUE				
D	C	30	*Army Pictures, Cartoons etc (c1916)	H.12	£75.00	<u> </u>
BU	RSTI	EIN,	ISAACS & CO., London			
			npany, B.I. & Co. Ltd)			
D	T-1920 BW	25			05.00	
D	BW	25	Famous Prize-Fighters, Nd. 1-25 (1923) Famous Prize-Fighters, Nd. 26-50 (1924)		£5.00 £5.00	
D	P	28	London View Series (1922)		£4.00	<u> </u>
BY	RTW	001	O & CO., Bristol			- 4
	-1919					
A2		25	*Pretty Girl Series — 'BAGG' (c1900)	H.45	£120.00	_
CA	BANA	A CIO	GAR CO., London			
	-1919					
	BW	1	Advertisement Card — 'Little Manturios'			
			(63 × 49mm) (1905)			£180.00
PE	RCY	E. C	ADLE & CO. LTD, Cardiff	100 M		
	-1919					
A1	BW	20	*Actresses 'BLARM' (c1900)	H.23	£30.00	97 A 1
C	U	26	*Actresses — 'FROGA A' (c1900):			
			A Printed Back		£35.00	-
C	C	26	B Rubber — Stamped Back *Actresses — 'FROGA B' (c1900)	H 20	£125.00 £45.00	- 1 T
C	BW	12	*Boer War and Boxer Rebellion Sketches (c1901)	H.46	£45.00 £40.00	
C	BW	10	*Boer War Generals — 'FLAC' (c1901)	H.47	£60.00	
A	BW	20	*Footballers (c1904)		£40.00	

Size	Print-	Numb	per	Handbook	Price	Complete
	ing	in set		reference	per card	set
A	PRE-19	19 ISS	CUES			
_	C		*Flags of the Allies (shaped) (c1915):	H.49		
		1	1 Grouped Flags:			
			A 'All Arms' Cigarettes		£40.00	10.0
			B 'Black Cat' Cigarettes		£40.00	_
		5	2 Allies Flags:			
			A 'Black Cat' Cigarettes		£40.00	-
			B 'Life Ray' Cigarettes		£75.00	_
A	C	140	Raemaeker's War Cartoons (1916):			1000
			A 'Black Cat' Cigarettes		£1.10	£155.00
			B Carreras Cigarettes		£3.50	
A	C	50	The Science of Boxing (c1916):		11-73-	
			A 'Black Cat' back		£2.50	£125.00
			B 'Carreras Ltd' back		£3.50	
A	C	80	Types of London (1919)		£1.25	£100.00
A	C	50	Women on War Work (c1916)		£6.00	£300.00
В	POST-1	920 IS	SUES. Mostly home issues, export only issues indicated			
A	CP	24	Actresses and Their Pets (1926) (export)		£4.00	******** ***
	C	48	Alice in Wonderland (1930):			
A			A Small size, rounded corners		£1.35	£65.00
A			B Small size, square corners		£2.80	
B2			C Large size		£1.60	£80.00
		1	D Instruction Booklet		_	£15.00
A	C	50	Amusing Tricks and How to Do Them (1937)		70p	£35.00
97.	C		Battle of Waterloo (1934):	Ha.533		
C		1	1 Paper insert, with instructions		_	£9.00
_		15	*2 Soldiers and Guns, large size (67 × 70mm)		£3.00	
A			*3 Soldiers and Guns, small size:			
		10	Soldiers — Officers' Uniforms		£1.50	
		12	Soldiers and Guns		£1.50	-
C1	C	50	Believe it or Not (1934)		50p	£25.00
A	C	50	Birds of the Countryside (1939)		80p	£40.00
A	C	50	Britain's Defences (1938)		60p	£30.00
	C	25	British Costumes (1927):		•	
C2			A Small size		£1.20	£30.00
B2			B Large size		£1.20	£30.00
A	P	27	British Prime Ministers (1928) (export)		£1.30	£35.00
A1	C	1	Calendar for 1934		_	£20.00
A	C	50	Celebrities of British History (1935):			
			A Brown on cream back (two shades of ink)		90p	£45.00
			B Pale brown on bluish black		90p	£45.00
A	C	25	Christie Comedy Girls (1928) (export)		£1.60	£40.00
A	Ü	20	Cricketers (1934):			
	0	30	A 'A Series of Cricketers'		£3.00	£90.00
		50	B 'A Series of 50 Cricketers':			
		50	1 Front in brown and white		£3.20	£160.00
			2 Front in black and white		£35.00	- 1 - 1 - 1 - 1 - 1 - 1 - 1 - 1 - 1 - 1
A	BW	50	Dogs and Friend (1936)		28p	£14.00
A	C	50	Do You Know? (1939)		22p	£11.00
A	C	50	Famous Airmen and Airwomen (1936)		£1.40	£70.00
	C	20	Famous Escapes (1926):			
A	_	25	A Small size		£1.20	£30.00
B2		25	B Large size		£1.20	£30.00
-		10	C Extra-large size (133 × 70mm)		£2.20	£22.00
		96	Famous Film Stars (1935)		£1.00	£95.00

CARRERAS LTD, London (continued)

	Print-ing			Handbook reference	Price per card	Complete
Α	C		Famous Footballers (1935):		7	
A	-	48	A Set of 48		C1 10	CEE 00
		24	B Nos. 25-48 redrawn		£1.10	£55.00
Α	C	25			£1.50	£36.00
B2	P	24	Famous Men (1927) (export)		£1.20	£30.00
A VITTOR OF			Famous Naval Men (1929) (export)		£1.20	£30.00
B2	P	12	Famous Soldiers (1928) (export)		£5.00	£60.00
A	P	27	Famous Women (1929) (export)		£1.20	£32.00
A	C	25	Figures of Fiction (1924)		£1.60	£40.00
	P	54	Film and Stage Beauties (1939):			
A2 —			A Small size		40p	£22.00
			(a) Without full point after 'Carreras Ltd'		50p	£27.00
	-		(b) With full point after 'Carreras Ltd		50p	£27.00
	P	36	Film and Stage Beauties:			
B1			A Large size (1939)		75p	£27.00
J2			B Extra-large size (1938)		£1.00	£36.00
A	C	50	Film Favourites (1938)		£1.00	£50.00
A	P	54	Film Stars — 'A Series of 54' (1937)		75p	£40.00
	P	54	Film Stars (1938):			
A			A Small size, 'Second Series of 54'		50p	£27.00
_			B Medium size $(68 \times 60 \text{mm})$, 'A Series of 54'		85p	£45.00
J2	P		Film Stars (export):			
		36	'A Series of 36' (c1935)		£2.50	-
		36	'Second Series of 36' (c1936)		£2.50	-
		36	'Third Series of 36' (c1937)		£2.50	
		36	'Fourth Series of 36' (c1938)		£2.50	_
A2	C	50	Film Stars, by Florence Desmond (1936)		80p	£40.00
-		72	Film Stars, oval $(70 \times 30 \text{mm})$ (1934):			
	P		A Inscribed 'Real Photos'		£2.00	_
	U		B Without 'Real Photos'		£1.25	£90.00
A	C	50	Flowers (1936)		50p	£25.00
A2	C	75	*Footballers (1934):			
			A 'Carreras Cigarettes' on front 27mm long		£1.40	£105.00
			B 'Carreras Cigarettes' on front 26mm long		£1.40	£105.00
	C	36	'Fortune Telling' (1926):			
A			A Small size:			
			1 Card inset		44p	£16.00
			2a Head inset, black framelines		30p	£11.00
			2b Head inset, brown framelines		75p	£27.00
B2			B Large size:			
			1 Card inset		30p	£11.00
			2 Head inset		44p	£16.00
		1	Instruction Booklet		_	£8.00
	P		Glamour Girls of Stage and Films (1939):			
A2		54	A Small size		45p	£25.00
-		54	B Medium size (70 × 60mm)		45p	£25.00
_		36	C Large size (76 × 70mm)		£1.00	£36.00
J2		36	D Extra-large size		£1.25	£45.00
	C	50	'Gran-Pop' by Lawson Wood (1934):			
C1			A Small size		35p	£17.50
В			B Large size		35p	£17.50
	C	52	Greyhound Racing Game (1926):		ээр	217.50
Α			A Small size		25p	£12.50
B2			B Large size		25p 25p	£12.50
		1	C Instruction Leaflet		23p	£9.00
						29.00

CARRERAS LTD, London (continued)

Size	Print-ing	Num in se		Handbook reference	Price per card	Complete set
	C	48	Happy Family (1925):			
A1			A Small size		32p	£16.00
B2			B Large size		30p	£15.00
A	C	25	Highwaymen (1924)		£2.00	£50.00
A	C	50	History of Army Uniforms (1937)		£1.00	£50.00
					90p	£45.00
A	C	50	History of Naval Uniforms (1937)			
A		25	A Small size		£1.60	£40.00
B2		20	B Large size		£1.60	£32.00
_		10	C Extra-large size (133 × 70mm)		£2.80	£28.00
	C	50	Kings and Queens of England (1935):			
A			A Small size		£1.30	£65.00
B2			B Large size		£2.00	£100.00
A	U	50	A 'Kodak' at the Zoo 'Series of Fifty' (1924)		60p	£30.00
A	Ü	50	A 'Kodak' at the Zoo '2nd Series' (1925)		60p	£30.00
A	P	27	Malayan Industries (1929) (export)		40p	£11.00
A	P	24			чор	211.00
	Р	24	Malayan Scenes (1928):		£2.00	£50.00
A			A Small size			
-			B Medium size $(70 \times 60 \text{mm}) \dots \dots$		60p	£15.00
_	C	53 50	*Miniature Playing Cards $(44 \times 32 \text{mm})$ (c1935) The 'Nose' Game (1927):		18p	£9.00
Α.		30	A Small size		40p	£20.00
A B2			B Large size		40p	£20.00
D2		1			40 p	£9.00
	_	1	C Instruction Leaflet		_	19.00
	C	50	Notable MPs (1929):		00	040.00
A			A Small size		80p	£40.00
_			B Medium size $(69 \times 60 \text{mm})$		50p	£25.00
A	P	25	Notable Ships — Past and Present (1929) (export)		£1.20	£30.00
	C		Old Staffordshire Figures (1926):			
A		24	A Small size		£1.25	£30.00
_		12	B Extra-large size $(134 \times 71 \text{mm})$		£2.50	£30.00
В	C	24	Old Staffordshire Figures (different subjects) (1926)		£1.50	£36.00
	C	24	Orchids (1925):			
A	C	24	A Small size		£1.00	£25.00
B					£1.00	£25.00
ь					£3.00	£75.00
-			C Extra-large size $(133 \times 70 \text{mm})$	II. 526	23.00	273.00
A	C	••	Our Navy (1937):	Ha.536	C1 00	c20.00
		20	A Thick card, selected numbers		£1.00	£20.00
		50	B Thin card		£1.00	£50.00
C1	C	50	Palmistry (1933)		40p	£20.00
A	P	27	Paramount Stars (1929) (export)		£1.00	£27.00
A	C	25	Picture Puzzle Series (1923)		£1.40	£35.00
_	C	53	Playing Cards (68 × 42mm) (c1925)	Ha.535-1A	£1.20	_
	C		*Playing Cards and Dominoes (1929):	Ha.535-IB		
C		52	A Small size — (a) Numbered		30p	£15.00
		-	(b) Unnumbered		30p	£15.00
		26	B Large size $(77 \times 69 \text{mm})$:			
			(a) Numbered		40p	£10.00
			(b) Unnumbered		40p	£10.00
A	C	48	Popular Footballers (1936):			
			A White back		90p	£45.00
			B Cream back		90p	£45.00
13 5	C		Popular Personalities, oval (70 × 30mm) (1935):	Ha.629	- 7	
		72	1 Normal issue		70p	£50.00
		10	2 Replaced subjects (Nos. 1-10) for issue in Eire		£20.00	250.00
		10	2 Replaced subjects (1908, 1-10) for issue iii Elfe		220.00	

CARRERAS LTD, London (continued)

Size		t- Nun	nber	Handbook Price	Complete
	ing	in se		reference per card	sei
	C		Races — Historic and Modern (1927):		
A		25	A Small size	£2.00	£50.00
В		25	B Large size		£50.00
_		12	C Extra-large size (133 × 69mm)		£50.00
	C		Regalia Series (1925):		
A		25	A Small size	50p	£12.50
В		20	B Large size	60p	£12.00
		10	C Extra-large size (135 × 71mm)	£2.00	£20.00
	C	50	'Round the World' Scenic Models (folders) (83 ×		
	C		73mm) (c1930)	60p	£30.00
A		50	A Small size	80p	£40.00
В		40	B Large size	75p	£30.00
_		20	C Extra-large size (134 × 76mm)		
C1	C	48	Tapestry Reproductions of Famous Paintings (sectional)	£2.00	£40.00
CI	-	40	(1938)	60p	£30.00
A	C	50	Tools — And How to Use Them (1935)	80p	£40.00
A	P	27	Views of London (1929) (export)		
A	P	27	Views of the World (1927) (export)	30p	£8.00
A	C	25	Wild Flower Art Series (1022)	75p	£20.00
			Wild Flower Art Series (1923)	£1.10	£27.50
A	U	50	British Aircraft (1953)	00-	C45 00
A	U	50	Pritich Fish (1054)	90p	£45.00
A	U	50	British Fish (1954)	40p	£20.00
			British Railway Locomotives (1952)	£1.20	£60.00
A	U	50	Celebrities of British History (1951)	£1.20	£60.00
A	U	50	Famous British Fliers (1956)	£3.00	
A	U	50	Famous Cricketers (1950)	£4.50	-
A	U	50	Famous Dog Breeds (1952)	£1.60	£80.00
A	U	50	Famous Film Stars (1949)	£2.00	
A	U	50	Famous Footballers (1951)	£2.80	-
A	U	50	Film Favourites (1948)	£2.80	
A	U	50	Film Stars (1947)	£2.00	
A	U	50	Footballers (1948)	£3.00	
A	U	50	Olympics (1948)	£3.00	
A	U	50	Radio Celebrities (1950)	£1.20	£60.00
A	U	50	Sports Series (1949)	£2.00	<u> </u>
A	U	50	Zoo Animals (1955)	40p	£20.00
(N.F	3. The	se price	es are for the full slides. If only the cut slides are required t	hese will be half Catalog	gue price.)
D	POST	1940 1	ISSUES	COLUMN TO THE PARTY OF THE PART	
A	C	50	British Birds (1976)	15p	£3.75
A	C	50	Flowers All the Year Round (1977)	20p	£10.00
A	C	50	Kings and Queens of England (1977)	25p	£12.50
A	C	50	Military Uniforms (1976)	15p	£3.75
A	C	50	Palmistry (1980)	£1.00	25.72
A	C	50	Sport Fish (1978)	15p	£3.75
A	C	50	Vintage Cars (1976):		23.75
		50	A With word 'Filter' in white oval:		
			i Thin card, bright red oblong at top	18p	£9.00
				15p	£7.50
			iii Thin card, dull red oblong at top	15p	27.50
			B Without word 'Filter' in white oval	30p	C4 50
E	MISC	ELLAN	NEOUS PRE-1919 ISSUES	15p	£4.50
D1	BW	5	The Black Cat Handy French-English Dictionary		
			(Booklets) (1915)	£20.00	_
D1	BW		The Black Cat Library (Booklets) (c1910)		
_	_	?	Lace Motifs (c1915) (various sizes)		
			HOLEN BESTERNEN (1987년 1일) HELD (1987년 1987년		

CARRERAS I	LTD, London (continued)			
Size Print- Num ing in se		Handbook reference	Price per card	Complete set
F MISCELLAN	VEOUS POST-1940 ISSUES			
A C 60 — C	Flags of All Nations (unissued) (c1960)		40p	£24.00
4	A Military Mug Series (1971)		80p	_
8	B Order Up the Guards (1970)		80p	_
16	C Send for the Guards (1969)		80p	-
— C 7	Millionaire Competition Folders (68 × 30mm) (1971)		£1.50	£10.00
A U 50	Radio & Television Favourites (unissued) (c1965)		£8.00	_
G SILKS — C 12	Miscellaneous Series Cabinet size (1915)		£160.00	
CARRICK &	k CO., Hull	i series		
PRE-1919 ISSUE D C 12	*Military Terms (1901)	H.50	£55.00	_
P. J. CARRO	OLL & CO. LTD, Dundalk, Glasgow and	Liverpool		
A PRE-1919 IS	SUFS			
D C 25	British Naval Series (c1915)	H.51	£36.00	_
A P 20	County Louth G.R.A. Team and Officials (1913)		£24.00	
D BW 25	*Derby Winners (1914-15):	H.52		
	A Back in black		£80.00	_
	B Back in green		£80.00	
B POST-1920 I.	SSUES			
D C 25	Ship Series (1937)		£5.00	£125.00
D U 24	Sweet Afton Jig-Saw Puzzles (1935)		£18.00	_
C MISCELLAN	VEOUS			
D C 25	Birds (prepared but not issued) (c1940)	Ha.537	65p	£16.00
THE CASKI	ET TOBACCO & CIGARETTE CO. LTD	, Manche	ster	
PRE-1919 ISSUE	ES .			
A2 U ?2	Cricket Fixture Cards, Coupon back (1905-06)		£250.00	_
A2 U 1	Cyclists Lighting-up Table (1909)		_	£200.00
A2 U ?11	*Football Fixture Cards, Coupon back (1905-11)	H.53	£200.00	-
A2 BW ?2	Road Maps (c1910)	H.54	£200.00	- 14 .
S CAVANDI	ER & CO., London and Portsea	175 (25) 48 -	colonies.	11 1 35
PRE-1919 ISSUE D BW ? 3	*Beauties — selection from 'Plums' (1898)	H.186	£180.00	5 % s - '
CAVANDER	S LTD, London and Glasgow—			10 8
POST-1920 ISSU				
	Ancient Chinese (1926)		£1.00	£25.00
A C 25 A C 25	Ancient Egypt (1928)		£1.00	£25.00
B C 25	Ancient Egypt (1928)		£1.00	£25.00
A P 36	Animal Studies (1936)		40p	£14.00
CP 50	Beauty Spots of Great Britain (1927):			
Α	A Small size		25p	£12.50
	B Medium size (76 × 52mm)		25p	£12.50
CP	Camera Studies (1926):			
A 54	A Small size		20p	£10.00
_ 56	B Medium size (77 × 51mm)		25p	£12.50
A C 30	Cinema Stars — Set 6 (1934)	Ha.515	£1.10	£33.00

CAVANDERS LTD, London (continued)

Size	Printing	- Num in se		Handbook reference	Price per card	Complete set
	CP	30	The Colonial Series $(77 \times 51 \text{mm})$ (1925) :	rejerence	per cura	50.
	Ci	30	A Small caption, under lmm high		10n	612.00
			B Larger caption, over lmm high		40p 40p	£12.00 £12.00
_	C	25	Coloured Stereoscopic (77 × 51mm) (1931)		50p	£12.00
D	C	25	Feathered Friends or Foreign Birds (1926):	Ha.516	ЗОР	123.00
			A Titled 'Feathered Friends'	114.510	£2.00	
			B Titled 'Foreign Birds'		£1.40	£35.00
_	C	258	Glorious Britain (76 × 51mm) (1930)		40p	£20.00
			The Homeland Series (1924-26):	Ha.539	400	220.00
A			Small size:	114.557		
	CP	50	A Back in blue		80p	£40.00
	CP	50	B Back in black, glossy front		80p	£40.00
	CP	54	C Back in black, matt front		30p	£15.00
			Medium size $(77 \times 51 \text{mm})$:			410.00
	CP	50	D Back inscribed 'Hand Coloured Real Photos'		18p	£9.00
	CP	56	E As D, with 'Reprinted' at base		32p	£17.50
	CP	56	F As D, but words 'Hand Coloured' dropped		32p	£17.50
	P	56	G As D, but words 'Hand Coloured' dropped		32p	£17.50
A	C	25	Little Friends (1924)	Ha.540	£1.00	£25.00
_	C	25	The Nation's Treasures $(77 \times 51 \text{mm}) (1925) \dots$		50p	£12.50
-	P	260	Peeps into Many Lands — 'A Series of' (1927):			
D		36§	A Small size		35p	£25.00
-		36§	B Medium size $(75 \times 50 \text{mm})$		50p	£36.00
1	P	36	C Extra-large size (113 × 68mm)		£1.80	_
D	Р	36§	Peeps into Many Lands — 'Second Series' (1928):			
D			A Small size		50p	£36.00
	P	248	B Medium size (75 × 50mm)		50p	£36.00
D	1	248	Peeps into Many Lands — 'Third Series' (1929): A Small size			
D					32p	£16.00
					70p	£35.00
			-, Reprinted by Special		70	025.00
	P	24§	Request'		70p	£35.00
	•	248	(1930):			
D			A Small size		40	620.00
_			B Medium size (75 × 50mm)		40p	£20.00
_	P			Ho 541	60p	£30.00
		30	*Photographs (54 × 38mm) (1924): 1 Animal Studies	Ha.541	C1 20	640.00
		3	2 Royal Family		£1.30	£40.00
_	C	48	Regimental Standards (76 × 70mm) (c1924)	He 502 7	£3.30	- 10 T
C	C	25	Reproductions of Celebrated Oil Paintings (1925)	Ha.502-7	£10.00	C25 00
	CP	108	River Valleys (1926):	Па.542	£1.00	£25.00
A	-	100	A Small size		200	620.00
_			B Medium size (75 × 50mm)		29p	£30.00
A	C	25	School Badges (1928):	Ha.543	30p	£32.00
			A Back in dark blue	114.545	£1.00	£25.00
			B Back in light blue		£1.00	£25.00
_	CP	30	Wordsworth's Country (76 × 51mm) (1926)		70p	£23.00 £21.00
8 5+	araasa		eries, consisting of a Right and a Left card for each t			

§ Stereoscopic series, consisting of a Right and a Left card for each number, a complete series is thus double the number shown.

R.S. CHALLIS & CO. LTD, London-

ros	1-1920	1336	ES		
D1	C	50	Comic Animals (1936)	60p	£30.00
A	BW	44	Flickits (Greyhound Racing Flickers) (1936) Ha.589-1	£35.00	_
			0	~~~	

A.S. CHALLIS & CO. LTD, London (continued)	142	0.0
	ce Complete rd set	Price per card
1 U 36 Wild Birds at Home (1935): Ha.626		
		60p £1.25
I. CHAPMAN & Co.		
RE-1919 ISSUE		
	0 —	£75.00
CHARLESWORTH & AUSTIN LTD, London—		
RE-1919 ISSUES		
	0 —	£24.00
		£45.00
C 30 Colonial Troops (c1900): H.40		
	0 —	£30.00
		£30.00
		£250.00
C 30 *Flags and Flags with Soldiers (c1903) H.41 £27.0	0 —	£27.00
CHESTERFIELD CIGARETTES——————————————————————————————————		
OST-1940 ISSUE		
- C 6 Chesterfield Collection (76 × 45mm) (1979) £1.2	5 —	£1.25
- C 6 Cocktails (76 × 45mm) 1980	p £2.50	40p
SHEW & CO. Bredford		
THEW & CO., Bradford———————————————————————————————————	= £ 10% 5	
RE-1919 ISSUE C 30 *Army, Pictures, Cartoons etc (c1916)	0 —	£75.00
V.A. & A.C. CHURCHMAN, Ipswich—		
6 page reference book available — £3.50		
PRE-1919 ISSUES		
	0 —	£28.00
	0 —	£35.00
	0 —	£55.00
C 25 Army Badges of Rank (1916) H.56 £5.0	0 £125.00	£5.00
	0 —	£50.00
	0 —	£85.00
	0 —	£400.00
	-	£120.00
		£70.00
	-	£6.00
		£90.00
20 *Boer War Generals' — 'CLAM' (c1901): H.61		
	0 —	£35.00
Z DW A DIACK HOIL		£35.00
	-	
		£3.30
U B Brown front £35.0 C 50 Boy Scouts (1916) H.62 £5.5	0 £275.00	£5.50
U B Brown front £35.0 C 50 Boy Scouts (1916) H.62 £5.5 C 50 Boy Scouts, 2nd series (1916) H.62 £5.5 C 50 Boy Scouts, 3rd series (1916) H.62 H.62	0 £275.00	
U B Brown front £35.0 C 50 Boy Scouts (1916) H.62 £5.5 C 50 Boy Scouts, 2nd series (1916) H.62 £5.5 C 50 Boy Scouts, 3rd series (1916) H.62 H.62	0 £275.00 0 £275.00	
U B Brown front £35.0 C 50 Boy Scouts (1916) H.62 £5.5 C 50 Boy Scouts, 2nd series (1916) H.62 £5.5 C 50 Boy Scouts, 3rd series (1916): H.62 A Brown back £5.5 £5.5 B Blue back £9.0	0 £275.00 0 £275.00 0 £275.00	£5.50
U B Brown front £35.0 C 50 Boy Scouts (1916) H.62 £5.5 C 50 Boy Scouts, 2nd series (1916) H.62 £5.5 C 50 Boy Scouts, 3rd series (1916): H.62 A Brown back £5.5 £5.5 B Blue back £9.0	0 £275.00 0 £275.00 0 £275.00 —	£5.50 £5.50

W.A. & A.C. CHURCHMAN, Ipswich (continued)

a.						
Size	Print-			Handbook		Complete
	ing	in se	I	reference	per card	set
A		50	East Suffolk Churches:			
	BW		A Black front, cream back (1912)		£2.00	£100.00
	BW		B Black front, white back (1912)		£2.00	£100.00
	U		C Sepia front (1917)		£2.00	£100.00
A	C	50	Fish and Bait (1914)	H.65	£5.00	£250.00
A	C	50	Fishes of the World (1911):	H.66	_	£250.00
			30 cards as re-issued 1924		£1.65	£50.00
			20 cards not re-issued		£10.00	
A	C	50	Flags and Funnels of Leading Steamship Lines (1912)	H.67	£6.00	
A	C	50	Football Club Colours (1909)	H.68	£8.00	£400.00
A	U	50	*Footballers — Photogravure Portraits (c1910)		£22.00	<u> </u>
A	C	50	Footballers — Action Pictures & Inset (1914)		£12.00	£600.00
C	C	40	*Home and Colonial Regiments (1902):	H.69		
			20 Caption in blue		£40.00	_
			20 Caption in brown		£40.00	_
A	C	50	Interesting Buildings (1905)	H.70	£6.00	£300.00
A	C	50	*Medals (1910)	H.71	£6.00	£300.00
A	C	50	*Phil May Sketches (1912):	H.72		
			A 'Churchman's Gold Flake Cigarettes'		£6.00	£300.00
			B 'Churchman's Cigarettes'		£7.00	
A	C	50	*Regimental Colours and Cap Badges (1911)	H 73	£6.00	£300.00
A	C	50	Sectional Cycling Map (1913)		£6.00	£300.00
A	C	50	Silhouettes of Warships (1915)	11.77	£7.00	2300.00
A	C	50	A Tour Round the World (1911)	H.75	£6.00	£300.00
A1	C	25	*Types of British and Colonial Troops (c1900)		£45.00	2300.00
A	C	50	Wild Animals of the World (1907)		£6.00	£300.00
				11.77	20.00	2300.00
B	POST-1			TT 544	22	016.00
-	C	48	Air-Raid Precautions (68 × 53mm) (1938)	Ha.544	32p	£16.00
A	U	50	Association Footballers (1938)		60p	£30.00
A	U	50	Association Footballers, 2nd series (1939)		90p	£45.00
A	C	25	Boxing (1922)	H.311	£5.00	
A	U	50	Boxing Personalities (1938)		£1.80	£90.00
A	U	25	British Film Stars (1934)		£1.60	£40.00
A	C	55	Can You Beat Bogey at St Andrews? (1933):			
			A Without overprint		£2.75	_
			B Overprinted in red 'Exchangeable'		£2.75	_
	U		Cathedrals and Churches (1924):	Ha.545		
A		25	A Small size		£1.80	£45.00
J		12	B Extra-large size		£9.00	_
A	C	50	Celebrated Gateways (1925)		£2.00	£100.00
A	C	25	Civic Insignia and Plate (1926)		£1.80	£45.00
A	C	50	Contract Bridge (1935)		40p	£20.00
A	C	50	Cricketers (1936)		£3.20	
	C		Curious Dwellings:			
A		25	A Small size (1926)		£1.80	£45.00
В		12	B Large size (1925)		£4.00	- 15.00
A	C	25	Curious Signs (1925)		£1.80	£45.00
	C		Eastern Proverbs:	Ha.521	21.00	215.00
			A Small size:	114.521		
Α		25	1 'A Series of 25' (1931)		80p	£20.00
A		25	2 '2nd Series of 25' (1932)			£20.00
A		23	B Large size:		80p	120.00
В		12			£2.20	
В		12			£3.30	624.00
В		12			£2.00	£24.00
В		12			£1.25	£15.00
В		12	4 '4th Series of 12' (1934)		£1.25	£15.00

W.A. & A.C. CHURCHMAN, Ipswich (continued)

****	. a A		chekeminan, ipswich (commuca)			
Size	Print- ing	Numi in sei		Handbook reference	Price per card	Complete set
A	C	50	Empire Railways (1931)		£2.00	£100.00
A	Č	25	Famous Cricket Colours (1928)		£3.60	£90.00
A	U	23	Famous Golfers:		25.00	270.00
	U	50	A Small size (1927)		£9.00	
A		30			19.00	
-			B Large size:		620.00	
В		12	1 'A Series of 12' (1927)		£20.00	-
В		12	2 '2nd Series of 12' (1928)		£20.00	
	C		Famous Railway Trains:			
A		25	A Small size (1929)		£2.60	£65.00
			B Large size:			
В		12	1 'Series of 12' (1928)		£4.50	£55.00
В		12	2 '2nd Series of 12' (1929)		£4.50	£55.00
A	C	52	'Frisky' (1935)		£3.50	_
A	C	50	History and Development of the British Empire (1934)		£1.20	£60.00
	U	48	Holidays in Britain (Views and Maps) (68 × 53 mm)			
			(1937)		30p	£15.00
	C	48	Holidays in Britain (views only) $(68 \times 53 \text{mm})$ (1938)		30p	£15.00
A	C	25	The Houses of Parliament and Their Story (1931)		£1.60	£40.00
A	C	23	Howlers:		21.00	240.00
^	C	40	그 프로그램 그 그 그 그 그 그 그 그 그 그 그 그 그 그 그 그 그 그		20p	£8.00
A						
В		16	B Large size (1936)		50p	£8.00
A	C	25	The Inns of Court (1932)		£2.40	£60.00
A	C	25	Interesting Door-Knockers (1928)		£2.20	£55.00
A	C	25	Interesting Experiments (1929)		£1.40	£35.00
A	C	50	'In Town To-night' (1938)		22p	£11.00
В	C	12	Italian Art Exhibition, 1930 (1931)		£1.50	£18.00
В	C	12	Italian Art Exhibition, 1930 — '2nd Series' (1931)		£1.50	£18.00
	C		The King's Coronation (1937):			
A		50	A Small size		18p	£9.00
В		15	B Large size		80p	£12.00
A	U	50	Kings of Speed (1939)		60p	£30.00
•	Č		Landmarks in Railway Progress:		·	
A	-	50	A Small size (1931)		£2.50	£125.00
^		50	B Large size:		22.50	2123.00
D		12			£4.80	£55.00
В		12				
В	**	12	2 '2nd Series of 12' (1932)	II. 546	£4.80	£55.00
	U			Ha.546	00.50	0407.00
A		50	A Small size		£2.50	£125.00
В		12	B Large size		£8.00	_
	C		Legends of Britain (1936):			
A		50	A Small size		80p	£40.00
В		12	B Large size		£1.50	£18.00
	C		Life in a Liner (1930):			
A		25	A Small size		£1.40	£35.00
В		12	B Large size		£2.75	1.43
	C		Men of the Moment in Sport:			
A	_	50	A Small size (1928)		£3.00	£150.00
-		50	B Large size:		25.00	2130.00
В		12	1 '1st Series of 12' (1929)		£7.00	
					£7.00	
В	0	12	2 '2nd Series of 12' (1929)			C16.00
-	C	48	Modern Wonders (68 × 53mm) (1938)	11 547	32p	£16.00
A	C	25	Musical Instruments (1924)	Ha.54/	£2.60	£65.00
	C		Nature's Architects (1930):			
A		25	A Small size		£1.20	£30.00
В		12	B Large size		£2.25	£27.00
_	U	48	The Navy at Work $(68 \times 53 \text{mm}) (1937) \dots$		28p	£14.00

W.A. & A.C. CHURCHMAN, Ipswich (continued)

Size	Print-ing	Num in se		Handbook reference	Price per card	Complete set
Α	C	25	Pipes of the World (1927)		£2.40	£60.00
A		50	A Small size		£8.00	
В		12	B Large size		£20.00	
	C		The 'Queen Mary' (1936):			
A		50	A Small size		£1.20	£60.00
В		16	B Large size		£2.00	£32.00
A	C	50	Racing Greyhounds (1934)		£2.40	£120.00
	C	48	The RAF at Work (68 × 53mm) (1938)		80p	£40.00
	C		Railway Working	Ha.548	СОР	210.00
			A Small size:	114.540		
A		25	1 'Series of 25' (1926)		£3.00	£75.00
A		25	2 '2nd Series of 25' (1927)		£2.40	£60.00
			B Large size:			200.00
В		12	1 'Series of 12' (1926)		£8.00	
В		13	2 '2nd Series, 13' (1927)		£8.00	_
В		12	3 '3rd Series, 12' (1927)		£8.00	
A	BW	50	Rivers and Broads (1922):			
			A Titled 'Rivers & Broads'		£5.00	_
			B Titled 'Rivers & Broads of Norfolk & Suffolk'		£5.00	_
A	C	50	Rugby Internationals (1935)		£1.40	£70.00
A	C	50	Sporting Celebrities (1931)		£2.20	£110.00
	C		Sporting Trophies (1927):			
A		25	A Small size		£2.20	£55.00
В		12	B Large size		£4.50	_
A	C	25	Sports and Games in Many Lands (1929)		£3.00	£75.00
	C		The Story of London (1934):			
A		50	A Small size		£1.20	£60.00
В		12	B Large size		£2.50	£30.00
	C		The Story of Navigation:			
A		50	A Small size (1937)		22p	£11.00
В		12	B Large size (1935)		£1.25	£15.00
A	C		3 Jovial Golfers in search of the perfect course (1934):			
		36	A Home issue		£3.50	_
		72	B Irish issue, with green over-printing		£6.50	_
	C		Treasure Trove:			
A		50	A Small size (1937)		20p	£10.00
В		12	B Large size (1935)		£1.25	£15.00
	C		Warriors of All Nations:			
A		25	A Small size (1929)		£2.40	£60.00
			B Large size:			
В		12	1 'A Series of 12' (1929)		£3.75	£45.00
В		12	2 '2nd Series of 12' (1931)		£3.75	£45.00
	C		Well-known Ties (1934):			
A		50	A Small size		80p	£40.00
			B Large size:			
В		12	1 'A Series of 12'		£1.75	£21.00
В		12	2 '2nd Series of 12'		£1.75	£21.00
A	C	50	Well-known Ties, '2nd Series' (1935)		70p	£35.00
A	U	25	Wembley Exhibition (1924)		£2.00	£50.00
A	U	50	West Suffolk Churches (1919)		£1.60	£80.00
-	C	48	Wings Over the Empire $(68 \times 53 \text{mm}) (1939) \dots$		30p	£15.00
	C		Wonderful Railway Travel (1937):			
A		50	A Small size	THE WEST OF	35p	£17.50
В		12	B Large size		£1.25	£15.00

W.A	4. & A	.C. (CHURCHMAN, Ipswich (continued)			
Size	Print-	Num in se		Handbook reference	Price per card	Complete set
	MISCE			,		
<i>c</i>	BW U	1 55	Christmas Greetings Card (68 × 53mm) (1938) Olympic Winners Through The Years (Package Designs,		_	£1.50
			30 small, 25 large) (1960)		£1.50	
=	C	48 40	Pioneers (68 × 53mm) (Prepared but not issued) (c1940) The World of Sport (Package Designs, 30 small, 10		_	_
			large) (1961)		£1.50	-
A	С	50	World Wonders Old and New (prepared but not issued) (c1950)		35p	£17.50
WI	M. CI	ARI	KE & SON, Dublin—			
PRI	E-1919	SSUE	ES .			
A	C	25	Army Life (1915)	H.78	£10.00	£250.00
A1	BW	16	*Boer War Celebrities — 'CAG' (c1901)	H.79	£22.00	- <u>11</u>
A	C	50	Butterflies and Moths (1912)		£7.00	£350.00
A	BW	30	Cricketer Series (1901)		£120.00	
A1	BW	66	Football Series (1902)	H.81	£17.00	7
A	C	25	Marine Series (1907)		£12.00	£300.00
A	Č	50	Royal Mail (1914)	H.82	£9.00	£450.00
	Č	50	Sporting Terms (38 × 58mm) (c1900):	H.83		
		50	14 Cricket Terms		£35.00	_
			12 Cycling Terms		£35.00	
			12 Football Terms		£35.00	_
			12 Golf Terms		£35.00	_
	0	? 20	*Tobacco Leaf Girls (shaped) (c1898)	Н 94	£375.00	
	C	25	Well-known Sayings (71 × 32mm) (c1900)		£20.00	£500.00
J.H	I. CL	URE	, Keighley—			
DDI	E-1919	CCITE	75			
	C	30	*Army Pictures, Cartoons, etc (c1900)	H 12	£75.00	
D			War Portraits (1916)	H 86	£65.00	
A	U	50	war Portraits (1916)	11.00	203.00	
J. 1	LOM	AX (COCKAYNE, Sheffield————			
DDI	E-1919	CCIII	7			
A	U	50	War Portraits (1916)	H.86	£65.00	
Λ		50	wai i ordans (1710)	Contractor		
CC	HEN	WE	ENEN & CO. LTD, London			
A	PRE-19	19 IS	SUES			
_	P	40	*Actresses, Footballers and Jockeys (26 × 61mm)			
die ou		.0	(c1901)	H.87	£40.00	_
A1	U	26	*Actresses — 'FROGA A' (c1900)		£55.00	
A	C	25	*Beauties — selection from 'BOCCA' (c1900)		£70.00	_
A1	C	25	*Beauties — 'GRACC' (c1900)		£80.00	_
D2	BW	25	*Boxers (c1912):		200.00	
DZ	DW	23	A Black back		£12.00	
					£12.00	£250.00
			B Green back		£15.00	2230.00
SET OF	D		C Without Maker's Name		£13.00	
A	BW		*Celebrities — Black and white (1901):		C4 50	
		65	A 'Sweet Crop, over 250' back		£4.50	-
		? 19	B 'Sweet Crop, over 500' back		£9.50	_

COHEN WEENEN & CO. LTD, London (continued)

Size	Prin ing	in se		Handbook reference	Price per card	Complete set
Α	C		*Celebrities — Coloured (1901):	H.89		
		45	I 1-45 Boer War Generals etc. 'Sweet Crop, over			
			100' back:		_	£180.00
			A Toned back		£4.00	_
			B White back		£4.00	
			C Plain Back		£8.00	
		121	II 1-121 Including Royalty, etc. 'Sweet Crop, over 250' back:			
			1-45 as in I		£8.00	_
			46-121 additional subjects		£4.00	£300.00
-	C		*Celebrities — 'GAINSBOROUGH I' (1901):	H.90		
-		? 16	A In metal frames $(46 \times 67 \text{mm})$		£100.00	
D2		39	B 'Sweet Crop, over 250' back		£35.00	20 <u></u>
D		30	C 'Sweet Crop, over 400' back		£11.00	£330.00
		2	D 1902 Calendar Back gilt border to front		£100.00	_
D1		39	E Plain Back		£12.00	£475.00
_	P	? 172	*Celebrities — 'GAINSBOROUGH II' (c1901):	H.91		A. 12 T A.
			A In metal frames $(46 \times 67 \text{mm})$		£15.00	
			B Without frames showing Frame Marks		£5.00	
			C Without Frames no Frame Marks (as issued)		£10.00	
A2	C	20	*Cricketers, Footballers, Jockeys (c1900):	H.92		
			A Caption in brown		£16.00	£320.00
			B Caption in grey-black		£16.00	£320.00
D	C	40	T. 1 D. 1	H.93	210.00	2320.00
			A 'Copyright Regd.' on front	11.73	£10.00	£400.00
			B Without 'Copyright Regd.'		£10.00	£400.00
A2	C	60	Football Captains, 1907-8 — Series No. 5	H 04	£11.00	2400.00
A2	BW	100	*Heroes of Sport (c1898)	H 05	£70.00	101 1515
A	C	40	*Home and Colonial Regiments (c1901):	H.69	170.00	7.5
**		40	A 'Sweet Crop, over 100' back:	п.09		
			20 Caption in blue		ce 00	0160.00
			20 Caption in brown		£8.00	£160.00
			B 'Sweet Crop, over 250' back:		£8.00	£160.00
			20 Caption in blue		C11 00	
			20 Caption in brown		£11.00	
A2	C	20	20 Caption in brown* *Interesting Buildings and Views (1902)	11.00	£11.00	C100.00
K2	C	52	*Ministrum Planing Conda Part C.	H.96	£9.00	£180.00
K2	-	32	*Miniature Playing Cards — Bandmaster Cigarettes		24.00	
D2	C		(c1910)	Latin of the	£4.00	_
DZ	-	20		H.97		
		20	A Blue back		£11.00	£220.00
		20	B Plain back — gilt border		£100.00	_
-	-	1	C 1902 Calender back		£100.00	-
D	C	40	Naval and Military Phrases (c1904):	H.14		
			A Red back, 'Series No. 1'		£16.00	£640.00
-			B 'Sweet Crop, over 250' back		£26.00	9001-
D2	С	50	Owners, Jockeys, Footballers, Cricketers — Series No. 2 (c1906)	H.98	£12.00	£600.00
D2	C	20	Owners, Jockeys, Footballers, Cricketers — Series No. 3 (c1907)			
D	C	30	*Proverbs, 'Sweet Crop, over 400' back (c1905)		£12.00	£240.00
A	C	20			£14.00	
A	BW	25	Russo-Japanese War Series (1904)	H.100	£14.00	T.
D1			*Silhouettes of Celebrities (c1905)		£12.00	£300.00
DI	C	50	Star Artistes — Series No. 4 (c1905):	H.102	Bar eres	
			20 With stage background		£10.00	£200.00
			30 No stage, plain background		£9.00	£270.00

Size	CO	HEN '	WEE	ENEN & CO. LTD, London (continued)			
S1-75 — dull greyish card £8.00 £200.00	Size						
To-100 — glossy white card	D	C	50	51-75 — dull greyish card			£200.00
A Thick card	D	U	50	76-100 — glossy white card* *War Series (World War I) (1915):	H.103		£200.00
A Maker's Name on back £38.00				A Thick card			
Di				A Maker's Name on back			£200.00
D2				Wonders of the World — 'Series No. 6' (c1908)	H.104		£210.00
D2						£11.00	
Di					H.97		£90.00
Cooper	D1	C		Wonders of the World (1923)	H.104		
POST-1920 ISSUES	-	С	16	*Victoria Cross Heroes II (72 × 70mm) (paper-backed) (c1915)	Ha.504-2	£37.00	_
Al U 25 Homes of England (1924) £6.00 £150.00 F. COLTON Jun., Retford— PRE-1919 ISSUES D C 30 *Army Pictures, Cartoons, etc (c1916) H.12 £75.00 — A U 50 War Portraits (1916) H.86 £65.00 — T. W. CONQUEST, London— PRE-1919 ISSUE D C *30 Army Pictures, Cartoons etc (c1916) H12 £75.00 — THE CONTINENTAL CIGARETTE FACTORY, London— POST-1920 ISSUES A C 25 Charming Portraits (c1925): Ha.549 A Back in blue, with firm's name £5.00 — B Back in blue, with firm's name £5.00 — C Back in brown, inscribed 'Club Mixture Tobacco' £6.00 — C Back in brown, inscribed 'Club Mixture Tobacco' £7.00 — *D Plain back £5.00 — *COOPER & CO'S STORES LTD, London— PRE-1919 ISSUES A BW 25 *Boer War Celebrities— 'STEW' (c1901): H.105 A 'Alpha Mixture' back £100.00 — B 'Gladys Cigars' back £100.00 — CO-OPERATIVE WHOLESALE SOCIETY LTD, Manchester— A PRE-1919 ISSUES A C ? 5 *Advertisement Cards (c1915) H.106 £260.00 —							
## C 25 Sports and Pastimes — Series I (1923)						06.00	0150.00
D C 30 *Army Pictures, Cartoons, etc (c1916)							
D C 30 *Army Pictures, Cartoons, etc (c1916)	F.	COLI	ON	Jun., Retford—			
D C 30 *Army Pictures, Cartoons, etc (c1916)	PRI	E-1919	ISSUI	ES			
PRE-1919 ISSUE D C *30 Army Pictures, Cartoons etc (c1916) H12 £75.00 — THE CONTINENTAL CIGARETTE FACTORY, London POST-1920 ISSUES A C 25 Charming Portraits (c1925): Ha.549 A Back in blue, with firm's name £5.00 — B Back in blue, inscribed 'Club Mixture Tobacco' £6.00 — C Back in brown, inscribed 'Club Mixture' £7.00 — *D Plain back £5.00 — COOPER & CO'S STORES LTD, London PRE-1919 ISSUES A 'Alpha Mixture' back £100.00 — B 'Gladys Cigars' back £100.00 — CO-OPERATIVE WHOLESALE SOCIETY LTD, Manchester A PRE-1919 ISSUES A2 C ? 5 *Advertisement Cards (c1915) H.106 £260.00 —	D	C	30	*Army Pictures, Cartoons, etc (c1916)			
THE CONTINENTAL CIGARETTE FACTORY, London	Т.	w. cc	NQ	UEST, London—			
THE CONTINENTAL CIGARETTE FACTORY, London	PRI	E-1919	ISSUI	E			
POST-1920 ISSUES					H12	£75.00	<u></u>
A C 25 Charming Portraits (c1925): A Back in blue, with firm's name	TH	IE CC	NT	INENTAL CIGARETTE FACTORY, Lon	don		
A Back in blue, with firm's name	POS	ST-1920	ISSL	VES			
B Back in blue, inscribed 'Club Mixture Tobacco' £6.00 — C Back in brown, inscribed 'Club Mixture Tobacco' £7.00 — *D Plain back £5.00 — *D Plain back £5.00 — *COOPER & CO'S STORES LTD, London— **PRE-1919 ISSUES** A BW 25 *Boer War Celebrities — 'STEW' (c1901): H.105 A 'Alpha Mixture' back £100.00 — B 'Gladys Cigars' back £100.00 — **CO-OPERATIVE WHOLESALE SOCIETY LTD, Manchester— **A PRE-1919 ISSUES** A2 C ? 5 *Advertisement Cards (c1915) H.106 £260.00 —	A	C	25		Ha.549		
Tobacco' £7.00 — *D Plain back £5.00 — COOPER & CO'S STORES LTD, London— PRE-1919 ISSUES A BW 25 *Boer War Celebrities — 'STEW' (c1901): H.105 A 'Alpha Mixture' back £100.00 — B 'Gladys Cigars' back £100.00 — CO-OPERATIVE WHOLESALE SOCIETY LTD, Manchester— A PRE-1919 ISSUES A2 C ? 5 *Advertisement Cards (c1915) H.106 £260.00 —				B Back in blue, inscribed 'Club Mixture Tobacco'			=
COOPER & CO'S STORES LTD, London— PRE-1919 ISSUES A BW 25 *Boer War Celebrities — 'STEW' (c1901): H.105 A 'Alpha Mixture' back £100.00 — B 'Gladys Cigars' back £100.00 — CO-OPERATIVE WHOLESALE SOCIETY LTD, Manchester— A PRE-1919 ISSUES A2 C ? 5 *Advertisement Cards (c1915) H.106 £260.00 —				Tobacco'			
PRE-1919 ISSUES A BW 25 *Boer War Celebrities — 'STEW' (c1901): H.105 A 'Alpha Mixture' back £100.00 — B 'Gladys Cigars' back £100.00 — CO-OPERATIVE WHOLESALE SOCIETY LTD, Manchester A PRE-1919 ISSUES A2 C ? 5 *Advertisement Cards (c1915) H.106 £260.00 —	00	ODE	D 0			25.00	
A BW 25 *Boer War Celebrities — 'STEW' (c1901): H.105				있는 보고 있는 것은 것이 하면 있다. 그런 선생님들은 선생님들은 선생님들은 보고 있는 것이 없는 그 없다고 있다. 그렇게 하고 있다.		O THE	
CO-OPERATIVE WHOLESALE SOCIETY LTD, Manchester A PRE-1919 ISSUES A2 C ? 5 *Advertisement Cards (c1915)				*Boer War Celebrities — 'STEW' (c1901): A 'Alpha Mixture' back			<u> </u>
A PRE-1919 ISSUES A2 C ? 5 *Advertisement Cards (c1915) H.106 £260.00 —	CC	ODI	TD A				100
A2 C ? 5 *Advertisement Cards (c1915) H.106 £260.00 —					anchester		
	A2	C	?5	*Advertisement Cards (c1915)	H.106		

CO-OPERATIVE WHOLESALE SOCIETY LTD, Manchester (continued)

Size	Printing	- Num in se	. 프로젝트 (B. 1985) (1985) (1985) (1985) (1985) (1985) (1985) (1985) (1985) (1985) (1985) (1985) (1985) (1985) (1	Handbook reference	Price per card	Complete set
						361
A	C	50	British Sport Series§ (c1914)		£26.00	_
A	C	28	*Co-operative Buildings and Works (c1914)		£12.00	£325.00
A	C	25	Parrot Series (1910)		£28.00	-
A	C	18	War Series (c1915)		£25.00	_
§No toba	te: Car	rds ad	vertise non-tobacco products, but are believed to have l	been packed	with cigare	ttes and/or
B	POST-	1920 I	SSUES			
A	C	24	African Types (1936)		50p	£12.00
	U	50	Beauty Spots of Britain $(76 \times 51 \text{mm}) (1936) \dots$		25p	£12.50
A2	C	50	Boy Scout Badges (1939)		80p	£40.00
A	C	48	British and Foreign Birds (1938)		60p	£30.00
D	C	25	*Cooking Recipes (1923)		£2.20	£55.00
A	Č	24	English Roses (1924)		£3.50	£85.00
A	C	50	Famous Bridges (48 + 2 added) (1937)			
A	C	48	Famous Buildings (1935)		70p	£35.00
A2	C	25	How to Do It (1924):	II. 550	60p	£30.00
AZ	-	23		Ha.550	CO 10	
					£2.40	_
					£2.40	-
					£2.40	
A	C	10			£2.40	
A	C	48	Musical Instruments (1934)		£3.30	£170.00
A	C	48	Poultry (1927)		£5.50	£275.00
A	C	48	Railway Engines (1936)		£3.00	£150.00
A	C	24	Sailing Craft (1935)		£1.40	£35.00
A2	C	48	Wayside Flowers, brown back (1923)		£1.70	£85.00
A2	C	48	Wayside Flowers, grey back (1928)		70p	£35.00
A2	C	48	Wayside Woodland Trees (1924)		£2.50	£125.00
C	POST-	1940 I.	SSUE			
A	C	24	Western Stars (1957)		45p	£11.00
CO	PE B	ROS	S & CO. LTD, Liverpool			
A	PRE-19	21 010	SUES			
** *	BW	20	*Actresses — 'BLARM' (c1900):	H.23		
A1	ъ,,	20	A Plain backs. Name panel ¼" from border	П.23	C25 00	
A1					£35.00	
D					£35.00	
The William St.	TT	26		** ***	£35.00	- C 10 TT
A	U	?6	*Actresses — 'COPEIS' (c1900)	H.108	£120.00	_
A	U	26	*Actresses 'FROGA A' (c1900)	H.20	£85.00	
D1	P	50	*Actresses and Beauties (c1900)	H.109	£12.00	_
KI		? 46	*Beauties, Actors and Actresses (c1900)		£22.00	_
A	C	52	*Beauties — P.C. inset (c1898)		£42.00	
A	C	15	*Beauties 'PAC' (c1898)	H.2	£70.00	<u> </u>
A1	C	50	Boats of the World (c1910)		£11.00	£550.00
D2	BW	126	Boyers (c1015):			
			1-25 Boxers		£12.00	£300.00
			26-50 Boxers		£10.00	£250.00
			51-75 Boxers		£10.00	£250.00
			76-100 Boxers		£15.00	£375.00
			101-125 Army Boxers		£12.00	£300.00
			126 'New World Champion'		212.00	
A1	C	35	*Roy Scouts and Girl Guides (=1010)	H 122	C10 00	£35.00
D	BW	25	*Boy Scouts and Girl Guides (c1910)	П.132	£10.00	£350.00
A CONTRACT OF THE PARTY OF THE			British Admirals (c1915)	H.103	£11.00	£275.00
A2	C	50	British Warriors (c1912):		0= 05	00.50
			A Black on white backs		£7.00	£350.00
			B Grey on toned backs		£8.00	£400.00

COPE BROS & CO. LTD, Liverpool (continued)

Size	Print ing	- Num in se		Handbook reference	Price per card	Complete set
Α	C	50	Characters from Scott (c1900):			
			A Wide card		£10.00	£500.00
			B Narrow card — officially cut		£10.00	
	U	115	Chinese Series (c1903):	H.113		
A1		110	Nos 1-20		£11.00	_
A1			Nos-21-40		£11.00	
			Nos 41-65:			
D			A Thick brown card		£11.00	<u> </u>
Al			B Re-drawn, smaller format		£11.00	_
A2			Nos 66-115		£11.00	
A	C	50	Cope's Golfers (1900):			
			A Wide card		£70.00	_
			B Narrow card — officially cut		£70.00	
A	C	50	Dickens' Gallery (1900)		£9.00	£450.00
A	C	50	Dogs of the World (by Cecil Aldin) (c1910)		£9.00	£450.00
A	C	25	Eminent British Regiments Officers' Uniforms (c1908):		_	£275.00
			A Yellow-brown back		£11.00	-
			B Claret back		£11.00	_
A2	C	30	*Flags of Nations (c1903):	H.114		
			A 'Bond of Union' back		£11.00	£330.00
			B Plain back		£9.00	
D	C	24	*Flags, Arms and Types of Nations (c1904):	H.115		- 5
			A Numbered		£7.00	£175.00
			B Unnumbered		£40.00	_
_	U	20	*Kenilworth Phrases (80 × 70mm) (c1910)	H.116	£150.00	· · · · · · · · · · · · · · · · · · ·
A2	C	50	Music Hall Artistes (c1910):			
			A Inscribed 'Series of 50'		£35.00	
			B Without the above		£9.00	£450.00
A	U	472	Noted Footballers — 'Clips Cigarettes' (c1910):	Ha.474		
			1 Unnumbered — Wee Jock Simpson		_	£38.00
			120 Series of 120:			
			A Greenish-blue frame		£10.00	· · · · · · · · ·
			B Bright blue frame		£10.00	T .
			162 Series of 282:			
			A Greenish-blue frame		£10.00	_
			B Bright blue frame		£10.00	4 T
			471 Series of 500. Bright blue frame		£10.00	_
D	P	195	Noted Footballers — 'Solace Cigarettes' (c1910)		£10.00	 :
A	C	24	*Occupations for Women (1897)	H.117	£90.00	- T
A	C	52	*Playing Cards 'Rulers' as Court Cards. Blue backs			
			(c1902):	H.118	24 6 00	
			A Rounded Corners		£16.00	
			B Square Corners		£12.00	
-	C	24	Photo Albums for the Million (c1902):	H.119	016.00	
			12 Buff cover (25 × 39mm)		£16.00	- 15 an a 1977
			12 Green cover $(25 \times 39 \text{mm}) \dots$		£16.00	
A	C	50	Shakespeare Gallery (c1900):		20.00	0.450.00
			A Wide card		£9.00	£450.00
			B Narrow card — officially cut	** 100	£9.00	_
A1	C	25	*Uniforms of Soldiers and Sailors (c1900):	H.120	000.00	
			A Circular Medallion back, wide card		£28.00	· ·
			B Square Medallion back, wide card		£50.00	
Mal.			C Square Medallion back, narrow card, officially cut		£22.00	77
D	BW		VC and DSO Naval and Flying Heroes:	II 101	06.00	6300.00
		50	Unnumbered (1916)	H.121	£6.00	£300.00 £175.00
		25	Numbered 51-75 (1917)		£7.00	£1/3.00

Size	Print-ing	Number in set	Handbook reference	Price per card	Complete set
D	BW				
D	BW			£9.00	£180.00
A1	C	 *War Series (War Leaders and Warships) (c1915) Wild Animals and Birds (c1908) 	H.103	£12.00	
		220 ISSUES		£16.00	
D	BW	25 Boxing Lessons (1935)		64.00	C100.00
_	C	25 Bridge Problems (folders) (85 × 50mm) (1924)		£4.00 £22.00	£100.00
A1	U	()			620.00
A1	U	25 Castles§ (1939)		£1.20	£30.00
	C	25 Dickens' Character Series (75 × 58mm) (1939)		£1.40 80p	£35.00 £20.00
	C	25 The Game of Poker§ (75 × 58mm) (1936)		30p	£7.50
	Č	50 General Knowledge§ (70 × 42mm) (1925)		£3.50	27.50
_	BW	32 Golf Strokes (70 × 45mm) (1923)		£12.00	
A1	C	60 'Happy Families' (1937)		£1.25	£75.00
	C	Household Hints\(\) (advertisement fronts\(\) (70 \times 45mm)		21.23	273.00
		(1925)		£1.30	£65.00
C	BW	30 Lawn Tennis Strokes (1924):		21.50	203.00
		A Numbers 1 to 25		£5.00	
		B Numbers 26 to 30		£15.00	
	U	50 Modern Dancing (folders) (74 × 43mm) (1926)		£13.00	SVA SKEE
A2	C	25 Pigeons (c1926)		£7.00	£175.00
A2	C	25 Song Birds (c1926)		£6.00	£150.00
A1	C	25 Sports and Pastimes (1925)	Ha.551	£4.00	£100.00
_	C	Toy Models (The Country Fair) $(73 \times 66 \text{mm})$ (c1930)	Ha.552	36p	£9.00
A	C	25 The World's Police (c1935)		£4.00	£100.00
§Joir	nt Cope	and Richard Lloyd issues.			
E. (CORC	NEL, London—			
	-1919 I		Habitet I		
A	C	25 *Types of British and Colonial Troops (1900)	H.76	£60.00	_
DA	VID C	ORRE & CO., London—			
PRE	-1919 IS	SUF			
_	C	1 Advertisement Card — The New Alliance (70 × 42mm)			
	-	(c1915)			£275.00
D	C	40 *Naval and Military Phrases (1900)	H 14	£65.00	1275.00
		Traval and Filliages (1900)	11.14	203.00	
JOI	HN C	OTTON LTD., Edinburgh————		No. of the same	11.53448
200	T-1920 I	SSUES			
POS		50 *Bridge Hands (folders) (82 × 66mm) (1934)		£8.00	
POS:	C	Driege Hands (folders) (62 × 00Hin) (1954)			
_	C	50 *Golf Strokes — A/B (1936)			
_ A1	U	50 *Golf Strokes — A/B (1936)		£8.00	1.444
A1 A1	U U	50 *Golf Strokes— C/D (1937)		£8.00 £9.00	
A1 A1 A1	U U U	50 *Golf Strokes— C/D (1937)		£8.00	=
A1 A1 A1 A1	U U U U	50 *Golf Strokes— C/D (1937) 50 *Golf Strokes— E/F (1938) 50 *Golf Strokes — G/H (1939)		£8.00 £9.00	_
A1 A1 A1 A1	U U U	50 *Golf Strokes— C/D (1937)		£8.00 £9.00	
A1 A1 A1 A1	U U U U U	50 *Golf Strokes— C/D (1937) 50 *Golf Strokes— E/F (1938) 50 *Golf Strokes — G/H (1939)	and and	£8.00 £9.00	
A1 A1 A1 A1 A1 A1	U U U U U	50 *Golf Strokes— C/D (1937) 50 *Golf Strokes— E/F (1938) 50 *Golf Strokes — G/H (1939) 50 *Golf Strokes — I/J (1939) OUDENS LTD, London—	age of	£8.00 £9.00	
A1 A1 A1 A1 A1 A. &	U U U U U	50 *Golf Strokes— C/D (1937) 50 *Golf Strokes— E/F (1938) 50 *Golf Strokes — G/H (1939) 50 *Golf Strokes — I/J (1939) OUDENS LTD, London— SSUES	Ha 553	£8.00 £9.00	
A1 A1 A1 A1 A1 A. &	U U U U U V J. C	50 *Golf Strokes— C/D (1937) 50 *Golf Strokes— E/F (1938) 50 *Golf Strokes — G/H (1939) 50 *Golf Strokes — I/J (1939) OUDENS LTD, London— SSUES 60 British Beauty Spots (1923):	Ha.553	£8.00 £9.00 £13.00	f65 00
A1 A1 A1 A1 A1 A. &	U U U U U V J. C	50 *Golf Strokes— C/D (1937) 50 *Golf Strokes— E/F (1938) 50 *Golf Strokes — G/H (1939) 50 *Golf Strokes — I/J (1939) OUDENS LTD, London— SSUES 60 British Beauty Spots (1923):	Ha.553	£8.00 £9.00 £13.00 — — £1.10	£65.00
A1 A1 A1 A1 A1 A. &	U U U U U V J. C	50 *Golf Strokes— C/D (1937) 50 *Golf Strokes— E/F (1938) 50 *Golf Strokes — G/H (1939) 50 *Golf Strokes — I/J (1939) OUDENS LTD, London— SSUES 60 British Beauty Spots (1923): A Printed back, numbered B Printed back, unnumbered	Ha.553	£8.00 £9.00 £13.00 — — £1.10 £2.00	£65.00
A1 A1 A1 A1 A1 A. &	U U U U U V J. C	50 *Golf Strokes— C/D (1937) 50 *Golf Strokes— E/F (1938) 50 *Golf Strokes — G/H (1939) 50 *Golf Strokes — I/J (1939) OUDENS LTD, London— SSUES 60 British Beauty Spots (1923): A Printed back, numbered B Printed back, unnumbered	Ha.553	£8.00 £9.00 £13.00 — — £1.10	£65.00

Size Print- Numb		Handbook reference	Price per card	Complete set
A P 60 A2 BW 25	Holiday Resorts in East Anglia (1924)	Ha.551	£1.00 £7.00	£60.00 £175.00
THE CRAIG	MILLAR CREAMERY CO. LTD, Midlothi	an——		
PRE-1919 ISSUE H C 1	*Views of Craigmillar (c1901)		_	£250.00
WR DANIE	L & CO., London—			
PRE-1919 ISSUE A2 C 30	*Colonial Troops (c1902).	H.40		
712 0 30	A Black back		£75.00	5 - 1 J
	B Brown back		£75.00	_
A2 C 25	*National Flags and Flowers — Girls (c1901)	H.123	£110.00	
W.T. DAVIES	S & SONS, Chester—			
A PRE-1919 ISS	SUES			
A C ?37	*Actresses — 'DAVAN' (c1902)	H.124	£70.00	and the
A C 25	Army Life (1915)		£10.00	
A BW 12	*Beauties (1903)	H.125	£35.00	
A C 50	Flags and Funnels of Leading Steamship Lines (1913)	H.0/	£9.00 £125.00	
A BW ? 12	Newport Football Club (c1904)	H.120	£123.00 £160.00	
A BW 5	Royal Welsh Fusiliers (c1904)	П.127	£100.00	700
B POST-1920 IS A2 U 42		Ha.554		
A2 U 42	Aristocrats of the Turf (1924): 1 Nos 1-30 — 'A Series of 30'	Па.334	£4.50	24 / 21 <u>- 1</u>
	2 Nos 31-42 — 'A Series of 42'		£14.00	
A2 U 36	Aristocrats of the Turf, Second Series (1924)		£4.50	
A C 25	Boxing (1924)	H.311	£4.00	£100.00
S. H. DAWES	S. Luton—			
	5, Lucon			
PRE-1919 ISSUE D C 30	*Army Pictures, Cartoons, etc (c1916)	H.12	£75.00	-
I.W. DEWHI	URST, Morecambe—			
PRE-1919 ISSUE D C 30	*Army Pictures, Cartoons, etc (c1916)	H.12	£75.00	_
R.I. DEXTE	R & CO., Hucknall			
PRE-1919 ISSUE D2 U 30	*Borough Arms (1900)	H.128	90p	£27.00
A. DIMITRI	OU, London—		437	11 11/11
POST-1920 ISSU				
— C ?3	Advertisement Cards (100 × 65mm) (c1930)		£100.00	_
GEORGE DO	OBIE & SON LTD, Paisley—	AR STAND		
A POST-1920 IS				
— C ? 22	Bridge Problems (folders) (circular 64mm diam.)			
	(c1933)		£22.00	_

GE	ORGI	E DO	DBIE & SON LTD, Paisley (continued)			
Size	Print-ing	Num in se	그래요 그런 사람이 아니까 얼마나 얼마나 아는 아는 아니는 아니는 아니는 아니는 아니는 아니는 아니는 아니는 아	Handbook reference	Price per card	Complete set
A	C	25	Weapons of All Ages (1924)		£6.00	£150.00
В	POST-1	940 1				
=	C C C	32 32 32	Four-Square Book (Nd 1-32) $(75 \times 50 \text{mm}) (1963) \dots$ Four-Square Book (Nd 33-64) $(75 \times 50 \text{mm}) (1963) \dots$ Four-Square Book (Nd 65-96) $(75 \times 50 \text{mm}) (1963) \dots$		£1.50 £1.50 £1.00	£32.00
DC	BSO	N &	CO. LTD	verage is th		- 14
PRI	E-1919 I	ISSIII				
A	С	8	The European War Series (c1917)	H.129	£38.00	_
TH	E DO	MI	NION TOBACCO CO. (1929) LTD, Lond	on——		
POS	ST-1920	ISSU	VES .			
A	U	25	Old Ships (1934)		£1.60	£40.00
A	U	25	Old Ships (Second Series) (1935)		70p	£17:50
A	U	25	Old Ships (Third Series) (1936)		70p	£17.50
A	U	25	Old Ships (Fourth Series) (1936)		£1.00	£25.00
JO	SEPH	W.	DOYLE LTD, Manchester—	jagniti ir	4.4	90 - Se
	ST-1920					
_	P	18	*Beauties, Nd X.1-X.18 (89 × 70mm) (c1925)		£12.00	
D	P	12	Dirt Track Riders Nd. CC.A.1-CC.A.12 (c1925)		£45.00	A
D	P	12	Views Nd. CC.B.1-CC.B.12 (c1925)		£26.00	
D	P	12	Views Nd CC.C.1-CC.C.12 (c1925)		£26.00	
D	P	12	*Beauties Nd. CC.D.1-CC.D.12 (c1925)		£26.00	
D	P	12	*Beauties Nd CC.E.1-CC.E.12 (c1925)		£26.00	, -
MA	JOR	DR	APKIN & CO., London—	. t. Emil. A.		
	PRE-19					
D	BW	12	*Actresses 'FRAN' (c1910)	H 175	C6 00	
_	BW	?1	*Army Insignia (83 × 46mm) (c1915)	H 130	£6.00 £130.00	
_	4.2	111	'Bandmaster' Conundrums (58 × 29mm) (c1910)	H 131	£8.00	
A2	BW '		Boer War Celebrities 'JASAS' — 'Sweet Alva Cigar-		20.00	
			ettes' (c1901)	H133	£100.00	_
A1	P		*Celebrities of the Great War (1916):	H.135		
		36	A Printed back		70p	£25.00
	DW	34	B Plain back	music of B	70p	£24.00
A	BW C	96 25	Cinematograph Actors (42 × 70mm) (1913)		£9.00	AND THE
A	C	23	How to Keep Fit — Sandow Exercises (c1912): A 'Drapkin's Cigarettes'	H.136	C12.00	6200.00
			A1 'Drapkin's Cigarettes' short cards, cut offic-		£12.00	£300.00
			ially		£12.00	HARRE
D	U	40	B 'Crayol Cigarettes'	** 105	£12.00	£300.00
D	C	48 25	Photogravure Masterpieces (1915)	H.137	£9.00	077.00
		25	*Soldiers and Their Uniforms, cutouts (1914):	H.138	From OO	£75.00
			B 'Crayol Cigarettes'		From 90p From 90p	
D	BW		*Views of the World (c1912):	H.176	1 10III 30p	W0 3 4
		12	A Caption in two lines	and The solo	£4.50	£55.00
		8	B Caption in one line		£30.00	_
D	BW	8	*Warships (c1912)	H.463	£9.00	-

MAJOR DRAPKIN & CO., London (continued)

Size	Print-ing	Num in se		Handbook reference	Price per card	Complete set
B	POST-1	920 1	SSUES			
C	C	8	*Advertisement Cards (c1925):	Ha.555		
_			1 Packings (4)		£7.00	£28.00
			2 Smokers (4)		£6.50	£26.00
	BW	50	Around Britain (1929) (export):			
C	DW	50	A Small size		£1.20	£60.00
B1			B Large size		£2.50	
DI	C	50	Around the Mediterranean (1926) (export):	Ha.610	22.50	
_	-	30	A Small size	114.010	£1.30	£65.00
C					£2.25	205.00
B1	D	40	B Large size		£1.70	£70.00
A2	P		British Beauties (1930) (export)		£2.40	£60.00
A1	U	25			12.40	200.00
	C	15	Dogs and Their Treatment (1924):		£5.00	£75.00
A			A Small size		£6.00	£90.00
B2		40	B Large size		£3.25	£130.00
A	C	40	The Game of Sporting Snap (1928)		13.23	
	_		Instruction Booklet			£10.00
	C	50	Girls of Many Lands (1929):		CO 50	
D			A Small size		£2.50	C16 00
	11 65		B Medium size $(76 \times 52 \text{mm})$	** ***	32p	£16.00
A2	\mathbf{BW}	54	Life at Whipsnade Zoo (1934)	Ha.556	50p	£27.00
D2	C	50	'Limericks' (1929):	Ha.557	0.0	0.45.00
			A White card		90p	£45.00
			B Cream card	1.0	90p	£45.00
A2	P	36	National Types of Beauty (1928)	Ha.558	60p	£22.00
	C	25	Optical Illusions (1926):			
A			A Small size. Home issue, name panel $(23 \times 7 \text{mm})$		£2.40	£60.00
A			B Small size. Export issue, name panel $(26 \times 10 \text{mm})$		£2.40	£60.00
B2			C Large 'size. Home issue		£3.00	£75.00
	C	25	Palmistry:			
A			A Small size (1927)		£2.60	£65.00
В			B Large size (1926)		£2.60	£65.00
	C	25	Puzzle Pictures (1926):			
A	-	23	A Small size		£2.80	£70.00
В			B Large size		£3.40	£85.00
A2	P	36	Sporting Celebrities in Action (1930) (export)			£250.00
AZ	1	30	35 different (No. 18 withdrawn)		£4.00	£140.00
-	CILVE		33 different (No. 18 withdrawn)		24.00	2140.00
C	SILKS	40	Regimental Colours and Badges of the Indian Army			
_	C	40		Ha.502-5		
			(70 × 50mm) (paper-backed) (c1915):	Ha.302-3	£3.50	
			A The Buffs' back			144 - I
			B No brand back		£27.00	
			NEOUS			
Α .	C	1	'Grey's' Smoking Mixture Advertisement Card (plain			27.00
			back) (c1935)		_	£5.00
np	ADK	IN &	MILLHOFF, London—			
	-1919 1	SSUE		Ha.139-1		
A	U	0.1	*Beauties 'KEWAI' (c1898): A 'Eldona Cigars' back	114.139-1	£100.00	
		? 1				· ·
		? 1	B 'Explorer Cigars' back	TT 140	£100.00	_
A	BW	25	*Boer War Celebrities — 'PAM' (c1901)		£27.00	778 10
C	C	30	*Colonial Troops (c1902)		£45.00	
	BW	?7	*'Pick-me-up' Paper Inserts (112 × 44mm) (c1900)	H.141	£90.00	
-						
_ _ A2	U	?1	*Portraits (48 × 36mm) (c1900)		£90.00 £125.00	947 T

A PRE-1919 ISSUES D1 C 48 *Flags, Arms and Types of Nations (c1910): A Back in Blue	J.]	DUNG	CAN	& CO. LTD, Glasgow—	AL 20 TRAILERS	100 (03)	TAX TAX GOT
D1 C 48 *Flags, Arms and Types of Nations (c1910): H.115 A Back in Blue	Size						Complete ser
A Back in Blue	A	PRE-19	919 IS.	SUES			
A Back in Blue	D1	C	48	*Flags, Arms and Types of Nations (c1910):	H.115		
A C 20 Inventors and Their Inventions (c1915)				A Back in Blue		£27.00	_
A C 20 Inventors and Their Inventions (c1915)				B Back in Green		£50.00	
A C 30 Scottish Clans, Arms of Chiefs and Tartans (c1910): H.142 A Back in place (c) A Back in Dlack (c) B Back in green filt (c) A Back in Dlack (c) B Back in green filt (c) A Back in Dlack (c) B Back in green filt (c) A Back in Dlack (c) B Back in green filt (c) A Back in Back in green filt (c) A Back in	A		20	Inventors and Their Inventions (c1915)			
A Back in black B Back in green C Scottish Gems: (58 × 84mm): — C 72	A	C	30	Scottish Clans, Arms of Chiefs and Tartans (c1910):	H.142		
B Back in green				A Back in black		£80.00	
C Scottish Gems; (58 × 84mm): C 72 1st series (c1912)				B Back in green		£17.00	_
C S0	-					£12.00	
C	-			2nd series (c1913)		£12.00	
### POST-1920 ISSUES DI C	-			3rd series (c1914)		£12.00	
C S0 Evolution of the Steamship' (c1925) Ha.559 — £65.0 47/50 ditto — £23.0 C Volimpia II — £23.0 C Castalia' and 'Athenia' £6.00 EDUNCOMBE, Buxton C Castalia' and 'Athenia' £6.00 EVOLUCOMBE, Buxton EVOLUCOMBE, Buxt				*Types of British Soldiers (c1910)	H.144	£45.00	
### 47/50 ditto ### 2000.00 Costalia' and 'Athenia' ### 200.00 Costalia' and 'Athenia' ## 200.00 Costalia' and 'Athenia' and 'Athenia' ## 200.00 Costalia' and 'Athenia' and 'Athenia	3	POST-	1920 15	SSUES			
### 47/50 ditto)1	C	50	'Evolution of the Steamship' (c1925)	Ha.559		£65.00
Colimpia II Castalia' and 'Athenia' £23.0 £25.0				47/50 ditto		65p	£30.00
'Castalia' and 'Athenia'							£23.00
### BW 50 Scottish Gems (known as '4th Series') (c1925) Ha.143D 50p £25.6 #### G. DUNCOMBE, Buxton ### Buxto				'Castalia' and 'Athenia'		f6.00	223.00
### Company of the co	H1	BW	50	Scottish Gems (known as '4th Series') (c1925)	Ha 143D		£25.00
### Process of the Control of the Co	~				ita sasta gener	ЗОР	225.00
ALFRED DUNHILL LTD., London COST-1940 ISSUE U 25 Dunhill Kingsize Ransom (75 × 45mm) (1985) £1.40 EDWARD VII CIGARETTES PRE 1919 ISSUE L2 C 40 *Home and Colonial Regiments (c1900) H.69 £200.00 EDWARDS, RINGER & CO., Bristol PRE 1919 ISSUE BW 50 How to Count Cribbage Hands (79 × 62mm) (c1908) £75.00 EDWARDS, RINGER & BIGG, Bristol PRE-1919 ISSUES L2 C 40 *Home and Colonial Regiments (c1900) £8.00 £200.0 B 'Statue of Liberty' back £8.00 £200.0 C 'Stag Design' back £8.00 £200.0 B 'Statue of Liberty' back £8.00 £200.0 A 'Statue of Liberty' back £8.00 £200.0 B 'Stag Design' back £8.00 £200.0 C 1 Calendar (1905) H.60 £11.00 £550.0 C 2 S 'Boer War and Boxer Rebellion Sketches (c1901) £100.00 C 1 Calendar (1905), Exmore Hunt Stag design back £250.00 £250.00 C 1 Calendar (1905), Exmore Hunt Stag design back £250.00 £250.00	j.	DUN	COM	IBE, Buxton————			
ALFRED DUNHILL LTD., London POST-1940 ISSUE U 25 Dunhill Kingsize Ransom (75 × 45mm) (1985) £1.40 = EDWARD VII CIGARETTES PRE 1919 ISSUE L2 C 40 *Home and Colonial Regiments (c1900) H.69 £200.00 = EDWARDS, RINGER & CO., Bristol PRE 1919 ISSUE B 50 How to Count Cribbage Hands (79 × 62mm) (c1908) £75.00 = EDWARDS, RINGER & BIGG, Bristol PRE-1919 ISSUES A Type-set back £8.00 £200.0 B 'Statue of Liberty' back £8.00 £200.0 C 'Stag Design' back £8.00 £200.0 A 'Statue of Liberty' back £8.00 £200.0 A 'Statue of Liberty' back £8.00 £200.0 B 'Stag Design' back £8.00 £200.0 A 'Statue of Liberty' back £8.00 £200.0 A 'Statue of Liberty' back £8.00 £200.0 B 'Stag Design' back £8.00 £200.0 A 'Statue of Liberty' back £8.00 £200.0 B 'Stag Design' back £8.00 £200.0 C 12 *Beauties — 'CERF' (1905) H.57 £55.00 £8.00 £200.0 B 'Stag Design' back £8.00 £200.0 C 50 *Birds and Eggs (1906) H.60 £11.00 £550.0 B W ?1 Boer War and Boxer Rebellion Sketches (c1901) £100.00 £250.00							
### Properties of Caracters Part)	C	30	*Army Pictures, Cartoons, Etc (c1916)	H.12	£75.00	-
EDWARD VII CIGARETTES PRE 1919 ISSUE A C 40 *Home and Colonial Regiments (c1900) H.69 £200.00 — EDWARDS, RINGER & CO., Bristol PRE 1919 ISSUE B W 50 How to Count Cribbage Hands (79 × 62mm) (c1908) £75.00 — EDWARDS, RINGER & BIGG, Bristol PRE-1919 ISSUES A U 25 Abbeys and Castles — Photogravure series (c1912): A Type-set back £8.00 £200.0 B 'Statue of Liberty' back £8.00 £200.0 C 'Stag Design' back £8.00 £200.0 A 'Statue of Liberty' back £8.00 £200.0 B 'Stag Design' back £8.00 £200.0 C Stag Design' back £8.00 £200.0 B 'Stag Design' back £8.00 £200.0 C C 12 *Beauties — 'FECKSA', 1900 Calendar back H.58 £32.00 — C S Birds and Eggs (1906) H.60 £11.00 £550.0 B W 25 *Boer War and Boxer Rebellion Sketches (c1901) £100.00 — C C 1 Calendar for 1899 £250.00 — C C Calendar for 1899 £250.00 —					englija (K. 17) 19. vena (K. 17)		
EDWARD VII CIGARETTES PRE 1919 ISSUE A2 C 40 *Home and Colonial Regiments (c1900) H.69 £200.00 — EDWARDS, RINGER & CO., Bristol— PRE 1919 ISSUE — BW 50 How to Count Cribbage Hands (79 × 62mm) (c1908) £75.00 — EDWARDS, RINGER & BIGG, Bristol— A PRE-1919 ISSUES A U 25 Abbeys and Castles — Photogravure series (c1912): A Type-set back £8.00 £200.0 B 'Statue of Liberty' back £8.00 £200.0 C 'Stag Design' back £8.00 £200.0 B 'Statue of Liberty' back £8.00 £200.0 B 'Stag Design' back £8.00 £200.0 A U 25 Alpine Views — Photogravure series (c1912): A 'Statue of Liberty' back £8.00 £200.0 B 'Stag Design' back £8.00 £200.0 A C 12 *Beauties — 'CERF' (1905) H.57 £55.00 — A C 50 *Birds and Eggs (1906) H.60 £11.00 £550.0 A BW ?1 Boer War and Boxer Rebellion Sketches (c1901) £100.00 — A BW 25 *Boer War Celebrities — 'STEW' 1901 Calendar back H.105 £40.00 — A C 1 Calendar (1905), Exmore Hunt Stag design back £250.00 —	POS —					£1.40	2011 <u>2</u>
### PRE 1919 ISSUE A2 C	ED	WAR	D VI	I CIGARETTES—	o sant tethy <u>institution winds</u>		
### A2 C 40 **Home and Colonial Regiments (c1900) H.69 £200.00 — ##################################							
### PRE 1919 ISSUE ### BW 50 How to Count Cribbage Hands (79 × 62mm) (c1908) £75.00 — ### EDWARDS, RINGER & BIGG, Bristol ### A PRE-1919 ISSUES ### A U 25 Abbeys and Castles — Photogravure series (c1912): ### A Type-set back £8.00 £200.0 ### B 'Statue of Liberty' back £8.00 £200.0 ### A U 25 Alpine Views — Photogravure series (c1912): ### A 'Statue of Liberty' back £8.00 £200.0 ### B 'Stag Design' back £8.00 £200.0 ### A C 12 *Beauties — 'CERF' (1905) H.57 £55.00 — ### A U 25 *Beauties — 'FECKSA', 1900 Calendar back H.58 £32.00 — ### A C 50 *Birds and Eggs (1906) H.60 £11.00 £550.0 ### BW ?1 Boer War and Boxer Rebellion Sketches (c1901) £100.00 — ### BW 25 *Boer War Celebrities — 'STEW' 1901 Calendar back H.105 £40.00 — ### A C 1 Calendar for 1899 £250.00 — ### C 1 Calendar (1905), Exmore Hunt Stag design back £250.00 —					H.69	£200.00	- 1
### BW 50 How to Count Cribbage Hands (79 × 62mm) (c1908)	ED	WAR	DS, F	RINGER & CO., Bristol—			
EDWARDS, RINGER & BIGG, Bristol— A PRE-1919 ISSUES A U 25 Abbeys and Castles — Photogravure series (c1912): A Type-set back	PRE						
A PRE-1919 ISSUES A U 25 Abbeys and Castles — Photogravure series (c1912): A Type-set back		BW	50	How to Count Cribbage Hands $(79 \times 62 \text{mm})$ (c1908)		£75.00	
A U 25 Abbeys and Castles — Photogravure series (c1912): A Type-set back B 'Statue of Liberty' back C 'Stag Design' back B 'Statue of Liberty' back A U 25 Alpine Views — Photogravure series (c1912): A 'Statue of Liberty' back B 'Stag Design' back E8.00 £200.0 £8.00 £200.0	ED	WAR	DS,	RINGER & BIGG, Bristol—	2001 400	1 312	2. 45
A U 25 Abbeys and Castles — Photogravure series (c1912): A Type-set back B 'Statue of Liberty' back C 'Stag Design' back A U 25 Alpine Views — Photogravure series (c1912): A 'Statue of Liberty' back B 'Stag Design' back E8.00 £200.0 £8.00 £200.0	1	PRE-19	19 ISS	SUES			
A Type-set back							
B 'Statue of Liberty' back	198					ce 00	6200 00
C 'Stag Design' back £8.00 £200.0 A U 25 Alpine Views — Photogravure series (c1912): A 'Statue of Liberty' back £8.00 £200.0 B 'Stag Design' back £8.00 £200.0 Experiment £8.00 £200.0 £8.00 £200.0 £8.00 £200.0 £8.00 £200.0 £8.00 £200.0 £8.00 £200.0 £8.00 £200.0 £8.00 £200.0 £8.00 £200.0 £8.00 £200.0 £8.00 £200.0 £8.00 £200.0 £8.00 £200.0 £8.00 £200.0 £8.00 £200.0 £9.00 — £9.00							
A U 25 Alpine Views — Photogravure series (c1912): A 'Statue of Liberty' back . £8.00 £200.0 B 'Stag Design' back . £8.00 £200.0 A C 12 *Beauties — 'CERF' (1905) . H.57 £55.00 — A U 25 *Beauties — 'FECKSA', 1900 Calendar back . H.58 £32.00 — A C 50 *Birds and Eggs (1906) . H.60 £11.00 £550.0 B BW ?1 Boer War and Boxer Rebellion Sketches (c1901) . £100.00 — B W 25 *Boer War Celebrities — 'STEW' 1901 Calendar back . H.105 £40.00 — C 1 Calendar for 1899 . £250.00 — C 1 Calendar (1905), Exmore Hunt Stag design back . £250.00 —				C 'Stag Design' back			
A 'Statue of Liberty' back		II	25	Alnine Views — Photogravure series (c1012):		18.00	£200.00
B 'Stag Design' back			23	Δ 'Statue of Liberty' back		00.00	C200 00
C 12 *Beauties — 'CERF' (1905)				B 'Stag Design' back			
U 25 *Beauties — 'FECKSA', 1900 Calendar back		C	12	*Reguties - 'CEPE' (1905)	11.57		£200.00
C 50 *Birds and Eggs (1906)				*Requires — 'FECKSA' 1000 Colondon book	П.5/		11.
BW ? 1 Boer War and Boxer Rebellion Sketches (c1901)				*Birds and Eggs (1006)	H.58		0.550 55
BW 25 *Boer War Celebrities — 'STEW' 1901 Calendar back H.105 £40.00 — C 1 Calendar for 1899 £250.00 — C 2 1 Calendar (1905), Exmore Hunt Stag design back £250.00 —				Poor War and Dayor Daballian Clastakas (1991)	H.60		£550.00
C 1 Calendar for 1899				*Poor War Calabritian (STEW) 1001 G	*****		-
C 1 Calendar (1905), Exmore Hunt Stag design back £250.00				Gelevater for 1900	H.105		_
2250.00				Calendar (1005) France II (5)			_
£250.00 =		1967530 57,1000					-
	1	-	1	Calcildar (1910)		£250.00	-

ED	WARL	S, R	INGER & BIGG, Bristol (continued)			
Size	Print-ing	Numi in sei		Handbook reference	Price per card	Complete set
		25	Coast and Country — Photogravure series (1911):			
A	U	23	A 'Statue of Liberty' back		£8.00	£200.00
			B 'Stag Design' back		£8.00	£200.00
	C	22	*Dogs series (1908):	H.64		
A	C	23		11.01	£8.00	
					£4.00	£90.00
		•	B 'Klondyke' back	H 146	£275.00	
A	C	3	Flags of All Nations, 1st series (1906)	Н 37	£7.00	£175.00
A	C	25	Flags of All Nations, 1st series (1900)	Н 37	£11.00	£135.00
A	C	12		H.37	211.00	2133.00
A	C	37	*Flags of All Nations (1907):	11.57	£6.00	_
			A Globe and Grouped Flags back		20.00	
			B 'Exmoor Hunt' back:		£7.00	
			i 4½d per oz		£7.00	50 A S <u>S</u>
			ii Altered to 5d by hand		£9.00	- L
			iii 5d label added		£6.00	£225.00
			C 'Stag' design back		£7.00	2225.00
. 3		=0	D Upright titled back	Н 38	£8.50	1
A	C	50	Life on Board a Man of War (1905)	П.36	20.50	£400.00
_	C	1	'Miners Bound for Klondyke' (41 × 81mm) (1897)			2400.00
A	C	10	Portraits of His Majesty the King in Uniforms of the	II 147	£35.00	£350.00
			British and Foreign Nations (1902)	H.14/	£8.00	£400.00
A	C	50	A Tour Round the World (Mar. 1909)	H./3	£9.00	2400.00
A	C	56	War Map of the Western Front (1916)		19.00	100
A	U	54	War Map of the Western Front, etc Series No. 2 (1917):		00.00	
			A 'Exmoor Hunt' back		£9.00	100
			B 'New York Mixture' back		£9.00	64 on 1154
В	POST-1	920 I	SSUES			
A	C	25	British Trees and Their Uses (1933)		£2.40	£60.00
A	C	50	Celebrated Bridges (1924)	H.346	£2.20	£110.00
	U		Cinema Stars (1923):			
A2		50	A Small size		£1.20	£60.00
		25	B Medium size (67 × 57mm)		£1.60	£40.00
A	C	25	Garden Life (1934)	H.449	£3.00	£75.00
A	Č	25	How to Tell Fortunes (1929)		£3.60	£90.00
A	Č	50	Mining (1925)	H.450	£2.20	£110.00
A	C	25	Musical Instruments (1924)	Ha.547	£3.20	£80.00
A	C	25	Optical Illusions (1936)	Ha.560	£2.20	£55.00
A	C	25	Our Pets (1926)	Ha.561	£2.20	£55.00
A	C	25	Our Pets, 2nd series (1926)	Ha.561	£2.20	£55.00
	C	25	Past and Present (1928)		£3.20	£80.00
A	C	25	Prehistoric Animals (1924)		£4.00	£100.00
A	C	25	Sports and Games in Many Lands (1935)		£3.20	£80.00
A	C	23	Sports and Games in Many Lands (1999)			
S.	EISIS	KI,	Rhyl————————————————————————————————————	Princip charge Transport		
PRI	-1919	ISSUE	ES de la companya de			
D	U	? 4	*Actresses 'ANGOOD' (c1900)	H.187	£125.00	_
A	Ü	?6	*Actresses — 'COPEIS' (c1900)	H.108	£125.00	7 H) (1
A		? 22	*Beauties — 'FENA' (c1900)	H.148	£125.00	
A	U	?1	*Beauties — 'KEWA I', back inscribed 'Eisiski's New			
A	U	. 1	Gold Virginia Cigarettes' (c1900)	Ha.139-1	£125.00	Walter A
٨	U	? 1	*Beauties — 'KEWA II', back inscribed 'Eisiski's Rhyl	Managaran .		
A	U	. 1	Best Bird's Eye Cigarettes' (c1900)	Ha.139-2	£125.00	
		22	*Beauties — 'KEWA II' Rubber-stamped back (c1900)		£125.00	10 m
A	U	?3	Beauties — KEWA II Rubbel-stamped back (C1900)	11.137	2125.00	

EI	DO	NS LT	TD-			
Size	Prin	it- Num		Handbook reference	Price per card	Complete
PR	F_101	9 ISSUI	7	rejerence	per curu	sei
	C	30	*Colonial Troops — 'Leon de Cuba' Cigars (c1900)	H.40	£95.00	_
R.	J. El	LLIO	TT & CO. LTD., Huddersfield————			
PR	E 1919	ISSUE				
	C	1	Advertisement Card — Bulldog (c1910)		_	£150.00
EN	APIF	RE TO	DBACCO CO., London——————————————————————————————————			
PRI	E-1919	ISSUE				
D	C	?6	Franco-British Exhibition (c1907)	Ha.471	£150.00	_
TH	IE E	XPRI	ESS TOBACCO CO. LTD, London———	san Lizzton		V 4
POS	ST-192	20 ISSU	E			
	U	50	'How It is Made' (Motor Cars) $(76 \times 51 \text{mm})$ (1931)		£2.50	
L.	& J.	FAB	IAN, London—	and amusic	4.60	
POS	ST-192	20 ISSU	E			
D1	P	24	The Elite Series (Beauties) (most numbers preceded by letters 'LLF') (c1935)		£34.00	_
FA	IRV	FATI	HER & SONS, Dundee			
				SET FORT HE		
A	C C	50	Historic Buildings of Scotland (c1914)		£40.00	_
W.	& F	. FAU	LKNER, London-	-aller.		
12 p	oage re	eference	book available — £3.50			
A	PRE-	1919 IS	SUES			
C	C	26	*Actresses — 'FROGA A' (c1900)	H.20	£40.00	
D2	C	12	*'Ation Series (1901)		£20.00	
C	C	? 24	*Beauties (c1898)	H.150	£60.00	_
A	U	49	*Beauties — 'FECKSA' (1901)	H 58	£17.00	A 1/41-
A	BW	16	*British Royal Family (1901)	H 28	£32.00	1
D2	C	12	*Coster Series (1900)	H 151	£20.00	To have a fine
A	BW	20	Cricketers Series (1901)	H.29	£225.00	740 E (<u>11</u> 14
D2	C	12	Cricket Terms (1899)	H.152	£60.00	
D2	C	12	Football Terms, 1st Series (1900)	H.153	£20.00	
D2	C	12	Football Terms, 2nd Series (1900)	H 154	£20.00	
D2	C	12	*Golf Terms (1901)	H 155	£75.00	
D2	C	12	Grenadier Guards (1899)	H 156	£20.00	191 3 191
A2	C	40	*Kings and Queens (1902)	H 157	£20.00	(1) A (1)
D2	C	12	Kipling Series (1900)	H 158	£20.00	
D2	C	12	The Language of Flowers (1900):	H.159	220.00	
			A 'Grenadier' Cigarettes		£30.00	
			B 'Nosegay' Cigarettes		£30.00	IS LEADING TO
D2	C	12	*Military Terms, 1st series (1899)	H.50	£20.00	
D2	C	12	*Military Terms, 2nd series (1899)	H 160	£22.00	
D2	C	12	*Nautical Terms, 1st series (1900)	H 161	£18.00	PLASTER I
D2	C	12	*Nautical Terms, 2nd series (1900):	H.162	210.00	
			A 'Grenadier' Cigarettes		£18.00	Established
			B 'Union Jack Cigarettes'		£20.00	

,	w	& F. F	AUL	KNER, London (continued)			
	Size	Print-ing	Numi in set		Handbook reference	Price per card	Complete set
1	D2	C		'Our Colonial Troops' (1900):			
	_			A Grenadier Cigarettes:			
			30	i With copyright Nos 1-30		£22.00	_
			90	ii Without copyright Nos 1-90		£12.00	_
			60	B Union Jack Cigarettes Nos 31-90		£14.00	1 1 T
	A	C	20	Our Gallant Grenadiers, 1-20:	H.163		
				A Without ITC Clause (1901):		24 6 00	2220.00
				i Thick card		£16.00	£320.00
				ii Thin card		£16.00	£320.00 £500.00
				B With ITC Clause, thin card (1902)		£25.00 £20.00	£300.00 £400.00
	A	C	20	Our Gallant Grenadiers, 21-40 (1903)	H 164	£28.00	1400.00
	D2	C	. 12	*Policemen of the World (1899)		£20.00	_
	D2	C	12	*Police Terms (1899)	H.166	120.00	
	D2	C	12	*Puzzle series (1897): A 'Grenadier Cigarettes	11.100	£125.00	_
				A 'Grenadier Cigarettes B 'Nosegay Cigarettes		£50.00	X - Y G
		BW	25	*South African War Scenes (1901)	H 167	£12.00	£300.00
	A D2	C	12	Sporting Terms (1900)	H.168	£25.00	_
	D2 D2	C	12	Street Cries (1902)	H.169	£20.00	4. 20 - 20
	200	POST-1	25	Angling (1929)		£6.00	
	A	C	50	Celebrated Bridges (1925)	H.346	£2.20	£110.00
	A A	C	25	Old Sporting Prints (1930)	Ha.563	£3.00	£75.00
	A	C	25	Optical Illusions (1935)	Ha.560	£2.40	£60.00
	A	C	25	Our Pets (1926)	Ha.561	£3.00	£75.00
	A	C	25	Our Pets, 2nd series (1926)	Ha.561	£2.60	£65.00
	A	C	25	Prominent Racehorses of the Present Day (1923)		£2.80	£70.00
	A	C	25	Prominent Racehorses of the Present Day, 2nd series (1924)		£4.60	£130.00
	FIE	ELD F	AVO	OURITES CIGARETTES—			
	PRE	-1919	ISSUE				
	D	P	? 1			£300.00)
				O. LTD, Newcastle-on-Tyne and London—	April 18 to 18 I	or the state	1977 m
		2-1919		Our Girls (c1910)	H 170	£125.00	
	D1	BW	?8	World's Aircraft (c1912)	H.170		-07.51
	A	U	30	World's Aircraft (C1912)		200.00	
	FL	YNN,	Dub	lin			
		-1919					
	A	C	26	*Beauties — 'HOL' (c1900)	H.192	£200.00	
	C .	D. FO	THE	ERGILL, St Helens—			
	PRE	E-1919	ISSUE				
	_	C	? 1	*'Play Up' Sporting Shields (c1895)		£125.00	3.76 T 1T
	FR	AEN	KEL	BROS, London	record to the		
	PRE	E-1919	ISSUI	ES			
	A2	C	?2	*Beauties — 'Don Jorg (c1898)	H.493-1	£180.00	
	A	U	? 22	*Beauties — 'FENA' (c1898)	H.148	£90.00	_

A C 25 *Beauties — 'GRACC' (c1898) H.59 £12 A U 24 *Beauties — 'HUMPS' (c1900) H.222 £10 A U 26 *Music Hall Artistes (c1900): H.171 A Pink card £9 B White card £9 A2 C 25 *Types of British and Colonial Troops (c1900) H.76 FRANKLYN, DAVEY & CO., Bristol A PRE-1919 ISSUES A C 12 *Beauties — 'CERF' (1905) H.57 £5	20.00 20.00 20.00 20.00 20.00 55.00	sei
A U 24 *Beauties — 'HUMPS' (c1900) H.222 £10 A U 26 *Music Hall Artistes (c1900): H.171 A Pink card . £9 B White card . £9 A2 C 25 *Types of British and Colonial Troops (c1900) H.76 FRANKLYN, DAVEY & CO., Bristol— A PRE-1919 ISSUES A C 12 *Beauties — 'CERF' (1905) H.57 F5	00.00	=
A U 24 *Beauties — 'HUMPS' (c1900) H.222 £10 A U 26 *Music Hall Artistes (c1900): H.171 A Pink card £9 B White card £9 A2 C 25 *Types of British and Colonial Troops (c1900) H.76 FRANKLYN, DAVEY & CO., Bristol A PRE-1919 ISSUES A C 12 *Beauties — 'CERF' (1905) H.57 F5	00.00	=
A U 26 *Music Hall Artistes (c1900): A Pink card	00.00	=
B White card	00.00	=
FRANKLYN, DAVEY & CO., Bristol A PRE-1919 ISSUES A C 12 *Beauties — 'CERF' (1905) H.57 f.5		=
FRANKLYN, DAVEY & CO., Bristol— A PRE-1919 ISSUES A C 12 *Beauties — 'CERF' (1905)	55.00	-
A PRE-1919 ISSUES A C 12 *Beauties — 'CERF' (1905)		
A C 12 *Beauties — 'CERF' (1905)		
A C 12 *Beauties — 'CERF' (1905)		
	5.00	
D2 C 50 *Birds (c1895)	5.00	
	5.00	
A C 25 Ceremonial and Court Dress (Oct. 1915) H.145	8.00	1 Le
A C 50 *Football Club Colours (1909)	1.00	£550.00
A C 50 Naval Dress and Badges (1916)	9.00	_
A C 25 *Star Girls (c1898)	5.00	
A C 10 Types of Smokers (c1898)	0.00	£500.00
A C 50 Wild Animals of the World (c1902) H.77 £1	0.00	£500.00
B POST-1920 ISSUES		
A C 25 Boxing (1924)	3.00	£75.00
A C 50 Children of All Nations (1934)	70p	£35.00
A C 50 Historic Events (1924)	2.40	£120.00
A II 50 M. I D G. MOOO	1.00	£25.00
1 2 2 2 2 2 2 2 2 2 2 2 2 2 2 2 2 2 2 2	3.60	£180.00
	70p	£35.00
A C 50 Overseas Dominions (Australia) (1923) H.451 £ C MISCELLANEOUS	4.00	£200.00
103 × 03 mm) (1070) 11a.470	-	£250.00
A.H. FRANKS & SONS, London—		
PRE-1919 ISSUES		
D1 BW 56 *Beauties — 'Beauties Cigarettes' (c1900) H.173 £6	0.00	
	0.00	
	5.00	
	0.00	
J.J. FREEMAN, London—		
PRE-1919 ISSUES		
D BW 12 *Actresses — 'FRAN' (c1912) H.175 £3	5.00	_
D BW 12 *Views of the World (c1910) H.176 £3	5.00	_
J. R. FREEMAN, London—		
A POST-1920 ISSUE		
II 10 #01 11:10 1 == 10	0.00	
B POST-1940 ISSUE	0.00	
CI II 22 F I II CI II	4.00	- 10 <u>- 14</u>
C. FRYER & SONS LTD, London—		
A PRE-1919 ISSUES	TE ST	1.414
11.13	0.00	
D C 1 61 1 1 1 1 1 1 1 1 1 1 1 1 1 1 1 1	0.00	-
C Green daisy design back £10	0.00	_
t 10	0.00	-

C. 1	FRYE	ER &	SONS LTD, London (continued)			
Size	Print ing	- Num in se		Handbook reference	Price per card	Complete set
D A2		40 ? 10 • 1920 I	*Naval and Military Phrases (c1905)		£45.00 £130.00	=
_	_	50	Clan Sketches (101 × 74mm) (paper folders with wording only) — 'Pibroch Virginia' (c1930)	Ha.628	£9.00	_
FR	YER	& C	OULTMAN, London————			
PRI	E-1919	ISSUE				
-	C	12	*French Phrases, 1893 Calendar back (96 \times 64 mm)	H.178	£200.00	
J. (GAB	RIEL	, London—			
PRI	E-1919	ISSUI	ES			
A	BW	10	*Actresses — 'HAGG A' (1900)	H.24	£65.00	_
A2	C	25	*Beauties — 'GRACC' (c1898)	H.59	£120.00	
A	BW	20	Cricketers series (1901)	H.29	£325.00	_
A	C	40	*Home and Colonial Regiments (c1902):	H.69		
			20 Caption in blue		£80.00	
			20 Caption in brown		£80.00	_
A	U	? 52	*Pretty Girl series — 'BAGG' (c1898)	H.45	£70.00	_
A2	C	25	*Types of British and Colonial Troops (c1900)	H.76	£65.00	-
PRI	E-1919	ISSUI	RETTES————		in the	6120.00
D1	U	? 1	Stamp Card c1910	Ha.589-2		£120.00
GA	LLA	HEF	R LTD, Belfast and London—			
			book available — £3.50			
		1919 IS	*Actors and Actresses (c1900)	H 170	£4.50	
D	P	110	*Actors and Actresses (c1900)	П.179	14.50	2 1962 - 10 27
D	C	25	The Allies Flags: (1914):		£5.00	
			A Toned card		£5.00	
-		100	B White card		13.00	
D	C	100	Association Football Club Colours (1910):		£6.00	
			A Grey border		£6.00	
		50	B Brown border	H.180	20.00	
A	C	52	*Beauties (c1900):	П.160	£12.00	
			A Without inset		£12.00	
	0	50	B With Playing Card inset	H.60	112.00	
D	C	50	*Birds and Eggs (c1905)	11.00	£35.00	
			A 'Gallaher Ltd' Label		£7.50	
-	0	100	B 'Manufactured by Gallaher' Label		27.50	1
D	C	100	Birds' Nests and Eggs series (1919):		£1.40	£140.00
			A White card		£1.40	
-	-				21.40	
D	C	100	Boy Scout series Grey-green back (1911):		£1.70	£170.00
		100	A 'Belfast and London' B 'London and Belfast'		£2.00	
-	**	86			£4.50	£225.00
D	U	50	British Naval series (1914)		£3.20	
D	P	100	English and Scotch Views (c1910)		13.20	1320.00
D	C	100	Fables and Their Morals, (1912):		£1.50	£150.00
			A Numbered Outside Set Title Panel		£1.50	£130.00
-	C	100	B & C Later printings, see Post-1920 issues		£2.30	£230.00
D	C	100	The Great War series (1915)		12.30	2230.00

GALLAHER LTD, Belfast and London (continued)

Cina	Duine	λ/	h	77 11 1	ъ.	C 1.
Size	ing	Num in se		Handbook reference	per card	Complete
D				rejerence		
D	C	100	The Great War series — Second Series (1916) The Great War, Victoria Cross Heroes (1915-16):	7.630	£2.30	£230.00
D	-	25	1st series 1-25		£4.00	£100.00
		25	2nd series 26-50		£4.00	£100.00
		25	3rd series 51-75		£4.00	£100.00
		25	4th series 76-100		£4.00	£100.00
		25	5th series 101-125		£4.00	£100.00
		25	6th series 126-150		£4.00	£100.00
		25	7th series 151-175		£4.00	£100.00
		25	8th series 176-200		£4.00	£100.00
D	C	100	How to do it (1916)		£3.00	£300.00
D			Irish View Scenery (c1910):	H.181		
	BW	400	1-400, matt:			
			A Numbered on back		£2.00	 .
	P	400	B Unnumbered, plain back		£3.00	
	P	400	1-400, glossy — see H.181 A Black photo		00	0260.00
			F		90p	£360.00
			B Brown photo		£2.50 £2.00	
			D Numbered 1-200 plain back		£3.00	
	P	600	1-600, glossy — see H.181		23.00	
			A Nos 1 to 500		90p	£450.00
			B Nos 501 to 600		£4.00	
D	C	100	'Kute Kiddies' series (1916)		£3.50	£350.00
D	P	50	Latest Actresses (1910):			
			A Black photo		£12.00	
100	_		B Chocolate photo		£17.00	_
A	C	50	*Regimental Colours and Standards (Nd 151-200)			
		50	(1899)		£6.00	£300.00
A	C	50	Royalty series (1902)		£6.00	£300.00
. A	C	111	The South African series (Nd 101-211) (1901): A White back		05.00	
			A White back		£5.00	
D	C	100	'Sports' series (1912)		£5.00 £5.00	C500 00
D	U	? 87	*Stage and Variety Celebrities (collotype) (c1898):	H.182	13.00	£500.00
Sun or			A 'Gallager' back	11.102	£65.00	
			B 'Gallaher' back		£65.00	
			C As B but larger lettering, etc		£65.00	
D	C	100	Tricks and Puzzles series, green back (1913)		£3.75	£375.00
A	C	50	*Types of the British Army — unnumbered (1897):	H.183		20,0100
			A 'Battle Honours' back		£8.00	
			B 'The Three Pipe' — green back		£8.00	
A	C	50	*Types of the British Army — Nd 1-50 (1898):			
			A 'The Three Pipes' — brown back		£8.00	<u> </u>
	-		B 'Now in Three' — brown back		£8.00	
Α	C	50	*Types of British and Colonial Regiments - Nd			
			51-100 (1900):		4	
			A 'The Three Pipes' — brown back		£8.00	
D	C	100	B 'Now in Three' — brown back		£8.00	-
D	U	100	Useful Hints series (1915)		£2.80	£280.00
D	C	50	Views in North of Ireland (1912)		£42.00	£250.00
D	C	100	'Why is it?' series (1915):		£5.00	£250.00
Oliver	1	100	A Green back		£3.00	£300.00
			B Brown back		£3.00	£300.00
D	C	100	Woodland Trees series (1912)		£4.00	£400.00
					21.00	2.00.00

GALLAHER LTD, Belfast and London (continued)

Size	Print-	Num in se		Handbook reference	Price per card	Complete set
В	POST-1	020 1	SSUES			
D	C	48	Aeroplanes (1939)		80p	£40.00
A2	C	25	Aesop's Fables (1931):	Ha.518		
			A Inscribed 'A Series of 25'		£1.20	£30.00
			B Inscribed 'A Series of 50'		£1.20	£30.00
D	C	100	Animals and Birds of Commercial Value (1921)		70p	£70.00
D	C	48	Army Badges (1939)		70p	£35.00
_	U	24	Art Treasures of the World $(76 \times 56 \text{mm})$ (1930)		44p	£11.00
1	P	48	Beautiful Scotland (77 × 52mm) (1939)		80p	£40.00
D	C	100	Boy Scout Series brown back (1922)		£1.60	£160.00
D	C	48	British Birds (1937)		30p	£15.00
D	C	100	British Birds by Rankin (1923): A 'By Rankin'	Ha.537		
			A 'By Rankin'		£12.00	
			B 'By George Rankin'		£1.10	£110.00
D	C	75	British Champions of 1923 (1924)		£1.50	£110.00
D	C	48	Butterflies and Moths (1938)		28p	£14.00
D	C	25	Champion Animals & Birds of 1923 (1924)		£1.40	£35.00
D	C	48	Champions (1934):			
			A Front without letterpress		50p	£25.00
			B Front with captions, subjects re-drawn		50p	£25.00
D	C	48	Champions, 2nd Series (1935)		45p	£22.00
D	C	48	Champions of Screen & Stage (1934):			
			A Red back		60p	£30.00
			B Blue back, 'Gallaher's Cigarettes' at base		90p	£45.00
			C Blue back, 'Gallaher Ltd' at base		90p	£45.00
D	U	100	Cinema Stars (1926)		£1.50	£150.00
_	P	48	Coastwise (77 × 52mm) (1938)		80p	£40.00
	C	24	Dogs (1934):			
			A Captions in script letters:			
D			1 Small size		£1.70	£40.00
В			2 Large size		£1.70	£40.00
			B Captions in block letters:			
D			B Captions in block letters: 1 Small size		£1.00	£24.00
В			2 Large size		£1.00	£24.00
D	C	48	Dogs (1936)		45p	£22.00
D	C	48	Dogs Second Series (1938)		40p	£20.00
D	Č	100	Fables and Their Morals:			
D	-	100	A First printing, pre-1919 issues			
			B & C Numbered in set title panel			
			B Thin numerals (1922)			
			1 White card		75p	£75.00
			2 Yellow card		75p	£75.00
			C Thick numerals (1922)		75p	£75.00
D	U	100	Famous Cricketers (1926)		£2.50	£250.00
D	C	48	Famous Film Scenes (1935)		60p	£30.00
D	U	100	Famous Footballers, green back (1925)		£1.60	£160.00
D	C	50	Famous Footballers, brown back (1926)		£1.80	£90.00
D	C	48	Famous Jockeys (1936)		£1.00	£50.00
D	C	48	Film Episodes (1936)		60p	£30.00
D	C	48	Film Partners (1935)		70p	£35.00
_	P	48	Flying (77 × 52mm) (1938)	Ha 564-3	£1.00	
D	C	100	Footballers, red back (1928):	214.007.0	~1.00	
D	-	100	1 Nos. 1-50 — Action pictures		£1.80	£90.00
			2 Nos. 51-100 — Portraits		£2.00	£100.00
D	C	50	Footballers in Action (1928)		£1.80	£90.00
D	C	48	Garden Flowers (1938)		20p	£10.00
D		40	Garden Flowers (1936)		20p	210.00

GA	LLA	HER	LTD, Belfast and London (continued)			
Size	Print ing	- Num in se		Handbook reference	Price per card	Complete
D		100	Interesting Views:			
	P		A Uncoloured, glossy (1923)		£1.60	£160.00
	CP		B Hand-coloured, matt (1925)		£2.25	£225.00
B2	P	48	Island Sporting Celebrities (Channel Islands) (1938)		£1.40	£70.00
D	C	50	Lawn Tennis Celebrities (1928)		£3.20	
A	C	24	Motor Cars (1934)		£4.00	£100.00
D	C	48	My Favourite Part (1939)		60p	£30.00
D	C	48	The Navy (1937):			turensi.
			A 'Park Drive' at base of back		60p	£30.00
			B 'Issued by' at base of back		90p	£45.00
_	P	48	Our Countryside (72 × 52mm) (1938)	Ha.564-4	90p	
D	C	100	Plants of Commercial Value (1923)		80p	£80.00
D	C	48	Portraits of Famous Stars (1935)		£1.00	£50.00
D	C	48	Racing Scenes (1938)		60p	£30.00
D	C	100	The Reason Why (1924)		75p	£75.00
D	C	100	Robinson Crusoe (1928)		£1.50	£150.00
B2	P	48	Scenes from the Empire (1939) (export)	Ha 565	30p	£15.00
	P	24	Shots from the Films $(77 \times 52 \text{mm}) (1936) \dots$	Ha 566	£2.50	£60.00
D	C	48	Shots from Famous Films (1935)	114.500	60p	£30.00
D	C	48	Signed Portraits of Famous Stars (1935)		£1.80	230.00
D	C	48	Sporting Personalities (1936)		40p	£20.00
D	C	48	Stars of Screen & Stage (1935):		чор	220.00
9		.0	A Back in green		60p	£30.00
			B Back in brown		£1.50	£75.00
D	C	48	Trains of the World (1937)		80p	£40.00
D	C	100	Tricks & Puzzles Series, black back (1933):		оор	140.00
		00272	Nos. 1-50		80p	£40.00
			Nos. 51-100		80p	£40.00
D	C	48	Wild Animals (1937)		28p	£14.00
D	C	48	Wild Flowers (1939)		40p	£20.00
D	C	100	The 'Zoo' Aquarium (1924)		£1.20	£120.00
D	C	50	'Zoo' Tropical Birds, 1st Series (1928)		£1.30	£65.00
D	C	50	'Zoo' Tropical Birds, 2nd Series (1929)		£1.30	£65.00
C .	SILKS	STATE OF			21.50	205.00
	C	24	Flags — Set 1 (68 × 48mm) (paper-backed)			
	Ŭ		(1916) (1916) (paper-backed)	Ha.501-1	£7.50	<u> </u>
			0			
SA	MUE	L GA	AWITH, Kendal—		7.1957.0	195 FIRE
		ISSU				
	BW	25	The English Lakeland (90 × 70mm) (1926)		£18.00	6.10 -
F. (GENI	NARI	LTD, London	igerge-mayb.	6 16	MI - LA
		ISSUE				
A	U	50	War Portraits (1916)	H.86	£65.00	_
LO	UIS	GER.	ARD LTD, London—			
		ISSU		xuvau0		
D1	U	50	Modern Armaments (1938):	Ha.567		
			A Numbered	AL GOSSON -A	80p	£40.00
			B Unnumbered		£1.00	£50.00
					~1.00	250.00

Size	Print-			Handbook	Price	Complete
	ing	in se		reference	per card	se
D1	U	24	Screen Favourites (1937):	Ha.568		
			A Inscribed 'Louis Gerard & Company'		£3.00	
			B Inscribed 'Louis Gerard Limited'	to bould fill	£3.00	2440.00
D1	С	48	Screen Favourites and Dancers (1937)	Ha.569	£2.20	£110.00
W.C	G. GI	ASS	S & CO. LTD, Bristol—		4 15	
	-1919 1					
A	BW	20	*Actresses — 'BLARM' (c1900)	H.23	£65.00	_
A2	BW	10	*Actresses — 'HAGG A' (c1900)	H.24	£65.00	
A	U	25	*Beauties — 'FECKSA (c1901)'	H.58	£80.00	-
D1	BW	20	*Boer War Cartoons ('Roseland Cigarettes') (c1901)	H.42	£80.00	
Α	BW	25	*Boer War Celebrities — 'STEW' (c1901)		£70.00	
A	BW	16	*British Royal Family (1901)	H.28	£65.00	- 1 - 1 - 1 - 1 - 1 - 1 - 1 - 1 - 1 - 1
A2	BW	20	Cricketers Series (1901)	H.29	£325.00	- 15
D	C	40	*Naval and Military Phrases (c1902)	H.14	£90.00	
A	BW	19	*Russo-Japanese Series (1904)		£55.00	1 1 1 <u>1 1 1 1 1 1 1 1 1 1 1 1 1 1 1 1 </u>
R.	P. GL	OA	G & CO, London	and a orthogo		- 12 - 13
(Car	ds hear	adver	tisements for 'Citamora' and/or 'The Challenge Flat Brilli	antes' withou	t maker's n	ame)
7.7.7.7.7	-1919 1			H 105	£180.00	
A2	U	?8	*Actresses — 'ANGLO' (c1896)		£180.00	
D	L.		*Beauties — Selection from 'Plums' (c1898):	H.186		
	BW		A 'The Challenge Flat' front:		005.00	
		? 41	(a) front in black and white		£85.00	
	U	? 3	(b) front in brown printed back		£130.00	_
	U	?3	(c) front in brown, plain back		£130.00	
		? 10	B 'Citamora' front in black and white	** **	£130.00	7 0
A	C	40	*Home and Colonial Regiments (c1900):	H.69	0.15.00	
			20 Caption in blue		£45.00	- 19 - I
			20 Caption in brown		£45.00	1 9 T
D	C	30	*Proverbs (c1901)	H.15	£80.00	
A2	C	25	*Types of British and Colonial Troops (c1900)	H.76	£55.00	-
GL	OBE	CIG	GARETTE CO.	early to Mile	10.000.000	41111
PRE	-1919	ICCIII	7			
D	BW		*Actresses — French (c1900)	H.1	£160.00	THV. A.2
GO	or ne	ITT), Birmingham————		1011	PURE
	2-1919				0075.00	
A2	BW	1	Advertisement Card (Chantecler) (c1905)		£275.00	ortonia 😨
C	C	18		Ha.469	0.50.00	
			A Back in blue, numbered		£50.00	HVL-30T
			B Back in grey, numbered		£60.00	F-11 - 7
			C Back in grey, unnumbered	** **	£60.00	
-	BW	? 14	*Prints from Noted Pictures (68 × 81mm) (c1908)	Ha.216	£110.00	· ·
T. 1	P. & 1	R. G	OODBODY, Dublin and London—	GUTA GE	1/11/10	81 10 1
	PRE-19					
Α.		? 20	*Actresses — 'ANGOOD' (36 × 60mm) (c1898)	H 187	£140.00	A Company
A2	U	? 4	*Beauties — 'KEWA' (c1898)		£125.00	
AZ	U	. 4	Deductes — INLITE (C1090)	.14.137	2125.00	

			ODBODY, Dublin and London (continued)			
Size	Print-ing	in se		Handbook reference	Price per card	Complete set
D	BW		*Boer War Celebrities — 'CAG' (1901)		per cara	Sc.
	2	25	See H.79 — Fig. 79-B		£30.00	
		16	See H.79 — Fig. 79-C		£35.00	
		16	See H.79 — Fig. 79-D		£35.00	
A2	C	10	Colonial Forces (c1900):	H.188	233.00	
		? 40	A Brown back	11.100	£70.00	
		? 40	B Black back		£70.00	
_		? 49	*Dogs (1910) (36 × 60mm)	Ц 190	£70.00	X181 - 1 1 1 1 1 1 1 1 1 1 1 1 1 1 1 1 1
C	Č	26	Eminent Actresses — 'FROGA A' (c1900)	П.109		18-34-3
C	C	20	Irish Scenery (Five Printings) (c1905)	H 100	£40.00	
A2	Ü	20	*Pretty Girl Series — 'BAGG' (c1898):	П.190	£40.00	V TO THE
112	0	?3	A Red stamped back	п.43	6110.00	
		?4	B Violet stamped back		£110.00	UN - 18 (1)
A	C	25		TT 144	£110.00	5 5 6
D	U	20	Types of Soldiers (c1914)* *War Pictures (c1915)	H.122	£55.00	
C	C	12	*War Pictures (c1915)		£25.00	
			'With the Flag to Pretoria' (c1901)	H.191	£100.00	
			SSUES			
D A	C	50	Questions & Answers in Natural History (1924)		£2.60	£120.00
A	C	25	Sports & Pastimes — Series 1 (1925)	H.225	£6.00	£150.00
~~						
GO	RDO	N'S,	Glasgow————			
PRE	-1919	ISSUE				
	BW		Billiards — By George D. Gordon (c1910)		£200.00	
***	D	00.711	Billiards — By George D. Gordon (C1910)		1200.00	41 - 181
GR	AVE	SON	, Mexboro'	Futores intest	A S	
					A LOG	
	-1919 1					
A2	C	30	*Army Pictures, Cartoons, Etc (c1916)	H.12	£75.00	_
A	U	50	War Portraits (1916)	H.86	£65.00	Y
ED	ED C	DAY	Rirmingham			
			, Dir iningnam	Demokalpedi		V 1
PRE	-1919 1	ISSUE				
A	C	25	*Types of British Soldiers (c1914)	H.144	£90.00	<u> </u>
~~			The second of the second of the property of the property of the second o			
GR	IFFI	THS	BROS., Manchester—			
POS	T-1920	ISSII	E			
		18	*Beauties (89 × 70mm) (c1925)		£70.00	
			20ddies (05 × 70mm) (01925)		270.00	
W.	I. HA	RRI	IS, London—			
				Same Service		
	-1919 1		S			
A2		26	*Beauties 'HOL' (c1900)	H.192	£30.00	
C	C	30	*Colonial Troops (c1900)	H.40	£80.00	
A1	C	25	*Star Girls (c1899)	H.30	£180.00	
***			A CONTRACTOR OF THE PROPERTY O			
JAS	. H.	HAR	RRISON, Birmingham—————	the stay on the		-
PRE	-1919 1	SSUE				
C	C	18	Motor Cycle Series (c1914)	Ha 469	£70.00	
			2,112 001100 (01711)	114.409	270.00	reog a
HA	RVE	Y &	DAVEY, Newcastle-on-Tyne	mukt 19 kör	A 1-102	000
			그리는 사람들은 사람들은 아이들은 살아왔다. 그렇게 되었다면 그렇게 되었다면 하는 것이 없는 것이 없는 것이 없었다면 하는 것이 없는데 없는데 없는데 없는데 없는데 없는데 없는데 없는데 없는데 없다면	abovery 1986	Alto Bitte	SAL A
D1	-1919 1		프로마트 플러스 시민에 열면 있었다면 하는데 이 때문에 가장하면 가장 하는데 가장 하는데 가장 하는데	in Raid Process	21.05	
וע	-	50	*Birds and Eggs (c1905)	H.60	£4.00	£200.00

	Print-	Num		Handbook		Complete
	ing	in se		reference	per card	set
A1		? 11	*Chinese and South African Series (c1901)		£110.00	taga e e d a
C	C	30	*Colonial Troops (c1900)	H.40	£65.00	_
A1	· C	25	*Types of British and Colonial Troops (c1901)	H.76	£75.00	_
w.	& H.	HE	ATON, Birkby—	entir Storger		
PRI	E-1919	ISSII	7			
-	BW	?6	Birkby Views (70 × 39mm) (c1912)	H.226	£150.00	
HE	ENLY	& V	VATKINS LTD, London—		A1 1 1 1 1 1 1 1 1 1 1 1 1 1 1 1 1 1 1	
	ST-1920					
A1	C C	25	Ancient Egyptian Gods — 'Matossian's			
AI	C	23	Cigarettes' (1924)	Ha.570		
			*A Plain back		£5.00	£125.00
			B Back in blue		£6.00	£150.00
ш	CNE	гт в	ROS. & CO., Liverpool			
	PRE-1		SUES	11.20	050.00	
C	C	26	*Actresses — 'FROGA A' (c1900)	H.20	£50.00 £22.00	
A2	U	25	*Actresses — Photogravure (c1900)	H.194	£22.00	41.40 × 2.44
D1	BW	28	*Actresses — 'PILPI I' (c1901)	П.193	£12.00	
D1	P	50	*Actresses — 'PILPI II' (c1901)	П.190	112.00	£325.00
A	U	1	Advertisement Card. Smoking mixture (c1890)	H 107	£27.00	1323.00
_	C	60	Animal Pictures (38 × 70mm) (c1900)	H.198	127.00	100
D	U	50	*Beauties — gravure (c1898):	11.196	£65.00	KIND OF
			A 'Cavalier' back B 'Golden Butterfly' back		£65.00	
0	С	? 2	*Beauties — 'CHOAB' (c1900)	H 21	£110.00	
C A1	C	? 19	Cabinet, 1900		£70.00	_
	C	25	Cathedrals and Churches (1909)	11.177	£4.40	£110.00
A	C	25	Company Drill (1915)		£4.40	£110.00
A	C	25	Greetings of the World (1907 — re-issued 1922)		£3.00	£75.00
A	C	50	Interesting Buildings (1905)	H.70	£5.00	£250.00
A	C	40	*Medals (34 × 72mm) (1901):	H 200		
100	C	40	A 'Butterfly Cigarettes'		£22.00	1 1 1 1 1 1 1 1 1 1 1
			B Officially cut for use in other brands		£22.00	1007-1121-11921
A	BW	25	Military Portraits (1914)	H.201	£5.00	£125.00
A	C	25	Modern Statesmen (1906):			
		- 55	A 'Butterfly' back		£5.00	£125.00
			B 'Pioneer' back		£5.00	£125.00
A	C	20	*Music Hall Artistes (c1900)	H.202	£50.00	2016 1-0 TO
_	C	1	Oracle Butterfly (shaped) (c1898)		_	£125.00
A	C	25	Panama Canal (1914)		£6.00	£150.00
A2	C	12	*Pretty Girl Series — 'RASH' (c1900)	H.8	£50.00	
_	BW	25	*V.C. Heroes (35 × 72mm) (1901)		£45.00	_
A	C	20	*Yachts (c1902):			
			A Gold on black back		£60.00	PRESENT
			B Black on white back		£60.00	0.0
B			SSUES	** *** *	04.50	075.00
A	C	50	Actors — Natural and Character Studies (1938)	Ha.571-1	£1.50	£75.00
A	C	50	A.F.C. Nicknames (1933)	Ha.571-2	£4.50	C40.00
A	C	50	Air-Raid Precautions (1939)	Ha.544	80p	£40.00
A	C	50	Arms and Armour (1924)	H.2/3	£2.80	£140.00

HIGNETT BROS. & CO., Liverpool (continued)

			aosi a con ziver poor (commuca)			
Size	Print- ing	Num in se		Handbook reference	Price per card	Complete set
A	C	50	British Birds and Their Eggs (1938)	Ha.571-3	£2.20	
A	U	50	Broadcasting (1935)		£2.00	<u> </u>
A	U	50	Celebrated Old Inns (1925)		£2.80	£140.00
A	C	50	Champions of 1936 (1937)	Ha.571-5	£2.60	£130.00
A	C	25	Common Objects of the Sea-Shore (1924)		£2.20	£55.00
A	C	50	Coronation Procession (sectional) (1937)	Ha.571-6	£2.00	
A	C	50	Dogs (1936)	Ha 571-7	£1.80	£90.00
A	C	50	Football Caricatures (1935)	Ha.571-8	£2.80	£140.00
A	C	50	Football Club Captains (1935)	Ha.571-9	£2.80	£140.00
A	U	25	Historical London (1926)		£2.40	£60.00
A	C	50	How to Swim (1935)	Ha.571-10	80p	£40.00
A	C	25	International Caps and Badges (1924)		£3.40	£85.00
A	C	25	Life in Pond & Stream (1925)		£2.60	£65.00
A	C	50	Modern Railways (1936)	Ha.571-11	£2.40	£120.00
A	C	50	Ocean Greyhounds (1938)	Ha.571-12	£1.40	£70.00
A	U	25	*The Prince of Wales' Empire Tour (1924)		£2.40	£60.00
A	U	50	Prominent Cricketers of 1938 (1938)	Ha.571-13	£2.80	£140.00
A	C	50	Prominent Racehorses of 1933 (1934)	Ha 571-14	£2.50	£125.00
A	C	50	Sea Adventure (1939)	Ha 571-15	40p	£20.00
A	C	25	Ships Flags & Cap Badges (1926)	114.571 15	£3.00	£75.00
A	C	25	Ships Flags & Cap Badges, 2nd Series (1927)		£3.60	£90.00
A	C	50	Shots from the Films (1936)	Ha 571-16	£3.00	£150.00
A	C	50	Trick Billiards (1934)	Ha 571-17	£3.00	2130.00
A	U	25	Turnpikes (1927)	114.571 17	£2.40	£60.00
A	C	50	Zoo Studies (1937)	Ha 571-18	90p	£45.00
				114.571 10	УОР	245.00
R.	& J. I	HIL	L LTD, London—			
28 p	age refe	rence	book available — £3.50			
A	PRE-19	19 IS	SUES			
A	C	26	*Actresses — 'FROGA A' (c1900)	H 20	£50.00	
D	BW	30	*Actresses, Continental (c1905):	H.205	230.00	
			A 'The Seven Wonders' back	11.203	£16.00	
			B 'Black and White Whisky' back		£25.00	
			C Plain back		£16.00	
D	BW		*Actresses — 'HAGG B' (c1900):	H.24	£10.00	And the second
		16	A 'Smoke Hill's Stockrider'	11.24	C25 00	
		10	B 'Issued with Hill's High Class'		£35.00	-
	BW	25	*Actresses (Belle of New York Series) (1899):	11207	£35.00	
	D	23	A White back $(41 \times 75 \text{mm})$		600.00	
			B Toned back, thick card (39 × 74mm)		£22.00	-
D1	U	20			£22.00	
DI	U	20		H.207		
					£16.00	_
					£20.00	_
C	C	20			£16.00	_
C	C	20	*Animal Series (1909):			
			A 'R. & J. Hill Ltd.' back		£24.00	1 11-
			B 'Crowfoot Cigarettes' back		£23.00	_
			C 'The Cigarettes with which' back		£30.00	-
			D Space at back		£20.00	
	DW	111	E Plain Back		£25.00	
A	BW ?	14	*Battleships (c1908): A 'For the Pipe Smoke Oceanic' back	H.208		
			A 'For the Pipe Smoke Oceanic' back		£130.00	_
	- (1)		B Plain back		£50.00	J
A	C	25	*Battleships and Crests (1901)		£16.00	£400.00
D2	C	12	*Boer War Generals ('Campaigners') (c1901)	H.209	£32.00	£385.00

м. с	x J. 1	IILL	LID, London (commuea)			
Size	Print- ing	Numi		Handbook reference	Price per card	Complete set
A1	C	20	Breeds of Dogs (1914):	H.211		
AI	_	20	A 'Archer's M.F.H.' back	11.211	£17.00	. 10 - 10 <u>10 10 10 10 10 10 10 10 10 10 10 10 10 1</u>
					£17.00	
						- N
			C 'Hill's Verbena Mixture' back		£17.00	
			D 'Spinet Tobacco' back	*** ***	£17.00	_
D1	BW	? 48	*British Navy Series (c1902)	H.210	£25.00	
A	BW	? 1	*Celebrated Pictures (c1905)		£150.00	_
C	C		*Colonial Troops (c1900):	H.40		
		30	A i 'Hill's Leading Lines' back		£22.00	_
		30	A ii 'Perfection vide Dress' back		£22.00	_
		50	B 1-50. 'Sweet American' back		£22.00	_
D1	U	28	Famous Cricketers Series (1912):			
			A Red back, blue picture		£60.00	. 1 part - 12
			B Deep blue back, brown picture		£60.00	_
			C Blue back, black picture		£60.00	
D1	BW	20	Famous Footballers Series (1912)		£18.00	£360.00
DI	U	25	Famous Pictures: $(41 \times 70 \text{mm})$ (c1912):	H.468	210.00	2200.00
	U	23	A 'Prize Coupon' back	11.400	£4.00	£100.00
			B Without 'Prize Coupon' back		£4.00	£100.00
C	C	30	들는 보고 있는 것이 없는	Ци1	£22.00	2100.00
C	C		*Flags and Flags with Soldiers (c1902)	П41	122.00	
_	C	24	*Flags, Arms and Types of Nations, 'Black & White'	TT 115	C10.00	C240.00
			Whisky advert back $(41 \times 68 \text{mm})$ $(c1910)$	H.115	£10.00	£240.00
D	BW	20	Football Captain Series. Nd. 41-60 (1906):		620.00	
			A Small title		£28.00	
			B Larger title, back re-drawn		£35.00	— I
_		10	Fragments from France $(38 \times 67 \text{mm})$ (1916) :	H.212		
	C		A Coloured, caption in script		£20.00	£200.00
	U		B Sepia-brown on buff, caption in block		£22.00	£220.00
	U		C As B, but black and white		£65.00	<u> </u>
_	C	10	Fragments from France, different subjects, caption			
			in block (38 × 67mm) (1916)	H.212	£20.00	£200.00
A1	U	25	Hill's War Series (c1916)		£11.00	£275.00
C2	C	20	Inventors and Their Inventions Series, Nd. 1-20, (1907):		211.00	2275.00
CZ	C	20	A Black back, white card	11.213	£4.50	£90.00
			D Diede beek toned cond (charter)		£6.00	290.00
CO	0	20	B Black back, toned card (shorter)			£140.00
C2	C	20	Inventors and Their Inventions Series, Nd. 21-40, (1907)	11.014	£7.00	£140.00
_	_	15	*Japanese Series $(40 \times 66 \text{mm})$ (1904) :	H.214	250.00	
	C		A 'Hills' on red tablet		£60.00	
	BW		B 'Hills' on black tablet		£42.00	_
_	C	20	Lighthouse Series — without frame lines to picture			
			$(42 \times 68 \text{mm}) (c1903) \dots \dots \dots \dots \dots \dots$		£35.00	_
_	C	30	Lighthouse Series — with frame line. Nos. 1-20 re-			
			touched and 10 cards added (c1903)		£35.00	_
D	C	20	National Flag Series (1914)	Ha.473	£7.00	£140.00
			Plain back		£7.00	
Contract to	BW	24	*Naval Series Unnumbered (42 × 64mm) (1901)	H 215	£45.00	
D1	BW	30	Naval Series Nd. 21-50 (1902):	H.215	213.00	
DI	DW	30	A Numbered 21-40	11.213	£12.00	
					£50.00	
-	_	20	B Numbered 41-50	11.00		C240.00
C	C	20	Prince of Wales Series (1911)		£12.00	£240.00
_	U	? 14	*Prints from Noted Pictures $(68 \times 81 \text{mm})$ (c1908)		£100.00	- 1 -
_	BW	20	Rhymes — black and white sketches (c1905)		£24.00	
A1		30	*Statuary — Set 1 (c1900):	Ha.218-1		
	U		A Brown front		£75.00	_
	BW		B Black and white front, matt		£30.00	_
	BW		C Black and white front, varnished		£11.00	-

1	a J.	HILL	LID, London (continuea)			
Size	Prin ing	t- Nun in se		Handbook reference	Price per card	Complete set
A	BW	30	*Statuary — Set 2 (c1900):	Ha.218-2		
			A Front in black and white		£8.00	£240.00
			B Front greenish-black		£8.00	2240.00
C1	BW		*Statuary — Set 3 (c1900):	Ha.218-3	20.00	
-		? 21	A Name panel white lettering on black background	114.210-3	£20.00	
		? 4	B Name panel black lettering on grey background		£50.00	
		? 23	C Name panel black lettering on white background		£50.00	
D	C	20	*Types of the British Army (1914):		250.00	
		20	A 'Badminton' back		£27.00	
			B 'Verbena' back		£27.00	
Α	U	25	World's Masterpieces — 'Second Series' (c1915)		£2.00	£50.00
					12.00	130.00
			ISSUES (1024)			
C	U	30	The All Blacks (1924)		£4.50	£135.00
A	BW	25	Aviation Series (1934):			
			A 'Issued by R. & J. Hill'		£2.60	£65.00
	**		B 'Issued with "Gold Flake Honeydew"'		£3.00	£75.00
-	U	50	Caricatures of Famous Cricketers (1926):			
C			A Small size		£2.60	£130.00
B1	-		B Large size		£1.70	£85.00
D1	C	50	Celebrities of Sport (1939):			
			A 'Issued by R. & J. Hill'		£1.80	£90.00
	-		B 'Issued with "Gold Flake Honeydew"'		£3.00	-
A2	C	35	Cinema Celebrities (1936):	Ha.572		
			A Inscribed 'These Cigarettes are guaranteed'		85p	£30.00
			B Inscribed 'The Spinet House'		£1.00	£35.00
D1	BW	40	Crystal Palace Souvenir:			
			A Front matt (1936)		£1.50	£60.00
201			B Front varnished (1937)		£1.40	£55.00
D1	C	48	Decorations and Medals (1940):			
			A 'Issued by R. & J. Hill'		£1.50	£75.00
			B 'Issued with Gold Flake Cigarettes'		£3.00	
	P		Famous Cinema Celebrities (1931):	Ha.573		
		? 48	Set 1:			
_			A Medium size $(74 \times 56 \text{mm})$ inscribed 'Series A'		£4.00	
A			B1 Small size, inscribed 'Spinet Cigarettes'		£4.00	_
A			B2 Small size, without 'Spinet Cigarettes'		£4.00	_
		50	Set 2:			
-			C Small size (66 × 41mm) inscribed 'Series C':			
			1 'Devon Cigarettes' at base of back		£7.00	
			2 'Toucan Cigarettes' at base of back		£6.00	_
			3 Space at base of back blank		£4.00	<u> </u>
			D Medium size $(74 \times 56 \text{mm})$ inscribed 'Series D':			
			1 'Kadi Cigarettes' at base of back		£4.00	
			2 Space at base of back blank		£4.00	<u> </u>
C	U	40	Famous Cricketers (1923)		£4.50	£180.00
	U	50	Famous Cricketers, including the S. Africa Test		24.50	2100.00
			Team — 'Sunripe Cigarettes' (1924):			
C			Team — 'Sunripe Cigarettes' (1924): A Small size		£3.50	£175.00
B1			B Large size		£4.00	£200.00
	C	30	Famous Engravings — Series XI (80 × 61mm) (c1920)		£4.50	2200.00
A2	BW	40	Famous Film Stars (1938):		~7.50	
			A Text in English		£1.00	£40.00
			B Text in Arabic, caption in English (see also		21.00	240.00
			Modern Beauties)		£1.00	£40.00
C	U	50	Famous Footballers (1923)		£2.50	£125.00
					22.30	2123.00

14.	Z J. 11	ILL	DID, Dondon (commuca)				
Size	Print-ing	Numi in set		Handbook reference	Price per card	Complete set	
D	C	50	Famous Footballers (1939):	Ha.574			
		1	A Shoreditch address		£1.80	£90.00	
			B 'Proprietors of Hy. Archer'		£2.00	£100.00	
D	C	25	Famous Footballers, Nd. 51-75 (1939)		£2.40	£60.00	
D	C	50	Famous Ships:				
			A Front matt (1939)		90p	£45.00	
			B Front varnished (1940)		80p	£40.00	
D	C	48	Film Stars and Celebrity Dancers (1935)		£1.40	£70.00	
	C		Historic Places from Dickens' Classics (1926):				
D		50	A Small size		60p	£30.00	
B1			B Large size:				
			1 Nos. 2-26, small numerals		70p	£17.50	
			2 Nos. 1-50, large numerals		60p	£30.00	
	U	50	Holiday Resorts (1925):				
C			A Small size:		00	0.45.00	
			1 Back in grey		90p	£45.00	
			2 Back in brown		£1.30	_	
B1			B Large size:		00	640.00	
			1 Back in grey		80p	£40.00	
	DIII	20	2 Back in brown	TI 212	£1.30	C25 00	
A	BW	20	*Inventors and Their Inventions (plain back) (1934)	H.213	£1.25	£25.00	
	DIII		Magical Puzzles — see 'Puzzle Series'				
A2	BW	50	Modern Beauties (1939):		£1.00	£50.00	
		50	A Titled 'Modern Beauties'. Text in English		11.00	230.00	
		40	B Titled 'Famous Film Stars' (selection). Text in		£2.00		
	C	30	Arabic, no captions		12.00	avr. 1 - 1 0	
DI	C	30	A Small size		£1.85	£55.00	
D1					£1.85	£55.00	
B1	C	30	B Large size		£1.20	£36.00	
D C2	C	30	Nautical Songs (1937)		90p	£27.00	
CZ	U	30	'Our Empire' (1929):		УОР	227.00	
D1	U	30	A Small size		33p	£10.00	
B1			B Large size		40p	£12.00	
ы	BW		Popular Footballers — Season 1934-5 (68 × 49mm):		тор	212.00	
	DW	30	'Series A' — Nd. 1-30		£2.50	£75.00	
		20	'Series B' — Nd. 31-50		£2.75	£55.00	
	U	20	Public Schools and Colleges (1923):	Ha.575	. /		
		50	A 'A Series of 50':				
C		50	1 Small size		70p	£35.00	
B1			2 Large size		70p	£35.00	
		75	B 'A Series of 75':				
C			1 Small size		90p	£70.00	
B1			2 Large size		90p	£70.00	
A1	C	50	Puzzle Series:				
			A Titled 'Puzzle Series' (1937)		£1.00	£50.00	
			B Titled 'Magical Puzzles' (1938)		£1.50	£75.00	
	U	50	The Railway Centenary — 'A Series of 50' (1925):				
C			A Small size		£1.30	£65.00	
B1			B Large size:				
			1 Back in brown		£1.30	£65.00	
			2 Back in grey		£3.00	mul -	
	U	25	The Railway Centenary — '2nd Series — 51 to 75'				
			(1925):			2105-	
C			A Small size		£1.60	£40.00	
B1			B Large size		£1.60	£40.00	

Size	Print ing	- Num in se		Handbook reference	Price per card	Complete set
C2	P	42	Real Photographs — Set 1 (Bathing Beauties) (c1930):		per cara	sei
-		72	A 'London Idol Cigarettes' at base of back:	11a.370-1		
			1 Front black and white, glossy		£2.50	<u></u>
			2 Front brown, matt		£2.50	
			B Space at base of back blank:			
			1 Front black and white, glossy		£2.50	_
00	D	10	2 Front brown, matt		£2.50	_
C2	P	42	Real Photographs — Set 2 (Beauties) (c1930)	Ha.576-2	£3.00	_
D1	P	50	The River Thames — see 'Views of the River Thames'			
DI	Г	30	Scenes from the Films (1932): A Front black and white		£2.50	
			B Front sepia		£2.50	
A2	BW	40	Scenes from the Films (1938)		75p	£30.00
D1		35	Scientific Inventions and Discoveries (1929):	Ha.213	75p	230.00
	C	55	A Small size, 'The Spinet House' back	11a.213	£1.00	£35.00
	BW		B Small size, 'The Spotlight Tobaccos' back		£1.00	£35.00
B1	C		C Large size		£1.00	£35.00
DI	P	50	Sports (1934):		21.00	233.00
			A Titled 'Sports', numbered front and back		£4.00	<u> </u>
			B Titled 'Sports Series', numbered front only		£10.00	_
			*C Untitled, numbered front only		£10.00	<u> </u>
D1	C	100	*Transfers (c1935)	Ha.596-2	£5.00	
B2	CP		Views of Interest:			
		48	'A First Series' Nd. 1-48 (1938):			
			A 'The Spinet House' back		25p	£12.50
		40	B 'Sunripe & Spinet Ovals' back		25p	£12.50
		48	'Second Series' Nd. 49-96 (1938)		25p	£12.50
		48 48	'Third Series' Nd. 97-144 (1939)		. 25p	£12.50
		48	'Fourth Series' Nd. 145-192 (1939) 'Fifth Series' Nd. 193-240 (1939)		40p	£20.00
B2	CP	40	Views of Interest — British Empire Series:		40p	£20.00
DZ	CI	48	'1st Issue — Canada — Nos. 1-48' (1940)		20-	C15.00
		48	'2nd Issue — India — Nos. 49-96' (1940)		30p £2.50	£15.00 £120.00
	U	50	Views of London (1925):	Ha.577	12.50	1120.00
C			A Small size	11a.577	80p	£40.00
B1			B Large size		90p	£45.00
	C	50	Views of the River Thames (1924):		Joh	213.00
D			A Small size:			
			Nos. 1-25		£1.60	£40.00
			Nos. 26-50		£1.40	£35.00
B1			B Large size:			
			1 Back in green (thin card)		£1.30	£65.00
			2 Back in green and black (thick card)		£1.30	£65.00
	U.	50	Who's Who in British Films (Nov. 1927):			
A2			A Small size		£1.60	£80.00
B2	-		B Large size		£1.60	£80.00
C	C	84	Wireless Telephony (1923)		£1.20	£100.00
B1	U	20	Wireless Telephony — Broadcasting Series (1923)		£2.25	£45.00
	U	50	Zoological Series (1924):	Ha.578		
C			A Small size:			
			1 Back in light brown		80p	£40.00
B1			2 Back in grey		90p	£45.00
DI			B Large size: 1 Back in light brown		00-	£45.00
			2 Back in dark brown		90p 90p	£45.00 £45.00
			2 Back in dark brown		90p	243.00

Size Print- Number ing in set	Handbook reference	Price per card	Complete set
C POST-1940 ISSUE			
A U 50 Famous Dog Breeds 1954 (Admiral Cigarettes Slides)		£7.00	_
D CANVASES. Unbacked canvases. The material is a linen fabric, glazed	to give the	appearance	of canvas.
Specimens are found rubber stamped in red on back 'The Pipe Tobacco de I	uxe Spinet N	Aixture'.	
_ C 30 'Britain's Stately Homes' (78 × 61mm) (c1915)		£3.50	_
— C *Canvas Masterpieces — Series 1 (73 × 61mm) (c1915):			
A 'Badminton Tobacco Factories' back:			
40 1 'H.T. & Co., Ltd., Leeds' at right base		£1.30	_
20 2 Cardigan Press, Leeds' at right base (Nos. 21-			
40)		£1.30	
Without printers' credit (Nos. 21-30)		£1.30	
3 4 As 3, but size 73×53 mm (Nos. 23-25)		£1.30	
40 B 'The Spinet House' back		£2.00	£80.00
— C 40 *Canvas Masterpieces — Series 2, Nd. 41-80 (73 ×			
61mm) (c1915)		£2.00	£80.00
 C 10 *Canvas Masterpieces — Series 2, Nd. 1-10 (c1915): 			
Nos. 1 to 5		£2.00	£10.00
Nos. 6 to 10		£3.00	£15.00
 C Schinese Pottery and Porcelain — Series 1 (132 × 			
108mm) (c1915)		_	£20.00
4 Different (minus No. 5)		60p	£2.50
 C 11 Chinese Pottery and Porcelain — Series 2 (107 × 			
62mm) (c1915)		£5.00	
 C 23 *Great War Leaders — Series 10 (73 × 60mm) (1919) 		£5.00	_
L. HIRST & SON, Leeds—			
PRE-1919 ISSUE	**	2127.00	
— C ? 5 *Soldiers and their Uniforms (cutouts) (c1915)	H.138	£125.00	- -
J. W. HOBSON, Huddersfield—			
옷을 잃었다면 하면 있다면 다시 아이들이 되는 아이들이 하면 하는데 모든 중에 가는데 되었다면 되었다면 되었다.			
PRE-1919 ISSUE	II. 460	C75 00	
C2 C 18 Motor Cycle Series (c1914)	Ha.469	£75.00	
J. & T. HODGE, Glasgow—		2	
, and a second s			
PRE-1919 ISSUES	11 210	c200 00	
— C ? 4 *British Naval Crests (70 × 38mm) (c1896)	H.219	£200.00	8 1 5 TV
A BW 16 British Royal Family (c1901)	II. 220	£130.00	-
U *Scottish Views (c1898):	Ha.220	C100.00	
? 11 A Thick card (74 × 39mm)		£100.00	
? 10 B Thin card (80 × 45mm)		£100.00	
HOOK OF HOLLAND CIGARETTES—	701		
PRE-1919 ISSUE			
A U ? 3 *Footballers (c1905)		£180.00	
		2100.00	
HUDDEN & CO. LTD, Bristol—			
A PRE-1919 ISSUES			
C C 26 *Actresses — 'FROGA A' (c1900)	H.20	£55.00	
C C 25 *Beauties — 'CHOAB' (c1900)	H.21	£50.00	
A2 U ? 20 *Beauties — 'Crown Seal Cigarettes' (c1898)	H.221	£110.00	
A U ? 24 *Beauties — 'HUMPS' (c1898):	H.222		
A Blue scroll back		£60.00	27 L
B Orange scroll back		£55.00	
C Typeset back in brown		£200.00	
2,7,70000			

HUDDEN & CO	. LTD, Bristol	(continued)
-------------	----------------	-------------

Tibel (communica)			
Size Print- Number ing in set	Handbook	Price	
	reference	per card	set
D1 C ? 12 Comic Phrases (c1900)	. H.223	£100.00	
A C 25 *Flags of All Nations (c1905)	. Н.37	£16.00	£400.00
 C 48 *Flowers and Designs (55 × 34mm) (c1900): 	H.224	210.00	2100.00
A 'Hudden Cigarettes' back		£85.00	
B 'Hudden's — Dandy Dot' back			
Dunley Dot buck		£120.00	-
	. H.8	£70.00	_
		£40.00	1
A C 25 *Star Girls (c1900)	. H.30	£80.00	
A C 25 Types of Smokers (c1903)		£40.00	_
B POST-1920 ISSUES. All export			
D U 25 Famous Boxers (1927)	Ha 579	£30.00	
C U 50 Public Schools and Colleges (c1925)	Ha 575	£2.00	£100.00
A C 25 Sports and Pastimes Series 1 (c1925)	. H.225	£55.00	2100.00
HUDGON			
HUDSON—			
PRE-1919 ISSUE			
C C 25 *Beauties — selections from 'BOCCA' (c1900)	. Н.39	£200.00	
		2200.00	
HUNTER, Airdrie	tree to be transcored		
PRE-1919 ISSUE			
A BW ? 11 *Footballers (c1910)	. Н.227	£280.00	-
J. T. ILLINGWORTH & SONS, Kendal	inoi POS		
A PRE-1919 ISSUE			
A BW ? 12 Views from the English Lakes (c1895)	. H.228	£140.00	-
B POST-1920 ISSUES			
— P 48 Beautiful Scotland (77 × 52mm) (1939)	Ha 564-1	£1.50	
C1 C 25 *Cavalry (1924)	. 114.5011	£5.00	£125.00
— P 48 Coastwise (77 × 52mm) (1938)	Но 564 2	£1.00	£50.00
A C 25 'Comicartoons' of sport (1927)	. Ha.304-2		
- P 48 Flying (77 × 52mm) (1938)		£5.00	£125.00
	. Ha.564-3	£1.25	£60.00
		£7.00	£175.00
A C 25 *Old Hostels (1926)	ue mitel appears	£6.00	£150.00
— P 48 Our Countryside (77 × 52mm) (1938)	Ha.564-4	£1.50	£75.00
— P 24 Shots from the Films (1937)	Ha.566	£3.50	_
THE IMPEDIAL TODA GGO GO (& G P			
THE IMPERIAL TOBACCO CO. (of Great Britain	& Ireland)	Ltd, Br	istol—
PRE-1919 ISSUES			
A C 50 British Birds (c1910)	H.229	£4.50	
C C 1 Folder — Coronation of His Majesty King Edward			
VII (1902)	datavandeSk ne	o *	£90.00
Control of the Contro	N. LIEBER		270.00
INTERNATIONAL TOBACCO CO. LTD, London—			
POST-1920 ISSUES			
A HOME ISSUES			
— C 28 Domino cards (69 × 35mm) (1938)		225	66.00
U Famous Buildings and Monuments of Britain (1934	Alena of the way	22p	£6.00
(bronze metal plaques in cellophane envelopes):	Ha.580		
50 'Series A':			
A1 1 Nos. 1-30, small size		80p	£24.00
B2 2 Nos. 31-50, large size		90p	£18.00
50 'Series B':			
A1 1 Nos. 51-80, small size		£1.40	£42.00
B2 2 Nos. 81-100, large size		£1.40	£28.00

INTERNATIONAL TOBACCO	O CO. LTD, London (continued)		
Size Print- Number ing in set	Handbook reference	Price per card	Complete set
	of Signals (1934)	70p £3.00	£35.00
B EXPORT ISSUES. Inscribed 'Inte	ernational Tobacco (Overseas), Ltd.'		
A2 C 100 Film Favourites (c		21.00	
	· · · · · · · · · · · · · · · · · · ·	£1.80	_
	k	£1.80	_
	Eing!' — (60 small, 40 large) (1937): Ha.582	40p	£40.00
	k	20p	£20.00
*The same plaques were also used (Overseas), Ltd.'	for an export issue, with envelopes inscribed '		l Tobacco
J.L.S. TOBACCO CO., Lor	ndon		
PRE-1919 ISSUES			
('Star of the World	'Cigarettes)		
D BW 20 *Boer War Cartoon	ns (1901) H.42	£80.00	_
B2 BW ? 29 *Boer War Celebri	ties — 'JASAS' (c1901) H.133	£100.00	T -
A2 C 30 *Colonial Troops (c1901) H.40	£65.00	1.00 m
PETER JACKSON, Londo	n	100	
POST-1920 ISSUES			
A HOME ISSUES			
P Beautiful Scotland		01.05	025.00
		£1.25 £1.00	£35.00 £50.00
	e, 77 × 52mm	11.00	230.00
P Coastwise (1938): D 28 A Small size		£1.25	£35.00
	e, 77 × 52mm	£1.25	£60.00
	34)	£3.00	£80.00
	(1935)	£3.00	£85.00
)	£3.00	£85.00
B P 28 Film Scenes (1936)	£4.50	£125.00
P Flying (1938):	Ha.564-3	an magaza	
		£3.00	
	e (77 × 52mm)	£3.00	£42.00
	1937)	£1.50 £2.00	£42.00 £55.00
	(1937)	£2.00	233.00
	1938).	£1.00	£28.00
	e (77 × 52mm)	£1.25	£60.00
P Shots from the File			
		£2.50	£70.00
	e (77 × 52mm)	£3.00	£75.00
D P 28 Stars in Famous F	ilms (1935)	£3.00	£85.00
B EXPORT ISSUES. Inscribed 'Pe	ter Jackson (Overseas), Ltd.'		
	King!' (60 small, 40 large) (1937): Ha.582		
	on International black back	£1.00	£100.00
B Overprinted	on International blue back	£1.00	_
B Overprinted C Reprinted w	on International blue back		
B Overprinted C Reprinted w i Back in	on International blue back	£1.00 80p £1.50	£80.00

PETER JACKSO	ON, London (continued)			
Size Print- Number ing in set		Handbook reference		Complete set
— C 150 Th	he Pageant of Kingship — 90 small, 60 large (1937): A Inscribed 'Issued by Peter Jackson'		50p	£75.00
— C 250 Sr	1 Printed on board		50p 33p	£75.00 £50.00
— C 250 S _I	peed — Through the Ages (170 small, 80 large) (1937)	Ha.583	30p	£75.00
JACOBI BROS	S. & CO. LTD, London		- 0	
PRE-1919 ISSUE				
A BW ? 29 *E	Boer War Celebrities — 'JASAS' (c1901): A Black and white front	H.133	£110.00 £110.00	=
JAMES & CO.	(Birmingham) LTD			
PRE-1919 ISSUE				
	rms of Countries (c1915): A Size 70 × 40mm B Size 70 × 49mm		£110.00 £110.00	=
JAMES'S (GO)	LD LEAF NAVY CUT)			
PRE-1919 ISSUE A U ? 11 Pro	etty Girl Series — 'BAGG' (c1898)		£180.00	_
J.B. JOHNSON	& CO., London	in the resid		
PRE-1919 ISSUE				
	National Flags and Flowers — Girls (c1900)	H.123	£130.00	-
JOHNSTON'S	CIGARETTES—			
PRE-1919 ISSUE A U ? 1 *B	British Views (c1910)		£150.00	_
JONES BROS.,	Tottenham-			
PRE-1919 ISSUES				
(B)	purs Footballers (1912): A 12 small titles B 5 large titles C 1 Team Group of 34		From £8.00 From £8.00 £350.00	=
A.I. JONES &	CO. Ltd, London			
PRE-1919 ISSUE				
	Advertisement Card — Alexia Mixture (80 × 46mm) (c1900)		£350.00	
D C 12 Na	nutical Terms (c1905)	H.231	£40.00	_
A.S. JONES, G	rantham			
PRE-1919 ISSUE D C 30 Ar	my Pictures, Cartoons, etc (c1916)	H.12	£75.00	_

AL	EX.	JONI	ES & CO., London—	***************************************		
Size	Prin ing	t- Num in se		Handbook reference	Price per card	Complete set
PRE D2 A	E-1919 U BW	? 9 1	*Actresses — 'ANGOOD' (c1898)	Ha.187	£130.00	£130.00
Т.	E. Jo	ONES	& CO., Aberavon			
		ISSUE				
D A2 D	C	13 48 ? 41 ? 12	*Conundrums (c1900)	H.233	£130.00 £80.00 £110.00 £140.00	=
C.I	H. JC	ORDE	N LTD, London—			
		ISSUE				
	P	? 12	*Celebrities of the Great War (c1915) (35 $\times64\text{mm})$	H.236	£70.00	_
J. 6	& E.	KEN	NEDY, Dublin-			
PRE	E-1919	ISSUE				
A	U	25	*Beauties — 'FECKSA' (c1900)	H.58	£45.00	_
RI	СНА	RD K	KENNEDY, Dundee			
		ISSUE				
_	C	? 24	*Naval & Military Cartoons (130 × 90mm) (c1905)		£125.00	_
A	U	50	War Portraits (1916)	H.86	£65.00	-
KI	NNE	AR L	TD, Liverpool—			
PRE	-1919	ISSUE				
A	C	? 13	*Actresses (c1898)		£110.00	_
D1	BW		*Australian Cricketers (1897)		£225.00	_
A A2	C	? 12	*Cricketers (c1895)*Footballers and Club Colours (c1898)		£350.00 £125.00	
AZ	U	2	The Four Generations (Royal Family) $(65 \times 70 \text{mm})$	11.239	2123.00	
		_	(1897)		£275.00	_
_	BW	1	'A Gentleman in Kharki' (44 × 64mm) (1900)			£65.00
A	C		*Jockeys (1896):	H.240	0.40,00	
		12	— see H.240—A		£40.00 £80.00	_
		1	— see H.240—B		£80.00	
		3	— see H.240—D		£80.00	_
		25	— see H.240—E		£80.00	_
A	C	? 2	*Prominent Personages (c1902)		£220.00	_
D1	U	13	*Royalty (1897)	H.241	£40.00	_
_	U	? 24	Views (49 × 35mm) (c1899)		£225.00	_
B.	KRI	EGSF	TELD & CO., Manchester—			
		ISSUE				00.50.00
	C	1	*Advertisement Card— Apple Blossom (c1900)	H 120	_	£350.00
A2	U	? 45	*Beauties — 'KEWA' (c1900): A Matt surface	H.139	£80.00	
			B Glossy surface		£130.00	
A	C	? 9	Celebrities (c1900)	H.242	£130.00	_
A	C	50	*Flags of All Nations (c1900)		£60.00	_
A	C	50	*Phrases and Advertisements (c1900)	H.243	£80.00	_

A.	KUI	r lt	D, Manchester—		2 2 21 32 4	
Size	Print- ing	- Num in se		Handbook reference	Price per card	Complete set
PRE	E-1919	ISSIII	ES			
_	C	? 12	Arms of Cambridge Colleges (17 × 25mm) (c1914)	H 458	£80.00	
	C	? 12	Arms of Companies $(30 \times 33 \text{mm})$ $(c1914)$		£80.00	
	C	30	British Beauties — oval card $(36 \times 60 \text{mm})$ (c1914)		£50.00	
_	P	? 14	*'Crosmedo'Bijoucards (55 × 37mm) (c1915)		£110.00	
A	U	25	Principal Streets of British Cities and Towns (1916)	11.2 13	£100.00	
A	CP	50	Types of Beauty (c1914)	H.246	£100.00	-
Τ.Δ	MRE	RT	& BUTLER, London—			
			book available — £3.50			
A Al	PRE-1			11.00	222.00	2452.00
AI	BW	20	*Actresses — 'BLARM' (c1900)		£23.00	£460.00
7	C	10	*Actresses and Their Autographs (c1898):	H.247	24.40.00	
			A Wide card (70 × 38mm): 'Tobacco' back B Narrow card (70 × 34mm): 'Cigarettes' back		£140.00	
42	BW	50	- Committee Comm	*****	£120.00	
A2	BW	50	*Admirals (1900):	H.248	016.00	
			A 'Flaked Gold Leaf Honeydew' back B 'May Blossom' back		£16.00	
			B 'May Blossom' back		£16.00	
					£16.00	T-1
C	C	1		11.040	£20.00	6250.00
A	C	40	*Advertisement Card — Spanish Dancer (1898)	H.249	C4 00	£350.00
A	C	25	Arms of Kings and Queens of England (1906) Aviation (1915)		£4.00	£160.00
A2	C	26	Aviation(1915)* *Beauties — 'HOL' (c1900):	II 100	£3.20	£80.00
AZ	C	20	A 'Flaked Gold Leaf Honey Dew' back	H.192	622.00	
					£32.00	
					£32.00	
					£32.00	
۸	C	50		11.60	£32.00	-
A C	BW	25	Birds and Eggs (1906)	H.60	£3.20	£160.00
C	BW	10			£26.00	_
C	U	20	*Boer War Generals — 'FLAC' (1901) *Boer War Generals 'CLAM' (1900):		£32.00	
C	U	20	I 10. No frame lines to back:	H.61		
			A Brown back		C20 00	
			B Black back		£28.00	Fig. 1875
			II 10. With frame lines to back:		£28.00	
			A Brown back		C28 00	
			B Black back		£28.00	
C	U	1	*Boer War Series — 'The King of Scouts' (Col. R.S.S.		£28.00	
-	U		Baden-Powell) (1901)			6250.00
	C	50	*Conundrums (38 × 57mm) (1901):	11.050	1 1 1 1 1 1 1 1 1 1 1 1 1 1 1 1 1 1 1	£350.00
	C	30		H.250	610.00	
			A Blue back — thick card		£18.00	7 Table 1
A2	C	12		11.051	£13.00	-
A	C	20	Coronation Robes (1902)	H.251	£18.00	£220.00
			International Yachts (1902)		£50.00	
A	C	25	Japanese Series (1904):			
			A Thick toned card		£7.00	£175.00
	-		B Thin white card		£7.00	£175.00
	C	4	*Jockeys, no frame lines $(35 \times 70 \text{mm})$ (c1903)	H.252	£40.00	£160.00
_	C	10	*Jockeys with frame lines $(35 \times 70 \text{mm})$ (c1903)	H.252	£40.00	£400.00
A	C	1	*Mayblossom Calendar, 1900		_	£400.00
A	C	25	Motors (1908):			
			A Green back		£25.00	-
			B Plain back		£25.00	-

LAMBERT & BUTLER, London (continued)

Size	Print-ing	Num in se		Handbook reference	Price per card	Complete set
A A	BW BW	25 50	Naval Portraits (1914)		£3.60 £3.60	£90.00 £180.00
A	C	50	The Thames from Lechlade to London:		CE 00	C250.00
			A Small numerals (1907)		£5.00 £5.00	£250.00 £250.00
			B Large numerals (1908)		£5.00	£230.00
	C	4	C Plain back* *Types of the British Army & Navy (35 × 70mm)		25.00	
300	C	-	(c1897):	H.254		
			A 'Specialities' back in brown		£65.00	
			B 'Specialities' back in black		£65.00	_
			C 'Viking' back in black		£65.00	
A	C	25	*Waverley series (1904)	H.255	£10.00	£250.00
A	C	25	Winter Sports (1914)		£3.60	£90.00
A	C	25	Wireless Telegraphy (1909)		£4.80	£120.00
A	C	25	World's Locomotives, Nd. 1-25 (1912)		£4.00	£100.00
A	C	50	World's Locomotives Nd. 1-50 (1912)		£4.60	£230.00
A	C	25	World's Locomotives, Nd. 1A-25A (c1913)		£4.60	£115.00
	POST-1				C1 50	675.00
A	C	50	Aeroplane Markings (1937)		£1.50	£75.00
A	C	25	British Trees and Their Uses (1927)		£1.80 £2.00	£45.00 £50.00
A	C	25	Common Fallacies (1928)		£4.00	£100.00
A	C	25	Dance Band Leaders (1936)		£1.60	£80.00
A	C BW	50 25	Famous British Airmen and Airwomen (1935)		£1.60	£40.00
A	U	25	Fauna of Rhodesia (1929)		£1.00	£25.00
A	Č	50	Find Your Way:		21.00	220.00
^	-	30	A Address 'Box No. 152, London' (1932)		£1.40	£70.00
			B Address 'Box No. 152, Drury Lane, London'			
			(1932)		£1.40	£70.00
			C Overprinted in red (1933)		£1.40	£70.00
A	BW	1	D Joker Card (1932)		_	£11.00
A	C	50	Footballers 1930-1 (1931)		£3.50	_
A	C	25	Garden Life (1930)	H.449	90p	£22.50
A	C	25	Hints and Tips for Motorists (1929)		£3.60	£90.00
A	U	25	A History of Aviation:		02.00	050.00
			A Front in green (1932)		£2.00	£50.00
			B Front in brown (1933)		£2.40 £2.20	£60.00 £110.00
A	C	50	Horsemanship (1938)		£2.20	£55.00
A	C	25 50	How Motor Cars Work (1931)		22.20	233.00
A	C	30	and Air Force (1939)		£1.00	£50.00
A	C	25	Interesting Musical Instruments (1929)		£2.60	£65.00
A	C	50	Interesting Sidelights on the Work of the GPO (1939)		£1.00	£50.00
A	Č	50	Keep Fit (1937)		80p	£40.00
A	Č	25	London Characters (1934):			
1			A With Album Clause		£2.00	£50.00
			B Without Album Clause		£20.00	_
A	C	25	Motor Car Radiators (1928)		£6.00	£150.00
A	C	25	Motor Cars — 'A Series of 25', green back (1922)		£2.40	£60.00
A	C	25	Motor Cars — '2nd Series of 25' (1923)		£2.40	£60.00
A	C	50	Motor Cars — '3rd Series of 50' (1926)		£3.80	£190.00
A	C	25	Motor Cars — 'A Series of 25', grey back (1934)		£3.40 £3.50	£85.00 £175.00
A	C	50	Motor Cycles (1923)		£3.50 £2.50	£175.00 £125.00
A	C	50	Motor Index Marks (1926)	Ha 584	£1.20	£30.00
A	U	25 25	Rhodesian Series (1928)	114.504	£1.00	£25.00
A	C	23	Thoughting of the (1720)		31.00	

A U 25 Third Rhodesian Series (1930) 60p £15 A C 25 Wonders of Nature (1924) 60p £15 LAMBKIN BROS., Cork POST-1920 ISSUES A C 36 *Country Scenes — Small size (1924) (6 sets of 6):				BUTLER, London (continued)			
A C 25 Wonders of Nature (1924)	Size						Complete se
A C 25 Wonders of Nature (1924)	A	U	25	Third Rhodesian Series (1930)		60p	£15.00
POST-1920 ISSUES	A	C	25	Wonders of Nature (1924)			£15.00
POST-1920 ISSUES	LA	MBK	IN	BROS., Cork—		- 4	
A C 36 *Country Scenes — Small size (1924) (6 sets of 6):							
Series 1 — Yachting							
Series 2 — Country				Series 1 — Yachting		£5.00	_
Series 3 — Far East				Series 2 — Country		£5.00	
Series 5 — Country £5.00				Series 3 — Far East			
Series 6 — Country £5.00				Series 4 — Sailing			-
C C 36				Series 5 — Country			-
Series 7 — Yachting	_	C	26	*Country Secret Learning (1924) (6 - 1966)		£5.00	-
Series 8 — Country		C	30	Series 7 Vachting		05.00	
Series 9 — Far East				Series 8 — Country			
Series 10 — Sailing				Series 9 — Far Fast			-
Series 11 — Country				Series 10 — Sailing			
Series 12 — Windmill Scenes £5.00				Series 11 — Country			
**Trish Views, anonymous. inscribed 'Eagle, Cork' (68				Series 12 — Windmill Scenes			
X 67mm) (c1925)	_	C	?9	*Irish Views, anonymous, inscribed 'Eagle, Cork' (68)		20.00	
LANCS & YORKS TOBACCO MANUFACTURING CO. LTD, Burnley (L. & Y. Tob. Mfg. Co.) PRE-1919 ISSUE C C 26 *Actresses — 'FROGA A' (c1900)				× 67mm) (c1925)	Ha.585	£40.00	
CL. & Y. Tob. Mfg. Co.		C	? 5	*'Lily of Killarney' Views $(73 \times 68 \text{mm})$ (c1925)	Ha.586	£70.00	_
PRE-1919 ISSUES A C 25 *Types of British Soldiers (c1914)	c.	& J.	LAV		11.20	2100.00	
A C 25 *Types of British Soldiers (c1914)							
A U 50 War Portraits (1916) H.86 £65.00 R.J. LEA LTD, Manchester— A PRE-1919 ISSUES A C 1 *Advertisement Card — Swashbuckler (c1913) £250.00 Al C 50 Chairman Miniatures 1-50 (1912): A No border £2.80 £140. B Gilt border £2.80 £140. Chairman and Vice Chair Miniatures, 51-100 (1912) £2.80 £140. Al BW 25 Chairman War Portraits (marked 'War Series' on front) (1915) . £5.00 £125. A C 70 Cigarette Transfers (Locomotives) (1916) £7.00 A BW 25 Civilians of Countries Fighting with the Allies (1914) £10.00 £250. Al C 50 Modern Miniatures (1913) £4.00 £200. Al C 50 Modern Miniatures (1913) £1.30 £60. A Green borders £80.00 B Red borders £80.00 B Red borders £80.00 CAI C 50 Old English Pottery and Porcelain, 1-50 (1912) £2.00 £100. A 'Chairman Cigarettes' £1.60 £80.00			7575		Ш 144	£22.00	
R.J. LEA LTD, Manchester— A PRE-1919 ISSUES A C 1 *Advertisement Card — Swashbuckler (c1913)	100			War Portraits (1916)	H 86		
A PRE-1919 ISSUES A C 1 *Advertisement Card — Swashbuckler (c1913) £250.00 A1 C 50 Chairman Miniatures 1-50 (1912):	n 1				11.00	205.00	
A C 1 *Advertisement Card — Swashbuckler (c1913) £250.00 A1 C 50 Chairman Miniatures 1-50 (1912):							
A1 C 50 Chairman Miniatures 1-50 (1912): A No border							
A No border				"Advertisement Card — Swashbuckler (c1913)		£250.00	-
B Gilt border	AI	C	30			02.00	21.10.00
A1 C 50 Chairman and Vice Chair Miniatures, 51-100 (1912) £2.80 £140. A1 BW 25 Chairman War Portraits (marked 'War Series' on front) (1915) £5.00 £125. A C 70 Cigarette Transfers (Locomotives) (1916) £5.00 £125. A1 C 50 Flowers to Grow (The Best Perennials) (1913) £10.00 £250. A1 C 50 Modern Miniatures (1913) £4.00 £200. A1 C 12 More Lea's Smokers (1906): H.256 A Green borders £80.00 B Red borders £80.00 A1 C 50 Old English Pottery and Porcelain, 1-50 (1912) £2.00 £100.00 A1 C 50 Old Pottery and Porcelain, 51-100 (1912): A 'Chairman Cigarettes' £1.60 £80.00							
A1 BW 25 Chairman War Portraits (marked 'War Series' on front) (1915)	A1	C	50	Chairman and Vice Chair Miniatures 51-100 (1912)			
(1915)				Chairman War Portraits (marked 'War Series' on front)		12.80	£140.00
A C 70 Cigarette Transfers (Locomotives) (1916) £7.00 A BW 25 Civilians of Countries Fighting with the Allies (1914) £10.00 £250. A1 C 50 Flowers to Grow (The Best Perennials) (1913) £4.00 £200. A1 C 50 Modern Miniatures (1913)				(1915)		£5.00	£125.00
A BW 25 Civilians of Countries Fighting with the Allies (1914)	A	C	70	Cigarette Transfers (Locomotives) (1916)			2125.00
A1 C 50 Flowers to Grow (The Best Perennials) (1913) £4.00 £200. A1 C 50 Modern Miniatures (1913)				Civilians of Countries Fighting with the Allies (1914)			£250.00
46 different, less 1, 8, 12, 32 £1.30 £60. A1 C 12 More Lea's Smokers (1906): A Green borders £80.00 B Red borders £80.00 A1 C 50 Old English Pottery and Porcelain, 1-50 (1912): A 'Chairman Cigarettes' £1.60 £80.0				Flowers to Grow (The Best Perennials) (1913)		£4.00	£200.00
46 different, less 1, 8, 12, 32 £1.30 £60. A1 C 12 More Lea's Smokers (1906): A Green borders £80.00 B Red borders £80.00 A1 C 50 Old English Pottery and Porcelain, 1-50 (1912) £2.00 £100. A1 C 50 Old Pottery and Porcelain, 51-100 (1912): A 'Chairman Cigarettes' £1.60 £80.00	A1	C	50	Modern Miniatures (1913)		_	£355.00
A Green borders		-		46 different, less 1, 8, 12, 32		£1.30	£60.00
B Red borders	AI	C	12		H.256		
A1 C 50 Old English Pottery and Porcelain, 1-50 (1912)							-
A1 C 50 Old Pottery and Porcelain, 51-100 (1912): A 'Chairman Cigarettes' £1.60 £80.0	41	C	50	Old English Potters and Porcelain 1 50 (1912)			0100 00
A 'Chairman Cigarettes'						£2.00	£100.00
B 'Recorder Cigarettee'				A 'Chairman Cigarettes'		£1.60	£80.00
- Recorder Cigarettes				B 'Recorder Cigarettes'		£5.00	200.00

R.J. LEA LTD, Manchester (continued)

Size	Print- ing	Num in se		Handbook reference	Price per card	Complete set
A1	C	50	Old Pottery and Porcelain, 101-150 (1912):			
***	Č	50	A 'Chairman Cigarettes'		£1.60	£80.00
			B 'Recorder Cigarettes'		£5.00	_
A1	C	50	Old Pottery and Porcelain, 151-200 (1913)		£1.60	£80.00
A1	C	50	Old Pottery and Porcelain, 201-250 (1913)		£1.60	£80.00
A	BW	25	War Pictures (1915)		£4.40	£110.00
D	POST-1	020 1	CCHEC			
B	POSI-I	48	Coronation Souvenir (1937):			
A2	P	70	A Small size, glossy:			
112			1 Lea's name		50p	£25.00
8-1-1			2 'Successors to'		40p	£20.00
A2	BW		B Small size, matt:		F	
112	D		1 Lea's name		60p	£30.00
			2 Successors to		45p	£22.50
_	P		C Medium size (77 × 51mm)		60p	£30.00
A2	C	50	Dogs (1923):			
			1 Nos. 1-25 — A White card		£3.60	
			B Cream card		£3.60	, i
			2 Nos. 26-50		£5.40	_
A2	C	25	English Birds (1922):			
			A Glossy front		£2.60	£65.00
			B Matt front		£4.00	£100.00
A2	C	25	The Evolution of the Royal Navy (1925)		£1.80	£45.00
A2	P	54	Famous Film Stars (1939)		£1.30	£70.00
	CP	48	Famous Racehorses of 1926 (1927):			
A2			A Small size		£2.20	£110.00
			B Medium size $(75 \times 50 \text{mm})$		£2.60	£130.00
		48	Famous Views (1936):			
A2	P		A Small size — 1 Glossy		25p	£12.50
	BW		2 Matt		60p	£30.00
_	P		B Medium size $(76 \times 51 \text{mm})$		50p	£25.00
A2	P	36	Film Stars — 'A First Series' (1934)		£2.50	£90.00
A2	P	36	Film Stars — 'A Second Series' (1934)		£2.25	£80.00
A2	C	25	Fish (1926)		£1.80	£45.00
A2		48	Girls from the Shows (1935):			2400.00
	P		A Glossy front		£2.00	£100.00
	BW	200	B Matt front		£2.20	£110.00
A2	7.2	54	Radio Stars (1935):		01.00	005.00
The second	P		A Glossy front		£1.80	£95.00
	BW	50	B Matt front		£2.00	£110.00
A2	C	50	Roses (1924)		£1.40	£70.00
A2	C	50	Ships of the World (1925)		£1.80	£90.00
		48	Wonders of the World (1938):		50-	C25 00
A2	P		A Small size — 1 Glossy		50p	£25.00
	BW		2 Matt		60p	£30.00 £30.00
	P		B Medium size $(76 \times 50 \text{mm})$		60p	130.00
C	SILKS.	All pa	aper-backed.			
_	C		*Butterflies and Moths III (c1925):	Ha.505-7		
		12	1 Small size (70 × 44mm)		£4.00	£50.00
		12	2 Large size (70 × 88mm)		£4.00	£50.00
		6	3 Extra-large size (143 × 70mm)		£4.50	£27.00
_	C	54	*Old Pottery — Set 1 (68 × 38mm) (c1915)	Ha.505-14	90p	£50.00
_	C	72	*Old Pottery — Set 2 (61×37 mm) ($c1915$)	Ha.505-14	90p	£65.00
-	C	50	Regimental Crests and Badges — Series I (48mm sq.)			
			(c1920)	Ha.502-4	£1.20	£60.00
Marin and						

R.J	. LEA	LTD	, Manchester (continued)			
Size	Print-	Num in se		Handbook reference	Price per card	Complete set
_	С	50	Regimental Crests and Badges — Series II (48 mm sq.) (c1920)	Ha.502-4	£1.80	£90.00
D	MISCE	ELLAN	NEOUS			
-	C	24	Old English Pottery and Porcelain (Post Card Size) (Inscribed Chairman Cigarette Series or other firms' names) (c1910)	Ha.257	£6.00	-
AL	FREI) L. I	LEAVER, London-		1 / A - A -	
POS	ST-1920	ISSU	E			
_	U	12	Manikin Cards (70 × 51mm) (c1925)	Ha481	£70.00	-
J.	LEES	, No	rthampton			
PRI	E-1919	ISSUE				
A	C	? 21	Northampton Town Football Club (No. 301-321)			
			(c1912)		£90.00	_
A.	LEW	IS &	CO. (WESTMINSTER) LTD, London-		100	
	PRE-19					
A	U	50	War Portraits (1916)	H.86	£65.00	_
	POST-		SSUE			
A2	С	52	Horoscopes (1938)	Ha.587	80p	£42.00
H.	C. LI	LOY	D & SON, Exeter—			
PRI	E-1919	ISSUE	ES			
A	U	28	Academy Gems (c1900):	H.258		
			A Red-brown tint		£50.00	_
			B Purple tint		£50.00	_
D	BW	2 26	C Green tint*Actresses and Boer War Celebrities (c1900)	ш 260	£50.00	_
_	BW	: 20	*Devon Footballers and Boer War Celebrities (c1901):	H.259	£40.00	
		? 42	Set 1 — Without framelines (70 × 41mm)	11.23)	£45.00	_
		?6	Set 2 — With framelines $(70 \times 45 \text{mm})$		£100.00	_
A1	C	25	*Star Girls — 'Tipsy Loo Cigarettes' (c1898)	H.30	£200.00	_
	BW	36	War Pictures (73 × 69mm) (c1914)		£120.00	_
RI	CHAI	RD L	LOYD & SONS, London—			
	PRE-19					
_	BW	25	*Boer War Celebrities (35 × 61mm) (1899)	H.261	£32.00	_
_	U	? 21	*General Interest — Actresses, Celebrities and Yachts			
			(62 × 39mm) (c1900)		£85.00	_
Al	C	96	*National Types, Costumes and Flags (c1900)		£30.00	
A B	C	10	Scenes from San Toy (c1905)	H.462	£9.00	£90.00
A	C C	25	SSUES. Most cards inscribed 'Branch of Cope Bros. & Co Atlantic Records (1936)	o., Ltd. See al	so under 'C £2.80	
A2	P	27	Cinema Stars, glossy — 'A Series of 27', Nd. 1-27		12.00	£70.00
			(c1934)		£6.00	
A2	P	27	Cinema Stars, glossy — 'A Series of 27', Nd. 28-54			
			(c1934)		£1.50	£40.00
A2	P	27	Cinema Stars, glossy — 'Third Series of 27', Nd. 55-81		06.00	
A2	U	25	(1935)		£6.00 £1.60	£40.00
A	BW	25	*Famous Cricketers (Puzzle Series) (1930)		£5.50	240.00

RIC	CHAR	D LL	OYD & SONS, London (continued)			
Size	Print-ing	Num in se		Handbook reference	Price per card	Complete set
D A A2	C BW U	25 25 50 25 25	Old Inns: A1 Titled 'Old English Inns' (1923) A2 Titled 'Old Inns — Series 2' (1924) B Titled 'Old Inns' (1925) Tricks and Puzzles (1935) Types of Horses (1926): A Back in light brown		£1.40 £2.60 £1.20 80p	£35.00 £65.00 £60.00 £20.00
A2	U	25	B Back in dark brown 'Zoo' Series (1926)	Ha.588	£3.20 90p	£80.00 £22.50
LU	SBY	LTD	, London-			
PRE	E-1919 I C	SSUE 25	Scenes from Circus Life (c1900)	H.264	£110.00	-
HU	GH N	AcC.	ALL, Edinburgh, Glasgow and Aberdeer	1	75	
POS C	ST-1920 C	ISSU . ? 1	E *RAF Advertisement Card (c1924)	Ha.594	£130.00	
D.	& J. I	MAC	CDONALD, Glasgow—			
PRE A A —	E-1919 I C BW BW C	? 10 25	*Actresses — 'MUTA' (c1891)	H.266	£110.00 £325.00 £225.00 £750.00	=
MA	CKE	NZI	E & CO., Glasgow—			
PRE	E-1919 I					
=	P U	50 50	*Actors and Actresses (32 × 58mm) (c1902)	H.268	£17.00 £18.00	
A	BW	50	The Zoo (c1910)		£22.00	<u>-</u>
WI	м. м'	KIN	NELL, Edinburgh—			
PRI A A	E-1919 I C U	20 50	European War Series (1915)		£75.00 £65.00	<u> </u>
MA	CNA	UGI	HTON, JENKINS & CO. LTD, Dublin-			
POS -	S T-1920 C	ISSU 50	ES Castles of Ireland (1924): A Size 76 × 45mm B Size 74 × 44mm Various Uses of Rubber (1924)		£2.80 £3.20 £2.20	£140.00 £110.00
A	МсТА	VISI	H, Elgin————			
	E-1919 I C			H12	£75.00	_
Mo	WAT	TIE	& SONS, Arbroath			
PRI D	E-1919 I C	30	*Army Pictures, Cartoons etc (c1916)	H.12	£75.00	in a g

THE MANXLAND TOBACCO CO., Isle of Man—			
Size Print- Number ing in set	Handbook reference	Price per card	Complete set
PRE-1919 ISSUES D BW ? 5 *Views in the Isle of Man (c1900)	Ha.491	£200.00	_
MARCOVITCH & CO., London—			
A POST-1920 ISSUE			
A2 P 18 *Beauties (anonymous with plain backs, numbered left base of front) (1932)	Ha.627	£1.00	£18.00
- U 7 The Story in Red and White (75 × 66mm) (1955)		£1.80	£12.50
MARCUS & CO., Manchester—		1. (4.6.2.)	17.7
PRE-1919 ISSUES			
A C ? 12 *Cricketers, 'Marcus Handicap Cigarettes' (1895) A C 25 *Footballers and Club Colours (1896)	H.269 H.239	£350.00 £120.00	- Ξ
T.W. MARKHAM, Bridgwater—			
PRE-1919 ISSUE — BW ? 18 Somerset Views and scenes (68 × 42mm) (c1906)		£100.00	· · · · ·
MARSUMA LTD, Congleton—		No.	1.788
PRE-1919 ISSUE A BW 50 *Famous Golfers and Their Strokes (c1914)		£40.00	-
C. MARTIN, Moseley—			
PRE-1919 ISSUE D C 30 *Army Pictures, Cartoons etc. (c1916)	H12	£75.00	_
MARTINS LTD, London—			
PRE-1919 ISSUES			
A C 1 "Arf a Mo', Kaiser!' (c1915)	H.270	£90.00 £22.00	£60.00 £550.00
R. MASON & CO., London—			
PRE-1919 ISSUES			
C C 30 *Colonial Troops (c1902)	H.40 H.14	£50.00 £45.00	_
JUSTUS VAN MAURIK—			
POST-1920 ISSUE			
— C 12 *Dutch Scenes (108 × 70mm) (c1920)	Ha.622	£100.00	
MAY QUEEN CIGARETTES—			
POST-1940 ISSUE — C 12 Interesting Pictures (68 × 48mm) (c1960)		£1.00	_
MENTORS LTD, London—			2.5.126
PRE-1919 ISSUE — C 32 Views of Ireland (42 × 67mm) (c1912)	H.271	£9.00	— ;

			FF & CO. LTD, London————	77 11 1	D'	C1-4-
Size	Print ing	- Num in se		Handbook reference	Price per card	Complete
A		919 IS	SUE			
1	I KL-I	717 15	Theatre Advertisement Cards (c1905):			
	BW	? 9	A Medium size (83 × 56mm)		£90.00	_
	BW	? 2	B Large size (108 × 83mm)		£100.00	_
B			SSUES			
ь	CP	17201	Antique Pottery (1927):			
A2	CI	54	A Small size		80p	£43.00
AL		56	B Medium size (74 × 50mm)		80p	£45.00
	C	50	Art Treasures:		oop	
D		30	A Small size (1927)		90p	£27.00
В		50	B Large size (1926)		60p	£30.00
В	C	25	Art Treasures — '2nd Series of 50', Nd. 51-75 (1928)		90p	£22.50
В	C	25	England, Historic and Picturesque — 'Series of 25'			
_			(1928)		£1.00	£25.00
В	C	25	England, Historic and Picturesque — 'Second Series'			
			(1928)		90p	£22.50
A2	P	27	Famous Golfers (1928)		£12.00	_
	P	27	Famous 'Test' Cricketers (1928):			
A2	- 7		A Small size		£4.50	_
			B Medium size $(76 \times 51 \text{mm})$		£4.50	_
_	C	25	Gallery Pictures (76 × 51mm) (1928)		£1.20	£30.00
A2	C	50	'Geographia' Map Series (sectional) (1931)		£1.60	£80.00
	CP		The Homeland Series (1933):	Ha.539		
A2		54	A Small size		28p	£15.00
_		56	B Medium size $(76 \times 51 \text{mm})$		38p	£20.00
A2	P	36	In the Public Eye (1930)		£1.25	£45.00
D	C	25	Men of Genius (1924)		£4.00	£100.00
В	C	25	Picturesque Old England (1931)		£1.00	£25.00
A2	P		Real Photographs:	Ha.538		
		27	'A Series of 27' —			
			A Matt front (c1931)		75p	£20.00
			B Glossy front (c1931)		40p	£11.00
		27	'2nd Series of 27' (c1931)		75p	£20.00
		27	'3rd Series of 27' (c1932)		40p	£11.00
		27	'4th Series of 27' (c1932)		75p	£20.00
		27	'5th Series of 27' (c1933)		£1.00	£27.00
		27	'6th Series of 27' (c1933)		£1.00	£27.00
C	C	25	Reproductions of Celebrated Oil Paintings (1928)	Ha.542	£1.20	£30.00
В	C	25	Roses (1927)		£2.40	£60.00
A2	C	50	Things to Make — 'De Reszke Cigarettes' (1935)		60p	£30.00
A2	C	50	What the Stars Say — 'De Reszke Cigarettes' (1934)		50p	£25.00
A2	P	36	Zoological Studies (1929)		25p	£9.00
C	MISC	ELLAN	NEOUS			
_	U		'RILETTE' Miniature Pictures (60 × 45mm) (c1925):			
		20	A Inscribed Series of 20		£3.50	_
		25	B Inscribed Series of 25		£3.50	_
		30	C Inscribed Series of 30		£3.50	_
		42	D Inscribed Series of 42		£3.50	-
		43	E Inscribed Series of 43		£3.50	
		56	F Inscribed Series of 56		£3.50	_
		74	G Inscribed Series of 74		£3.50	-
MI	RAN	IDA 1	LTD, London-			
-		0 ISSU		****	c= c-	
A	C	20	Dogs (c1925)	H.211	£7.00	_

MIRANDA LTD, London (continued) Size Print- Number

Size	Print-ing	Num in se		Handbook reference	Price per card	Complete set
A	C	25	Sports and Pastimes — Series I (c1925)	H.225	£5.00	£125.00
ST	EPHE	EN N	MITCHELL & SON, Glasgow—			
A	PRE-19	19 IS	SUES			
C	C	51	*Actors and Actresses — Selection from 'FROGA B			
			and C' (c1900)	H.20	£18.00	
C	U	25	*Actors and Actresses — 'FROGA C' (c1900)	H.20	£18.00	
C	U	50	*Actors and Actresses — 'FROGA D' (c1900)	H.20	£18.00	<u> </u>
C	U	26	*Actresses — 'FROGA B' (c1900)	H.20	£18.00	
A	U	1	Advertisement Card 'Maid of Honour' (c1900)		1011 Tel	£350.00
A	C	50	Arms and Armour (1916)	H.273	£3.60	£180.00
A	C	25	Army Ribbons and Buttons (1916)		£4.00	£100.00
C	BW	25	*Boxer Rebellion — Sketches (c1904)	H.46	£25.00	
D1	BW	25	British Warships, 1-25 (1915)		£6.00	£150.00
D1	BW	25	British Warships, Second series 26-50 (1915)		£6.00	£150.00
A	C	50	Interesting Buildings (1905)	H 70	£6.00	£300.00
A	C	25	Medals (1916)	H 71	£5.00	£125.00
A	C	25	Money (1913)	11.71	£4.60	£115.00
A	C	25	*Regimental Crests, Nicknames and Collar Badges		24.00	2115.00
			(1900)	H 274	£11.00	£275.00
A	C	25	Scottish Clan Series No. 1 (1903)		£12.00	£300.00
A	C	25	Seals (1911)	11.55	£4.60	£115.00
A	Č	25	Sports (1907)	Ц 275	£12.00	£300.00
A	Č	25	Statues and Monuments (1914)	H.273	£4.60	£115.00
	POST-1				14.00	£115.00
A	C	50	Air Raid Precautions (1938)	Ho 544	00-	C45.00
A	C	25	Angling (1028)	па.344	90p	£45.00
A	C	50	Angling (1928)		£4.40	£110.00
A	C	25	Clan Tartans — '2nd Series, 25' (1927)		£1.80	£90.00
	C	25	Empire Embilities Control 1020 (1020)		90p	£22.50
A A2	C		Empire Exhibition, Scotland, 1938 (1938)		80p	£20.00
		25	Famous Crosses (1923)		70p	£17.50
A	C	50	Famous Scots (1933)		80p	£40.00
A	U	50	First Aid (1938)		£1.00	£50.00
A	U	50	A Gallery of 1934 (1935)		£2.00	£100.00
A	U	50	A Gallery of 1935 (1936)		£1.90	£95.00
A	C	50	Humorous Drawings (1924)	Ha.590	£2.20	£110.00
A	C	40	London Ceremonials (1928)		£1.25	£50.00
A	C	30	A Model Army (cut-outs) (1932)		£1.20	£36.00
A	C	25	Old Sporting Prints (1930)	Ha.563	£1.40	£35.00
A	U	50	Our Empire (1937)		50p	£25.00
A	C	70	River and Coastal Steamers (1925)		£2.40	
A	C		A Road Map of Scotland (1933):			
		50	A Small numerals		£2.00	£100.00
		50	B Large numerals in circles		£2.00	£100.00
		50	C Overprinted in red		£3.00	£150.00
		1	D Substitute card (Blue)		25.00	£16.00
A	C	50	Scotland's Story (1929)		£2.00	£100.00
A	U	50	Scottish Footballers (1934)		£2.00	£100.00
A	Ü	50	Scottish Football Snaps (1935)		£2.00	£100.00
A	Č	25	Stars of Screen and History (1939)		£2.00	£50.00
1	C	25	Village Models Series (1925):	Ha.591	22.00	250.00
A		25	A Small size	Ha.391	co 20	CEE 00
A					£2.20	£55.00
	C	25			£4.00	£100.00
A	-	25	Village Models Series — 'Second' (1925):		00.00	055.00
A			A Small size		£2.20	£55.00
			B Medium size (68 × 62mm)		£4.00	£100.00

STI	EPHE	N MI	TCHELL & SON, Glasgow (continued)			
Size	Print-ing	Num in se		dbook erence	Price per card	Complete set
A A	U U	50 50	Wonderful Century (1937)		60p £1.00	£30.00 £50.00
MO	ORG	GATI	E TOBACCO CO., London			
POS	T-1940	ISSU	E			
_	BW	30	The New Elizabethan Age (20 small, 10 large) (1953):			
			A Matt front		£2.50 £1.80	£55.00
B.	MOR	RIS	& SONS LTD, London—			
A	PRE-1	919 IS	SUES			
_	\mathbf{BW}	30	*Actresses (41 × 68mm) (1898) H.27		£2.00	£60.00
C	U		*Actresses — 'FROGA A (c1900): H.20		C27 00	
		? 24	A 'Borneo Queen' back		£27.00 £27.00	1
		? 15	B 'Gold Seals' back		£27.00	_
		? 7	D 'Tommy Atkins' back		£75.00	_
_	C	? 4	*Actresses — selection from 'FROGA B' — 'Morris's			
			High Class Cigarettes' on front (76 × 66mm)			
			(c1900) H.20		£250.00	-
A1	P	1	*Advertisement Card (Soldier and Girl) (c1900)	7	_	£350.00
A	U	21	*Beauties — 'MOM' (c1900): H.27	/	£27.00	
			A 'Borneo Queen' back		£27.00	_
			C 'Morris's Cigarettes' back		£27.00	- <u> </u>
			D 'Tommy Atkins' back		£75.00	
A	C		*Beauties — 'CHOAB' (c1900): H.21			
		? 17	A 'Gold Flake Honeydew' back		£40.00	
		? 29	B 'Golden Virginia' back		£40.00	_
		? 19	C 'Levant Favourites' back		£40.00	
		? 21	D 'Reina Regenta' back		£40.00	15 .
A	U	? 47	*Beauties — Collotype (c1897)	8	£120.00	_
A	C	20	Boer War, 1900 (VC Heroes)	9	£35.00 £24.00	_
A	BW	25 30	*Boer War Celebrities — 'PAM' (c1901) H.14 *General Interest — six cards each entitled (c1910): H.28		124.00	· · · · ·
A	C	30	i Agriculture in the Orient		£6.50	£40.00
			ii Architectural Monuments		£6.50	£40.00
			iii The Ice Breaker		£6.50	£40.00
			iv Schools in Foreign Countries		£6.50	£40.00
			v Strange Vessels		£6.50	£40.00
D	BW	20	London Views (c1905): H.34	2.3		
			A 'American Gold' back		£30.00	49.0
			B 'Morris's Gold Flake' back		£30.00	_
			C 'Smoke Borneo Queen' back		£30.00 £30.00	_
		25	D 'Smoke Reina Regenta' back	1	£4.00	£100.00
A D	C	50	National and Colonial Arms (1917)	1	£6.00	£300.00
C	U	25	War Celebrities (1915)		£5.00	£125.00
D	Č	25	War Pictures (1916)		£7.00	£175.00
			SSUES			
A1	C C	50	Animals at the Zoo (1924): Ha.5	20		
Al	-	50	A Back in blue		70p	£35.00
			B Back in grey		80p	£40.00
A1	C	35	At the London Zoo Aquarium (1928)		50p	£17.50

B.	MOR	RIS	& SONS LTD, London (continued)			
	e Print ing		nber	Handbook reference	Price per card	Complete set
A1	BW	25	Australian Cricketers (1925)		£3.00	£75.00
A2	C	25	Captain Blood (1937)		£1.00	£25.00
D	U	50	Film Star Series (1923)		£3.00	_
D	U	25	Golf Strokes Series (1923)		£6.00	£150.00
A1	_	12	Horoscopes (wording only) (1936): A White card		£1.00	_
A2	C	25	B Cream card		50p	£6.00
			A White card		£1.20	£30.00
A1	BW	50			£1.40	£35.00
A1	C	25	How to Sketch (1929)		£1.00	£50.00
D	U	25	Measurement of Time (1924)		£1.20	£30.00
A1	C	25	Motor Series (Motor parts) (1922)		£4.00	£100.00
D	U	25	The Queen's Dolls' House (1925)		£2.80	£70.00
A1	BW	24	Racing Greyhounds — 'Issued by Forecasta' (1939)		£1.40	£35.00
A1	C	13	Shadowgraphs (1925)		£2.20	£55.00
A1	C	50	Treasure Island (1924)		£1.20	£16.00
A	C	25	Victory Signs (1928)		50p	£25.00
	C		Wax Art Series (1931)		50p	£12.50
A D	C	25	Whipsnade Zoo (1932)		50p	£12.50
C	SILKS	25	Wireless Series (1923)		£3.60	£90.00
C		? 24	P-wl-shi- G - 1 (70 - 50) / 1 1 1 1 1 1 1 1 1 1			
_	C	25	Battleship Crests (70 × 50mm) (paper backed) (c1915) English Flowers (78 × 56mm) (paper backed) (c1915): A Series of 25	Ha.504-3 Ha.505-4	£28.00	_
		50			£3.60	£90.00
	C	25			£4.20	-
	С	25	English and Foreign Birds (78 × 56mm) (paper backed) (c1915)	Ha.505-1	£4.00	£100.00
	Č	23	*Regimental Colours IV (75 × 55m) (unbacked and anonymous (c1915))	Ha.502-9	£2.80	£70.00
PF	IILIP	MO	RRIS & CO. LTD, London—			
	ST-1920					
	U	50	British Views (1924):			
C			A Small size		£2.70	
_			B Large size (79 × 67mm)			
			B Large size (79 × 67mm)		£2.70	
P.	MOU	AT &	& CO., Newcastle-on-Tyne—			
PR	E-1919	ISSUE	E			
C	С	30	*Colonial Troops (c1902)	H.40	£110.00	_
M	OUST	AFA	LTD, London—			
PO	ST-1920	ISSII	ES			
	CP	50	Camera Studies (1923):			
			A Front with number and caption, back in black		£2.70	
			* B Front without letterpress, plain back		£2.70	
D2	C	25	Cinema Stars — Set 8 (1924)	Uo 515 9	£4.00	
A2	Č	40	Leo Chambers Dogs Heads (1924)	114.515-8	£4.00 £2.50	£100.00
D2	C	25	Pictures of World Interest (1923)			£100.00
A2	P	25	Real Photos (Views) (1925)		£2.60 40p	£10.00
			asgow		40p	210.00
	E-1919 I					
C	C	? 1	Colonial Troops (c1900)		£130.00	_

B. MURATTI SONS & CO. LTD, Manchester and London-

			1 BOND & CO. ELD, Munchester und Elo			_			
Size	Prin ing	t- Num in se		Handbook reference	Price per card	Complete set			
A PRE-1919 ISSUES									
_	U	? 24	*Actresses, cabinet size, collotype (106×69 mm)						
			(c1898)	H.282	£125.00	_			
C	C	26	*Actresses — 'FROGA A' (c1900):	H.20					
		-	A 'To the Cigarette Connoisseur' back		£22.00	_			
			B 'Muratti's Zinnia Cigarettes' back		£25.00	_			
_	C		*Actresses and Beauties - Green Corinthian column						
			framework — 'Neb-Ka' vertical backs (117 × 67mm)						
			(c1900):						
		? 15	Actresses — selection from 'FROGA C'	H.20	£140.00	_			
		? 3	Beauties — selection from 'MOM'	H.277	£140.00	_			
_	C		*Actresses and Beauties - brown and yellow orna-						
			mental framework (117 \times 67mm) (c1900):						
			I 'Neb-Ka' horizontal backs:	** **	21.40.00				
		? 17	i Actresses — selection from 'FROGA A'		£140.00	_			
		? 20	ii Beauties — selection from 'CHOAB'	H.21	£140.00	_			
		? 6	II Rubber stamped back. Beauties — selection	11.01	61.40.00				
			from 'CHOAB'	H.21	£140.00	_			
		? 24	III Plain back — Beauties — selection from	11.01	£140.00				
	-		'CHOAB'	H.21	£140.00	-			
_	C		*Advertisement Cards, Globe design back (88 × 66mm)	H.283					
		0.10	(c1900):	П.203	£275.00				
		? 10	i Brown borders to front		£275.00				
0	C	50	ii White borders to front	H.21	2275.00				
C	C	30	A Black printing on back	11.21	£40.00	_			
			B Olive green printing on back		£45.00	_			
	С	? 54	*Beautiful Women, Globe design back (54 × 75mm)		243.00				
	C	: 34	(c1900)	H 284	£90.00	_			
	BW	20	*Boer War Generals — 'ČLAM' (35 × 61mm) (c1901)	H.61	£32.00	· · · · · · · · · · · · · · · · · · ·			
100	C	15	*Caricatures (42×62 mm) (c1903):	H.285	202.00				
	C	13	A 'Sole Manufacturers of' brown back	11.200	£25.00	_			
			B 'Muratti's Zinnia Cigarettes' brown back		£25.00	_			
			C 'Muratti's Zinnia Cigarettes' black back		£25.00	_			
			D 'Muratti's Vassos Cigarettes' (not seen)			_			
			E As D, but 'Vassos' blocked out, brown back		£45.00	_			
_	C	35	Crowned Heads (53 × 83mm) (c1912)		£13.00	_			
C	Č	52	*Japanese Series, Playing Card inset (c1904)		£13.00				
_	_	02	Plain back		£12.00				
	P		Midget Post Card Series (1902):	H.286					
		? 99	A Matt Front (90 × 70mm)		£11.00	_			
		? 5	B Matt Front (80 × 65mm)		£11.00	_			
			C Glossy front $(85 \times 65 \text{mm few } 75-80 \times 65 \text{mm})$:						
		? 136	i With serial numbers		£11.00	_			
		? 76	ii Without serial numbers		£11.00	_			
_	P	? 99	'Queens' Post Card Series (90 × 70mm) (c1902):	H.287					
			A Front in black/sepia		£15.00	_			
			B Front in reddish brown	Epologia - 1	£15.00	-			
A1	BW	19	*Russo-Japanese Series (1904)		£11.00	£210.00			
A1	C	25	*Star Girls (c1898)	H.30	£140.00				
A	U	? 51	*Views of Jersey (c1912):	H.288	012.00				
			A Plain back		£13.00	_			
			B 'Opera House, Jersey' back	11 200	£16.00	- -			
A	U	25	*War Series — 'MURATTI I', white card (1916)	H.289	£20.00	_			
A	U	50	*War Series — 'MURATTI II', toned card (1917)	Н 200	£12.00				
			Nos. 1-25 (and alternative cards)	11.290	112.00	985.			

Size Print	B.	MUR	ATTI	SONS & CO. LTD, Manchester and London	(continued)		
B POST-1920 ISSUES A2 P 24 Australian Race Horses (export) (c1930) 80p £20.00 £20.00	Size						
A2 P 24 Australian Race Horses (export) (c1930)	R	POST	1920 1	ISSUES		P	50.
C SHLKS. For summary of paper-backed issues, see Ha.497. Seriags — Series C, Nd. 20.44 18.501-3 18.501-3 25.50 28.50 29.50 29.50 20.50						90-	620.00
C **Flags — Set 3 (70 x 52mm) (paper backed) (e1915): Ha.501-3 24 21 Steries — Series C, Nd. 20-44 25 1st Series — Series C, Nd. 20-44 Series E, Nd. 48-72, paper backing in grey (No. 52 unissued) Series E, Nd. 48-72, paper backing in green (No. 52 unissued) Series E, Nd. 48-72, paper backing in green (No. 52 unissued) Series E, Nd. 48-72, paper backing in green (No. 52 unissued) Series E, Nd. 48-72, paper backed) (e1915): Ha.501-8 **Flags — Set 8 (paper backed) (e1915): Ha.501-8 Series B, Nd. 1-7 (No × 76mm) — £10.00 18 Series B, Nd. 19 (70 × 76mm) — £8.50 — £8.50 Series E, Nd. 1-18 (89 × 115mm) — £8.50 — £8.50 Series E, Nd. 1-18 (89 × 115mm) — £8.50 — £8.50 Series E, Nd. 47-78 (89 × 115mm) — £8.50 — £8.50 Series E, Nd. 47-78 (89 × 115mm) — £8.50 — £8.50 Series E, Nd. 47-78 (89 × 115mm) — £8.50 — £8.50 C C **Regimental Badges I (paper backed) (e1915): Ha.502-1 48 Series B, Nd. 1-25 (70 × 52mm) — £4.50 48 Series B, Nd. 1-8 (76 × 70mm) — £5.50 — £8.50 C Series B, Nd. 41-8 (76 × 70mm) — £5.50 — £8.50 C C 25 **Regimental Colours I — Series CB (76 × 70mm) — £8.00 — £8.00 C 27 **Regimental Colours I — Series CB (76 × 70mm) — £8.00 — £8.00 D CANVASES. Urbacked canvases. The material is not strictly canvas, but a linen fabric glazed to give the appearance of canvas. C 40 Canvas Masterpieces — Series M (71 × 60mm) (e1915): A Shaded back design, globe 12mm diam — £5.50 — £8.00 MURRAY, SONS & CO. LTD, Belfast— A PRE-1919 ISSUES A **Pincapple Cigarettes' back — £90.00 — £90.0				summary of paper-backed issues see Ha 407		оор	120.00
25	_	C	. 1013	*Flags — Set 3 (70 \times 52mm) (paper backed) (c1015):	Ha 501 3		
24 2nd Series Series A, Nd. 26-49 Series E, Nd. 48-72, paper backing in grey (No. 52 unissued) £3.50 Series E, Nd. 48-72, paper backing in grey (No. 52 unissued) £3.50 Series E, Nd. 48-72, paper backing in green (No. 52 unissued) £3.50 Series E, Nd. 48-72, paper backing in green (No. 52 unissued) £3.50 Series E, Nd. 49-70 (1900) £3.50 Series E, Nd. 1-3 (89 × 115mm) £8.50 £10.00 £8.50 £10.00 £8.50 Series B, Nd. 1-9 (70 × 76mm) £8.50 £10.00 £8.50 Series E, Nd. 73-78 (89 × 115mm) £8.50 £8.50 £7.50 £8.50 \$6 Series F, Nd. 73-78 (89 × 115mm) £8.50 £8			25	1st Series — Series C Nd 20-44	па.501-5	62 50	
Series A, Nd. 26-49				2nd Series:		13.30	1
Series E, Nd. 48-72, paper backing in grey (No. 52 unissued)			-			£2 50	
Series E, Nd. 48-72, paper backing in green (No. 52 unissued) Series E, Nd. 48-72, paper backing in green (No. 52 unissued) Series E, Nd. 1-3 (89 × 115mm) Fas.50 Series E, Nd. 1-3 (89 × 115mm) Fas.50 Series E, Nd. 1-18 (89 × 115mm) Fas.50 Series E, Nd. 1-18 (89 × 115mm) Fas.50 Series E, Nd. 1-37 (89 × 115mm) Fas.50 Series E, Nd. 7-37 (89 × 115mm) Series E, Nd. 1-18 (70 × 52mm) Series E, Nd. 1-25 (70 × 52mm) Fas.50 Series E, Nd. 1-25 (70 × 52mm) Fas.50 Series E, Nd. 1-25 (70 × 52mm) Fas.50 Series E, Nd. 1-18 (76 × 70mm) Series E, Nd. 1-18 (70 × 52 mm) Series E, Nd. 1-1				Series E. Nd. 48-72, paper backing in grey (No.		25.50	
Series E, Nd. 48-72, paper backed) (c1915):				52 unissued)		f3 50	
S2 unissued S3.50				Series E, Nd. 48-72, paper backing in green (No.		25.50	
C *Flags — Set 8 (paper backed) (c1915):						£3.50	
Series B, Nd. 1-3 (89 × 115mm)	_	C		*Flags — Set 8 (paper backed) (c1915):	Ha.501-8	40.00	
1 Series B, Nd. 19 (70 × 76mm) £8.50 —			3	Series A, Nd. 1-3 (89 × 115mm)		£8.50	_
18				Series B, Nd. 19 $(70 \times 76 \text{mm})$		_	£10.00
Series B, Nd. 43-47 (89 × 115mm)				Series C, Nd. 1-18 (89 × 115mm)		£8.50	_
6 Series F, Nd. 73-78 (89 × 115mm) (paper backed) (c1916)				Series D, Nd. 45-47 (89 × 115mm)		£8.50	
C 18 *Great War Leaders — Series P (89 × 115mm) (paper backed) (c1915) Ha.504 £11.00 —				Series F, Nd. 73-78 (89 × 115mm)		£7.50	_
#Regimental Badges I (paper backed) (c1915): Ha.502-1 25	_	C	18	*Great War Leaders — Series P (89 × 115mm) (paper			
25 Series A, Nd. 1-25 (70 × 52mm)		-		backed) (c1916)		£11.00	_
48 Series B, Nd. 418 (76 × 70mm)		C	25	*Regimental Badges I (paper backed) (c1915):	Ha.502-1		
15				Series B. Nd. 1-25 (70 × 52mm)			_
16				Series B, Nd. 1-48 (76 × 70mm)			_
C 25				Series G. Nd. 70.04 (76 × 70mm)			_
(paper backed) (c1915)		C		*Regimental Colours I Sories CD (76 × 70 mm)		£8.00	_
#Regimental Colours V — Series RB (70 × 52 mm) (paper backed) (c1915)			23	(naner backed) (c1015)	II- 500 6	00.50	
(paper backed) (c1915)	_	C	72	*Regimental Colours V — Series DR (70 × 52 mm)	Ha.302-6	£8.50	
D CANVASES. Unbacked canvases. The material is not strictly canvas, but a linen fabric glazed to give the appearance of canvas. — C 40 Canvas Masterpieces — Series M (71 × 60mm) (c1915):				(paper backed) (c1915)	Ha 502 10	65.50	
the appearance of canvas. — C 40 Canvas Masterpieces — Series M (71 × 60mm) (c1915): — A Shaded back design, globe 12mm diam	D	CANV	ASES	Unbacked canyages The material is not strictly conve	11a.302-10	£3.30	. –
— C 40 Canvas Masterpieces — Series M (71 × 60mm) (c1915):	the	appear	ance o	of canvas	s, but a linen	Tabric glaz	ed to give
A Shaded back design, globe 12mm diam . £5.50	_						
B Unshaded back design, globe 6mm diam £2.00				A Shaded back design globe 12mm diam		65.50	
C 16 Canvas Masterpieces Series P (114 × 90mm)				B Unshaded back design, globe 6mm diam			680 00
MURRAY, SONS & CO. LTD, Belfast A PRE-1919 ISSUES	-	C	16	Canvas Masterpieces — Series P (114 × 90mm)		12.00	200.00
MURRAY, SONS & CO. LTD, Belfast A PRE-1919 ISSUES A BW 20 *Actresses — 'BLARM' (c1900): B 'Special Crown Cigarettes' back				(c1915)		£12.00	
A PRE-1919 ISSUES A BW 20 *Actresses — 'BLARM' (c1900): H.23 A 'Pineapple Cigarettes' back						212.00	
A BW 20 *Actresses — 'BLARM' (c1900): H.23 A 'Pineapple Cigarettes' back	MU	URRA	AY, S	ONS & CO. LTD, Belfast			
A BW 20 *Actresses — 'BLARM' (c1900): H.23 A 'Pineapple Cigarettes' back	A	PRE-1	919 IS	SUES			
A 'Pineapple Cigarettes' back £90.00					H 23		
B 'Special Crown Cigarettes' back £100.00 — C C C 15 Chess and Draughts Problems — Series F (1912) H.291 £55.00 — A BW 54 *Cricketers and Footballers — Series H (c1912): H.292 20 Cricketers. A Thick card £65.00 — B Thin card £65.00 — C Brown Printing £120.00 — 34 Footballers. A Thick card £28.00 — B Thin card £28.00 — C 20 Football Flags (shaped) (60 × 32mm) (c1905): A Maple Cigarettes £60.00 — B Murray's Cigarettes £60.00 — C C 25 *Football Rules (c1911): 1-12 Rugby Football £27.00 — 13-25 Association Football £27.00 —				A 'Pineapple Cigarettes' back	11.23	£90.00	
C C 15 Chess and Draughts Problems — Series F (1912) . H.291 £55.00 — A BW 54 *Cricketers and Footballers — Series H (c1912): H.292 20 Cricketers. A Thick card . £65.00 — E Thin card . £65.00 — E Thin card . £120.00 — 34 Footballers. A Thick card . £28.00 — E Thin card . £28				B 'Special Crown Cigarettes' back			
A BW 54 *Cricketers and Footballers — Series H (c1912): H.292 20 Cricketers. A Thick card	C	C	15	Chess and Draughts Problems — Series F (1912)	H 291		
20 Cricketers. A Thick card £65.00 — B Thin card £65.00 — C Brown Printing £120.00 — 34 Footballers. A Thick card £28.00 — B Thin card £28.00 — B Thin card £28.00 — C 20 Football Flags (shaped) (60 × 32mm) (c1905): A Maple Cigarettes £60.00 — B Murray's Cigarettes £60.00 — C C 25 *Football Rules (c1911): 1-12 Rugby Football £27.00 — 13-25 Association Football £27.00 —	A	BW	54	*Cricketers and Footballers — Series H (c1912):		233.00	
B Thin card £65.00				20 Cricketers. A Thick card	111272	£65.00	
C Brown Printing £120.00 — 34 Footballers. A Thick card £28.00 — B Thin card £28.00 — C 20 Football Flags (shaped) (60 × 32mm) (c1905): A Maple Cigarettes £60.00 — B Murray's Cigarettes £60.00 — C C 25 *Football Rules (c1911): 1-12 Rugby Football £27.00 — 13-25 Association Football £27.00 —				B Thin card			_
34 Footballers. A Thick card £28.00 — B Thin card £28.00 — C 20 Football Flags (shaped) (60 × 32mm) (c1905): A Maple Cigarettes £60.00 — B Murray's Cigarettes £60.00 — C C 25 *Football Rules (c1911): 1-12 Rugby Football £27.00 — 13-25 Association Football £27.00 —				C Brown Printing			
B Thin card £28.00 — C 20 Football Flags (shaped) (60 × 32mm) (c1905): A Maple Cigarettes £60.00 — B Murray's Cigarettes £60.00 — C C 25 *Football Rules (c1911): 1-12 Rugby Football £27.00 — 13-25 Association Football £27.00 —				34 Footballers. A Thick card			
C 20 Football Flags (shaped) (60 × 32mm) (c1905): £60.00				B Thin card		£28.00	<u></u>
A Maple Cigarettes . £60.00 — B Murray's Cigarettes . £60.00 — C C 25 *Football Rules (c1911): 1-12 Rugby Football . £27.00 — 13-25 Association Football . £27.00 —	_	C	20	Football Flags (shaped) $(60 \times 32 \text{mm})$ (c1905):			
B Murray's Cigarettes . £60.00 — C C 25 *Football Rules (c1911): 1-12 Rugby Football . £27.00 — 13-25 Association Football . £27.00 —				A Maple Cigarettes		£60.00	_
C C 25 *Football Rules (c1911): 1-12 Rugby Football	-			B Murray's Cigarettes			
13-25 Association Football £27.00	C	C	25	*Football Rules (c1911):			
A BW 104 *Footballers — Series J (c1910) H.293 £28.00 —				1-12 Rugby Football		£27.00	_
A BW 104 "Pootoallers — Series J (c1910)	A	DW	104	13-25 Association Football			_
	A	DW	104	Footballers — Series J (c1910)	H.293	£28.00	-

MURRAY, SONS & CO. LTD, Belfast (continued)

Size	Print-	Num	ber	Handbook		Complete
	ing	in se	t	reference	per card	set
C	U	25	*Irish Scenery Nd. 101-125 (1905):			
			A 'Hall Mark Cigarettes'		£22.00	
			B 'Pine Apple Cigarettes'		£22.00	_
			C 'Special Crown Cigarettes'		£22.00	_
			D 'Straight Cut Cigarettes'		£22.00	14.5
			E 'Yachtsman Cigarettes'	11.204	£22.00	-
C	BW	25	Polo Pictures — E Series (1911)		£22.00	_
-	U	50	Prominent Politicians — B Series (41 × 70mm) (1909):	H.295	£18.00	
			A Without ' in two strengths' in centre of back		£2.50	£125.00
-	**	25	B With ' in two strengths' in centre of back Reproduction of Famous Works of Art — D Series		12.50	2125.00
C	U	25	(1910)	H 296	£18.00	£450.00
C	U	25	Reproductions of High Class Works of Art — C Series	11.270	210.00	2.00.00
-	U	23	(1910)	H.297	£20.00	£500.00
A1	C	35	*War Series — Series K (1915)		£22.00	<u> </u>
C2	Ü	25	*War Series — Series L, Nd. 100-124 (c1916):			
			A Sepia		£3.00	£75.00
			B Grey-brown		£3.00	_
			C Purple-brown		£3.00	_
B	POST-	1920 I	SSUES			
D1	P	22	Bathing Beauties (1929)		£5.00	
A1	BW	40	Bathing Belles (1939)	Ha.592	25p	£10.00
D1	P	22	Cinema Scenes (1929)		£6.00	100
A1	BW	25	Crossword Puzzles (c1925)		£60.00	
D1	P	26	Dancers (1929)		£5.00	
D	P		Dancing Girls (1929):		£3.00	£75.00
		25	A 'Belfast-Ireland' at base		£2.60	£65.00
		25	B 'London & Belfast' at base		£3.00	203.00
		26	C Inscribed 'Series of 26'	На 503	£9.00	
A	C	20	Inventors Series (1924)	H 213	£4.00	£80.00
A1	C	20 50	Puzzle Series (1924)	11.213	24.00	200.00
A1	C	30	A With coupon attached at top		£16.00	_
AI			B Without coupon		£6.00	_
D2	C	50	Stage and Film Stars — 'Erinmore Cigarettes' (c1926)		£2.50	£125.00
A1	BW	25	Steam Ships (1939)		£1.20	£30.00
A1		50	The Story of Ships (1940)		35p	£17.50
A2		25	Types of Aeroplanes (1929)		£1.20	£30.00
C	C	20	Types of Dogs (1924):	Ha.211		
			A Normal back		£5.00	
			B Normal back, with firm's name rubber-stamped			
			in red		£5.00	-
C	SILKS					
_	C	? 16	*Flags, small (70 × 42mm) — 'Polo Mild Cigarettes'			
			(plain paper backing) (c1915)	Ha.498-1	£20.00	_
_	C	? 3	*Flags and Arms, large (102 × 71mm) — 'Polo Mild			
			Cigarettes' (plain paper backing) (c1915)		£65.00	_
_	C	? 31	*Orders of Chivalry II, 'Series M' (70 × 42mm) (paper		016.00	
			backed, Nd. 35-65) (c1915)	Ha.504-15	£16.00	_
_	C	? 25	*Regimental Badges (70 × 42mm) — 'Polo Mild Ciga-	Ho 109 2	£16.00	
			rettes' (plain paper backing) (c1915)	114.470-3	₹10.00	- T
. v						
H	J. NA	THA	AN, London————			
PR	E-1919	ISSU	E			
D	C	40	Comical Military and Naval Pictures (c1905)	H.14	£55.00	

JAMES NELSON, London—			
Size Print- Number ing in set	Handbook reference	Price per card	Complete set
PRE-1919 ISSUE A P ? 22 *Beauties — 'FENA' (c1899)	H.148	£160.00	_
THE NEW MOSLEM CIGARETTE CO., London-	* *		
PRE-1919 ISSUE			
D C 30 *Proverbs (c1902)	H.15	£70.00	_
E.J. NEWBEGIN, Sunderland—			
PRE-1919 ISSUES			
- P 50 *Actors and Actresses (39 × 60mm) (c1902)	H.299	£45.00	_
A BW 10 *Actresses — 'HAGG A' (c1900) D C ? 4 Advertisement Cards (c1900)	Ha.24	£130.00	_
A BW 20 Cricketers Series (1901)	H 29	£375.00 £325.00	
A BW 19 *Russo-Japanese Series (1904)		£120.00	
D C ? 12 Well-Known Proverbs (c1905)	H.235	£120.00	_
D C 25 Well-Known Songs (c1905)	H.300	£120.00	_
W.H. NEWMAN, Birmingham			
PRE-1919 ISSUES			
C C 18 Motor Cycle Series (c1914)	Un 460	£70.00	
	па.409	£70.00	_
THOS. NICHOLLS & CO., Chester—			
PRE-1919 ISSUE			
A C 50 Orders of Chivalry (1916)	H.301	£6.00	£300.00
THE NILMA TOBACCO COY., London—			
PRE-1919 ISSUES			
A C 40 *Home and Colonial Regiments (c1903):	H.69		
20 Caption in blue		£80.00	<u></u>
D C 30 *Proverbs (c1903)		£80.00	_
D C 30 *Proverbs (c1903)	H.15	£80.00	_
M.E. NOTARAS LTD, London—			
POST-1920 ISSUES			
A2 P 36 National Types of Beauty (c1925)	Ha.558	75p	£27.00
— U 24 *Views of China (68 × 43mm) (1925)		60p	£15.00
OGDENS LTD, Liverpool—			
244 page reference book available — £12.50			
A PRE-1919 ISSUES			
Home Issues (excluding 'Guinea Gold' and 'Tabs', but including some early	issued abroad	d).	
C ? 25 *Actresses — coloured, 'Ogden's Cigarettes contain no			
glycerine' back (c1895): A Titled in black	H.302		
A Titled in black		£85.00	7
D2 U ?1 *Actresses — green, green borders (c1900)	H.303	£85.00 £200.00	
DI U 50 *Actresses — green photogravure (c1900)	H.304	£8.50	
D P ? 583 *Actresses — 'Ogden's Cigarettes' at foot (c1900)	H.305	£2.30	_
D P *Actresses and Beauties — collotype (c1895):	H.306		
A Plain back		670.00	
B 'Midnight Flake' back		£70.00 £45.00	
		~75.00	

OG	DE	NS LID	, Liverpool (continued)			
Size	Pri	nt- Numb	ber	Handbook		Complete
	ing	in set		reference	per card	set
		? 21	ii unnamed:			
		. 21	A Plain back		£70.00	_
			B 'Midnight Flake' back:		£45.00	
			(blue)		£70.00	<u> </u>
D	р		*Actresses and Beauties — collotype, 'Ogden's Ciga-		270.00	
D	P		rettes' back (1895):	H.306		
		? 41	i named	11.500	£45.00	_
		? 36	ii unnamed		£45.00	_
Α	P	? 204	*Actresses and Beauties — woodbury-type (c1894)	H 307	£35.00	
_	C	192	Army Crests and Mottoes (39 × 59mm) (c1902)	11.507	£4.00	
Δ	C	28		H.39	£23.00	
	C	50	*Beauties — 'CHOAB' (c1900):	H.21		
		50	1-25 (size 65 × 36mm)		£26.00	_
			26-50 (size 67 × 37mm)		£26.00	_
Α	C	26	*Beauties — 'HOL' (c1900):	H.192		
			A 'Guinea Gold' red rubber stamp back		£110.00	_
			B Blue Castle Design back		£17.00	£440.00
A2	C	52	*Beauties — 'Playing Card' series (c1900):	H.308		
			A 52 with playing card inset		£26.00	_
			B 26 without playing card inset		£32.00	_
A2	C	52	*Beauties and Military — PC inset (c1898)		£26.00	
	P	50	Beauty Series, numbered, 'St. Julien Tobacco' (36 ×		62.50	C125 00
			54mm) (c1900)	11 200	£2.50	£125.00
D	P	? 65	Beauty Series, unnumbered, issued Australia (c1900)	H.309	£65.00	
A	C	50	Birds' Eggs (1904):		£1.90	£95.00
			A White back			£90.00
_		0.1.11	B Toned back		£1.80	190.00
D	P	? 141	*Boer War and General Interest — 'Ogden's Cigar-	Н 210	£2.60	
110	D	0.50	ettes' at foot (c1900)	H.310	12.00	
H2	P	? 52			£30.00	
	ъ	2.2	at foot (c1900)		250.00	
	P	? 3	ettes' at foot (72 × 55mm) (c1900)	H 310	£130.00	
٨	C	50	Boxers (1915)	11.510	£6.00	£300.00
A	C	25	Boxing (1914)	H 311	£5.00	£125.00
A	C	? 6	*Boxing Girls (165 × 94mm) (c1895)	Ha.482	£350.00	_
A	C	50	Boy Scouts (1911):	H.62		
^	-	50	A Blue back		£2.50	£125.00
			B Green back		£3.60	£180.00
Α	C	50	Boy Scouts, 2nd series (1912):	H.62		
and the same			A Blue back		£2.50	£125.00
			B Green back		£3.60	£180.00
A	C	50	Boy Scouts, 3rd series (1912):	H.62		
			A Blue back		£2.50	£125.00
			B Green back		£3.60	£180.00
A	C	50	Boy Scouts, 4th series, green back (1913)		£2.60	£130.00
A	C	25	Boy Scouts, 5th series, green back (1914)		£2.80	£70.00
A	C	50	British Birds:	H.229	04.63	005.00
			A White back (1905)		£1.90	£95.00
			B Toned back (1906)		£1.80	£90.00
A	C	50	British Birds, Second Series (1908)	11 212	£2.00	£100.00
A	C	50	British Costumes from 100 BC to 1904 (1905)	H.312	£6.00	£300.00
A	C	50	Club Badges (1914)	Ц 212	£5.00 £275.00	£250.00
-	C	? 24	*Comic Pictures (1890-95) (size varies)		£275.00 £325.00	<u> </u>
A2	C	12	*Cricket and Football Terms — Women (c1896)	11.314	2323.00	_

U	GDEN	S LI	D, Liver poor (commuea)			
Si	ze Prini ing	t- Nun in se		Handbook reference	Price per card	Complete set
A A	U	? 50 28	*Cricketers and Sportsmen (c1898)	H.315 H.20	£65.00	_
			A Mitred corners (7 backs)		£24.00	_
		-	B Unmitred corners (7 backs)		£24.00	-
A		28	*Dominoes — Beauties — 'MOM' back (c1900)	H.277	£24.00	_
A		55	*Dominoes — black back (1909)		£1.40	£75.00
A		50	Famous Footballers (1908)		£3.80	£190.00
A	. C	50 43	Flags and Funnels of Leading Steamship Lines (1906) *Football Club Badges (shaped for buttonhole)	H.67	£4.00	£200.00
A	С	51	(c1910)	H.316 H.68	£6.00	
			Nos. 1-50		£3.50	£175.00
A	C	50	No. 51	11.64	c2 00	£5.00
_	· c	1	Fowls, Pigeons and Dogs (1904)* *History of the Union Jack (threefold card)	H.04	£2.80	£140.00
A	BW	50	(51 × 37mm closed) (1901)	11 017		£200.00
K		52	Infantry Training (1915)	H.317	£2.40	£120.00
			back (c1900):	H.319		
			I Unnamed, no numeral (76 backs known)		£4.00	
			II Unnamed, 'numeral 40' (26 backs known)		£4.00	_
			III Named, 'numeral 46' (26 backs known)	H.20	£4.00	_
K	2 C	52	IV Named, no numeral (26 backs known) *Miniature Playing Cards, blue Tabs 'Shield and	H.20	£4.00	_
77			Flower' design back (1909)		£3.00	_
K	2 C	52	*Miniature Playing Cards, yellow 'Coolie Plug' design back:			
			A Yellow back (1904)		£3.00	_
	DW	50	B Yellow back with white border (1904)		£3.00	-
A	BW	50	Modern War Weapons (1915):	H.320		
			A Original numbering		£2.80	£140.00
	C	50	B Numbering re-arranged		£10.00	_
A	C	50	Orders of Chivalry (1907)		£3.00	£150.00
A	C	25	Owners, Racing Colours and Jockeys (1914)		£4.00	£100.00
A A	C	50 25	Owners, Racing Colours and Jockeys (1906) Poultry (1915):		£3.00	£150.00
			A 'Ogden's Cigarettes' on front		£4.00	£100.00
	-		B Without 'Ogden's Cigarettes' on front		£4.00	£100.00
A	C	25	Poultry, 2nd series, as 'B' above (1916)		£4.40	£110.00
A A	C	25 25	Pugilists and Wrestlers, Nd. 1-25 (1908) Pugilists and Wrestlers, Nd.26-50:		£4.00	£100.00
			A White back (1909)		£4.00	£100.00
	-		B Toned back (1908)		£4.00	£100.00
A	C	25	Pugilists and Wrestlers, 2nd series, Nd. 51-75 (1909)		£4.00	£100.00
A	C	50	Racehorses (1907)		£3.00	£150.00
A	C	25	Records of the World (1908)		£2.80	£70.00
A	C	50	Royal Mail (1909)	H.82	£4.20	£210.00
A	C	50	Sectional Cycling Map (1910)		£3.20	£160.00
A	С	50	*Shakespeare Series (c1903): A Unnumbered	H.321	£13.00	£650.00
			B Numbered		£13.00	£650.00
A	C		Soldiers of the King (1909):		213.00	1030.00
		50	A Grey printing on front		£4.50	£225.00
		25	B Brown printing on front		£6.00	2225.00
D	C	25	*Swiss Views, Nd. 1-25 (c1905)		£4.00	£100.00
D	C	25	*Swiss Views, Nd. 26-50 (c1905)		£5.00	£125.00
					20.00	~125.00

Size	Prin ing	t- Numl in set		Handbook reference	Price per card	Complete set
D	C	48	Victoria Cross Heroes (1901)	H.322	£12.00	£600.00
		ea Gold Book).	' Series (The S and X numbers represent the reference	e numbers qu	uoted in th	e Ogden's
D	P	1148	1-1148 Series (c1900):			
D	1	1140	Nos. 1-200		40p	£80.00
			Nos. 201-500		£1.00	200.00
			Nos. 501-900, excl. 523 and 765		90p	
					£1.50	
			Nos. 901-1000, excl. 940, 943, 947 and 1000 Nos. 1001-1148, excl. 1003, 1006-8, 1024, 1030, 1033, 1034, 1037, 1040, 1042, 1048, 1066, 1081,		11.50	_
					£1.50	
			1082, 1088		21.50	
			1008, 1024, 1030, 1033, 1034, 1037, 1040, 1042,			
			1048, 1066, 1088		£40.00	-
			Very scarce Nos. 765, 1006, 1081, 1082		_	
D	CP	?	Selected numbers from 1-1148 Series (c1900)		£4.00	_
D	P		400 New Series I (c1902)		90p	£360.00
D	P		400 New Series B (c1902)		£1.00	£400.00
D	P		300 New Series C (c1902)		90p	£270.00
D	P	? 318	Set 73S Base B Actresses (c1900)		£2.50	_
D		. 510	Set 75S Base D (c1900):		22.00	
D	P	? 320	List DA — White Panel Group		£1.00	
D	P	? 58	List DB — The Denumbered Group		£2.20	
	P	? 62	List DC — The Political Group		£1.00	100
D			List DD — Boer War etc		70p	
D	P	? 186			£3.80	
D	P	? 46	List DE — Pantomime and Theatre Group		£1.20	
D	P	? 374	List DF — Actors and Actresses			
D	P	? 40	Set 76S Base E Actors and Actresses (c1900)		£3.00	
D	P	? 58	Set 77S Base F Boer War etc (c1901)		90p	_
			Set 78S Base I (c1900):			
			List IA — The small Machette Group:		24.00	
D	P	83	I Actors and Actresses		£1.00	
D	P	14	II London Street Scenes		£3.00	_
D	P	32	III Turner Pictures		£1.50	
D	P	11	IV Cricketers		£12.00	_
D	P	18	V Golf		£20.00	_
D	P	10	VI Views and Scenes Abroad		£1.60	_
D	P	30	VII Miscellaneous		£1.30	
D	P	639	List IB — The Large Machette Group		£1.00	
D	P	5	List IC — The White Panel Group		£5.00	
D	P	30	Set 79S Base J Actresses (c1900)		£3.50	
D	P	239	Set 80S Base K Actors and Actresses (c1900)		£2.30	_
D	P	215	Set 81S Base L Actors and Actresses (c1900) Set 82S Base M (c1901):		£2.20	_
D	P	3	List Ma Royalty		£3.00	£9.00
D	P	77	List Mb Cricketers		£22.00	
D	P	50	List Mc Cyclists		£5.50	
D	P	150	List Md Footballers		£10.00	_
D	P	50	List Me Pantomime and Theatre Group		£6.00	
D	P	33	List Mf Footballers and Cyclists		£10.00	_
D	P	27	List Mg Boer War and Miscellaneous		90p	
D		2948	List Mh Actors and Actresses		90p	
					УОР	
Ba			Series, Large and Medium		614.00	
	P	71	Set 73X Actresses Base B (c1900)		£14.00	640.00
	P	1	Set 74X Actress Base C (c1900)		_	£40.00

OG	DLI	S LI	b, Livel pool (commuea)		
Size		t- Nun			Complete
	ing	in se	et	reference per care	l set
	P	571	Set 75X Actors, Actresses, Boer War Etc Base D		
			(c1901)	From £2.00) _
	P	21	Set 78X Actresses Base I (c1900)	£40.00	
	P	403	Set 82X Actors, Actresses, Boer War Etc Base M		
			(c1901)	£1.50	_
C	TAR	S' SER	IES		
			그 프로그램 그 경기를 들어 있다면 하는 아이를 보고 있다면 하는 것이 없는 것이 없다면 없다면 없다.		
Refe	rence	Rook	rentheses following word 'item' represent the referen The listing includes both home and overseas 'Tabs' is:	ice numbers quoted	in Ogden's
D	BW	200			
D	BW	200	*Actresses (item 7) (c1900)	£2.50	
D		? 331	*Composite Tabs Series, with 'Labour Clause' (item	£2.00	_
		. 551	63) (1901):		
			1 General de Wet		£5.00
			1 General Interest		£6.00
			17 Heroes of the Ring	£6.00	
			1 HM the Queen	20.00	£5.00
			2 HRH the Prince of Wales	£4.00	
			14 Imperial Interest	£1.00	
			106 Imperial or International Interest	80p	
			3 International Interest	£2.00	£6.00
			14 International Interest or a Prominent British		
			Officer	80p	
			22 Leading Athletes	£2.20	
				£3.50	
				£1.00	
			2 Members of Parliament	£3.50	
			12 Our Leading Cricketers	£6.00 £13.00	
			17 Our Leading Footballers	£5.00	
			37 Prominent British Officers	90p	
			1 The Yacht 'Columbia'	<u> </u>	£6.00
			1 The Yacht 'Shamrock'	4	£6.00
D	BW	? 65	*Composite Tabs Series, without 'Labour Clause' (item		20.00
			64) (c1900):		
			36 General Interest	£24.00	
			29 Leading Artists of the Day	£22.00	<u> </u>
D	BW	? 114	*Composite Tabs Series, Sydney issue (item 65) (c1900):		
			1 Christian de Wet	£10.00	<u> </u>
			1 Corporal G. E. Nurse, VC	£9.00	<u></u>
			15 English Cricketer Series	£45.00	
			1 Imperial Interest	£10.00	_
			27 Imperial or International Interest	£8.00	-
			6 International Interest	£8.00	-
			1 Lady Sarah Wilson	£9.00	
			13 Prominent British Officers	£8.00	-
D	BW	150	13 Prominent British Officers General Interest, Series 'A' (1901)	£8.00	-
D	BW	200	General Interest, Series 'B' (1902)	60p	£90.00
D	BW	470	General Interest, Series 'C' (1902):	60p	£120.00
			C.1-200	60p	£120.00
			C.201-300	£2.20	2120.00
			C.301-350	80p	£40.00
			No Letter, Nd 1-120	90p	£110.00
D	BW	200	General Interest, Series 'D' (1902)	60p	£120.00
D	BW	120	General Interest, Series 'E' (1902)	90p	£110.00
			스 마음이 있는 아이들은 아이들은 아이들은 아이들은 아이들은 아이들이 되었다면 살아 있다면 살아 있다.		

UG	DEN	LIL	, Liverpoor (continuea)			
Size	Print-ing	Num in se		Handbook reference	Price per card	Complete set
D	BW	420	General Interest, Series 'F' (1902):			
	2	120	F.1-200		90p	
			F.201-320		90p	_
			F.321-420		£2.50	
D	BW?	500	General Interest, Sydney issue (c1902):			
			Nd 1-100 on front		£2.75	grand and the
			Nd 101-400 on back		£2.75	_
			Unnumbered, mostly similar numbered cards 101-			
			200 (item 99-a)		£5.00	_
D	BW	196	*General Interest, unnumbered, similar style C.201-300			
			(item 95) (1902):			
			75 Stage Artists		80p	_
			42 Celebrities		80p	_
			56 Footballers		£2.50	
_	DIII	100	23 Miscellaneous		80p	_
D	\mathbf{BW}	100	*General Interest, unnumbered, similar style C.301-350			
			(item 96) (1902):		90p	
			28 Actresses		£1.00	-
			40 Castles		£1.00	
			20 Miscellaneous		£2.00	-
D	BW	300	*General Interest, unnumbered, similar style F.321-420		22.00	
D	DW	300	(item 97) (1903):			
			A 100 with full stop after caption		£1.20	£120.00
			B Without full stop after caption:		21.20	2120.00
			79 I Stage Artistes		90p	£70.00
			21 II Cricketers		£10.00	
			25 III Football		£4.00	
			15 IV Golf		£15.00	_
			10 V Cyclists		£5.00	_
			9 VI Fire Brigades		£5.00	
			5 VII Aldershot Gymnasium		£3.00	£15.00
			36 VIII Miscellaneous		80p	_
D	BW?	110	*General Interest, 'oblong' back (item 98) (c1900)		£14.00	_
D	BW	? 75	*Leading Artistes of the Day, numbered 126-200, plain			
			backs (item 109) (see H.1) (c1900)		£11.00	
D	\mathbf{BW}	? 71	Leading Artistes of the Day with 'Labour Clause' (item			
			110) (c1900):		24.00	
			A Type-set back		£1.00	_
D	DW	0.25	B Plain back		£20.00	_
D	BW	! 25	Leading Artistes of the Day, without 'Labour Clause'			
			(item 111-1) (c1900): A With caption, type-set back		£13.00	
			A With caption, type-set back		£13.00	
			C Without caption, type-set back		£13.00	
D	BW	2 86	Leading Artistes of the Day, without 'Labour Clause'		213.00	
	D	. 00	(item 111-2) (c1900):			
			A Type-set back		£11.00	
			B Plain back		£11.00	
D	BW	25	Leading Generals at the War, with descriptive text			
			(item 112) (c1900):			
			A 'Ogden's Cigarettes' back		£2.00	_
			B 'Ogden's Tab Cigarettes' back		£1.40	£35.00
D	BW		Leading Generals at the War, without descriptive text			
			(item 113) (c1900):			
		? 47	A 'Ogden's Tab Cigarettes' back (47 known)		£1.00	_

Size	Print-	Numi in sei		Handbook		Complete
	ing			reference	per card	set
_		? 25	B 'Ogden's Lucky Star' back (25 known)		£4.50	_
D	BW	50	*Stage Artistes and Celebrities (item 157) (c1900)		£2.20	£110.00
D	POST-1	920 I	SSUES			
A	C	25	ABC of Sport (1927)		£2.80	£70.00
A	C	50	Actors — Natural and Character Studies (1938)	Ha 571-1	£1.00	£50.00
A	C	50	AFC Nicknames (1933)	Ha.571-2	£4.00	£200.00
A	C	50	Air-Raid Precautions (1938)		70p	£35.00
A	C	50	Applied Electricity (1928)		£1.10	£55.00
A	U	36	Australian Test Cricketers, 1928-29		£3.00	£110.00
A	C	50	Billiards, by Tom Newman (1928)		£1.50	£75.00
A	C	50	Bird's Eggs (cut-outs) (1923)		90p	£45.00
A	C	50	The Blue Riband of the Atlantic (1929)		£2.50	£125.00
A	C	50	Boy Scouts (1929)		£1.50	£75.00
A	C	50	British Birds (Cut-Outs) (1923)		90p	£45.00
A	C	50	British Birds and Their Eggs (1939)	Ha.571-3	£2.50	£125.00
A	U	50	Broadcasting (1935)		£1.20	£60.00
A	C	50	By the Roadside (1932)		£1.00	£50.00
A	C	44	Captains of Association Football Clubs and Colours			
			(1926)		£2.75	£120.00
A	U	50	Cathedrals and Abbeys (1936):			
			A Cream card		90p	£45.00
			B White card		90p	£45.00
A	C	50	Champions of 1936 (1937)	Ha.571-5	£1.60	£80.00
A	C	50	Children of All Nations (cut-outs) (1923)		90p	£45.00
A	C	50	Colour in Nature (1932)		90p	£45.00
A	C	50	Construction of Railway Trains (1930)		£2.20	£110.00
A	C	50	Coronation Procession (sectional) (1937)	Ha.571-6	£1.40	£70.00
A	U	50	Cricket, 1926		£2.40	£120.00
A	C	25	Derby Entrants, 1926		£2.40	£60.00
A	C	50	Derby Entrants, 1928		£1.80	£90.00
A	U	50	Derby Entrants, 1929		£2.20	£110.00
A	C	50	Dogs (1936)	Ha.571-7	£1.80	£90.00
A	C	25	Famous Dirt-Track Riders (1929)		£3.80	£95.00
A	U	50	Famous Rugby Players (1926-27)		£2.00	£100.00
A	C	50	Football Caricatures (1935)		£2.20	£110.00
A	C	50	Football Club Captains (1935)	Ha.571-9	£1.80	£90.00
A	C	50	Foreign Birds (1924)		80p	£40.00
A	U	25	Greyhound Racing — '1st Series' (1927)		£3.60	£90.00
A	C	25	Greynound Racing — 2nd Series (1928)	II 671 10	£3.60	£90.00
		50	How to Swim (1935)	Ha.5/1-10	80p	£40.00
A	C	50	Jockeys, and Owners' Colours (1927)		£2.40	£120.00
A	C	50 50	Jockeys, 1930		£2.40	£120.00
A	C	25	Leaders of Men (1924)		£1.80	£90.00
A	C	50	Marvels of Motion (1928)		£1.80	£45.00
A	C	50	Modern British Pottery (1925)		90p	£45.00
A	C	25	Modern Railways (1936)		£2.00 £2.40	£100.00
A	C	50	Motor Races (1931)			£60.00
A	C	50	Ocean Greyhounds (1938)	Ho 571 12	£2.40 £1.00	£120.00
A	C	25	Optical Illusions (1923)	Ha 560	£1.00 £2.40	£50.00 £60.00
A	C	25	Picturesque People of the Empire (1927)	11a.500	£1.40	£35.00
A	U	50	Picturesque Villages (1936)		£1.40	£50.00
A	C	25	Poultry Alphabet (1924)		£3.00	£75.00
A	Č	25	Poultry Rearing and Management — '1st Series'		25.00	275.00
		23	(1922)		£2.40	£60.00
					22.40	200.00

OG	DENS	LTI), Liverpool (continued)			
Size	Print-ing	Num in se		Handbook reference	Price per card	Complete set
A	C	25	Poultry Rearing and Management — '2nd Series'			
			(1923)		£2.40	£60.00
A	U	50	Prominent Cricketers of 1938 (1938)		£1.80	£90.00
A	C	50	Prominent Racehorses of 1933 (1934)	Ha.571-l4	£1.80	£90.00
A	U	50	Pugilists in Action (1928)		£3.50	£175.00
A	C	50	Racing Pigeons (1931)		£3.00	£150.00
A	C	50	Sea Adventure (1939)		25p	£12.50
A	C	50	Shots from the Films (1936)	Ha.5/1-16	£1.80	£90.00
A	U	25	Sights of London (1923)		£1.60 £1.80	£40.00 £90.00
A	C	50	Smugglers and Smuggling (1932)		£1.80	£90.00
A	U C	50 50	Steeplechase Celebrities (1931)		£1.80	£90.00
A	C	50	The Story of Sand (1934)		80p	£40.00
A	C	50	Swimming, Diving and Life-Saving (1931)	Ha 523	£1.10	£55.00
A	C	25	Trainers, and Owners' Colours — '1st Series' (1925)	114.525	£2.20	£55.00
A	C	25	Trainers, and Owners' Colours — '2nd Series'			
11	_	20	(1926)		£2.40	£60.00
Α	C	50	Trick Billiards (1934)	Ha.571-17	£1.40	£70.00
A	C	50	Turf personalities (1929)		£2.40	£120.00
A	C	25	Whaling (1927)		£2.60	£65.00
A	C	50	Yachts and Motor Boats (1930)		£2.00	£100.00
A	C	50	Zoo Studies (1937)	Ha.571-18	50p	£25.00
A	С	40	*Home & Colonial Regiments (c1901) 20 Caption in blue		£200.00 £200.00	_
OS	BOR	NE T	OBACCO CO. LTD, Portsmouth & Lon	don		
POS	T-1940	ISSU	ES			
A	U	50	Modern Aircraft (1953):			
			A Dark Blue back		40p	£20.00
			B Light Blue back		50p	£25.00
			C Brown back		50p	£25.00
w.	r. os	BOR	RNE & CO., London			
PRE	-1919 1	SSUE				
D	C	40	*Naval and Military Phrases (c1904)	H.14	£40.00	_
J.A	. PAT	TRI	EIOUEX, Manchester—			
A	1920s	PHOT	OGRAPHIC SERIES. Listed in order of letters are word 'back' refer to the nine backs illustrated in Hand	nd/or number	rs quoted	on cards.
H2	P	50	*Animals and Scenes — Unnumbered ('Junior			
112		50	Member'). Back 4 (c1925)	Ha.595-1	£1.20	
H2	P	50	Animals and Scenes, Nd 1-50. Back 1 (c1925)		£1.20	
H2	P	50	*Scenes, Nd 201-250 ('Junior Member'). Back 4			
	1.9		(c1925)		£1.20	_
C	P	96	Animals and Scenes, Nd 250-345 (c1925):			
			A Back in style 2 in (i) grey		£1.00	
			(ii) brown		£1.00	_
			* B 'Junior Member' back 9		£1.00	_

J.A. PATTREIOUEX, Manchester (continued)

C:	Duina	N/	L			
Size	Print-ing	in se		Handbook		Complete
				reference	per card	set
C	P	96	Animals and Scenes, Nd 346-441 (c1925):			
			A Back 2		£1.00	_
			B Back style 1 and back 3		£1.00	
	-		* C 'Junior Member' back 9		£1.00	_
Н	P	50	*Animal Studies, Nd A42-A91 ('Junior Member').			
**			Back 4 (c1925)		£1.00	_
H	P	50	*Animal Studies, Nd A92-A141 ('Junior Member').			
	-		Back 4 (c1925)		£1.00	_
H	P	50	*Animal Studies, Nd A151-A200 ('Junior Member').			
-	-		Back 4 (c1925)		£1.00	
C	P	20	*Natives and Scenes (c1925):			
		36	A 'Series 1/36 B' on front, Nd 1-36 ('Junior Mem-			
		0.	ber'). Back 9		£1.30	_
-	_	96	B 'Series 1/96 B' on front, Nd 1-96. Back 6		£1.00	
C	P	96	*Foreign Scenes, Nd 1/96C-96/96C. Back 6 (c1925)		£1.00	
C	P	96	Cricketers, Nd C1-C96, 'Casket Cigarettes' on front			
			(c1925):			
			A Back 5		£40.00	
			* B Plain back		£40.00	
C	P	96	*Animals — 'Series Nos CA1 to 96'. Back 7 (c1925)		£1.00	
C	P	96	*Natives and Scenes (c1925):			
			A 'C.B.1 to 96' on front. Back 7:			
			1 Nd 1-96		£1.00	
			2 Nd C.B.1-C.B.96		£1.00	_
			B 'J.S. 1 to 96' on front. 'Junior Member'. Back 9		£1.00	_
C	P	96	*Animals and Scenes — 'CC1 to 96' on front. Back 7			
			(c1925)		£1.00	
H2	P	50	*British Scenes — 'Series C.M.1-50.A' on front. Back		21.00	
			style 7 (c1925)		£1.20	
H2	P	50	*Foreign Scenes (c1925):		21.20	
			A 'Series CM. 1/50 B' on front. Back style 7		£1.20	
			B 'J.M. Series 1/50' on front. 'Junior Member'		21.20	
			back 9		£1.20	
H2	P	50	*Foreign Scenes (c1925):		21.20	
			A 'Series C.M. 101-150.S' on front. Back style 7		£1.20	
			B Nd S.101-S.150 on front. Back 4		£1.20	
C	P	96	*Foreign Scenes, Nd 1/96D-96/96D. Back 6 (c1925)			_
H2	P	50	*Foreign Scenes, Nd 1/50E-50/50E. Back 6 (c1925)		£1.30	
H2	P	50	*Foreign Scenes, Nd 1/50F-50/50F. Back 6 (c1925)		£1.20	_
C	P	96	Footballers, Nd F.1-F.96. 'Casket' and 'Critic' back		£1.20	7 T
-	•	70	etyle 5 (c1025)		00.00	
C	P	96	style 5 (c1925)		£8.00	-
C	1	90	Footballers, Nd F.97-F.192. 'Casket' and 'Critic' back			
Н	P	50	styles (c1925)		£8.00	
11	r	30	Football Teams, Nd F.193-F.242. ('Casket' and 'Critic')			
C	P	96	(c1925)		£20.00	_
C	Г	90	*Footballers — 'Series F.A. 1/96' on front. Back 8			
C	P	01	(c1925)		£5.50	-
C	P	96	*Footballers — 'Series F.B. 1/96' on front. Back 8			
-	-	01	(c1925)		£5.50	_
C	P	96	*Footballers — 'Series F.C. 1/96' on front. Back 8 (c1925)		£5.50	_
H2	P	50	*Scenes — 'G. 1/50' on front. 'Junior Member'.			
***	-		Back 9 (c1925)		£1.50	_
H2	P	50	*Scenes — '1/50. H' on front. 'Junior Member'.			
***	_		Back 9 (c1925)		£1.20	_
H2	P	50	*Animals and Scenes, Nd I.1-I.50. Back style 6			
			(c1925)		£1.20	

J.A. PATTREIOUEX, Manchester (continued)

0.77			Collin, Municipester (communica)			
Size	Prin ing	t- Numi		Handbook reference	Price per card	Complete set
H2	P	50	Famous Statues — 'J.C.M. 1 to 50 C' on front. Back style 6 (c1925)		£1.60	_
H2	P	50	*Scenes, Nd JCM 1/50D-JCM 50/50D (c1925):		C1 20	
			A Back style 6		£1.30 £1.30	_
В1	P	30	Child Studies, Nd J.M. No. 1-J.M. No. 30. 'Junior Member', back style 9 (c1925)		£3.50	_
B1	P	30	*Beauties, Nd J.M.1-J.M.30. 'Junior Member', back style 9 (c1925)		£2.25	_
H2	P	50	*Foreign Scenes — 'J.M. 1 to 50 A' on front. 'Junior Member', back style 9 (c1925)		£1.20	_
H2	P	50	British Empire Exhibition 'J.M. 1 to 50 B' on front (c1925)		£1.80	_
C	P	96	*Animals and Scenes — 'J.S. 1/96A'on front. 'Junior Member', back style 9 (c1925)		£1.00	_
H2	P	50	*Scenes, Nd S.1-S.50.' Junior Member', back 4 (c1925)		£1.20	
H2	P	50	*Scenes, Nd S.51-S.100.' Junior Member', back 4		21.20	
			(c1925)		£1.20	_
B1	P	50	*Cathedrals and Abbeys, Nd S.J. 1-S.J. 50. Plain back (c1925)	Ha.595-3	£2.30	_
B1	P	50	(c1925)	Ha.595-3	£2.30	
H2	P	4	*Scenes, Nd V.1-V.4. 'Junior Member', back 4 (c1925)		£5.00	_
B	COLO	URED	AND LETTERPRESS SERIES			
A	C	50	British Empire Exhibition Series (c1928)		£2.50	£125.00
A	C	50	Builders of the British Empire (c1929)		£3.00	£150.00
A	C	50	Celebrities in Sport (c1930)		£4.00	£200.00
A	Č	75	Cricketers Series (c1928)		£8.00	
A	C	50	Dirt Track Riders (c1929)		£8.00	_
A	C	30	Drawing Made Easy (c1930)		£2.50	£75.00
	C	52	The English and Welsh Counties (c1928)		£2.00	£105.00
A	C	32	Footballers Series (c1928):		22.00	2105.00
A	C	50			£6.00	
		50	A Captions in blue		£6.00	grant the second
	0	100	B Captions in brown		£12.00	_
A	C	25	'King Lud' Problems (c1935)			_
A	C	26	Maritime Flags (c1932)		£9.00	100
A	U	25	Photos of Football Stars (c1930)		£25.00	
D	C	50	Railway Posters by Famous Artists (c1930)		£7.00	C125 00
A	C	50	Sports Trophies (c1931)	II. 507	£2.50	£125.00
A2	CP	51	*Views (c1930)	Ha.597	£1.10	£55.00
C .		PHOTO	OGRAPHIC SERIES			
	P		Beautiful Scotland (1939):	Ha.564-1		14.2
D		28	A Small size		£1.00	£28.00
		48	B Medium size $(77 \times 52 \text{mm})$		25p	£12.00
_	P	48	The Bridges of Britain $(77 \times 52 \text{mm}) (1938) \dots$		25p	£12.00
_	P	48	Britain from the Air $(77 \times 52 \text{mm})$ (1939)		25p	£12.00
_	P	48	British Railways (77 × 52mm) (1938)		60p	£30.00
	P		Coastwise (1939):	Ha.564-2		
D		28	A Small size		£1.00	£28.00
_		48	B Medium size (77 × 52mm)		25p	£12.00
D	P	54	Dirt Track Riders (1930):			
			A Descriptive back		£12.00	_
			* B Non-descriptive back		£20.00	_
_	P	48	Dogs (76 × 51mm) (1939)		35p	£17.50

J.A.	. PAT	TREIOUEX, Manchester (continued)			
Size	Print-ing	Number in set	Handbook reference	Price per card	Complete set
	P	Flying (1938):	Ha.564-3		
D		28 A Small size		£1.50	_
		48 B Medium size (77 × 52mm)		40p	£20.00
A2	P	78 Footballers in Action (1934)		£3.00	_
-	P	48 Holiday Haunts by the Sea $(77 \times 52 \text{mm})$ (1937)		25p	£12.00
_	P	48 The Navy (1937):			
		A Large captions		50p	£24.00
	D	B Smaller captions	II- 564.4	50p	£24.00
D	P	Our Countryside (1938): 28 A Small size	Ha.564-4	£1.25	£35.00
D		48 B Medium size (77 × 52mm)		25p	£33.00 £12.00
A2	P	54 Real Photographs of London (1936)		£2.00	112.00
D	P	28 Shots from the Films (1938)		£2.00	£55.00
_	P			25p	£12.00
-	P	 48 Sights of Britain — 'Series of 48' (76 × 51 mm) (1936) 48 Sights of Britain — 'Second Series' (76 × 51 mm) (1936): 			
		A Large captions		25p	£12.00
		B Smaller captions		30p	£15.00
_	P	48 Sights of Britain — 'Third Series' (76 × 51mm)			
_	P	(1937)		25p	£12.00
_	P	(1935)		50p	£25.00
		Jubilee Pictures' (76 × 51mm) (1935)		80p	£10.00
A2	P	54 Sporting Celebrities (1935)		£2.50	£135.00
42	P P	96 Sporting Events and Stars (76 × 50mm) (1935)		£1.75	£175.00
A2	P	54 Views of Britain (1937)		£1.60	C15 00
D		940 ISSUES		30p	£15.00
D	C C	24 Cadet's Jackpot Jigsaws (90 × 65mm) (1969)		£1.50	
	C	24 Treasure Island (65 × 45mm) (1968)		£1.50	
w.	PEPI	PERDY-			
PRE	-1919 1	SSUES			
A	C	30 *Army Pictures, Cartoons, etc (c1916)	H.12	£75.00	-
M.	PEZ	ARO & SON, London—			
PRE	-1919 1	SSUES			
D	C	25 *Armies of the World (c1900):	H.43		
		A Cake Walk Cigarettes	11.43	£100.00	
		B Nestor Virginia Cigarettes		£100.00	
D	C ·	Song Titles Illustrated (c1900)	H.323	£130.00	-
GO	DFR	EY PHILLIPS LTD, London—————			
40 p	age refe	rence book available — £3.50			
		19 ISSUES			
D1	C	25 *Actresses 'C' Series, Nd 101-125 (c1900):			
		A Blue Horseshoe design back		£27.00	
		B Green back, 'Carriage' Cigarettes		£30.00	
				£85.00	_
		C Blue back, 'Teapot' Cigarettes		£85.00	
		E Blue back, 'Derby' Cigarettes		£85.00	_
		F Blue back 'Ball of Beauty' Cigarettes		£85.00	<u>-</u>

00	DIK		india di Di Di Donaton (commuca)			
Size	Print-			Handbook		Complete
	ing	in sei		reference	per card	set
	C	50	*Actresses — oval card $(38 \times 62 \text{mm})$ (1916) :	H.324		
			A With name		£6.00	
			B Without Maker's and Actress's Name		£5.00	£250.00
D	C	40	Animal Series (c1905)		£5.50	£220.00
D1	Č	25	*Beauties, Nd B.801-825 (c1902)	H.325	£10.00	£250.00
A1		? 24	*Beauties, collotype — 'HUMPS' (c1895)		£70.00	_
A	Č	30	*Beauties, 'Nymphs' (c1896)		£70.00	_
D	C	30	*Beauties — 'Plums' (1897):	H.186	€70.00	
D	BW	? 14		11.100	£130.00	
					£55.00	
	C	50	B Plum-coloured background		£55.00	_
	C	50	C Green background	11 204	133.00	_
A1	C	50	Beautiful Women (c1905):	H.284	C10.00	
			A Inscribed 'W.I. Series'		£10.00	_
			B Inscribed 'I.F. Series'		£10.00	_
	C	50	Beautiful Women, Nd W.501-550 (55 × 75mm)		21 = 22	
			(c1905)		£17.00	
D1	C	25	*Boxer Rebellion — Sketches (1904)	H.46	£25.00	_
_	C	30	*British Beauties - Oval Card (36 × 60mm) Plain			
			back (c1910)	H.244	£2.50	£75.00
D	U	50	'British Beauties' photogravure (c1916)	H.327	£6.00	£300.00
1	PC	76	British Beauties $(37 \times 55 \text{mm})$ (c1916)		£2.60	£200.00
Α	C	54	British Beauties Nd 1-54 (1914):	H.328		
			(a) Blue back, grey-black, glossy front		£2.25	£120.00
			(b) Plain back, grey-black, glossy front		£3.50	
			(c) Plain back, sepia, matt front		£3.50	
Α.	C	54	British Beauties Nd 55-108 (1914):	H.328	25.50	
A	C	34		11.320	£2.25	£120.00
			A Blue back, grey-black, semi-glossy front		£2.25	£120.00
			B Blue back, grey-black matt front			£120.00
			C Plain back, grey-black matt front		£3.50	0125.00
D1	C	30	British Butterflies, No. 1 issue (1911)		£4.50	£135.00
D1	U	25	British Warships, green photo style (1915)		£6.00	£150.00
L	U	25	British Warships, green photo style (1915)		£35.00	
A1	P	80	British Warships, 'real photographic' (c1916)	H.329	£12.00	_
D1	C	50	*Busts of Famous People (1906):			
			A Pale green back, caption in black		£20.00	
			B Brown back, caption in black		£30.00	
			C Green back, caption in white		£6.00	£300.00
D1	C	25	*Chinese Series (c1910):	H.330		
			A Back in English		£6.00	£150.00
			B 'Volunteer' Cigarettes back		£7.00	£175.00
۸	C	50	*Colonial Troops (1904)	H 40	£22.00	
A D1	C	30	Eggs, Nests and Birds, No. 1 issue (1912):	11.40	222.00	
DI	C	30		LI 221	£6.00	£180.00
			A Unnumbered	п.ээт	£6.00	£180.00
_	_		B Numbered			
D	C	25	First Aid Series, green back (1914)	TT 222	£6.00	£150.00
A	C	13	*General Interest (c1895)	H.332	£40.00	£520.00
_	\mathbf{BW}	100	*Guinea Gold Series, unnumbered (64 × 38mm)			
			Inscribed 'Phillips' Guinea Gold', matt (1899)	H.333	£5.00	
_	\mathbf{BW}	90	*Guinea Gold Series, numbered 101-190 (68×41 mm).			
			Inscribed 'Smoke Phillips' (1900):			
			A Glossy		£4.00	
			B Matt		£4.00	_
			*Guinea Gold Series, unnumbered (63 × 41mm) (c1900)	H.333		
			Actresses:			
	BW	135	A Black front		£4.00	
	U	100	B Brown front		£8.50	_
	U	100	D DIOWII HOIR		20.50	

00	DIA		Hiller S Erb, London (commuea)			
Size	Print- ing	Num in se		Handbook reference	Price per card	Complete set
	BW	26	Celebrities, Boer War		£4.50	
D1	C	25	How to do it Series (1913)		£7.00	C175 00
D	C	25	Indian Series (1908)			£175.00
K1	C	52	*Miniatura Playing Cards (a1005)	11 224	£14.00	£350.00
D1	C	30	*Miniature Playing Cards (c1905)		£90.00	
DI	C	30	Morse and Semaphore Signalling (1916):	H.335		
			'Morse Signalling' back		£8.00	£240.00
			'Semaphore Signalling' back		£8.00	£240.00
_	P	27	Real Photo Series - Admirals and Generals of the			
			Great War. Cut-outs for buttonhole — 20 × 40mm			
			(c1915)		£7.50	_
A	C	20	Russo-Japanese War Series (1904)	H.100	£130.00	
		30	Semaphore Signalling — See 'Morse and Semaphore Signalling'			
D1	C	25			017.00	
			Sporting Series (c1910)		£17.00	
D1	C	25	*Statues and Monuments (cut-outs) (1907):			
			A Provisional Patent No. 20736		£8.00	£200.00
			B Patent No. 20736		£8.00	£200.00
D	C	25	*Territorial Series (Nd 51-75) (1908)		£20.00	_
A1	C	25	*Types of British and Colonial Troops (1899)	H.76	£40.00	<u> </u>
D1	C	25	*Types of British Soldiers (Nd M.651-75) (1900)	H.144	£16.00	£400.00
A	C	63	*War Photos (1916)	H.336	£8.00	_
В	POST-1	020 1	SSUES			
A2	C	1	*Advertisement Card — 'Grand Cut' (1934)			015.00
A2	C	1	*Advertisement Card — 'La Galbana Fours' (1934)		_	£15.00
A	C	50	Aircreft (1029)	II 500	-	£15.00
	C		Aircraft (1938)	Ha.598	£1.20	£60.00
A2	C	54	Aircraft — Series No. 1 (1938):			
			A Millhoff and Philips names at base		£4.00	
			B Phillips and Associated Companies at base:			
			1 Front varnished		£2.50	£135.00
			2 Front matt		50p	£27.00
A2	U	50	*Animal Studies (Australia) (c1930)	Ha.538	£2.00	
_	C	30	Animal Studies (61 × 53mm) (1936)		25p	£7.50
A2	C	50	Annuals (1939):		259	27.50
		-	A Home issue		22-	C11 00
			B New Zealand issue (dates for planting 4-6		22p	£11.00
			months later		01.00	050.00
D	C	25	months later)		£1.00	£50.00
В	C	25	Arms of the English Sees (1924)		£4.40	£110.00
D	BW	50	Australian Sporting Celebrities (Australia) (1932)		£2.50	
A	C	44	Beauties of Today, small — 'A Series of 44' (1937)		£1.35	£60.00
A	C	50	Beauties of Today, small — 'A Series of 50' (1938)	Ha.514	80p	£40.00
A2	P	54	Beauties of Today, small — 'A Series of Real Photo-			
			graphs' (1939)		£1.30	£70.00
A	C	36	Beauties of Today, small — 'A Series of 36 Second		41.00	2,0.00
			Series' (1940)		90p	£33.00
	P		Beauties of Today, large (83 × 66mm) (c1938)		90p	133.00
	1	36	Einst amon assessed language (63 × 60 mm) (C1938)		00.50	
			First arrangement, known as 'Series A'		£3.50	_
10	D	36	Second arrangement, known as 'Series B'		£4.50	-/25 -
J2	P	36	Beauties of Today, extra-large, unnumbered (1937)		£1.50	£55.00
J2	P	36	Beauties of Today, extra-large — 'Second Series'			
			(1938)		£1.25	£45.00
J2	P	36	Beauties of Today, extra-large — 'Third Series' (1938)		90p	£32.00
J2	P	36	Beauties of Today, extra-large — 'Fourth Series'		УОР	252.00
			(1938)		90p	£32.00
J2	P	36	Beauties of Today, extra-large — 'Fifth Series' (1938)			
		50	Demarks of Today, extra-large — Tilli Selles (1938)		90p	£32.00

	Size	Print- ing	Num in se		Handbook reference	Price per card	Complete set
	J2 J2	P P	36 36	Beauties of Today, extra-large — 'Sixth Series' (1939) Beauties of Today, extra-large — Unmarked (1939):		90p	£32.00
	, 2	1	30	A Back 'Godfrey Phillips Ltd'		90p	£32.00
				B Back 'Issued with B.D.V. Medium Cigarettes'		30p	£11.00
1	A2	BW	36	Beauties of the World — Stage, Cinema, Dancing Cele-			
				brities (1931)		£1.40	£50.00
1	A2	C	36	Beauties of the World — Series No. 2 — Stars of		01.50	054.00
		0	20	Stage and Screen (1933)		£1.50	£54.00
	_	C	30	Beauty Spots of the Homeland $(126 \times 89 \text{mm})$ (1938)		50p	£15.00
	A	C	50	Bird Painting (1938)		40p	£20.00
	A	C	50 25	British Birds and Their Eggs (1936)	Ha.517-1	90p	£45.00
1	A	C	23	A Back in pale blue (1923)	Ha.317-1	£1.00	£25.00
				B Back in dark blue (1927)		80p	£20.00
				C 'Permacal' transfers (1936)		80p	£20.00
1	A2	C	25	British Orders of Chivalry and Valour (1939):	Ha.599	•	
				A Back 'Godfrey Phillips Ltd'		£1.60	£40.00
				B Back 'De Reszke Cigarettes' (no maker's name)		£1.60	£40.00
-	_	C	36	Characters Come to Life $(61 \times 53 \text{mm}) (1938) \dots$		90p	£33.00
ŀ	-	P	25	*Cinema Stars — Circular (57mm diam.) (1924)		£3.00	_
	A	P	52	Cinema Stars — Set 1 (c1925)		£2.50	_
	A2	U	30	Cinema Stars — Set 2 (c1928)		£2.20	C45 00
	A2	U C	30	Cinema Stars — Set 3 (c1928)		£1.50 £1.50	£45.00 £48.00
	A2 A2	BW	32 32	Cinema Stars — Set 4 (c1930)		£1.50	£48.00
1	4.2	DW	32	Come to Life Series — see 'Zoo Studies'	11a.515-5	21.50	240.00
		C		Coronation of Their Majesties (1937):			
	A2	-	50	A Small size		25p	£12.50
_	-12		36	B Medium size (61 × 53mm)		25p	£9.00
_			24	C Postcard size (127 × 89mm)		£1.25	£30.00
		P		Cricketers (1924):			
1	K2		198	*A Miniature size, 'Pinnace' photos (Nd 16c-225c)		£8.00	_
1	D		192	B Small size, brown back (selected Nos)		£8.00	_
0.00	B1		? 58	*C Large size, 'Pinnace' photos		£35.00	
	B1		25	D Large size, brown back (selected Nos)		£20.00	_
	_		165	*E Cabinet size		£35.00	COE 00
	D	C	25	Derby Winners and Jockeys (1923)	H- 600	£3.40 £1.00	£85.00 £25.00
	D1	C	25	Empire Industries (1927)	на.000	£1.00	£90.00
1	A2	C	50	Evolution of the British Navy (1930)		£1.00	£50.00
1	D	C	25	Famous Boys (1924)		£2.40	£60.00
	D	C	32	Famous Cricketers (1926)		£4.50	200.00
	A	C	25	Famous Crowns (1938)		32p	£8.00
	A2	Č	50	Famous Footballers (1936)		£1.50	£75.00
-	_	C	36	Famous Love Scenes $(60 \times 53 \text{mm}) (1939) \dots$		60p	£22.00
1	A 2	C	50	Famous Minors (1936)		30p	£15.00
-	_	C	26	Famous Paintings (128×89 mm) (1938)		£1.25	£32.00
	D	C	25	Feathered Friends (1928)		£1.20	£30.00
	A2	C	50	Film Favourites (1934)	Ha.517-2	50p	£25.00
	D	BW	50	Film Stars (Australia) (1934)		£1.80	620.00
1	A2	C	50	Film Stars (1934)		60p	£30.00
-		C	24	*Film Stars — ' No of a series of 24 cards' (128 × 89mm) (1934):			
				A Postcard format back		£2.80	£70.00
				B Back without postcard format		£4.00	~ 70.00
						200	

00			india bib, bollati (communa)			
Size	Print-			Handbook	Price	Complete
	ing	in sei	t	reference	per card	set
	C	24	*Film Stars — ' No of a series of cards', Nd			
	C	24	25-48 (128 × 89mm) (1935):			
					c2 00	
					£3.00	-
	0	24	B Back without postcard format		£6.00	
_	C	24	*Film Stars ' No of a series of cards', vivid back-			
			grounds $(128 \times 89 \text{mm}) (1936)$:			
			A Postcard format back	Ha.517-3	£1.60	£40.00
			B Back without postcard format	The street of the	£3.00	_
D	C	50	First Aid (1923)		£1.40	£70.00
D	C	25	*Fish (1924)		£2.40	£60.00
	C	30	Flower Studies (1937):			
_			A Medium size (61 × 53mm)		22p	£6.50
-			*B Postcard size (128 × 89mm)		70p	£21.00
	P		Footballers — 'Pinnace' photos (1922-24):		F	
K2			A Miniature size:			
	es show	vn ann	bly to numbers 1 to 940, for numbers above 940 prices are	doubled)		
(2.116	CB BIIO	112	1a 'Oval' design back, in brown	doubled.)	£2.50	
		400	1b 'Oval' design back, in black			
		517	1b 'Oval' design back, in black		£1.25	
		109	3 Single-lined oblong back, address 'Photo'		£1.25	
	1	109	6 6 6		£1.00	-
			· bingie inied colong buck, uddiess			
	•	100	'Pinnace' photos:			
		462	a Name at head, team at base		£1.00	_
		651	b Name at base, no team shown		£1.00	-
	?	217	c Team at head, name at base		£1.00	_
			B Large size $(83 \times 59 \text{mm})$:			
		400	1 'Oval' design back		£3.00	
	? 2	000	2 Double-lined oblong back:			
			a Address 'Photo'		£3.00	<u></u> 1
			b Address 'Pinnace' photos		£3.00	
	? 2	462	3 Single-lined oblong back:			
			a Name at head, team at base		£3.00	
			b Name at base, no team shown		£3.00	
			c Team and name at base		£3.00	
	22	462	C Cabinet size			
	C	30	Garden Studies (128 × 89mm) (1938)		£8.00	612.00
A2	C	25	Hama Pata (1024)	TT 540	40p	£12.00
A2	U	25	Home Pets (1924)	Ha.540	£2.00	£50.00
			How to Build a Two Valve Set (1929)		£2.40	£60.00
D	C	25	How to Make a Valve Amplifier, Nd 26-50 (1924)		£2.60	£70.00
A	C	25	How to Make Your Own Wireless Set (1923)		£2.00	£50.00
A2	C	54	In the Public Eye (1935)		38p	£20.00
A2	C	50	International Caps (1936)		£1.50	£75.00
A2	C	37	Kings and Queens of England (1925):			
			Nos 1 and 4		£30.00	
			Other numbers		£2.00	£70.00
A2	U	25	Lawn Tennis (1930)		£2.60	£65.00
K2	C	53	*Miniature Playing Cards (1932-34):		22.00	205.00
			A Back with exchange scheme:			
			1 Buff. Offer for 'pack of playing cards'		500	
			2 Buff. Offer for 'playing cards, dominoes		50p	
			or chase'		50	025.00
			or chess'		50p	£25.00
			3 Buff. Offer for 'playing cards, dominoes			
			or draughts'		50p	£25.00
			4 Lemon		60p	-
			5 White, with red over-printing		60p	_
			B Blue scroll back, see Fig. 30, Plate 5, RB13		50p	£25.00

~				** 11 1	ъ.	C 1.
Size	Print-			Handbook		Complete
	ing	in set		reference	per card	set
A2	C	25	Model Railways (1927)		£2.60	£65.00
D	C	50	Motor Cars at a Glance (1924)		£3.60	£180.00
D	C	20	Novelty Series (1924)		£9.00	_
A2	C	48	The 'Old Country' (1935)		60p	£30.00
A	C	25	Old Favourites (1924)	Ha.517-4	£1.40	£35.00
	C	36	Old Masters (60 × 53mm) (1939)		30p	£11.00
A	U	36	Olympic Champions Amsterdam, 1928		£2.00	£75.00
A	C	25	Optical Illusions (1927)		£2.00	£50.00
	C		'Our Dogs' (1939):			
A2		36	A Small size (export)		£1.25	£45.00
		30	B Medium size (60 × 53mm)		50p	£15.00
		30	*C Postcard size (128 × 89mm)		£3.20	_
_	BW	48	'Our Favourites' (60 × 53mm) (1935)		25p	£12.50
	C	30	Our Glorious Empire (128 × 89mm) (1939)		70p	£21.00
	C	30	'Our Puppies' (1936):		•	
			A Medium size (60 × 53mm)		80p	£24.00
_			*B Postcard size (128 × 89mm)		£1.50	£45.00
A2	C	25	Personalities of Today (Caricatures) (1932)		£1.60	£40.00
A2	C	25	Popular Superstitions (1930)		£1.40	£35.00
A	C	25	Prizes for Needlework (1925)		£2.20	£55.00
D	C	25	Railway Engines (1924)		£2.60	£65.00
D	C	25	Red Indians (1927)	Ha.601	£2.60	£65.00
A	C	25	School Badges (1927)		£1.00	£25.00
A	C		Screen Stars (1936):			
		48	First arrangement, known as 'Series A':			
			i Frame embossed		£1.00	£50.00
			ii Frame not embossed		£1.40	£70.00
		48	Second arrangement, known as 'Series B'		90p	£45.00
A2	C		A Selection of B.D.V. Wonderful Gifts:			
		48	' based on 1930 Budget' (1930)		£1.00	£50.00
		48	' based on 1931 Budget' (1931)		£1.00	£50.00
		48	' based on 1932 Budget' (1932)		£1.00	£50.00
D	C	25	Ships and Their Flags (1924)	Ha.602	£2.60	£65.00
_	Č	36	Ships that have Made History $(60 \times 53 \text{mm}) (1938) \dots$		40p	£15.00
	C	48	Shots from the Films $(60 \times 53 \text{mm}) (1934) \dots$		75p	£35.00
A2	C	50	Soccer Stars (1936)		£1.40	£70.00
A2	C	36	Soldiers of the King (1939):	Ha.603		
112	C	50	A Inscribed 'This surface is adhesive'	114.000	£1.40	
			B Without the above:			
			1 Thin card		70p	£25.00
			2 Thick card		70p	£25.00
	C		Special Jubilee Year Series (1935):		· • P	
		20	A Medium size (60 × 53mm)		30p	£6.00
1		12	B Postcard size (128 × 89mm)		£2.00	£24.00
A2	U	30	Speed Champions (1930)		£1.65	£50.00
A2	Ü	36	Sporting Champions (1929)		£1.65	£60.00
D	C	25	Sports (1923):		21.05	200.00
D	C	23	A White card		£3.40	
			B Grey card		£3.40	
A2	C	50	*Sportsmen — 'Spot the Winner' (1937):		23.40	
AZ	C	30	A Inverted back		80p	£40.00
			B Normal back		£1.00	£50.00
A2	C		Stage and Cinema Beauties (1933):	Ha.572	21.00	250.00
AL		35	First arrangement — known as 'Series A'	114.572	£1.15	£40.00
		35	Second arrangement — known as 'Series B'		£1.15	£40.00
A2	C	50	Stage and Cinema Beauties (1935)	Ha 517-5	£1.13	£60.00
AL		50	Suge and Chieffa Deaddes (1933)	114.517-5	21.20	200.00

00	DIKI		illeri 5 ETD, London (commuea)			
Size	Print-	Num	ber	Handbook	Price	Complete
	ing	in se	t	reference	per card	set
D	C	50	Stars of British Films (Australia) (1934):			
D	C	30			C1 60	
			A Back 'B.D.V. Cigarettes'		£1.60	100
			B Back 'Grey's Cigarettes' C Back 'De Reszke Cigarettes'		£1.60	
					£1.60	
			D Back 'Godfrey Phillips (Aust)'		£1.60	
A2	CP	54	Stars of the Screen — 'A Series of 54' (1934)		£1.10	£60.00
A2	C	48	Stars of the Screen — 'A Series of 48' (1936):			
			A Frame not embossed		90p	£45.00
			B Frame embossed		90p	£45.00
			C In strips of three, per strip		£2.50	£40.00
D	BW	38	Test Cricketers, 1932-1933 (Australia):		42.00	4.0.00
			A 'Issued with Grey's Cigarettes'		£2.60	
			B 'Issued with B.D.V. Cigarettes'		£2.60	
			C Back 'Godfrey Phillips (Aust.)'		£2.60	
٨	U	25				C 40 00
A		25	The 1924 Cabinet (1924)		£1.60	£40.00
A	C	50	This Mechanized Age — First Series (1936):			
			A Inscribed 'This surface is adhesive'		25p	£12.50
			B Without the above		30p	£15.00
A	C	50	This Mechanized Age — Second Series (1937)		30p	£15.00
D2	C		Victorian Footballers (Australia) (1933):			
		50	1 'Series of 50':			
			A 'Godfrey Phillips (Aust.)'		£2.30	
			B 'B.D.V. Cigarettes'		£2.30	_
			C 'Grey's Cigarettes'		£2.30	
		75	2 'Series of 75':		22.50	
			D 'B.D.V. Cigarettes'		£2.30	
D	BW	50	Victorian League and Association Footballers		22.50	
-	D ***	50	(Australia) (1934)		c2 20	
A2	C	100			£2.30	
AZ	C	30	*Who's Who in Australian Sport (Australia) (1933)		£2.50	
	C	30	Zoo Studies — Come to Life Series (101×76 mm)			
			(1939)		£1.20	£36.00
-			Spectacles for use with the above		_	£8.00
C	SILKS.	Know	vn as 'the B.D.V. Silks'. All unbacked. Inscribed 'B.D.	V. Cigarettes	or 'G.P.	' (Godfrey
Phill	ips), or		mous. Issued about 1910-25.			
_	C	62	*Arms of Countries and Territories (73 × 50mm) —			
			Anonymous	Ha.504-12	£3.50	
_	C	32	*Beauties — Modern Paintings (B.D.V.):	Ha.505-13		
			A Small size (70 × 46mm)		£10.00	
			B Extra-large size (143 × 100mm)		£40.00	
	C	100	*Birds II (68 × 42mm) — B.D.V	Ha 505 2	£2.30	
	C	12	*Birds of the Tropics III — B.D.V.:	Ha.505-2	12.30	
	-	12		па.505-5	011.00	
			(((£11.00	
			B Medium size (71 × 63mm)		£13.00	_
			C Extra-large size (150 × 100mm)		£17.00	
_	U	24	*British Admirals (83 \times 76mm) — Anonymous		£5.00	-
	C		*British Butterflies and Moths II — Anonymous:	Ha.505-6		
		40	*British Butterflies and Moths II — Anonymous: Nos 1-40. Large size, 76 × 61mm		£4.00	
		10	Nos 41-50. Medium size. 70 × 51mm		£4.00	_
_	C	108	*British Naval Crests II:	Ha.504-4		
			A B.D.V., size 70 × 47mm		£1.80	
			B Anonymous, size 70×51 mm		£1.80	
_	C	25	*Butterflies I (70 × 48mm) — Anonymous	Ha 505-5	£9.00	
	Č	47	Ceramic Art — B.D.V.:	Ha.505-16	27.00	
			A Small size $(70 \times 43 \text{mm})$	114.505-10	£1.00	£47.00
			B Small size (70 × 48mm)		£1.00	147.00
			C Medium size (70 × 45mm)			
			C Medium size $(70 \times 61 \text{mm})$		£1.75	

Size	Prin ing	t- Numi		Handbook reference	Price per card	Complete set
_	C		*Clan Tartans:			
			A Small size $(71 \times 48 \text{mm})$:	Ha505-15		
		49	1 Anonymous		£1.00	£50.00
R		65	2 B.D.V		£1.00	£65.00
		56	B Medium size $(70 \times 60 \text{mm})$ — B.D.V		£2.75	_
		12	C Extra-large size $(150 \times 100 \text{mm})$ B.D.V. (selec-		CE 00	
	0	100	ted Nos.)	Ha 502 2	£5.00	- T
7.0	C C	108 17	*Colonial Army Badges (71 × 50mm) — Anonymous County Cricket Badges (69 × 48mm):	Ha.502-3 Ha.505-8	£1.50	_
	C	17	A Anonymous		£17.00	
			B B.D.V		£17.00	
	C	108	*Crests and Badges of the British Army II:	Ha.502-2	217.00	
	_	100	A1 Small size (70 × 48mm) Anonymous:	114.502 2		
			(a) <i>Numbered</i>		£1.00	£110.00
			(b) Unnumbered		£1.10	£120.00
			A2 Small size (70 × 48mm) — B.D.V		£1.00	£110.00
			A3 Medium size $(70 \times 60 \text{mm})$:			
			(a) Anonymous		£1.30	
			(b) B.D.V		£1.50	_
-	C		*Flags — Set 4 — Anonymous:	Ha.501-4	01.70	
		? 143	A 'Long' size $(82 \times 53mm)$		£1.70	
		0.142	B 'Short' size $(70 \times 48mm)$:		C1 40	
		? 143	 First numbering arrangement (as A) Second numbering arrangement 		£1.40 90p	_
		? 108	2 Second numbering arrangement		90p	_
	C	: 113	*Flags — Set 5 — Anonymous:	Ha.501-5	90p	
	C		A Small size $(70 \times 50 \text{mm})$:	11a.301-3		
		20	1 With caption		£1.00	_
		6	2 Without caption, flag 40 × 29mm		£1.20	_
		? 6	3 Without caption, flag 60 × 41mm		£1.20	
		? 8	B Extra-large size $(155 \times 108 \text{mm})$		£14.00	_
_	C	18	*Flags — Set 6 — Anonymous:	Ha.501-6		
			A Size 69 × 47mm		£1.00	£18.00
			B Size 71 × 51mm		£1.00	£18.00
_	C	20	*Flags — Set 7 (70 \times 50mm) — Anonymous	Ha.501-7	£1.00	_
	C	50	*Flags — Set 9 — ('5th Series') (70 × 48mm) —			
			Anonymous		£1.60	£80.00
_	C	1.1.	*Flags — Set 10:	Ha.501-10	-	
		120	'7th Series' (70 × 48mm) — Anonymous		80p	
		120	'10th Series' $(70 \times 62mm)$ — Anonymous		£1.00	_
		120	'12th Series' (70 × 48mm) — Anonymous		90p £1.10	_
		65 65	'15th Series' (70 × 62mm) (selected Nos.) — B.D.V '16th Series' (70 × 62mm) (selected Nos.) — B.D.V.		£1.10	_
		132	'20th Series' $(70 \times 62 \text{hill})$ (selected Nos.) — B.D.V. '20th Series' $(70 \times 48 \text{ mm})$ — B.D.V. in brown or red		90p	- T
26		126	'25th Series' $(70 \times 48 \text{ mm}) - \text{B.D.V.}$ in brown or		90p	
		120	black		80p	_
		62	'25th Series' '(70 × 62mm) (selected Nos.) — B.D.V.		£2.75	_
		112	'26th Series' (70 × 48mm) — B.D.V. in brown or			
			blue		80p	_
		70	'28th Series' (70 × 48mm) (selected Nos.) — B.D.V.		£1.00	
_	C		*Flags — Set 12:	Ha.501-12		
		1	A 'Let 'em all come' $(70 \times 46mm)$ — Anonymous .		_	£11.00
			B Allied Flags (grouped):			
		1	Four Flags — Anonymous:			20.00
(C) (C)			1 Small size (70 × 46mm)		_	£9.00
			2 Extra-large size $(163 \times 120mm)$			_
1000						

C:	D		L	77 11 1	n ·	c 1.
Size	ing	t- Num in se		Handbook reference		Complete
	ing			rejerence	per card	sei
		1	Seven Flags (165×116 mm):			
			1 Anonymous		_	£9.00
			2 B.D.V. in brown or orange		_	£9.00
	0	1	Eight Flags (165 × 116mm) — B.D.V	II. 501 12	_	£32.00
130	C	? 23	*Flags — Set 13: A Size 163 × 114mm — Anonymous	Ha.501-13	C1 75	
		? 27	A Size 163 × 114mm — Anonymous		£1.75	
		: 21	blue, green or black		£1.75	
		? 23	C Size 150 × 100mm — B.D.V.		£1.75	
_	C	26	*Flags — Set 14 ('House Flags') (68 × 47mm) —		21.75	
		20	Anonymous	Ha 501-14	£7.00	
_	C	25	*Flags — Set 15 (Pilot and Signal Flags) (70 × 50mm):		27.00	
			A Numbered 601-625 — Anonymous	114.501-15	£2.60	£65.00
			B Inscribed 'Series II' — B.D.V.		£1.80	£45.00
	C		*Football Colours:	Ha.505-9	21.00	245.00
	-	? 21	A Anonymous. size 68 × 49mm	11a.303-9	£5.50	
		? 86	B B.D.V., size 68 × 49mm		£5.00	3.0
		? 78	C B.D.V., size 150 × 100mm		£4.50	
	C	126	G.P. Territorial Badges (70 × 48mm)	Ha 502-12	£1.50	
	U	25	*Great War Leaders II (81 × 68mm) — Anonymous		£4.50	
	U	? 53	*Great War Leaders III and Warships, sepia, black or	114.504-7	14.30	
	U	: 33	blue on white or pink material (70 × 50mm) —			
			Anonymous	Ha 504 10	£6.00	
	C		*Great War Leaders IV and Celebrities:	Ha.504-10	20.00	
1	-	3	A Small size (70 × 48mm) — Anonymous	па.304-11	£5.50	
		4	B Small size (70 × 48mm) — Anonymous		£5.50	
		3	C Medium size $(70 \times 63mm)$ — Anonymous		£5.50	
		2	D Medium size (70 × 63mm) — Anonymous		£5.50	
		? 18	E Extra-large size $(150 \times 100 \text{mm})$ — B.D.V		£5.00	
		?4	F Extra-large size $(150 \times 100 \text{mm})$ — Anonymous		£5.00	£20.00
		?1	G Extra-large size (150 × 110mm) — B.D.V		25.00	£12.00
		? 26	H Extra-large size (163 × 117mm) — Anonymous		£4.50	112.00
		? 46	I Extra-large size (163 × 117mm) — B.D.V		£4.50	
	C	. 40	Heraldic Series — B.D.V.:	Ha.504-17	14.30	
	-	25	A Small size $(68 \times 47 \text{mm})$	Ha.304-17	£1.20	£30.00
		25	B Small size (68 × 43mm)		£1.20	£30.00
		25	C Medium size (68 × 60mm)		£3.00	230.00
		12	D Extra-large size (150 × 100mm) (selected Nos)		£5.00	£60.00
	C	10	*Irish Patriots — Anonymous:	Ha.505-11	25.00	200.00
	-	10	A Small size $(67 \times 50 \text{mm})$	11a.303-11	£12.00	
			B Large size $(83 \times 76mm)$		£12.00	
			C Extra-large size $(152 \times 110 \text{mm})$		£17.00	
	C	1	*Irish Republican Stamp (70 × 50mm)	Ho 505 12	217.00	£1.75
	C	54	*Naval Badges of Rank and Military Headdress	11a.303-12		£1.73
	C	54		Ha 504 0	£5.50	
	C	40	(70 × 47mm) — Anonymous		£28.00	
	C	20	*Old Masters — Set 1 (155 × 115mm) — B.D.V		128.00	
-	C	20	*Old Masters — Set 2 (150 × 105mm):	Ha.503-2	64.00	
			A Anonymous		£4.00	_
			B B.D.V. wording above picture		£4.00	-
	C		C B.D.V. wording below picture		£5.00	
	C	40	*Old Masters — Set 3A $(70 \times 50 \text{mm})$:	Ha.503-3A	CO 75	
		40	A B.D.V.		£2.75	_
		55	B Anonymous		£2.50	_
	C	30	*Old Masters — Set 3B (70 × 50mm) — Anonymous		£2.50	
	C	120	*Old Masters — Set 4 (70 \times 50mm) — Anonymous	Ha.503-4	£1.80	_

Size	Print- ing	in set		Handbook reference	Price per card	Complete set
	C		*Old Masters — Set 5 (70×50 mm):	Ha.503-5		
		20	A Unnumbered — Anonymous		£2.60	_
		60	B Nd. 1-60 — B.D.V		£1.20	£72.00
		20	C Nd. 101-120 — Anonymous:			
			1 Numerals normal size		£1.60	
			2 Numerals very small size		£1.60	£32.00
No. 2		20	D Nd. 101-120 — B.D.V		£1.60	£32.00
_	C	50	*Old Masters — Set 6 (67 × 42mm) — B.D.V	Ha.503-6	£1.20	£60.00
_	C	50	*Old Masters — Set 7, Nd. 301-350 (67 × 47mm) —			
			Anonymous	Ha.503-7	£2.00	· · ·
_	C	50	*Orders of Chivalry I (70 × 48mm) — Anonymous	Ha.504-14	£2.20	
_	C	24	*Orders of Chivalry — Series 10 (70 × 50mm):	Ha.504-16		
			A Nd. 1-24 — B.D.V		£1.60	£40.00
118			B Nd. 401-424 — G.P		£1.80	£45.00
_	C	72	*Regimental Colours II (76 × 70mm) — Anonymous	Ha.502-7	£4.00	
_	C		*Regimental Colours and Crests III:	Ha.502-8		
			A Small size $(70 \times 51 \text{mm})$:			
		40	1 Colours with faint backgrounds — Anony-			
			mous		£1.00	
Mr.		120	2 Colours without backgrounds — Anony-			
			mous		£1.20	
100		120	3 Colours without backgrounds — B.D.V		£1.20	-
		120	B Extra-large size $(165 \times 120 \text{mm})$:			
			1 Anonymous — Unnumbered		£5.00	
100			2 B.D.V. — Numbered		£4.50	_
-	C	50	*Regimental Colours — Series 12 (70 × 50mm) —			
			B.D.V	Ha.502-11	£1.80	£90.00
-	C	10	*Religious Pictures — Anonymous:	Ha.505-10		
			A Small size $(67 \times 50 \text{mm}) \dots \dots$		£18.00	
			B Large size $(83 \times 76 \text{ mm})$		£18.00	
			C Extra-large size $(155 \times 110 \text{mm}) \dots$		£27.00	
_	C	75	*Town and City Arms — Series 30 (48 unnumbered, 27 numbered 49-75) — B.D.V.:			
			27 numbered 49-75) — B.D.V.:	Ha.504-13		
			A Small size (70 × 50mm)		£1.80	· ·
BAL!			B Medium size $(70 \times 65 \text{mm})$		£2.20	_
_	C	25	*Victoria Cross Heroes I (70 × 50mm) — Anonymous	Ha.504-1	£9.00	_
_	C	? 25	*Victoria Cross Heroes II (70 × 50mm) — Anonymous	Ha.504-2	£11.00	_
_	C	90	*War Pictures (70 × 48mm) — Anonymous	Ha.504-8	£5.50	_
D	MISCI	ELLAN	VEOUS			
A	BW		B.D.V. Package Issues (1932-34):			
		17	Boxers		£6.00	
		54	Cricketers		£7.00	_
		67	Film Stars		£2.50	_
		132	Footballers		£3.50	_
49.		19	Jockeys		£3.50	_
		21	Speedway Riders		£8.00	_
		27	Sportsmen		£3.00	_
A	BW		Sports Package Issues:			
1000		25	Cricketers (1948)		£7.00	
		25	Cricketers (1951)		£7.00	
de la		25	Footballers (1948)		£5.00	
		50	Footballers (1950)		£5.00	
		25	Footballers (1951)		£5.00	_
		25	Football & Rugby Players (1952)		£5.00	
		25	Jockeys (1952)		£4.00	
		25	Radio Stars (1949)		£2.60	

Size Print- Number

in set

ing

		50	Sportsmen (1948)		£3.50	_
		25	Sportsmen (1949)		£3.50	_
		25	Sportsmen (1953)		£3.50	_
		25	Sportsmen (1954)		£3.50	
D	BW	1	Cricket Fixture Card (Radio Luxembourg) (1936)			£7.00
J2		20	'Private Seal' Wrestling Holds (export) (c1920)		£30.00	
			Rugs (miscellaneous designs) (c1920)		£9.00	
A	U	?	Stamp Cards (four colours, several wordings) (c1930)		£1.50	<u> </u>
			· · · · · · · · · · · · · · · · · · ·		21.50	
JO	HN	PLA	YER & SONS, Nottingham—			
44]	page re	eference	e book available — £3.50			
A	PRE-	1919 IS	SSUES			
A	C	25	*Actors and Actresses (1898)	H.337	£22.00	£550.00
A1	BW	50	*Actresses (c1897)		£22.00	_
A	C	7	*Advertisement Cards (1893-94)		From £260.00	
J	C	10	Allied Cavalry or Regimental Uniforms:	H.340	110111 2200.00	
		100	Allied Cavalry (1914)		£8.00	£80.00
			Regimental Uniforms (1914)		£7.00	£70.00
Α	C	50	Arms and Armour (1909)		£2.50	£125.00
A	C	25	Army Life (1910)	H 70	£1.80	£45.00
J	C	12	Artillery in Action (1917)	П./о		
A	C	50	Badges and Flags of British Regiments (1904):		£4.00	£50.00
A	C	50		H.341	02.50	0105.00
			11 Die in Caesi, amanicolog		£2.50	£125.00
	0	50			£2.50	£125.00
A	C	50	Badges and Flags of British Regiments (1903):			
			A Green back, thick card		£2.50	£125.00
			B Green back, thin card		£2.50	£125.00
_	P	10	*Bookmarks — Authors (148 × 51mm) (1905)	H.342	£60.00	_
A	C	50	British Empire Series (1904):	H.343		
			A Grey-white card, matt		£1.20	£60.00
			B White card, semi-glossy		£1.40	£70.00
	C	25	British Livestock:	H.344		
A			A Small card (1915)		£2.20	£55.00
J			B Extra-large card, brown back (May 1916)		£3.00	£75.00
A	C	50	Butterflies and Moths (1904)	H 80	£1.80	£90.00
	C		Bygone Beauties:	11.00	21.00	270.00
A		25	A Small card (1914)		£1.60	£40.00
J		10	B Extra-large card (1916)		£4.50	
-	U	? 28	*Cabinet Size Pictures, 1898-1900 (220 × 140mm):	Ha.476	14.50	£45.00
	U	. 20	A Plain back	па.470	00,000	
					£80.00	
	0	20		TT 0.15	£80.00	
A	C	20	Castles, Abbeys etc (c1894):	H.345		
			A Without border		£28.00	£560.00
	-		B White border		£28.00	£560.00
A	C	50	Celebrated Bridges (1903)		£2.60	£130.00
A	C		Celebrated Gateways (1909):	H.347		
		50	A Thick card		£1.40	£70.00
		25	B Thinner card (26-50 only)		£1.60	
A	C	25	Ceremonial and Court Dress (1911)	H.145	£1.80	£45.00
	C		Characters from Dickens:		22.00	2.2.30
A		25	Small card, lst series (1912)		£2.40	£60.00
J		10	Extra-large card (1912)		£6.00	£60.00
A	C	25	Characters from Dickens, 2nd series (1914)		£2.40	£60.00
A	C	25	Characters from Thackeray (1913)		£1.60	£40.00
**		23	Characters from Thackeray (1913)		11.00	240.00
			00			

Handbook Price Complete reference per card set

Size Print- Number

Size	Print- ing	Num in se		Handbook reference	Price per card	Complete set
A	C	50	Cities of the World (1900):			
1917111			A Grey-mauve on white back		£4.00	_
St.			B Grey-mauve on toned back		£4.00	_
			C Bright mauve on white back		£4.00	_
A	C	25	Colonial and Indian Army Badges (1916)		£1.40	£35.00
A	C	25	*Counties and Their Industries:	H.349		
			A Unnumbered (c1910)		£1.80	£45.00
1			B Numbered (1914)		£1.80	£45.00
A	C	50	*Countries — Arms and Flags:			
			A Thick card (1905)		80p	£40.00
			B Thin Card (1912)		£1.00	£50.00
A	C	50	*Country Seats and Arms (1906)		80p	£40.00
A	C		*Country Seats and Arms, 2nd series (1907):			
		25	A Nd. 51-75 First printing		£1.40	£35.00
		50	B Nd. 51-100 Second printing		80p	£40.00
A	C	50	*Country Seats and Arms, 3rd series (1907)		80p	£40.00
	C		Cries of London:	H.350		
A		25	Small cards, 1st series (1913)		£2.00	£50.00
J		10	Extra-large cards, 1st series (1912)		£4.50	£45.00
J		10	Extra-large cards, 2nd series (1914)		£4.00	£40.00
A	C	25	Cries of London, 2nd series (1916)		£1.00	£25.00
A	C	25	Egyptian Kings and Queens, and Classical Deities (1911)		£1.80	£45.00
J	C	10	Egyptian Sketches (1915)	H.351	£4.00	£40.00
A	C	25	*England's Military Heroes (1898):	H.352		
			A Wide card		£40.00	_
			A1 Wide card plain back		£40.00	_
			B Narrow card		£32.00	_
600			B2 Narrow card, plain back		£30.00	_
A	C	25	England's Naval Heroes (1897):	H.353		
			A Wide card		£40.00	
			B Narrow card		£24.00	£600.00
A	C	25	England's Naval Heroes (1898), descriptions on back:	H.353	2200	
			A Wide card		£40.00	_
			A2 Wide card, plain back		£40.00	
1/4			B Narrow card		£24.00	£600.00
lane.			B2 Narrow card, plain back		£24.00	
Α	C	25	Everyday Phrases by Tom Browne (1901):	H.354	2200	
**	_		A Thickcard	11.00	£15.00	£375.00
			B Thin card		£15.00	£375.00
	C	20	Famous Authors and Poets (1902):		213.00	2373.00
A	~	20	A Wide card		£26.00	£520.00
11			B Narrow card		£20.00	£400.00
J	C	10	Famous Paintings (1913)	H 355	£3.50	£35.00
A	Č	50	Fishes of the World (1903)		£2.20	£110.00
A	Č	50	Gallery of Beauty (1896):	H.356	22.20	2110.00
11	-	50	A Wide Card:	11.550		
			I Set of 50		£22.00	
100 G			II 5 Alternative Pictures		£50.00	
Server.			B Narrow Card:		250.00	
			I Set of 50		£20.00	
			II 5 Alternative Pictures		£50.00	
Α	C	25	Gems of British Scenery (1914)		80p	£20.00
A	C	25	Highland Clans (1908)		£3.60	£90.00
J	C	10	Historic Ships (1910):		23.00	250.00
3		10	A Thick card		£4.50	£45.00
			B Thin card		£4.50	£45.00
			D Timi card		14.30	243.00
100						

Handbook Price Complete

Size	Print-ing	Num in se		Handbook reference	Price per card	Complete set
Α	C	50	Life on Board a Man of War in 1805 and 1905			
			(1905)	H.38	£2.20	£110.00
A	C	50	Military Series (1900)		£17.00	£850.00
A	C	25	Miniatures (1916)		44p	£11.00
A	C	25	Napoleon (1915)	H.364	£1.60	£40.00
A		50	Small card (1908)		£1.30	£65.00
J		10	Extra-large card (Birds) (1908)		£12.00	_
J		10	Extra-large card (Animals) (1913)		£4.50	£45.00
A	C	50	Old England's Defenders (1898)		£17.00	£850.00
A	C	25	Players — Past and Present (1916)		90p	£22.50
A	C	25	Polar Exploration (1915)		£1.80	£45.00
A	C	25	Polar Exploration, 2nd series (1916)		£1.60	£40.00
A	C	25	Products of the World: A Thick card (1909)		70p	£17.50
			B Thin card (1908)		£1.20	£30.00
A	C	50	*Regimental Colours and Cap Badges (1907)		£1.20	£60.00
A	c	50	*Regimental Colours and Cap Badges — Territorial Regiments (1910):		£1.20	200.00
			A Blue back		£1.20	£60.00
J	С	10	B Brown back		£1.20	£60.00
A	C	50	Regimental Uniforms (1-50):			
			A Blue back (Jul. 1912)		£1.80	£90.00
			B Brown back (Jul. 1914)		£2.00	£100.00
A	C	50	Regimental Uniforms (51-100) (1914)		£1.40	£70.00
A	C	50	Riders of the World:	H.358		
			A Thick grey card (1905)		£1.60	£80.00
			B Thinner white card (1914)		£1.60	£80.00
_	P	6	The Royal Family $(101 \times 154 \text{mm}) (1902) \dots$	H.359	_	£270.00
_	P '	? 30	Rulers and Views (101 × 154mm) (1902)		£80.00	_
A	C	25	Shakespearian Series (1914)		£1.00	£25.00
A	C	25	Ships' Figureheads (1912):			
			A Numerals 'sans serif'		£1.80	£45.00
			B Numerals with serif		£1.60	£40.00
A	BW?	148	Stereoscopic Series (c1900)		£80.00	_
Α	C	25	Those Pearls of Heaven (1914)		90p	£22.50
A	BW	66	Transvaal Series (1902):	H.360		
			A Black front		£5.00	_
			B Violet-black front		£5.00	_
A	C	50	Useful Plants and Fruit (1904)	H.361	£2.20	£110.00
A	C	25	Victoria Cross (1914)		£2.00	£50.00
A	C	50	Wild Animals of the World (1902):	H.77		
			A 'John Player & Sons Ltd.'		£3.00	£150.00
			B 'John Player & Sons, Branch, Nottingham' C1 As B, 'Branch' omitted but showing traces of		£4.00	_
			some or all of the letters		£4.00	_
			C2 As B. New printing with 'Branch' omitted		£3.00	£150.00
A2	C	45	Wild Animals of the World, narrow card (1902):		20.00	
			A 'John Player & Sons Ltd.'		£5.00	£225.00
			B 'John Player & Sons, Branch, Nottingham'		£6.00	
			C1 As B, 'Branch' omitted but showing traces of		20.00	
			some or all of the letters		£5.00	
			C2 As B. New printing with 'Branch' omitted		£5.00	£225.00
Α	C	50	Wonders of the Deep (1904)		£1.60	£80.00
A	C	25	Wonders of the World, blue back (1913)		80p	£20.00
^		25	Wonders of the World, blue back (1913)	11.302	oop	220.00

Size	Print-ing	Num in se		Handbook reference	Price per card	Complete set
J	C	10	Wooden Walls (1909):			
			A Thick card		£5.50	£55.00
			B Thin card		£5.50	£55.00
A	C	25	Wrestling and Ju-Jitsu (blue back) (1911)	H.467	£1.60	£40.00
B	POST-1	920 IS	SSUES. Series with I.T.C. Clause.			
	C	1	*Advertisement Card (Sailor) (c1930):			
A			A Small size		_	£4.50
В			B Large size		_	£20.00
A	C	50	Aeroplanes (1935):		1.5	
			A Home issue — titled 'Aeroplanes (Civil)'		90p	£45.00
			B Irish issue — titled 'Aeroplanes'		£1.30	£65.00
A	C	50	Aircraft of the Royal Air Force (1938)		90p	£45.00
A	C	50	Animals of the Countryside (1939):		100	
			A Home issue — adhesive		22p	£11.00
			B Irish issue — non-adhesive, green numerals			
			overprinted		£1.00	
В	C	25	Aquarium Studies (1932)		£1.80	£45.00
В	C	25	Architectural Beauties (1927)		£2.00	£50.00
A	C	50	Army Corps and Divisional Signs, 1914-1918 (1924)		35p	£17.50
A	С	100	Army Corps and Divisional Signs, 1914-1918, '2nd Series' (1925):			
			Nos. 51-100		35p	£17.50
			Nos. 101-150		35p	£17.50
A	U	50	Association Cup Winners (1930)		£1.60	£80.00
	C		Aviary and Cage Birds:			
A		50	A Small size (1933):			
			1 Cards		90p	£45.00
			2 Transfers		40p	£20.00
В		25	B Large size (1935)		£3.00	£75.00
A	C	50	Birds and Their Young (1937):			
			A Home issue — adhesive		20p	£10.00
			B Irish issue — 1 Adhesive		£1.00	
			2 Non-adhesive		£1.00	_
A	C	25	Boxing (1934)		£6.00	
A	Č	50	Boy Scout and Girl Guide Patrol Signs and Emblems (1933):			
			A Cards		40p	£20.00
			B Transfers		30p	£15.00
В	C	25	British Butterflies (1934)		£3.80	£95.00
J	C	25	British Live Stock (blue back) (1923)	H.344	£2.20	£55.00
В	Č	25	British Naval Craft (1939)		70p	£17.50
J	Č	20	British Pedigree Stock (1925)		£2.50	£50.00
В	Č	25	British Regalia (1937)		£1.20	£30.00
A	Č	50	Butterflies (1932):		21120	20100
			A Cards		£1.20	£60.00
			B Transfers		40p	£20.00
В	C	24	Cats (1936)		£6.50	_
В	C	25	Championship Golf Courses (1936)		£7.00	£175.00
A	Č	50	Characters from Dickens (1923)	H.348	£1.40	£70.00
В	Č	25	Characters from Fiction (1933)	fragin I	£3.00	£75.00
В	Č	20	Clocks — Old and New (1928)		£4.50	£90.00
A	Č	50	Coronation Series Ceremonial Dress (1937)		28p	£14.00
B	Č	25	Country Sports (1930)		£5.00	£125.00
A	C	50	Cricketers, 1930 (1930)		£1.30	£65.00
A	Č	50	Cricketers, 1934 (1934)		90p	£45.00
		50	CHEROWIS, 1754 (1754)		УОР	~ 15.00

Size	Print-ing	Num in se		Handbook reference	Price per card	Complete set
Α	C	50	Cricketers, 1938 (1938)		80p	£40.00
A	C	50	Cricketers, Caricatures by 'Rip' (1926)		£1.50	£75.00
A	Č	50	Curious Beaks (1929)		80p	£40.00
A	C	50	Cycling (1939):		оор	240.00
			A Home issue — adhesive		80p	£40.00
			B Irish issue — 1 Adhesive		£1.20	<u> 11</u>
			2 Non-adhesive		£1.20	_
	C		Dandies (1932):			
A		50	A Small size		35p	£17.50
В		25	B Large size		£1.80	£45.00
A	C	50	Derby and Grand National Winners (1933):			
			A Cards		£1.70	£85.00
	C		B Transfers		50p	£25.00
Α	-	50	Dogs (1924) — Scenic backgrounds: A Small size		00-	045.00
J		12	B Extra-large size		90p £2.50	£45.00 £30.00
	C	12	Dogs — Heads:		12.30	230.00
A		50	A Small size — Home issue (1929)		90p	£45.00
A		25	B Small size — Irish issue, 'A Series of 25'		эор	243.00
			(1927)		£2.00	£50.00
A		25	C Small size — Irish issue, '2nd Series of 25'			20.00
			(1929)		£2.00	£50.00
В		20	D Large size — Home issue, 'A Series of 20'			
			(1926)		£2.50	£50.00
В		20	E Large size — Home issue, '2nd Series of 20'			
			(1928)		£2.50	£50.00
	C	50	Dogs — Full length:			
A		50	A Small size (1931):			
			1 Cards		70p	£35.00
В		25			40p	£20.00
A	C	50	B Large size (1933)		£2.20	£55.00
A	C	50	Dogs' Heads (silver-grey backgrounds) (1940) Drum Banners and Cap Badges (1924):		£2.80	-
•	-	50	A Base panel joining vertical framelines		90p	£45.00
			B Fractional space between the above		80p	£40.00
В	BW	25	Fables of Aesop (1927)		£2.40	£60.00
В	C	25	Famous Beauties (1937)		£1.60	£40.00
A	C	50	Famous Irish-Bred Horses (1936)		£3.00	£150.00
A	C	50	Famous Irish Greyhounds (1935)		£5.00	2150.00
A	C	50	Film Stars — 'Series of 50' (1934)		£1.00	£50.00
A	C	50	Film Stars — 'Second Series':			
			A Home issue — Album 'price one penny' (1934)		80p	£40.00
			B Irish issue — Album offer without price (1935)		£1.50	£75.00
A	C	50	Film Stars:			
			A Home issue — titled 'Film Stars — Third Series			
			' (1938)		70p	£35.00
D	DW	25	B Irish issue — titled 'Screen Celebrities' (1939)		£1.50	_
В	BW	25	Film Stars — Large size (1934):			
			A Home issue — with album offer		£2.60	£65.00
A	C	50			£6.00	
A	C	50	Fire-Fighting Appliances (1930) Flags of the League of Nations (1928)		£1.60	£80.00
A	C	50	Football Caricatures by 'Mac' (1927)		40p	£20.00
A	C	50	Football Caricatures by 'Rip' (1926)		£1.30 £1.30	£65.00 £65.00
A	C	50	Footballers, 1928 (1928)		£1.30 £1.40	£70.00
A	Č	25	Footballers, 1928-9 — '2nd Series' (1929)		£1.40	£35.00
			2 501105 (1727)		21.70	233.00

Size Print Number Robation Print Pri	JOI	IN PL	AIE	ak & SONS, Nottingham (continuea)			
C	Size	Print-	Numi	ber	Handbook	Price	Complete
A 50 A Small size, Home issue: 1 Pink card (1934) £1.10 £55.00 B 25 B Large size, Home issue — adhesive (1935) £2.40 £60.00 B 25 C Large size, Irish issue — non-adhesive (1935) £2.40 £60.00 A C 25 From Plantation to Smoker (1926) 32p £8.00 A 50 A Small size (1927) £1.40 £70.00 B 25 B Large size (1928) £4.00 £100.00 C Gilbert and Sullivan — 'A Series of' £1.10 £55.00 J 25 B Extra-large size (1926) £3.00 £75.00 J 25 B Extra-large size (1926) £3.00 £75.00 J 25 B Extra-large size (1927) £1.10 £55.00 A 50 A Small size (1927) £1.10 £55.00 B 25 B Large size (1928) £3.20 £80.00 B 25 B Large size (1928) £3.20 £80.00 B 25		ing	in sei	t	reference	per card	set
A 50 A Small size, Home issue: 1 Pink card (1934) £1.10 £55.00 B 25 B Large size, Home issue — adhesive (1935) £2.40 £60.00 B 25 C Large size, Irish issue — non-adhesive (1935) £2.40 £60.00 A C 25 From Plantation to Smoker (1926) 32p £8.00 A 50 A Small size (1927) £1.40 £70.00 B 25 B Large size (1928) £4.00 £100.00 C Gilbert and Sullivan — 'A Series of' £1.10 £55.00 J 25 B Extra-large size (1926) £3.00 £75.00 J 25 B Extra-large size (1926) £3.00 £75.00 J 25 B Extra-large size (1927) £1.10 £55.00 A 50 A Small size (1927) £1.10 £55.00 B 25 B Large size (1928) £3.20 £80.00 B 25 B Large size (1928) £3.20 £80.00 B 25		C		Erach Water Fishes			
1 Pink card (1933)	A .	C	50				
Section	A		30			£1.10	£55.00
B							
B	D		25				
A C 25 From Plantation to Smoker (1926) 32p £8.00 A 50 A Small size (1927) £1.40 £70.00 B 25 B Large size (1928) £1.00 £55.00 C Gilbert and Sullivan — 'A Series of' A 50 A Small size (1925) £1.10 £55.00 C Gilbert and Sullivan — 'A Series of' A 50 A Small size (1925) £1.10 £55.00 C Gilbert and Sullivan — '2nd Series of' B 25 B Extra-large size (1926) £3.00 £75.00 B 25 B Large size (1928) £3.20 £80.00 B 25 Golf (1939) £1.10 £55.00 A C 25 Hidden Beauties (1929) £4.20 £80.00 A C 25 Hidden Beauties (1929) £4.20 £60.00 A C 30 Hints on Association Football (1934) £5.20 £50.00 A C 50 History of Naval Dress: A 50 A Small size (1930) £1.20 £60.00 A C 50 History of Naval Dress: A 100 £1.20 £60.00 A C 50 Hints on Association Football (1934) £1.20 £50.00 A C 50 International Air Liners: A Home issue — Album 'price one penny' (1936) £2.20 £55.00 C 50 Kings and Queens of England (1935): A C 25 Irish Place Names — 'A Series of 25' (1929) £2.20 £55.00 C 50 Military Head-Dress (1931) £1.00 £50.00 A C 50 Military Uniforms of the British Empire Overseas (1938) £1.30 £50.00 A C 50 Military Uniforms of the British Empire Overseas (1938) £1.00 £50.00 B Irish issue — Album offer without price (1937) £1.00 £50.00 A C 50 Modern Naval Craft (1939): A Home issue — Album 'price one penny' (1936) £2.20 £55.00 B Irish issue — Home is price one penny' (1936) £2.20 £55.00 C 50 Modern Naval Craft (1939): A Home issue — Album 'price one penny' £1.30 £65.00 B Irish issue — Album 'price one penny' £1.30 £65.00 B Irish issue — Album 'price one penny' (1936) £2.20 £50.00 B Irish issue — Album 'price one penny' (1936) £2.20 £50.00 B Irish issue — Album 'price one penny' (1936) £2.20 £50.00 B Irish issue — Album 'price one penny' (1936) £2.20 £50.00 B Irish issue — Album 'price one penny' (1936) £2.20 £50.00 B Irish issue — Album 'price one penny' (1936) £2.50 £50.00 B Irish issue — Album 'price one penny' (1936) £2.50 £50.00 B Irish issue — Album 'price one penny' (1936) £2.50 £50.00 B Irish issue							
C Game Birds and Wild Fowl: A 50 A Small size (1928)		0					
A 50 A Small size (1927) £1.40 £70.00 B 25 B Large size (1928) £4.00 £100.00 C Gilbert and Sullivan — 'A Series of' £1.10 £55.00 C Gilbert and Sullivan — '2nd Series of' £1.10 £55.00 B C Gilbert and Sullivan — '2nd Series of' £1.10 £55.00 B C So A Small size (1927) £1.10 £55.00 B C So A Small size (1927) £1.10 £55.00 B C 25 BLarge size (1928) £3.20 £80.00 A C 25 Hidden Beauties (1929) £240 £60.00 A C 50 Hints on Association Football (1934) 55 £27.50 A C 50 Hints on Association Football (1934) 55 £27.50 A C 50 Hints on Association Football (1934) £1.20 £6.00 A C 50 International Air Liners: £2.20	A		23			32p	28.00
B 25 B Large size (1928) £4.00 £100.00 A C Gilbert and Sullivan — 'A Series of' £1.10 £55.00 J 25 B Extra-large size (1926) £3.00 £75.00 C Gilbert and Sullivan — '2nd Series of' £1.10 £55.00 A 50 A Small size (1927) £1.0 £55.00 B 25 B Large size (1928) £3.20 £80.00 B C 25 Golf (1939) £7.50 — A C 25 Hidden Beauties (1929) 24p £6.00 A C 25 Hidden Beauties (1929) 24p £6.00 B C 25 Hidden Beauties (1929) £1.20 £60.00 B C 25 Hidden Beauties (1929) £2.0 £7.50 C C Hidden Beauties (1929) £2.0 £50.00 B L35 B Large size (1929) £2.00 £50.00 B L35 B Large size (1930) £1.20 £60.00 B<		C	50			£1.40	670.00
C Gilbert and Sullivan — 'A Series of': A Son A Small size (1925)				A Siliali Size (1927)			
A 50 A Small size (1925)	D	C	23	Cilbert and Sullivan 'A Sories of '.		14.00	2100.00
C		C	50			61.10	655.00
C							
A	J	C	25			23.00	273.00
B	٨	C	50			£1.10	£55.00
B C 25 Golf (1939) £7,50 — A C 25 Hidden Beauties (1929) £6,00 C C Hiistory of Naval Dress: A 50 A Small size (1930) £1,20 £60,00 B 25 B Large size (1929) £2,00 £50,00 A C 50 International Air Liners: A A Home issue — Album offer without price (1937) £1,00 £50,00 B E1 irish Place Names — 'A Series of 25' (1927) £2,20 £55,00 C 25 Irish Place Names — 'A Series of 25' (1929) £2,20 £55,00 C 25 Irish Place Names — 'A Series of 25' (1929) £2,20 £55,00 C 25 Irish Place Names — 'A Series of 25' (1929) £2,20 £55,00 C 50 Kings and Queens of England (1935): L £1,20 £60,00 A C 25 Live Stock (1925) £3,20 £8,000 £1,20 £60,00 A							
A C 25 Hidden Beauties (1929) . 24p £6.00 A C 50 Hints on Association Football (1934) . 55p £27.50 C History of Naval Dress: A 50 A Small size (1930) . £1.20 £60.00 B 25 B Large size (1929) . £2.00 £50.00 International Air Liners: A Home issue — Album 'price one penny' (1936) B Irish issue — Album offer without price (1937) . £1.00 £50.00 A C 25 Irish Place Names — 'A Series of 25' (1927) . £2.20 £55.00 C 50 Kings and Queens of England (1935): A C 35 Irish Place Names — '2nd Series of 25' (1929) . £2.20 £55.00 C 50 Kings and Queens of England (1935): A Small size . £1.20 £60.00 B Large size . £2.50 £125.00 A C 25 Live Stock (1925) . £3.20 £80.00 A C 50 Military Head-Dress (1931) . £1.00 £50.00 A C 50 Military Uniforms of the British Empire Overseas (1938) . £1.00 £50.00 A C 50 Modern Naval Craft (1939): A Home issue — Album 'price one penny' . £1.30 £65.00 B Irish issue — non-adhesive . £1.00 — A C 50 Motor Cars — 'A Series of 50' (1936): A Home issue — Album 'price one penny' . £1.30 £65.00 B Irish issue — Album 'price one penny' . £1.30 £65.00 B Irish issue — Album 'price one penny' . £1.30 £65.00 B Irish issue — Album 'price one penny' . £1.30 £65.00 B Irish issue — Album 'price one penny' . £1.30 £65.00 B Irish issue — Album 'price one penny' . £1.30 £65.00 B Irish issue — Album 'price one penny' . £1.30 £65.00 B Irish issue — Album 'price one penny' . £1.30 £65.00 B Irish issue — Album 'price one penny' . £1.30 £65.00 B Irish issue — Album 'price one penny' . £1.30 £65.00 B Irish issue — Album 'price one penny' . £1.30 £65.00 C National Flags and Arms: A Home issue — Album 'price one penny' . £1.30 £50.00 B Irish issue — Album 'price one penny' . £1.00 £50.00 B Irish issue — Album 'price one penny' . £1.00 £50.00 B Irish issue — Album 'price one penny' . £1.00 £50.00 B Irish issue — Album 'price one penny' . £1.00 £50.00 B Irish issue — Album 'price one penny' . £1.00 £50.00 B Irish issue — Album 'price one penny' . £1.00 £50.00 B Irish issue — Album 'price one penny' . £1.00 £50.00 B Irish issu		C					200.00
A C 50 Hints on Association Football (1934)	1	_					£6.00
C History of Naval Dress: £1.20 £60.00 B 25 B Large size (1929) £2.00 £50.00 A C 50 International Air Liners: A Home issue — Album 'price one penny' (1936) 45p £22.50 A C 25 Irish Place Names — 'A Series of 25' (1927) £2.20 £55.00 A C 25 Irish Place Names — 'A Series of 25' (1929) £2.20 £55.00 A C 25 Irish Place Names — 'A Series of 25' (1929) £2.20 £55.00 A C 25 Irish Place Names — 'A Series of 25' (1929) £2.20 £55.00 A C 25 Irish Place Names — 'A Series of 25' (1929) £2.20 £55.00 A C 25 Irish Place Names — 'A Series of 25' (1929) £2.20 £55.00 A C 25 Irisk Bace Names — 'A Series of 25' (1929) £2.20 £55.00 B B Large size £1.20 £60.00 £1.20 £2.00 £2.00 £2.00 £2.00 £2.0							
A 50 A Small size (1930) £1.20 £60.00 B 25 B Large size (1929) £2.00 £50.00 A C 50 International Air Liners: A Home issue — Album 'price one penny' (1936) 45p £22.50 B Irish issue — Album offer without price (1937) £1.00 £50.00 A C 25 Irish Place Names — 'A Series of 25' (1927) £2.20 £55.00 C 50 Kings and Queens of England (1935): A Small size — £1.20 £60.00 B Large size £2.50 £125.00 A C 25 Live Stock (1925) £2.50 £125.00 A C 50 Military Head-Dress (1931) £1.00 £50.00 A C 50 Military Uniforms of the British Empire Overseas (1938) £1.00 £50.00 A C 50 Modern Naval Craft (1939): A Home issue — adhesive £1.00 £50.00 B Irish issue — Album 'price one penny' £1.30 £65.00 B Irish issue — Album 'price one penny' £1.30 £65.00 B Irish issue — Album 'price one penny' £1.30 £65.00 C National Flags and Arms: A Home issue — Album 'price one penny' £1.30 £50.00 C National Flags and Arms: A Home issue — Album 'price one penny' £1.50 £50.00 C National Flags and Arms: A Home issue — Album 'price one penny' £1.50 £50.00 C Natural History: A Son A Small size (1924) £2.50 £50.00 C Natural History: A Son A Small size (1924) £2.50 £50.00 B C 25 The Nation's Shrines (1929) £2.50 £50.00 C Natural History: A Son A Small size — '2nd Series of 12' (1923) £1.25 £15.00 B C 25 Old Hunting Prints (1938) £2.60 £65.00 B C 25 Old Hunting Prints (1938) £2.60 £65.00 B C 25 Old Hunting Prints (1938) £2.60 £65.00 B C 25 Old Hunting Prints (1938) £2.60 £65.00 B C 25 Old Naval Prints (1938) £2.60 £65.00 B C 25 Old Naval Prints (1938) £2.60 £65.00 B C 25 Old Sporting Prints (1936) £2.40 £60.00	A		30			ЗЭР	227.50
B	٨	C	50			£1.20	£60.00
A C 50 International Air Liners: A Home issue — Album offer without price (1937)				P. Lorge size (1930)			
A Home issue — Album 'price one penny' (1936) B Irish issue — Album offer without price (1937) A C 25 Irish Place Names — 'A Series of 25' (1927) £2.20 £55.00 C 50 Kings and Queens of England (1935): A C 25 Irish Place Names — '2nd Series of 25' (1929) £2.20 £55.00 C 50 Kings and Queens of England (1935): A Small size £1.20 £60.00 B B Large size £2.50 £125.00 A C 25 Live Stock (1925) £3.20 £80.00 A C 50 Military Head-Dress (1931) £1.00 £50.00 A C 50 Military Head-Dress (1931) £1.00 £50.00 A C 50 Military Uniforms of the British Empire Overseas (1938) 80p £40.00 A C 50 Modern Naval Craft (1939): A Home issue — adhesive £4.00 £4.00 £4.00 B Irish issue — mon-adhesive £4.00 £4.00 £4.00 A C 50 Motor Cars — 'A Series of 50' (1936): A Home issue — Album offer without price £4.00 £5.00 B U 20 Motor Cars — 'Second Series' (1937) £1.30 £65.00 B U 20 Motor Cars — 'Second Series' (1937) £1.00 £50.00 B U 20 Motor Cars — 'Second Series' (1937) £1.00 £50.00 B U 20 Motor Cars — 'Second Series' (1937) £1.00 £50.00 B C 25 The Nation's Shrines (1929) £2.50 £5.00 C Natural History: A Home issue — Album 'price one penny' (1936) £2.50 £50.00 C Natural History: A Sonall size (1924) \$3.00 £50.00 B C 25 The Nation's Shrines (1929) £2.00 £50.00 C Natural History: A Sonall size (1924) \$3.00 £50.00 B C 24 A Nature Calendar (1930) £2.50 £50.00 C 24 A Nature Calendar (1930) £2.50 £50.00 C 25 Old Hunting Prints' (1938) £2.60 £65.00 B C 25 Old Naval Prints (1938) £2.60 £65.00 B C 25 Old Naval Prints (1936) £2.40 £60.00 C 25 Picturesque Bridges (1929) £2.60 £65.00 C 25 Picturesque Bridges (1929) £2.60 £65.00 C 25 Picturesque Bridges (1929) £2.60 £65.00		C				12.00	250.00
B Irish issue — Album offer without price (1937)	A	C	30			45n	£22.50
A C 25 Irish Place Names — 'A Series of 25' (1927) £2.20 £55.00 C 25 Irish Place Names — '2nd Series of 25' (1929) £2.20 £55.00 C 50 Kings and Queens of England (1935): A Small size £1.20 £60.00 B							
A C 25		C	25				
C 50 Kings and Queens of England (1935): A Small size £1.20 £60.00 B Large size £2.50 £125.00 A C 25 Live Stock (1925) £3.20 £80.00 A C 50 Military Head-Dress (1931) £1.00 £50.00 A C 50 Military Uniforms of the British Empire Overseas (1938) 80p £40.00 A C 50 Modern Naval Craft (1939): A Home issue — adhesive 40p £20.00 B Irish issue — non-adhesive £1.00 — A C 50 Motor Cars — 'A Series of 50' (1936): A Home issue — Album 'price one penny' £1.30 £65.00 B Irish issue — Album offer without price £2.00 — A C 50 Motor Cars — 'Second Series' (1937) £1.00 £50.00 B U 20 Mount Everest (1925) £2.50 £50.00 A C 50 National Flags and Arms: A Home issue — Album offer without price one penny' (1936) £2.50 £50.00 B C 25 The Nation's Shrines (1929) £2.00 £50.00 Natural History: A 50 A Small size (1924) 30p £15.00 J 12 B Extra-large size — 'A Series of 12' (1923) £1.25 £15.00 B C 24 A Nature Calendar (1930) £2.60 £65.00 B C 25 Old Hunting Prints' (1938) £2.60 £65.00 B C 25 Old Naval Prints (1938) £2.60 £65.00 B C 25 Old Naval Prints (1938) £2.60 £65.00 B C 25 Picturesque Bridges (1929) £2.60 £65.00				Irish Place Names — A Series of 25 (1927)			
A Small size	A					12.20	133.00
B B Large size £2.50 £125.00 A C 25 Live Stock (1925) £3.20 £80.00 A C 50 Military Head-Dress (1931) £1.00 £50.00 A C 50 Military Uniforms of the British Empire Overseas (1938) 80p £40.00 A C 50 Modern Naval Craft (1939):	1	C	50			C1 20	660.00
A C 25 Live Stock (1925)							
A C 50 Military Head-Dress (1931)			25				
A C 50 Military Uniforms of the British Empire Overseas (1938)							
(1938) 80p £40.00 A C 50 Modern Naval Craft (1939):						£1.00	130.00
A C 50 Modern Naval Craft (1939): A Home issue — adhesive	A	C	50			90n	£40.00
A Home issue — adhesive £1.00			50			оор	140.00
B Irish issue — non-adhesive £1.00 — A C 50 Motor Cars — 'A Series of 50' (1936): A Home issue — Album 'price one penny' £1.30 £65.00 — B Irish issue — Album offer without price £2.00 — A C 50 Motor Cars — 'Second Series' (1937) £1.00 £50.00 — B U 20 Mount Everest (1925) £2.50 £50.00 — A C 50 National Flags and Arms: A Home issue — Album 'price one penny' (1936) 40p £20.00 — B Irish issue — Album offer without price (1937) £1.00 £50.00 — B Irish issue — Album offer without price (1937) £1.00 £50.00 — C Natural History: A 50 A Small size (1924) 30p £15.00 — J 12 B Extra-large size — 'A Series of 12' (1923) £1.25 £15.00 — J 12 C Extra-large size — '2nd Series of 12' (1924) £1.25 £15.00 — B C 24 A Nature Calendar (1930) £3.00 £75.00 — B C 25 Old Hunting Prints' (1938) £2.60 £65.00 — B C 25 Old Naval Prints (1936) £2.40 £60.00 — B C 25 Picturesque Bridges (1929) £2.60 £65.00	A	C	50			10n	620.00
A C 50 Motor Cars — 'A Series of 50' (1936): A Home issue — Album 'price one penny'							£20.00
A Home issue — Album 'price one penny'		_	50			£1.00	
B Irish issue — Album offer without price	A	C	50			C1 20	C65 00
A C 50 Motor Cars — 'Second Series' (1937) £1.00 £50.00 B U 20 Mount Everest (1925) £2.50 £50.00 A C 50 National Flags and Arms: A Home issue — Album 'price one penny' (1936) £1.00 £50.00 B Irish issue — Album offer without price (1937) £1.00 £50.00 C Natural History: A 50 A Small size (1924) 30p £15.00 J 12 B Extra-large size — 'A Series of 12' (1923) £1.25 £15.00 J 12 C Extra-large size — 'A Series of 12' (1924) £1.25 £15.00 B C 24 A Nature Calendar (1930) £3.00 £75.00 B C 25 Old Hunting Prints' (1938) £2.60 £65.00 J BW 25 Old Sporting Prints (1934) £2.40 £60.00 J BW 25 Old Sporting Prints (1924) £3.00 £75.00 B C 25 Picturesque Bridges (1929) £2.60 £65.00							105.00
B U 20 Mount Everest (1925) £2.50 £50.00 A C 50 National Flags and Arms: A Home issue — Album 'price one penny' (1936) 40p £20.00 B C 25 The Nation's Shrines (1929) £1.00 £50.00 C Natural History: A 30p £15.00 J 12 B Extra-large size — 'A Series of 12' (1923) £1.25 £15.00 J 12 C Extra-large size — '2nd Series of 12' (1924) £1.25 £15.00 B C 24 A Nature Calendar (1930) £3.00 £75.00 B C 25 'Old Hunting Prints' (1938) £2.60 £65.00 B C 25 Old Sporting Prints (1936) £2.40 £60.00 J BW 25 Old Sporting Prints (1924) £3.00 £75.00 B C 25 Picturesque Bridges (1929) £2.60 £65.00		0	50				C50.00
A C 50 National Flags and Arms: A Home issue — Album 'price one penny' (1936) B Irish issue — Album offer without price (1937). C The Nation's Shrines (1929). A 50 A Small size (1924). J 12 B Extra-large size — 'A Series of 12' (1923). J 12 C Extra-large size — '2nd Series of 12' (1924). B C 24 A Nature Calendar (1930). B C 25 Old Hunting Prints' (1938). C 25 Old Naval Prints (1936). C 25 Old Sporting Prints (1934). C 25 Picturesque Bridges (1929). A 40p £20.00 £20.00 £50.00 £50.00 £1.00 £1.00 £1.25 £15.00 £3.00 £75.00 £3.00 £75.00 £2.40 £60.00 £3.00 £75.00							
A Home issue — Album 'price one penny' (1936) B Irish issue — Album offer without price (1937). B C 25 The Nation's Shrines (1929). C Natural History: A 50 A Small size (1924)						£2.50	£30.00
B Irish issue — Album offer without price (1937). £1.00 £50.00 C Natural History: A 50 A Small size (1924)	A	C	50			40-	620.00
B C 25 The Nation's Shrines (1929) £2.00 £50.00 C Natural History: A 50 A Small size (1924) 30p £15.00 J 12 B Extra-large size — 'A Series of 12' (1923) £1.25 £15.00 J 12 C Extra-large size — '2nd Series of 12' (1924) £1.25 £15.00 B C 24 A Nature Calendar (1930) £3.00 £75.00 B C 25 'Old Hunting Prints' (1938) £2.60 £65.00 J BW 25 Old Sporting Prints (1936) £2.40 £60.00 J BW 25 Old Sporting Prints (1924) £3.00 £75.00 C 25 Picturesque Bridges (1929) £2.60 £65.00				A Home issue — Album 'price one penny' (1936)			
C Natural History: A 50 A Small size (1924) 30p £15.00 J 12 B Extra-large size — 'A Series of 12' (1923) £1.25 £15.00 J 12 C Extra-large size — '2nd Series of 12' (1924) £1.25 £15.00 B C 24 A Nature Calendar (1930) £3.00 £75.00 B C 25 'Old Hunting Prints' (1938) £2.60 £65.00 B C 25 Old Saval Prints (1936) £2.40 £60.00 J BW 25 Old Sporting Prints (1924) £3.00 £75.00 B C 25 Picturesque Bridges (1929) £2.60 £65.00		~					
A 50 A Small size (1924)	В		25			£2.00	£50.00
J 12 B Extra-large size — 'A Series of 12' (1923) £1.25 £15.00 J 12 C Extra-large size — '2nd Series of 12' (1924) £1.25 £15.00 B C 24 A Nature Calendar (1930) £3.00 £75.00 B C 25 'Old Hunting Prints' (1938) £2.60 £65.00 B C 25 Old Naval Prints (1936) £2.40 £60.00 J BW 25 Old Sporting Prints (1924) £3.00 £75.00 B C 25 Picturesque Bridges (1929) £2.60 £65.00		C				20-	015.00
B C 24 A Nature Calendar (1930) £3.00 £75.00 B C 25 'Old Hunting Prints' (1938) £2.60 £65.00 B C 25 Old Naval Prints (1936) £2.40 £60.00 J BW 25 Old Sporting Prints (1924) £3.00 £75.00 B C 25 Picturesque Bridges (1929) £2.60 £65.00				A Small size (1924)			
B C 24 A Nature Calendar (1930) £3.00 £75.00 B C 25 'Old Hunting Prints' (1938) £2.60 £65.00 B C 25 Old Naval Prints (1936) £2.40 £60.00 J BW 25 Old Sporting Prints (1924) £3.00 £75.00 B C 25 Picturesque Bridges (1929) £2.60 £65.00				B Extra-large size — 'A Series of 12' (1923)			
B C 25 'Old Hunting Prints' (1938) £2.60 £65.00 B C 25 Old Naval Prints (1936) £2.40 £60.00 J BW 25 Old Sporting Prints (1924) £3.00 £75.00 B C 25 Picturesque Bridges (1929) £2.60 £65.00		0					
B C 25 Old Naval Prints (1936) £2.40 £60.00 J BW 25 Old Sporting Prints (1924) £3.00 £75.00 B C 25 Picturesque Bridges (1929) £2.60 £65.00							
J BW 25 Old Sporting Prints (1924) £3.00 £75.00 B C 25 Picturesque Bridges (1929) £2.60 £65.00							
B C 25 Picturesque Bridges (1929)							
B C 25 Picturesque Cottages (1929)							
	В	C	25	ricturesque Cottages (1929)		12.00	103.00

Size	Print-	Num	sher	Handbook	Duine	Complete
Size	ing	in se		Handbook reference	per card	Complete
В	C	25	Dieturasque London (1021)			
В	C	25	Picturesque London (1931)		£3.20 £2.20	£80.00 £55.00
A	C	50	Poultry (1931):		12.20	133.00
Λ	-	30	A Cards		£1.50	£75.00
			B Transfers		40p	£20.00
A	C	50	Products of the World — Scenes only (1928)		25p	£12.50
A	C	25	Racehorses (1926)		£5.00	£125.00
A	U	40	Racing Caricatures (1925)		75p	£30.00
В	C	25	Racing Yachts (1938)		£3.20	£80.00
A	C	50	RAF Badges (1937):			
			A Without motto		60p	£30.00
			B With motto		60p	£30.00
A	C	50	Regimental Standards and Cap Badges (1930)		70p	£35.00
_	C	1	The Royal Family $(55 \times 66 \text{mm}) (1937) \dots$			£2.50
		50	Screen Celebrities — see Film Stars			
A	C	50	Sea Fishes: A Home issue — Album 'price one penny' (1935)		25	017.50
					35p	£17.50
A	C	50	B Irish issue — Album offer without price (1937). A Sectional Map of Ireland (1937)		£1.00 £2.40	
В	C	20	Ship-Models (1926)		£2.40 £2.50	£50.00
В	Č	25	Ships' Figure-Heads (1931)		£1.80	£45.00
A	C	50	Speedway Riders (1937)		£1.50	£75.00
A	C	50	Straight Line Caricatures (1926)		50p	£25.00
A	C	25	Struggle for Existence (1923)		32p	£8.00
A	C	50	Tennis (1936)		90p	£45.00
В	C	25	Treasures of Britain (1931)			£40.00
A	C	25	Treasures of Ireland (1930)		£1.80	£45.00
В	C	25	Types of Horses (1939)		£3.40	£85.00
A	C	50	Uniforms of the Territorial Army (Oct. 1939)		70p	£35.00
A	C	90	War Decorations and Medals (1927)		70p	£65.00
	C	50	Wild Animals:			
A		50 25	A Small size — 'Wild Animals' Heads' (1931)		60p	£30.00
A		23	B Small transfers, number in series not stated		61.50	
A		50	(1931)		£1.50	C20 00
B		25	D Large size — 'Wild Animals — A Series of'		40p	£20.00
ь		23	(1927)		£1.80	£45.00
В		25	E Large size — 'Wild Animals — 2nd Series'		11.00	143.00
			(1932)		£1.80	£45.00
	C		Wild Birds:		21.00	243.00
A		50	A Small size (1932):			
			1 Cards		40p	£20.00
			2 Transfers		35p	£17.50
В		25	B Large size (1934)		£2.40	£60.00
В	C	25	Wild Fowl (1937)		£2.80	£70.00
A	C	25	Wonders of the World (grey back) (1926)		£1.40	£35.00
A	C	25	Wrestling and Ju-Jitsu (grey back) (1925)	H.467	£1.40	£35.00
A	C	26	Your Initials (transfers) (1932)		60p	£16.00
В	C	25	Zoo Babies (1938)		60p	£15.00
	POST-1					
G	C	30	African Wildlife (1990)		40p	£12.00
_	BW	9	Basket Ball Fixtures $(114 \times 71 \text{mm}) (1972) \dots$		£6.00	_
G	C	32	Britain's Endangered Wildlife:			
			A Grandee Issue (1984)			£8.00
H2	C	20	B Doncella Issue (1984)		F	£9.00
H2	C	30	Britain's Maritime History (1989)		40p	£12.00

	Print-			Handbook reference	Price per card	Complete set
				rejerence	per cara	501
G	C	30	Britain's Nocturnal Wildlife:		27p	£8.00
			A Grandee Issue (1987)		40p	£12.00
C	C	30	Britain's Wayside Wildlife (1988)		30p	£9.00
G G	C C	30	Britain's Wild Flowers:		ЗОР	27.00
G	C	30	A Grandee Issue (1986)		25p	£7.50
			B Doncella Issue (1986)		40p	£12.00
G	C	32	British Birds (1980)		50p	£16.00
G	C	32	British Butterflies:		БОР	210,00
U	C	32	A Grandee Issue (1983)		40p	£13.00
			B Doncella Issue (1984)		37p	£12.00
G	C	30	British Mammals:			
J	_	50	A Grandee Issue (1982):			
			1 Imperial Tobacco Ltd		27p	£8.00
			2 Imperial Group PLC		30p	£9.00
			B Doncella Issue (1983)		40p	£12.00
G	C	32	Country Houses and Castles (1981)		20p	£6.50
	U	116	Corsair Game (63 × 38mm) (1965)		90p	_
H2	C	32	Exploration of Space (1983)		20p	£6.50
G	C	28	Famous MG Marques (1981)		80p	£22.00
G	C	24	The Golden Age of Flying (1977)		25p	£6.00
G	C	1	The Golden Age of Flying Completion Offer (1977)		_	£3.50
G	C	24	The Golden Age of Motoring (1975):			
			A With set completion offer		£3.50	06.50
			B Without set completion offer		27p	£6.50
G	C	24	The Golden Age of Sail (1978)		25p	£6.00
G	C	1	The Golden Age of Sail Completion Offer (1978)		25	£3.50
G	C	24	The Golden Age of Steam (1976)		25p	£6.00
G	C	1	The Golden Age of Steam Completion Offer (1976)		CO 00	£3.50
G	U	7	Grandee Limericks (1977)		£8.00	£12.00
H2	C	30	History of Britain's Railways (1987)		40p	£12.00
H2	C	30	History of British Aviation (1988)		70p	£21.00
H2	C	30	History of Motor Racing (1986):		70p	£20.00
			A Imperial Tobacco Ltd		70p	£20.00
-		24	B Imperial Group PLC		90p	£22.00
G	C C	24	History of the VC (1980)		ЭОР	£5.00
G		1 5	Jubilee Issue (70 × 55mm) (1960)		£1.50	£7.50
G	BW C	30	The Living Ocean:		21.50	27.50
G	C	30	A Grandee Issue (1985)		25p	£7.50
			B Doncella Issue (1985)		40p	£12.00
H2	C	32	Myths and Legends (1982)		90p	£30.00
G	C	24	Napoleonic Uniforms (1979)		20p	£5.00
G	C	1	Napoleonic Uniforms Completion Offer (1979)			£3.50
G	C	7	Panama Puzzles (1975)		£6.00	-
G	BW	6	Play Ladbroke Spot-Ball (1975)		£6.00	
_	U	4	Tom Thumb Record Breakers (82 × 65mm) (1976)		£6.00	
G	Č	25	Top Dogs (1979)		£1.00	£25.00
H2	Č	32	Wonders of the Ancient World (1984)		40p	£12.50
H2	C	30	Wonders of the Modern World (1985)		30p	£9.00
G	Č	6	World of Gardening (1976)		£8.00	_
			SERIES			
A	C	25	Birds and Their Young, 1st series (1955)		24p	£6.00
A	Č	25	Birds and Their Young, 2nd series (1955)		16p	£4.00
A	Č	25	Cries of London, '2nd Series' (black back) (1916)		£5.00	
A	Č	50	Decorations and Medals (c1940)		£1.90	£95.00
		-				

JO	HN PI	AYI	ER & SONS, Nottingham (continued)			
Size	Print- ing	Num in se		Handbook reference	Price per card	Complete set
A B A E	C C C	50 25 50	Dogs' Heads by Biegel (c1955) Dogs — Pairs and Groups (c1955) Shipping (c1955)		60p £1.20 £1.50	£30.00 £30.00 £75.00
B A	BW C C	1 1 ?	Advertisement Card — Wants List (1936)		=	£1.00 £5.00
	C	8	Football Fixture Folders (1946-61) Snap Cards (93 × 65mm) (c1930)		£12.00 £6.50	$-\sqrt{2}$
JA	S. PL	AYF	AIR & CO., London—			
	E-1919 I					
A	С	25	How to Keep Fit — Sandow Exercises (c1912)	H.136	£32.00	_
			IER TOBACCO MANUFACTURERS LT	D, Londo	n	
	ST-1920					
D K2	U C	48 52	Eminent Stage and Screen Personalities (1936) *Ministure Playing Cords (c1935)	Ha.569	£1.50	
- K2	BW	32	*Miniature Playing Cards (c1935)		£7.00	-
		100	A Back in grey		£1.30	
		50	B Back in brown (Nos. 51-100)		£1.80	
PR	ITCH	ARI	D & BURTON LTD, London—		1 (19)	
PRI	E-1919 I	SSUE	ZS.			
A2	C	50	*Actors and Actresses — 'FROGA B and C' (c1900):	H.20		
			A Blue back	9.6 (Buyge Kila	£18.00	_
			B Grey-black back		£40.00	<u>-11</u>
A	C	15	*Beauties 'PAC' (c1900)	H.2	£55.00	-
D A1	BW C	20	*Boer War Cartoons (1900)	H.42 H.41	£80.00	
		30	1st printing		£14.00	£420.00
		15	2nd printing		£20.00	
D	**	15	B Flagstaff not Draped (Flags only)		£20.00	_
D A	U C	25 40	*Holiday Resorts and Views (c1902)	H.366 H.69	£16.00	
			20 Caption in brown		£45.00 £45.00	_
D	U	25	*Royalty series (1902)	H 367	£20.00	-
D	U	25	*South African Series (1901)	H.368	£17.00	
A2	C	25	*Star Girls (c1900)	H.30	£130.00	
G.	PRUI	ОНО	E, Darlington—	As a season	* 15	
PRI	E-1919 I	SSIJE	S			
C	C	30	*Army Pictures, Cartoons, etc (c1916)	Ha.12	£75.00	77 OR <u>84</u>
JA	MES	QUI	NTON LTD, London——————			23.27 - 23.79
PRE	E-1919 I	SSUE				
A	С	26	*Actresses — 'FROGA A' (c1900)	H.20	£130.00	_
RA	Y & (co.	LTD, London—	s de la constante		
PRE A	E-1919 I BW		War Series — 1-25 — Battleships (c1915)		£11.00	_

RA	Y & C	o. L	TD, London (continued)			
Size	Print-ing	Num in se		Handbook reference	Price per card	Complete set
A	C	75	War Series — 26-100 — British and Foreign Uniforms			
			(c1915)		£8.00	_
A	С	24	War Series — 101-124 — British and Dominion Uniforms (c1915)		£18.00	
RA	YMO	ND	REVUEBAR, London—			
	T-1940					
_	P	25	Revuebar Striptease Artists (72 \times 46mm) (1960)		£13.00	_
RE	COR	D C	IGARETTE CO., London—	<u> </u>		
POS	T-1920	ISSU	E			
-	U	? 34	The 'Talkie' Cigarette Card — (gramophone record on reverse) (70mm square) (c1935)		£35.00	<u>-</u>
J. 1	REDF	ORI	D & CO., London			
PRE	E-1919 I	SSUE	ES .			
A	BW	20	*Actresses — 'BLARM' (c1900)	H.23	£70.00	_
A2	C	25	*Armies of the World (c1901)		£55.00	-
A2	C	25	*Beauties — 'GRACC' (c1899)		£90.00	_
A2	C	30	*Colonial Troops (c1902)		£50.00	F-3 51-8
D		24	*Nautical Expressions (c1900)		£80.00	_
D2	C	40 25	*Naval and Military Phrases (c1904)		£50.00 £65.00	
A	C	25	Picture Series (c1905)		£70.00	- 7 th - 100
D1	BW	50	Stage Artistes of the Day (c1908)		£14.00	£700.00
RE	LIAN	CE	TOBACCO MFG. CO. LTD			
POS	T-1920	ISSU	ES			
A2	C	24	British Birds (c1935)	Ha.604	£4.50	_
A2	C	35	Famous Stars (c1935)		£4.50	· · · · · · · · · · · · · · · · · · ·
RIC	CHAR	RDS	& WARD—			
PRE	-1919 1	SSUE				
3/77		? 11	*Beauties — 'Topsy Cigarettes' (c1900)	H.371	£175.00	-
A. S	s. RIC	CHA	RDSON, Luton—			
POS	T-1920	ISSU	E			
-	U	12	*Manikin Cards (79 × 51mm) (c1920)	Ha.481	£70.00	_
TH	E RIC	CHN	IOND CAVENDISH CO. LTD, London-		48	4141 - 514
PRE	-1919 I	SSUE	ES .			
A2	C	26	*Actresses — 'FROGA A' (c1900)		£26.00	7 My <u></u>
D2	BW	28	*Actresses — 'PILPI I' (c1902)		£13.00	-
D	P	50	*Actresses 'PILPI II' (c1902)	H.196	£8.50	- 1 T
A	U		*Actresses Photogravure, 'Smoke Pioneer Cigarettes'	11.070		
		50	back (c1905):	H.372	06.00	C200 00
	2	50 179	I Reading bottom to top		£6.00 £6.00	£300.00
		2 13	B Plain back		£10.00	1 1
		10	Out		210.00	

Size	Print-ing	Num in se	귀 구하는 아이지 않는 아니었다면 되고 하는 것이 없는 것이 없다면 없다면 없다.	Handbook reference	Price per card	Complete
A	C	14	*Beauties 'AMBS' (1899):	H.373		
		10.00	A Verses 'The Absent-minded Beggar' back (4	11.575		
			verses and 4 choruses)		£45.00	
			B Verses 'Soldiers of the Queen' back (3 verses		243.00	
			and 1 chorus)		£45.00	0.00
A	C	52	*Beauties — 'ROBRI' playing card inset (c1898)	H 374	£45.00	
	C	40	*Medals (34 × 72mm) (c1900)		£18.00	£720.00
A2	Č	20	Music Hall Artistes (c1902)	H 202	£40.00	2720.00
A	C	12	*Pretty Girl Series — 'RASH' (c1900)	H 8	£40.00	
A	C	20	*Yachts (c1900):	H.204	240.00	
			A Gold on black back	11.204	£60.00	
			B Black on white back		£60.00	
			2 2 min on white out		200.00	** 1 List
R.	ROB	ERT	S & SONS, London—			
PRE	-1919	SSUE	SS			
A2	C	26	*Actresses — 'FROGA A' (c1900)	H.20	£55.00	
A	C	25	*Armies of the World (c1900):	H.43		
			A 'Fine Old Virginia' back		£45.00	_
			B Plain back		£45.00	<u> </u>
A2	C	50	*Beauties — 'CHOAB' (c1900):	H.21		
			1-25 without borders to back		£65.00	-
			26-50 with borders to back		£85.00	_
A2	C	50	*Colonial Troops (c1902):	H.40		
			1-30 'Fine Old Virginia'		£40.00	-
			31-50 'Bobs Cigarettes'		£40.00	_
A	BW	28	*Dominoes (c1905)		£80.00	-
K1	C	52	*Miniature Playing Cards (c1905)		£50.00	
D2	C	? 24	*Nautical Expressions (c1900):	H.174		
			A 'Navy Cut Cigarettes' on front		£55.00	1 1 1 1 1 1 1 1 1 1 1 1 1 1 1 1 1 1 1
			B Firm's name only on front		£55.00	-1
A2	C	70	Stories without words (c1905)		£50.00	
A2	С	25	*Types of British and Colonial Troops (c1900)	H.76	£45.00	-
RO	BINS	ON	& BARNSDALE LTD, London—			
PRE	-1919 1	SSUE	S			
_	C	1	*Advertisement Card — Soldier, 'Colin Campbell			
			Cigars' (29 × 75mm) (c1897)		—	£110.00
-	BW '	? 24	*Actresses, 'Colin Campbell Cigars' (c1898):	H.375		
			A Size 43 × 70mm		£130.00	
			B Officially cut narrow — 32×70 mm		£130.00	
A		? 28	*Actresses, 'Cupola' Cigarettes (c1898)	H.376	£140.00	- 1 m
A1	P		*Beauties — collotype (c1895):	H.377		
		? 5	A 'Our Golden Beauties' back in black		£130.00	_
		? 10	B 'Nana' back in red on white		£130.00	-
		? 10	C 'Nana' back in vermillion on cream		£130.00	
A	C	? 1	*Beauties — 'Blush of Day' (c1898)	H.378	£130.00	
_	C '	? 13	*Beauties — 'Highest Honors' $(44 \times 73 \text{mm})$ (c1895)	H.379	£180.00	
E. I	ROBI	NSO	N & SONS LTD, Stockport		4	We se
	PRE-19					
A1	C	10	*Beauties 'ROBRI' (c1900)	H 374	£60.00	
4		? 38	Derbyshire and the Peak (c1905)		£90.00	W.J.
A2	C	25	Egyptian Studies (c1914)	11.300	£22.00	
		6	Medals and Decorations of Great Britain (c1905)	Ha 484	£130.00	100
A	C					

E. 1	ROBIN	IOS	N & SONS LTD, Stockport (continued)			
Size	Print-ing	Num in se		Handbook reference	Price per card	Complete set
A2 A2 A2	C C C	40 25 25	Nature Studies (c1912) Regimental Mascots (1916) Wild Flowers (c1915)		£20.00 £60.00 £18.00	£800.00 £450.00
B A	POST-1 C	920 I. 25	SSUE King Lud Problems (c1934)		£18.00	_
RC	MAN	STA	AR CIGARS—			
PRI	E-1919 I	SSUE	ES			
C A	C	? 26 25	*Actresses 'FROGA A' (c1900)		£120.00 £120.00	=
RC	THM	AN	S LTD, London—			
A	POST-1	920 I	SSUES			
D1	С	40 24	Beauties of the Cinema (1939): A Small size B Circular cards, 64mm diam:	Ha.605	£1.25	£50.00
	_		1 Varnished		£3.50 £3.50	£85.00 £85.00
A2 B C D1	P P U U	24 25 36 50	Cinema Stars — Small size (c1925) Cinema Stars — Large size (c1925) Landmarks in Empire History (c1936) Modern Inventions (1935)		£1.20 90p £1.10 £1.10	£30.00 £22.50 £40.00 £55.00
B2 D1 A2	P U BW	54 24 50	New Zealand (c1930) Prominent Screen Favourites (1934) 'Punch Jokes' (c1935)	Ha.568	80p 90p 50p	£43.00 £22.50 £25.00
B A1	POST-1 C C	30 5	Country Living (Consulate) (112 × 102mm) (1973) Rare Banknotes (1970)		£3.50	£15.00
C	MISCE	LLAN	NEOUS			
	C C	6 50	Diamond Jubilee Folders (127 × 95mm) (1950) International Football Stars (unissued) (1984)		£12.00	
		?	Metal Charms (c1930)		£3.00	
WI	M. RU	DD:	ELL LTD, Dublin and Liverpool—			
POS	ST-1920	ISSU	YES			
K	U	?	*Couplet Cards (c1925)		£11.00	
D	C	25	Grand Opera Series (1924)		£7.00	£175.00 £150.00
A2 D	C	25 50	Rod and Gun (1924)		£6.00 £3.20	£160.00
I. I	RUTT	ER	& CO., Mitcham			
	E-1919 I					
D	BW	15	*Actresses — 'RUTAN' (c1900): A Rubber-stamped on plain back B Red printed back	H.381	£60.00 £50.00	
A	BW	1	C Plain back	Ha 485	£35.00	£350.00
A D1	BW C	7 54	*Boer War Celebrities (c1901)	H.382	£45.00 £16.00	

I. I	RUTTI	ER &	CO., Mitcham (continued)			
Size	Print-ing	Num in se		Handbook reference	Price per card	Complete set
A C	BW C	20	Cricketers Series (1901)*Flags and Flags with Soldiers (c1902):	H.29 H.41	£250.00	_
		15 15	A Flagstaff Draped, 2nd printing	11.71	£24.00	_
			(a) white back		£24.00	_
			(b) cream back		£24.00	_
C	C	24	*Girls, Flags and Arms of Countries (c1900):	H.383		
			A Blue back		£35.00	1
٨	C	25	B Plain back	****	£25.00	-
A	C	25 25	Proverbs (c1905)	H.384	£40.00	
A	C	25	*Shadowgraphs (c1905)	H.44	£35.00	
S.I).V. T	OBA	ACCO CO. LTD, Liverpool			
PRI	E-1919 I	SSUE	ES			
A	BW	16	British Royal Family (c1901)	H.28	£180.00	10 (10 <u>10</u>)
				11.20	2100.00	
ST	. DUN	ISTA	AN'S, London—			
POS	ST-1920	ISSI	TF			
-	C	6	Famous Posters (folders) (65 × 41mm) (1923)	Ha.606	£22.00	_
ST	PET	ERS	BURG CIGARETTE CO. LTD, Portsmo	uth		
	E-1919 I		#####################################	utii-	4.3	
A	BW			TT 410	0250.00	
A	DW	: 11	Footballers (c1900)	H.410	£250.00	_
SA	LMO	N &	GLUCKSTEIN LTD, London—			
				100		
A	PRE-19					
_	C	1	*Advertisement Card ('Snake Charmer' Cigarettes)			
0	-	15	(73 × 107mm) (c1897)			£400.00
C	C	15	*Billiard Terms (c1905):			
			A Small numerals		£50.00	-
A	C	12	B Larger numerals	** 100	£50.00	_
A	C	12 30	British Queens (c1897)	Ha.480	£45.00	_
	C	30	*Castles, Abbeys and Houses (76 × 73mm) (c1906):		017.00	
					£17.00	
C	C	32	B Red back*Characters from Dickens (c1903)	11 205	£23.00	-
A	C	25	Coronation Series (1911)	H.385	£25.00	C225 00
_	Ü	25	*Famous Pictures — Brown photogravure (57 × 76mm)		£9.00	£225.00
			(c1910)	H 386	£9.00	£225.00
_	U	25	*Famous Pictures — Green photogravure (58 × 76mm)	11.500	27.00	2223.00
			(c1910)	H.387	£8.00	£200.00
A2	C	6	Her Most Gracious Majesty Queen Victoria (1897):	H.388		
			A Thin card		£50.00	£300.00
			B Thick card		£50.00	£300.00
A	C	50	The Great White City (c1908)		£11.00	£550.00
C	C	40	Heroes of the Transvaal War (1901)	H.389	£15.00	£600.00
C	C	30	*Music Hall Celebrities (c1902)		£50.00	-
_		26	*Occupations (64 × 18mm) (c1898)	H.390	£350.00	-
C	C	20	'Owners and Jockeys' Series (c1900)	H.392	£60.00	11 1 1 1 1 1 1 1 1 1 1 1 1 1 1 1 1 1 1
	C	48	*The Post in Various Countries $(41 \times 66 \text{mm})$ (c1900)		£23.00	
A2	C	6	*Pretty Girl Series — 'RASH' (c1900)	H.8	£65.00	-

SA	LMON	8 (GLUCKSTEIN LTD, London (continued)			
Size	Print-ing	Num in se		Handbook reference	Price per card	Complete set
	C	22	Shakespearian Series (c1902):	H.393		
	C	22	A Large format, frame line back (38 × 69mm) B Re-drawn, small format, no frame line back	11.393	£32.00	-
	C	25	(37 × 66mm)	H.30	£32.00	-
A	C	25	*Star Girls (c1900):	п.30	C120.00	
			A Red back		£120.00	
A	C	25	B Brown back, different setting		£120.00	
			A Large numerals		£11.00	£275.00
			B Smaller numerals, back redrawn		£12.00	£300.00
B	POST-1	920 I	SSUES			
D2	C	25	Magical Series (1923)		£5.00	£125.00
A2	C	25	Wireless Explained (1923)		£5.00	£125.00
C	SILKS					
	C	50	*Pottery Types (paper-backed) (83 × 55mm) (c1915):			
			A Numbered on front and back		£3.50	
			B Numbered on back only		£3.50	
W.	SANI	OOR	RIDES & CO. LTD, London————			
nos	T 1020	ICCI	TEC			
POS	ST-1920			Ha 607		
-	U	25	Aquarium Studies from the London Zoo (1925):	Ha.607		
C2			A Small size:		£3.20	£80.00
			1 Small lettering on back			
			2 Larger lettering on back		£3.20	£80.00
B1			B Large size	II. 520	£3.20	£80.00
	C	25	Cinema Celebrities (1924):	Ha.530	02.60	065.00
C2			A Small size		£2.60	£65.00
_			B Extra-large size $(109 \times 67 \text{mm})$		£4.00	£100.00
	C	25	Cinema Stars (export) (c1924):	Ha.530		
C2			A Small size, with firm's name at base of back		£6.00	
C2			B Small size, 'Issued with Lucana Cigarettes		£6.00	_
C2			C Small size, 'Issued with Big Gun Cigarettes'		£8.00	_
_			D Extra-large size $(109 \times 67 \text{mm})$ 'Issued with Big			
			Gun Cigarettes		£2.40	£60.00
_			E Extra-large size (109 \times 67mm) issued with			
			Lucana 66		£7.00	_
	U	50	Famous Racecourses (1926) — 'Lucana':	Ha.608		
C2			A Small size		£2.80	£140.00
B1			B Large size		£3.80	£190.00
C2	U	50	Famous Racehorses (1923):	Ha.609		
			1A Back in light brown		£2.80	£140.00
			1B Back in dark brown		£2.80	£140.00
			2 As 1A, with blue label added, inscribed 'Issued			
			with Sandorides Big Gun Cigarettes'		£12.00	
A	C	25	Sports & Pastimes — Series 1 — 'Big Gun Cigarettes			
			(c1924)	H.225	£12.00	
			(61)21)			
SA	NSON	I'S	CIGAR STORES, London—			
PDI	E-1919 I	CCIT	7			
IKL	P P	? 2	*London Views (52 × 37mm) (c1915)		£200.00	
	r	: 4	London views (32 × 3/mm) (C1913)		2200.00	
NI	СНОІ	AS	SARONY & CO., London—			
A	PRE-19			11 204	0200	
	U	? 2	Boer War Scenes $(67 \times 45 \text{mm}) (c1901) \dots$	п.394	£200.00	_

NICHOLAS SARONY & CO., London (continued)

Size	Print-ing	Num in se		Handbook reference	Price per card	Complete set
B	POST-1	920 IS	SSUES			
	C	50	Around the Mediterranean (1926):	Ha.610		
C2			A Small size		90p	£45.00
B1			B Large size		£1.00	£50.00
	U	25	Celebrities and Their Autographs, Nd 1-25 (1923):			
C1			A Small size		80p	£20.00
B1			B Large size		80p	£20.00
	U	25				
C1			A Small size:			
			1 Small numerals		80p	£20.00
B1			2 Large numerals		80p	£20.00
DI			B Large size: 1 Small numerals		00-	cao oo
					80p	£20.00
	U	25	2 Large numerals		80p	£20.00
C1	C	23	A Small size		80p	£20.00
B1			B Large size		80p	£20.00
-	U	25	Celebrities and Their Autographs, Nd 76-100 (1925):		вор	220.00
C1			A Small size		80p	£20.00
B1			B Large size		80p	£20.00
A2	U	50	Cinema Stars — Set 7 (1933)	Ha.515-7	£1.20	£60.00
_	U		Cinema Stars — Postcard size (137 × 85mm):			
		38	'of a Series of 38 Cinema Stars' (1929)		£9.00	_
		42	'of a second Series of 42 Cinema Stars' (c1930)		£4.50	£190.00
		50	'of a third Series of 50 Cinema Stars' (c1930)		£4.50	£225.00
		42	'of a fourth Series of 42 Cinema Stars' (c1931)		£4.50	£190.00
D	**	25	'of a fifth Series of 25 Cinema Stars' (c1931)		£4.50	£110.00
D	U C	25	Cinema Studies (1929)		£1.10	£27.50
C2	C	25	A Day on the Airway (1928): A Small size		C1 00	625.00
B2					£1.00	£25.00
A2	P	54	8	II. 556	£1.20	£30.00
AZ	BW	25	Life at Whipsnade Zoo (1934) Links with the Past — First 25 subjects, Nd 1-25	Ha.550	55p	£30.00
	ъ.,	23	(1925):			
C1			A Small size		36p	£9.00
В			B Large size		36p	£9.00
	BW	25	Links with the Past — Second 25 subjects (1926):		Зор	27.00
C			A Home issue, Nd 26-50:			
			1 Small size		30p	£7.50
В			2 Large size, descriptive back		24p	£6.00
В			3 Large size, advertisement back		£1.60	<u> </u>
			B Sydney issue, Nd 1-25:			
C			1 Small size		60p	£15.00
В			2 Large size		60p	£15.00
-			C Christchurch issue, Nd 1-25:			
C			1 Small size		50p	£12.50
В	DW	25	2 Large size		40p	£10.00
	BW	25	Museum Series (1927):			
C2			11 Home issue.		20	07.50
B			1 Small size		30p	£7.50
В			2 Large size, descriptive back		30p	£7.50
В			B Sydney issue, large size		60p	£15.00 £12.50
			C Christchurch issue:		50p	112.30
C2			1 Small size		50p	£12.50
В			2 Large size		50p	£12.50
					БОР	2.2.00

NIC	CHOL	AS S	ARONY & CO., London (continued)			
Size	Print-ing	Num in se		Handbook reference	Price per card	Complete set
	P	36	National Types of Beauty (1928):	Ha.558		
A2	•	50	A Small size		32p	£12.00
_			B Medium size (76 × 51mm)		32p	£12.00
	C	15	Origin of Games (1923):		02.70	055.00
A			A Small size		£3.70 £3.70	£55.00 £55.00
B2		50	B Large size	Ha.557	13.70	£33.00
D2	C	50	'Saronicks' (1929): A Small size	11a.337	32p	£16.00
D2			B Medium size (76 × 51 mm)		32p	£16.00
	C	50	Ships of All Ages (1929):			
D			A Small size		60p	£30.00
_			B Medium size $(76 \times 52 \text{mm})$		70p	£35.00
D	C	25	Tennis Strokes (1923)		£2.80	£70.00
T. 5	S. SAU	JNT,	, Leicester—			
	-1919 1					
D	C	30	*Army Pictures, Cartoons etc (c1916)	H.12	£75.00	_
			CO-OPERATIVE WHOLESALE SOCIETY	LTD, Gla	asgow	
('S.	C.W.	S.')-		The Park The Are		
POS	T-1920	ISSU	YES			
A2	C	25	Burns (1924):	Ha.611		
			A Printed back:		00.00	
			1 White card		£2.20	C25 00
			2 Cream card		£1.40 £6.00	£35.00
-		20	*B Plain back	Н 211	£10.00	
C A2	C	20 25	Dogs (1925)	Ha.612	210.00	7.59
AZ	C	23	Dwellings of All Nations (1924): A Printed back:	114.012		
			1 White card		£3.50	_
			2 Cream card		£2.20	£55.00
			*B Plain back		£6.00	
В	C	25	Famous Pictures (1924)		£7.00	_
H2	C	25	Famous Pictures — Glasgow Gallery (1927):			
			A Non-adhesive back		£2.20	£55.00
			B Adhesive back		£1.40	£35.00
H2	C	25	Famous Pictures — London Galleries (1927):		£2.20	£55.00
			A Non-adhesive back		£1.40	£35.00
A2	C	50	B Adhesive back		21.40	233.00
AZ	C	30	A Grey borders		£2.00	£100.00
			B White borders:			
			1 Non-adhesiveback		£2.00	£100.00
			2 Adhesive back		£1.40	£70.00
A	C	25	Racial Types (1925)		£8.00	£200.00
A2	C	50	Triumphs of Engineering (1926):			0100.00
			A Brown border		£2.00	£100.00
	_		B White border		£2.00	£160.00
A2	C	50	Wireless (1924)		£3.20	£160.00
SE	LBY'	STO	OBACCO STORES, Cirencester—			-
	T-1920					
	U	12	'Manikin' Cards (79 × 51mm) (c1920)		£70.00	_
	U	14	Transition Cardo (12 / 2 Ithin) (C12 20)			

			SNOWDEN, London	100000		1111
Size		it- Nun	프로그램은 대통령이 되었습니다. 살아보고 그는 말리 얼마나 이 경에 가장이 이 이번 때문에 모르기 위에 되었다.	Handbook		Complete
	ing	in se		reference	per card	set
		9 ISSU				
A	U	? 1 ? 21	*Views of England (c1905)	11 205	£130.00	_
A	U	: 21	*Views of London (c1905)	H.395	£130.00	-
W.	J. S	HEPE	IERD, London—			
PRI	E-191	9 ISSU	ES			
A	U	25	*Beauties — 'FECKSA' (c1900)	H.58	£85.00	-
SH	OR	Γ'S, I	London————			
POS	ST-192	20 ISSU	UE			
-	BW		*Short's House Views (c1925):	Ha.562		
		? 13	1 Numbered (75 × 60mm)		£50.00	_
		. ? 8	2 Unnumbered (77 × 69mm)		£40.00	-
JO	HN	SINC	LAIR LTD, Newcastle-on-Tyne		1	100
		1919 19	프로젝트 전략			
D2	U	? 69	*Actresses (42 × 63 mm) (c1900)	Н 306	£65.00	
D	P	? 52	Football Favourites (c1910)	11.390	£85.00	V-m
A	BW		*North Country Celebrities (c1905)	H.397	£65.00	£260.00
D	P	? 55	Northern Gems (c1902)		£55.00	_
A	C	50	Picture Puzzles and Riddles (c1910)		£22.00	_
A	C	50	Trick Series (c1910)		£24.00	
D2	C	50	World's Coinage (c1915)	H.398	£17.00	£850.00
B		-1920 1	SSUES			
\overline{c}	P	0.20	*Birds (1924):	Ha.613		
		? 30	A Small size, back 'Specimen Cigarette Card'		£6.00	_
C		48	B Small size, descriptive back:			
			1 White front		£1.80	_
		50	2 Pinkish front		£1.80	-
A	C	50 50	C Large size (78 × 58mm)		£5.00	
A	P	50	British Sea Dogs (1926)		£4.50	£225.00
A2	r	54	Champion Dogs — 'A Series of' (1938): A Small size			
B2		52			75p	£40.00
DZ	P	32			75p	£40.00
A2	1	54				
B2		52			£2.50	£130.00
A2	P	50			£3.00	
A	P	54	English and Scottish Football Stars (1935)		£1.30	£65.00
A	P	54	Film Stars — 'A Series of 54 Real Photos' (1934) Film Stars — 'A Series of Real Photos', Nd 1-54 (1937)		£1.60	£85.00
A	P	54	Film Stars — 'A Series of Real Photos', Nd 1-54 (1937) Film Stars — 'A Series of Real Photos', Nd 55-108		£1.40	£75.00
**		54	(1937)		61.00	065.00
	P			Ha.614	£1.20	£65.00
C		? 24	A Small size, back 'Specimen Cigarette Card'		£6.00	
C		96	B Small size, descriptive back:		20.00	
			1 White front		£2.00	
			2 Pinkish front		£2.00	
_		? 48	C Large size, 78 × 58mm		£6.00	THE THE
A	P	54	Radio Favourites (1935)		£1.50	£80.00
K2	C	53	Rubicon Cards (miniature playing cards) (c1935)		£6.00	200.00
A	BW	50	Well-Known Footballers — North Eastern Counties		20.00	
			(1938)		£1.20	£60.00
A	BW	50	Well-Known Footballers — Scottish (1938)		£1.20	£60.00
			200000 (1900)		21.20	200.00

Size		it- Num	ber	Handbook	Price	Complete
	ing	in se	rt	reference	per card	sei
\boldsymbol{C}	SILK	S				
_	C		*Flags — Set 2 (70 × 52mm) (unbacked and anony-			
			mous) (c1915):	Ha.501-2		
		? 12	A Numbered Nos 25-36		£14.00	
		224	B Unnumbered:		00.00	
		? 24	1 Caption in red		£8.00	_
		? 20	2 Caption in myrtle-green		£6.50 £6.50	
		? 23	4 Caption in blue		£8.00	
		? 25	5 Caption in black		£10.00	
	C	. 23		Ha.501-11	210.00	
	_	50	'Fourth Series' (49 × 70mm)	114.501 11	£6.00	
		50	'Fifth Series' (49 × 70mm)		£6.00	_
		50	'Sixth Series':			
			1 Nos 1-25 (49 × 70mm)		£7.00	_
			2 Nos 26-50 (68 \times 80mm)		£7.00	_
	-	? 10	<i>'Seventh Series'</i> (115 × 145mm)		£45.00	_
_	C	? 1	The Allies $(140 \times 100 \text{mm})$ (Numbered 37) $(c1915)$			£35.00
_	C	50	*Regimental Badges I (paper backed) $(70 \times 52 \text{mm})$	II. 500 1	05.00	
	C	? 24	(c1915)	Ha.502-1	£5.00	_
100	C	: 24		Ha.502-7		
			1 Nos 38-49 (No. 49 not seen) $(76 \times 70 \text{mm})$	Ha.302-7	£13.00	
			2 Nos 50-61 (65 × 51mm)		£13.00	Spirit Control
RO	BEI	RT SI	NCLAIR TOBACCO CO. LTD, Newcastl	e-on-Tvne		
			그러지 않는 아이들은 사람들은 사람들이 되었다.			
A A	U U	1919 IS 28			£50.00	
A	BW		Dominoes (c1900)	Н 300	£30.00	_
D	C	12	*Policemen of the World (c1899)		£130.00	1 100 100
		-1920 I.		11.101	2150.00	
C2	C	1,201,	Billiards by Willie Smith (1928):			
-	_	10	1 First set of 10		£8.00	£80.00
		15	2 Second Set of 15		£8.00	£120.00
		3	3 Third Set of 25 (Nos 26-28 only issued)		£15.00	£45.00
	C	12	The 'Smiler' Series (1924):			
A			A Small size (inscribed ' 24 cards'),		£6.00	_
H			B Large size		£10.00	_
C .		S. Unbo	acked silks, inscribed with initials 'R.S.' in circle.			
-	C	4	*Battleships and Crests (73 × 102mm) (c1915)		£50.00	_
-	C	?9	*Flags (70 × 51 mm) (c1915)	Ha.499-2	£26.00	,
-	C	? 6	*Great War Area — Cathedrals and Churches (140 ×			
	-	0.10	102mm) (c1915)		£38.00	_
_	C	? 10	*Great War Heroes (70 × 51 mm) (c1915)		£32.00	CEO 00
	C	? 5	*Red Cross Nurse (73 × 102mm) (c1915)		626.00	£50.00
	C	: 3	*Regimental Badges (70 × 51 mm) (c1915)	па.499-0	£26.00	- · · · · -
J. S	SINE	FIELD), Scarborough—			
PRE	-1919	ISSUE				
A	U	? 24	*Beauties — 'HUMPS' (c1900)	H.222	£200.00	_
CIN	ICI	ETO	J & COLE LTD Shramahaan			
			N & COLE LTD, Shrewsbury—			
AA	PRE-	1919 IS 50	*Atlantic Liners (1910)		£17.00	1050.00
11		50	Auditic Linels (1910)		£17.00	£850.00

SIN	GLE	TON	& COLE LTD, Shrewsbury (continued)			
Size	Print- ing	- Num in se		Handbook reference	Price per card	Complete set
D1	BW	50	*Celebrities — Boer War Period (c1901):	H.400		
			25 Actresses		£17.00	£425.00
			25 Boer War Celebrities		£17.00	£425.00
A	BW	35	Famous Officers — Hero Series (1915):			
			A1 'Famous Officers' on back toned card		£14.00	£490.00
			A2 'Famous Officers' thin white card		£35.00	_
			B 'Hero Series' on back		£180.00	_
D1	BW	50	*Footballers (c1905)		£90.00	_
C	C	40	*Kings and Queens (1902)		£18.00	_
A	C	25	Maxims of Success (c1905):	H.401	22.5.00	
			A Orange border		£25.00	-
	DW		B Lemon yellow border	TT 400	£125.00	_
A	BW	0	Orient Royal Mail Line (c1905):	H.402	045.00	
		8	A 'Orient-Pacific Line' Manager's back		£45.00	_
		8	B 'Orient Royal Mail Line' Singleton and Cole		045.00	
		2.12	back		£45.00	
A	C	? 12 25	C 'Orient Line' Manager's back		£45.00	
			Wallace Jones — Keep Fit System (c1910)		£20.00	-
A	C	25	Bonzo Series (1928)		£7.00	£175.00
A2	BW	35			17.00	11/3.00
AZ	DW	33	Famous Boxers (1930): A Numbered		£12.00	
			B Unnumbered		£40.00	
A2	BW	25	Famous Film Stars (1930)		£8.00	
_	U	12	'Manikin' Cards (79 × 51mm) (c1920)	H 481	£70.00	
C	SILKS				270.00	
_	C	110	Crests and Badges of the British Army (paper-backed)			
			(66 × 40mm) (c1915)	Ha.502-2	£4.00	_
			TH, Glasgow—		14 0 g	
			book available — £3.50			
		919 IS				
A	C	25	*Advertisement Cards (1899)	H.403	£200.00	
A	C	50	Battlefields of Great Britain (1913)	Ha.475	£12.00	£600.00
A1	BW	25	*Boer War Series 'Studio' Cigarettes back (1900)		£60.00	_
A	C	50	*Boer War Series (1900)		£24.00	
D	BW		*Champions of Sport (1902):	H.404	065.00	
		50	Red back. Numbered		£65.00	
	**	50	Blue back. Unnumbered		£75.00	-
A	U	50	Cricketers (1912)		£13.00	£650.00
A	U	20	Cricketers, 2nd Series, Nd 51-70 (1912)		£30.00	£600.00
A	C	50 50	Derby Winners (1913)		£12.00	£600.00
D	U	120	Famous Explorers (1911)		£12.00	£600.00
A	U	50	*Footballers, blue back Nd 1.52 (Nos. 1 and 13 not		£28.00	
A	U	30	*Footballers, blue back Nd 1-52 (Nos 1 and 13 not issued) (1910):			
					611.00	
					£11.00	20012-013
	U	50			£11.00	
A	U	50	*Footballers, blue back. Nd 55-104 (Nos 53 and 54 not			
			issued) (1910):		C11 00	
			A Black portrait		£11.00	
٨	U	150			£11.00	de 1 1 1 1 1 1 1 1 1 1 1 1 1 1 1 1 1 1 1
A	U	130	*Footballers, yellow frame line (1914): A Pale blue back		£11.00	
			B Deep blue back		£11.00	_
			B Deep blue back		£11.00	

F.	& J. SI	ит	H, Glasgow (continued)			
Siz	e Print-	Nun in se		Handbook reference	Price per card	Complete set
A A A	C C	50 50	Football Club Records, 1913 to 1917 (1918) Fowls, Pigeons and Dogs (1908) *Medals:		£13.00 £8.00	£650.00 £400.00
11		20 50 50	A Unnumbered — thick card (1902)		£12.00 £8.00	£240.00 £400.00
		50	card (1903)		£32.00	
A	C	50	thin card (1906)	H.172	£9.00	£450.00 £450.00
Α	C	50	B Non-descriptive back (1914) *Phil May Sketches, blue-grey back (1908)	H.72	£9.00 £8.00	£450.00 £400.00
A	C	40	Races of Mankind (1900): A Series title on front	Ha.483	£45.00	_
A	C	25	*B Without series title Shadowgraphs (1915)	H.466	£60.00 £6.00	£150.00
A	С	50	*A Tour Round the World: A Script Advertisement back (1904)		£22.00 £40.00	_
A A	C BW	50 25	A Tour Round the World (titled series) (1906) War Incidents (1914):	H.75 H.405	£8.00	£400.00
			A White back	II 405	£6.00 £6.00	£150.00 £150.00
A	BW	25	War Incidents, 2nd series (1915): A White back	H.405	£6.00 £6.00	£150.00 £150.00
В	POST-1	920 I				
A A A	C C C	25 50 25	'Cinema Stars' (1920) Football Club Records, 1921-22 (1922) Holiday Resorts (1925)	Ha.615	£8.00 £13.00 £7.00	£200.00 £650.00 £175.00
A A	C C	50 50	Nations of the World (1923)	H.454 Ha.72	£6.00 £5.50 £10.00	£300.00 £275.00 £250.00
A	С	25	Prominent Rugby Players (1924)		110.00	2230.00
SN	ELL &	& C	O., Plymouth and Devonport			
PR A	E-1919 I BW	SSUI 25	*Boer War Celebrities — 'STEW' (c1901)	H.105	£130.00	, i.e. 1
SC	CIET	E J	OB, London (and Paris)			
A	PRE-19	19 IS	SUES	VI 106	010.00	0450.00
D D	BW BW	25 25	*Dogs (1911)	H.406 H.407	£18.00 £30.00	£450.00

51	TELL	a c	O., Flymouth and Devonport	deposit vel		
PK	E-1919	ISSU	E			
A	BW	25	*Boer War Celebrities — 'STEW' (c1901)	H.105	£130.00	_
S	OCIET	ге ј	OB, London (and Paris)			
A	PRE-1	919 15	SUES			
D	BW	25	*Dogs (1911)	H.406	£18.00	£450.00
D	BW	25	*Liners (1912)	H.407	£30.00	_
D	BW	25	*Racehorses — 1908-09 Winners (1909)	H.408	£18.00	£450.00
B	POST-	1920 1	SSUES			
A	C	25	British Lighthouses (c1925)		£5.60	£140.00
_	U		*Cinema Stars (c1926):	Ha.616		
		48	A Unnumbered size $(58 \times 45 \text{mm})$:			
			1 Complete Set		_	£65.00
			2 46 different (minus Love, Milovanoff)		90p	£42.00
		43	B Unnumbered size (58 × 36mm)		£3.00	_
		?	C Numbered		£4.00	_
			109			
			107			

SOCIETE JOB, London (and Paris) (continued)			
Size Print- Number ing in set	Handbook reference	Price per card	Complete set
D1 C 52 *Miniature Playing Cards (c1925) A2 C 25 Orders of Chivalry (1924) A2 C 25 Orders of Chivalry (Second series) (1927) A2 C 3 Orders of Chivalry (unnumbered) (1927)		£7.00 £3.00 £3.00 £8.00	£75.00 £75.00 £24.00
LEON SOROKO, London			
POST-1920 ISSUE — U 6 Jubilee series (1935): A Small size (75 × 41mm)		£30.00 £30.00	Ξ
SOUTH WALES TOB. MFG CO. LTD, Newport and	London-		
PRE-1919 ISSUES A BW ? 91 Game of Numbers (c1910) A U 25 *Views of London (c1910)		£60.00 £22.00	£550.00
SOUTH WALES TOBACCO CO. (1913) LTD, Newpo	rt——		
PRE-1919 ISSUE D C 30 *Army Pictures, Cartoons, etc. (c1916)	H.12	£75.00	-
S.E. SOUTHGATE & SON, London—			
PRE-1919 ISSUE A1 C 25 *Types of British and Colonial Troops (c1900)	H.76	£100.00	_
T. SPALTON, Macclesfield—			
PRE-1919 ISSUE D C 30 *Army Pictures, cartoons etc (c1916)	H.12	£75.00	_
SPIRO VALLERI & CO—			
PRE-1919 ISSUE A BW ? 10 Noted Footballers (c1905)		£250.00	_
G. STANDLEY, Newbury	7.64.7		
POST-1920 ISSUE — U 12 'Manikin' Cards (79 × 51mm) (c1920)	Ha.481	£70.00	
A. & A.E. STAPLETON, Hastings—			
POST-1920 ISSUE — U 12 *'Manikin' Cards (79 × 51mm) (c1920)	Ha.481	£70.00	-
H. STEVENS & CO., Salisbury	No pener		144 A
POST-1920 ISSUES A1 C 20 *Dogs (1923) A1 U 25 *Zoo series (1926)	H.211 Ha.588	£8.00 £5.50	=
A. STEVENSON, Middleton—			
PRE-1919 ISSUE A U 50 War Portraits (1916)	H.86	£65.00	_

			OCKWELL, Porthcawl	Handbook	Dwine	Complete
Size	Print ing	in se		reference	per card	Complete set
PRE	E-1919	ISSUI	E			
D	C	30	*Army Pictures, Cartoons, etc (c1916)	H.12	£75.00	_
ST	RAT	нмс	ORE TOBACCO CO. LTD, London——			
POS	ST-1926	O ISSU	VE			
_	U	25	British Aircraft (76 × 50mm) (1938)		£2.40	£60.00
TA	DDY	& C	CO., London—			
			book available — £3.50			
PKE	E-1919 U	? 72	*Actresses — collotype (40 × 70mm) (c1897)	H 411	£90.00	
A	C	25	*Actresses — with flowers (c1900)	11.411	£80.00	
A	\widetilde{BW}	37	Admirals and Generals — The War (c1915):			
1830			A 25 Commoner Cards	H.412	£15.00	_
			B 12 Scarce Cards (Nos 8, 9, 10, 13, 14, 17, 18, 21,			
			22, 23, 24, 25)		£40.00	-
A	BW	25	Admirals and Generals — The War (South African			
	-		printing) (c1915)	TT 412	£35.00	C400.00
A	C	25	Autographs (c1910)	H.413	£16.00	£400.00
A	C	20	Boer Leaders: (c1901) A White back		£18.00	£360.00
			B Cream back		£18.00	2300.00
A	C	50	British Medals and Decorations — Series 2 (c1905)		£10.00	£500.00
A	C	50	British Medals and Ribbons (c1903)		£10.00	£500.00
A	C	20	*Clowns and Circus Artistes (c1915)	H.414	£700.00	_
C2	Č	30	Coronation series (1902):			
			A Grained card		£20.00	£600.00
			B Smooth card		£20.00	£600.00
A	BW	238	County Cricketers (c1907)	H.415	£40.00	_
A	C	50	Dogs (c1900)		£25.00	
C	U	5	*English Royalty — collotype (c1898)	H.416	£600.00	A
A	C	25	Famous Actors — Famous Actresses (c1903)		£16.00	£400.00
A	$_{\mathrm{BW}}$	50	Famous Horses and Cattle (c1912)		£95.00	_
A2	C	25	Famous Jockeys (c1905):	H.417	026.00	0.000.00
			A Without frame line — blue title		£26.00	£650.00
	DIV	50	B With frame line — brown title	II 410	£24.00	£600.00
A	BW	50	Footballers (export issue) (c1906)	п.418	£65.00 £16.00	£400.00
A	C	25 25	'Heraldry' series (c1910)		£18.00	£450.00
A C	C	10	Honours and Ribbons (c1910)		£65.00	£650.00
C	BW	60	Leading Members of the Legislative Assembly (export		205.00	2050.00
C	BW	00	issue) (c1900)		£500.00	_
A	C	25	*Natives of the World (c1900)	H.419	£60.00	_
A	C	25	Orders of Chivalry (c1911)		£16.00	£400.00
A	C	25	Orders of Chivalry, second series (c1912)		£22.00	£550.00
A	BW		Prominent Footballers — Grapnel and/or Imperial			
			back:	H.420		
		? 595	A without 'Myrtle Grove' footnote (1907)		£12.00	_
		? 405	B with 'Myrtle Grove' footnote (1908-9)		£12.00	_
A	BW '	? 375	Prominent Footballers — London Mixture back			
			(1913-14)		£30.00	-
-	C	20	*Royalty, Actresses, Soldiers $(39 \times 72 \text{mm})$ (c1898)	H.421	£180.00	0407.00
A	C	25	'Royalty' series (c1908)		£17.00	£425.00
A	C	25	*Russo-Japanese War (1-25) (1904)		£16.00	£400.00
A	C	25	*Russo-Japanese War (26-50) (1904)		£22.00	£550.00

TADDY	&	CO.,	London	(continued)
--------------	---	------	--------	-------------

			in Donata (communica)			
Size	Print- ing	Num in se		Handbook reference	Price per card	Complete set
A	BW	16	South African Cricket Team 1907	H 422	£60.00	
A	BW	26	South African Football Team 1906-07		£22.00	_
A	C	25	Sports and Pastimes — Series 1 (c1912)	H.225	£18.00	£450.00
A	C	25	Territorial Regiments — Series 1 (1908)		£18.00	£450.00
A	C	25	Thames series (c1903)		£32.00	£800.00
C	C	20	Victoria Cross Heroes (1-20) (c1900)		£55.00	_
C	C	20	Victoria Cross Heroes (21-40) (c1900)		£55.00	_
A	C	20	VC Heroes — Boer War (41-60) (1901):			
			A White back		£16.00	-
		20	B Toned back		£16.00	£320.00
A	C	20	VC Heroes — Boer War (61-80) (1901): A White back		016.00	
					£16.00	c220 00
A	C	20	B Toned back		£16.00	£320.00
11	-	20	A White back		£18.00	
			B Toned back		£18.00	£360.00
A	C	25	Victoria Cross Heroes (101-125) (1905)		£50.00	2300.00
A2	BW	2	*Wrestlers (c1910)	H 424	£300.00	
				11.121	2500.00	
TA	DDY	& C	O., London and Grimsby			
POS	T-1940	ISSI	ES			
_	C	8	Advertisement Cards, three sizes (1980)		60p	£5.00
A	C	26	Motor Cars, including checklist (1980):		оор	23.00
			A 'Clown Cigarettes' back		40p	£10.00
			B 'Myrtle Grove Cigarettes' back		40p	£10.00
A	C	26	Railway Locomotives including checklist (1980):			210.00
			A 'Clown Cigarettes' back		40p	£10.00
			B 'Myrtle Grove Cigarettes' back		40p	£10.00
w.	& M.	TAY	YLOR, Dublin—			
PRE	-1919 I	SSIJE	'S			
A	C	8	European War series (c1915):	H.129		
	Č		A 'Bendigo Cigarettes' back	H.129	£45.00	
			B 'Tipperary Cigarettes' back		£45.00	
A	U	25	*War series — 'Muratti II' (c1915):	H.290	243.00	
			A 'Bendigo Cigarettes' back	11.270	£60.00	
			B 'Tipperary Cigarettes' back		£14.00	£350.00
			11 , 5		211.00	2550.00
TA	YLOF	W	OOD, Newcastle—			
PRE	-1919 I	SSIIE				
C	C	18	Motor Cycle series (c1914)	Ua 160	£75.00	
	Ŭ	10	Motor Cycle series (C1714)	11a.409	175.00	
TE	OFAN	II &	CO. LTD, London—			
A	POST-1	920 H	OME ISSUES			
			Cards inscribed with Teofani's name.			
A2	C	24	Past and Present — Series A — The Army (1938):			
			A With framelines		£2.00	£50.00
			B Without framelines		£1.50	£36.00
A2	C	24	Past and Present — Series B — Weapons of War (1939)		80p	£20.00
A2	C	4	Past and Present — Series C — Transport (1940)		£4.00	
B	POST-1	920 E.	XPORT ISSUES			
			Cards mostly without Teofani's name.			
			그리고 가장 살았다. 하면 하는 것 같아요 하는 것이 그 사람이 되었다. 그런 그 사람이 되었다. 그는 것이 그 사람이 되었다.			

TEOFANI & CO. LTD, London (continued)

		,		oo, Erb, Bondon (commun)			1000
S	lize	Print-ing	Num in se		Handbook reference	Price per card	Complete set
(22	U	25	Aquarium Studies from the London Zoo ('Lucana' cards with green label added, inscribed 'Issued with			
Г	01	U	50	Teofani Windsor Cigarettes') (c1925)	Ha.607 Ha.617	£11.00	_
-				A 'Presented with Broadway Novelties' B 'Presented with these well-known choice cigar-		£5.00	_
				ettes'		£3.50	_
		C	25	Cinema Stars (c1928):	Ha.530		
				1 Anonymous printings:		26.50	
(2			A Small size		£6.50	_
				B Extra-large size (109 × 67mm) 2 Teofani printings:		£6.50	_
(22			A Small size — 'Issued with Blue Band Cig-		67.00	
				arettes		£7.00 £7.00	_
	22			B Small size — 'Three Star Cigarettes' C Small size — 'Three Star Magnums'		£6.50	_
	C2			D Extra-large size (109 × 67mm) — 'Three		20.50	
				Star Magnums'		£6.50	_
Ι)	U	25	*Famous Boxers — 'Issued with The 'Favourite Mag-			
				nums' (c1925)	Ha.579	£8.00	- I
(22	P	32	Famous British Ships and Officers — 'Issued with		00.00	00,00
				these High Grade Cigarettes' (1934)		£2.80	£90.00
ŀ	31	U	50	Famous Racecourses ('Lucana' cards with mauve label added, inscribed 'Issued with The Favourite Cigar-			
				ettes' (c1926)	Ha.608	£15.00	_
1	A	U	? 24	Famous Racehorses (c1925)	714.000	£12.00	_
_	_	BW	12	*Film Actors and Actresses (56 × 31mm) (plain back)			
				(1936)	Ha.618	£1.00	£12.00
(22	C	20	Great Inventors (c1924)		£4.50	_
F	A	C	20	*Head Dresses of Various Nations (plain back) (c1925)		£12.00	£6.00
-	_	BW	12	*London Views (57 × 31mm) (plain back) (c1936)		50p 90p	£45.00
)2	U C	48 50	Modern Movie Stars and Cinema Celebrities (1934)		£14.00	243.00
(4	U	50	Public Schools and Colleges — 'Issued with these Fine	114.017-2	214.00	
				Cigarettes' (c1924)	Ha.575	£3.60	_
Ι)	C	50	Ships and Their Flags — 'Issued with these well-known	На 602	£2.80	£140.00
1	A	С	25	cigarettes' (c1925)	11a.002	12.00	2140.00
				ettes always' (c1925)	H.225	£14.00	_
-	-	P	22	*Teofani Gems I — Series of 22 (53 \times 35mm) (plain	11 (21.1	ć2.00	
			20	back) (c1925)	Ha.621-1	£3.00	_
-	-	P	28	*Teofani Gems II — Series of 28 (53 × 35mm) (plain back) (c1925)	Ha.621-2	£1.00	· · · · ·
		P	36	*Teofani Gems III — Series of 36 (53 \times 35mm) (plain	11a.021-2	21.00	
10		1	50	back) (c1925) pseudo of 50 (55 × 55mm) (ptant	Ha.621-3	£3.00	_
_	_	P	2	Teofani Gems — Unnumbered (53 × 35mm) (plain			
				back) (c1925)		£3.00	£6.00
A	42	P	36	Views of the British Empire — 'Issued with these Famous Cigarettes' (c1928):			
				A Front in black and white		£1.00	£36.00
				B Front in light brown		£1.00	£36.00
(C	U	50	Views of London — 'Issued with these World Famous		02.22	
	70		2.4	Cigarettes' (c1925)	Ha.5/7	£2.20 £6.00	oren er fall
	C2	U C	24 50	Well-Known Racehorses (c1924)		£14.00	
	A C	U	50	Zoological Studies (c1924)		£3.50	_
,		0	50	Louis Judios (C1724)			

	Prin ing	t- Num in se		Handbook	Price	
nn				reference	per card	se
A2		ISSUE 1		TT 105		
A	U	50	*'The Allies' (grouped flags) (c1915)	H.425	065.00	£250.00
D	C	25	War Portraits (c1916) World's Coinage (1914)	H.80	£65.00	
	C	23	world's Comage (1914)	H.398	£50.00	-
TH	IEM.	ANS	& CO., Manchester—			
		1919 IS				
A	C	? 2	*Advertisement card with Riddles (c1913)	H.426	£200.00	
A1	C	? 1	Allied Flags ('United Strength' in centre) (c1915)	Ha.486	£350.00	
A	_	55	Dominoes (Sunspot brand issue) (c1914)		£80.00	
C	C	18	Motor Cycle series (c1914)	Ha.469	£65.00	
A	U	50	*War Portraits (1916)	H.86	£40.00	<u> </u>
_		14	War Posters (63 × 41 mm) (c1916)		£150.00	
3	SILKS	S				
			Anonymous silks with blue border, plain board backing.			
			Reported also to have been issued with firm's name			
	C		rubber stamped on backing.			
	C	?8	*Miscellaneous Subjects (c1915):	Ha.500		
		?3	Series B1 — Flags (50 × 66mm)		£10.00	100 - 1
			Series $B2 - Flags (50 \times 66mm)$		£10.00	-
		? 12	Series $B3$ — Regimental Badges (50×66 mm)		£7.00	
		?7	Series B5 — British Views and Scenes $(50 \times 66mm)$		£20.00	-
		? 48	Series $B6$ — Film Stars $(50 \times 66mm)$		£10.00	
		? 2	Series C1 — Flags (65 × 55mm)		£10.00	-
		?3	Series C2 — Flags (70 × 65mm)		£10.00	_
		? 4	Series C3 — Regimental Badges (64 × 77mm)		£10.00	-
		? 2	Series C4 — Crests of Warships (64 × 77mm)		£10.00	
		? 1	Series D1 — Royal Standard (138 \times 89mm)		£15.00	
		? 1	Series D2 — Shield of Flags (138 × 89mm)		£15.00	
		? 1	Series $D3$ — Regimental Badge (138 \times 89mm)		£15.00	(C)
		? 1	Series D5 — British Views and Scenes (138 × 89mm)		£20.00	
		? 14	Series $D6$ — Film Stars $(138 \times 89mm)$		£10.00	-
ГН	OM	SON	& PORTEOUS, Edinburgh		- 34	
		ISSUE				
D2	C	50	Arms of British Towns (c1905)		£13.00	£650.00
4	BW	25	*Boer War Celebrities — 'STEW' (c1901)	H 105	£50.00	2030.00
A	C	20	European War series (c1915)	H 120	£12.00	6240.00
1	C	25	*Shadowgraphs (c1905)	П.129	£34.00	£240.00
À	C	41	VC Heroes (c1915):		134.00	
•		71		H.427	C11 00	0500.00
					£11.00	£500.00
					-	£450.00
			B Without Maker's Name		£11.00	£450.00
		100	SUPPLY SYNDICATE, London (T.S.S.)-			
го	BAC	COS				
PRE		ISSUE ? 24		H.174	£80.00	97, 13 91 - 5 -
PRE	C C	? 24	*Nautical Expressions (c1900)	H.174	£80.00	V/ 139
PRE D	-1919 C RKI	ISSUE ? 24 SH M	*Nautical Expressions (c1900)	H.174	£80.00	V/ 139
PRE D	-1919 C RKI -1919	ISSUE ? 24 SH M ISSUE	*Nautical Expressions (c1900)	H.174	£80.00	W. 13
PRE O FU	-1919 C RKI	ISSUE ? 24 SH M	*Nautical Expressions (c1900)	1 13	£80.00	

UN	ITEL	KI	NGDOM TOBACCO CO., London——			
Size	Print- ing	Num in se		Handbook reference	Price per card	Complete set
POS	T-1920	ISSU	ES			
A	C	50	Aircraft — 'The Greys Cigarettes' (1938)	Ha.598	£1.20	£60.00
_	U	48	Beautiful Britain — 'The Greys Cigarettes' (140 ×			
			90mm) (1929)		£1.40	£70.00
_	U	48	Beautiful Britain — Second series 'The Greys			
			Cigarettes' (140 × 90mm) (1929)		£1.40	£70.00
A2	C	25	British Orders of Chivalry and Valour — 'The Greys			
			Cigarettes' (1936)	Ha.599	£1.40	£35.00
A	U	24	Chinese Scenes (1933)		75p	£18.00
A2	U	32	Cinema Stars — Set 4 (1933)	Ha.515-4	£1.50	£50.00
A2	U	50	Cinema Stars — Set 7 (1934):	Ha.515-7		
			A Anonymous back		£1.80	£90.00
			B Back with firm's name		£1.50	£75.00
A2	C	36	Officers Full Dress (1936)		£1.70	£60.00
A2	C	36	Soldiers of the King — 'The Greys Cigarettes' (1937)	Ha.603	£1.70	£60.00
		· ar	DATE OF THE OF T	T		
UN	HEL) SE	RVICES MANUFACTURING CO. LTD,	London-		
A	POST-1	1920 I	SSUES			
A1	C	50	Ancient Warriors (1938)		£1.60	£80.00
A1	BW	50	Bathing Belles (1939)	Ha.592	50p	£25.00
D	U	100	Interesting Personalities (1935)		£2.20	· .
D	U	50	Popular Footballers (1936)		£4.00	_
D	U	50	Popular Screen Stars (1937)		£3.50	_
B	POST-1	940 I				
A	C	25	Ancient Warriors (1954)		£4.00	-
PRE A	C-1919	ISSUE ? 9	*Actresses — 'MUTA' (c1900)		£130.00	
A2	C	12	*Pretty Girl Series 'RASH' (c1900)	H.8	£150.00	_
WA	LKE	R'S	TOBACCO CO. LTD, Liverpool—	The second second		<u> </u>
PRE	-1919	ISSUE				
A	BW	28	*Dominoes 'Old Monk' issue (1908)		£60.00	
	T-1920					
C	P	60	*British Beauty Spots (c1925)	Ha.553	£17.00	18 77 . <u>18 .</u>
D2	U	28	*Dominoes 'W.T.C.' Monogram back (c1925)	Ha.535-2	£4.00	
A2	P	32	Film Stars — 'Tatley's Cigarettes' (1936)	Ha.623	_	£70.00
112		32	31 Different (minus Lombard)		£1.50	£46.00
A2	P	48	*Film Stars — Walker's name at base (1937)	Ha.623	£4.50	_
WA	LTE	RS T	OBACCO CO. LTD, London———			
POS	T-1920	ISSU	E			
В	U	6	Angling Information (wording only) (1939)	Ha.624	£1.50	£9.00
The state of	Section 1980		and a commence of the second			
E.T	. WA	TER	MAN, Coventry—		190/01	100
PRE	-1919	ISSUE				
D	C	30	*Army Pictures, Cartoons, etc. (1916)	H.12	£75.00	_
XX/T	DD 9	2. D	ASSELL, Reigate-	Take the	art Ha	
PRE	-1919			10,400		
A	U	50	War Portraits (1916)	H.86	£65.00	

PRE-1919 ISSUE — BW ? 7 *Barnum and Bailey's Circus (60 × 42mm) (c1900) . H.428 £150.00 — HENRY WELFARE & CO., London PRE-1919 ISSUE D P ? 22 Prominent Politicians (c1911) H.429 £70.00 — WESTMINSTER TOBACCO CO. LTD, London POST-1920 ISSUES Inscribed 'Issued by the Successors in the United Kingdom to the Westminster Tobacco Co., Ltd. For other issues see Section II Foreign Cards. A2 P 36 Australia — 'First Series' (1932) 25p £9.0 A2 P 48 British Royal and Ancient Buildings (1925): 80p £40.0 B Numbered, with descriptive text 60p £30.0 A2 P 36 Canada — 'First Series' (1927) 60p £30.0 A2 P 36 Canada — 'First Series' (1927) 60p £22.0 A2 P 48 Indian Empire — 'First Series' (1928) 60p £22.0 A2 P 36 New Zealand — 'First Series' (1929) 30p £15.0 A2 P 36 New Zealand — 'First Series' (1929) 30p £15.0 A2 P 36 New Zealand — 'First Series' (1930) 25p £9.0 A2 P 36 New	H.	C. W	EBST	TER (Q.V. Cigars)—————	43.00.0		<u> </u>
BW ?7 *Barnum and Bailey's Circus (60 × 42mm) (c1900) H.428	Size						Complete
HENRY WELFARE & CO., London	PRI	E-1919	ISSUE				
PRE-1919 ISSUE D P ? 22 Prominent Politicians (c1911) H.429 £70.00	_	BW	? 7	*Barnum and Bailey's Circus (60×42 mm) (c1900)	H.428	£150.00	_
D P ? 22 Prominent Politicians (c1911) H.429	HE	ENRY	WE	LFARE & CO., London—	<u> </u>		
WESTMINSTER TOBACCO CO. LTD, London	PRI	E-1919	ISSUE				
POST-1920 ISSUES	D	P	? 22	Prominent Politicians (c1911)	H.429	£70.00	
POST-1920 ISSUES	WI	ESTN	IINS	TER TOBACCO CO. LTD, London—	1.35		Yes 198
Inscribed 'Issued by the Successors in the United Kingdom to the Westminster Tobacco Co., Ltd.							
A2 P 36 Australia — 'First Series' (1932). 25p £9.0 A2 P 48 British Royal and Ancient Buildings (1925):				Inscribed 'Issued by the Successors in the United Kingdom to the Westminster Tobacco Co., Ltd'. For other issues see Section II Foreign Cards.			
A2 P 48 British Royal and Ancient Buildings (1925): A Unnumbered, without descriptive text 60p £40.0 A2 P 48 British Royal and Ancient Buildings — 'A Second Series' (1926) 30p £15.0 A2 P 36 Canada — 'First Series' (1927) 60p £22.0 A2 P 36 Canada — 'Second Series' (1928) 60p £22.0 A2 P 48 Indian Empire — 'First Series' (1928) 30p £15.0 A2 P 48 Indian Empire — 'First Series' (1928) 30p £15.0 A2 P 36 New Zealand — 'Second Series' (1927) 30p £15.0 A2 P 36 New Zealand — 'First Series' (1927) 30p £15.0 A2 P 36 New Zealand — 'Second Series' (1930) 25p £9.0 A2 P 36 South Africa — 'First Series' (1930) 60p £22.0 NOT ISSUED A2 P 36 Australia, Seond Series, plain back (1933) 25p £9.0 WHALE & CO. PRE-1919 ISSUE A C 13 Conundrums (c1900) H.232 £150.00 — WHITE & CO., London PRE-1919 ISSUE D C 30 *Army Pictures, Cartoons etc. (c1916) H.23 £130.00 — WHITFORD & SONS, Evesham POST-1920 ISSUE C2 C 20 *Inventors series (c1924) H.213 £45.00 — WHOLESALE TOBACCO SUPPLY CO., London ('Hawser' Cigarettes) PRE-1919 ISSUES A C 25 Armies of the World (c1902) H.43 £65.00 —		P	36	Australia — 'First Series' (1932)		25p	£9.00
B Numbered, with descriptive text 60p £30.0 A2 P 48 British Royal and Ancient Buildings — 'A Second Series' (1926)	A2	P	48	British Royal and Ancient Buildings (1925):			
Accord				A Unnumbered, without descriptive text		80p	£40.00
Series' (1926)	A2	P	48	British Royal and Ancient Buildings — 'A Second		60p	£30.00
A2 P 36 Canada — 'First Series' (1927). 60p £22.0 A2 P 36 Canada — 'Second Series' (1928). 60p £22.0 A2 P 48 Indian Empire — 'First Series' (1926). 30p £15.0 A2 P 48 Indian Empire — 'Second Series' (1927). 30p £15.0 A2 P 36 New Zealand — 'First Series' (1927). 30p £15.0 A2 P 36 New Zealand — 'Second Series' (1930). 25p £9.0 A2 P 36 South Africa — 'First Series' (1930). 60p £22.0 A2 P 36 South Africa — 'First Series' (1930). 60p £22.0 A2 P 36 South Africa — 'Second Series' (1931). 60p £22.0 A2 P 36 South Africa — 'Second Series' (1931). 60p £22.0 A2 P 36 Australia, Seond Series, plain back (1933). 25p £9.0 WHALE & CO. WHALE & CO. WHALE & CO. M. WHITE & CO., London PRE-1919 ISSUE — BW 20 *Actresses — 'BLARM' (c1900). H.23 £150.00 — WHITFIELD'S, Walsall— PRE-1919 ISSUE D C 30 *Army Pictures, Cartoons etc. (c1916). H.12 £75.00 — WHITFORD & SONS, Evesham— POST-1920 ISSUE C2 C 20 *Inventors series (c1924). H.213 £45.00 — WHOLESALE TOBACCO SUPPLY CO., London ('Hawser' Cigarettes)— PRE-1919 ISSUES A C 25 Armies of the World (c1902). H.43 £65.00 —				Series' (1926)		30p	£15.00
A2 P 48 Indian Empire — 'First Series' (1926) 30p £15.0 A2 P 48 Indian Empire — 'Second Series' (1927) 30p £15.0 A2 P 36 New Zealand — 'First Series' (1929) 30p £11.0 A2 P 36 New Zealand — 'Second Series' (1930) 25p £9.0 A2 P 36 South Africa — 'First Series' (1930) 60p £22.0 A2 P 36 South Africa — 'First Series' (1930) 60p £22.0 A2 P 36 South Africa — 'Second Series' (1931) 60p £22.0 A2 P 36 South Africa — 'Second Series' (1931) 60p £22.0 A2 P 36 Australia, Seond Series, plain back (1933) 25p £9.0 WHALE & CO. PRE-1919 ISSUE A C 13 Conundrums (c1900) H.232 £150.00 — M. WHITE & CO., London PRE-1919 ISSUE — BW 20 *Actresses — 'BLARM' (c1900) H.23 £130.00 — WHITFIELD'S, Walsall— PRE-1919 ISSUE D C 30 *Army Pictures, Cartoons etc. (c1916) H.12 £75.00 — WHITFORD & SONS, Evesham— POST-1920 ISSUE C2 C 20 *Inventors series (c1924) H.213 £45.00 — WHOLESALE TOBACCO SUPPLY CO., London ('Hawser' Cigarettes)— PRE-1919 ISSUES A C 25 Armies of the World (c1902) H.43 £65.00 —				Canada — 'First Series' (1927)		60p	£22.00
A2 P 48 Indian Empire — 'Second Series' (1927). 30p £15.0 A2 P 36 New Zealand — 'First Series' (1929). 30p £11.0 A2 P 36 New Zealand — 'Second Series' (1930). 25p £9.0 A2 P 36 South Africa — 'First Series' (1930). 60p £22.0 A2 P 36 South Africa — 'Second Series' (1931). 60p £22.0 A2 P 36 South Africa — 'Second Series' (1931). 60p £22.0 A2 P 36 South Africa — 'Second Series' (1931). 60p £22.0 A2 P 36 Australia, Seond Series, plain back (1933). 25p £9.0 WHALE & CO. PRE-1919 ISSUE A C 13 Conundrums (c1900). H.232 £150.00 — M. WHITE & CO., London— PRE-1919 ISSUE — BW 20 *Actresses — 'BLARM' (c1900). H.23 £130.00 — WHITFIELD'S, Walsall— PRE-1919 ISSUE D C 30 *Army Pictures, Cartoons etc. (c1916). H.12 £75.00 — WHITFORD & SONS, Evesham— POST-1920 ISSUE C2 C 20 *Inventors series (c1924). H.213 £45.00 — WHOLESALE TOBACCO SUPPLY CO., London ('Hawser' Cigarettes)— PRE-1919 ISSUES A C 25 Armies of the World (c1902). H.43 £65.00 —				Canada — 'Second Series' (1928)		60p	£22.00
A2 P 36 New Zealand — 'First Series' (1929) 30p £11.0 A2 P 36 New Zealand — 'Second Series' (1930) 25p £9.0 A2 P 36 South Africa — 'First Series' (1930) 60p £22.0 A2 P 36 South Africa — 'Second Series' (1931) 60p £22.0 A2 P 36 South Africa — 'Second Series' (1931) 60p £22.0 NOT ISSUED A2 P 36 Australia, Seond Series, plain back (1933) 25p £9.0 WHALE & CO. PRE-1919 ISSUE A C 13 Conundrums (c1900) H.232 £150.00 — M. WHITE & CO., London— PRE-1919 ISSUE — BW 20 *Actresses — 'BLARM' (c1900) H.23 £130.00 — WHITFIELD'S, Walsall— PRE-1919 ISSUE D C 30 *Army Pictures, Cartoons etc. (c1916) H.12 £75.00 — WHITFORD & SONS, Evesham— POST-1920 ISSUE C2 C 20 *Inventors series (c1924) H.213 £45.00 — WHOLESALE TOBACCO SUPPLY CO., London ('Hawser' Cigarettes)— PRE-1919 ISSUES A C 25 Armies of the World (c1902) H.43 £65.00 —				Indian Empire — 'First Series' (1926)		30p	£15.00
A2 P 36 New Zealand — 'Second Series' (1930) 25p £9.0 A2 P 36 South Africa — 'First Series' (1930) 60p £22.0 A2 P 36 South Africa — 'Second Series' (1931) 60p £22.0 NOT ISSUED A2 P 36 Australia, Seond Series, plain back (1933) 25p £9.0 WHALE & CO. PRE-1919 ISSUE A C 13 Conundrums (c1900) H.232 £150.00 — M. WHITE & CO., London PRE-1919 ISSUE — BW 20 *Actresses — 'BLARM' (c1900) H.23 £130.00 — WHITFIELD'S, Walsall— PRE-1919 ISSUE D C 30 *Army Pictures, Cartoons etc. (c1916) H.12 £75.00 — WHITFORD & SONS, Evesham— POST-1920 ISSUE C2 C 20 *Inventors series (c1924) H.213 £45.00 — WHOLESALE TOBACCO SUPPLY CO., London ('Hawser' Cigarettes)— PRE-1919 ISSUES A C 25 Armies of the World (c1902) H.43 £65.00 —		-		Indian Empire — 'Second Series' (1927)		30p	£15.00
A2 P 36 South Africa — 'First Series' (1930) . 60p £22.0 A2 P 36 South Africa — 'Second Series' (1931) . 60p £22.0 NOT ISSUED A2 P 36 Australia, Seond Series, plain back (1933) . 25p £9.0 WHALE & CO. PRE-1919 ISSUE A C 13 Conundrums (c1900) . H.232 £150.00 — M. WHITE & CO., London PRE-1919 ISSUE — BW 20 *Actresses — 'BLARM' (c1900) . H.23 £130.00 — WHITFIELD'S, Walsall— PRE-1919 ISSUE D C 30 *Army Pictures, Cartoons etc. (c1916) . H.12 £75.00 — WHITFORD & SONS, Evesham— POST-1920 ISSUE C2 C 20 *Inventors series (c1924) . H.213 £45.00 — WHOLESALE TOBACCO SUPPLY CO., London ('Hawser' Cigarettes)— PRE-1919 ISSUES A C 25 Armies of the World (c1902) . H.43 £65.00 —				New Zealand — 'First Series' (1929)			£11.00
A2 P 36 South Africa — 'Second Series' (1931) 60p £22.0 NOT ISSUED A2 P 36 Australia, Seond Series, plain back (1933) 25p £9.0 WHALE & CO.— PRE-1919 ISSUE A C 13 Conundrums (c1900) H.232 £150.00 — M. WHITE & CO., London— PRE-1919 ISSUE — BW 20 *Actresses — 'BLARM' (c1900) H.23 £130.00 — WHITFIELD'S, Walsall— PRE-1919 ISSUE D C 30 *Army Pictures, Cartoons etc. (c1916) H.12 £75.00 — WHITFORD & SONS, Evesham— POST-1920 ISSUE C2 C 20 *Inventors series (c1924) H.213 £45.00 — WHOLESALE TOBACCO SUPPLY CO., London ('Hawser' Cigarettes)— PRE-1919 ISSUES A C 25 Armies of the World (c1902) H.43 £65.00 —		- 10 - 10 - 10 - 10 - 10 - 10 - 10 - 10	E 100	New Zealand — 'Second Series' (1930)			£9.00
NOT ISSUED A2 P 36 Australia, Seond Series, plain back (1933) 25p £9.0 WHALE & CO. PRE-1919 ISSUE A C 13 Conundrums (c1900) H.232 £150.00 M. WHITE & CO., London PRE-1919 ISSUE BW 20 *Actresses — 'BLARM' (c1900) H.23 £130.00 WHITFIELD'S, Walsall PRE-1919 ISSUE C 30 *Army Pictures, Cartoons etc. (c1916) H.12 £75.00 WHITFORD & SONS, Evesham POST-1920 ISSUE C2 C 20 *Inventors series (c1924) H.213 £45.00 WHOLESALE TOBACCO SUPPLY CO., London ('Hawser' Cigarettes) PRE-1919 ISSUES A C 25 Armies of the World (c1902) H.43 £65.00							£22.00
A2 P 36 Australia, Seond Series, plain back (1933)				South Africa — Second Series' (1931)		60p	£22.00
WHALE & CO.— PRE-1919 ISSUE A C 13 Conundrums (c1900)				Australia Second Series plain back (1922)		25	00.00
PRE-1919 ISSUE A C 13 Conundrums (c1900) H.232 £150.00 — M. WHITE & CO., London — PRE-1919 ISSUE — BW 20 *Actresses — 'BLARM' (c1900) H.23 £130.00 — WHITFIELD'S, Walsall — PRE-1919 ISSUE — — E75.00 — WHITFORD & SONS, Evesham — POST-1920 ISSUE — — H.213 £45.00 — WHOLESALE TOBACCO SUPPLY CO., London ('Hawser' Cigarettes) — PRE-1919 ISSUES — — H.43 £65.00 —	112		30	Australia, Seona Series, plain back (1955)		25p	£9.00
A C 13 Conundrums (c1900) H.232 £150.00 — M. WHITE & CO., London— PRE-1919 ISSUE — BW 20 *Actresses — 'BLARM' (c1900) H.23 £130.00 — WHITFIELD'S, Walsall— PRE-1919 ISSUE D C 30 *Army Pictures, Cartoons etc. (c1916) H.12 £75.00 — WHITFORD & SONS, Evesham— POST-1920 ISSUE C2 C 20 *Inventors series (c1924) H.213 £45.00 — WHOLESALE TOBACCO SUPPLY CO., London ('Hawser' Cigarettes)— PRE-1919 ISSUES A C 25 Armies of the World (c1902) H.43 £65.00 —							
M. WHITE & CO., London PRE-1919 ISSUE — BW 20 *Actresses — 'BLARM' (c1900)							
PRE-1919 ISSUE — BW 20 *Actresses — 'BLARM' (c1900) H.23 £130.00 — WHITFIELD'S, Walsall— PRE-1919 ISSUE — — D C 30 *Army Pictures, Cartoons etc. (c1916) H.12 £75.00 — WHITFORD & SONS, Evesham— — POST-1920 ISSUE — C2 C 20 *Inventors series (c1924) H.213 £45.00 — WHOLESALE TOBACCO SUPPLY CO., London ('Hawser' Cigarettes)— PRE-1919 ISSUES — A C 25 Armies of the World (c1902) H.43 £65.00 —	A	С	13	Conundrums (c1900)	H.232	£150.00	<u> </u>
— BW 20 *Actresses — 'BLARM' (c1900) H.23 £130.00 — WHITFIELD'S, Walsall— PRE-1919 ISSUE D C 30 *Army Pictures, Cartoons etc. (c1916) H.12 £75.00 — WHITFORD & SONS, Evesham— POST-1920 ISSUE C2 C 20 *Inventors series (c1924) H.213 £45.00 — WHOLESALE TOBACCO SUPPLY CO., London ('Hawser' Cigarettes)— PRE-1919 ISSUES A C 25 Armies of the World (c1902) H.43 £65.00 —	M.	WHI	TE &	& CO., London	95.7	1077	
WHITFIELD'S, Walsall— PRE-1919 ISSUE D C 30 *Army Pictures, Cartoons etc. (c1916)	PRE	2-1919	ISSUE				
PRE-1919 ISSUE D C 30 *Army Pictures, Cartoons etc. (c1916) H.12 £75.00 — WHITFORD & SONS, Evesham— POST-1920 ISSUE C2 C 20 *Inventors series (c1924) H.213 £45.00 — WHOLESALE TOBACCO SUPPLY CO., London ('Hawser' Cigarettes)— PRE-1919 ISSUES A C 25 Armies of the World (c1902) H.43 £65.00 —	-	BW	20	*Actresses — 'BLARM' (c1900)	H.23	£130.00	_
D C 30 *Army Pictures, Cartoons etc. (c1916)	WI	HITF	ELD	'S, Walsall—		r David	
D C 30 *Army Pictures, Cartoons etc. (c1916)	PRE	2-1919	ISSUE				
POST-1920 ISSUE C2 C 20 *Inventors series (c1924) H.213 £45.00 — WHOLESALE TOBACCO SUPPLY CO., London ('Hawser' Cigarettes) PRE-1919 ISSUES A C 25 Armies of the World (c1902) H.43 £65.00 —					H.12	£75.00	_
C2 C 20 *Inventors series (c1924)	WI	HITF	ORD	& SONS, Evesham—	114		1.00
C2 C 20 *Inventors series (c1924)	POS	T-1920	ISSI				
PRE-1919 ISSUES A C 25 Armies of the World (c1902) H.43 £65.00					H.213	£45.00	_
PRE-1919 ISSUES A C 25 Armies of the World (c1902) H.43 £65.00	WI	HOLI	ESAL	E TOBACCO SUPPLY CO., London ('H	lawser' Ci	igarettes	s)——
A C 25 Armies of the World (c1902)						3	
205.00				[[[[[[[[]]]]]] [[[[[]]]] [[[[]]] [[]] [[] [[]] [[] [[]] [[] [[]] [[] [[]] [[] [[] [[]] [[] [[]] [[] [[] []] [[] [[] [[] []] [[] [[] []	H 43	£65.00	

P.	WHY	TE,	England-			
	Print-		사람이 가는 사람들이 되었다면 살아 있다면 하는 것이 되었다면 하는 것이 없는 것이 없는 것이 없다면 하는 것이다.	Handbook	Price	Complete
٥٠٠	ing	in se		reference	per card	set
DDI	E-1919	ICCITE	7			
D	C C	30	*Army Pictures, Cartoons, etc. (1916)	H 12	£75.00	
D	-	30	Army Fictures, Cartoons, etc. (1910)	11.12	275.00	
W.	WIL	LIA	MS & CO., Chester—			
A	PRE-1	919 IS	SUES			
A	BW	25	*Boer War Celebrities 'STEW' (c1901)		£65.00	_
A	C	50	Interesting Buildings (c1910)	H.70	£13.00	£650.00
A	BW	12	Views of Chester (c1910)		£25.00	£300.00
A	BW	12	Views of Chester — As It Was (c1910):	H.430		
			A Toned card		£27.00	£325.00
			B Bleuté card		£27.00	-
	POST-			10		040500
A	U	30	Aristocrats of the Turf (c1925)	Ha.554	£6.50	£195.00
A	U	36	Aristocrats of the Turf 2nd series (c1925)	*****	£14.00	-
A	C	25	Boxing (c1924)	H.311	£8.00	£200.00
W.	D. &	H.O.	. WILLS, Bristol			
			e book available — £10.00			
			1902 — INCLUDING SERIES ISSUED ABROAD.			
A	U	DIO	*Actresses — collotype (c1894):	H.431		
A	U	25	A 'Wills' Cigarettes'	11.431	£80.00	_
		43	B 'Wills's Cigarettes'		£80.00	
A	C	?9	*Actresses, brown type-set back (c1895)	H 432	£750.00	
	C	52	*Actresses, brown scroll back, with PC inset (c1898)	11.432	£15.00	£825.00
A	C	52	*Actresses, grey scroll back (c1897):	H.433	215.00	2025.00
A	C	32	A Without PC inset	11.433	£15.00	£825.00
			B With PC inset		£15.00	£825.00
	U		*Actresses and Beauties — collotype, 'Three Castles'		215.00	2025.00
A	U		and 'Firefly' front (c1895):	H.434		
		? 86	Actresses	11.454	£90.00	- I
		? 32	Beauties		£90.00	
Α	C	: 32	*Advertisement Cards:	H.435	290.00	
A	C	24	1888 issue (tobacco packets)	11.433	£800.00	
		? 1	1889-90 issue (serving maid)		£650.00	
		? 11	1890-93 issues (tobacco packings)		£600.00	
		?3	1893 issue (various backs) (showcards)		£300.00	
		?6	1893-94 issue (posters)		£300.00	
٨	С	50	*Animals and Birds in Fancy Costumes (c1896)	H 436	£45.00	1 N 150
A		? 17	*Beauties — collotype (c1894):	H.437	245.00	
A	U	. 1/	A 'W.D. & H.O. Wills' Cigarettes'	11.73/	£100.00	_
			B 'Firefly' Cigarettes		£100.00	100000
A1	C	?9	*Beauties ('Girl Studies'), type-set back (c1895)	H 438	£750.00	
	C	. ,	*Beauties, brown backs (c1897):	H.439	2750.00	
A	C	52	A With PC inset — scroll back	11.737	£15.00	£825.00
		10	B As A, 10 additional pictures		£45.00	2025.00
		? 48	C 'Wills' Cigarettes' front, scroll back		£140.00	100
		? 35	D 'Wills' Cigarettes' front, type-set back		£175.00	
K	C	52	*Beauties, miniature cards, PC inset, grey scroll back		2175.00	20 1 1 10
17		32	(c1896)		£24.00	_
Α	C	50	Builders of the Empire (1898):		224.00	
А		50	A White card		£6.00	£300.00
			B Cream card		£6.00	£300.00
Α	C	60	Coronation Series (1902):		20.00	2500.00
A		00	A 'Wide arrow' type back		£5.00	£300.00
			B 'Narrow arrow' type back		£5.00	£300.00
			b italiow allow type back		25.00	2500.00

Size	Print- ing	Num in se		Handbook reference	Price per card	Complete set
A A	C C	50	*Cricketers (1896)	H.440	£60.00	-
		50	A With Vignette		£22.00	
		25	B Without Vignette		£22.00	
A	C	23	*Double Meaning (1898):		122.00	
A	-	50	A Without PC inset		£9.00	C150.00
		52	B With PC inset			£450.00
	•	50		TT 441	£9.00	£470.00
A	C		Japanese series (c1900)	H.441 H.442	£35.00	7
A1		50	A Short card (1897):			
			a Grey back, thin card		£5.00	£250.00
			b Grey back, thick card		£5.00	£250.00
			c Brown back		£9.00	
A			B Standard size card (1902):			
		51	a Blue-grey back with 5 substitute titles		£5.50	£280.00
		50	b Grey back, different design, thinner card		£11.00	
A	C		*Locomotive Engines and Rolling Stock:	H.443		
		50	A Without ITC Clause (1901)		£7.00	£350.00
		7	B As A, 7 additional cards (1901)		£20.00	~5550.00
			C With ITC Clause — See B Period		220.00	
A	C	50	*Medals: (1902)	H.71		
		-	A White card	11.71	£2.50	£125.00
			B Toned card			
Α	C	25	*National Costumes (c1895)		£2.50	£125.00
A	C	?8	*Notional Types (a1902)		£180.00	- TE
A	C	20	*National Types (c1893)	TT 162	£600.00	
A	C	20	Our Gallant Grenadiers (c1901):	H.163	222.00	
			A Deep grey on toned card		£28.00	
	-	50	B Blue-grey on bluish card		£28.00	
A	C	50	Seaside Resorts (1899)		£9.00	£450.00
A	C		*Ships:	H.444		
		25	A Without 'Wills' on front (1895):			
			a 'Three Castles' back		£28.00	£700.00
			b Grey scroll back		£28.00	£700.00
		50	B With 'Wills' on front, dark grey back (1896)		£18.00	_
		100	C Green scroll back on brown card (1898-1902):			
			i 1898-25 subjects as A		£17.00	<u></u>
			ii 1898-50 subjects as B		£17.00	
			iii 1902-25 additional subjects		£17.00	<u></u>
A	C		*Soldiers of the World (1895-7):	H.445	217.00	
			A Without PC inset:	11.775		
		100	a With 'Ld.' back, thick card		£6.50	£650.00
		100	b With 'Ld.' back, thin card			2030.00
		100	c Without 'Ld.' back, thin card		£7.00	C(50.00
					£6.50	£650.00
		1 52	Additional card (as c) 'England, Drummer Boy'		-	£100.00
	-		B With PC inset		£22.00	£1150.00
A	C	50	*Soldiers and Sailors (c1894):	H.446		
			A Grey back		£40.00	_
			B Blue back		£40.00	_
A	C	50	Sports of All Nations (1900)		£9.00	£450.00
A	BW		Transvaal series:	H.360		
		50	A With black border (1899)		£8.00	_
		66	Bi Without black border (1900-01)		£1.75	£115.00
		258	Bii Intermediate cards — additions and alter-		21.75	
			natives (1900-01)		£1.75	
		66	C Final 66 subjects, as issued with 'Capstan' back		21.73	
		00	(see B Period) (1902).			

A C	Si	e Print- ing	Num in se		Handbook reference	Price per card	Complete set
So	A	C		'Vanity Fair' series (1902):	H 447		
Society			50			£5.00	£250.00
Social Content							
A C			50				
Social Content				subjects		£5.00	£250.00
Second	A	C		Wild Animals of the World (c1900):	H.77		
77 C Text back £30,00 — CLAUSE A C 50 Allied Army Leaders (1917) £1.60 £80,00 A C 50 Alpine Flowers (1913) 90p £45,00 A C 50 Arms of the Bishopric (1907) 90p £45,00 A C 50 Arms of the British Empire (1910) 80p £40,00 A C 50 Arms of Companies (1913) 80p £40,00 A C 50 Arms of Foreign Cities (1912): 80p £40,00 A C 50 Arms of Foreign Cities (1912): 80p £40,00 A C 50 Aviation (1910) £1.70 £85,00 A C 50 Aviation (1910) £1.70 £85,00 A C 50 Billands (1909) £1.70 £85,00 A C 50 Billands (1909) £1.70 £85,00 A C 50 Billands (1909) £1.00 £1.00 £50,00 A C 50 *Borough Arms (15-10): *1.00 £1.00 £50,00 A C 50 *Borough Arms (10-150): 70p £35,00 70p £35,00 70p £35,00 A C 50 *Borough Arms (10-150): 70p							
B PERIOD 1902-1919 — HOME ISSUES I.E. SERIES BEARING IMPERIAL TOBACCO CO. (V.T.C.') CLAUSE A C							£570.00
CLAUSE							
A C 50 Allied Army Leaders (1917)			D 190	02-1919 — HOME ISSUES I.E. SERIES BEARING IM	PERIAL TOB	ACCO CO). ('I.T.C.')
A C 50 Arms of the Bishopric (1907) 90p £45.00 A C 50 Arms of the British Empire (1910) 80p £45.00 A C 50 Arms of Companies (1913) 80p £40.00 A C 50 Arms of Companies (1913) 80p £40.00 A C 50 Arms of Foreign Cities (1912): A White card 90p — C As A, with 'Mark' £1.00 — A C 50 Aviation (1910) £1.70 £85.00 A C 50 Billiards (1909) £1.00 £50.00 D 2 And Edition —1-50 (1906) 70p £35.00 D 2 And Edition —1-50 (1906) 70p £35.00 A C 50 *Borough Arms (51-100); A 2 C 50 *Borough Arms (51-100); A 3 C 50 *Borough Arms (51-100); A 3 C 50 *Borough Arms (15-150); A 3 C 50 *Borough Arms (15-150); A 3 C 50 *Borough Arms (15-150); A 3 C 50 *Borough Arms (101-150); A 10 C 50 *Borough Arms (101-150); A 2 C 50 *Borough Arms (101-150); A 3 C 50 *Borough Arms (101-150); A 2 C 50 *Borough Arms (101-150); A 2 C 50 *Borough Arms (101-150); A 3 C 50 *Borough Arms (101-150); A 10 C 50 *Borough Arms (101-150); A 2 C 50 *Borough Arms (101-150); A 3 C 50 *Borough Arms (101-150); A 50 C 50 *Borough Arms (101-150); A 6 C 50 *British Birds (1917) £1.00 £50.00 C 1 *C 2nd Edition, 101-150 (1906) 70p £35.00 C 2 nd Edition, 101-150 (1906) 70p £35.0			50	Allied Amery Leaders (1017)		£1.60	00 00
A C 50 Arms of the Bishopric (1907) 80p £45.00 A C 50 Arms of the British Empire (1910) 80p £40.00 A C 50 Arms of Companies (1913) 80p £40.00 A C 50 Arms of Foreign Cities (1912): A White card 80p £40.00 B Cream card 90p — C As A, with 'Mark' £1.00 — C As Eventual (1909) £1.70 £85.00 B Billiards (1909) £1.70 £85.00 A C 50 Billiards (1909) £1.70 £85.00 A C 50 **Borough Arms (1-50): A S Croll back, unnumbered (1904) £10.00 — C Descriptive back, numbered on front (1904) £10.00 — C Descriptive back numbered on back (1905) £1.00 £50.00 D 2nd Edition — 1-50 (1906) 70p £35.00 A C 50 **Borough Arms (51-100): A 2nd Series (1905) 70p £35.00 B 2nd Edition, 51-100 (1906) 70p £35.00 B 3rd Series, Album clause in grey (1905) 90p £45.00 B 3rd Series, Album clause in grey (1905) 70p £35.00 C 2nd Edition, 101-150 (1906) 70p £35.00 C 2 nd Edition — 100 (1006) 70p £35.00 C 2 nd Edition — 100 (1006) 70p £35.00 C 2 nd Edit							
A C 50 Arms of the British Empire (1910) 80p £40.00 A C 50 Arms of Companies (1913) 80p £40.00 A C 50 Arms of Foreign Cities (1912): A White card 90p — C As A, with 'Mark' £1.00 — C As A, with 'Mark' £1.00 — B Cream card 90p — C As A, with 'Mark' £1.00 £85.00 A C 50 Billiards (1909) £1.70 £85.00 A C 50 Billiards (1909) £1.70 £85.00 A C 50 Billiards (1909) £1.70 £85.00 D 2nd Edition — 1-50 (1906) £1.00 £0.00 D 2nd Edition — 1-50 (1906) 70p £35.00 A C 50 *Borough Arms (51-100): A 2nd Series (1905) 70p £35.00 A C 50 *Borough Arms (51-100): A 2nd Series (1905) 70p £35.00 B 2nd Edition, 51-100 (1906) 70p £35.00 B 3rd Series, Album clause in grey (1905) 90p £45.00 C 2nd Edition, 101-150 (1906) 70p £35.00 A C 50 *Borough Arms (151-200), 4th series (1905) 70p £35.00 A C 50 *Borough Arms (1905) 70p £35.00 C 2nd Edition, 101-150 (1906) 70p £35.00 C 2nd Edition, 101-150 (1906) 70p £35.00 A C 50 *Borough Arms (1905) 70p £35.00 C 2nd Edition, 101-150 (1906) 70p £35.00 C 2nd Edition, 101-150 (1906) 70p £35.00 C 2nd Edition (101-150 (1906) 70p £35.00 C 2 2nd Edition (101-150 (1906) 70							
A C 50 Arms of Companies (1913). A C 50 Arms of Foreign Cities (1912): A White card 80 \$\text{900}\$ \$\text{-}\$ B Cream card 900 \$\text{-}\$ C As A, with 'Mark' \$\text{-}\$ A C 50 Aviation (1910) \$\text{-}\$ A C 50 Billiards (1909) \$\text{-}\$ A S C 50 Billiards (1909) \$\text{-}\$ A 2nd Edition — 1-50 (1906) \$\text{-}\$ A 2nd Series (1905) \$\text{-}\$ A 2nd Series (1905) \$\text{-}\$ A 3rd Series, Album clause in grey (1905) \$\text{-}\$ B 3rd Series, Album clause in red (1905) \$\text{-}\$ A C 50 *Borough Arms (151-1200), 4th series (1905) \$\text{-}\$ A C 2 4 Britain's Part in the War (1917) \$\text{-}\$ A C 50 British Birds (1917) \$\text{-}\$ A C 1 *Calendar for 1911 (1910) \$\text{-}\$ A C 1 *Calendar for 1912 (1911) \$\text{-}\$ A C 2 1 *Calendar for 1912 (1911) \$\text{-}\$ A Deep brown back \$\text{-}\$ B U 25 Celebrated Pictures (1916) \$\text{-}\$ A C 50 Firsh & titp (1910) \$\text{-}\$ A 1-25 'Wills's' at top front \$\text{-}\$ B C 25 Dogs, 2nd Series (1915) \$\text{-}\$ A C 50 Firsh & Billiar's (1915) \$\text{-}\$ B C 25 Dogs, 2nd Series (1915) \$\text{-}\$ A Without Album Clause (1913) \$\text{-}\$ B With Album Clause (1913) \$\text{-}\$ B With Album Clause (1915) \$\text{-}\$ B With Album Clause (1915) \$\text{-}\$ B With Album Clause (1915) \$\te							
A C 50 Arms of Foreign Cities (1912): A White card							
A White card 80p							
C As A, with 'Mark'						80p	£40.00
A C 50 Aviation (1910)				B Cream card			_
A C 50 Billiards (1909)				C As A, with 'Mark'			 -
A C 50 *Borough Arms (1-50): A Scroll back, unumbered (1904)							1 1 1 1 1 1 1 1 1 1 1 1 1 1 1 1 1 1 1
A Šcroll back, unnumbered (1904)						£1.70	£85.00
B Scroll back, numbered on front (1904) £10.00 — C Descriptive back, numbered on back (1905) £1.00 £50.00 D 2nd Edition — 1-50 (1906) 70p £35.00 A C 50 *Borough Arms (51-100): A 2nd Series (1905) 70p £35.00 B 2nd Edition, 51-100 (1906) 70p £35.00 A C 50 *Borough Arms (101-150): A 3rd Series, Album clause in grey (1905) 90p £45.00 B 3rd Series, Album clause in red (1905) 70p £35.00 C 2nd Edition, 101-150 (1906) 70p £35.00 C 2nd Edition, 101-150 (1906) 70p £35.00 C 2nd Edition, 101-150 (1906) 70p £35.00 A C 50 *Borough Arms (151-200), 4th series (1905) 70p £35.00 A C 24 *Britain's Part in the War (1917) £1.00 £25.00 A C 50 British Birds (1917) £1.00 £25.00 A C 1 *Calendar for 1911 (1910) — £1.10 £25.00 A C 1 *Calendar for 1912 (1911) — £8.00 B U 25 Celebrated Pictures (1916): A Deep brown back £2.00 £50.00 B Yellow-brown back £1.80 £45.00 B V 25 Celebrated Pictures, 2nd Series (1916) £2.20 £55.00 A C 50 The Coronation Series (1911) £1.00 £50.00 B C 50 Cricketers (1908): A 1-25 'Wills's at top front £6.00 £150.00 B C 25 Dogs (1914) £3.00 £75.00 B C 25 Dogs, 2nd Series (1915) £3.00 £75.00 B C 50 First Aid: A Without Album Clause (1913) £1.10 £55.00 B With Album Clause (1913) £1.10 £55.00 B With Album Clause (1915) £1.10 £55.00	A	C	50		TT 440	C1 00	C50.00
C Descriptive back, numbered on back (1905) D 2nd Edition — 1-50 (1906) A C 50 *Borough Arms (51-100): A 2nd Series (1905) B 2nd Edition, 51-100 (1906) A C 50 *Borough Arms (101-150): A 3rd Series, Album clause in grey (1905) B 3rd Series, Album clause in grey (1905) C 2nd Edition, 101-150 (1906) A C 50 *Borough Arms (101-150): A C 50 *Borough Arms (151-200), 4th series (1905) A C 24 *Britain's Part in the War (1917) A C 50 British Birds (1917) A C 1 *Calendar for 1911 (1910) A C 1 *Calendar for 1911 (1910) A C 1 *Calendar for 1912 (1911) B U 25 Celebrated Pictures (1916): A Deep brown back B Yellow-brown back B Yellow-brown back C 50 Celebrated Pictures, 2nd Series (1916) C Celebrated Ships (1911) C 50 Coricketers (1908): A C 50 Cricketers (1908): A C 50 Cricketers (1918) C 50 Cricketers (1916) B C 25 Dogs (1914) C 50 CFirst Aid: A Without Album Clause (1913) B C 55 First Aid: A Without Album Clause (1915) B With Album Clause (1915) B With Album Clause (1915) C 50 First Aid: C 50 Fish & Bait (1910) B C 55 Fish & Bait (1910) B C 55 First Aid: C 50 Fish & Bait (1910) B C 55 First Aid:					H.448		£50.00
D 2nd Edition — 1-50 (1906) . 70p £35.00 A C 50 *Borough Arms (51-100):							£50.00
A C 50 *Borough Arms (51-100): A 2nd Series (1905) . 70p £35.00 B 2nd Edition, 51-100 (1906) . 70p £35.00 A C 50 *Borough Arms (101-150): A 3rd Series, Album clause in grey (1905) . 90p £45.00 B 3rd Series, Album clause in red (1905) . 70p £35.00 C 2nd Edition, 101-150 (1906) . 70p £35.00 C 2nd Edition, 101-150 (1906) . 70p £35.00 C 2nd Edition, 101-150 (1906) . 70p £35.00 A C 50 *Borough Arms (151-200), 4th series (1905) . 70p £35.00 A C 50 British Birds (1917) . £1.00 £25.00 A C 50 British Birds (1917) . £1.10 £55.00 A C 1 *Calendar for 1911 (1910) . — £14.00 A C 1 *Calendar for 1912 (1911) . — £8.00 B U 25 Celebrated Pictures (1916): A Deep brown back . £2.00 £50.00 B Yellow-brown back . £1.80 £45.00 A C 50 Celebrated Pictures, 2nd Series (1916) . £2.20 £55.00 A C 50 The Coronation Series (1911) . £1.00 £50.00 A C 50 The Coronation Series (1911) . £1.00 £50.00 B 1-50 'Wills's' at top front . £6.00 £150.00 B 1-50 'Wills's' at top front . £6.00 £300.00 B C 25 Dogs (1914) . £3.00 £75.00 B C 50 Famous Inventions (1915) . £3.00 £75.00 B With Album Clause (1913) . £1.10 £55.00 B With Album Clause (1915) . £1.10 £55.00 B With Album Clause (1915) . £1.10 £55.00 B With Album Clause (1915) . £1.10 £55.00							
A 2nd Series (1905) B 2nd Edition, 51-100 (1906) A C 50 *Borough Arms (101-150): A 3rd Series, Album clause in grey (1905) B 3rd Series, Album clause in red (1905) C 2nd Edition, 101-150 (1906) A C 50 *Borough Arms (151-200), 4th series (1905) A C 24 *Britain's Part in the War (1917) A C 50 British Birds (1917) A C 50 British Birds (1917) A C 1 *Calendar for 1911 (1910) A C 1 *Calendar for 1912 (1911) B U 25 Celebrated Pictures (1916): A Deep brown back B Yellow-brown back B Yellow-brown back C 50 Celebrated Ships (1911) C 50 Celebrated Ships (1915) C 50 Celebrated Ships (1915) C 50 Celebrated Ships (1915) C 50 Famous Inventions (1915) C 50 Famous Inventions (1915) C 50 First Aid: A Without Album Clause (1913) B With Album Clause (1913) B With Album Clause (1915) C 50 Fish & Bait (1910) C 50 C 50 Fish & Bait (19	٨	C	50			70p	233.00
B 2nd Edition, 51-100 (1906)	A	C	30			70n	£35.00
A C 50 *Borough Arms (101-150): A 3rd Series, Album clause in grey (1905) 90p £45.00 B 3rd Series, Album clause in red (1905) 70p £35.00 C 2nd Edition, 101-150 (1906) 70p £35.00 A C 50 *Borough Arms (151-200), 4th series (1905) 70p £35.00 A C 24 *Britain's Part in the War (1917) £1.00 £25.00 A C 50 British Birds (1917) £1.00 £25.00 A C 1 *Calendar for 1911 (1910) — £14.00 A C 1 *Calendar for 1912 (1911) — £8.00 B U 25 Celebrated Pictures (1916): A Deep brown back £2.00 £50.00 B Yellow-brown back £1.80 £45.00 A C 50 Celebrated Ships (1911) £1.00 £55.00 A C 50 Celebrated Ships (1911) £1.00 £50.00 A C 50 The Coronation Series (1916) £1.00 £50.00 A C 50 Cricketers (1908): A 1-25 'Wills' S' at top front £6.00 £150.00 B C 25 Dogs (1914) £3.00 £75.00 B C 25 Dogs (2914) £3.00 £75.00 A C 50 Famous Inventions (1915) £1.00 £50.00 A C 50 First Aid: A Without Album Clause (1913) £1.10 £55.00 B With Album Clause (1915) £1.10 £55.00							
A 3rd Series, Album clause in grey (1905) B 3rd Series, Album clause in red (1905) C 2nd Edition, 101-150 (1906) C 2nd Edition, 101-150 (1905) C 2nd Edition	A	C	50			, op	200.00
B 3rd Series, Album clause in red (1905) C 2nd Edition, 101-150 (1906) C 2nd Edition, 101-150 (1905) C 2nd Edition, 101-150 (1						90p	£45.00
A C 50 *Borough Arms (151-200), 4th series (1905) 70p £35.00 A C 24 *Britain's Part in the War (1917) £1.00 £25.00 A C 50 British Birds (1917) £1.10 £55.00 A C 1 *Calendar for 1911 (1910) — £14.00 A C 1 *Calendar for 1912 (1911) — £8.00 B U 25 Celebrated Pictures (1916):						70p	£35.00
A C 50 *Borough Arms (151-200), 4th series (1905) 70p £35.00 A C 24 *Britain's Part in the War (1917) £1.00 £25.00 A C 50 British Birds (1917) £1.10 £55.00 A C 1 *Calendar for 1911 (1910) — £14.00 A C 1 *Calendar for 1912 (1911) — £8.00 B U 25 Celebrated Pictures (1916):				C 2nd Edition, 101-150 (1906)		70p	£35.00
A C 50 British Birds (1917)	A	C	50	*Borough Arms (151-200), 4th series (1905)		70p	£35.00
A C 1 *Calendar for 1911 (1910) — £14.00 A C 1 *Calendar for 1912 (1911) — £8.00 B U 25 Celebrated Pictures (1916): A Deep brown back £2.00 £50.00 B Yellow-brown back £1.80 £45.00 A C 50 Celebrated Pictures, 2nd Series (1916) £2.20 £55.00 A C 50 Celebrated Ships (1911) £1.00 £50.00 A C 50 The Coronation Series (1911) £1.00 £50.00 A C 50 Cricketers (1908): A 1-25 'Wills' S' at top front £6.00 £300.00 B C 25 Dogs (1914) £3.00 £75.00 B C 25 Dogs, 2nd Series (1915) £3.00 £75.00 A C 50 Famous Inventions (1915) £1.00 £50.00 A C 50 First Aid: A Without Album Clause (1913) £1.10 £55.00 B With Album Clause (1915) £1.10 £55.00	A		24				
A C 1 *Calendar for 1912 (1911)	A		50			£1.10	
B U 25 Celebrated Pictures (1916):						_	
A Deep brown back £2.00 £50.00 B Yellow-brown back £1.80 £45.00 B U 25 Celebrated Pictures, 2nd Series (1916) £2.20 £55.00 A C 50 Celebrated Ships (1911) £1.00 £50.00 A C 50 The Coronation Series (1911) £1.00 £50.00 A C 50 Cricketers (1908): A 1-25 'Wills' S' at top front £6.00 £150.00 B 1-50 'Wills's' at top front £6.00 £300.00 B C 25 Dogs (1914) £3.00 £75.00 B C 25 Dogs, 2nd Series (1915) £3.00 £75.00 A C 50 Famous Inventions (1915) £1.00 £50.00 A C 50 First Aid: A Without Album Clause (1913) £1.10 £55.00 B With Album Clause (1915) £1.10 £55.00			Programme and the second				£8.00
B Yellow-brown back £1.80 £45.00 B U 25 Celebrated Pictures, 2nd Series (1916) £2.20 £55.00 A C 50 Celebrated Ships (1911) £1.00 £50.00 A C 50 The Coronation Series (1911) £1.00 £50.00 A C 50 Cricketers (1908): A 1-25 'Wills' S' at top front £6.00 £150.00 B 1-50 'Wills's' at top front £6.00 £300.00 B C 25 Dogs (1914) £3.00 £75.00 B C 25 Dogs, 2nd Series (1915) £3.00 £75.00 A C 50 Famous Inventions (1915) £1.00 £50.00 A C 50 First Aid: A Without Album Clause (1913) £1.10 £55.00 B With Album Clause (1915) £1.10 £55.00 A C 50 Fish & Bait (1910) H.65 £1.70 £85.00	В	U	25			62.00	050.00
B U 25 Celebrated Pictures, 2nd Series (1916) £2.20 £55.00 A C 50 Celebrated Ships (1911) £1.00 £50.00 A C 50 The Coronation Series (1911) £1.00 £50.00 A C 50 Cricketers (1908): A 1-25 'Wills' S' at top front £6.00 £300.00 B C 25 Dogs (1914) £3.00 £75.00 B C 25 Dogs, 2nd Series (1915) £3.00 £75.00 A C 50 Famous Inventions (1915) £3.00 £75.00 A C 50 First Aid: A Without Album Clause (1913) £1.10 £55.00 B With Album Clause (1915) £1.10 £55.00 A C 50 Fish & Bait (1910) H.65 £1.70 £85.00							
A C 50 Celebrated Ships (1911)	D	II	25				
A C 50 The Coronation Series (1911) £1.00 £50.00 A C 50 Cricketers (1908):							
A C 50 Cricketers (1908): A 1-25 'Wills' S' at top front £6.00 £150.00 B 1-50 'Wills's' at top front £6.00 £300.00 B C 25 Dogs (1914) £3.00 £75.00 B C 25 Dogs, 2nd Series (1915) £3.00 £75.00 A C 50 Famous Inventions (1915) £1.00 £50.00 A C 50 First Aid: A Without Album Clause (1913) £1.10 £55.00 B With Album Clause (1915) £1.10 £55.00 A C 50 Fish & Bait (1910) H.65 £1.70 £85.00							
A 1-25 'Wills' S' at top front £6.00 £150.00 B 1-50 'Wills's' at top front £6.00 £300.00 B C 25 Dogs (1914) £3.00 £75.00 B C 25 Dogs, 2nd Series (1915) £3.00 £75.00 A C 50 Famous Inventions (1915) £1.00 £50.00 A C 50 First Aid: A Without Album Clause (1913) £1.10 £55.00 B With Album Clause (1915) £1.10 £55.00 A C 50 Fish & Bait (1910) H.65 £1.70 £85.00						21.00	250.00
B 1-50 'Wills's' at top front £6.00 £300.00 B C 25 Dogs (1914) £3.00 £75.00 B C 25 Dogs, 2nd Series (1915) £3.00 £75.00 A C 50 Famous Inventions (1915) £1.00 £50.00 A C 50 First Aid: A Without Album Clause (1913) £1.10 £55.00 B With Album Clause (1915) £1.10 £55.00 A C 50 Fish & Bait (1910) H.65 £1.70 £85.00	11	-	30			£6.00	£150.00
B C 25 Dogs (1914) £3.00 £75.00 B C 25 Dogs, 2nd Series (1915) £3.00 £75.00 A C 50 Famous Inventions (1915) £1.00 £50.00 A C 50 First Aid: A Without Album Clause (1913) £1.10 £55.00 B With Album Clause (1915) £1.10 £55.00 A C 50 Fish & Bait (1910) H.65 £1.70 £85.00							
A C 50 Famous Inventions (1915)	В	C	25			£3.00	£75.00
A C 50 First Aid: A Without Album Clause (1913) £1.10 £55.00 B With Album Clause (1915) £1.10 £55.00 A C 50 Fish & Bait (1910) H.65 £1.70 £85.00	В	C	25	Dogs, 2nd Series (1915)		£3.00	£75.00
A Without Album Clause (1913) £1.10 £55.00 B With Album Clause (1915) £1.10 £55.00 A C 50 Fish & Bait (1910) H.65 £1.70 £85.00	A		50	Famous Inventions (1915)		£1.00	£50.00
B With Album Clause (1915)	A	C	50				
A C 50 Fish & Bait (1910)							

A U 00 *rootball Series (1902) H.81 £6.50 —							£85.00
	A	U	00	FOODBall Series (1902)	H.81	£0.50	_

Instance	W.D	. « п	.0. 1	WILLS, Bristoi (continuea)			
A C 50 Garden Life (1914)							Complete
A C 50 Gems of Belgian Architecture (1915). A White card		ing	in sei			per card	set
A C 50 Gems of Belgian Architecture (1915). A White card	A	C	50	Garden Life (1914)	H.449	70p	£35.00
A C 50 Gems of French Architecture (1917): A White card B Bleuté card C Rough brown card C Rough brown card G1.44 C 50 Gems of Russian Architecture (1916) C 80 Historic Events (1912) B Clause (1902) For issue without 1 T. C. Clause see Period A. Hilitary Motors (1916) A C 50 Military Motors (1916) A Without 'Passed by Censor' B With 'Passed by Censor' A Without 'Passed by Censor' B With 'Passed by Censor' A C 50 Mining (1916) A C 50 Musical Celebrities (1911) C 8 C 50 Musical Celebrities (1911) C 9 C 10 C	A	C	50	Gems of Belgian Architecture (1915)		60p	£30.00
A White card B Bleuté card £1,20	A	C	50	Gems of French Architecture (1917):		oop	20.00
B Bleuté card C C Rough brown card				A White card		£1.20	£60.00
C Rough brown card				B Bleuté card		£1.40	
A C 50 Gems of Russian Architecture (1916) 70, A C 50 Historic Events (1912) H.464 £1.16 A C 50 *Locomotive Engines and Rolling Stock, with LT.C. Clause (1902) £70 fissue without IT.C. Clause see Period A. A C 50 Military Motors (1916): A Without Passed by Censor' £1.76 B With 'Passed by Censor' £1.77 A C 50 Mining (1916) H.450 £1.16 A C 50 Musical Celebrities (1911) £2.56 A C 50 Musical Celebrities — Second Series (1916): H.465 Set of 50 with 8 substituted cards £3.00 8 original cards (later substituted) £220.00 A C 50 Naval Dress & Badges (1909) H.172 £2.26 A C 50 Nelson Series (1905) £1.00 A C 50 Old English Garden Flowers (1910) £1.00 A C 50 Old English Garden Flowers, 2nd Series (1913) £1.00 A C 50 Overseas Dominions (Australia) (1915) H.451 601 A C 50 Overseas Dominions (Canada) (1914) 601 A C 50 Overseas Dominions (Canada) (1914) 601 A C 50 Physical Culture (1914) 901 B U 25 Punch Cartoons (1916): A Toned card £3.44 B Glossy white card £3.46 B Glossy white card £5.46 B C 50 Roses, 2nd Series (1915) H.452 £7.56 A C 50 Roses (1912) £1.10 A C 50 Roses (1912) £1.10 A C 50 School Arms (1906) 707 A C 50 Transvaal Series (1911) H.453 £1.36 A C 50 Transvaal Series (1915) H.454 £1.44 A BW 66 Transvaal Series (1915) H.455 £1.36 A C 50 Time and Money in Different Countries (1906) H.454 £1.44 A BW 66 Transvaal Series (1915) £2.60 A C 25 The World's Dreadnoughts (1902) H.360 £5.50 For other 'Transvaal Series' see A Period. A C A Home issue— adhesive back 500 A C 48 Animalloys (sectional) (1934) 32p B C 25 Animals and Their Furs (1929) 51.10				C Rough brown card		£1.40	_
A C 50 Historic Events (1912) H.464 A C 50 *Locomotive Engines and Rolling Stock, with LT.C. Clause (1902) For issue without I T. C. Clause see Period A. A C 50 Military Motors (1916): A Without 'Passed by Censor' £1.76 B With 'Passed by Censor' £1.76 A C 50 Mining (1916) H.450 £1.10 A C 50 Musical Celebrities (1911) £2.56 Set of 50 with 8 substituted cards \$2.50 Set of 50 with 8 substituted cards £1.70 A C 50 Naval Dress & Badges (1909) H.172 £2.20 A C 50 Nelson Series (1905) £2.88 A C 50 Old English Garden Flowers (1910) £2.20 A C 50 Old English Garden Flowers (1910) £1.00 A C 50 Overseas Dominions (Australia) (1915) H.451 60p A C 50 Overseas Dominions (Canada) (1914) 60p A C 50 Physical Culture (1914) 60p A U 100 *Portraits of European Royalty (1908): Nos. 1-50 £1.30 B U 25 Punch Cartoons (1916): A Toned card £3.40 B G lossy white card £6.00 B U 25 Punch Cartoons —Second Series (1917) £1.00 A C 50 Roses (1912) £1.10 A C 50 Second Arms (1906) £1.10 A C 50 Roses (1912) £1.10 A C 50 Time and Money in Different Countries (1906) £1.30 A C 50 Time and Money in Different Countries (1906) £1.30 A C 50 Time and Money in Different Countries (1906) £1.40 A C 50 Time and Money in Different Countries (1906) £1.40 A C 50 Time and Money in Different Countries (1906) £1.40 A C 50 A Home issues, i.e. series with I.T.C. Clause. A C A A C A A A A A A A A A A A A A A			50	Gems of Russian Architecture (1916)		70p	£35.00
Locomotive Engines and Rolling Stock, with LT.C. Clause (1902) For issue without I T. C. Clause see Period A. A C 50 Military Motors (1916): A Without 'Passed by Censor' B With 'Passed by Censor' A C 50 Mining (1916) A C 50 Musical Celebrities (1911) A C 50 Musical Celebrities (1911) B original cards (later substituted cards a briginal cards (later substituted) Set of 50 with 8 substituted cards for ground for substituted (1916) A C 50 Naval Dress & Badges (1909) A C 50 Naval Dress & Badges (1909) B A C 50 Old English Garden Flowers (1910) A C 50 Old English Garden Flowers (1910) A C 50 Overseas Dominions (Australia) (1915) B A C 50 Overseas Dominions (Australia) (1915) B O C 50 Physical Culture (1914) A C 50 Physical Culture (1914) B O C 50 Punch Cartoons (1916): A Toned card B Glossy white card B Glossy white card B Glossy white card C 50 Roses (1912) C A C 50 Roses, 2nd Series (1917) C A C 50 Roses, 2nd Series (1917) C A C 50 Roses, 2nd Series (1914) C C 50 Roses, 2nd Series (1914) C C 50 Roses, 2nd Series (1914) C C 70 School Arms (1906) C C 70 Strups and Money in Different Countries (1906) C POST-1920 ISSUES Home issues, i.e. series with LT.C. Clause C A C Al Raid Precautions (1938): A C A C Al Raid Precautions (1938): C A A Home issue — adhesive back C A C Al Rainalloys (sectional) (1934) C A C Al Rainalloys (sectional) (1934) C A C Al Rainalloys (sectional) (1934) C C C Al Rainalloys (sectional) (1934) C C C Al Rainalloys (sectional) (1934) C C C C S Al Alimalloys (sectional) (1934) C C C S Alimals and Their Furs (1929) C For ther Furnals and Their Furs (1929) C For the Furnals and Their Furs (1929) C For the Furnals Al Rainalloys (19	A	C	50			£1.10	£55.00
Clause (1902) For issue without I T. C. Clause see Period A.	A	C	50	*Locomotive Engines and Rolling Stock, with I.T.C.			200.00
For issue without 1 T. C. Clause see Period A. A C 50 Military Motors (1916): B With 'Passed by Censor'						£7.00	£350.00
A C 50 Military Motors (1916):				For issue without IT. C. Clause see Period A.			200.00
A Without 'Passed by Censor' B With 'Passed by Censor' A C 50 Mining (1916) A C 50 Musical Celebrities (1911) A C 50 Musical Celebrities (1911) B original cards (later substituted cards soriginal cards (later substituted) B original cards (later substituted) C 50 Naval Dress & Badges (1909) H.172 £2.26 A C 50 Naval Dress & Badges (1909) H.172 £2.26 A C 50 Old English Garden Flowers (1910) A C 50 Old English Garden Flowers (1910) A C 50 Overseas Dominions (Australia) (1915) H.451 60 A C 50 Overseas Dominions (Australia) (1914) A C 50 Overseas Dominions (Canada) (1914) A C 50 Physical Culture (1914) A U 100 *Portraits of European Royalty (1908): Nos. 1-50 Nos. 51-100 B U 25 Punch Cartoons (1916): A Toned card B Glossy white card B Glossy white card A C 50 Roses (1912) A C 50 Roses (1911) A C 50 Time and Money in Different Countries (1906) A C 25 The World's Dreadnoughts (1910) £2.60 A C 25 The World's Dreadnoughts (1910) £2.60 A C 26 A Home issue, i.e. series with I.T.C. Clause. A C A Home issue — adhesive back A C 48 Animalloys (sectional) (1934) B C 25 Animals and Their Furs (1929) £1.80	A	C	50				
B With 'Passed by Censor' A C 50 Mining (1916) H.450 £1.10 A C 50 Musical Celebrities (1911) £2.50 A C 50 Musical Celebrities — Second Series (1916): H.465 Set of 50 with 8 substituted cards £200.00 A C 50 Naval Dress & Badges (1909) H.172 £2.20 A C 50 Nelson Series (1905) £2.80 A C 50 Nelson Series (1905) £2.80 A C 50 Old English Garden Flowers (1910) £1.00 A C 50 Old English Garden Flowers, 2nd Series (1913) £1.00 A C 50 Overseas Dominions (Australia) (1915) H.451 60 A C 50 Overseas Dominions (Canada) (1914) 60 A C 50 Physical Culture (1914) 90 A U 100 *Portraits of European Royalty (1908):						£1.70	£85.00
A C 50 Mining (1916)				B With 'Passed by Censor'			£85.00
A C 50 Musical Celebrities (1911)	A	C	50	Mining (1916)	H 450		£55.00
A C 50 Musical Celebrities — Second Series (1916): Set of 50 with 8 substituted cards 8 original cards (later substituted) 4 C 50 Naval Dress & Badges (1909)	A	C	50	Musical Celebrities (1911)	11.150		£125.00
Set of 50 with 8 substituted cards £3.00 £200.00				Musical Celebrities — Second Series (1916):	H 465	22.50	2125.00
8 original cards (later substituted) £200.00 A C 50 Naval Dress & Badges (1909) H.172 £2.20 A C 50 Nelson Series (1905) £2.80 A C 50 Old English Garden Flowers (1910) £1.00 A C 50 Old English Garden Flowers, 2nd Series (1913) £1.00 A C 50 Overseas Dominions (Australia) (1915) H.451 60p A C 50 Overseas Dominions (Canada) (1914) 60p A C 50 Physical Culture (1914) 90p A U 100 *Portraits of European Royalty (1908): Nos. 1-50 £1.30 Nos. 51-100 £1.30 B U 25 Punch Cartoons (1916): A Toned card £3.44 B Glossy white card £6.00 A C 12 Recruiting Posters (1915) H.452 £7.50 A C 50 Roses, 2nd Series (1914) £1.10 A C 50 School Arms (1906) 70p A C 50 Signalling Series (1911) H.453 £1.30 A C 50 Signalling Series (1911) H.453 £1.30 A C 50 Time and Money in Different Countries (1906) H.454 £1.40 A C 25 The World's Dreadnoughts (1910) £2.60 C POST-1920 ISSUES Home issues, i.e. series with I.T.C. Clause. A C 48 Animalloys (sectional) (1934) 32p B C 25 Animals and Their Furs (1929) £1.80				Set of 50 with 8 substituted cards	11.403	£3.00	£150.00
A C 50 Naval Dress & Badges (1909)				8 original cards (later substituted)			2130.00
A C 50 Nelson Series (1905)	A	C	50	Naval Dress & Badges (1909)	H 172		£110.00
A C 50 Old English Garden Flowers (1910) £1.00 A C 50 Old English Garden Flowers, 2nd Series (1913) £1.00 A C 50 Overseas Dominions (Australia) (1915) H.451 60p A C 50 Overseas Dominions (Canada) (1914) 60p A C 50 Physical Culture (1914) 90p A U 100 *Portraits of European Royalty (1908):			50	Nelson Series (1905)			£140.00
A C 50 Old English Garden Flowers, 2nd Series (1913) £1.00 A C 50 Overseas Dominions (Australia) (1915) H.451 60pt A C 50 Overseas Dominions (Canada) (1914) 60pt A C 50 Physical Culture (1914) 90pt A U 100 *Portraits of European Royalty (1908): Nos. 1-50 £1.30 Nos. 51-100 £1.30 B U 25 Punch Cartoons (1916): A Toned card £3.40 B Glossy white card £6.00 A C 12 Recruiting Posters (1915) H.452 £7.50 A C 50 Roses (1912) £11.00 A C 50 Roses, 2nd Series (1914) £1.00 A C 50 School Arms (1906) 70pt A C 50 Signalling Series (1911) H.453 £1.30 A C 50 Time and Money in Different Countries (1906) H.454 £1.40 A BW 66 Transvaal Series, 'Capstan' back (1902) H.360 £5.50 For other 'Transvaal Series' see A Period. A C 25 The World's Dreadnoughts (1910) £2.60 C POST-1920 ISSUES Home issues, i.e. series with I.T.C. Clause. A C 48 Animalloys (sectional) (1934) 32pt B C 25 Animals and Their Furs (1929) £1.80			50	Old English Garden Flowers (1910)			£50.00
A C 50 Overseas Dominions (Australia) (1915)							£50.00
A C 50 Overseas Dominions (Canada) (1914) 607 A C 50 Physical Culture (1914) 907 A U 100 *Portraits of European Royalty (1908): Nos. 1-50 51-100 51-				Overseas Dominions (Australia) (1915)	H 451		£30.00
A C 50 Physical Culture (1914) 90F A U 100 *Portraits of European Royalty (1908):				Overseas Dominions (Canada) (1914)	11.431		£30.00
A U 100 *Portraits of European Royalty (1908): Nos. 1-50			2	Physical Culture (1914)			£45.00
Nos. 1-50				*Portraits of European Royalty (1908):		90p	143.00
Nos. 51-100 £1.30				Nos 1-50		£1 20	665.00
B U 25 Punch Cartoons (1916): A Toned card B Glossy white card B U 25 Punch Cartoons — Second Series (1917) A C 12 Recruiting Posters (1915) A C 50 Roses (1912) A C 50 Roses, 2nd Series (1914) A C 50 School Arms (1906) A C 50 Signalling Series (1911) A C 50 Signalling Series (1911) B W 66 Transvaal Series, 'Capstan' back (1902) For other 'Transvaal Series' see A Period. A C 25 The World's Dreadnoughts (1910) C POST-1920 ISSUES Home issues, i.e. series with I.T.C. Clause. A C A Home issue — adhesive back 40 B Irish issue — non-adhesive back 50p A C 48 Animalloys (sectional) (1934) B C 25 Animals and Their Furs (1929) £3.46 £3.46 £3.46 £6.00 £1.60 £3.46 £3				Nos. 51-100			£65.00 £65.00
A Toned card B Glossy white card B Glossy white card B U 25 Punch Cartoons — Second Series (1917) A C 12 Recruiting Posters (1915) B C 150 Roses (1912) C 160 Roses, 2nd Series (1914) C 170 Roses, 2nd Series (1914) C 180 Roses, 2nd Series (1914) C 181 Roses C	B	U	25	D		11.30	103.00
B Glossy white card £6.00 B U 25 Punch Cartoons — Second Series (1917) £16.00 A C 12 Recruiting Posters (1915) H.452 £7.50 A C 50 Roses (1912) £1.10 A C 50 Roses, 2nd Series (1914) £1.10 A C 50 School Arms (1906) 70p A C 50 Signalling Series (1911) H.453 £1.30 A C 50 Time and Money in Different Countries (1906) H.454 £1.40 A BW 66 Transvaal Series, 'Capstan' back (1902) H.360 £5.50 For other 'Transvaal Series' see A Period. A C 25 The World's Dreadnoughts (1910) £2.60 C POST-1920 ISSUES Home issues, i.e. series with I.T.C. Clause. A C Air Raid Precautions (1938): Ha.544 50 A Home issue — adhesive back £1.00 A C 48 Animalloys (sectional) (1934) 32p B C 25 Animals and Their Furs (1929) £1.80				A Toned card		62.40	COE 00
B U 25 Punch Cartoons — Second Series (1917)				B Glossy white card			£85.00
A C 12 Recruiting Posters (1915)	R	II	25	Punch Cartoons — Second Series (1017)			- T
A C 50 Roses (1912)				Recruiting Posters (1015)	H 450		coo oo
A C 50 Roses, 2nd Series (1914)				Roses (1012)	H.452		£90.00
A C 50 School Arms (1906)				Roses 2nd Series (1014)			£55.00
A C 50 Signalling Series (1911) H.453 £1.30 A C 50 Time and Money in Different Countries (1906) H.454 £1.40 A BW 66 Transvaal Series, 'Capstan' back (1902) H.360 £5.50 For other 'Transvaal Series' see A Period. A C 25 The World's Dreadnoughts (1910) £2.60 C POST-1920 ISSUES Home issues, i.e. series with I.T.C. Clause. A C Air Raid Precautions (1938): Ha.544 50 A Home issue — adhesive back £1.00 A C 48 Animalloys (sectional) (1934) 32p B C 25 Animals and Their Furs (1929) £1.80				School Arms (1906)			£50.00
A C 50 Time and Money in Different Countries (1906) H.454 £1.40 A BW 66 Transvaal Series, 'Capstan' back (1902) H.360 £5.50 For other 'Transvaal Series' see A Period. A C 25 The World's Dreadnoughts (1910) £2.60 C POST-1920 ISSUES Home issues, i.e. series with I.T.C. Clause. A C Air Raid Precautions (1938): Ha.544 50 A Home issue — adhesive back £1.00 A C 48 Animalloys (sectional) (1934) 32p B C 25 Animals and Their Furs (1929) £1.80			1000	Signalling Series (1011)	TT 452		£35.00
A BW 66 Transvaal Series, 'Capstan' back (1902) H.360 For other 'Transvaal Series' see A Period. A C 25 The World's Dreadnoughts (1910) £2.60 C POST-1920 ISSUES Home issues, i.e. series with I.T.C. Clause. A C Air Raid Precautions (1938): Ha.544 50 A Home issue — adhesive back £1.00 A C 48 Animalloys (sectional) (1934) 32p B C 25 Animals and Their Furs (1929) £1.80				Time and Manay in Different Countries (1006)	H.455		£65.00
For other 'Transvaal Series' see A Period. A C 25 The World's Dreadnoughts (1910)			-	Transveral Series 'Constan' heat (1906)	H.454		£70.00
A C 25 The World's Dreadnoughts (1910) £2.60 C POST-1920 ISSUES Home issues, i.e. series with I.T.C. Clause. A C Air Raid Precautions (1938): Ha.544 50 A Home issue — adhesive back 50p 40 B Irish issue — non-adhesive back £1.00 A C 48 Animalloys (sectional) (1934) 32p B C 25 Animals and Their Furs (1929) £1.80	A	ъ "	00	For other 'Transparal Carias' and A Paried	H.300	£5.50	£365.00
C POST-1920 ISSUES Home issues, i.e. series with I.T.C. Clause. A C Air Raid Precautions (1938): Ha.544 50 A Home issue — adhesive back 50p 40 B Irish issue — non-adhesive back £1.00 A C 48 Animalloys (sectional) (1934) 32p B C 25 Animals and Their Furs (1929) £1.80	Δ	C	25			60.60	065.00
Home issues, i.e. series with I.T.C. Clause. A C Air Raid Precautions (1938): Ha.544 50 A Home issue — adhesive back 50p 40 B Irish issue — non-adhesive back £1.00 A C 48 Animalloys (sectional) (1934) 32p B C 25 Animals and Their Furs (1929) £1.80						£2.60	£65.00
A C Air Raid Precautions (1938): Ha.544 50 A Home issue — adhesive back . 50p 40 B Irish issue — non-adhesive back . £1.00 A C 48 Animalloys (sectional) (1934) . 32p B C 25 Animals and Their Furs (1929) . £1.80							
50 A Home issue — adhesive back 50p 40 B Irish issue — non-adhesive back £1.00 A C 48 Animalloys (sectional) (1934) 32p B C 25 Animals and Their Furs (1929) £1.80			168, 1.6				
40 B Irish issue — non-adhesive back £1.00 A C 48 Animalloys (sectional) (1934)	A	-	50		Ha.544		
A C 48 Animalloys (sectional) (1934)				A Home issue — adhesive back			£25.00
B C 25 Animals and Their Furs (1929)		0		B Irish issue — non-adhesive back			_
				Animaloys (sectional) (1934)		32p	£16.00
B (/) Arms of the British Himpire (First Carles) (1021)				Animais and Their Furs (1929)		£1.80	£45.00
£1.60				Arms of the British Empire — 'First Series' (1931) Arms of the British Empire — 'Second Series' (1932)		£1.60	£40.00
						£1.60	£40.00
B C 42 Arms of Oxford and Cambridge Colleges (1922) £1.30				Arms of Oxford and Cambridge Colleges (1922)		£1.30	£55.00
B C 25 Arms of Public Schools — '1st Series' (1933)				Arms of Public Schools — '1st Series' (1933)		£1.60	£40.00
B C 25 Arms of Public Schools — '2nd Series' (1934) £1.60			100 miles	Arms of Public Schools — '2nd Series' (1934)		£1.60	£40.00
B C 25 Arms of Universities (1923)	A TOTAL OF THE PARTY OF		1955	Arms of Universities (1923)		£1.40	£35.00
A C 50 Association Footballers 'Frameline' back (1935) £1.20	A	C	50	Association Footballers 'Frameline' back (1935)		£1.20	£60.00

Ci	Duine		h	Handbook	Drice	Complete
Size	Print-ing	in se		reference	per card	Complete set
				rejerence	percura	50.
A	C	50	Association Footballers — 'No frameline' back (1939):		C1 20	060.00
			A Home issue — adhesive back		£1.20	£60.00
-		25	B Irish issue — non-adhesive back		£2.00 £2.20	£100.00
В	C	25	Auction Bridge (1926)			£55.00
В	C	25	Beautiful Homes (1930)		£2.40 £1.00	£60.00
A	C	50	British Butterflies (1927)			£50.00
В	C	25	British Castles (1925)		£2.20	£55.00
В	C	25	British School of Painting (1927)		£1.20	£30.00
_	BW	48	British Sporting Personalities $(66 \times 52 \text{mm}) (1937) \dots$		75p	£36.00
В	C	40	Butterflies and Moths (1938)		80p	£32.00
В	C	25	Cathedrals (1933)		£2.80	£70.00
A	C	25	Cinema Stars — 'First Series' (1928)		£1.60	£40.00
A	C	25	Cinema Stars — 'Second Series' (1928)		£1.60	£40.00
A	U	50	Cinema Stars — 'Third Series' (1931)		£1.80	£90.00
A	C	50	Cricketers, 1928 (1928)		£1.80	£90.00
A	C	50	Cricketers — '2nd Series' (1929)		£1.60	£80.00
A	C	50	Dogs — Light backgrounds (1937):		50-	C25 00
			A Home issue — adhesive back		50p	£25.00
			B Irish issue — non-adhesive back		£1.10	£55.00
A	C	50	Do You Know:		40p	£20.00
		50	'A Series of 50' (1922)			£20.00
		50	'2nd Series of 50' (1924)		40p 40p	£20.00
		50	'3rd Series of 50' (1926)			£25.00
		50	'4th Series of 50' (1933)		50p	
A	C	50	Engineering Wonders (1927)		70p	£35.00
A	C	50	English Period Costumes (1929)		90p	£45.00
В	C	25	English Period Costumes (1927)		£2.40	£60.00
В	C	40	Famous British Authors (1937)		£1.50	£60.00
В	C	30	Famous British Liners — 'First Series' (1934)		£3.50	
В	C	30	Famous British Liners — 'Second Series' (1935)		£3.00	£90.00
В	C	25	Famous Golfers (1930)		£16.00	_
A	C		A Famous Picture — (sectional):		20	24.5.00
		48	Series No. 1 — 'Between Two Fires' (1930)		30p	£15.00
		48	Series No. 2 — 'The Boyhood of Raleigh' (1930)		30p	£15.00
		48	Series No. 3 — 'Mother and Son' (1931)		30p	£15.00
		48	'The Toast' (1931):			
			A Home issue — Series No. 4		50p	£24.00
			B Irish issue — Series No. 1		£1.80	_
		48	'The Laughing Cavalier' (1931):			
			A Home issue — Series No. 5:		1.5	
			1 No stop after numeral		40p	£20.00
			2 Full stop after numeral		40p	£20.00
			B Irish issue — Series No. 2		£1.80	_
		49	Series No. 6 — 'And When did you Last See Your			
			Father?' (1932)		90p	£45.00
A	C	25	Flags of the Empire (1926)		£1.00	£25.00
A	C	25	Flags of the Empire — '2nd Series' (1929)		£1.00	£25.00
A	C	50	Flower Culture in Pots (1925)		45p	£22.50
В	C	30	Flowering Shrubs (1935)		£1.00	£30.00
A	C	50	Flowering Trees and Shrubs (1924)		70p	£35.00
A	C	50	Garden Flowers (1933)		50p	£25.00
A	C	50	Garden Flowers by Richard Sudell (1939):			
			A Home issue — four brands quoted at base		25p	£12.50
			B Irish issue — no brands at base		40p	£20.00
В	C	40	Garden Flowers — New Varieties — 'A Series' (1938)		60p	£24.00
В	C	40	Garden Flowers — New Varieties — '2nd Series' (1939)		50p	£20.00

Size	Print-			Handbook reference	Price per card	Complete set
Α	C	50	Cordon Hints (1028).	rejerence	percura	sei
A	C	30	Garden Hints (1938): A Home issue — Albums 'one penny each'			
					17p	£8.50
A	C	50	The same of the sa		30p	£15.00
B	C	25	Gardening Hints (1923)		25p	£12.50
В	C	25	Golfing (1924)		£8.00	
A2	P	54	Heraldic Signs and Their Origin (1925)		£1.80	£45.00
A	C	50	Homeland Events (1932)		40p	£22.00
A	C	50	Household Hints (1927)		35p	£17.50
A	C	50	Household Hints — '2nd Series' (1930) Household Hints (1936):		40p	£20.00
**	-	50				20.50
			A Home issue — Albums 'one penny each' B Irish issue — Album offer without price		17p	£8.50
Α	BW	50	Hurlers (1927)		40p	£20.00
A	C	25	Irish Beauty Spots (1929)		£1.30	£65.00
A	C	25	Irish Holiday Resorts (1930)		£4.00	
A	Č	50	Irish Industries (1937):		£4.00	
**	-	50	A Back 'This surface is adhesive'		02.00	
			B Back 'Ask your retailer'		£3.00	-
A	U	25	B Back 'Ask your retailer' Irish Rugby Internationals (1928)		£1.00	£50.00
A	C	50	Irish Sportsmen (1935)		£8.00	
В	C	40	The King's Art Treasures (1938)		£3.00	-
В	C	25	Lawn Tennis, 1931 (1931)		30p	£12.00
A	C	50	Life in the Royal Navy (1939)		£6.00	-
A	C	50	Life in the Tree Tops (1925)		22p	£11.00
A	C	50	Lucky Charms (1923)		35p	£17.50
A	C	50	Merchant Ships of the World (1924)		50p	£25.00
K2	C	53	*Miniature Playing Cards (1932-34):		£1.20	£60.00
112		33	A Home issue, blue back — 'narrow 52' (2			
			narrow 32 (2		50	005.00
			printings)		50p	£25.00
			C Home issue, pink back (3 printings)		50p	£25.00
			D Irish issue, blue back (7 printings)		60p	
В	C	25	Modern Architecture (1931)		£1.00	-
В	U	30	Modern British Sculpture (1928)		£1.40	£35.00
В	C	25	Old Furniture — '1st Series' (1923)		£1.30	£40.00
В	C	25	Old Furniture — 'St Series' (1923) Old Furniture — '2nd Series' (1924)		£2.80	£70.00
В	C	40	Old Inns - 'A Series of 40' (1026)		£2.80	£70.00
В	C	40	Old Inns — 'A Series of 40' (1936)		£3.00	£120.00
В	C	25	Old London (1020)		£1.60	£65.00
В	C	30	Old Pottery and Posselsin (1934)		£3.00	£75.00
В	C	25	Old Silver (1934)		£1.10	£33.00
В	C	25	Old Silver (1924)		£2.40	£60.00
A	BW	50	Old Sundials (1928)		£2.80	£70.00
B	C	25	Our King and Queen (1937)		20p	£10.00
В	C	40	Public Schools (1927)		£2.40	£60.00
A	C	50	Racehorses and Jockeys, 1938 (1939)		£1.75	£70.00
A	-	30	A Home issue — back 'This surface '			A CASE
			cuest imb builded		80p	£40.00
A	C	50			£1.50	
A	C	50	Radio Celebrities — 'Second Series — (1935):			
			A Home issue — back 'This surface'		50p	£25.00
٨	C	50	B Irish issue — back 'Note. This surface'		£1.00	
A	C	50	Railway Engines (1924)		£1.00	£50.00
A	-	50	Railway Engines (1936):			
			A Home issue — back 'This surface'		90p	£45.00
	0	50	B Irish issue — back 'Note. This surface'		£1.40	£70.00
A	C	50	Railway Equipment (1939)		22p	£11.00

Size	Print-	Num in se		Handbook reference	Price per card	Complete set
Α	C	50	Railway Locomotives (1930)		£1.40	£70.00
A	Č	50	The Reign of H. M. King George V (1935)		60p	£30.00
В	C	25	Rigs of Ships (1929)		£3.40	£85.00
A	Č	50	Romance of the Heavens (1928):			
			A Thin card		60p	£30.00
			B Thick card		60p	£30.00
A	C	50	Roses (1926)		90p	£45.00
В	C	40	Roses (1936)		£1.25	£50.00
	BW	48	Round Europe (66 × 52mm) (1937)		30p	£15.00
A	C	50	Rugby Internationals (1929)		£1.40	£70.00
A	C	50	Safety First (1934):			
			A Home issue — 'This surface'		90p	£45.00
			B Irish issue — 'Note. This surface'		£1.50	_
A	C	50	The Sea-Shore (1938):			
			A Home issue — special album offer		22p	£11.00
			B Irish issue — general album offer		70p	£35.00
A	U	40	Shannon Electric Power Scheme (1931)		£1.50	£60.00
A	U	50	Ships' Badges (1925)		70p	£35.00
A	C	50	Speed (1930)		£1.30	£65.00
A	C	50	Speed (1938):			
			A Home issue — four brands quoted at base		30p	£15.00
			B Irish issue — no brands at base		70p	£35.00
A	C	50	Strange Craft (1931)		£1.00	£50.00
В	C	40	Trees (1937)		£1.60	£65.00
В	C	25	University Hoods and Gowns (1926)		£2.40	£60.00
A	C	50	Wild Flowers (1923):			
			A With dots in side panels		55p	£27.50
			B Without dots in side panels		55p	£27.50
A	C	50	Wild Flowers — 'Series of 50' (1936):			
			A Home issue — back 'This surface'		35p	£17.50
			B Irish issue — back 'Note. This surface'		70p	
A	C	50	Wild Flowers — '2nd Series.' (1937):		200	
			A Home issue — adhesive back		20p	£10.00
			B Irish issue — non-adhesive back		60p	£30.00
A	C	50	Wonders of the Past (1926)		50p	£25.00
A	C	50	Wonders of the Sea (1928)		40p	£20.00
Control of the Contro			SSUES			
H2	C	30	Britain's Motoring History (1991)		£1.20	£36.00
-	C	6	Britain's Motoring History (1991) Beer Mats		£1.00	_
H2	C	30	Britain's Steam Railways (1998)		£1.00	-
G2	C	30	British Aviation (1994)		£1.00	£30.00
_	C	6	British Aviation (1994) Beer Mats		35p	£2.00
G2	C	30	Classic Sports Cars (1996)		£1.00	£30.00
G2	C	30	Donington Collection (1993)		£1.20	£36.00
_	C	6	Donington Collection (1993) Beer Mats		£1.00	250.00
G2	\mathbf{BW}	48	Familiar Phrases (1986)		£1.00	£50.00
H2	C	30	History of Britain's Railways (1987)		£1.20	£36.00
H2	C	30	History of Motor Racing (1987)		£1.50	626.00
G2	C	30	In Search of Steam (1992)		£1.20	£36.00
	C	6	In Search of Steam (1992) Beer Mats		£1.00	CC 000
G2	BW	5	Pica Punchline (1984)		£1.20	£6.00
H2	U	144	Punch Lines (1983)		60p	4
G2	U	288	Punch Lines (1983)		60p	_
G2	U	48	Ring the Changes (1985):		£1.00	
			A With 'Wills' name		£1.00	_
			B Without 'Wills' Name		£1.00	

W.I	D. & I	I.O.	WILLS, Bristol (continued)			
Size	Print-ing	Num in se		Handbook reference	Price per card	Complete set
_	C	12	Russ Abbot Advertising Cards (80 × 47mm) (1993)		£1.25	
G2	C	30	Soldiers of Waterloo (1995)		£1.00	£30.00
G2	BW	10	Spot the Shot (1986)		£2.50	230.00
G2	C	30	The Tank Story (1997)		£1.00	
-	C	56	Wonders of the World (1986):		21.00	
			A Size 90 × 47mm		50p	£28.00
			B Size 80 × 47mm		70p	220.00
			C Size 80 × 35mm		90p	_
C1	C	36	World of Firearms (1982)		25p	£9.00
C1	C	36	World of Speed (1981)		25p	£9.00
E	UNISS	HED .	SERIES			
A	P	50	Gems of Italian Architecture (1960) (reprint)		70-	C25 00
A	C	50	Life in the Hedgerow (c1950)		70p	£35.00
A	Č	50	Life of King Edward VIII (1936)		50p	£25.00
A	C	25	Pond and Aquarium 1st Series (c1950)		-	£800.00
A	Č	25	Pond and Aquarium 2nd Series (c1950)		32p	£8.00
В	C	40	Puppies (c1950)		32p	£8.00
A	C	50	Waterloo(c1916)		-	-
					£90.00	_
			VEOUS			
В	BW	1	Advertisement Card — Wants List (1935)		<u> </u>	75p
_	_	? 8	Boer War Medallions (c1901)		£80.00	_
- 100 0	C	12	The British Empire $(133 \times 101 \text{mm})$ $(c1930)$		£8.00	_
1 -	C	12	Cities of Britain (133 × 101mm) (c1930)		£8.00	_
	C	6	Flags of the Allies (shaped) (c1915)		£12.00	_
-	C	32	Happy Families (non-insert) $(91 \times 63 \text{mm})$ (c1935)		£4.00	
-	C	12	Industries of Britain (133 × 101mm) (c1930)		£8.00	_
-	-	1	Pinchbeck Medallion (1897)		£100.00	
			Three Castles Sailing Ship Model advertisement cards			
			(1965):			
A	C	1	A View from Stern:			
			I. Three Castles Cigarettes		<u> </u>	£4.00
			II. In the eighteenth century			£1.50
A	C	1	B Views from Bows:			41.00
			I. Three Castles Filter			£1.50
			II. Three Castles Filter magnum			£1.50
A	BW	1	C Sailing Ship Black Line Drawing		_	£5.00
A	BW	1	D Three Castles Shield Black Line Drawing			£5.00
-	C		200th Anniversary Presentation Packs (2 sets of			25.00
			Playing Cards) (1986)			£80.00
						200.00
WI	ISON	J &	CO., Ely—			
					320 - 15 15 19	
PRE	-1919 1	SSUE				
A	C	50	War Portraits (1916)	H.86	£65.00	
					202.00	
W	WIT	CON	, Birmingham————			
			BB 100 (BB 100 H) -			
PRE	-1919 1	SSUE				
D	C	30	*Army Pictures. Cartoons, etc (1916)	H.12	£75.00	
					2.2.00	
HF	NRI	WIN	TERMANS (UK) LTD-			
	T-1940		ES			
G	C	30	Disappearing Rain Forest (1991)		40p	£12.00
G	C	30	Wonders of Nature (1992)		40p	£12.00
					Р	~12.00

Size	Print-	Numb in set		Handbook reference	Price per card	Complete
noc		ICCIT	EC	,		
POS	T-1920	15501	Cinema Cavalcade (50 coloured, 200 black and white;			
100	_		sizes — 70 small, 110 large, 70 extra-large):			
		250	'A Series of 250' ('Max Cigarettes') (1939)		90p	
		250	'2nd Series of 250' ('Max Cigarettes') (1940) .		90p	£225.00
A2	C	100	Film Favourites — 'Series of 100' (c1937)	Ha 581-1	£2.00	2225.00
A2	C	100	Film Favourites — '2nd Series of 100' (c1938)	Ha 581-2	£2.00	5 a 1 1 1 1 1 1 1 1 1 1 1 1 1 1 1 1 1 1
A2	C	100	Film Favourites — '3rd Series of 100' (c1939)	Ha 581-3	£1.00	£100.00
J1	C	100	*Men of Destiny (folders) (P.O. Box 5764, Johannes-	114.501 5	21.00	2100.00
31	C	100	burg) (c1935)		£2.00	
	C	250	Speed Through the Ages (171 small, 79 large) (1938):	Ha 583	22.00	
	C	230	A Back in English and Afrikaans	114.505	32p	£80.00
			B Back in English		40p	£100.00
	C	250	This Age of Power and Wonder (170 small, 80 large)		чор	2100.00
	C	250	('Max Cigarettes') (c1935)		30p	£75.00
			(Max Cigarcucs) (C1933)		ЗОР	275.00
1 1	VIX.	& SO	ONS LTD, London—			
	POST-		경영하다 경영화 중에 가장하는 것이라면 사용하다고 하는데 되는데 그 나는데 그리다.			
		50			32p	£16.00
C A2	C C	50	Builders of Empire — 'Kensitas' (1937)		32p	210.00
AZ	C	30	A J. Wix back:			
			1. Linen finish		25p	£12.50
			2. Varnished		35p	£17.50
					25p	£12.50
				Ha.625	23p	112.50
	C		Henry: 'A Series of' (1935):	114.025		
D1		50			60p	£30.00
B1		25	A Large size		£2.60	£65.00
		23	'2nd Series' (1935):		22.00	205.00
В1		50	A Large size		90p	£45.00
DI		25	B Extra-large size		£2.80	£70.00
D1					70p	£35.00
B1		50	3rd Series (1936)			£35.00
B1		50	4th Series (1936)		70p	£30.00
B1	**	50	5th Series (1936)		60p	130.00
00	U	25	물이 가게 되었다. [1] 이 경기 시간에 되었다면 하는 사람들이 되었다면 하는 것이 되었다면 하는 것이 없는 것이 없는 것이 없는 것이 없는 것이 없다면 하는데 없었다면 하는데 없었다면 하는데 없다면 하는데 없		£2.60	£65.00
C2			A Small size		£2.60	£65.00
B1			B Large size		£4.50	103.00
	**	10	C Extra-large size (127 × 88mm)		14.30	_
	U	19				
00			(1932) (Nos. 5, 9, 13, 20, 23, 24 withdrawn):		£2.50	£50.00
C2			A Small size		£3.00	£60.00
B1			B Large size			100.00
***		50	C Extra-large size (127 × 88mm)	TT- 525 2 A	£6.50	
K2	C	53	*Miniature Playing Cards (anonymous) (c1935):	Ha.535-3A		
			A Scroll design:		10	00.00
			1 Red back		18p	£9.00
			2 Blue back		25p	£12.50
			B Ship design:		20	017.00
			1 Red border — Nelson's 'Victory'		30p	£15.00
			2 Black border — Drake's 'Revenge'		30p	£15.00
U		25	Scenes from Famous Films — 'Third Series' (1933):			0
			A Small size		£2.60	£65.00
C2			B Extra-large size (127 × 88mm)		£6.00	205.00

J. WIX & SONS LTD, London (continued)

Size	Print-ing	in set		Handbook reference	Price per card	Complete se
B	SILKS					
_	C	48	British Empire Flags — 'Kensitas' (78 × 54mm) (1933)	Ha.496-4		
			A Inscribed 'Printed in U.S.A.'		80p	£40.00
		60	B Without the above		80p	£40.00
	C	60	Kensitas Flowers — 'First Series', small $(68 \times 40 \text{mm})$ (1934):	TT 106 1		
			1 Back of folder plain	Ha.496-1	c2 00	
			2 Back of folder printed in green:		£3.00	
			(a) Centre oval, 19mm deep		£3.00	
			(b) Centre oval, 22mm deep		£3.00	
			(c) As (b), inscribed washable' below			
	C	60	number		£3.00	_
	С	60	Kensitas Flowers — 'First Series', medium (76 ×	TT 106.1		
			55mm) (1934): A Back of folder plain	Ha.496-1	C4.50	
			B Back of folder printed in green		£4.50 £4.50	
	C	30	Kensitas Flowers — 'First Series' Extra-large (138 ×		24.50	
			96mm) (1934):	Ha.496-1		
			A Back of folder plain		£40.00	
		40	B Back of folder printed in green		£40.00	
	C	40	Kensitas Flowers — 'Second Series' (1935):	Ha.496-2		
			A Small size, 68 × 40mm		£5.00	-
	C	60	B Medium size, 76 × 55mm	He 406 2	£6.00	000 00
C I	POST-1			па.490-3	£1.00	£60.00
	031-1	740 13	Ken-cards (102 × 118mm):			
		12	Series 1. Starters/Snacks (1969)			CE 00
		12	Series 2. Main Courses (1969)			£5.00 £5.00
		12	Series 3. Desserts (1969)			£5.00
		12	Series 4. Motoring (1969)		_	£5.00
		12	Series 5. Gardening (1969)		_	£5.00
		12	Series 6. Do It Yourself (1969)		_	£5.00
		12 12	Series 7. Home Hints (1969)		_	£5.00
n ,	MICCE		Series 8. Fishing (1969)			£5.00
U I	MISCE. C					
	C		Bridge Favours and Place Cards (diecut) (1937)		£12.00	-
	-	42	Bridge Hands (140 × 105mm) (1930)	Ha.535-3B	£12.00	-
			A Size 70 × 34mm	па.333-3Б	£3.50	
			B Size 70 × 41mm		£3.50	
	U		Jenkynisms:		25.50	
			A 'The K4's' Series $(75-78 \times 65 \text{mm})$ (c1932):			
		101	I. Known as 1st Series		80p	_
		50	II. Known as 2nd Series		80p	£40.00
		30	III. Known as 3rd Series		80p	-
		1	IV. Known as 4th Series		_	£2.00
			(c1932):			
		20	I. Series of Quotations		£3.00	
	?	43	II. 'Today's Jenkynisms'		£3.00	
WO	OD	DO	Fingland			
			S., England—————	1000 2000	54,042,00	100
	1919 I	CCITE				
PRE-	BW		Dominoes (63 × 29mm) (c1910)			

T. WOOD, Cleckheaton—			
Size Print- Number ing in set	Handbook reference	Price per card	Complete set
PRE-1919 ISSUE D C 30 *Army Pictures, Cartoons, etc (1916)	. Н.12	£75.00	
JOHN J. WOODS, London—			
PRE-1919 ISSUE A BW ? 21 *Views of London (c1905)	. Н.395	£130.00	1 m
W. H. & J. WOODS LTD., Preston—			
A PRE-1919 ISSUE			
A C 25 *Types of Volunteers and Yeomanry (c1902)	. Н.455	£24.00	£600.00
B POST-1920 ISSUES A2 U 25 Aesop's Fables (c1932) A2 P 50 Modern Motor Cars (c1936) D C 25 Romance of the Royal Mail (c1933)		£1.60 £4.50 £1.00	£40.00 £225.00 £25.00
J. & E. WOOLF———————————————————————————————————			
A U ? 3 *Beauties 'KEWA' (c1900)	. Н.139	£230.00	_
M. H. WOOLLER, London-			
PRE-1919 ISSUE A — 25 Beauties 'BOCCA' (c1900)	•	£230.00	_
T. E. YEOMANS & SONS LTD., Derby—	Secretary of P		
PRE-1919 ISSUES			
— C A 72 Beautiful Women (75 × 55mm) (c1900) A U 50 War Portraits (1916)		£150.00 £65.00	=
JOHN YOUNG & SONS LTD., Bolton—	1 1 1 1 1 1 1 1 1 1 1 1 1 1 1 1 1 1 1		
PRE-1919 ISSUES			
A2 C 12 Naval Skits (c1904)		£130.00 £70.00	=

ANONYMOUS SERIES-

Size Print Number mg in set mg in set mg in set	AIT	ONI	MOC	OS SERIES—			
A 'U '? 40	Size						
A 'U '? 40	A	PRE-19	19 ISS	SUES. WITH LETTERPRESS ON BACK OF CARD			
B Space at back H. 139 £100.00 — D BW 25 *Boxers, green back See Cohen Weenen — <td></td> <td></td> <td></td> <td></td> <td></td> <td></td> <td></td>							
A U 7 40				A 'The cigarettes with which' back			
D							
Al	A		? 40	*Beauties — 'KEW A' 'England Expects' back	H.139	£100.00	_
D C							
Calendar back, gilt border to front. See Cohen Weenen Weenen Weenen Weenen Weenen Weenen Weenen Weenen Weenen H.90						-	-
Weenen	D	C	? 2				
A2 C 20 *Interesting Buildings and Views, 1902 Calendar back Ha.96 Ma.97							
Calendar back Ha.96	40	-	20		H.90		
D2 C	A2	C	20		II. 06		
A C 25 *Types of British Soldiers, 'General Favourite Onyx' back	D	C	2.1				
back					Ha.97		
D C 25 V.C. Heroes (Nos. 51-75 — See Cohen Weenen) A C 41 V.C. Heroes — 'Pure Virginia Cigarettes' — Dobson Molle & Co. Ltd. — Printers £8.00 — D U 50 *War Series (Cohen Weenen — Nos. 1-50) H.103 A C 41 V.C. Heroes — See Thomson and Porteous H.427 B PRE-1919 ISSUES. WITH PLAIN BACK A U 25 *Actors and Actresses — 'FROGA C' H.20 £12.00 — D2 U ? 5 *Actresses — 'Anglo' Ha.185 £50.00 — W *Actresses — 'Anglo' Ha.187 — — — ?13 A Brown tinted — —<	A	C	23		H 144		
A C 41 V.C. Heroes — 'Pure Virginia Cigarettes' — Dobson	D	C	25		П.144		
Molle & Co. Ltd. — Printers							
D U 50 *War Series (Cohen Weenen — Nos. 1-50) H.103 A C 41 V.C. Heroes — See Thomson and Porteous H.427 B PRE-1919 ISSUES. WITH PLAIN BACK A U 25 *Actors and Actresses — 'FROGA C' H.20 £12.00 — D2 U ?5 *Actresses — 'Anglo' Ha.185 £50.00 — U *Actresses — 'Anglo' H.187 ?13 A Brown tinted — i. Thick board ii. Thin board ?10 C Black tinted . £30.00 — A Portrait in red only B Portrait in red only B Portrait in red only B Portrait in colour A D U 26 *Actresses — 'FROGA A' H.20 A POST BACTRESSES — 'HAGG B' H.24 £10.00 — A BW 15 *Actresses — 'HAGG B' H.24 £10.00 — A BW 15 *Actresses — 'RUTAN' See Rutter H.381 A C ? 12 *Arms of Campidge Colleges (17 × 25mm). See Kuit H.458 C C ? 12 *Arms of Companies (30 × 33mm). See Kuit H.459 A BW ? 13 *Battleships. See Hill H.208 A C ? 14 *A Post of Colleges (17 × 25mm). See Kuit H.459 A BW ? 15 *Actresses See Hill H.208 A C ? 18 *Beauties — 'GHOGA' H.30 B B C ? 18 *Beauties — 'GHOGA' H.30 B B C ? 18 *Beauties — 'GHOGA' H.30 B B C ? 18 *Beauties — 'GHOGA' H.30 B B B C ? 18 *Beauties — 'GHOGA' H.30 B B C ? 18 *Beauties — 'GHOGA' H.30 B B C ? 18 *Beauties — 'GHOGA' H.30 B B C ? 18 *Beauties — 'GHOGA' H.30 B B C ? 18 *Beauties — 'GHOGA' H.30 B B C ? 18 *Beauties — 'GHOGA' H.30 B B C ? 18 *Beauties — 'GHOGA' H.30 B B C ? 18 *Beauties — 'GHOGA' H.30 B B C ? 18 *Beauties — 'GHOGA' H.30 B B C ? 25 *Beauties — 'GHOGA' H.30 B B C ? 25 *Beauties — 'GHOGA' H.30 B B C ? 25 *Beauties — 'GHOGA' H.30 B C C ? 26 *Beauties — 'GHOGA' H.30 B C C ? 26 *Beauties — 'GHOGA' H.30 B C C ? 25 *Beauties — 'GHOGA' H.30 B C C ? 25 *Beauties — 'GHOGA' H.30 B C C ? 25 *Beauties — 'GHOGA' H.30 B C C ? 25 *Beauties — 'GHOGA' H.30 B C C ? 25 *Beauties — 'GHOGA' H.30 B C C ? 25 *Beauties — 'GHOGA' H.30 B C C ? 25 *Beauties — 'GHOGA' H.30 B C C ? 25 *Beauties — 'GHOGA' H.30 B C C ? 25 *Beauties — 'GHOGA' H.30 B C C ? 25 *Beauties — 'GHOGA' H.30 B C C ? 25 *Beauties — 'GHOGA' H.30 B C C ? 25 *Beauties — 'GHOGA' H.30 B C C ? 25 *Beauties — 'GHOGA' H.30 B C C ? 25 *Beauties — 'GHOGA' H.30 B C C ? 30 *Beauties — 'GHOGA'	^		71	Molle & Co Itd — Printers		£8.00	
A C 41 V.C. Heroes — See Thomson and Porteous H.427	D	U	50	*War Series (Cohen Weenen — Nos. 1-50)	H 103	28.00	
B PRE-1919 ISSUES. WITH PLAIN BACK							
A U 25 *Actors and Actresses - 'FROGA C'							
D2 U ?5 **Actresses - 'Anglo'	B	PRE-19	19 ISS				
D2 U ?5 **Actresses - 'Anglo'	A	U	25	*Actors and Actresses — 'FROGA C'	H.20	£12.00	_
V	D2		? 5	*Actresses — 'Anglo'	Ha.185	£50.00	_
i. Thick board ii. Thin board ?1 B Green tinted ?10 C Black tinted				*Actresses — 'ANGOOD':			
ii. Thin board ?11 B Green tinted			? 13				
? 10 C Black tinted							
Reference						_	_
A1 BW 20 *Actresses — 'BLARM' H.23 £10.00 — D U 20 *Actresses — Chocolate tinted. See Hill H.207 A C ? 19 *Actresses — Chocolate tinted. See Hill H.207 A Portrait in red only £30.00 — B Portrait in colour £30.00 — D BW 12 *Actresses — 'FRAN'. See Drapkin H.175 A U 26 *Actresses — FROGA A' H.20 £12.00 — A1 BW ? 15 *Actresses — 'HAGG B' H.24 £10.00 — A BW 15 *Actresses — 'RUTAN' See Rutter H.381 — C 50 *Actresses Oval Card (as Phillips) Ha.324 A1 U *Actresses and Beauties — Collotype (See Ogden) H.306 C C 20 *Animal Series. See Hill H.306 C C ? 12 *Arms of Cambridge Colleges (17 × 25mm). See Kuit H.458 — C ? 12 *Arms of Companies (30 × 33mm). See Kuit H.459 A2 BW ? 13 *Battleships. See Hill H.208 A C 25 *Beauties — 'BOCCA' H.39 £14.00 — A 50 *Beauties — 'CHOAB': H.21 U A Unicoloured £12.00 — C B Coloured . £10.00 — A *Beauties — 'FECKSA': H.58 U 50 A Plum-coloured front £20.00 — D2 U ? 18 *Beauties — 'GRACC' H.19 £14.00 — A C 26 *Beauties — 'GRACC' H.59 £14.00 — A C 26 *Beauties — 'GRACC' H.59 £14.00 — A C 26 *Beauties — 'GRACC' H.59 £14.00 — A C 26 *Beauties — 'GRACC' H.59 £14.00 — A C 26 *Beauties — 'GRACC' H.59 £14.00 —				B Green tinted			-
D U 20 *Actresses — Chocolate tinted. See Hill H.207 A C ? 19 *Actresses — 'DAVAN': Ha.124 A Portrait in red only	A 1			C Black tinted	*** ***		
A C ? 19 **Actresses — 'DAVAN':				*Actresses — BLARM	H.23	£10.00	
A Portrait in red only E30.00 — B Portrait in colour E30.00 —							
B Portrait in colour £30.00 —	A	C	1 19		Ha.124		
D BW 12						620.00	_
A U 26 *Actresses - 'FROGA A'	D	RW	12	*Actrassas 'FRAN' Saa Drankin	Ц 175	130.00	
A1 BW ? 15 *Actresses — 'HAGG B'						£12.00	
A BW 15 *Actresses — 'RUTAN' See Rutter H.381 — C 50 *Actresses Oval Card (as Phillips) Ha.324 A1 U *Actresses and Beauties — Collotype (See Ogden) H.306 C C 20 *Animal Series. See Hill — C ? 12 *Arms of Cambridge Colleges (17 × 25mm). See Kuit H.458 — C ? 12 *Arms of Companies (30 × 33mm). See Kuit H.459 A2 BW ? 13 *Battleships. See Hill H.208 A C 25 *Beauties — 'BOCCA' H.39 £14.00 A See Beauties — 'CHOAB': H.21 U A Unicoloured £12.00 — C B Coloured £10.00 — A *Beauties — 'FECKSA': H.58 #.59.00 — U 50 A Plum-coloured front £20.00 — C ? 6 B Coloured front £20.00 — D U ? 18 *Beauties — 'FENA' H.148 £45.00 — A C 25 <td< td=""><td></td><td></td><td></td><td>*Actresses — 'HAGG R'</td><td>H 24</td><td></td><td></td></td<>				*Actresses — 'HAGG R'	H 24		
— C 50 *Actresses Oval Card (as Phillips) Ha.324 A1 U *Actresses and Beauties — Collotype (See Ogden) H.306 C C 20 *Animal Series. See Hill H.458 — C ? 12 *Arms of Cambridge Colleges (17 × 25mm). See Kuit H.459 A2 BW ? 13 *Battleships. See Hill H.208 A C 25 *Beauties — 'BOCCA' H.39 £14.00 — A See Euties — 'CHOAB': H.21 H.21 H.21 H.200 — C B Coloured £12.00 — E12.00 — A *Beauties — 'FECKSA': H.58 H.58 H.58 H.59 £9.00 — D C ? 6 B Coloured front £20.00 — £20.00 — D2 U ? 18 *Beauties — 'FENA' H.148 £45.00 — A2 C 25 *Beauties — 'GRACC' H.59 £14.00 — A C 26				*Actresses — 'PLITAN' See Putter	H 391	£10.00	
A1 U *Actresses and Beauties — Collotype (See Ogden) . H.306 C C 20 *Animal Series. See Hill	_			*Actresses Oval Card (as Phillips)	H ₂ 324		
C C 20 *Animal Series. See Hill	A1		50	*Actresses and Reauties — Collotyne (See Ooden)	H 306		
— C ? 12 *Arms of Cambridge Colleges (17 × 25mm). See Kuit H.458 — C ? 12 *Arms of Companies (30 × 33mm). See Kuit H.459 A2 BW ? 13 *Battleships. See Hill H.208 A C 25 *Beauties — 'FBCCCA' H.39 £14.00 — A 50 *Beauties — 'CHOAB': H.21 — £12.00 — C B Coloured £10.00 — A *Beauties — 'FECKSA': H.58 — £9.00 — C ? 6 B Coloured front £20.00 — D2 U ? 18 *Beauties — 'FENA' H.148 £45.00 — A2 C 25 *Beauties — 'GRACC' H.59 £14.00 — A C 26 *Beauties — 'HOL' H.192 £10.00 —			20		11.500		
C ? 12 *Arms of Companies (30 × 33mm). See Kuit H.459 A2 BW ? 13 *Battleships. See Hill H.208 A C 25 *Beauties — 'BOCCA' H.39 £14.00 — A 50 *Beauties — 'CHOAB': H.21 — £12.00 — C B Coloured £10.00 — A *Beauties — 'FECKSA': H.58 — U 50 A Plum-coloured front £9.00 — C ? 6 B Coloured front £20.00 — D2 U ? 18 *Beauties — 'FENA' H.148 £45.00 — A2 C 25 *Beauties — 'GRACC' H.59 £14.00 — A C 26 *Beauties — 'HOL' H.192 £10.00 —	_				H 458		
A2 BW ? 13 *Battleships. See Hill H.208 A C 25 *Beauties — 'BOCCA' H.39 £14.00 — A 50 *Beauties — 'CHOAB': H.21 — U A Unicoloured £12.00 — C B Coloured £10.00 — A *Beauties — 'FECKSA': H.58 — U 50 A Plum-coloured front £9.00 — C ? 6 B Coloured front £20.00 — D2 U ? 18 *Beauties — 'FENA' H.148 £45.00 — A2 C 25 *Beauties — 'GRACC' H.59 £14.00 — A C 26 *Beauties — 'HOL' H.192 £10.00 —	_						
A C 25 *Beauties — 'BOCCA' H.39 £14.00 — A 50 *Beauties — 'CHOAB': H.21 U A Unicoloured £12.00 — C B Coloured £10.00 — *Beauties — 'FECKSA': H.58 U 50 A Plum-coloured front £9.00 — C ?6 B Coloured front £20.00 — D2 U ?18 *Beauties — 'FENA' H.148 £45.00 — A2 C 25 *Beauties — 'GRACC' H.59 £14.00 — A C 26 *Beauties — 'HOL' H.192 £10.00 —	A2						
A 50 *Beauties — 'CHOAB': H.21 U A Unicoloured £12.00 — C B Coloured . £10.00 — A *Beauties — 'FECKSA': H.58 U 50 A Plum-coloured front £9.00 — C ?6 B Coloured front £20.00 — D2 U ?18 *Beauties — 'FENA' . H.148 £45.00 — A2 C 25 *Beauties — 'GRACC' H.59 £14.00 — A C 26 *Beauties — 'HOL' H.192 £10.00 —						f14.00	
U A Unicoloured £12.00 — C B Coloured £10.00 — A *Beauties — 'FECKSA': H.58 U 50 A Plum-coloured front £9.00 — C ? 6 B Coloured front £20.00 — D2 U ? 18 *Beauties — 'FENA' H.148 £45.00 — A2 C 25 *Beauties — 'GRACC' H.59 £14.00 — A C 26 *Beauties — 'HOL' H.192 £10.00 —						214.00	
C B Coloured £10.00 — A *Beauties — 'FECKSA': H.58 U 50 A Plum-coloured front £9.00 — C ? 6 B Coloured front £20.00 — D2 U ? 18 *Beauties — 'FENA' H.148 £45.00 — A2 C 25 *Beauties — 'GRACC' H.59 £14.00 — A C 26 *Beauties — 'HOL' H.192 £10.00 —		U			11.21	£12.00	_
A *Beauties — 'FECKSA': H.58 U 50 A Plum-coloured front £9.00 — C ?6 B Coloured front £20.00 — D2 U ?18 *Beauties — 'FENA' . H.148 £45.00 — A2 C 25 *Beauties — 'GRACC' H.59 £14.00 — A C 26 *Beauties — 'HOL' H.192 £10.00							
U 50 A Plum-coloured front £9.00 — C ? 6 B Coloured front £20.00 — D2 U ? 18 *Beauties — 'FENA' H.148 £45.00 — A2 C 25 *Beauties — 'GRACC' H.59 £14.00 — A C 26 *Beauties — 'HOL' H.192 £10.00 —	A				H.58	210.00	
C ? 6 B Coloured front £20.00 — D2 U ? 18 *Beauties — 'FENA' H.148 £45.00 — A2 C 25 *Beauties — 'GRACC' H.59 £14.00 — A C 26 *Beauties — 'HOL' H.192 £10.00 —		U	50			£9.00	
D2 U ? 18 *Beauties — 'FENA' H.148 £45.00 — A2 C 25 *Beauties — 'GRACC' H.59 £14.00 — A C 26 *Beauties — 'HOL' H.192 £10.00 —							_
A2 C 25 *Beauties — 'GRACC' H.59 £14.00 — A C 26 *Beauties — 'HOL' H.192 £10.00 —	D2		? 18	*Beauties — 'FENA'	H.148		_
A C 26 *Beauties — 'HOL' H.192 £10.00 —	A2	C	25	*Beauties — 'GRACC'	H.59		_
A U ?41 *Beauties 'KEWA'	A	C	26	*Beauties — 'HOL'	H.192	£10.00	_
	A	U	? 41	*Beauties 'KEWA'	H.139	_	_

AITT	J111	MOOK	SERIES (commuea)			
Size	Print ing	t- Numl in set		Handbook reference	Price per card	Complete set
A D1	C U U	30 ? 17	*Beauties — Oval card (36 × 60mm.) (See Phillips) *Beauties — Collotype* *Bewlay's War Series:	Ha.278 Ha.477	_	_
		12	1. Front without captions			
		? 1	2. Front with captions			_
A2 A	BW C	20 ? 25	*Boer War Cartoons* *Boer War and General Interest:	H.42 H.13	£20.00	_
			A Plain cream back		£40.00	
			B Brown Leaf Design back		£40.00	
95			C Green Leaf Design back		£40.00	_
			D Green Daisy Design back		_	
A2	BW	? 16	*Boer War Celebrities — 'CAG'	H.79	_	_
A		? 8	Boer War Celebrities 'RUTTER':	Ha.382		
	BW		A Front in Black and White		£25.00	
			B Front in light orange brown		£25.00	
D2	BW	20	*Boer War Generals — 'CLAM'	H.61	£16.00	
A1	BW	? 12	*Boer War Generals — 'FLAC'		£16.00	_
D	C	25	*Boxer Rebellion — Sketches (1904)		£12.00	
A	C	54	*British Beauties (Phillips) (1-54)			
A	C	54	*British Beauties (Phillips) (55-108) Matt	H.328		
A	C	12	British Queens	Ha.480	£20.00	
A	BW	16	*British Royal Family	H.28	£10.00	
A	C	45	*Celebrities — Coloured (Cohen Weenen)	H.89		
D	C	39	*Celebrities - 'GAINSBOROUGH I'. See Cohen			
			Weenen	H.90		
D	BW	? 147	*Celebrities — 'GAINSBOROUGH II'. See Cohen Weenen	H.91		
A1	P	36	*Celebrities of the Great War (1916). See Major Drapkin & Co	7 . 7		
A A	BW C	? 12	Celebrities of the Great War *Colonial Troops:	Ha.236 H.40	· ·	_
71	-	30	A Cream card	11.10	_	
10		50	B White card		£15.00	
A	BW	20	Cricketers Series	H 29	£200.00	
A	C	50	Dogs (as Taddy)		£24.00	
A	C	25	*England's Military Heroes. See Player: A Wide card	H.352	224.00	
			B Narrow card			
A	C	25	*England's Naval Heroes. See Player:	H.353		
	-		A Wide card			
			B Narrow card			
A	C	20	*The European War Series	H.129	£6.00	
A	Č	20	*Flags, Arms and Types of Nations:	H.115		
	_	24	A Numbered		£7.00	
		? 1	B Unnumbered			_
A	C		*Flags and Flags with Soldiers:	H.41		
**		30	A Flagstaff Draped	11.11	£7.00	
		15	B Flagstaff not Draped (Flags only)		£7.00	
A1	C	30	*Flags of Nations. See Cope	H.114	27.00	
A1	C	24	*Girls, Flags and Arms of Countries. See Rutter			
A	C	40	*Home and Colonial Regiments: 20. Caption in blue	H.69		
					67.00	
A	C	52	20. Caption in brown* *Japanese Series, P.C. Inset. See Muratti		£7.00	
A1 C	P C	? 2	*King Edward and Queen Alexandra	H.460	£18.00	_
		20	manoran Pang Series. See Hill			

	0111		S SERVED (Communica)			
Size	Print ing	- Numi		Handbook reference	Price per card	Complete set
D	C	20	*Nations, gilt border. See Cohen Weenen	H.97		
D	C	40	*Naval and Military Phrases:	H.14		
			A Plain front (no border)		£8.00	_
			B Front with gilt border		_	_
_	U	? 1	*Portraits. See Drapkin & Millhoff (48 × 36mm)	H.461		
A	U	? 47	*Pretty Girl Series — 'BAGG'	H.45	£15.00	_
A2	C	12	*Pretty Girl Series 'RASH' (c1897)	H.8	£16.00	_
A1	C	20	*Prince of Wales Series. See Hill	H.22	£12.00	_
D	C	30	*Proverbs	H.15	£10.00	Y68. 44
A	\mathbf{BW}	19	Russo-Japanese Series	Ha.184	£20.00	_
A	C	20	Russo-Japanese War Series		£20.00	 -
A	C	10	Scenes from San Toy. See Richard Lloyd			
A	C	25	Sports and Pastimes Series No. 1		£7.00	-
A	C	25	*Star Girls		£12.00	-
A1	BW	? 28	*Statuary (Hill A-D)	H.218		
A	C	25	*Types of British and Colonial Troops	H.76		-
A2	C	25	*Types of British Soldiers		£10.00	_
<u>_</u>	U	? 21	Views and Yachts (narrow, abt. 63 × 30mm)		£50.00	-
D D	BW BW	12	*Views of the World. See Drapkin			
D	DW	0	*Warships. See Drapkin			
D	U	?1	A Front in brown	Ha.103		
	BW	? 2	B Front in black and white			_
	DW	. 2	B From in black and white			
C 1			SSUES. WITH LETTERPRESS ON BACK			
	C	25	Cinema Stars — see Teofani:	Ha.530		
C2			A Small size			
_			B Extra-large size $(109 \times 67mm)$			
A2	U	50	Cinema Stars — Set 7 — see United Kingdom			
D0			Tobacco Co	Ha.515-7		
D2	C	25	Cinema Stars — Set 8 — see Moustafa	Ha.515-8		
A2	C	50	Evolution of the British Navy — see Godfrey Phillips .			
A2	BW	40	Famous Film Stars, text in Arabic (two series) — see			
12		50	Hill			
A2	C	50	Famous Footballers — see Godfrey Phillips			
A2 C2	C	35 20	Famous Stars — see Reliance Tobacco Mfg. Co	Ha.5/2		
D2	U	48	Great Inventors — see Teofani	H.213		
DZ	U	40	Modern Movie Stars and Cinema Celebrities — see	II- 560		
D2	C	25	Teofani	Ha.569		
C2	U	24	Pictures of World Interest — see Moustafa	Ha 600		
CZ	U	24	Well-Known Racehorses — see Teofani	па.009		
D	POST-	1920 IS	SSUES. WITH DESIGNS ON BACK			
A	BW	25	Careless Moments (1922)		80p	£20.00
D2	U	28	*Dominoes ("W.T.C." monogram back) — see			
			Walker's Tobacco Co	Ha.535-2		
_	C	53	*Miniature Playing Cards (68 × 42mm) (red back,			
			black cat trade mark in centre) — see Carreras	Ha.535-1		
K2	C	53	*Miniature Playing Cards (blue scroll back) — see			
			Godfrey Phillips			
K2	C	53	*Miniature Playing Cards — see J. Wix:	Ha.535-3		
			A Scroll design:			
			1 Red back			
			2 Blue back			
			B Ship design:			
			2 Black border — Drake's "Revenge"			

Size Print- Number

in set

ing

	0			3	1	
	C		*Playing Cards and Dominoes — see Carreras:	Ha.535-1		
C		52	A Small size:			
			1 Numbered			
			2 <i>Unnumbered</i>			
_		26	B Large size $(77 \times 69mm)$:			
			1 Numbered			
			2 Unnumbered			
E	POST	-1920 IS	SUES. WITH PLAIN BACK			
A2	P	36	Australia. Second Series — see Westminster			
A2	P	18	*Beauties — see Marcovitch			
A1	P		*British Beauty Spots — see Coudens	Ha.553		
B 1	P	50	*British Castles, Nd. S.J.51-S.J.100 — see	1.5		
			Pattreiouex			
-	C	108	*British Naval Crests (74 × 52mm)	Ha.504-4	_	_
D2	CP	50	*Camera Studies — see Moustafa			
B1	P	50	*Cathedrals and Abbeys. Nd. S.J.1-S.J.50 — see			
			Pattreiouex	Ha.595-3		
A	C	25	*Charming Portraits — see Continental Cigarette			
			Factory			
A2	U		*Cinema Stars — Set 3		_	
A2	U	30	*Cinema Stars — Set 6		65p	£20.00
_	C	110	*Crests and Badges of the British Army $(74 \times 52mm)$:	Ha.502-2		
			(a) Numbered		_	_
			(b) Unnumbered			_
_	BW	12	*Film Actors and Actresses (56 × 31mm) — see			
			Teofani	Ha.618		
A	C		*Head Dresses of Various Nations — see Teofani			
A	_		*Inventors and Their Inventions — see Hill			
-	C	?9	*Irish Views (68 × 67mm) — see Lambkin			
_	BW	12	*London Views (57 × 31mm) — see Teofani			
A	C		*Natives in Costume — see Teofani			
_	P	30	*Photographs (Animal Studies) (64 × 41mm)	Ha.541	£1.50	
_	C		*Regimental Colours II (76 × 70mm)	Ha.502-7	£12.00	_
_	P	22	*Teofani Gems I — Series of 22 (53 × 35mm) — see Teofani	Ha.621-1		
_	P	28	*Teofani Gems II — Series of 28 (53 × 35mm) see Teofani	Ha.621-2		
_	P	36	*Teofani Gems III — Series of 36 (53 × 35mm) — see			
A	С	50	Teofani*World's Smokers — see Teofani			

Handbook

reference

Price Complete

per card

F POST-1920 ISSUES. ANONYMOUS SERIES — Silks and Other Novelty Issues

For Anonymous Metal Plaques — see International Tobacco Co. For Anonymous Metal Charms — see Rothman's.

For Anonymous Miniature Rugs — see Godfrey Phillips.

For Anonymous Lace Motifs — see Carreras.

For Anonymous Woven Silks — see Anstie and J. Wix.

For Anonymous Printed Silks with Blue Borders — see Themans.

Anonymous ordinary printed British silks which are found unbacked are listed below, with cross-reference to issuing firms. Entries marked § are only anonymous when the paper backings are missing, and in these cases the indication applies only to the silks without backings.

*Arms of Countries and Territories see Phillips	Ha.504-12
*Battleship Crests I — see Morris§	
*British Admirals — see Phillips	Ha.504-5

Tito (tommed)			
Size Print- Number ing in set	Handbook reference	Price per card	Complete set
*British Butterflies and Moths II — see Phillips	На 505 6		
*British Naval Crests II — see Phillips			
*Butterflies I — see Phillips			
*Butterflies and Moths III — see Leaf			
*Clan Tartans — see Phillips			**
*Colonial Army Badges — see Phillips			
County Cricket Badges — see Phillips	Ha 505		
*Crests and Badges of the British Army II — see Phillips and Singleton &	11a.505		
Cole§	Ha 502-2		123475
*English Flowers — see Morris§	Ha.505-4		
*English and Foreign Birds I — see Morris§	Ha.505-1		
*Flags — Set 1 — see Gallaher§			
*Flags — Set 2 — see Muratti			
*Flags — Set 3 — see Muratti§	Ha.501-3		
*Flags — Set 4 — see Phillips	Ha.501-4		
*Flags — Set 5 — see Phillips	Ha.501-5		4.7
*Flags — Set 6 — see Phillips	Ha.501-6		
*Flags — Set 7 — see Phillips	Ha.501-7		
*Flags — Set 8 — see Muratti§	Ha.501-8		
*Flags — Set 9 — see Phillips	Ha.501-9		
*Flags — Set 10 (7th, 10th and 12th Series) — see Phillips	Ha501-10		
*Flags — Set 11 (Fourth to Seventh Series) — see John Sinclair	Ha.501-11		
*Flags — Set 12 ("Let 'em all come" and Allies grouped Flags) — see			
Phillips	Ha.501-12		
*Flags — Set 13 — see Phillips	Ha.501-13		
*Flags — Set 14 (House Flags) — see Phillips	Ha.501-14		
*Flags — Set 15 (Pilot and Signal Flags) — see Phillips	Ha.501 -15		
*Football Colours — see Phillips	Ha.505-9		
*Great War Leaders I — see Muratti§	Ha.504-6		
*Great War Leaders II — see Fittings Phillips	Ha.504-7		
*Great War Leaders III and Warships — see Phillips	Ha.504-10		
*Irish Patriots — see Phillips	Ha.504-11		
*Naval Badges of Rank and Military Headdress — see Phillips	Ha.503-11		
*Old Masters — Set 2 — see Phillips	Па.504-9		
*Old Masters — Set 2 — see Phillips	Па.503-2		
*Old Masters — Set 3B — see Phillips	Ha 502 2B		
*Old Masters — Set 4 — see Phillips	Ha 503-3B		
*Old Masters — Set 5 — see Phillips	Ha 503-5		
*Old Masters — Set 7 — see Phillips	Ha 503-7		
*Old Pottery — see Lea§	Ha 505-14		
*Orders of Chivalry I — see Phillips	Ha 504-14		
*Orders of Chivalry II — see Murray§	Ha.504-15		
*Pottery Types — see Salmon & Gluckstein§ (see RB21/311)			
*Regimental Badges I — see Muratti\{\} and John Sinclair\{\} \	Ha.502-1		
*Regiment Colours I — see Muratti§	Ha.502-6		
*Regimental Colours II — see Phillips and John Sinclair	Ha.502-7		
*Regimental Colours III — see Phillips	Ha.502-8		
*Regimental Colours IV — see Morris	Ha.502-9		
*Regimental Colours V — see Muratti§	Ha.502-10		
*Regimental Colours & Badges of the Indian Army — see Drapkin§	Ha.502-5		
*Regimental Crests and Badges III — see Lea§	Ha.502-4		
*Religious Pictures — see Phillips	Ha.505-10		
*Victoria Cross Heroes I — see Phillips	Ha.504-1		
*Victoria Cross Heroes II — see Phillips and Cohen Weenen§	Ha.504-2		
*War Pictures — see Phillips	Ha.504-8		

SECTION II

FOREIGN CIGARETTE CARDS

INDEX OF BRANDS

- Admiral Cigarettes see National Cigarette & Tobacco Co.
- Albert Cigarettes see British American Tobacco Co.
- S. Anargyros see American Tobacco Co.
- Between the Acts see American Tobacco Co.
- Big Run Cigarettes see American Tobacco Co.
- Black Spot Cigarettes see Scerri
- British Consuls see Macdonald
- Broadleaf Cigarettes see American Tobacco Co.
- Cairo Monopol Cigarettes see American Tobacco Co.
- Carolina Brights see American Tobacco Co.
 Copain Cigarettes see British American
 Tobacco Co.
- Coronet Cigarettes see Sniders & Abrahams
- Cycle Cigarettes see American Tobacco Co.
- Derby Little Cigars see American Tobacco Co.
- Domino Cigarettes see British American Tobacco Co.
- Egyptienne Luxury see American Tobacco Co.
- Emblem Cigarettes see American Tobacco Co.
- Fez Cigarettes see American Tobacco Co. Fume Emblem — see Westminster Tobacco Co.
- Gold Coin Tobacco see Buchner
- Hassan Cigarettes see American Tobacco Co.

- Havelock Cigarettes see Wills
- Helmar Cigarettes see American Tobacco Co.
- Herbert Tareyton Cigarettes see American Tobacco Co.
- Hindu Cigarettes see American Tobacco Co.
- Hoffman House Magnums see American Tobacco Co.
- Honest Long Cut see Duke or American Tobacco Co.
- Hustler Little Cigars see American Tobacco Co.
- Islander, Fags, Specials, Cubs see Bucktrout
- Jack Rose Little Cigars see American Tobacco Co.
- Just Suits Cut Plug see American Tobacco Co.
- Kopec Cigarettes see American Tobacco Co.
- Lennox Cigarettes see American Tobacco
- Le Roy Cigars see Miller
- Lifeboat Cigarettes see United Tobacco Co.
- Lotus Cigarettes see United Tobacco Co.
- Lucky Strike Cigarettes see American Tobacco Co. Luxury Cigarettes — see American Tobacco
- Magpie Cigarettes see Schuh
- Mascot Cigarettes see British American Tobacco Co.
- Mecca Cigarettes see American Tobacco
- Milo Cigarettes see Sniders & Abrahams

Miners Extra Smoking Tobacco — see American Tobacco Co.

Mogul Cigarettes — see American Tobacco

Murad Cigarettes — see American Tobacco

Nebo Cigarettes — see American Tobacco

OK Cigarettes — see African Tobacco Mfrs. Obak Cigarettes — see American Tobacco Co.

Officers Mess Cigarettes — see African Tobacco Mfrs.

Old Gold Cigarettes — see American Tobacco Co.

Old Judge Cigarettes - see Goodwin Old Mills Cigarettes — see American Tobacco Co.

One of the Finest - see Buchner Our Little Beauties — see Allen & Ginter Oxford Cigarettes — see American Tobacco Co.

Pan Handle — see American Tobacco Co. Perfection Cigarettes — see American Tobacco Co.

Peter Pan Cigarettes — see Sniders & Abrahams

Picadilly Little Cigars — see American Tobacco Co.

Piedmont Cigarettes — see American Tobacco

Pinhead Cigarettes — see British American Tobacco Co.

Pirate Cigarettes - see Wills

Polo Bear Cigarettes — see American Tobacco Co.

Puritan Little Cigars — see American Tobacco Co.

Purple Mountain Cigarettes — see Wills

Recruit Little Cigars - see American Tobacco Co.

Red Cross — see Lorillard or American Tobacco Co.

Richmond Gem Cigarettes — see Allen &

Richmond Straight Cut Cigarettes - see American Tobacco Co.

Royal Bengal Little Cigars — see American Tobacco Co.

St. Leger Little Cigars — see American Tobacco Co.

Scots Cigarettes — see African Tobacco Mfrs Scrap Iron Scrap — see American Tobacco

Senator Cigarettes — see Scerri Sensation Cut Plug — see Lorillard

Silko Cigarettes — see American Tobacco

Sovereign Cigarettes — see American Tobacco Co.

Sportsman — see Carreras

Springbok Cigarettes — see United Tobacco

Standard Cigarettes — see Carreras or Sniders & Abrahams

Sub Rosa Cigarros — see American Tobacco

Sultan Cigarettes — see American Tobacco

Sweet Caporal — see Kinney or American Tobacco Co. or ITC Canada

Sweet Lavender — see Kimball

Teal Cigarettes — see British American Tobacco Co.

Three Bells Cigarettes — see Bell Tiger Cigarettes — see British American Tobacco Co.

Tokio Cigarettes — see American Tobacco

Tolstoy Cigarettes — see American Tobacco

Trumps Long Cut — see Moore & Calvi Turf Cigarettes — see Carreras
Turkey Red Cigarettes — see American

Tobacco Co.

Turkish Trophy Cigarettes — see American Tobacco Co.

Twelfth Night Cigarettes — see American Tobacco Co.

U.S. Marine — see American Tobacco Co. Uzit Cigarettes — see American Tobacco Co.

Vanity Fair Cigarettes — see Kimball Vice Regal Cigarettes — see Wills Virginia Brights Cigarettes — see Allen &

Wings Cigarettes — see Brown & Williamson

AF	RICA	N CIGARETTE CO. LTD, Egypt————————————————————————————————————		
Size	Numbe in set	er	Price per card	Complete set
L	50 25	Actresses ALWICS (c1905)	£9.00 £7.00	=
AF	RICA	N TOBACCO MANUFACTURERS, South Africa		
A	CARD I	ISSUES		
L	29 60	All Blacks South African Tour (1928)	£12.00	_
		A Cut Outs B Not Cut Out	£3.50 £3.25	_
	25	The Arcadia Fair (1924)	£8.00	_
MP	48	British Aircraft (1932)	£4.00	
	50	Chinese Transport (1930)	£3.25	
MP	48	Cinema Artistes (1930)	£3.25	-
	50	Cinema Stars "OMBI" Officers Mess Issue 1st Series (1921)	£1.80	£90.00
	50	Cinema Stars "OMBI" Officers Mess Issue 2nd Series (1921)	£1.80	£90.00
M	50	Famous and Beautiful Women (1938)	£2.00	
L	50	Famous and Beautiful Women (1938)	£1.50 £6.00	
	33 58	Houses of Parliament (c1920) Miniatures (c1925)	£6.00	_
MP	48	National Costume (1930)	£3.25	
K	53	Playing Cards MP-SA Virginia Cigarettes (c1930)	£1.60	
K	53	Playing Cards, OK Cigarettes (c1930)	£1.60	
K	53	Playing Cards, Scotts Cigarettes (c1930)	£1.60	
MP	48	Popular Dogs (1930)	£4.00	_
M	100	Postage Stamps, Rarest Varieties (1929)	£1.50	£150.00
M	80	Prominent NZ and Australian Rugby Players and Springbok 1937 Touring Team (1937)	£2.00	_
L	80	Prominent NZ and Australian Rugby Players and Springbok 1937 Touring Team (1937)	£2.00	_
	25	The Racecourse (1924)	£9.00	_
M	132	S. African Members of the Legislative Assembly (1921)	£25.00	
M	100	The World of Sport (1938)	£2.50	-
L	100	The World of Sport (1938)	£2.50	_
	SILK IS 30	Some Beautiful Roses (c1925)	£8.00	
M M	25	Types of British Birds (c1925)	£8.00	_
M	20	Types of British Butterflies (c1925)	£8.00	
M	25	Types of Railway Engines (c1925)	£22.00	
M	25	Types of Sea Shells (c1925)	£11.00	
AL	LEN	& GINTER, USA—		
ALL	SERIE	ES ISSUED 1885-95		
	?	Actors and Actresses (sepia photographic)	£4.00	_
	?	Actresses and Beauties (coloured)	£8.00	_
	50	American Editors	£25.00	
L	50	American Editors	£30.00 £17.00	_
	50 50	Arms of All Nations	£17.00	£500.00
L	50	Birds of America	£18.00	2500.00
L	50	Birds of the Tropics	£12.00	£600.00
L	50	Birds of the Tropics	£22.00	_
	50	Celebrated American Indian Chiefs	£24.00	_
	50	City Flags	£10.00	_
	50	Fans of the Period	£20.00	-

ALLEN & GINTER, USA (continued)

Size	Numb in set	er	Price per card	Complete set
	50	Fish from American Waters	£12.00	
L	50	Fish from American Waters	£22.00	
	50	Flags of All Nations (series title curved)	£6.50	£325.00
	48	Flags of All Nations (series title in straight line)	£6.50	£325.00
	50	Flags of All Nations, 2nd series	£8.00	£400.00
	47	Flags of the States and Territories	£9.00	_
	50	Fruits	£16.00	_
	50	Game Birds	£10.00	£500.00
L	50	Game Birds	£22.00	_
	50	General Government and State Capitol Buildings	£10.00	_
	50	Great Generals	£25.00	_
	50	Natives in Costume	£22.00	
	50	Naval Flags	£11.00	£550.00
	50	Parasol Drill	£18.00	-
	50	Pirates of the Spanish Main	£25.00	_
	50 50	Prize and Game Chickens	£18.00	_
L	50	Quadrupeds	£13.00	-
L	50	Quadrupeds	£22.00	-
	30	A Front with white frame	£17.00	
		B Front without white frame	£17.00	
	50	Song Birds of the World	£17.00	£500.00
L	50	Song Birds of the World	£22.00	2300.00
	50	Types of All Nations	£16.00	
	50	Wild Animals of the World	£12.00	<u> </u>
	50	The World's Beauties, 1st series	£16.00	
	50	The World's Beauties, 2nd series	£16.00	- <u>- 12</u>
	50	The World's Champions, 1st series	£20.00	
	50	The World's Champions, 2nd series	£25.00	
L	50	The World's Champions, 2nd series	£45.00	_
	50	The World's Decorations	£11.00	£550.00
L	50	The World's Decorations	£22.00	
	50	World's Dudes	£16.00	<u> 100</u> 1
	50	The World's Racers	£20.00	<u></u>
	50	World's Smokers	£14.00	£700.00
	50	World's Sovereigns	£22.00	
AL	LEN	TOBACCO CO., USA		
L	?	Views and Art Studies (c1910)	£4.00	
TH	E AM	IERICAN CIGARETTE CO. LTD, China————		
	25	Beauties Group 1 (c1900)	£16.00	
	? 15	Beauties Group 2 (c1900)	£18.00	
	50	Flowers (c1900)	£12.00	
			212.00	
		IERICAN TOBACCO COMPANY, USA		_
		S ISSUED 1890-1902		
A		ET BACK IN BLACK		
	28	Beauties Domino Girls	£16.00	_
	25	Beauties Group 1 RB18/4	£4.00	_
	? 1	Beauties Group 2 RB18/20	_	_
	25	Beauties Group 3 RB18/25	£4.00	_
	27 25	Beauties Group 3 RB18/26	£4.00	£110.00
	23	Beauties Group 3 RB18/27	£4.00	_

TH	IE AM	ERICAN TOBACCO COMPANY, USA (continued)		
Siz	e Numbe	er	Price	Complete
512	in set		per card	set
		D C 2 PD19/20	£4.00	
	25	Beauties Group 3 RB18/29	14.00	
	50	Beauties Group 4 RB18/36: a Coloured	£4.00	£200.00
	? 50	a Colouredb Sepia	£15.00	
	52	Beauties PC Inset	£7.00	£365.00
	25	Beauties — Star Girls	£13.00	
	25	Dancers	£9.00	
	50	Dancing Women	£15.00	
	50	Fancy Bathers	£15.00	
	36	Japanese Girls	£40.00	
	25	Military Uniforms RB18/101	£12.00	
	25	Military Uniforms RB18/102	£12.00	
	27	Military Uniforms RB18/103	£7.00	
	50	Musical Instruments	£12.00	_
	50	National Flag and Arms	£8.00	
	25	National Flag and Flowers — Girls	£16.00	
	50	Savage Chiefs and Rulers	£18.00	
В		ESIGN BACK IN GREEN		
	25	Beauties — black background RB18/62	£8.00	_
	25	Beauties — Curtain Background RB18/65	£7.00	£175.00
	25	Beauties Flower Girls RB18/67	£7.00	_
	25	Beauties Group 1 RB18/1	£4.00	_
	27	Beauties Group 1 RB18/2	£4.00	
	25	Beauties Group 1 RB18/3	£4.00	_
	24	Beauties Group 1 RB18/4	£4.00	
	25	Beauties Group 1 RB18/5	£4.00	_
	25	Beauties Group 1 RB18/6	£4.00	_
	50	Beauties Group 1 RB18/10	£4.00	_
	25	Beauties Group 2 RB18/16	£4.00	_
	25	Beauties Group 2 RB18/17	£4.00	_
	? 24	Beauties Group 2 RB18/18	£4.00	_
	25	Beauties Group 2 RB18/19	£4.00	
	25	Beauties Group 2 RB18/20	£4.00	
	25	Beauties Group 2 RB18/21	£5.00	_
	36	Beauties Group 2 RB18/22	£6.00	
	25	Beauties Group 3 RB18/25	£4.00	_
	? 10	Beauties Group 3 RB18/28		
	25	Beauties Group 3 RB18/30	£4.00	_
	25	Beauties Group 3 RB18/31	£8.00	
	25	Beauties Group 3 RB18/32	£4.00	
	50	Beauties Marine and Universe Girls	£20.00	- T
	25	Beauties Palette Girls		
	25	Beauties Star Girls		
	25	Beauties — stippled background RB18/78		_
	20	Beauties — thick border RB18/79	£22.00	
	52	Beauties with Playing Card inset Set 1 RB18/85	£7.50	£375.00
	52	Beauties with Playing Card inset Set 2 RB18/86	£7.50	13/3.00
	25	Boer War Series II — Series A:	64.00	£100.00
		a) numbered		£100.00
		b) unnumbered	£5.00 £6.00	
	22	c) unnumbered and untitled "series A"		
	22	Boer War Series II — Series B		1.20
	25	Chinese Girls		
	25	International Code of Signals	£8.00	_
	25 27	Military Uniforms numbered	£5.00	
	21	wintary Chilornis numbered	25.00	

11	IE ANI	ERICAN TOBACCO COMPANT, USA (continuea)		
Siz	e Numbe	er .	Price	Complete
	in set		per card	set
	25	Military Uniforms unnumbered	£10.00	
	50	National Flags and Arms	£10.00	
	25	Old and Ancient Ships 1st Series	£4.00	£100.00
	25	Old and Ancient Ships 2nd Series	£6.00	£150.00
	25	Star Series — Beauties	£12.00	2130.00
_			212.00	
C	NET DE	ESIGN BACK IN BLUE		
-	0.000	Actresses:		
P	? 300	A Large Letter Back	£4.00	_
P	? 300	B Small Letter Back	£5.00	—
	25	Beauties blue frameline:		
		A Matt	£20.00	_
	•••	B Varnished	£20.00	_
	28	Beauties — Domino Girls	£18.00	_
	28	Beauties Group 1 dull backgrounds	£10.00	
	23	Beauties Group 1 vivid coloured backgrounds set 1	£10.00	_
	25	Beauties Group 1 vivid coloured backgrounds set 2	£10.00	
	25	Beauties:		
		A Front in black and white	£18.00	_
		B Front in mauve	£12.00	
	24	Beauties — orange framelines	£25.00	_
		Beauties — playing cards:		
	52	A Inscribed 52 subjects	£7.50	_
	53	B Inscribed 53 subjects	£7.50	_
	32	Celebrities	£5.00	_
	25	Comic Scenes	£7.50	
P	? 149	Views	£3.00	
D	"OLD G	GOLD" BACK		
	25	Beauties Group 1 RB18/1	£4.00	
	27	Beauties Group 1 RB18/2	£4.00	
	25	Beauties Group 1 RB18/3	£4.00	
	24	Beauties Group 1 RB18/4	£4.00	
	25	Beauties Group 1 RB18/5	£4.00	
	25	Beauties Group 1 RB18/6	£4.00	
	? 47	Beauties Group 2 RB18/16, 17, 18	£4.00	
	25	Beauties Group 2 RB18/22	£4.00	
	25	Beauties Group 3 RB18/25	£4.00	
	27	Beauties Group 3 RB18/26	£4.00	
	25	Beauties Group 3 RB18/27	£4.00	
	25	Beauties Group 3 RB18/28	£4.00	
	25	Beauties Group 3 RB18/30	£4.00	
	25	Flowers Inset on Beauties	£6.00	£150.00
	25	International Code of Signals:	20.00	£130.00
		A With series title	£6.00	£150.00
		B Without series title	£6.00	£150.00
-			20.00	2130.00
E	LABELS			
	35	Beauties Group 1 RB18/2-3	£4.00	·
	25	Beauties Group 2 1st Set RB18/15	£4.00	
	25	Beauties Group 2 2nd Set RB18/16	£4.00	_
		Beauties Group 3 RB18/25-26:		
	27	A Old Gold Label	£4.00	
	26	B Brands Label	£4.00	_
F	OTHER	BACKS WITH NAME OF FIRM		
P	100	Actresses RB18/91	£4.00	
	44	Australian Parliament	£4.00	£170.00
			27.00	2170.00

ın	E AIVI	ERICAN TOBACCO COMPANT, OSA (commune)		
Size	Numbe	er		Complete
	in set		per card	set
	25	Battle Scenes	£9.00	_
		Columbian and Other Postage Stamps (1892)	٠,.٥٥	£12.00
	1	Congress of Beauty — Worlds Fair	£18.00	212.00
	50	Fish from American Waters	£9.00	
	50	FISH ITOM AMERICAN WATERS	£10.00	
	50	Flags of All Nations	£6.00	£150.00
	25	Flower Inset on Beauties	£6.00	£150.00
	25	International Code of Signals	20.00	£130.00
	25	Songs A (1896):	00.00	
		A Thicker board size 70 × 39mm	£9.00	6225 00
		B Thinner board size 67 × 39mm	£9.00	£225.00
	25	Songs B:	00.00	C225 00
		A Size 70 × 39mm	£9.00	£225.00
		B Size 67 × 39mm	£9.00	_
	25	Songs C 1st series	£6.00	_
	25	Songs C 2nd series	£9.00	0150 00
	25	Songs D	£6.00	£150.00
	27	Songs E	£9.00	_
	25	Songs F	£9.00	_
	25	Songs G	£7.00	_
	25	Songs H	£15.00	
	25	Songs I	£20.00	
ISSU	UES 19	03-1940		
L	50	Actors	£5.00	_
	85	Actress Series	£6.00	_
L	50	Actresses	£8.00	_
_		Animals:		
L	40	A Descriptive back	£1.80	_
L	40	B Non descriptive back	£1.80	_
Ĺ	25	Arctic Scenes	£3.00	_
M	15	Art Gallery Pictures	£5.00	_
M	50	Art Reproductions	£5.00	
IVI	21	Art Series	£15.00	
		Ask Dad	£12.00	_
	18	Assorted Standard Bearers of Different Countries	£5.00	_
L	50		£12.00	
	25	Auto-drivers	£12.00	
M	50	Automobile Series	£18.00	
L	50	Baseball Folder series (T201) (1911)	£35.00	
M	121	Baseball series (T204)		
	208	Baseball series (T205) (1911)	£16.00	-
	522	Baseball series (T206)	£16.00	_
	200	Baseball series (T207) (1910)	£25.00	_
	565	Baseball series (T210)	£20.00	_
	75	Baseball series (T211)	£20.00	_
	426	Baseball series (T212)	£20.00	_
	180	Baseball series (T213)	£25.00	_
	90	Baseball series (T214)	£60.00	_
	100	Baseball series (T215)	£20.00	_
L	76	Baseball Triple Folders (T202) (1912)	£30.00	
		Bird series:		
	50	A With white borders	£2.00	_
	50	B With gold borders	£2.00	_
	30	Bird Series with Fancy Gold Frame	£2.50	_
M	360	Birthday Horoscopes	£2.00	_
M	24	British Buildings "Tareyton" issue	£2.50	_
M	42	British Sovereigns "Tareyton" issue	£2.50	_
M	50	Butterfly Series	£4.00	_
1.1	50		_	

111	IL AW	ERICAN TOBACCO CONTANT, USA (continuea)		
Size	Numb	er		Complete
	in set		per card	set
L	153	Champion Athlete & Prize Fighter series (size 73 × 64mm)	£5.00	
L	50	Champion Athlete and Prize Fighter series (size 83 × 63 mm)	£10.00	
L	50	Champion Pugilists	£17.00	_
EL	100	Champion Women Swimmers	£6.00	_
M	150	College series	£2.00	
M	50	Costumes and Scenery for All Countries of the World	£3.00	_
L	49	Cowboy series	£5.50	_
M	38	Cross Stitch	£9.00	_
M	17	Embarrassing Moments or Emotional Moments	£14.00	
M	50	Emblem Series	£2.50	
L	100	Fable Series	£2.25	_
LP	53	Famous Baseball Players, American Athletic Champions and Photoplay		
	50	Stars	£25.00	_
	50	Fish Series inscribed "1 to 50" — 1st 50 subjects	£2.00	_
	200	Fish Series inscribed "1 to 100" — 2nd 50 subjects	£2.00	_
M	100	Flags of All Nations	£1.25	_
IVI	50	Flags of All Nations	£8.00	_
L	505	Foreign Stamp Series	£5.00	-
M	79	Fortune Series	£1.80	-
L	50	Henry "Tareyton" issue	£2.00	_
M		Heroes of History	£5.00	_
	50	Historic Homes	£3.50	-
L	25	Historical Events Series	£5.50	
M	25	Hudson — Fulton Series	£6.00	_
L	50	Indian Life in the 60s (1910)	£5.50	_
L	221	Jig Saw Puzzle Pictures	£5.50	
L	50	Light House Series	£4.00	_
L	50	Men of History	£5.50	
	100	Military Series white borders	£4.00	
	50	Military Series gilt borders	£4.50	_
	50	Military Series "Recruit" issue:		
		A Uncut cards	£4.00	_
		B Die-cut cards	£4.00	
	50	Movie Stars	£4.50	
L	100	Movie Stars	£4.00	
	33	Moving Picture Stars	£16.00	
EL	50	Murad Post Card Series	£7.00	
	100	Mutt & Jeff Series (black and white)	£4.00	
	100	Mutt & Jeff Series (coloured)	£4.00	
EL	16	National League and American League Teams	£25.00	
	50	Pugilistic Subjects	£15.00	
EL	18	Puzzle Picture Cards	£12.00	
M	200	Riddle Series	£2.30	-
EL	60	Royal Bengal Souvenir Cards	£6.00	
M	150	Seals of the United States and Coats of Arms		
L	25	Series of Champions	£1.50	
L	50	Sights and Scenes of the World	£20.00	_
L	50	Silhouettes	£3.00	
L	25	Song Rird Series	£6.00	
-	39	Song Bird Series	£8.00	_
	45	Sports Champions	£20.00	_
		Stage Stars	£6.00	_
T	25	State Girl Series	£5.00	_
L	50	Theatres Old and New Series	£5.50	
M	50	Toast Series	£5.50	-
M	550	Toast Series	£2.00	_
L	25	Toasts	£9.00	-

Size	Numb	er	Price	Complete
	in set		per card	se
	50	Types of Nations:		
		A Without series title	£2.20	_
		B With series title	£2.20	_
		C Anonymous back	£2.20	_
_	25	Up to Date Baseball Comics	£15.00	-
	25	Up to Date Comics	£7.00	_
•	340	World Scenes and Portraits	£3.00	_
	250	World War I Scenes	£2.00	_
_	50 25	World's Champion Athletes	£9.00 £3.00	
	E AN	MERICAN TOBACCO CO. OF NEW SOUTH WALES I	TD, A	ustrali:
	25	Beauties Group 1 RB18/8 (c1900)	£10.00	_
	25	Beauties Group 2 (c1900)	£10.00	_
	23	Beauties Group 2 (c1900)	10.73	
ГН	E AN	IERICAN TOBACCO CO. OF VICTORIA LTD, Austra	lia	
	? 98	Beauties Group 2 (c1900)	£10.00	-
A (TE)		CICA DETTE EACTODY Molto		
AI.	LAM	CIGARETTE FACTORY, Malta—		
M	65	Beauties back in blue (c1925)	£2.30	_
	150	Beauties back in brown (c1925)	£4.50	_
M	519	Celebrities (c1925)	£1.20	_
L	50	Views of Malta (c1925)	£4.50	_
M	128	Views of the World (c1925)	£4.50	_
BA	NNE	R TOBACCO CO., USA		
L	25	Girls (c1890)	£25.00	_
ги	OMA	AS BEAR & SONS LTD		400
1 11			C2 40	
	50	Aeroplanes (1926)	£3.40	
	50	Cinema Artistes Set 2 (c1935)	£3.50 £3.50	7 1 1 1 1 1 1 1 1 1 1 1 1 1 1 1 1 1 1 1
	50	Cinema Artistes Set 4 (c1935) Cinema Stars coloured (1930)	£1.80	£90.0
	50	Cinema Stars coloured (1930)	£1.50	£75.0
	50	Do You Know (1923)	£1.20	275.0
	270	Javanese series 4 yellow background (c1925)	£8.00	
	100	Stage and Film Stars (1926)	£3.00	
	50	Stage and Film Stars (1920)	23.00	
AU	G BE	ECK & CO. USA		
	? 34	Picture Cards (c1890)	£50.00	_
т .	2. IC I	DELL LTD Danmark	dian.	. A. 1945
J. 6		BELL LTD, Denmark————————————————————————————————————	000.00	
	60	Rigvaabner (Arms of Countries) (c1925)	£30.00	_
	60	Women of Nations (1924)	£30.00	_

48 Ancient and Modern Fire Fighting Equipment (1947) £5.00

BRITISH AMERICAN TOBACCO CO. LTD-

Size	Numb in set		Price per card	Complete
A	WITH	MAKER'S NAME NET DESIGN IN GREEN (ISSUES 1902-05)	per cara	set
	25	Beauties Art series RB18/61	00.00	
	25	Beauties — black background RB18/62	£8.00 £8.00	_
	25	Beauties — Blossom Girls RB18/63		
	25	Beauties — Flower Girls RB18/67	£35.00 £6.00	
	25	Beauties — Fruit Girls RB18/68	£10.00	
	25	Beauties — Girls in Costumes RB18/69	£9.00	
	20	Beauties Group 1 RB18/9	£7.00	
	25	Beauties — Lantern Girls RB18/70	£6.00	£150.00
	50	Beauties — Marine and Universe Girls RB18/71	£8.00	£130.00
	25	Beauties — Palette Girls RB18/74:	20.00	
		A Plain border to front	£8.00	
		B Red border to front	£12.00	
	24	Beauties — Smoke Girls RB18/75	£14.00	
	25	Beauties — Star Girls RB18/76	£14.00	
	25	Beauties — stippled background RB18/78	£6.00	£150.00
	25	Beauties — Water Girls RB18/80	£6.00	£150.00
	50	Buildings RB18/131	£8.00	2130.00
	25	Chinese Girls 'A' RB18/111	£8.00	
	25	Chinese Girls 'B' RB18/112:	20.00	
		A Background plain	£8.00	
		B Background with Chinese letters	£8.00	<u> </u>
	25	Chinese Girls 'C' RB18/113	£8.00	
	25	Chinese Girls 'D' RB18/114	£8.00	
	25	Chinese Girls 'E' RB18/115	£8.00	<u> </u>
	25	Chinese Girls 'F' Set 1 RB18/116	£8.00	
	25	Chinese Girls 'F' Set 2 RB18/116:	20.00	
		A Yellow border	£8.00	
		B Gold border	£10.00	
	50	Chinese Girls 'F' Set 3:		
		A Plain background	£8.00	_
		B Chinese characters background	£9.00	
_	40	Chinese Trades	£6.00	
B	WITH	MAKER'S NAME NET DESIGN IN BLUE (ISSUES 1902-05)		
	25	Beauties — numbered	£16.00	
_	53	Beauties — Playing Cards	£7.00	<u> </u>
		MAKER'S NAME OTHER BACKS		
MP	50	Beauties (1925)	£1.70	£85.00
MP	40	Beauties (1926)	£1.70	_
M	50	Birds, Beasts and Fishes (1925)	£1.70	£85.00
	50	Danish Athletes (1905)	£10.00	_
	28	Dominoes (1905)	£5.50	
	48	Fairy Tales (1926)	£3.00	
	48	A Famous Picture — The Toast (c1930)	£3.00	
	25	New York Views (c1908)	£8.50	
	53	Playing Cards (1905)	£8.50	_
M	50	Wild Animals (c1930)	£1.30	
		S WITH BRAND NAMES		
		IGARETTES (C) 10 (1025)		
M	50	Aeroplanes (Civil) (1935)	£5.00	1 1 1 1 1 1 1 1 1 1 1 1 1 1 1 1 1 1 1
	50	Artistes de Cinema Nd 1-50 (1932)	£2.00	
	50	Artistes de Cinema Nd 51-100 (1933)	£2.00	
MD	50 ? 67	Artistes de Cinema Nd 101-150 (1934)	£2.00	_
MP		Beauties (c1928)	£4.00	_
M M	75 50	Belles Vues de Belgique (c1930)	£2.50	-
IVI	30	Birds, Beasts & Fishes (c1930)	£4.00	_

BR	ITISH	AMERICAN TOBACCO CO. LTD (continued)		
Size	Numb	er	Price	Complete
	in set		per card	set
	50	D C: (C: 1) (100C)	64.60	
M	50	Butterflies (Girls) (1926)		_
M	50	Cinema Stars (brown photogravure) (c1927)	£2.25	_
M	100	Cinema Stars (numbered, coloured) (c1928)		_
M	208	Cinema Stars (unnumbered, coloured) (c1929)	£2.00	
M	100	Circus Scenes (c1930)	£2.50	_
M	100	Famous Beauties (1916)	£3.50	
M	50	L'Afrique Equitoriale de l'Est a l'Ouest (c1930)	£2.50	
M	100	La Faune Congolaise (c1930)	£1.30	_
M	50	Les Grandes Paquebots du Monde (1924)	£4.50	_
M	50	Merveilles du Monde (1927)	£3.50	_
M	50	Women of Nations (Flag Girls) (1922)	£3.50	_
ATL		GARETTES	25.00	
	50	Buildings (1907)	£5.00	
	25	Chinese Beauties (1912)	£2.50	_
	50	Chinese Trades Set IV (1908)	£2.50	
	85	Chinese Trades Set VI (1912)	£2.50	_
BAT	TLE A.	X CIGARETTES		
M	100	Famous Beauties (1916)	£4.00	_
M	50	Women of Nations (Flag Girls) (1917)	£4.50	_
COP	PAIN C	GARETTES		
	52	Birds of Brilliant Plumage (1927)	£5.50	
DOM	MINO (CIGARETTES		
	25	Animaux et Reptiles (1961)	16p	£4.00
	25	Corsaires et Boucaniers (1961)	15p	£2.50
	25	Figures Historiques 1st series (1961)	15p	£3.00
	25	Figures Historiques 2nd series (1961)	50p	£12.50
	25	Fleurs de Culture (1961)	15p	£2.50
	25	Les Oiseaux et l'Art Japonais (1961)	70p	£17.50
	25	Les Produits du Monde (1961)	15p	£2.50
	50	Voitures Antiques (1961)	£1.00	
EAG	LE BI	RD CIGARETTES		
	50	Animals and Birds (1909)	£2.00	
	50	Aviation series (1912)	£2.80	_
	25	Birds of the East (1912)	£1.80	£45.00
	25	China's Famous Warriors (1911)	£2.60	£65.00
	25	Chinese Beauties 1st series (1908):		
		A Vertical back	£3.00	
		B Horizontal back	£3.00	_
	25	Chinese Beauties 2nd series (1909):		
		A Front without framelines	£2.00	
		B Front with framelines	£2.00	_
	50	Chinese Trades (1908)	£2.00	£100.00
	25	Cock Fighting (1911)	£5.00	_
	60	Flags and Pennons (1926)	£1.20	£72.00
	50	Romance of the Heavens (1929)	£2.00	_
	50	Siamese Alphabet (1922)	£1.20	£60.00
	50	Siamese Dreams and Their Meanings (1923)		£55.00
	50	Siamese Horoscopes (c1915)	£1.10	£55.00
	50	Siamese Play-Inao (c1915)	£1.30	£65.00
	50	Siamese Play-Khun Chang Khun Phaen 1st series (c1915)		£60.00
	50	Siamese Play-Khun Chang Khun Phaen 2nd series (c1915)		£60.00
	36	Siamese Play-Phra Aphaiu 1st series (c1918)	£1.25	£45.00
	36	Siamese Play-Phra Aphaiu 2nd series (1919)		£45.00
	150	Siamese Play — Ramakien I (c1913)		
	50	Siamese Play — Ramakien II (1914)	£1.20	£60.00
	50	Siamese Uniforms (1915)		£90.00
	50		_1.00	

Ditt	LIDI	AMERICAN TOBACCO CO. LID (commuea)		
Size	Numb			Complete
	in set		per card	set
	50	Views of Siam (1928)	£1.50	£75.00
	50	Views of Siam (Bangkok) (1928)	£1.50	£75.00
	30	War Weapons (1914)	£2.00	£60.00
KON		NG CIGARETTES	12.00	200.00
NON	60	Animals (cut-outs) (1912)	C4 50	
1/16	-	CIGARETTES	£4.50	
MAS				
	100	Cinema Stars (Nd 201-300) (1931)	£3.00	_
M	208	Cinema Stars unnumbered (1924)	£2.00	-
MIL		K CIGARETTES		
	60	Animals (cut-outs):		
		A '1516' at base of back (1922)	£1.00	_
		B '3971' at base of back (1923)	80p	£48.00
NAS	SA CIO	GARETTES		
M	50	Birds, Beasts and Fishes (1924)	£4.00	<u></u>
PED	RO CI	GARETTES (see also Imperial Tobacco Co. of India)		
	50	Actors and Actresses (c1905)	£3.50	
	40	Nautch Girls. Coloured (1905)	£2.00	
	37	Nautch Girls. Red border (c1905)	£2.00	The second second
PINI	HEAD	CIGARETTES	22.00	
	50	Chinese Modern Beauties (1912)	£1.50	
	33	Chinese Heroes Set 1 (1912)	£1.80	
	50	Chinese Heroes Set 2 (1913)	£1.80	
	50	Chinese Trades Set III (1908)		675.00
	50	Chinese Trades Set IV (1909)	£1.50	£75.00
	50	Chinese Trades Set V (1910)	£1.50	£75.00
	50	Types of the British Army (1909)	£1.50	£75.00
DATI		CICA DETTES (I.	£3.00	_
KAII	37	CIGARETTES (see also Imperial Tobacco Co. of India)		
TT.		Nautch Girls series (1907)	£2.00	_
IEA.		ARETTES		
	30	Chinese Beauties (c1915)	£4.00	11.1
	50	Cinema Stars (1930):		
		A Back in blue	£1.50	-
		B Back in red brown	£1.50	
	30	Fish series (1916)	£1.80	£55.00
	50	War Incidents (1916)	£1.80	£90.00
TIGI	ER CIC	GARETTES		
	52	Nautch Girls series (1911):		
		A Without frameline to front	£2.40	_
		B With frameline to front:		
		i With crossed cigarettes on back	£1.60	<u> </u>
		ii Without crossed cigarettes on back	£2.00	_
EF	RINT	ED ON BACK NO MAKER'S NAME OR BRAND		
(See	also In	nperial Tobacco Co. of Canada Ltd and United Tobacco Companies (South)	Itd)	
		Actresses 'ALWICS' (c1905):	Ciu)	
	175	A Portrait in black	£2.50	
	50	B Portrait in red	£4.00	
	50	Aeroplanes (1926)	£2.00	£100 00
	50	Aeroplanes of Today (1936)		£100.00 £40.00
	25	Angling (1930)	80p	£40.00
	50	Arms and Armour (1910)	£4.00	
	25	Army I ife (c1010)	£3.50	-
	50	Army Life (c1910)	£5.00	
	1	Art Photogravures (1913)	£1.00	-
	22	Automobielen (c1925)	06.00	£14.00
	75	Automobielen (c1925)	£6.00	_
	13	Aviation (1910)	£2.80	

Size	Numbe	er	Price per card	Complete set
	in set		per cara	sei
	50	Aviation series (1911):		
		A With album clause		_
		B Without album clause	£2.80	_
		Beauties Set I (1925):	01.50	675.00
P	50	A Black and white		£75.00
MP	50	B Coloured	£1.70	_
P	50	Beauties 2nd series (1925):	£1.50	£75.00
		A Black and white		£73.00
D	50	B Coloured		£75.00
P	50 50	Beauties and series (1926) Beauties red tinted (c1906)		275.00
	30	Beauties tobacco leaf back (c1908):	22.00	
	52	A With PC inset	£2.50	£130.00
	50	B Without PC inset		£180.00
P	50	Beauties of Great Britain (1930):		
•	50	A Non-stereoscopic	60p	£30.00
		B Stereoscopic	£1.20	_
P	50	Beautiful England (1928)		£25.00
MP	60	La Belgique Monumentale et Pittoresque (c1925)		_
	50	Best Dogs of Their Breed (1916)	£3.40	_
	50	Billiards (1929)		
	50	Birds, Beasts and Fishes (1937)		£25.00
M	50	Birds, Beasts and Fishes (1929)	£1.20	£60.00
	24	Birds of England (1924)	£2.20	£55.00
	50	Boy Scouts (1930) — without album clause	£1.80	£90.00
	50	Britain's Defenders (1915):		
		A Blue grey fronts		
		B Mauve fronts	£1.40	£70.00
	50	British Butterflies (1930)	£1.00	£50.00
	50	British Empire series (1913)	£2.50	
	25	British Trees and Their Uses (1930)	£1.80	£45.00
	50	British Warships and Admirals (1915)	£2.50	_
	50	Butterflies and Moths (1911):	22.00	
		A With album clause		
		B Without album clause		
	50	Butterflies (Girls) (1928)		£250.00
M	50	Butterflies (Girls) (1928)	£5.00	£250.00
M	50	Celebrities of Film and Stage (1930):	C1 20	065.00
		A Title on back in box	£1.30	£65.00
		B Title on back not in box	£1.30	£65.00
LP	48	Channel Islands Past and Present (1939):	£1.20	
		A Without '3rd Series'		£15.00
		B With '3rd Series'	ЗОР	213.00
	40	Characters from the Works of Charles Dickens (1919):		£45.00
		A Complete set	60p	£23.00
	50	B 38 different (— Nos 33, 39)	£1.20	£60.00
	50	Cinema Artistes, black and white set 4 (Nd 101-150) (c1928)		£60.00
	50	Cinema Artistes brown set 1 (c1930):	21.20	200.00
	60	A With 'Metro Golden Mayer'	£1.20	£70.00
	50	B Without 'Metro Golden Mayer'	£1.40	
	50	Cinema Artistes brown set 2 (c1931):	21.10	
	30	A Oblong panel at top back	£1.20	£60.00
		B Oval panel at top back		£70.00
L	48	Cinema Artistes set 3 (c1931)	£1.50	£75.00
L	48	Cinema Celebrities (C) (1935)	90p	£45.00
	10		1	

		(commuca)		
Size	Numb	er		Complete
	in set		per card	set
L	48	Cinema Celebrities (C) (1935)	£1.00	£50.00
L	56	Cinema Celebrities (D) (1936)	£2.50	_
	50	Cinema Favourites (1929)	£2.20	£110.00
	50	Cinema Stars Set 2 (Nd 1-50) (1928)	£1.00	£50.00
	50	Cinema Stars Set 3 (Nd 51-100) (1929)	£1.00	
	50	Cinema Stars Set 4 (Nd 101-150) (1930)	£1.00	_
	100	Cinema Stars 'BAMT' (coloured) (1931)	£1.50	£150.00
P	50	Cinema Stars Set 1 (c1928)	£1.00	_
P	50	Cinema Stars Set 2 (c1928)	£1.00	£50.00
P	50	Cinema Stars Set 3 (c1928)	£1.00	_
MP	52	Cinema Stars Set 4 (c1928)	£1.50	_
MP	52	Cinema Stars Set 5 (c1928)	£1.50	_
MP	52	Cinema Stars Set 6 (c1928)	£1.75	_
LP	48	Cinema Stars Set 7 (c1928)	£2.00	· -
P	50	Cinema Stars Set 8 (Nd 1-50) (c1928)	£1.00	£50.00
P	50	Cinema Stars Set 9 (Nd 51-100) (c1928)	£1.00	£50.00
P P	50	Cinema Stars Set 10 (Nd 101-150) (c1928)	£1.00	£50.00
P	50	Cinema Stars Set 11 (Nd 151-200) (c1928)	£1.00	£50.00
	25	Derby Day series (1914)	£7.50	
	50	Do You Know? (1923)	45p	£22.50
	50	Do You Know? 2nd series (1931)	45p	£22.50
	25 25	Dracones Posthistorici (c1930)	£6.00	
	50	Dutch Scenes (1928)	£2.40	£60.00
	40	Engineering Wonders (1930)	50p	£25.00
P	25	English Costumes of Ten Centuries (1919)	£1.25	£50.00
1	26	English Cricketers (1926)	£2.60	£65.00
P	50	Etchings (of Dogs) (1926)	£2.00	£55.00
1	50	Famous Bridges (1935)	70p	£35.00
	50	Famous Footballers Set 1 (1923)	£2.80	_
	50	Famous Footballers Set 2 (1924)	£2.80	_
	25	Famous Pootballers Set 3 (1925)	£2.80	-
	25	Famous Racehorses (1926)	£2.60	£65.00
	50	Famous Railway Trains (1929)	£2.00	£50.00
	50	Favourite Flowers (c1925) . Film and Stage Favourites (c1925)	70p	£35.00
	75	Film Favourites (1928)	£1.50	£75.00
	50	Flags of the Empire (1928)	£1.20	£90.00
	50	Foreign Birds (1930)	80p	£40.00
	50	Game Birds and Wild Fowl (1929)	70p	£35.00
LP	45	Grace and Beauty (Nos 1-45) (1938)	£1.40	£70.00
LP	45	Grace and Beauty (Nos 46-90) (1939)	40p	£18.00
LP	48	Guernsey, Alderney and Sark Past and Present 1st series (1937)	30p	£13.50
LP	48	Guernsey, Alderney and Sark Past and Present 2nd series (1938)	32p	£16.00
L	80	Guernsey Footballers Priaulx League (1938)	32p	£16.00
P	52	Here There and Everywhere:	40p	£32.00
		A Non stereoscopic (1929)	40p	£20.00
		B Stereoscopic (1930)		£40.00
	25	Hints and Tips for Motorists (1929)	80p £2.40	£40.00 £60.00
P	50	Homeland Events (1928)	60p	£30.00
	50	Horses of Today (1906)	£4.50	230.00
	32	Houses of Parliament (red back) (1912)	£1.75	
	32	Houses of Parliament (brown backs with verse) (1912)	£7.50	
	50	Indian Chiefs (1930)	£7.00	
	50	Indian Regiment series (1912)	£8.00	
	50	International Airliners (1937)	70p	£35.00
	25	Java Scenes (1929)	£7.50	233.00
			~1.50	

Size	Numb in set	er	Price per card	Complete set
LP	48	James Than and New 1st series (1025)	60p	£30.00
LP	48	Jersey Then and Now 1st series (1935) Jersey Then and Now 2nd series (1937)	30p	£15.00
LI	50	Jiu Jitsu (1911)	£2.50	213.00
	50	Keep Fit (1939)	80p	£40.00
	50	Leaders of Men (1929)	£2.20	~ 10.00
	50	Life in the Tree Tops (1931)	50p	£25.00
	50	Lighthouses (1926)	£1.20	£60.00
	40	London Ceremonials (1929)	£1.25	£50.00
P	50	London Zoo (1927)	70p	£35.00
	50	Lucky Charms (1930)	£1.50	£75.00
	25	Marvels of the Universe series (c1925)	£2.20	£55.00
	45	Melbourne Cup Winners (1906)	£5.00	_
	50	Merchant Ships of the World (1925)	£3.00	_
	25	Merchant Ships of the World (1925)	£3.00	_
	25	Military Portraits (1917)	£2.40	_
	36	Modern Beauties 1st series (1938)	75p	£27.00
	36	Modern Beauties 2nd series (1939)	60p	£22.00
MP	54	Modern Beauties 1st series (1937)	90p	£50.00
MP	54	Modern Beauties 2nd series (1938)	90p	£50.00
MP	36	Modern Beauties 3rd series (1938)	£1.25	£45.00
MP	36	Modern Beauties 4th series (1939)	90p	£33.00
ELP	36	Modern Beauties 1st series (1936)	£1.10	£40.00
ELP	36	Modern Beauties 2nd series (1936)	75p	£27.00
ELP	36	Modern Beauties 3rd series (1937)	85p	£30.00
ELP	36	Modern Beauties 4th series (1937)	£1.00	£36.00
ELP	36	Modern Beauties 5th series (1938)	60p	£22.00
ELP	36	Modern Beauties 6th series (1938)	60p	£22.00
ELP	36	Modern Beauties 7th series (1938)	75p	£27.00
LP	36	Modern Beauties 8th series (1939)	£1.00	£36.00
LP	36	Modern Beauties 9th Series (1939)	£1.25	£45.00
LP	36	Modern Beauties (1939)	£1.25	£45.00
	50	Modern Warfare (1936)	70p	£35.00
M	48	Modern Wonders (1938)	£3.00	_
	25	Modes of Conveyance (1928)	£1.60	£40.00
	48	Motor Cars green back (1926)	£3.00	_
	36	Motor Cars brown back (1929)	£3.50	_
	50	Motorcycles (1927)	£3.20	_
P	50	Native Life in Many Lands (1932)	60p	£30.00
P	50	Natural and Man Made Wonders of the World (1937)	60p	£30.00
P	50	Nature Studies stereoscopic (1928)	60p	£30.00
P	48	Nature Studies stereoscopic (1930)	80p	£40.00
	50	Naval Portraits (1917)	£2.20	<u></u>
	25	Notabilities (1917)	£2.40	£60.00
	25	Past and Present (1929)	£1.80	£45.00
P	48	Pictures of the East (1930):		
		A 'A Series of 48' 17mm long	70p	£35.00
		B 'A Series of 48' 14mm long	70p	£35.00
M	48	Picturesque China (c1925):		
		A With 'P' at left of base	£1.25	£60.00
		B Without 'P' at left of base	£1.25	£60.00
M	53	Playing Cards Ace of Hearts Back (c1935)	22p	£11.00
K	53	Playing Cards designed back (c1935):		
		A Blue back	80p	_
		B Red back	80p	_
	36	Popular Stage, Cinema and Society Celebrities (c1928)	£2.50	_
	25	Prehistoric Animals (1931)	£2.60	£65.00

Size	Numbe in set	r	Price per card	Complete set
	50	Prominent Australian and English Cricketers (1911)	£30.00	_
	25	Puzzle series (1916)	£4.00	_
	50	Railway Working (1927)	£1.20	£60.00
	10	Recruiting Posters (1915)	£7.00	_
	33	Regimental Pets (1911)	£5.00	_
	50	Regimental Uniforms (1936)	£1.30	£65.00
	50	Romance of the Heavens (1929)	60p	£30.00
P	50	Round the World in Pictures stereoscopic (1931)	70p	£35.00
	50	Royal Mail (1912)	£3.00	_
P	50	Royal Navy (1930)	£2.00	_
	27	Rulers of the World (1911)	£6.00	-
	40	Safety First (1931)	80p	£32.00
	25	Ships' Flags and Cap Badges 1st series (1930)	£2.00	£50.00
-	25	Ships' Flags and Cap Badges 2nd series (1930)	£2.00	£50.00
P	50	Ships and Shipping (1928)	70p	£35.00
	50	Signalling series (1913)	£2.20 £9.00	
	100 50	Soldiers of the World (tobacco leaf back) (c1902)	60p	£30.00
	25	Sports and Games in Many Lands (1930)	£4.00	£100.00
	50	Stage and Film Stars (1926)	£1.20	2100.00
M	50	Stars of Filmland (1927)	£2.00	
141	48	Transport Then and Now (1940)	45p	£22.00
	32	Transport of the World (1917)	45p	222.00
	20	Types of North American Indians (c1930)	£10.00	
P	50	Types of the World (1936)	70p	£35.00
P	270	Views of the World stereoscopic (1908)	£3.00	
	25	Warriors of All Nations (gold panel) (1937)	£1.20	£30.00
	50	War Incidents (brown back) (1915)	£1.40	£70.00
	50	War Incidents (blue back) (1916)	£1.40	£70.00
	50	Warships (1926)	£2.60	
	25	Whaling (1930)	£1.80	£45.00
P	50	Who's Who in Sport (1926)	£2.50	£125.00
	50	Wild Animals of the World (tobacco leaf back) (1902)	£6.00	_
	25	Wireless (1923)	£3.00	_
	50	Wonders of the Past (1930)	70p	£35.00
	50	Wonders of the Sea (1929)	70p	£35.00
	25	Wonders of the World (c1928)	70p	£17.50
	40	World Famous Cinema Artistes (1933)	£1.00	£40.00
M	40	World Famous Cinema Artistes (1933)	£1.00	£40.00
-	50	World's Products	50p	£25.00
P	50	The World of Sport (1927)	£2.00	£100.00
P	50	Zoo (1935)	60p	£30.00
	50	Zoological Studies (1928): A Brown back	50p	£25.00
		B Black back	£1.50	123.00
F	PLAIN		21.50	
•	50	Actors and Actresses 'WALP' (c1905):		
	50	A Portraits in black and white, glossy	£1.80	£90.00
		B Portraits flesh tinted, matt	£1.80	£90.00
	50	Actresses 'ALWICS' (c1905)	£2.00	
	50	Actresses, four colours surround (c1905)	£1.80	£90.00
	30	Actresses unicoloured (c1910):	21.00	~70.00
	30	A Fronts in purple brown	90p	£27.00
		B Fronts in light brown	90p	£27.00
	50	Animals and Birds (1912)	£1.80	£90.00
	60	Animals — cut-outs (1912)	£1.10	

Size	Numbe	or	Price	Complete
Dize	in set		per card	set
	50	Art Photogravures (1912)	£1.40	_
	50	Aviation series (1911)	£2.50	_
	40	Beauties — brown tinted (1913)	£2.20	_
	50	Beauties with backgrounds (1911)	£2.20	
	32	Beauties Picture Hats I with borders (1914)	£2.50	
	45	Beauties Picture Hats II without borders (1914)	£2.50	
	30	Beauties and Children (c1910)	£5.00	<u> </u>
	30	Beauties 'Celebrated Actresses' (c1910)	£3.00	_
	52	Birds of Brilliant Plumage — PC inset (1914)	£2.20	
	25	Bonzo series (1923):	22.20	
	23	A With series title	£3.40	100
		B Without series title	£3.40	
	20	Boy Scouts Signalling (c1920):	23.40	7 - 1 - 1 - 1 - 1 - 1
	30		£2.50	£75.00
		A Captions in English	£2.50	£75.00
	50		£8.00	273.00
	50	British Man of War series (1910)	£1.40	T
	50	Butterflies and Moths (1910)	£1.40	
	50	Cinema Artistes (c1928)	£1.00	
	50	Cinema Stars RB21/259 (c1930):	61.00	£50.00
		A Front matt	£1.00 £1.00	230.00
		B Front glossy		_
	50	Cinema Stars RB21/260 (Nd 1-50) (c1930)	£1.00	
	50	Cinema Stars RB21/260 (Nd 51-100) (c1930)	£1.00	1 1 7 7 1
	50	Cinema Stars RB21/260 (Nd 101-150) (c1930)	£1.00	-
	100	Cinema Stars RB21/260 (Nd 201-300) (c1930)	£1.00	£100.00
	50	Cinema Stars 'FLAG' (c1930)	£1.00	_
	27	Dancing Girls (1913)	£1.50	_
	32	Drum Horses (1910)	£4.50	
	50	English Period Costumes	70p	£35.00
	50	Flag Girls of All Nations (1911)	£1.60	_
		Flags, Pennons and Signals (c1910):		
	70	A Numbered 1-70	70p	
	70	B Unnumbered	70p	_
	50	C Numbered 71-120	70p	_
	45	D Numbered 121-165	80p	
	20	Flowers (1915)	£1.00	£20.00
	50	Girls of All Nations (1908)	£1.80	_
	30	Heroic Deeds (1913)	£1.80	_
	25	Hindou Gods (1909)	£5.50	
	32	Houses of Parliament (1914)	£3.00	
	25	Indian Mogul Paintings (1909)	£8.00	_
	53	Jockevs and Owners Colours — PC inset (c1914)	£2.75	
	30	Merrie England Female Studies (1922)	£5.00	<u> </u>
K	36	Modern Beauties 1st series (1938)	£2.50	
K	36	Modern Beauties 2nd series (1939)	£2.30	
P	48	Movie Stars (c1930)	£1.50	
r	50	Music Hall Celebrities (1911):	21.50	
	30	A Blue border	£2.20	
		B Gilt border	£2.20	
		C Red border	£2.20	
		D Yellow border	£4.00	
D	50		£1.50	
P	50	New Zealand, Early Scenes and Maori Life (c1928)	£4.00	K In the second
	50	Poultry and Pidgeons (c1926)	£1.00	£25.00
	25	Products of the World (1914)	£5.00	223.00
	50	Royal Mail (1912)	£3.00	
	36	Ships and Their Pennants (1913)	12.00	

G.	NI I	(community)		
Siz	ze Numb in set	er	Price per card	Complete set
	75	Soldiers of the World (c1902)	£8.00	
	30	Sporting Girls (1913)	£4.00	
	50	Sports of the World (1917):	24.00	
	50	A Brown front	£3.50	
		B Coloured front		
M	50	Stars of Filmland (1927)	£1.80	
1.1	32	Transport of the World (1917)	£1.20	
	50	Types of the British Army (1908):	11.20	
	50	A Numbered	£2.20	
		B Unnumbered	£2.20	
P	50	Types of the World (1936)	£1.80	
P	50	Units of the British Army and RAF (c1930)	£1.80	
M		Women of Nations (Flag Girls) (1922)		
			£2.50	-
G		BACKED SILKS ISSUED 1910-1917		
M		Arabic Proverbs	£11.00	
M	50	Arms of the British Empire:		
		A Back in blue	£3.00	_
M	50	B Back in brown	£4.00	-
M		Australian Wild Flowers	£3.00	_
M		Best Dogs of their Breed	£5.50	
	110	Crests and Badges of the British Army	£2.50	-
M		Crests and Badges of the British Army	£2.00	
M	50	Crests and Colours of Australian Universities, Colleges and Schools	£2.25	_
B	RITISI	H AMERICAN TOBACCO COMPANY (CHINA) LTD-		
	32	Sectional Picture — 'Beauties of Old China' (1934)	£5.00	
D	DITICI		25.00	
D		H AMERICAN TOBACCO CO. LTD, Switzerland——		
	30	Series Actrices (1921)	£6.00	_
B	ROWN	& WILLIAMSON TOBACCO CORP, USA (Wings Cig	garettes)——
M	50	Modern American Airplanes (c1938):		
		A Inscribed 'Series A'	£3.50	
		B Without 'Series A'	£2.50	
M	50	Modern American Airplanes 'Series B' (c1938)	£2.50	
M	50	Modern American Airplanes 'Series C' (c1938)	£2.50	<u> 110</u>
	50	Movie Stars (1940) (Golden Grain Tobacco)	£5.00	
			20.00	
D	. BUCH	INER & CO., USA————		
	48	Actors (1887)	£20.00	
L	50	Actresses (c1890)	£22.00	
	144	Baseball Players (c1890)	£65.00	_
L	28	Butterflies and Bugs (c1890)	£50.00	
L	52	Morning Glory Maidens (c1890)	£36.00	
L	23	Musical Instruments (c1890)	£45.00	<u></u>
L	21	Yacht Club Colours (c1890)	£45.00	_
			4.0.00	
		ROUT & CO. LTD, Guernsey, Channel Islands———		
M	UCKTI 416	Around the World (1926):		
		Around the World (1926): A Inscribed 'Places of Interest' Nd. 1-104	50p	£52.00
		Around the World (1926): A Inscribed 'Places of Interest' Nd. 1-104	50p 50p	£52.00 £52.00
		Around the World (1926): A Inscribed 'Places of Interest' Nd. 1-104 B Inscribed 'Around the World' Nd. 105-208 C Inscribed 'Around the World' Nd. 209-312		
		Around the World (1926): A Inscribed 'Places of Interest' Nd. 1-104	50p	£52.00

BU	CKTF	COUT & CO. LTD, Guernsey, Channel Islands (continued)		
Size	Numb in set	er	Price per card	Complete set
M M	24 50 50 50 22 123 20 25 53 25	Birds of England (1923)	£3.00 £1.70 £1.90 £2.50 80p £2.20 80p £2.20 70p £3.60	£75.00 £85.00 £95.00 £125.00 £18.00 £16.00 £55.00 £35.00
CA	LCU	TTA CIGARETTE CO., India——————		
	25	Actresses — 'ALWICS' (c1905): A Fronts in blue B Fronts in chocolate	£20.00 £25.00	=
A.	G. C	AMERON & SIZER, USA (including Cameron & Came	ron)—	
	25 24	The New Discovery (1889): A Without overprint B With overprint Occupations for Women (1895) Photographic Cards (c1890):	£25.00 £25.00 £45.00	Ξ
L	? 3 ? 2 343	Actresses Actresses Framed Paintings	£17.00 £20.00 £5.00	Ξ
V. (CAM	ILLERI, Malta———————————————————————————————————		
MP	104	Popes of Rome (1922): A Nd. 1-52 B Nd. 53-104	£1.50 £1.50	£75.00 £75.00
CA	MLE	R TOBACCO COY, Malta—		
P M	? 247 96	Footballers (c1925) Maltese Families Coats of Arms: A Thick board (c1925) B Thin board (1958)	£1.20	=
CA	RRE	RAS LTD, Australia & Canada—————		
M	72 72 72 24 72 72	Canadian Wild Animals (1984): A Complete set B 15 Different Film Star Series (1933) Football Series (1933) Personality Series (1933) Personality Series Film Stars (1933) Personality Series Footballers (1933)		£3.00
CH	ING	& CO., Jersey, Channel Islands		
L L 67	24 24 25	Around and About in Jersey, 1st series (1964) Around and About in Jersey, 2nd series (1964) Do You Know? (1962)	80p	£7.50 £20.00 £2.25

CH	ING &	& CO., Jersey, Channel Islands (continued)		
	Numb in set			Complete
			per card	set
	48	Flowers (1962)	80p	£40.00
L	24	Jersey Past and Present, 1st series (1960)	20p	£5.00
L	24	Jersey Past and Present, 2nd series (1962)	30p	£7.50
L	24	Jersey Past and Present, 3rd series (1963)	20p	£5.00
	25 50	Ships and Their Workings (1961)	15p	£2.25
		Veteran and Vintage Cars (1960)	35p	£17.50
W.	4. &	A.C. CHURCHMAN, Channel Islands—————		
		vithout ITC clause)		
M	48	Air Raid Precautions (1938)	£1.50	_
M	48	Holidays in Britain (sepia) (1937)	£1.50	_
M	48	Holidays in Britain (coloured) (1938)	£1.50	
M	48	Modern Wonders (1938):		
		A ITC clause blocked out in silver	£5.00	_
M	48	B Reprinted without ITC clause	£1.50	_
M	48	The Navy at Work (1937)	£1.50	_
M	48	The RAF at Work (1939)	£1.50	-
141	40	Wings Over the Empire (1939)	£1.50	-
TH	E CI	GARETTE COMPANY, Jersey, Channel Islands———		
	72	Jersey Footballers (c1910)	£5.00	_
LA	CIG	ARETTE ORIENTAL DE BELGIQUE, Belgium———		
L				
		Famous Men Throughout the Ages (c1940)	15p	£15.00
C.	COL	OMBOS, Malta———————		
MP	200	Actresses (c1900)	£3.00	
MP	59	Actresses (c1900)	£15.00	
	50	Actresses (coloured) (c1900)	£10.00	
MP	57	Celebrities (c1900)	£15.00	
P	136	Dante's Divine Comedy (c1914)	£1.80	_
		Famous Oil Paintings (a1010).		
MP	72	1 Series A	£1.00	
MP	108	2 Series B	£1.00	_
MP	240	3 Series C	£1.00	
MP	100	4 Series D	£1.00	_
LP	91	5 Large size	£6.00	_
MP	100	Life of Napoleon Bonaparte (c1914)	£2.20	_
MP MP	70	Life of Nelson (c1914)	£2.20	1884 - 1
MP	70 100	Life of Wellington (c1914)	£2.20	_
MP	30	National Types and Costumes (c1910)	£2.40	_
IVII	120	Opera Singers (c1900)	£30.00	_
M	112	Paintings and Statues (c1912) Povelty and Calebritics (c1010)	65p	£80.00
		Royalty and Celebrities (c1910)	£2.40	_
D. 6	CONI	DACHI & SON, Malta—		
	? 15	Artistes & Beauties (c1905)	£16.00	_
CO	NSO	LIDATED CIGARETTE CO., USA		
		Ladies of the White House (c1895):		
	14	A Size 73 × 43mm, white borders	630.00	
	25	B Size 70 × 38mm, no borders	£30.00 £25.00	-
			123.00	

COPE BROS. & CO. LTD-Price Complete Size Number per card in set INDIAN ISSUE £50.00 DANISH ISSUES £30.00 50 £40.00 30 £30.00 35 £25.00 25 £35.00 25 A.G. COUSIS & CO., Malta-Actors and Actresses (c1910): Back with framework £2.00 P 100 £2.00 KP 100 80p 254 K £1.50 KP 100 £1.50 KP 80 Actresses (c1910): P 100 £1.50 Series I A £1.50 B £1.50 C Series IV £1.50 D £1.50 E £1.50 F Series VII £1.50 G £1.50 H £1.50 £1.50 T £1.50 K Series XII £1.50 L £1.50 M £1.50 N £1.50 Series XV 0 £1.50 £1.50 O Series XVIII £1.50 R £1.50 S Actresses (c1910): 80p 2281 KP 90p 1283 P Actresses, Celebrities and Warships (c1910) £9.00 MP 325 Actresses, Partners and National Costumes (c1910): £1.70 KP 200 A £1.70 P 100 Beauties, Couples and Children (c1908): MP 50 £2.50 Back inscribed 'Collection No. 1' £2.50 Back inscribed 'Collection No. 2' B £2.50 Back inscribed 'Collection No. 3' C £2.00 K 50 P Celebrities Numbered Matt (c1910): 402 £1.25 Front inscribed 'Cousis' Cigarettes', Nd. 301-402 £1.50

80p

80p

P

2162

Celebrities Unnumbered (c1910):

A.G. COUSIS & CO., Malta (continued)

	00	cois a co., Marta (commea)		
Size	Numb in set	er	Price per card	Complete set
MP	72	Grand Masters of the Order of Jerusalem (c1910)	£2.50	
P	100	National Costumes (c1910)	£2.50	
MP	? 57	Paris Exhibition 1900 (c1901)	£25.00	
MP	102	Paris Series (1902)	£25.00	
	102	Popes of Rome (c1910):	£25.00	-
MP	182	A Back inscribed 'A.G. Cousis' Dubec Cigarettes'	C1 50	
MP	81	B Back inscribed 'Cousis' Dubec Cigarettes'		_
P	100	Statues and Monuments (c1910):	£2.50	-
	100	A Numbered	C1 50	
		B Unnumbered	£1.50	
KP	127	Views of Malta (c1910)	£1.50	
P	115	Views of Malta Numbered (c1910)	£2.00	_
MP	127	Views of Malta Numbered (c1910)	90p	
MP	? 65	Views of Malta Unnumbered (c1910)	90p	
P	559	Views of the World (c1910):	90p	
	337	A Small size 59 × 39mm	21.00	
		B Medium size 65 × 45mm	£1.00	7 Table 1
P	99	Warships, white border (c1910)	£1.00	_
	,,	Warships, Liners and Other Vessels (c1904):	£2.40	_
MP	105	A 'Cousis' Dubec Cigarettes'		
MP	22		£3.50	
MP	40		£3.50	- -
MP	851		£4.00	_
KP	851		£1.40	_
Kr	031	E 'Cousis' Cigarettes'	£1.00	-
CR	OWN	TOBACCO CO., India	- 1	
		National Types, Costumes and Flags (c1900)		
	. 13	reactional Types, Costumes and Flags (C1900)	£35.00	_
DIX	KSON	I, Australia—————		
	50	Australian MPs and Celebrities (c1900)	£12.00	_
DO	MIN	ION TOBACCO CO., Canada———————		
	50	The Smokers of the World (c1905)	£40.00	
			£40.00	
DO	MIN	ION TOBACCO CO. LTD, New Zealand—		
	50	Coaches and Coaching Days (c1928)	£1.80	
	50	People and Places Famous in New Zealand History (c1928)	£1.80	
	50	Products of the World (c1928)	£1.00	£50.00
	50	USS Co's Steamers (c1928)	£2.40	130.00
		22 2 3 5 Conners (C1720)	12.40	
DU	DGE	ON & ARNELL, Australia		
K	16	1934 Australian Test Team (1934)	£5.50	£90.00
K	55	Famous Ships (1933)	£2.50	190.00
			12.50	
W.	DUK	E, SONS & CO., USA		
ALL	SERIE	S ISSUED 1885-95		
	50	Actors and Actresses Series No. 1	£12.00	
	50	Actors and Actresses Series No. 2	£12.00	
	25	Actresses RB18/27	£12.00	
EL	25	Albums of American Stars		
EL	25	Battle Scenes	£38.00	_
LL	23	Data occincs	£26.00	-

W. DUKE, SONS & CO., USA (continued)

Size	Numbe	er		Complete
	in set		per card	set
EL	25	Breeds of Horses	£26.00	_
EL	25	Bridges	£22.00	
	50	Coins of All Nations	£12.00	_
EL	25	Comic Characters	£22.00	_
EL	25	Cowboys Scenes	£28.00	_
EL	50	Fairest Flowers in the World	£22.00	
	50	Fancy Dress Ball Costumes	£12.00	
EL	50	Fancy Dress Ball Costumes	£23.00 £14.00	_
ET	50	Fishers and Fish	£24.00	
EL	25	Flags and Costumes	£12.00	_
EL	50 25	Floral Beauties and Language of Flowers	£22.00	_
EL	25	Gems of Beauty	£22.00	_
EL	50	Great Americans	£18.00	
	25	Gymnastic Exercises	£25.00	
EL	25	Habitations of Man	£22.00	
LL	50	Histories of Generals (Booklets)	£28.00	_
	50	Histories of Poor Boys who have become rich and other famous people	£23.00	100
	50	Holidays	£13.00	£650.00
EL	25	Illustrated Songs	£23.00	
EL	25	Industries of the States	£26.00	_
	50	Jokes	£13.00	_
EL	25	Lighthouses (die cut)	£24.00	-
EL	25	Miniature Novelties	£22.00	_
	50	Musical Instruments	£18.00	
	36	Ocean and River Steamers	£22.00	_
M	240	Photographs from Life RB23/D76-84	£6.00	
	53	Playing Cards	£11.00	_
	50	Popular Songs and Dancers	£17.00	_
	50	Postage Stamps	£13.00	
		Rulers, Flags and Coats of Arms (1888):		
EL	50	A Thick card type	£22.00	_
EL	50	B Thin folders	£13.00	
	50	Scenes of Perilous Occupations	£17.00	_
EL	25	Sea Captains	£28.00	
	50	Shadows	£12.00	£600.00
EL	25	Snap Shots from Puck	£22.00	_
EL	25	Stars of the Stage, 1st series:	000.00	0550.00
		A With Duke	£22.00	£550.00
		B Inscribed '3rd Series'	£22.00	_
EL	25	Stars of the Stage, 2nd series	£22.00	C550 00
EL	25	Stars of the Stage, 3rd series	£22.00	£550.00
EL	25	Stars of the Stage, 4th series (die cut)	£22.00 £22.00	
EL	48	State Governors' Coats of Arms	£13.00	
EL	48	State Governors' Coats of Arms (folders)	£13.00	
ET	50	The Terrors of America and Their Doings	£22.00	_
EL	50 50	The Terrors of America and Their Doings	122.00	_
	30	A Standard size	£17.00	100
		B Die cut to shape	£17.00	
EL	25	Types of Vessels (die cut)	£23.00	_
EL	50	Vehicles of the World	£18.00	_
	50	Yacht Colors of the World	£12.00	_
рн		APHIC CARDS	212.00	
	340	Actors and Actresses, 'Cross-Cut Cigarettes' with number and caption in		
	2.3	design, Group 1	£4.00	_
		V A STORE TO STORE THE ST		

W. DUKE, SONS & CO., USA (continued)

***	DUK	e, sons & co., osa (commea)		
Size	e Numb	er		Complete
			per card	set
	260	Actors and Actresses, 'Cross-Cut Cigarettes' in design, number and caption		
		at base, Group 2	£4.00	
	?	Actors and Actresses, 'Cross-Cut Cigarettes' and all wording at base,		
		Group	£4.00	
	148	Actors and Actresses, 'Dukes Cameo Cigarettes' in design, number and		
		caption at base, Group 4	£4.00	
	?	Actors and Actresses, 'Dukes Cameo Cigarettes', number and caption at		
		base, Group 5	£4.00	
	?	Actors and Actresses, 'Dukes Cigarettes' in design, number and caption at		
		base, Group 6	£4.00	<u> </u>
	?	Actors and Actresses, 'Dukes Cigarettes' and all wording at base, Group 7.	£4.00	_
	?	Actors, Actresses and Celebrities, printed back:		
		1 Horizontal 'Dukes Cameo Cigarettes' back	£4.00	
		2 Vertical 'Sales 1858' back	£4.00	F 10 -
ET	0	3 Horizontal 'Dukes Cigarettes' back	£4.00	_
EL	?	Actors, Actresses, Celebrities etc	£4.00	_
н	FILL	S & CO., USA—		
11.				
	25	Breeds of Dogs (c1890)	£37.00	_
	25	Costumes of Women (c1890)	£50.00	_
	25	Generals of the Late Civil War (c1890)	£65.00	
	25	Photographic Cards — Actresses (c1887)	£7.00	_
FO	U CD	IONG, China		
FU	In Ch	orto, emili	STEER STEER	
M	10	Chinese Series (c1930)	_	£20.00
G.	W. GA	AIL & AX., USA—		
EL	25	Battle Scenes (c1890)	C20 00	
EL	25	Bicycle and Trick Riders (c1890)	£28.00	-
EL	25	French Novelties (c1890)	£35.00	
EL	25	Industries of the States (c1890)	£26.00 £26.00	
EL	25	Lighthouses (die cut) (c1890)	£24.00	-
EL	25	Novelties (die cut) (c1890)	£24.00	
EL	?	Photographic Cards (c1890)		
EL	25	Stars of the Stage (c1890)	£5.00 £26.00	
		State of the Stage (C1090)	120.00	
GE	ENER	AL CIGAR COMPANY, Montreal, Canada————		
		Northern Birds:		
EL	24		01.00	
EL	12		£1.20	-
LL	12	B Without series title, Nd. 25-36 (1977)	£1.40	
GC	OODV	VIN & CO, USA——————		1 1 1 1 1 1 1 1
	15	Beauties — 'PAC' (c1888)	CEE 00	
	50		£55.00	-
	50	Champions (c1888)	£27.00	_
	50	Dogs of the World (c1888)	£17.00	_
	50	Games and Sports Series (c1888)	£17.00 £22.00	
	50	Holidays (c1888)	£22.00	
	50	Occupations for Women (c1888)	£23.00 £55.00	-
	50	Photographic Cards (c1888):	£33.00	
	?	Actors and Actresses	£5.00	
	?	Baseball Players	£50.00	
	?	Celebrities and Prizefighters	£30.00 £25.00	
		and the digitors	223.00	

GOODWIN & CO, USA (continued) Size Number Price Complete per card in set £23.00 50 GUERNSEY TOBACCO CO., Channel Islands— A Famous Picture: £1.50 49 48 £1.50 £1.50 48 C 80p K THOS. H. HALL, USA-£60.00 4 £16.00 14 £16.00 140 £16.00 112 £16.00 ? 158 £16.00 £18.00 52 £28.00 12 £22.00 25 £60.00 11 £60.00 12 £60.00 4 Presidents of the United States RB23/-H6-11 (c1888) £28.00 22 £28.00 25 HIGNETT BROS. & CO., New Zealand-MP Beauties, Set 1 (1926): £1.50 £1.20 £60.00 £1.20 £60.00 MP R. & J. HILL LTD-£70.00 THE HILSON CO., USA £22.00 EL IMPERIAL TOBACCO COMPANY OF CANADA LTD, Canada-WITH FIRM'S NAME £45.00 25 24 £45.00 £1.60 £80.00 50 M £2.50

1	=	~
- 1	0	1

Birds of Canada (Western Canada) (1925)

£5.00

£1.30

£1.30

£1.00

£1.00

70p

90p

£35.00

£45.00

£30.00

£50.00

£50.00

100

100

50

48

50

23

50

50

L

L

IMPERIAL TOBACCO COMPANY OF CANADA LTD, Canada (continued)

Size	Numb in set	er	Price per card	Complete set
	50	Film Favourites (1925):		
		A English Issue:		
		i Numbered	£2.80	
		ii Unnumbered	£3.20	
		B French Issue:	23.20	
		i Numbered	£6.00	
		ii Unnumbered	£6.00	_
	50	Fish and Bait (1924)	£1.30	£65.00
	50	Fishes of the World (1924)	£1.30	£65.00
	50	Flower Culture in Pots (1925)	60p	£30.00
	30	Game Bird Series (1925)	£1.20	£36.00
	50	Gardening Hints (1923)	60p	£30.00
M	25	Heraldic Signs and Their Origins (1925)	£1.20	£30.00
	50	How to Play Golf (1925)	£6.00	_
	50	Infantry Training (1915):		
		A Glossy card	£2.20	_
		B Matt card	£2.20	_
L	48	Mail Carriers and Stamps (1903)	£22.00	
	50	Merchant Ships of the World (1924)	£1.00	£50.00
	25	Military Portraits (1914)	£2.20	_
	50	Modern War Weapons, 'Sweet Caporal' issue (1914)	£3.50	_
	56	Motor Cars (1924)	£1.70	
	50	Naval Portraits (1914)	£2.20	_
	25	Notabilities (1914)	£2.20	
	53	Poker Hands (1924)	90p	_
	53	Poker Hands, New Series (1925)	90p	_
	25	Poultry Alphabet (1924)	£2.00	_
	50	Railway Engines (1924):		
		A With 'Wills' blanked out	£1.20	<u> </u>
		B Without 'Wills'	90p	£45.00
	50	The Reason Why (1924)	£1.00	£50.00
	127	Smokers Golf Cards (1925)	£4.50	_
B		OUT FIRM'S NAME		
	50	Arms of the British Empire (1911)	£2.20	_
	50	Around the World (c1910)	£3.50	_
	90	Baseball Series (1912)	£25.00	_
	30	Bird Series (c1910)	£2.00	
	50	Boy Scouts (1911) — with album clause	£4.50	<u> </u>
	50	Canadian Historical Portraits (1913)	£6.00	
	50	Canadian History Series (1914)	£1.30	
	50	Fish Series (c1910)	£2.20	
	50	Fowls, Pigeons and Dogs (1911)	£2.80	_
	45	Hockey Players (1912)	£9.00	_
	36	Hockey Series (coloured) (1911)	£9.00	_
	50	How To Do It (c1910)	£2.50	-
	100	Lacrosse Series, Leading Players (c1910)	£4.00	_
	100	Lacrosse Series (coloured) (c1910)	£4.00	_
	50	Lacrosse Series (black and white) (c1910)	£4.00	_
	50	L'Historie du Canada (1926)	£1.20	_
	50	Movie Stars (c1930)	£1.20	
L	50	Pictures of Canadian Life (c1910):		
		A Brown front	£7.00	-
	50	B Green front	£6.00	-
	50	Prominent Men of Canada (c1910)	£3.00	_
	50	Tricks and Puzzles (c1910)	£7.00	-
	50	Types of Nations (c1910)	£3.00	_

IMPERIAL TOBACCO COMPANY OF CANADA LTD, Canada (continued) Size Number Price Complete in set per card set 25 £2.40 £60.00 L 45 £6.00 25 £2.60 C SILKS ISSUED 1910-25 Animals with Flags 55 £2.80 M EL 50 £11.00 M 121 £3.50 55 £2.50 M M 55 £2.50 Regimental Uniforms of Canada M 55 £3.50 50 £6.00 M THE IMPERIAL TOBACCO CO. OF INDIA LTD, India— Indian Historical Views (1915): £2.00 £2.00 40 Nautch Girl Series: £2.00 'Railway Cigarettes' (c1907) £2.00 52 Nautch Girl Series, PC inset: £2.00 'Railway Cigarettes' (c1907) £2.00 £1.50 K 53 Playing Cards, red back (1919) Playing Cards, blue back (1933) £1.00 THE JERSEY TOBACCO CO. LTD, Channel Islands— K 90p JUST SO, USA— EL. £10.00 KENTUCKY TOBACCO PTY. LTD. South Africa——— WM. S. KIMBALL & CO., USA————— ALL SERIES ISSUED 1885-95 ? 33 £55.00 72 Ancient Coins £26.00 48 Arms of Dominions £16.00 Ballet Queens 50 £17.00 52 £17.00 EL 20 £25.00 50 Butterflies £20.00 Champions of Games and Sports 50 £28.00 Dancing Girls of the World 50 £16.00 50 Dancing Women £16.00 50 Fancy Bathers £16.00 Goddesses of the Greeks & Romans

Household Pets

Photographic Actresses RB23/K26-15-2

£18.00

£25.00

£5.00

50

25

EL.

WM. S. KIMBALL & CO., USA (continued)

B Narrow card — officially cut	Size	Numbe in set	er	Price per card	Complete set
ALL SERIES ISSUED 1885-95 25	EL				Ξ
25	KI	NNEY	BROS, USA		
25	ALL	SERIE	S ISSUED 1885-95		
25		25	Actresses Group 1 Set 1 RB18/1	£7.50	
25		25	Actresses Group 1 Set 2 RB18/2	£11.00	<u> </u>
25		25		£13.00	
25 Actresses Group 2 RB18/15: A Subjects named		25	Actresses Group 1 Set 4	£15.00	
25 Actresses Group 2 RB18/15: A Subjects named		25	Actresses Group 1 Set 5	£15.00	_
A Subjects named			Actresses Group 2 RB18/15	£6.00	_
B Subjects unnamed		25	Actresses Group 2 RB18/16:		
25 Actresses Group 3 RB18/26 £6.00 25 Actresses Group 4 RB18/36 £6.00 150 Actresses Group 4 BB18/36 £6.00 25 Animals £16.00 25 Animals £16.00 25 Animals £16.00 50 Butterflies of the World. Light background £13.00 50 Butterflies of the World. Gold background £13.00 51 Famous Gems of the World £16.00 52 Harlequin Cards 1st series £16.00 53 Harlequin Cards 2nd series (1889) £16.00 54 Harlequin Cards 2nd series (1889) £16.00 55 Harlequin Cards 2nd series (1889) £16.00 60 International Cards £32.00 61 £16.00 £16.00 62 Leaders: £18.00 £4 6 B Narrow card — officially cut £18.00 £4 60 Magic Changing Cards (1881) £20.00 £4 60 Military series From £4.50 £18.00 £4 61 Magic Changing Cards (1881) £				£6.00	
25 Actresses Group 3 RB18/29 £6.00 50 Actresses Group 4 RB18/36 £6.00 150 Actresses Group 4 £6.00 25 Animals £16.00 10 Butterflies of the World. Light background £16.00 50 Butterflies of the World. Gold background £16.00 52 Harlequin Cards for World £16.00 52 Harlequin Cards Series (1889) £16.00 53 Harlequin Cards 2nd series (1889) £16.00 54 Laders £32.00 55 Leaders: £32.00 65 Leaders: £32.00 65 Leaders: £18.00 £4 60 Magic Changing Cards (1881) £20.00 £4 60 Magic Changing Cards (1881) £20.00 £5 61 Magic Changing Cards (1881) £20.00 £6 62 Military series From £4.50 £6 50 National Dances: £18.00 £16.00 62 Navial Vessels of the World				£6.00	
50 Actresses Group 4 RB18/36			Actresses Group 3 RB18/26	£6.00	
150			Actresses Group 3 RB18/29	£6.00	
25			Actresses Group 4 RB18/36	£6.00	
10 Butterflies of the World. Light background					_
50 Butterflies of the World			Animals	£16.00	<u>- 19 - 19 - 19 - 19 - 19 - 19 - 19 - 19</u>
25				£16.00	_
52 Harlequin Cards 1st series £16.00 53 Harlequin Cards 2nd series (1889) £16.00 K 24 Jocular Oculars £32.00 K 24 Jocular Oculars £36.00 25 Leaders: £18.00 £4 B Narrow card — officially cut £18.00 £4 50 Magic Changing Cards (1881) £20.00 622 Military series From £4.50 50 National Dances: From £4.50 A Front with white border £12.00 £6 B Front without border £16.00 £6 25 Naval Vessels of the World £18.00 £0 50 New Year 1890 (1889) £18.00 £18.00 50 Novelties Type 1. Thick circular, no border £22.00 £0 50 Novelties Type 2. Thin circular with border £9.00 Novelties Type 3. Die cut: £6.50 25 A Inscribed '55 Styles' £6.50 £6.50 50 B Inscribed '55 Styles' £6.50 50 Novelties Type 5. Standard size cards		100000000000000000000000000000000000000	Butterflies of the World. Gold background	£13.00	_
53 Harlequin Cards 2nd series (1889) £16.00 K 24 Jocular Oculars £32.00 25 Leaders: £36.00 25 Leaders: £18.00 £4 B Narrow card — officially cut £18.00 £4 50 Magic Changing Cards (1881) £20.00 622 Military series From £4.50 50 National Dances: From £4.50 A Front with white border £12.00 B Front without border £16.00 25 Naval Vessels of the World £18.00 50 New Year 1890 (1889) £18.00 25 Novelties Type 1. Thick circular, no border £22.00 50 Novelties Type 2. Thin circular with border £9.00 Novelties Type 3. Die cut: £6.50 25 A Inscribed '25 Styles' £6.50 50 B Inscribed '55 Styles' £6.50 50 Novelties Type 5. Standard size cards £9.00 14 Novelties Type 5. Standard size cards £9.00 Photographic Cards: £26.00 Photogra			Famous Gems of the World	£16.00	_
L 50 International Cards £32.00 K 24 Jocular Oculars £36.00 25 Leaders: A Standard size £18.00 £4 B Narrow card — officially cut £18.00 £4 B Narrow card — officially cut £18.00 £4 50 Magic Changing Cards (1881) £20.00 622 Military series From £4.50 National Dances: A Front with white border £12.00 £6 B Front without border £18.00 25 Naval Vessels of the World £18.00 25 Novelties Type 1. Thick circular, no border £22.00 50 Novelties Type 2. Thin circular with border £22.00 50 Novelties Type 2. Thin circular with border £9.00 Novelties Type 3. Die cut: 25 A Inscribed '25 Styles' £6.50 50 B Inscribed '50 Styles' £6.50 50 Novelties Type 5. Standard size cards £9.00 14 Novelties Type 6. Oval Photographic Cards: ? A Actors and Actresses. Horizontal back with Kinney's name £4.00 Photographic Cards: A Actors and Actresses. Vertical, Sweet Caporal backs £4.00 Racehorses: A Back with series title 'Famous Running Horses' £18.00 B Back 'Return 25 of these small cards' 11 lines of text £16.00 25 English Horses 'Return 25 of these cards' with 6 lines of text £15.00			Harlequin Cards 1st series		_
K 24 Jocular Oculars £36.00 25 Leaders: £18.00 £4 B Natrow card — officially cut £18.00 £4 50 Magic Changing Cards (1881) £20.00 622 Military series From £4.50 50 National Dances: From £4.50 A Front with white border £12.00 £6 B Front without border £18.00 25 Naval Vessels of the World £18.00 50 New Year 1890 (1889) £18.00 25 Novelties Type 1. Thick circular, no border £22.00 50 Novelties Type 2. Thin circular with border £9.00 Novelties Type 3. Die cut: £6.50 25 A Inscribed '25 Styles' £6.50 50 B Inscribed '55 Styles' £6.50 50 B Inscribed '55 Styles' £6.50 50 Novelties Type 5. Standard size cards £9.00 14 Novelties Type 6. Oval £26.00 Photographic Cards: £4.00 ? A Actors and Actresses. Vertical, Sweet Caporal backs £4.00				£16.00	· —
25 Leaders: A Standard size B Narrow card — officially cut 50 Magic Changing Cards (1881) 622 Military series From £4.50 50 National Dances: A Front with white border B Front without border C B Front without border B Front without border C S Naval Vessels of the World C S Novelties Type 1. Thick circular, no border C S Novelties Type 2. Thin circular with border C S Novelties Type 3. Die cut: 25 A Inscribed '25 Styles' C Inscribed '50 Styles' C S				£32.00	_
A Standard size	K			£36.00	_
B Narrow card — officially cut		25			
50 Magic Changing Cards (1881) £20.00 622 Military series From £4.50 50 National Dances: 4 A Front with white border £12.00 £6 B Front without border £18.00 £18.00 50 New Year 1890 (1889) £18.00 £18.00 £2.00 50 Novelties Type 1. Thick circular, no border £22.00 £9.00 Novelties Type 2. Thin circular with border £9.00 Novelties Type 3. Die cut: £6.50 <td></td> <td></td> <td></td> <td></td> <td>£450.00</td>					£450.00
622 Military series From £4.50 50 National Dances: £12.00 £6 A Front with white border £16.00 25 Naval Vessels of the World £18.00 50 New Year 1890 (1889) £18.00 25 Novelties Type 1. Thick circular, no border £22.00 50 Novelties Type 2. Thin circular with border £9.00 Novelties Type 3. Die cut: \$6.50 50 B Inscribed '55 Styles' £6.50 50 B Inscribed '50 Styles' £6.50 75 C Inscribed '55 Styles' £6.50 50 Novelties Type 5. Standard size cards £9.00 14 Novelties Type 5. Standard size cards £9.00 Photographic Cards: \$26.00 ? A Actors and Actresses. Horizontal back with Kinney's name £4.00 ? B Actors and Actresses. Vertical, Sweet Caporal backs £4.00 45 C Famous Ships £9.00 Racehorses: \$2.00 2 A Back with series title 'Famous Running Horses' £18.00 B Back 'Return 25 of these small cards' 11 lines of text £16.00			B Narrow card — officially cut		£450.00
50 National Dances: A Front with white border B Front without border \$16.00 25 Naval Vessels of the World \$18.00 50 New Year 1890 (1889) Novelties Type 1. Thick circular, no border \$18.00 50 Novelties Type 2. Thin circular with border Novelties Type 3. Die cut: 25 A Inscribed '25 Styles' C Inscribed '50 Styles' C Inscribed '55 Styles' Novelties Type 5. Standard size cards Novelties Type 5. Standard size cards Novelties Type 6. Oval Photographic Cards: A Actors and Actresses. Horizontal back with Kinney's name \$4.00 B Actors and Actresses. Vertical, Sweet Caporal backs \$4.00 C Famous Ships \$4.00 Racehorses: A Back with series title 'Famous Running Horses' A Back with series title 'Famous Running Horses' A Back with series title 'Famous Running Horses' E 18.00 B Back 'Return 25 of these small cards' 11 lines of text £15.00					_
A Front with white border				om £4.50	
B Front without border £16.00 25 Naval Vessels of the World £18.00 50 New Year 1890 (1889) £18.00 25 Novelties Type 1. Thick circular, no border £22.00 50 Novelties Type 2. Thin circular with border £9.00 Novelties Type 3. Die cut: 25 A Inscribed '25 Styles' £6.50 50 B Inscribed '50 Styles' £6.50 75 C Inscribed '75 Styles' £6.50 Novelties Type 5. Standard size cards £9.00 14 Novelties Type 6. Oval £26.00 Photographic Cards: ? A Actors and Actresses. Horizontal back with Kinney's name £4.00 ? B Actors and Actresses. Vertical, Sweet Caporal backs £4.00 45 C Famous Ships £9.00 Racehorses: 26 A Back with series title 'Famous Running Horses' £18.00 B Back 'Return 25 of these small cards' 11 lines of text £16.00 26 English Horses' Return 25 of these cards' with 6 lines of text £15.00		50			
25 Naval Vessels of the World £18.00 50 New Year 1890 (1889) £18.00 25 Novelties Type 1. Thick circular, no border £22.00 50 Novelties Type 2. Thin circular with border £9.00 Novelties Type 3. Die cut: £6.50 25 A Inscribed '55 Styles' £6.50 50 B Inscribed '50 Styles' £6.50 75 C Inscribed '75 Styles' £6.50 8 Novelties Type 5. Standard size cards £9.00 14 Novelties Type 6. Oval £26.00 Photographic Cards: £26.00 ? A Actors and Actresses. Horizontal back with Kinney's name £4.00 ? B Actors and Actresses. Vertical, Sweet Caporal backs £4.00 45 C Famous Ships £9.00 Racehorses: £9.00 25 1 American Horses: £18.00 B Back 'Return 25 of these small cards' 11 lines of text £16.00 25 2 English Horses 'Return 25 of these cards' with 6 lines of text £15.00			A Front with white border		£600.00
50 New Year 1890 (1889) . £18.00 25 Novelties Type 1. Thick circular, no border . £22.00 50 Novelties Type 2. Thin circular with border . £9.00 Novelties Type 3. Die cut: 25 A Inscribed '25 Styles' . £6.50 50 B Inscribed '50 Styles' . £6.50 75 C Inscribed '75 Styles' . £6.50 50 Novelties Type 5. Standard size cards . £9.00 14 Novelties Type 6. Oval . £26.00 Photographic Cards: 7 A Actors and Actresses. Horizontal back with Kinney's name . £4.00 7 B Actors and Actresses. Vertical, Sweet Caporal backs . £4.00 45 C Famous Ships . £9.00 Racehorses: 25 1 American Horses:			B Front without border	£16.00	_
25 Novelties Type 1. Thick circular, no border £22.00 50 Novelties Type 2. Thin circular with border £9.00 Novelties Type 3. Die cut: £6.50 25 A Inscribed '25 Styles' £6.50 50 B Inscribed '50 Styles' £6.50 75 C Inscribed '75 Styles' £6.50 50 Novelties Type 5. Standard size cards £9.00 14 Novelties Type 6. Oval £26.00 Photographic Cards: 2 ? A Actors and Actresses. Horizontal back with Kinney's name £4.00 ? B Actors and Actresses. Vertical, Sweet Caporal backs £4.00 45 C Famous Ships £9.00 Racehorses: £9.00 25 1 American Horses: £18.00 B Back 'Return 25 of these small cards' 11 lines of text £16.00 25 2 English Horses 'Return 25 of these cards' with 6 lines of text £15.00			Naval Vessels of the World	£18.00	
50 Novelties Type 2. Thin circular with border Novelties Type 3. Die cut: £9.00 25 A Inscribed '25 Styles' £6.50 50 B Inscribed '50 Styles' £6.50 75 C Inscribed '75 Styles' £6.50 50 Novelties Type 5. Standard size cards £9.00 14 Novelties Type 6. Oval £26.00 Photographic Cards: 2 ? A Actors and Actresses. Horizontal back with Kinney's name £4.00 ? B Actors and Actresses. Vertical, Sweet Caporal backs £4.00 45 C Famous Ships £9.00 Racehorses: 1 American Horses: 25 1 American Horses: A Back with series title 'Famous Running Horses' £18.00 B Back 'Return 25 of these small cards' 11 lines of text £16.00 25 2 English Horses 'Return 25 of these cards' with 6 lines of text £15.00			New Year 1890 (1889)	£18.00	
Novelties Type 3. Die cut: 25			Novelties Type 1. Thick circular, no border	£22.00	
25 A Inscribed '25 Styles' £6.50 50 B Inscribed '50 Styles' £6.50 75 C Inscribed '75 Styles' £6.50 50 Novelties Type 5. Standard size cards £9.00 14 Novelties Type 6. Oval £26.00 Photographic Cards: 2 ? A Actors and Actresses. Horizontal back with Kinney's name £4.00 ? B Actors and Actresses. Vertical, Sweet Caporal backs £4.00 45 C Famous Ships £9.00 Racehorses: 2 25 1 American Horses: A Back with series title 'Famous Running Horses' £18.00 B Back 'Return 25 of these small cards' 11 lines of text £16.00 25 2 English Horses 'Return 25 of these cards' with 6 lines of text £15.00		50	Novelties Type 2. Thin circular with border	£9.00	_
50 B Inscribed '50 Styles' £6.50 75 C Inscribed '75 Styles' £6.50 50 Novelties Type 5. Standard size cards £9.00 14 Novelties Type 6. Oval £26.00 Photographic Cards: 2 ? A Actors and Actresses. Horizontal back with Kinney's name £4.00 ? B Actors and Actresses. Vertical, Sweet Caporal backs £4.00 45 C Famous Ships £9.00 Racehorses: 2 25 1 American Horses: A Back with series title 'Famous Running Horses' £18.00 B Back 'Return 25 of these small cards' 11 lines of text £16.00 25 2 English Horses 'Return 25 of these cards' with 6 lines of text £15.00					
75 C Inscribed '75 Styles' £6.50 50 Novelties Type 5. Standard size cards £9.00 14 Novelties Type 6. Oval £26.00 Photographic Cards: 2 ? A Actors and Actresses. Horizontal back with Kinney's name £4.00 ? B Actors and Actresses. Vertical, Sweet Caporal backs £4.00 45 C Famous Ships £9.00 Racehorses: 2 25 1 American Horses: £18.00 B Back 'Return 25 of these small cards' 11 lines of text £16.00 25 2 English Horses 'Return 25 of these cards' with 6 lines of text £15.00			A Inscribed '25 Styles'	£6.50	
50 Novelties Type 5. Standard size cards £9.00 14 Novelties Type 6. Oval £26.00 Photographic Cards: ? A Actors and Actresses. Horizontal back with Kinney's name £4.00 ? B Actors and Actresses. Vertical, Sweet Caporal backs £4.00 45 C Famous Ships £9.00 Racehorses: 25 1 American Horses: A Back with series title 'Famous Running Horses' £18.00 B Back 'Return 25 of these small cards' 11 lines of text £16.00 25 2 English Horses 'Return 25 of these cards' with 6 lines of text £15.00			B Inscribed '50 Styles'		
14 Novelties Type 6. Oval £26.00 Photographic Cards: ? A Actors and Actresses. Horizontal back with Kinney's name £4.00 ? B Actors and Actresses. Vertical, Sweet Caporal backs £4.00 45 C Famous Ships £9.00 Racehorses: 25 1 American Horses: A Back with series title 'Famous Running Horses' £18.00 B Back 'Return 25 of these small cards' 11 lines of text £16.00 25 2 English Horses 'Return 25 of these cards' with 6 lines of text £15.00			C Inscribed '75 Styles'		<u> </u>
Photographic Cards: ? A Actors and Actresses. Horizontal back with Kinney's name £4.00 ? B Actors and Actresses. Vertical, Sweet Caporal backs £4.00 45 C Famous Ships £9.00 Racehorses: 25 1 American Horses: A Back with series title 'Famous Running Horses' £18.00 B Back 'Return 25 of these small cards' 11 lines of text £16.00 25 2 English Horses 'Return 25 of these cards' with 6 lines of text £15.00			Novelties Type 5. Standard size cards	£9.00	_
? A Actors and Actresses. Horizontal back with Kinney's name £4.00 ? B Actors and Actresses. Vertical, Sweet Caporal backs £4.00 45 C Famous Ships £9.00 Racehorses: 25 1 American Horses: A Back with series title 'Famous Running Horses' £18.00 B Back 'Return 25 of these small cards' 11 lines of text £16.00 25 2 English Horses 'Return 25 of these cards' with 6 lines of text £15.00		14	Novelties Type 6. Oval	£26.00	_
? B Actors and Actresses. Vertical, Sweet Caporal backs £4.00 45 C Famous Ships £9.00 Racehorses: 25 1 American Horses: A Back with series title 'Famous Running Horses' £18.00 B Back 'Return 25 of these small cards' 11 lines of text £16.00 25 2 English Horses 'Return 25 of these cards' with 6 lines of text £15.00					
45 C Famous Ships					_
Racehorses: 25 1 American Horses: A Back with series title 'Famous Running Horses'			and the second s		_
25 1 American Horses: A Back with series title 'Famous Running Horses'		45		£9.00	_
A Back with series title 'Famous Running Horses'					
B Back 'Return 25 of these small cards' 11 lines of text £16.00 25 2 English Horses 'Return 25 of these cards' with 6 lines of text £15.00		25			
25 2 English Horses 'Return 25 of these cards' with 6 lines of text £15.00				£18.00	_
				£16.00	
25 3 Great American Trotters				£15.00	_
20 Cicul American Hotters £20.00		25	3 Great American Trotters	£20.00	_
50 Surf Beauties		50	Surf Beauties	£18.00	_

KINNEY BROS, USA (continued)

Size	Numb in set	er	Price per card	Complete set
	52 25	Transparent Playing Cards		_
KR	AME	CRS TOBACCO CO. (PTY) LTD, South Africa		
	50	Badges of South African Rugby Football Clubs (1933)	£6.00	_
LA	MBE	RT & BUTLER—		
	50	Actors and Actresses — 'WALPS' (1905)	£2.60	_
	250	Actresses — 'ALWICS' (1905): A Portraits in black, border in red	£2.60	_
		B Portraits and border in black	£6.50	
	50	Beauties red tinted (1908)	£3.00	
	83	Danske Byvaabner (c1915)	£15.00	
M	26	Etchings of Dogs (1926)	£25.00	_
	25	Flag Girls of All Nations (1908)	£12.00	_
P	50	Homeland Events (1928)	£1.20	£60.00
P	50	London Zoo (1927)	£1.20	
Maria.	50	Merchant Ships of the World (1924)	£2.00	_
	30	Music Hall Celebrities (1916)	£4.00	
P	50	Popular Film Stars (1926):		
Cast of		A Series title in one line, no brand quoted	£1.20	£60.00
		B Series title in two lines, inscribed 'Varsity Cigarettes'	£1.80	
		C Series title in two lines, no brand quoted	£1.20	£60.00
P	50	The Royal Family at Home and Abroad (1927)	£1.20	£60.00
	100	Royalty, Notabilities and Events in Russia, China, Japan and South Africa (1902)	£12.00	# 14.5 m.
	100	Russo Japanese series (1905)	£4.50	_
P	50	Types of Modern Beauty (1927)	£1.00	£50.00
P	50	Who's Who in Sport (1926)	£3.00	£150.00
P	50	The World of Sport (1927)	£1.60	£80.00
LE	WIS	& ALLEN CO. USA		
L	? 120	Views and Art Studies (c1910)		_
LO	NE J	ACK CIGARETTE CO. USA—————		
		Language of Flowers (1888)		_
P. I	ORI	LLARD CO., USA		
		CC ICCUED 1995 09		
M	25	Actresses RB23/L70-4-3	£22.00	
M	25	Actresses RB23/L70-5		13.1
EL	25	Actresses RB23/L70-6:	222.00	
	23	A 'Red Cross' long cut	£22.00	
		B 'Sensation Cut Plug' front and back		_
		C 'Sensation Cut Plug' front only	£22.00	
EL	25	Actresses RB23/L70-8		
EL	25	Actresses in Opera Roles RB23/L70-9		
M	25	Ancient Mythology Burlesqued RB23/L70-10		
M	50	Beautiful Women RB23/L70-11:	~	
	20	A '5c Ante' front and back	£22.00	
2.5		B 'Lorillard's Snuff' front and back		
		C 'Tiger' front and back		_

P. L	ORII	LLARD CO., USA (continued)		
Size	Numb in set		Price per card	Complete sei
EL	25	Circus Scenes	£55.00	_
EL	50	Prizefighters		_
M	25	Types of the Stage	£22.00	_
W.	C. MA	ACDONALD INC., Canada——————————————————————————————————		
M	? 53	Aeroplanes and Warships (c1940) Playing Cards (different designs) (1926-47)		_
В. с	& J.P	B. MACHADO, Jamaica———————		
	25	British Naval series (1916)	£17.00	_
	50	The Great War — Victoria Cross Heroes (1916)	£15.00	_
P	50	Popular Film Stars (1926)	£5.00	_
P	50	The Royal Family at Home and Abroad (1927)	£5.00	_
P	52	Stars of the Cinema (1926)		_
P	50	The World of Sport (1928)		_
MA	CLI	N-ZIMMER-MCGILL TOB. CO., USA		
EL	53	Playing Cards — Actresses (c1890)	£22.00	_
н.	MAN	DELBAUM, USA—		
	20	Types of People (c1890)	£50.00	_
MA	RBU	URG BROS, USA—	19.10	
	48	National Costume Cards (c1890)	£50.00	_
PН	MA	YO & BROTHER, USA		
	25	Actresses RB23/M80-1 (c1890)		_
M	25	Actresses RB23/M80-3 (c1890)		_
L	? 39	Actresses RB23/M80-4 (c1890)	£50.00	_
	40	Actresses RB23/M80-5 (c1890)		3613
	20	Baseball Players (c1890)		_
	25	Costumes and Flowers (c1890)		
M	25	National Flowers (Girl and Scene) (c1890)	£26.00	
141	20	Naval Uniforms (c1890)	£25.00	
	35	Prizefighters (c1890)	£24.00 £35.00	
	20	Shakespeare Characters (c1890)	£25.00	_
м	MFI	ACHRINO & CO., Switzerland—	erelly4	
141.				
	52	Peuples Exotiques 1st series (c1925)	80p	£40.00
	52 52	Peuples Exotiques 2nd series (c1925) Peuples Exotiques 3rd series (c1925)	80p 80p	£40.00
			оор	210.00
MI	FSUL	O & AZZOPARDI, Malta———————————————————————————————————		
KP	59	First Maltese Parliament (1922)	£5.50	_
L.	MIL	LER & SONS, USA—		
M		Battleships (c1900)	£25.00	_
		T- ()	225.00	

L. MILLER & SONS, USA (continued)

Size	Numbe in set	er	Price per card	Complete set
M M L	25 24 50	Generals and Admirals (Spanish War) (c1900) Presidents of US (c1900) Rulers of the World (c1900)	£20.00	Ξ
СН	AS. J	. MITCHELL & CO., Canada—		
	26	Actresses — 'FROGA A' (1900): A Backs in brown B Backs in green		=
MI	rsui	& CO., Japan		
.,	?	Japanese Women (c1908)	£5.00	_
MO	ORF	& CALVI, USA-		
EL	53	Playing Cards — Actresses (c1890):		
EL.	33	A 'Trumps Long Cut' back B 'Hard-A-Port' with maker's name C 'Hard-A-Port' without maker's name	£18.00	=
MU	RAI	BROS & CO., Japan—		
	50 100 50 54	Actresses — 'ALWICS' (c1905) Beauties — 'THIBS' (c1900) Beauties Group 1 (c1902) Chinese Girls Set 3 (c1905)	£9.00 £24.00 £12.00 £7.50	=
	25 25 50	Chinese Beauties 1st series Peacock issue (c1910) Chinese Beauties 3rd series Peacock issue (c1910) Chinese Beauties, back in red (c1908)	£2.60 £4.00 £5.00	£65.00
	50 20 50	Chinese Children's Games without border Peacock issue (c1910)	£2.40 £2.60 £2.60	£120.00
	30 40 50	Chinese Series Peacock issue (c1910) Chinese Trades 1, back in black (c1905) Dancing Girls of the World (c1900)	£2.50 £4.50 £28.00	£75.00 —
NA'	ΓΙΟΝ	IAL CIGARETTE AND TOBACCO CO., USA———		
EL EL	13 ? 25 44	Art Miniatures (1892) Cabinet Pictures (c1890) National Types (c1890) National Types (c1890)	£22.00	Ξ
РНО	TOGR.	APHIC CARDS Actresses (c1888):		
		A Plain back B Printed back	£5.00 £7.00	=
OG	DEN	S LTD-		
	51 30	Actresses, black and white Polo issue (1906)	£3.00	÷
	17	A Tin foil at back white	£2.50 £3.00 £11.00	£75.00 £90.00

OGDENS LTD (continued)

Size	Numbe in set	r	Price per card	Complete
	60	Animals — cut-outs:		
	00	A Ruler issue (1912)	£2.50	-
		i With captions	£2.50	_
		ii Without captions		_
	50	Aviation series Tabs issue (1912):		
		A Ogdens at base	£6.00	_
		B Ogdens England at base	£6.00	_
		Beauties green net design back 1901:		
	? 66	A Front black & white	£12.00	-
	? 98	B Front coloured	£22.00	
	45	Beauties Picture Hats Polo issue (1911)	£5.50	_
	50	Best Dogs of Their Breed Polo issue (1916):		
		A Back in red	£7.00	_
	50	B Back in blue	£7.00	_
	52	Birds of Brilliant Plumage Ruler issue (1914):	02.00	
		A Fronts with framelines	£3.00	
	25	B Fronts without framelines	£3.00	645.06
	25	British Trees and Their Uses, Guinea Gold issue (1927)	£1.80	£45.00
	25	China's Famous Warriors, Ruler issue (1913)	£4.50	£60.00
	20	Flowers, Polo issue (1915):	£2.40	100.00
	20	A Without Eastern inscription	£5.50	
		B With Eastern inscription	£5.50	
	25	Indian Women, Polo issue (1919):	25.50	
		A Framework in apple green	£5.00	
		B Framework in emerald green	£5.00	
K	52	Miniature Playing Cards, Polo issue (1922) Music Hall Celebrities (1911):	£13.00	_
	30	A Polo issue	£5.00	
	50	B Tabs issue	£5.00	
	50	Riders of the World, Polo issue (1911)	£4.00	
	50	Russo-Japanese series (1905)	£22.00	
	36	Ships and Their Pennants, Polo issue (1911)	£5.50	
	32	Transport of the World, Polo issue (1917)	£5.50	
	, io	Service of the Hotel, 1010 issue (1917)	23.30	
OL	D FAS	SHION, USA———————		
L	? 200	Photographic Cards — Actresses (c1890)	£7.00	_
PE	NINS	ULAR TOBACCO CO. LTD, India—	-81	
	50	Animals and Birds (1910)	£1.80	
	52	Birds of Brilliant Plumage (1916):	11.00	
	32	A Back with single large packings	£3 00	
		B Back with two small packings		
	25	Birds of the East, 1st series (1912)		
	25	Birds of the East, 1st series (1912) Birds of the East, 2nd series (1912)		£45.00
	25	China's Famous Warriors:	21.00	243.00
	23	A Back 'Monchyr India'	£2.60	£65.00
		B Back 'India' only	£2.40	£60.00
	25	Chinese Heroes (1913)		£50.00
	50	Chinese Modern Beauties (1912)		250.00
	50	Chinese Trades (1908):	24.50	
	30	A Back with 'Monchyr'	£3.00	
		B Back without 'Monchyr'		
		Add 24 (20)	20.00	

PENINSULAR TOBACCO CO. LTD, India (continued)

Time	Size	Numb in set	er	Price per card	Complete set
25 Hindoo Gods (1909)		30	Fish series (1916)	£2.50	
37 Nauch Girl series (1910)		25		£2.00	£50.00
PLANTERS' STORES & AGENCY CO. LTD, India		37		£4.50	_
Page		25		£1.80	£45.00
Page	DI	ANTI	FDS' STODES & ACENCY CO. LTD. India		
DOHN PLAYER & SONS	IL		15. 전쟁 12. 12. 12. 12. 12. 12. 12. 12. 12. 12.	Paristic .	
A CHANNEL ISLANDS ISSUES (WITHOUT ITC CLAUSE)					_
A CHANNEL ISLANDS ISSUES (WITHOUT ITC CLAUSE) 50 Aircraft of the Royal Air Force (1938)		25	Beauties 'FECKSA' (1900)	£32.00	_
50 Aircraft of the Royal Air Force (1938) £1.10 £55.00 50 Animals of the Countryside (1939) 70p £35.00 50 Birds and Their Young (1937) 70p £35.00 50 Coronation series Ceremonial Dress (1937) 70p £35.00 50 Cricketers (1938) £1.50 £75.00 50 Crycling (1939) £1.20 £60.00 50 Famous Beauties (1937) £2.00 £50.00 50 Film Stars 3rd series (1938) £1.20 £60.00 51 Ditternational Air Liners (1936) £7.00 £40.00 50 Military Uniforms of the British Empire Overseas (1938): £1.20 £60.00 50 Modern Naval Craft (1939) 80p £40.00 50 Modor Cars 1st series (1936) £1.70 £85.00 50 Motor Cars 1st series (1936) £1.70 £85.00 50 Motor Cars 2nd series (1937) £1.70 £85.00 50 National Flags and Arms (1936) 70p £35.00 L 25 Old Hunting Prints (1938) £3.20 — L L 25 Old Naval Prints (1938) £3.20 — L L 25 Old Naval Prints (1938) £3.20 — L 50 RAF Badges (1937) £1.00 £50.00 50 Sea Fishes (1935) 70p £35.00 £3.00 — L 50 RAF Badges (1937) £1.00 £50.00 — L 50 RAF Badges (1937) £1.00 £50.00 — L 50 RAF Badges (1937) £2.00 — L 50 Badles and Arms (1926) £2.00 — L 50 Beauties 1st series (1925) £4.00 — L 50 Arms and Armour (1926) £2.00 — L 50 Beauties 1st series (1925) £4.00 — L 50 Beauties 2nd series (1925) £4.00 — L 50 Boy Scouts (1924) £2.00 — L 50 Boy Scouts (1923) £4.50 — L 50 Boy Scouts (1924) £5.00 — L 50 Boy Scouts (1924) £6.00 — L 50 Boy Scouts (1924) £5.00 — L 50 Boy Scouts (1924) £5.00 — L 50 Boy Scouts (1924) £5.00 — L 50 Boy Scouts (1924) £6.00 — L 50 Boy Scouts (1924) £6.00 — L 50 Boy Scouts (1924) £6.00 — L 50 Boy Scouts (1928) £6.00 —	JOI	HN P	LAYER & SONS——————		
50 Animals of the Countryside (1939) 70p £35.00 50 Birds and Their Young (1937) 70p £35.00 50 Coronation series Ceremonial Dress (1937) 70p £35.00 50 Cricketers (1938) £1.50 £75.00 50 Cycling (1939) £1.20 £60.00 50 Famous Beauties (1937) £2.00 £50.00 50 Film Stars 3rd series (1938) £1.20 £60.00 50 Film Stars 3rd series (1938) £1.20 £60.00 50 International Air Liners (1936) 80p £40.00 50 Military Uniforms of the British Empire Overseas (1938): £1.20 £60.00 50 Modern Naval Craft (1939) 80p £40.00 50 Modern Naval Craft (1939) 80p £40.00 50 Motor Cars 1st series (1937) £1.70 £85.00 50 Motor Cars 2nd series (1937) £1.70 £85.00 50 National Flags and Arms (1936) 70p £3.00 L 25 Old H	A (CHAN	NEL ISLANDS ISSUES (WITHOUT ITC CLAUSE)		
50 Birds and Their Young (1937) 70p £35.00 50 Coronation series Ceremonial Dress (1937) 70p £35.00 50 Cricketers (1938) £1.50 £75.00 50 Cycling (1939) £2.00 £50.00 50 Film Stars 3rd series (1937) £2.00 £60.00 L 25 Golf (1939) £7.00 — 50 International Air Liners (1936) 80p £40.00 50 Military Uniforms of the British Empire Overseas (1938): £1.20 £60.00 50 Molthor Cars 2nd Series (1936) 80p £40.00 50 Modern Naval Craft (1939) 80p £40.00 50 Motor Cars 1st series (1936) £1.70 £85.00 50 Motor Cars 2nd series (1937) £1.70 £85.00 50 Motor Cars 2nd series (1936) £3.20 — L 25 Old Hunting Prints (1938) £3.20 — L 25 Old Hunting Prints (1938) £3.20 — L 25 Old Naval Prints (1938) £3.20 — L		50	Aircraft of the Royal Air Force (1938)	£1.10	
50 Coronation series Ceremonial Dress (1937) 70p £35.00 50 Cricketers (1938) £1.50 £75.00 50 Cycling (1939) £1.20 £60.00 L 25 Famous Beauties (1937) £2.00 £50.00 50 Film Stars 3rd series (1938) £1.20 £60.00 L 25 Golf (1939) £7.00 — 50 International Air Liners (1936) 80p £40.00 50 Military Uniforms of the British Empire Overseas (1938): £60.00 £60.00 B Non-adhesive backs £1.30 £65.00 B Non-adhesive backs £1.30 £65.00 50 Motor Cars 1st series (1939) 80p £40.00 50 Motor Cars 2nd series (1939) £1.70 £85.00 50 Motor Cars 2nd series (1937) £1.70 £85.00 50 National Flags and Arms (1936) £3.20 — L 25 Old Naval Prints (1938) £3.20 — L 25		50			
50 Cricketers (1938) £1.50 £75.00 50 Cycling (1939) £60.00 50 Film Stars 3rd series (1937) £2.00 £50.00 50 Film Stars 3rd series (1938) £1.20 £60.00 L 25 Golf (1939) £7.00 £0.00 50 International Air Liners (1936) 80p £40.00 50 Military Uniforms of the British Empire Overseas (1938): £1.20 £60.00 A A Adhesive backs £1.30 £65.00 50 Modern Naval Craft (1939) 80p £40.00 50 Modern Naval Craft (1939) 80p £40.00 50 Motor Cars 1st series (1937) £1.70 £85.00 50 Motor Cars 2nd series (1937) £1.70 £85.00 50 Motor Cars 2nd series (1937) £1.70 £85.00 50 National Flags and Arms (1936) £3.20 — L 25 Old Hunting Prints (1938) £3.20 — L 25 Old Naval Prints (1938) £3.20 — L 25 Old Naval Prints (1938)<					
50 Cycling (1939) £1.20 £50.00 L 25 Famous Beauties (1938) £1.20 £50.00 50 Film Stars 3rd series (1938) £1.20 £60.00 50 International Air Liners (1936) 80p £40.00 50 Military Uniforms of the British Empire Overseas (1938): £1.20 £60.00 B Non-adhesive backs £1.30 £65.00 50 Modern Naval Craft (1939) 80p £40.00 50 Motor Cars Ist series (1936) £1.70 £85.00 50 Motor Cars 2nd series (1936) £1.70 £85.00 50 Motor Cars 2nd series (1936) £1.70 £85.00 50 Motor Cars 2nd series (1936) £1.70 £85.00 50 National Flags and Arms (1936) £3.20 — L 25 Old Hunting Prints (1938) £3.20 — L 25 Old Hunting Prints (1938) £4.00 — L 25 RAF Badges (1937) £1.00 £50.00 50 </td <td></td> <td></td> <td></td> <td></td> <td></td>					
L 25 Famous Beauties (1937)					
50 Film Stars 3rd series (1938) £1.20 £60.00 L 25 Golf (1939) £7.00 — 50 International Air Liners (1936) 80p £40.00 50 Military Uniforms of the British Empire Overseas (1938): ## \$1.20 £60.00 B Non-adhesive backs £1.30 £65.00 50 Modern Naval Craft (1939) 80p £40.00 50 Motor Cars Ist series (1936) £1.70 £85.00 50 Motor Cars 2nd series (1937) £1.70 £85.00 50 National Flags and Arms (1936) 70p £35.00 L 25 Old Hunting Prints (1938) £3.20 — L 25 Old Naval Prints (1936) £3.20 — L 25 Old Naval Prints (1936) £3.20 — L 25 Racing Yachts (1938) £4.00 — L 25 Racing Yachts (1938) £4.00 — L 25 Types of Horses (1939) £4.00 — L 25 Types of Horses (1939) £4.00 — </td <td>9.24</td> <td></td> <td></td> <td></td> <td></td>	9.24				
L 25 Golf (1939)	L		Famous Beauties (1937)		
50 International Air Liners (1936) 80p £40.00 50 Military Uniforms of the British Empire Overseas (1938): 260.00 A Adhesive backs £1.20 £60.00 50 Modern Naval Craft (1939) 80p £40.00 50 Motor Cars 1st series (1936) £1.70 £85.00 50 Motor Cars 2nd series (1937) £1.70 £85.00 50 National Flags and Arms (1936) 70p £35.00 L 25 Old Hunting Prints (1938) £3.20 — L 25 Racing Yachts (1938) £3.20 — L 25 Racing Yachts (1938) £4.00 — 50 RAF Badges (1937) £1.00 £50.00 50 Sea Fishes (1935) 70p £35.00 L 25 Types of Horses (1939) £4.00 — L 25 Types of Horses (1939) £4.00 — L 25 Types of Horses (1926) £2.00 — 50 Aeroplane series (1926) £2.00 — 50 Arms and Armour (1926) £					£60.00
Military Uniforms of the British Empire Overseas (1938): A Adhesive backs	L				£40.00
A Adhesive backs B Non-adhesive backs 50 Modern Naval Craft (1939) 50 Motor Cars 1st series (1936) 50 Motor Cars 2nd series (1936) 50 National Flags and Arms (1936) 50 National Flags and Arms (1936) 51 C 25 Old Hunting Prints (1938) 52 Racing Yachts (1938) 53 C 25 Racing Yachts (1938) 54 C 25 Racing Yachts (1938) 55 C 25 Racing Space (1937) 56 C 27 Racing Space (1937) 57 C 28 Racing Space (1937) 58 C 29 Racing Space (1937) 59 C 29 Racing Space (1937) 50 Sea Fishes (1935) 50 Sea Fishes (1935) 50 Sea Fishes (1937) 50 Sea Fishes (1939) 51 C 25 Types of Horses (1939) 52 C 25 Dos Babies (1937) 53 C 25 Dos Babies (1937) 54 C 25 Dos Babies (1937) 55 D 27 Dos Beauties 1st series (1926) 56 Arms and Armour (1926) 57 D 38 Dos Beauties 1st series (1925) 58 D 38 Dos Dos (1926) 59 D 39 Dos (1923) 50 Dos Beauties 2nd series (1925) 50 Beauties 2nd series (1925) 51 Dos Beauties 2nd series (1925) 52 Birds of Brilliant Plumage (1927) 53 Dos Dos (1923) 54 Dos Dos (1924) 55 Dos Couts (1924) 56 Dos Couts (1928) 57 Dos (Heads) (1928) 58 Dos Dos (1928) 59 Dos (Heads) (1927) 50 Butterflies (Girls) (1928) 50 Household Hints (1928-29) 50 Lawn Tennis (1928) 50 Leaders of Men (1925) 51 Leaders of Men (1925) 51 Leaders of Men (1925) 51 Lawn Tennis (1928) 51 Leaders of Men (1925) 51 Eaders of Men (1925) 51 Eader		-		оор	140.00
B Non-adhesive backs £1.30 £65.00 50 Modern Naval Craft (1939) 80p £40.00 50 Motor Cars 1st series (1936) £1.70 £85.00 50 Motor Cars 2nd series (1937) £1.70 £85.00 50 National Flags and Arms (1936) 70p £35.00 L 25 Old Hunting Prints (1938) £3.20 — L 25 Old Naval Prints (1938) £3.20 — L 25 Racing Yachts (1938) £4.00 — 50 RAF Badges (1937) £1.00 £50.00 L 25 Types of Horses (1939) £4.00 — L 25 Types of Horses (1939) £4.00 — L 25 Zoo Babies (1937) £2.00 — B GENERAL OVERSEAS ISSUES 50 Aeroplane series (1926) £2.00 — 50 Beauties 1st series (1925): A Black and white fronts £1.40 £70.00 B Coloured fronts £1.40 £70.00 52 Birds of Brilliant Plumage (1927) £3.50 — 50 Boy Scouts (1924) £2.00 — M 25 British Live Stock (1924) £5.00 — 50 Butterflies (Girls) (1928) £5.00 — 25 Flag Girls of All Nations (1908) £6.50 — 25 Flag Girls of All Nations (1908) £6.50 — 25 Flag Girls of All Nations (1908) £6.50 — 50 Household Hints (1928-29) 90p £45.00 — 50 Lawn Tennis (1928) £3.00 — 50 Leaders of Men (1925) £3.00 —		30		£1.20	£60.00
50 Modern Naval Craft (1939) 80p £40.00 50 Motor Cars 1st series (1936) £1.70 £85.00 50 Motor Cars 2nd series (1937) £1.70 £85.00 50 National Flags and Arms (1936) 70p £35.00 L 25 Old Hunting Prints (1938) £3.20 — L 25 Racing Yachts (1938) £4.00 — 50 RAF Badges (1937) £1.00 £50.00 50 Sea Fishes (1935) 70p £35.00 L 25 Types of Horses (1939) £4.00 — L 25 Types of Horses (1939) £4.00 — L 25 Types of Horses (1939) £4.00 — L 25 Types of Horses (1939) £2.00 — B GENERAL OVERSEAS ISSUES 50 Arms and Armour (1926) £2.00 — 50 Arms and Armour (1926) £2.00 — 50 Arms and Armour (1925) £2.00 — A Black and white fronts £1.50 £75.00 MP 50 B					
50 Motor Cars 1st series (1937) £1.70 £85.00 50 Motor Cars 2nd series (1937) £1.70 £85.00 50 National Flags and Arms (1936) 70p £35.00 L 25 Old Hunting Prints (1938) £3.20 — L 25 Old Naval Prints (1936) £3.20 — L 25 Racing Yachts (1938) £4.00 — 50 RAF Badges (1937) £1.00 £50.00 50 Sea Fishes (1935) 70p £35.00 L 25 Types of Horses (1939) £4.00 — B GENERAL OVERSEAS ISSUES £2.00 — 50 Aeroplane series (1926) £2.00 — 50 Aeroplane series (1926) £2.00 £1.00 — MP 50		50			
50 Motor Cars 2nd series (1937) £1.70 £85.00 50 National Flags and Arms (1936) 70p £35.00 L 25 Old Hunting Prints (1938) £3.20 — L 25 Old Naval Prints (1936) £3.20 — L 25 Racing Yachts (1938) £4.00 — 50 RAF Badges (1937) £1.00 £50.00 50 Sea Fishes (1935) 70p £35.00 L 25 Types of Horses (1939) £4.00 — L 25 Zoo Babies (1937) £2.00 — B GENERAL OVERSEAS ISSUES 50 Aeroplane series (1926) £2.00 — 50 Aeroplane series (1926) £2.00 — 50 Arms and Armour (1926) £2.60 £130.00 MP 50 Beauties 1st series (1925): * £1.40 £70.00 B Coloured fronts £1.50 £75.00 MP 50 Beauties 2nd series (1925) £1.40 £70.00 52 Birds of Brilliant Plumage (1927) £3.50 —					
50 National Flags and Arms (1936) 70p £35.00 L 25 Old Hunting Prints (1938) £3.20 — L 25 Old Naval Prints (1936) £3.20 — L 25 Racing Yachts (1938) £4.00 — 50 RAF Badges (1937) £1.00 £50.00 50 Sea Fishes (1935) 70p £35.00 L 25 Types of Horses (1939) £4.00 — L 25 Zoo Babies (1937) £2.00 — B GENERAL OVERSEAS ISSUES 50 Aeroplane series (1926) £2.00 — 50 Aeroplane series (1926) £2.60 £130.00 MP 50 Beauties 1st series (1925) \$2.60 £130.00 MP 50 Beauties 2nd series (1925) £1.40 £70.00 B Coloured fronts £1.50 £75.00 MP 50 Beauties 2nd series (1925) £1.40 £70.00 52 Birds of Brilliant Plumage (1927) £3.50 — 25 Borzo Dogs (1923) £4.50 —					
L 25 Old Hunting Prints (1938) £3.20 — L 25 Old Naval Prints (1936) £3.20 — L 25 Racing Yachts (1938) £4.00 — 50 RAF Badges (1937) £1.00 £50.00 50 Sea Fishes (1935) 70p £35.00 L 25 Types of Horses (1939) £4.00 — L 25 Zoo Babies (1937) £2.00 — B GENERAL OVERSEAS ISSUES 50 Aeroplane series (1926) £2.00 — 50 Arms and Armour (1926) £2.60 £130.00 MP 50 Beauties 1st series (1925): A Black and white fronts £1.40 £70.00 B Coloured fronts £1.40 £70.00 Seauties 2nd series (1925) £1.40 £70.00 — Seauties 2nd series (1926) £1.40 £70.00 — Seauties 2nd series (1926) £1.40 £70.00 — Seauties 2nd series (1926) £1.40 £70.00 — Seauties 2nd series 2nd serie					
L 25 Old Naval Prints (1936) £3.20 — L 25 Racing Yachts (1938) £4.00 — 50 RAF Badges (1937) £1.00 £50.00 50 Sea Fishes (1935) 70p £35.00 L 25 Types of Horses (1939) £4.00 — L 25 Zoo Babies (1937) £2.00 — B GENERAL OVERSEAS ISSUES 50 Aeroplane series (1926) £2.60 £130.00 MP 50 Beauties 1st series (1925): A Black and white fronts £1.40 £70.00 B Coloured fronts £1.50 £75.00 MP 50 Beauties 2nd series (1925) £1.40 £70.00 52 Birds of Brilliant Plumage (1927) £3.50 — 25 Bonzo Dogs (1923) £4.50 — 50 Boy Scouts (1924) £2.00 — M 25 British Live Stock (1924) £6.00 — 50 Butterflies (Girls) (1928) £5.00 — 25 Dogs (Heads) (1927) £1.20 £30.00 32 Drum Horses (1911) £7.00 — 25 Flag Girls of All Nations (1908) £6.50 — 25 Household Hints (1928-29) 90p £45.00 50 Leaders of Men (1925) £1.70 £85.00	I	-			_
L 25 Racing Yachts (1938) £4.00 — 50 RAF Badges (1937) £1.00 £50.00 50 Sea Fishes (1935) 70p £35.00 L 25 Types of Horses (1939) £4.00 — L 25 Zoo Babies (1937) £2.00 — B GENERAL OVERSEAS ISSUES 50 Aeroplane series (1926) £2.00 — 50 Arms and Armour (1926) £2.60 £130.00 MP 50 Beauties 1st series (1925) £1.40 £70.00 B Coloured fronts £1.50 £75.00 MP 50 Beauties 2nd series (1925) £1.40 £70.00 52 Birds of Brilliant Plumage (1927) £3.50 — 25 Bonzo Dogs (1923) £4.50 — 50 Boy Scouts (1924) £2.00 — M 25 British Live Stock (1924) £2.00 — 50 Butterflies (Girls) (1928) £5.00 — 25 Dogs (Heads) (1927) £1.20 £30.00 — <t< td=""><td></td><td></td><td></td><td></td><td>_</td></t<>					_
50 RAF Badges (1937) £1.00 £50.00 50 Sea Fishes (1935) 70p £35.00 L 25 Types of Horses (1939) £4.00 — L 25 Zoo Babies (1937) £2.00 — B GENERAL OVERSEAS ISSUES 50 Aeroplane series (1926) £2.00 — 50 Arms and Armour (1926) £2.60 £130.00 MP 50 Beauties 1st series (1925): £1.40 £70.00 B Coloured fronts £1.50 £75.00 MP 50 Beauties 2nd series (1925) £1.40 £70.00 52 Birds of Brilliant Plumage (1927) £3.50 — 25 Bonzo Dogs (1923) £4.50 — 50 Boy Scouts (1924) £2.00 — M 25 British Live Stock (1924) £5.00 — 25 Dogs (Heads) (1927) £1.20 £30.00 — 25 Dogs (Heads) (1927) £1.20 £30.00 — 25 Dogs (Heads) (1927) £1.20 £30.00 <t< td=""><td></td><td></td><td></td><td></td><td></td></t<>					
50 Sea Fishes (1935) 70p £35.00 L 25 Types of Horses (1939) £4.00 — L 25 Zoo Babies (1937) £2.00 — B GENERAL OVERSEAS ISSUES \$2.00 — 50 Aeroplane series (1926) £2.60 £130.00 MP 50 Beauties 1st series (1925): \$2.60 £130.00 MP 50 Beauties 1st series (1925): \$1.40 £70.00 MP 50 Beauties 2nd series (1925) £1.40 £70.00 52 Birds of Brilliant Plumage (1927) £3.50 — 25 Bonzo Dogs (1923) £4.50 — 50 Boy Scouts (1924) £2.00 — M 25 British Live Stock (1924) £2.00 — 50 Butterflies (Girls) (1928) £5.00 — 25 Dogs (Heads) (1927) £1.20 £30.00 32 Drum Horses (1911) £7.00 — 25 Flag Girls of All Nations (1908) £6.50 — 50 Household Hints (1928-29) <	_			£1.00	£50.00
L 25 Types of Horses (1939) £4.00 — L 25 Zoo Babies (1937) £2.00 — B GENERAL OVERSEAS ISSUES 50 Aeroplane series (1926) £2.00 — 50 Arms and Armour (1926) £2.60 £130.00 MP 50 Beauties 1st series (1925): A Black and white fronts £1.40 £70.00 B Coloured fronts £1.50 £75.00 MP 50 Beauties 2nd series (1925) £1.40 £70.00 52 Birds of Brilliant Plumage (1927) £3.50 — 25 Bonzo Dogs (1923) £4.50 — 25 Boy Scouts (1924) £2.00 — M 25 British Live Stock (1924) £6.00 — 50 Butterflies (Girls) (1928) £5.00 — 25 Dogs (Heads) (1927) £1.20 £30.00 32 Drum Horses (1911) £7.00 — 25 Flag Girls of All Nations (1908) £6.50 — 25 Household Hints (1928-29) 90p £45.00 50 Leaders of Men (1925) £1.70 £85.00				70p	£35.00
L 25 Zoo Babies (1937) . £2.00 — B GENERAL OVERSEAS ISSUES 50 Aeroplane series (1926) . £2.60 £130.00 MP 50 Beauties 1st series (1925): A Black and white fronts . £1.40 £70.00 B Coloured fronts . £1.50 £75.00 MP 50 Beauties 2nd series (1925) . £1.40 £70.00 52 Birds of Brilliant Plumage (1927) . £3.50 — 25 Bonzo Dogs (1923) . £4.50 — 50 Boy Scouts (1924) . £2.00 — M 25 British Live Stock (1924) . £2.00 — M 25 British Live Stock (1924) . £5.00 — 50 Butterflies (Girls) (1928) . £5.00 — 25 Dogs (Heads) (1927) . £1.20 £30.00 32 Drum Horses (1911) . £7.00 — 25 Flag Girls of All Nations (1908) . £6.50 — 50 Household Hints (1928-29) . 90p £45.00 50 Leaders of Men (1925) . £1.70 £85.00	L			£4.00	_
B GENERAL OVERSEAS ISSUES 50 Aeroplane series (1926) £2.00 — 50 Arms and Armour (1926) £2.60 £130.00 MP 50 Beauties lst series (1925): ** A Black and white fronts £1.40 £70.00 B Coloured fronts £1.50 £75.00 MP 50 Beauties 2nd series (1925) £1.40 £70.00 52 Birds of Brilliant Plumage (1927) £3.50 — 25 Bonzo Dogs (1923) £4.50 — 50 Boy Scouts (1924) £2.00 — M 25 British Live Stock (1924) £6.00 — 50 Butterflies (Girls) (1928) £5.00 — 25 Dogs (Heads) (1927) £1.20 £30.00 32 Drum Horses (1911) £7.00 — 25 Flag Girls of All Nations (1908) £6.50 — 50 Household Hints (1928-29) 90p £45.00 50 Lawn Tennis (1928) £3.00 — 50 Leaders of Men (1925) £1.70				£2.00	_
50 Aeroplane series (1926) £2.00 — 50 Arms and Armour (1926) £2.60 £130.00 MP 50 Beauties lst series (1925): ** ** A Black and white fronts £1.40 £70.00 B Coloured fronts £1.50 £75.00 MP 50 Beauties 2nd series (1925) £1.40 £70.00 52 Birds of Brilliant Plumage (1927) £3.50 — 25 Bonzo Dogs (1923) £4.50 — 50 Boy Scouts (1924) £2.00 — M 25 British Live Stock (1924) £6.00 — 50 Butterflies (Girls) (1928) £5.00 — 25 Dogs (Heads) (1927) £1.20 £30.00 32 Drum Horses (1911) £7.00 — 25 Flag Girls of All Nations (1908) £6.50 — 50 Household Hints (1928-29) 90p £45.00 50 Lawn Tennis (1928) £3.00 — 50 Leaders of Men (1925) £1.70 £85.00 <td>B (</td> <td>GENE</td> <td>RAL OVERSEAS ISSUES</td> <td></td> <td></td>	B (GENE	RAL OVERSEAS ISSUES		
50 Arms and Armour (1926) £2.60 £130.00 MP 50 Beauties 1st series (1925): A Black and white fronts £1.40 £70.00 B Coloured fronts £1.50 £75.00 MP 50 Beauties 2nd series (1925) £1.40 £70.00 52 Birds of Brilliant Plumage (1927) £3.50 — 25 Bonzo Dogs (1923) £4.50 — 50 Boy Scouts (1924) £2.00 — M 25 British Live Stock (1924) £6.00 — 50 Butterflies (Girls) (1928) £5.00 — 25 Dogs (Heads) (1927) £1.20 £30.00 32 Drum Horses (1911) £7.00 — 25 Flag Girls of All Nations (1908) £6.50 — 25 Household Hints (1928-29) 90p £45.00 50 Leaders of Men (1925) £3.00 — 50 Leaders of Men (1925) £3.00				£2.00	· ·
MP 50 Beauties 1st series (1925): A Black and white fronts £1.40 £70.00 B Coloured fronts £1.50 £75.00 MP 50 Beauties 2nd series (1925) £1.40 £70.00 52 Birds of Brilliant Plumage (1927) £3.50 — 25 Bonzo Dogs (1923) £4.50 — 50 Boy Scouts (1924) £2.00 — M 25 British Live Stock (1924) £6.00 — 50 Butterflies (Girls) (1928) £5.00 — 25 Dogs (Heads) (1927) £1.20 £30.00 32 Drum Horses (1911) £7.00 — 25 Flag Girls of All Nations (1908) £6.50 — 50 Household Hints (1928-29) 90p £45.00 50 Lawn Tennis (1928) £3.00 — 50 Leaders of Men (1925) £1.70 £85.00		50	Arms and Armour (1926)	£2.60	£130.00
B Coloured fronts £1.50 £75.00 MP 50 Beauties 2nd series (1925) £1.40 £70.00 52 Birds of Brilliant Plumage (1927) £3.50 — 25 Bonzo Dogs (1923) £4.50 — 50 Boy Scouts (1924) £2.00 — M 25 British Live Stock (1924) £6.00 — 50 Butterflies (Girls) (1928) £5.00 — 25 Dogs (Heads) (1927) £1.20 £30.00 32 Drum Horses (1911) £7.00 — 25 Flag Girls of All Nations (1908) £6.50 — 50 Household Hints (1928-29) 90p £45.00 50 Lawn Tennis (1928) £3.00 — 50 Leaders of Men (1925) £1.70 £85.00	MP	50			
MP 50 Beauties 2nd series (1925) £1.40 £70.00 52 Birds of Brilliant Plumage (1927) £3.50 — 25 Bonzo Dogs (1923) £4.50 — 50 Boy Scouts (1924) £2.00 — M 25 British Live Stock (1924) £6.00 — 50 Butterflies (Girls) (1928) £5.00 — 25 Dogs (Heads) (1927) £1.20 £30.00 32 Drum Horses (1911) £7.00 — 25 Flag Girls of All Nations (1908) £6.50 — 50 Household Hints (1928-29) 90p £45.00 50 Lawn Tennis (1928) £3.00 — 50 Leaders of Men (1925) £1.70 £85.00			A Black and white fronts	£1.40	£70.00
52 Birds of Brilliant Plumage (1927) £3.50 — 25 Bonzo Dogs (1923) £4.50 — 50 Boy Scouts (1924) £2.00 — M 25 British Live Stock (1924) £6.00 — 50 Butterflies (Girls) (1928) £5.00 — 25 Dogs (Heads) (1927) £1.20 £30.00 32 Drum Horses (1911) £7.00 — 25 Flag Girls of All Nations (1908) £6.50 — 50 Household Hints (1928-29) 90p £45.00 50 Lawn Tennis (1928) £3.00 — 50 Leaders of Men (1925) £1.70 £85.00			B Coloured fronts	£1.50	£75.00
25 Bonzo Dogs (1923) £4.50 — 50 Boy Scouts (1924) £2.00 — M 25 British Live Stock (1924) £6.00 — 50 Butterflies (Girls) (1928) £5.00 — 25 Dogs (Heads) (1927) £1.20 £30.00 32 Drum Horses (1911) £7.00 — 25 Flag Girls of All Nations (1908) £6.50 — 50 Household Hints (1928-29) 90p £45.00 50 Lawn Tennis (1928) £3.00 — 50 Leaders of Men (1925) £1.70 £85.00	MP	50	Beauties 2nd series (1925)		£70.00
50 Boy Scouts (1924) £2.00 — M 25 British Live Stock (1924) £6.00 — 50 Butterflies (Girls) (1928) £5.00 — 25 Dogs (Heads) (1927) £1.20 £30.00 32 Drum Horses (1911) £7.00 — 25 Flag Girls of All Nations (1908) £6.50 — 50 Household Hints (1928-29) 90p £45.00 50 Lawn Tennis (1928) £3.00 — 50 Leaders of Men (1925) £1.70 £85.00					<i>-</i>
M 25 British Live Stock (1924) £6.00 — 50 Butterflies (Girls) (1928) £5.00 — 25 Dogs (Heads) (1927) £1.20 £30.00 32 Drum Horses (1911) £7.00 — 25 Flag Girls of All Nations (1908) £6.50 — 50 Household Hints (1928-29) 90p £45.00 50 Lawn Tennis (1928) £3.00 — 50 Leaders of Men (1925) £1.70 £85.00		25			
50 Butterflies (Girls) (1928) £5.00 — 25 Dogs (Heads) (1927) £1.20 £30.00 32 Drum Horses (1911) £7.00 — 25 Flag Girls of All Nations (1908) £6.50 — 50 Household Hints (1928-29) 90p £45.00 50 Lawn Tennis (1928) £3.00 — 50 Leaders of Men (1925) £1.70 £85.00					
25 Dogs (Heads) (1927) £1.20 £30.00 32 Drum Horses (1911) £7.00 — 25 Flag Girls of All Nations (1908) £6.50 — 50 Household Hints (1928-29) 90p £45.00 50 Lawn Tennis (1928) £3.00 — 50 Leaders of Men (1925) £1.70 £85.00	M				
32 Drum Horses (1911) £7.00 — 25 Flag Girls of All Nations (1908) £6.50 — 50 Household Hints (1928-29) 90p £45.00 50 Lawn Tennis (1928) £3.00 — 50 Leaders of Men (1925) £1.70 £85.00					
25 Flag Girls of All Nations (1908) £6.50 — 50 Household Hints (1928-29) 90p £45.00 50 Lawn Tennis (1928) £3.00 — 50 Leaders of Men (1925) £1.70 £85.00					£30.00
50 Household Hints (1928-29) 90p £45.00 50 Lawn Tennis (1928) £3.00 — 50 Leaders of Men (1925) £1.70 £85.00					-
50 Lawn Tennis (1928) £3.00 — 50 Leaders of Men (1925) £1.70 £85.00					C45 00
50 Leaders of Men (1925)					£45.00
					£95.00
40 Fictures of the East (1951)		10.20			
		40	rictures of the East (1931)	22.00	2100.00

JOHN PLAYER & SONS (continued)

301		ENTER & BOTTS (commune)		
Size	Numb	er	Price	Complete
	in set		per card	set
	25	Picturesque People of the Empire (1928)	£2.00	£50.00
M	53	Playing Cards (1929)	£1.20	_
	50	Pugilists in Action (1928)	£3.40	_
	50	Railway Working (1926)	£1.60	£80.00
P	50	The Royal Family at Home and Abroad (1927)	£2.00	_
	50	Ships Flags and Cap Badges (1930)	£1.60	£80.00
	50	Signalling series (1926)	£1.30	
	25	Whaling (1930)	£2.60	£65.00
PO	LICA	NSKY BROS, South Africa—		
	50	Beautiful Illustrations of South African Fauna (1925)	£7.50	_
RIC	СНМ	OND CAVENDISH CO. LTD-		
P	28	Chinese Actors and Actresses (1922)	£4.00	
Р	50	Cinema Stars (1926)	£3.00	_
RU	GGII	ER BROS, Malta—		
M		Story of the Knights of Malta (c1925)	£5.00	
CC			20.00	
SC	EKKI	, Malta—————	-	_
		Beauties and Children (c1930):		
	150	A Black and white, no borders	80p	
	? 86	B Black and white, white border	£10.00	_
	45	C Coloured	£1.30	_
MP	50	Beautiful Women (c1935)	£1.60	£80.00
MP	480	Cinema Artists (c1935)	£1.80	-
MP	180	Cinema Stars (c1935)	£2.00	_
MP MP	50 60	Famous London Buildings (c1935)	£3.00	
MP	60	Film Stars 1st series Nos 1-60 (c1935)	£2.00	
IVII	52	Film Stars 2nd series Nos 61-120 (c1935) Interesting Places of the World (c1936)	£2.00	coc 00
P	25	International Footballers (c1935)	50p	£26.00
M	401	Malta Views (c1930)	£10.00	-
M	51	Members of Parliament — Malta (c1930)	60p 44p	£22.00
	146	Prominent People (c1930)	£1.00	122.00
MP	100	Scenes from Films (c1935)	£1.70	
LP	100	Talkie Stars (c1930)	£2.00	
M	100	World's Famous Buildings (c1930)	55p	£55.00
J.J.	SCH	IUH TOBACCO CO. PTY LTD, Australia————		
		ES ISSUED 1920-25		
ALL	60	Australian Footballers series A (half-full length)		
	40	Australian Footballers series B (Rays)	£4.00 £4.00	
	59	Australian Footballers series C (oval frame)	£7.50	
		Australian Jockeys:	27.30	
	30	A Numbered	£5.00	
	30	B Unnumbered	£5.00	
P	72	Cinema Stars	£1.70	
	60	Cinema Stars	£2.00	
L	12	Maxims of Success	£40.00	
P	72	Official War Photographs	£2.50	_
P	96	Portraits of Our Leading Footballers	£2.50	

G.	SCLI	VAGNOTI, Malta———————	1 2 2 2 2	
Size	Numbe in set	er	Price per card	Complete set
	50	Actresses and Cinema Stars (1923)	£2.00	_
MP	71	Grand Masters of the Orders of Jerusalem (1897)	£9.00	
P	102	Opera Singers (1897)	£9.00	_
M	100	Opera Singers (1897)	£9.00	_
SIN	MONE	TS LTD, Jersey, Channel Islands——————		
			64.50	
MP	36	Beautiful Women (c1925)	£4.50	_
P	24	Cinema Scenes series (c1925)	£5.50 £4.50	_
P	27	Famous Actors and Actresses (c1925)	£3.50	
	50	Local Footballers (c1914) Picture Series (c1920)	£4.00	
D	25 27	Sporting Celebrities (c1930)	£7.00	_
P LP	50	Views of Jersey (plain back) (c1940)	£2.00	_
			22.00	
TH	E SIN	SOCK & CO., Korea		
	20	Korean Girls (c1905)	£12.00	_
SN	IDER	S & ABRAHAMS PTY LTD, Australia————		
		Actresses (c1905):		
	30	A Gold background	£6.00	
	14	B White Borders	£6.00	
	20	Admirals and Warships of USA (1908)	£6.00	_
	60	Animals (c1912)	£3.00	_
	60	Animals and Birds (c1912):	20100	
	00	A 'Advertisement Gifts' issue	£2.50	_
		B 'Peter Pan' issue	£3.00	_
	15	Australian Cricket Team (1905)	£35.00	
	16	Australian Football Incidents in Play (c1906)	£7.00	39.7
	24	Australian Footballers (full length) series AI with blue framelines (1905)	£7.50	_
	50	Australian Footballers (full length) series AII without framelines (1905)	£7.50	
	76	Australian Footballers (½ length) series B (1906)	£6.00	_
	76	Australian Footballers (½ length) series C (1907)	£6.00	
	140	Australian Footballers (head and shoulders) series D (1908)	£5.00	
	60	Australian Footballers (head in oval) series E (1910)	£5.00	
	60	Australian Footballers (head in rays) series F (1911)	£5.00	_
	60	Australian Footballers (with pennant) series G (1912)	£5.00	inche i carre
	60	Australian Footballers (head in star) series H (1913)	£5.00	
	60	Australian Footballers (head in shield) series I (1914)	£5.00	_
	56	Australian Footballers (½-¾ length) series J (1910)	£7.50	_
	48	Australian Jockeys, back in blue (1907)	£3.00	daybaki ar
	83	Australian Jockeys, back in brown (1908)	£3.50	100000000000000000000000000000000000000
	56	Australian Racehorses, horizontal back (1906)	£3.50	- ·
	56	Australian Racehorses, vertical back (1907)	£3.50	
	40	Australian Racing Scenes (1911)	£3.50	, da 1
	? 133	Australian VCs and Officers (1917)	£5.00	
	12	Billiard Tricks (c1910)	£10.00	
	60	Butterflies and Moths, captions in small letters (c1912)	£1.60	_
	60	Butterflies and Moths, captions in block letters (c1912)	£1.60	- H
	60	Cartoons and Caricatures (c1908)	£5.50	-
	12	Coin Tricks (c1910)	£8.00	-
	64	Crests of British Warships (1915)	£4.50	_
	40	Cricketers in Action (1906)		_
	12	Cricket Terms (c1906)	£25.00	_

SNIDERS & ABRAHAMS PTY LTD, Australia (continued)

Size	Numb in set	er	Price per card	Complete set
	32 16	Dickens series (c1910)	£4.50	-
		A 'Standard' issue	£7.00	_
		1 White panel	£7.00	
		2 Gilt panel	£7.00	_
		C 'Coronet' issue	£7.00	
	6	Flags (shaped metal) (c1910)	£3.00	_
	60	Flags (shaped card) (c1910)	£3.00	9275
		A Front in green	£3.00	
	20	B Front in sepia brown	£3.00	_
	30 60	How to Keep Fit (c1908) Jokes (c1906):	£4.50	Ī
		A 'Aristocratica' issue	£3.50	_
	10	B 'Standard' issue	£3.50	-
	12	Match Puzzles (c1910)	£8.00	
M	48	Medals and Decorations (c1915)	£4.50	_
IVI	48 25	Melbourne Buildings (c1915)	£6.00	_
	12	Natives of the World (c1906)	£12.00	-
	29	Naval Terms (c1906)	£6.00	-
	40	Oscar Ashe, Lily Brayton and Lady Smokers (1911)	£4.50	_
	30	Shakespeare Characters (c1908)	£4.50	_
	14	Statuary (c1906)	£6.00	
	60	Street Criers in London, 1707 (c1916)	£8.00 £7.00	
	32	Views of Victoria in 1857 (c1908)	£8.00	
P	250	Views of the World 1908	£2.40	_
ST	AR T	OBACCO CO., India——————	237	
	52	Beauties (PC inset) (c1898)	£22.00	
	52	Indian Native Types (PC inset) (c1898)	£22.00	_
TE	OFAN	NI & CO. LTD		
LP	50	Teofani's Icelandic Employees (1930)	£6.00	-
TO	BAC	CO PRODUCTS CORPORATION, USA————		
		Movie Stars (1915)		_
TO	BAC	CO PRODUCTS CORPORATION OF CANADA LTD-	MS -th-	
	? 45	Canadian Sports Champions (c1920)	£10.00	
	60	Do You Know (1924)	£5.50	
	60	Hockey Players (1926)	£15.00	
	120	Movie Stars (c1920)	£2.50	
	? 163	Movie Stars Set 4 (c1920)	£3.00	_
TU	CKE	TT LIMITED, Canada——————————————————————————————————		
	25	Autograph series (c1913)	£26.00	
	? 210	Beauties and Scenes (c1910)	£8.00	
	25	Boy Scout series (c1915)	£18.00	_
P	100	British Views without Tucketts on front (c1912)	£1.80	_

TUCKETT LIMITED, Canada (continued)

Siz	e Numb in set		Price per card	Complete set
				501
P	? 224	British Views with Tucketts on front (c1912)	£1.80	
P	80	British Warships (c1915)	£7.50	_
P	50	Canadian Scenes (c1912)	£1.70	
	53	Playing Card Premium Certificates (c1930)	£7.50	_
	52	Tucketts Aeroplane series (1930)	£3.50	_
	52	Tucketts Aviation series (1929)	£3.50	_
	52	Tucketts Auction Bridge series (1930)	£5.00	_
111	NITED	TOBACCO COMPANIES (SOUTH) LTD, South Africa	a	
		[1] 전 10 THE THE THE PROPERTY OF THE PROPERTY		
A		FIRM'S NAME		
	50	Aeroplanes of Today (1936): A 'Box 78 Capetown'	£1.40	£70.00
			£1.40	£70.00
	50	B 'Box 1006 Capetown'	£5.50	270.00
	50	Arms and Crests of Universities and Schools of South Africa (1930)	£1.20	£30.00
L	24		£1.50	£80.00
L	52	Boy Scouts, Girl Guide and Voortrekker Badges (1932)	£1.50	£95.00
L	62	British Rugby Tour of South Africa (1938)	£1.00	193.00
	50	Children of All Nations (1928)	£1.80	£90.00
	50	Cinema Stars 'Flag Cigarettes' (1924)		£36.00
	60	Do You Know? (1929)	60p	
	50	Do You Know 2nd series (1930)	60p	£30.00
	50	Do You Know 3rd series (1931)	60p	£30.00
K	28	Dominoes 'Ruger Cigarettes' (1934)	£6.00	050.00
L	50	Exercises for Men and Women (1932)	£1.00	£50.00
	48	Fairy Tales 1st series Flag issue (1928)	£1.30	_
	48	Fairy Tales 2nd series Flag issue (1928)	£1.30	_
	24	Fairy Tales (1926) (booklets)	£10.00	_
L	120	Farmyards of South Africa (1934)	40p	£50.00
M	50	Household Hints (1926)	£2.00	
	25	Interesting Experiments (1930)	£1.40	£35.00
L	100	Medals and Decorations of the British Commonwealth of Nations (1941)	80p	_
	50	Merchant Ships of the World (1925)	£1.00	£50.00
	50	Motor Cars (1923)	£3.50	
L	100	Our Land (1938)	22p	£22.00
L	200	Our South Africa Past and Present (1938)	15p	£30.00
L	24	Pastel Plates (1938)	£1.20	£30.00
L	88	Philosophical Sayings (1938)	£1.20	
-	25	Picturesque People of the Empire (1929)	£1.40	£35.00
K	53	Playing Cards 'Flag' Cigarettes	£1.80	ALC: NO.
K	53	Playing Cards 'Lifeboat' Cigarettes (1934)	£1.60	
M	53	Playing Cards 'Lotus Cigarettes' (1934)	£2.00	_
L	53	Playing Cards 'Loyalist Cigarettes' (1934)	£2.00	_
K	53	Playing Cards 'MP Cigarettes' (1934)	£2.00	8 1 2
K	53	Playing Cards 'Rugger Cigarettes' (1934)	£3.00	41
		Racehorses South Africa Set 1 (1929)	£1.70	
L	50		21.70	_
L	52	Racehorses South Africa Set 2 (1930):	£1.70	
		A Inscribed 'a series of 50' B Inscribed 'a series of 52'	£1.70	4
				£75.00
	50	Regimental Uniforms (1937)	£1.50	
	50	Riders of the World (1931)	£1.20	£60.00
L	52	S. A. Flora (1935):	50	
		A With 'CT Ltd'	50p	c22 c2
		B Without 'CT Ltd'	40p	£22.00
	25	South African Birds 1st series (1927)	£1.40	_
	25	South African Birds 2nd series (1927)	£1.40	_

UNITED TOBACCO COMPANIES (SOUTH) LTD, South Africa (continued)

-		Tobales committee (comm	incu)	
Size	Numb in set	er		Complete
	ın sei		per card	set
L	52	South African Butterflies (1937)		£42.00
L	52	South African Coats of Arms (1931)	50p	£26.00
L	65	South African Rugby Football Clubs (1933)	£1.20	£80.00
L	52	Sports and Pastimes in South Africa (1936)	£1.30	£65.00
L	47	Springbok Rugby and Cricket Teams (1931)	£2.60	_
L	28	1912-13 Springboks (1913)	£35.00	_
	25	Studdy Dogs (1925)	£4.00	
L	40	Views of South African Scenery 1st series (1918):		
		A Text back	£4.50	11.
		B Anonymous plain back	£4.50	<u></u>
L	36	Views of South African Scenery 2nd series (1920)	£4.50	3 K 197
	25	Wild Flowers of South Africa 1st series (1925)	£1.20	_
	25	Wild Flowers of South Africa 2nd series (1926)	£1.20	_
	50	The World of Tomorrow (1938)	90p	£45.00
B	WITH	OUT FIRM'S NAME		
	50	African Fish (1937)	£1.30	£65.00
	50	British Aeroplanes (1933)	£1.40	203.00
EL	25	Champion Dogs (1934)	£3.00	J
	30	Do You Know (1933)	70p	£21.00
	50	Eminent Film Personalities (1930)	£2.00	221.00
	50	English Period Costumes (1932)	90p	£45.00
	25	Famous Figures from South African History (1932)	£2.00	243.00
L	100	Famous Works of Art (1939)	22p	£22.00
	25	Flowers of South Africa (1932)	£1.80	122.00
M	50	Humour in Sport (1929)	£2.50	1
L	100	Our Land (1938)	30p	9
M	150	Our South African Birds (1942)	27p	£40.00
L	150	Our South African Birds (1942)	27p	£33.00
M	100	Our South African Flora (1940)	20p	£20.00
L	100	Our South African Flora (1940)	17p	£17.00
M	100	Our South African National Parks (1941)	20p	£20.00
L	100	Our South African National Parks (1941)	1	£17.00
L	50	Pictures of South Africa War Effort (1942)	17p	£17.00
-	50	Riders of the World (1931)	30p	
	50	Safety First (1936)	£1.20	£60.00
	40	Ships of All Times (1931)	80p	£40.00
	25	South African Birds 2nd series	£1.60	15
L	17	South African Cricket Touring Team (1929):	£2.40	
-	17	A Fronts with autographs	C20 00	
		B Fronts with autographs	£20.00	
M	100	South African Defence (1939)		£25.00
L	50	South African Places of Interest (1934)	25p 30p	£15.00
P	50	Stereoscopic Photographs Assorted Subjects (1928)	1	£13.00
P	50	Stereoscopic Photographs Associed Subjects (1928) Stereoscopic Photographs of South Africa (1929)	90p	7
	50	The Story of Sand (1934)	90p	C45 00
M	50	Tavern of the Seas (1939)	90p	£45.00
141	25		50p	£25.00
	25	Warriors of All Nations (crossed swords at base) (1937)	£1.60	£40.00
	50		£1.60	£40.00
M	40	Wild Animals of the World (1932)	£1.20	£60.00
M	100	World Famous Poyers (c1035)	90p	7
M	100	World Famous Boxers (c1935)	£5.00	9 1
C	SILK IS			
M	20	British Butterflies (c1920)	£9.00	
M	30	British Roses (c1920)	£9.00	11 11 11
M	65	Flags of All Nations (c1920)	£3.00	_
		이번에 가장 아무슨 이 아니는 아무슨 아무는		

UNITED TOBACCO COMPANIES (SOUTH) LTD, South Africa (continued) Price Complete Size Number per card in set set 25 £8.00 M £6.50 50 M £3.50 M 50 M 50 f3 50 UNIVERSAL TOBACCO CO. PTY LTD, South Africa— 90p S.W. VENABLE TOBACCO CO., USA———— FI. Actresses (c1890) £27.00 WESTMINSTER TOBACCO CO. LTD-CARD ISSUES A £17.00 332 M £2.60 50 M £2.30 MP 100 M 50 £2.30 British Beauties (1915): £2.70 A Coloured M 102 £4.00 M 86 Uncoloured P 48 £1.00 £50.00 M 50 £2.20 £36.00 £1.00 P 36 Canada 1st series (1926) £36.00 P £1.00 36 £5.00 30 £3.00 100 50 £3.00 £3.00 48 £2.40 50 £2.80 MP 50 £2.80 MP 50 M 27 £5.50 £2.50 50 £5.00 24 100 M Famous Beauties (1916): £2.30 £2.30 Film Favourites (1927): MP 52 Uncoloured £3.50 Coloured £3.50 M 50 £3.50 50 Garden Flowers of the World (1917) £2.50 M £6.00 40 £1.00 £50.00 P 48 Indian Empire 2nd series (1926) £1.00 £50.00 P 48 Islenzkar Eimskipamyndir (1931) £2.20 £110.00 LP 50 LP 50 £2.00 £100.00 Islenzkar Landslagmyndir 2nd series (1929) £2.00 £100.00 LP 50 Merrie England Studies (1914) £7.00 40 36 £3.50 £3.30 MP 52

£1.00

£36.00

P

WESTMINSTER TOBACCO CO. LTD (continued)

~.		tional Tobrice of Co. ETD (commune)		
Siz	e Numbe	er		Complete
	in set		per card	set
P	36	New Zealand 2nd series (1929)	£1.00	£36.00
K	53	Playing Cards (1934)	£2.00	
M	55	Playing Cards (1934):		
		A Blue back	£2.00	_
		B Red back	£2.00	_
P	50	Popular Film Stars (1926)	£3.00	
P	36	South Africa 1st series (1928)	£1.00	£36.00
P	36	South Africa 2nd series (1928)	£1.00	£36.00
M	49	South African Succulents (1936)	25p	£12.50
M	100	Stage and Cinema Stars, captions in grey (1921)	£2.00	_
M	100	Stage and Cinema Stars, captions in black (1921)	£2.20	
M	50	Stars of Filmland (1927)	£2.80	
	50	Steamships of the World (1920)	£6.50	
M	50	Uniforms of All Ages (1917)	£9.00	
P	50	Views of Malaya (1930)	£6.00	
	25	Wireless (1923)	£4.50	
M	50	Women of Nations (1922)	£4.00	
	50	The World of Tomorrow (1938)	£1.00	£50.00
			11.00	230.00
B	SILK IS			
M	50	Garden Flowers of the World (c1914)	£4.50	_
M	24	Miniature Rugs (c1925)	£16.00	_
W	D. & 1	H.O. WILLS—		
A		VEL ISLAND ISSUES (without ITC clause)		
	50	Air Raid Precautions (1938)	70p	£35.00
	50	Association Footballers (1936)	£2.00	£100.00
	50	Dogs (1937)	70p	£35.00
	50	Garden Flowers by Richard Sudell (1939)	40p	£20.00
	50	Garden Hints (1938)	40p	£20.00
	50	Household Hints (1936)	40p	£20.00
	50	Life in the Royal Navy (1939)	40p	£20.00
	50	Our King and Queen (1937)	50p	£25.00
	50	Railway Equipment (1939)	40p	£20.00
	50	The Sea Shore (1938)	40p	£20.00
	50	Speed (1938)	40p	£20.00
	50	Wild Flowers 1st series (1936)	40p	£20.00
	50	Wild Flowers 2nd series (1937)	40p	£20.00
_			40p	120.00
B		AL OVERSEAS ISSUES		
	50	Actors and Actresses, scroll backs in green (c1905) Ref. 32:		
		A Portraits in black and white	£3.50	_
		B Portraits flesh tinted	£2.50	_
	30	Actresses — brown and green (1905) Ref. 116. Scissors issue	£3.30	£100.00
	50	Actresses — four colours surround (c1904) Ref. 117:		
		A Scissors issue	£5.50	
		B Green scroll back issue	£2.50	_
	30	Actresses — orange/mauve surround (c1915) Scissors issue Ref. 118:		
		A Surround in Orange	£2.50	£75.00
		B Surround in mauve	£1.50	£45.00
	100	Actresses (c1903) Ref. 34:		2.0.00
		A Capstan issue	£2.50	
		B Vice Regal issue	£2.50	
	250			
		Actresses (c1903) Ref. 33: A Front portrait in black	£2.50	
		B Front portrait in red		
		F	25.00	

	Numbe in set	er	Price per card	Complete set
	25 Actresses — Tabs type numbered Ref. 16 (1902)			
	50	Actresses — Tabs type unnumbered Ref. 119 Scissors issue (c1905)	£13.00 £12.00	_
	30	Actresses unicoloured 1 (c1908) Ref. 120: A Scissors issue, back in red	£1.70	£50.00
		B Scissors issue, back in purple brown	£2.50	£75.00
	30	Actresses — unicoloured 11 (c1908) Ref. 121 Scissors issue	£2.00	£60.00
	50	Aeroplanes (1925)	£2.80	200.00
	60	Animals (cut-outs) (1913):	22.00	
	.00	A Havelock issue	£1.60	_
		B Wills' Specialities issue	80p	£54.00
	50	Animals and Birds (1912):		
		A With text, without title	£4.00	
		B Without text, with title	£4.00 £5.00	_
	50	C Without text or title	13.00	_
	50	Arms and Armour (1910): A Capstan issue	£1.40	
		A Capstan issue	£3.00	_
		C Vice Regal issue	£1.40	_
		D United Service issue	£2.50	£125.00
	50	Arms of the British Empire (1910):		
	50	A Backs in black	90p	£45.00
		B Wills' Specialities issue	90p	
		C Havelock issue	£7.00	_
	25	Army Life 1910 Scissors issue	£2.20	£55.00
	50	Art Photogravures 1st series (1913):		
		A Size 67 × 33mm	70p	_
		B Size 67 × 44mm	70p	_
	50	Art Photogravures 2nd series (1913)	70p	_
	42	Australian Club Cricketers (1905) Ref. 59A:	015.00	
		A Dark blue backs	£17.00	
		B Green backs	£17.00 £17.00	_
	25	C Pale blue backs	£17.00	
	25 25	Australian and English Cricketers (1903) Ref. 59B	213.00	_
	23	A Capstan issue:		
		i Framework in scarlet	£13.00	_
		ii Framework in blue	£13.00	_
		B Vice Regal issue:		
		i Framework in scarlet	£13.00	10 / No - 1 3
		ii Framework in blue	£13.00	_
	60	Australian and South African Cricketers (1910) Ref. 59D:		
		A Capstan issue:		
		i Framework in scarlet	£15.00	_
		ii Framework in blue	£15.00	
		B Havelock issue: i Framework in scarlet	£35.00	
		ii Framework in blue	£35.00	_
		C Vice Regal issue:	233.00	
		i Framework in scarlet	£15.00	_
		ii Framework in blue	£15.00	_
M	100	Australian Scenic series (1928)	75p	_
	50	Australian Wild Flowers (1913):		
		A Wills' Specialities issue, grey-brown back	70p	£35.00
		B Wills' Specialities issue, green back	£2.00	_
		C Havelock issue	£3.50	

Size	Numbe	er	Price	Complete
	in set		per card	set
		Aviation (1910):		
	85	A Black backs 'Series of 85':		
		i Capstan issue	£1.80	
		ii Vice Regal issue	£1.80	<u> </u>
	75	B Black backs 'Series of 75':		
		i Capstan issue	£1.60	_
		ii Havelock issue	£2.50	
		iii Vice Regal issue	£1.60	_
	75	C Green back 'Series of 75':		
		i Capstan issue	£1.80	-
		ii Havelock issue	£3.50	_
	50	iii Vice Regal issue	£1.80	_
	30		00.05	
			£3.25	_
		B Anonymous backs with album clause	£3.00	-
	? 97	Baseball series (1912) Pirate issue	£3.00	
	40	Beauties — brown tinted (c1913):	£100.00	
		A Scissors issue	£1.40	656.00
		B Star circle and leaves issue	£3.00	£56.00
	30	Beauties — 'Celebrated Actresses' Ref. 140 Scissors issue (1921)	£4.50	
	52	Beauties — Heads and shoulders set in background Ref. 141 (1911):	24.50	
		A Scissors issue:		
		i Background to packets plain	£4.50	
		ii Background to packets latticework design	£3.00	£160.00
		B Star circle and leaves issue	£5.00	
P	25	Beauties 1st series (1924) Ref. 142	£3.00	
P	50	Beauties 2nd series (1924) Ref. 143	£3.00	
	32	Beauties — Picture Hats (c1914) Ref. 144:		
		A Scissors issue	£3.10	£100.00
		B Star circle and leaves issue	£5.50	
MP	72	Beauties — red star and circle back (c1920) Ref. 145	£11.00	
	50	Beauties — red tinted (1905) Ref. 146	£1.60	£80.00
	30	Beauties and Children (c1910) Ref. 147 Scissors issue	£2.30	£70.00
P	50	Beautiful New Zealand (c1928)	35p	£17.50
	50	Best Dogs of Their Breed (1916):		
		A Havelock issue	£6.00	_
		B Wills' Specialities issue	£3.50	
	20	C Anonymous back, Wills' on front	£7.00	_
	30	Birds and Animals (1911) Ruby Queen issue	£2.20	_
	50	Birds, Beasts and Fishes (c1925)	40p	£20.00
	100	Birds of Australasia (1912): A Green backs:		
			24.00	
		i Capstan issueii Havelock issue	£1.00	£100.00
			£2.50	
		iii Vice Regal issue	£1.00	£100.00
		사람들이 있다면 프로젝트에서 (Balling Sales Sales All Sale	CO 50	
			£2.50	-
	52	ii Wills' Specialities issue	£1.00	_
	32	A Four Aces issue (1924)	£2.50	
		B Pirate Issue:	£2.50	_
		i With border on front (1914)	£4.00	
		ii Without border on front (1916)	£4.00	
		C Red star, circle and leaves issue (1914)	£4.50	
	25	Birds of the East 1st series Ruby Queen issue (1912)	£1.40	£35.00
		(1712)	21.40	233.00

W.L). & H	I.O. WILLS (continued)		
Size	Numbe	er	Price	Complete
	in set		per card	set
	25	Birds of the East 2nd series Ruby Queen issue (1912)	£1.40	£35.00
	36	Boxers (1911):		
	50	A Scissors issue	£7.00	_
		B Green star and circle issue	£7.00	
		Britain's Defenders (1915):	27.00	
		A Wills' Specialities issue:		
	50	i Inscribed 'A Series of 50'	£1.40	£70.00
		ii Without inscription 'A Series of 50'	£8.00	270.00
	8		£2.50	_
	50	B Havelock issue	12.50	
	50	C Scissors issue:	£1.40	£70.00
		i Red upright 'Scissors' packet		£75.00
		ii Green upright 'Scissors' packet	£1.50 £1.40	£70.00
		iii Red slanting 'Scissors' packet	£1.70	270.00
	50	D Green star and circle issue	£5.00	_
	43	British Army Boxers (1913) Scissors issue	13.00	
	50	British Army Uniforms (c1910):	05.00	0250.00
		A Wild Woodbine issue	£5.00	£250.00
		B Flag issue	£5.00	
	1	C Scissors issue	£4.50	£225.00
	101	British Beauties (c1915)	£1.80	_
	50	British Empire series (1913):		212.00
		A Capstan issue	80p	£40.00
		B Havelock issue	£1.60	
		C Vice Regal issue	80p	£40.00
P	48	British Royal and Ancient Buildings (1925)	35p	£17.50
	45	British Rugby Players (1930)	£1.70	
	50	Chateaux (1925)	£4.00	_
	50	Children of All Nations (1925)	70p	£35.00
	100	China's Famous Warriors (1911) Pirate issue Ref. 357:		
		A First 25 subjects	£1.80	£45.00
		B Second 25 subjects	£1.80	£45.00
		C Third 25 subjects	£1.80	£45.00
		D Fourth 25 subjects	£1.80	£45.00
	28	Chinese Actors and Actresses (1907) Pirate issue Ref. 361	£2.80	200
	25	Chinese Beauties 1st Series (1907) Pirate issue Ref. 362:		
	23	A Vertical back	£1.40	£35.00
		B Horizontal back	£1.60	£40.00
	25	Chinese Beauties 2nd series (1909) Pirate issue Ref. 363:	21.00	
	23	A With framelines on front	£1.40	£35.00
		B Without framelines on front	£1.40	£35.00
	30	Chinese Children's Games (1911) Ruby Queen issue Ref. 364	£2.00	233.00
		Chinese Costumes Pirate issue (1911) Ruby Queen issue Ref. 364	£3.50	
E	50		£35.00	
EL	25	Chinese Pagodas (1905-10) Pirate issue Ref. 366	233.00	
	50	Chinese Proverbs brown Ref. 367 (1928):	C1 25	
		A Pirate issue	£1.25	_
		B Ruby Queen issue	£3.00	
	50	Chinese Proverbs coloured (1914-16) Pirate issue Ref. 368:		
		A Back in blue:	01.07	
		i Without overprint	£1.25	
		ii With overprint	£1.25	_
		B Back in olive green	£1.50	_
	40	Chinese Trades (c1905) Autocar issue	£6.00	10
	50	Chinese Transport (1914) Ref. 370 Ruby Queen issue	£2.50	_
	50	Cinema Stars Four Aces issue (c1926):		
		A Numbered	£1.60	£80.00
		B Unnumbered	£1.80	£90.00

****	, a I	i.O. WILLS (commuea)		
Size	Numb in set	er	Price per card	Complete set
	25 50	Cinema Stars (c1922) Scissors issue Coaches and Coaching Days (1925)	£2.20 £1.50	£55.00 £75.00
		Conundrums (c1900):		
	25	A With album clause	£10.00	_
	25	B Without album clause	£10.00	_
	25	C Without album clause redrawn	£10.00	_
	50	D Without album clause inscribed '50 Different'	£10.00	_
M P	68	Crests and Colours of Australian Universities, Colleges and Schools (1922)	60p	£40.00
P	63 25	Cricketers Ref. 59E (c1925)	£7.00	_
	50	Cricketer series Ref. 59F (1902) Cricketer series (1901) Ref. 59G	£90.00	
P	48	Cricket Season 1928-29	£90.00 £2.50	
	27	Dancing Girls (1915) Scissors issue:	12.50	
	'	A Inscribed '28 Subjects' (No. 3 not issued)	£2.30	
		B Inscribed '27 Subjects'	£2.30	
	25	Derby Day series (1914):	22.30	
		A Scissors issue:		
		i With title	£6.00	
		ii Without title	£8.00	
		B Star and circle issue	£7.00	
	50	Dogs — Scenic backgrounds (1925)	70p	£35.00
M	20	Dogs — Heads 1st series (1927):		
		A Wills' World Renown Cigarettes issue:		
		i With album clause	£2.60	
		ii Without album clause	£2.60	
M	20	B Three Castles and Vice Regal Cigarettes issue	£2.60	-
IVI	32	Dogs-Heads 2nd series (1927)	£2.60	
	32	A Scissors issue:		
		i Vertical format, open Scissors packet	£8.00	
		ii Horizontal format, closed Scissors packet	£6.00	£190.00
		B United Service issue	£6.00	2190.00
		C Green star, circle and leaves issue	£6.00	
P	25	English Cricketers (1926)	£2.40	£60.00
M	25	English Period Costumes (1928):	27.000	200.00
		A White card	£1.80	
		B Cream card	£1.80	£45.00
		Etchings (of Dogs) (1925):		
	26	A Small size English language issues:		
		i With 'Gold Flake Cigarettes'	£7.00	_
	21	ii Without 'Gold Flake Cigarettes'	£1.50	£40.00
	26	B Small size Dutch language issues:		
		i With framelines to back	£8.00	
M	26	ii Without framelines to back	£8.00	_
IVI	25		£3.00	
	23	The Evolution of the British Navy (c1915) Famous Film Stars (1934):	£2.60	£65.00
	100	A Small size	70-	
M	100	B Medium size:	70p	
	.00	i White card	£1.60	
		ii Cream card	£1.60	
MP	100	Famous Film Stars (c1936)	£2.40	
	50	Famous Footballers (1914):	~2.70	
		A Scissors issue	£7.00	_
		B Star and circle issue	£7.00	_
	50	Famous Inventions (without ITC clause) (1927)	70p	£35.00

Size	Numb in set	er	Price per card	Complete set
	75 50	Film Favourites Four Aces issue (1928)	£1.50	_
		A Capstan issue	70p	£35.00
		B Havelock issue	£1.30	
		C Vice Regal issue	70p	£35.00
		Flag Girls of All Nations (1908):	and Till	
	50	A Capstan issue	£2.00	
	50	B Vice Regal issue	£2.00	
	25	C United Service issue	£2.40	£60.00
	25	D Scissors issue:		
		i Numbered	£10.00	_
		ii Unnumbered	£10.00	-
	25	E Green star, circle and leaves issue	£2.40	£60.00
	8	Flags, shaped metal (1915)	£8.00	_
	126	Flags and Ensigns (1903)	£1.10	_
	25	Flags of the Empire (no ITC clause) (1926)	£5.50	_
		Flowers Purple Mountain issue (1914):	244.00	
	20	A Numbered	£11.00	_
	100	B Unnumbered	£11.00	
	50	Football Club Colours Scissors/Special Army Quality issue (1905)	£6.00	
	28	Football Club Colours and Flags (1913):	c2 00	
		A Capstan issue	£3.00	_
	200	B Havelock issue	£5.00	
	200	Footballers (1933):	60n	
		A Small size	60p £1.20	
	50	B Medium size	21.20	
	50	Girls of All Nations (1908): A Capstan issue	£2,20	
		A Capstan issue	£2.20	
		C Green star, circle and leaves issue	£2.50	
	25	Governors-General of India, Scissors issue (1911)	£6.00	
M	25	Heraldic Signs and Their Origins (1925)	£1.40	£35.00
IVI	30	Heroic Deeds (1914) Scissors issue	£2.40	£70.00
	50	Historic Events (1912):	22.10	270.00
	30	A Wills' Specialities issue	90p	£45.00
		B Havelock issue	£2.00	_
M	25	History of Naval Dress (1930)	£16.00	
P	50	Homeland Events (1927)	60p	£30.00
	50	Horses of Today (1906):		
		A Capstan issue	£2.20	
		B Havelock issue	£4.00	
		C Vice Regal issue	£2.20	_
	50	Household Hints (1927):		
		A With 'Wills' Cigarettes' at top back	50p	_
		B Without 'Wills' Cigarettes' at top back	£1.40	_
		Houses of Parliament (c1912):		
	33	A Pirate issue	£1.20	£40.00
	32	B Star and circle issue	£2.00	£65.00
	50	Indian Regiments (c1912):	0.5.0.5	
		A Scissors issue	£6.00	_
		B Star and circle issue	£7.50	-
	50	Interesting Buildings (1905)	£1.80	£90.00
	67	International Footballers Season 1909-1910:	07.00	
		A Scissors issue (1910)	£7.00	
		B United Services issue (1910)	£7.00	_
		C Flag issue (1911)	£7.00	

,,,,		i.o. Willis (commuca)		A
Size	Numb in set	er	Price per card	Complete set
		T' T' (1010)	per curu	sei
	50	Jiu-Jitsu (c1910):	27.00	
		A Scissors issue		
	52	B Flag issue	£4.50	_
	53	Jockeys and Owners Colours with PC inset Scissors issue (1914)	£6.00	_
	50	Lighthouses (1925)	£1.20	£60.00
	45	Melbourne Cup Winners (1906)	£6.00	-
	50	Merchant Ships of the World (1925) (without ITC clause)	£1.00	£50.00
	40	Merrie England Studies (Male) (1916)	£5.50	_
	24	Merveilles du Monde (1927)	£5.50	
	25	Military Portraits (1917) Scissors issue	£4.00	_
M	25	Miniatures — oval medallions (1914)	£50.00	_
K	52	Miniature Playing Cards Scissors issue (1906)	£11.00	_
	50	Modern War Weapons (1916):		
		A Wills' Specialities issue	£1.60	<u> </u>
		B Havelock issue	£2.70	
	25	Modes of Conveyance (1928) Four Aces issue	£1.60	£40.00
	48	Motor Cars (1924)	£1.60	£80.00
P	50	Motor Cars (1928)	£1.20	£60.00
	50	Motor Cycles (1926)	£3.00	£150.00
P	48	Movie Stars (1927)	£3.50	
	50	Music Hall Celebrities (1911) Scissors issue	£5.50	
	50	National Flags and Arms (1936)	£1.40	
M	25	The Nation's Shrines (1928)	£1.40	£35.00
P	50	Nature Studies (1928)	£1.30	_
	50	New Zealand Birds (1925)	70p	£35.00
P	50	New Zealand — Early Scenes and Maori Life (1926)	35p	£17.50
	50	New Zealand Footballers (1928)	70p	£35.00
	50	New Zealand Page Horses (1029).	10.00	
		A Cream card	80p	£40.00
		B White card	90p	_
	50	N.Z. Butterflies, Moths and Beetles (1925)	70p	£35.00
	25	Past and Present (1929)	£1.20	£30.00
	50	Past and Present Champions (1908).		40.00
		A Capstan Cigarette issue	£4.50	· <u> </u>
		B Capstan Tobacco issue	£6.00	
	25	Picturesque People of the Empire (1928)	£1.00	£25.00
	25	Pirates and Highwaymen (1925)	£1.00	£25.00
	25	Police of the World (1910)	£8.00	225.00
M	70	Practical Wireless (1923)	£6.00	V. Barrier
		Products of the World — Maps and Scenes (1913):	20.00	
	50	A Pirate issues	£1.20	
	25	B Green star, circle and leaves issue		
	50	Products of the World Scenes only (1000)	£1.60	617.50
	50	Products of the World — Scenes only (1929)	35p	£17.50
	23	Prominent Australian and English Cricketers (1907) Ref. 59H	£11.00	
	59	Prominent Australian and English Cricketers (1907) Ref. 591	£15.00	0
	39	Prominent Australian and English Cricketers (1911) Ref. 59J: A Capstan issue:		
		로마 계속 통계는 사람들은 바로 가득하는 경향을 통하는 이 회에는 사람이 있는 것이다. 그렇게 되어 있는 것이 없는 것이 없다.	010.00	
		i 'A Series of 50'	£12.00	05.
		ii 'A Series of/A Series of 59'	£12.00	
		B Vice Regal issue:		
		i 'A Series of 50'	£12.00	_
		ii 'A Series of/A Series of 59'	£12.00	_
		C Havelock issue	£35.00	_
	25	Puzzle series (1910) Scissors/United Service issue	£5.00	_
	50	Races of Mankind (1910)	£11.00	

Size	Numbe in set	er	Price per card	Complete set
	50 50	Railway Engines (1924)	80p £1.50	£40.00 £75.00
	50	Regimental Colours and Cap Badges (c1910): A Scissors issue	£1.30	£65.00
		B United Service issue: i Red back	£1.30	£65.00
		ii Blue back	£1.30	£65.00
	33	Regimental Pets (1911) Scissors issue	£5.50	_
	50	Regimental Standards and Cap Badges (1930)	60p	£30.00
	50	Riders of the World:		
		A Capstan/Vice Regal/Pennant/Wills' Specialities issue (1913)	£1.40	
		B Havelock issue (1913)	£3.00	_
		C Back in red-brown (1925)	90p	£45.00
	50	Romance of the Heavens (1928) (No ITC clause)	£1.40	_
	25	Roses (1912):		
		A Purple Mountain issues:	£5.00	
		i With Wills' Cigarettes on front	£5.00	_
		ii Without Wills' Cigarettes on front B Plain backs with Wills' Cigarettes on front	£5.00	_
P	50	The Royal Family at Home and Abroad (1927)	70p	
r	50	Royal Mail (with Wills' Cigarettes on fronts) (1913):	70p	
	30	A Capstan issue	£3.00	£150.00
		B Havelock issue (without Wills' Cigarettes on fronts)	£4.50	_
		C Vice Regal issue	£3.00	£150.00
		D With anonymous backs	£5.50	_
		E With plain back	£5.50	_
P	50	The Royal Navy (c1930)	£1.30	£65.00
	100	Royalty, Notabilities and Events in Russia, China and South Africa (1902)	£2.00	_
	27	Rulers of the World (1911)	£7.00	_
		Russo-Japanese series (1905):		
	100	A Fronts in black	£1.50	£150.00
	50	B Fronts in red	£7.00	
	50	Safety First (1937)	80p	£40.00
LP	48	Scenes from the Empire (1939)	£1.60	£80.00
	30	Semaphore Signalling (1910)	£3.00 60p	£90.00 £30.00
P	50	Ships and Shipping (1928)	£5.50	£30.00
	36 50	Ships and Their Pennants (1913) Ships' Badges (1926)	80p	£40.00
	50	Signalling series (1913):	оор	210.00
	30	A Capstan issue	£1.00	£50.00
		B Hayelock issue	£2.30	_
		C Vice Regal issue	£1.00	£50.00
	40	Sketches in black and white (1905)	£2.30	_
		Soldiers of the World (1903):		
	50	A Numbered	£6.50	_
	75	B Unnumbered	£9.00	_
	99	South African Personalities (1900)	£90.00	_
	30	Sporting Girls (1913) Scissors issue	£7.00	-
P	50	A Sporting Holiday in New Zealand (1928):	<i>(</i> 0-	620.00
		A Small size	60p	£30.00 £40.00
	25	B Medium size	80p	240.00
	25	Sporting Terms (1905): A Capstan issue	£10.00	
		A Capstan issue	£10.00	
	50	Sports of the World (1917)	£3.50	
	50	opolo of the mone (1717)		

****	D. C. 1	i.o. Willes (commuea)		
Size	Numb	er	Price	Complete
	in set		per card	set
	50	Stage and Music Hall Celebrities (1904) (Portrait in oval frame):		
		A Capstan issue	£3.00	_
		B Vice Regal issue	£3.00	
		C Havelock issue		
	50	Stage and Music Hall Celebrities (1904) (Portrait in oblong frame)	£3.00	_
P	52	Stars of the Cinema (1925):		
		A Text back	£4.50	
		B Four Aces issue		_
	50	Time and Money in Different Countries (1908):		
		A Capstan issue	£1.20	_
		B Havelock issue	£2.40	_
		C Vice Regal issue:		
		i With album clause	£1.20	£60.00
		ii Without album clause	£1.20	£60.00
	50	A Tour Round the World (1907)	£2.50	200.00
	50	Types of the British Army (1912):	22.50	
		A Capstan issue	£2.00	
		B Vice Regal issue	£2.00	
	50	Types of the Commonwealth Forces (1910):	22.00	
		A Capstan issue	£2.20	
		B Vice Regal issue	£2.20	
		C Havelock issue		
	25	United States Warships (1911):	24.50	
		A Capstan issue	£2.20	
		B Havelock issue	£4.00	
		C Vice Regal issue	£2.20	
P	50	Units of the British Army and RAF (1928)		£30.00
	50	USS Co's Steamers (1930)	60p	130.00
	50	VCe (1925)	£2.60	
	25	VCs (1925)	£1.50	£75.00
	23	Victoria Cross Heroes (c1915): A Havelock issue	01.00	
			£2.00	£50.00
	10		£2.40	£60.00
	10	Victorian Football Association (c1910):		
		A Capstan on front	£3.50	_
	10	B Havelock on front	£4.00	_
	19	Victorian Football League (c1910):		
		A Capstan on front	£3.50	_
		B Havelock on front	£4.50	
	215	Views of the World (1908):		
		A Numbers 1-50 plain backs (anonymous)	80p	_
		B Numbers 51-215 blue back Capstan issue	80p	_
		C Numbers 51-215 green back Vice Regal issue	80p	064 -
	25	Village Models series (1925):		
		A Small size	£1.20	£30.00
		B Medium size	£5.00	_
	50	War Incidents 1st series (1916):		
		A Wills' Specialities issue	£1.20	_
		B Havelock issue	£2.50	_
		C Scissors issue	£1.80	£90.00
	50	War Incidents 2nd series (1917):	21.50	2,0.30
		A Wills' Specialities issue	£1.50	£75.00
		B Havelock issue	£5.00	2,5.50
	50	War Pictures (1915):	25.00	
		A Wills' Specialities issue	£1.10	£55.00
		B Havelock issue	£2.20	~55.50
			22.20	

	Numb in set	er	Price per card	Complete set
	50	Warships (1925)	£1.30	£65.00
	30	What It Means (1916) Scissors issue	£1.20	£36.00
	50	A Small size titled 'Wild Animals' heads	60p	£30.00
14	25	B Medium size titled 'Wild Animals'	£1.20	£30.00
M	50	Wild Animals of the World (1906):	21.20	250.00
	50		£10.00	1950
		A Bristol and London issue	£4.50	£225.00
		B Celebrated Cigarettes issue	£7.00	1225.00
		C Star, circle and leaves issue	£1.20	£30.00
	25	Wonders of the World (1926)	11.20	230.00
	25	The World's Dreadnoughts (1910):	£2.00	
		A Capstan issue	£2.00	
		B Vice Regal issue		£55.00
		C No ITC clause	£2.20	233.00
	50	Zoo (1927):	64.00	
		A Scissors issue without descriptive back	£4.00	015.00
		B Wills' issue with descriptive back	30p	£15.00
MP	50	Zoological series (1922)	£1.80	
C	SILK I	SSUES 1911-17		
M	50	Arms of the British Empire	£3.00	
M	50	Australian Butterflies	£3.00	_
M	50	Birds and Animals of Australia	£3.00	_
M	50	Crests and Colours of Australian Universities, Colleges and Schools	£3.00	
EL	1	Flag	£25.00	
EL	28	Flags of 1914-18 Allies:		
	20	A Backs with letterpress in capitals	£2.00	
		B Backs with letterpress in small lettering	£2.00	
	38	Kings and Queens of England	£4.50	_
14	50	Popular Flowers:	21100	
M	30		£4.00	_
			£4.00	
	-	B Backs inscribed 'Now being inserted in the 1/- packets'	£3.00	
M	67	war Medais	23.00	
J. V	wix .	& SONS LTD		
		Royal Tour in New Zealand (1928)	£12.00	
P	24	Royal Tour in New Zealand (1928)	212.00	
GF	OF	YOUNG & BRO., USA—		
			005.00	
L	?	Actresses (c1890)	£25.00	_
AN	ONY	MOUS SERIES — Chinese Language————		
		Chinese Beauties (Ref ZE2-11) (c1930)		£20.00
M	10	Chinese Beauties (Ref ZE2-11) (C1930)	_	£20.00
M	10	Chinese Series (Ref ZE9-31) (c1930)		£20.00
	10	Chinese Views & Scenes (Ref ZE9-49) (c1930)	· ·	£10.00
	48	Hints on Association Football (Ref ZE3-2) (c1930)	_	£36.00
	30	Safety First (Ref ZE9-41) (c1930)		130.00

SECTION III

REPRINT SERIES

The following are classic series which have been reprinted, and are clearly marked as such on each card.

AL	LEN	& G	INTER/GOODWIN/KIMBALL (USA)——————	
Size	Print-	Num in se		Complete set
A	С	28	Baseball Greats of 1890 (reprinted 1991)	£6.00
AL	LEN	& G	INTER (USA)	
A A A	C C C	50 50 50	Celebrated American Indian Chiefs 1888 (reprinted 1989) Fruits (Children) 1891 (reprinted 1989) Pirates of the Spanish Main 1888 (reprinted 1996)	£7.50 £7.50 £7.50
BA	RBER	RS T	EA LTD—	
Α	C	24	Cinema & Television Stars 1955 (reprinted 1993)	£5.00
FE	LIX E	BER	LYN	
A	С	25	Golfing Series Humorous 1910 (reprinted 1989)	£6.00
AL	EXA	NDE	R BOGULAVSKY LTD	
A A	C C C	12 25 25	Big Events on the Turf (133 × 70mm) 1924 (reprinted 1995)	£7.50 £6.00 £6.00
BR	ITISI	HAN	MERICAN TOBACCO CO. LTD-	
A	C	50	Motorcycles 1927 (reprinted 1991)	£7.50
CA	RREI	RAS	LTD-	
A A	C C	50 75	Famous Airmen & Airwomen 1936 (reprinted 1996) Footballers 1934 (reprinted 1997)	£7.50 £13.50
W.A	4. &	A.C.	CHURCHMAN—————	
A A A B A	U C C C C C	50 52 50 50 12 50 48	Boxing Personalities 1938 (reprinted 1990) Frisky 1935 (reprinted 1994) Landmarks in Railway Progress 1931 (reprinted 1994) Prominent Golfers 1931 (reprinted 1989) Prominent Golfers 1931 (reprinted 1989) Racing Greyhounds 1934 (reprinted 1989) The RAF at Work (68 × 53mm) 1938 (reprinted 1995)	£7.50 £7.50 £7.50 £7.50 £5.00 £7.50 £14.00

CC	O-OPI		TIVE WHOLESALE SOCIETY LTD (C.W.S.)	
Size	Print ing		umber set	Complete se
A A	C	25 48	Parrot Series 1910 (reprinted 1996) Poultry 1927 (reprinted 1996)	£6.00 £7.50
CO	PE B	RO	S. & CO. LTD-	
A	C	50	British Warriors 1912 (reprinted 1996)	£7.50
A	C	50	Cope's Golfers 1900 (reprinted 1983)	27 5
A	C	50	Dickens Gallery 1900 (reprinted 1989)	£7.5
A	C	50 25	Shakespeare Gallery 1900 (reprinted 1989) Uniforms of Soldiers and Sailors 1898 (reprinted 1996)	£7.50 £6.00
EL	LIS	гов	. (USA)—	
A	C	25	Generals of the Late Civil War 1890 (reprinted 1991)	£6.0
w.	& F.	FAU	JLKNER	
D2	C	12	Cricket Terms 1898 (reprinted 1991)	4.55
D2	C	12	Golf Humour 1901 (reprinted 1998)	£2.0
D2	C	12	Police Humour 1899 (reprinted 1998)	f2 0
A	С	25	Prominent Racehorses of the Present day 1923 (reprinted 1993)	£6.00
J. (GABI	RIEI		
A	BW	20	Cricketers Series 1901 (reprinted 1992)	£3.50
GA	LLA	HEF	R LTD—	
A	C	50	Lawn Tennis Celebrities 1928 (reprinted 1997)	£7.50
A	C	25	Motor Cars 1934 (reprinted 1995)	£6.00
A	C	50 48	Regimental Colours and Standards 1899 (reprinted 1995)	£7.50
A	C	50	Signed Portraits of Famous Stars 1935 (reprinted 1997) Types of the British Army No. 1-50 1900 (reprinted 1995)	£7.50
A	č	50	Types of the British Army No. 51-100 1900 (reprinted 1995)	£7.50
R.	& J.	HIL	L LTD—	
A	C	25	Battleships and Crests 1901 (reprinted 1995)	£6.00
HU	DDE	N &	CO. LTD	1646
A	С	25	Famous Boxers 1927 (reprinted 1992)	£5.00
IM	PERI	AL	TOBACCO COMPANY OF CANADA LTD	JE545
A	C	45	Hockey Players 1912 (reprinted 1987)	£9.00
A	C	36	Hockey Series 1911 (reprinted 1987)	£9.00
JO	NES	BRC	OS., Tottenham—	HOLE
A	BW	18	Spurs Footballers 1912 (reprinted 1986)	£2.00
KI	NNE	BR	ROS. (USA)	
A	С	25	Famous English Running Horses 1889 (reprinted 1996)	£6.00
A	C	25	Leaders 1889 (reprinted 1990)	£6.0

J. K	(NIG	HT (HUSTLER SOAP)—————	
	Print-ing		mber set	Complete set
A	C	30	Regimental Nicknames 1924 (reprinted 1996)	£6.00
LA	MBE	RT &	& BUTLER—	
Α	С	25	Aviation 1915 (reprinted 1997)	£6.00
A	C	25	Dance Band Leaders 1936 (reprinted 1992)	£6.00
A	Č	25	Hints and Tips for Motorists 1929 (reprinted 1994)	£6.00
A	C	50	Horsemanship 1938 (reprinted 1994)	£7.50
A	C	25	London Characters 1934 (reprinted 1992)	£6.00
A	C	25	Motor Cars 1st series 1922 (reprinted 1988)	£4.00
A	C	25	Motor Cars 2nd series 1923 (reprinted 1988)	£4.00
A	C	25	Motor Cars 1934 (reprinted 1992)	£6.00
A	C	50	Motor Cycles 1923 (reprinted 1990)	£7.50 £6.00
A	C	25	Motors 1908 (reprinted 1992)	£7.50
Α	C	50	World's Locomotives 1912 (reprinted 1988)	27.30
R	J. LE	A LT		
A	C	50	Flowers to Grow 1913 (reprinted 1997)	£7.50
ST	ЕРНЕ	EN N	MITCHELL & SON————————————————————————————————————	
	С	25	Angling 1928 (reprinted 1993)	£6.00
A	C	25	Regimental Crests, Nicknames and Collar Badges 1900 (reprinted 1993)	£6.00
MU	IRRA	Y, S	ONS & CO. LTD	
A	BW	20	Cricketers 1912 (reprinted 1991)	£6.00
OG	DEN	S LI	TD-	
Α	С	50	A.F.C. Nicknames 1933 (reprinted 1996)	£7.50
A	C	50	Jockeys 1930 (reprinted 1990)	£7.50
A	Č	50	Modern Railways 1936 (reprinted 1996)	£7.50
A	Č	50	Motor Races 1931 (reprinted 1993)	£7.50
A	C	25	Poultry 1st Series 1915 (reprinted 1998)	£6.00
A	C	50	Soldiers of the King 1909 (reprinted 1993)	£7.50
Α	C	50	The Story of the Life Boat 1940 (reprinted 1989)	_
J.A	. PAT	TR	EIOUEX, Manchester—	
A	C	75	Cricketers Series 1928 (reprinted 1997)	£13.50
GO	DFR	EY P	PHILLIPS LTD-	
A	C	25	Railway Engines 1924 (reprinted 1997)	£6.00
A	C	25	Types of British Soldiers 1900 (reprinted 1997)	£6.00
JO	HN P	LAY	YER & SONS—————	
A	C	50	Aeroplanes (Civil) 1935 (reprinted 1990)	£7.50
A	C	50	Aircraft of The Royal Air Force 1938 (reprinted 1990)	£7.50
A	C	50	Aviary & Cage Birds 1933 (reprinted 1989)	£7.50
В	C	25	Aviary and Cage Birds 1935 (reprinted 1987)	£7.50
В	C	24	Cats 1936 (reprinted 1986)	£7.50
A	C	25	Characters from Dickens 1912 (reprinted 1990)	£6.00
A	C	25	Characters from Dickens 2nd series 1914 (reprinted 1990)	£6.00

			R & SONS (continued)	
Size	Print			Complete
	ing	in s	set	set
Α	C	50	Cricketers 1934 (reprinted 1990)	£7.50
A	C	50	Cricketers Caricatures by "Rip" 1926 (reprinted 1993)	£7.50
A	C	50	Derby and Grand National Winners 1933 (reprinted 1988)	£7.50
A	C	50	Dogs' Heads (silver-grey backgrounds) 1940 (reprinted 1994)	£7.50
A2	C	25		£10.00
A	C	50	England's Naval Heroes 1898 descriptive (reprinted 1987)	
A	C	50	Film Stars 3rd series 1938 (reprinted 1989)	£7.50
B	C	25		£7.50
A	C	50	Game Birds and Wild Fowl 1928 (reprinted 1987)	£7.50
B	C	25	Gilbert & Sullivan 2nd series 1927 (reprinted 1990)	£7.50
A	C	25	Golf 1939 (reprinted 1986)	£7.50
A	C	50	Highland Clans 1908 (reprinted 1997)	£6.00
A	C	50	Kings & Queens 1935 (reprinted 1990)	£7.50
A	C	50	Military Series 1900 (reprinted 1983)	£7.50
A	C	25	Motor Cars 1st series 1936 (reprinted 1990)	£7.50
A	C	50	Napoleon 1916 (reprinted 1989)	£6.00
B	C	25		
В	C	25	Old Hunting Prints 1938 (reprinted 1989) Old Naval Prints 1936 (reprinted 1989)	
В	C	25	Picturesque London 1931 (reprinted 1997)	£7.50
A	C	50	Poultry 1931 (reprinted 1993)	£7.50 £7.50
B	C	25	Racing Yachts 1938 (reprinted 1987)	
A	C	50	Regimental Standards & Cap Badges 1930 (reprinted 1993)	
A	C	50	Regimental Uniforms Nd. 51-100 1914 (reprinted 1995)	£7.50
B	C	24	Treasures of Britain 1931 (reprinted 1996)	£7.50
A	C	50	Uniforms of the Territorial Army 1939 (reprinted 1990)	£7.50
B	C	25	Wild Birds 1934 (reprinted 1997)	
RE	EVE	S LT1	Cricketers 1912 (reprinted 1993)	£8.00
D	-	23	Cheketers 1912 (reprinted 1993)	20.00
SA	LMO	N &	GLUCKSTEIN LTD—	
A	C	15	Billiard Terms 1905 (reprinted 1997)	£5.00
10	HNS	INCI	LAIR LTD—	
A	С	50	British Sea Dogs 1926 (reprinted 1997)	£7.50
SI	NGLI	ETO	N & COLE LTD-	
A	BW	35	Famous Boxers 1930 (reprinted 1992)	£6.00
F.	& J.	SMIT	ГН-	
A	C	25	Cinema Stars 1920 (reprinted 1987)	£6.00
A	Č	25	Prominent Rugby Players 1924 (reprinted 1992)	£8.00
TA	DDY	& C	20.	
Α	C	20	Clowns & Circus Artists 1920 (reprinted 1991)	£6.00
A	BW	238	County Cricketers 1907 (reprinted 1987) Individual Counties of the above set:	£27.50
		15	Derbyshire	£2.00
		15	Essex	
		16	Gloucestershire	
		15	Hampshire	
				-2.00

			(continued)	Complete
Size	Print ing		unber set	set
A A A A A A A A A A A A A A A A A A A	C BW BW BW BW BW BW BW BW C C C C C C C	15 15 15 15 15 15 15 15 15 15 15 15 15 1	Kent Lancashire Leicestershire Middlesex Northamptonshire Nottinghamshire Somersetshire Surrey Sussex Warwickshire Worcestershire Yorkshire Famous Jockeys 1910 (reprinted 1996) Prominent Footballers Aston Villa 1907 (reprinted 1992) Prominent Footballers Chelsea 1907 (reprinted 1998) Prominent Footballers Everton 1907 (reprinted 1998) Prominent Footballers Leeds 1907 (reprinted 1992) Prominent Footballers Leventon 1907 (reprinted 1992) Prominent Footballers Liverpool 1907 (reprinted 1992) Prominent Footballers Manchester Utd 1907 (reprinted 1992) Prominent Footballers Middlesbrough 1907 (reprinted 1992) Prominent Footballers Newcastle Utd 1907 (reprinted 1998) Prominent Footballers Newcastle Utd 1907 (reprinted 1992) Prominent Footballers Newcastle Utd 1907 (reprinted 1992) Prominent Footballers Sunderland 1907 (reprinted 1998) Prominent Footballers Woolwich Arsenal 1907 (reprinted 1996) Victoria Cross Heroes (Nos 1-20) 1900 (reprinted 1996) Victoria Cross Heroes (Nos 21-40) 1900 (reprinted 1996) VC Heroes — Boer War (Nos 41-60) 1901 (reprinted 1997) VC Heroes — Boer War (Nos 81-100) 1902 (reprinted 1997) Victoria Cross Heroes (Nos 101-125) 1905 (reprinted 1996)	£2.00 £2.00
D.	C. TH	ЮM	SON———	
A A	C C	24 20	Motor Bike Cards 1929 (reprinted 1993) Motor Cycles 1923 (Wizard Series) (reprinted 1993)	£6.00 £6.00
w.	D. &	H.O.	. WILLS—	
EL A B B A A A A A	0000000000000	4 50 50 25 25 50 25 50 50 50 50	Advert Postcards of Packings 1902 (reprinted 1988) Cricketers 1896 (reprinted 1982) Cricketers 1901 (reprinted 1983) Dogs 1914 (reprinted 1987) Famous Golfers 1930 (reprinted 1987) Fish & Bait 1910 (reprinted 1990) Lawn Tennis 1931 (reprinted 1988) Life in the Hedgerow 1950 (reprinted 1991, Swan Vestas) Military Aircraft (unissued c1967) (reprinted 1991) Military Motors 1916 (reprinted 1994) Musical Celebrities 2nd series including 8 substituted cards 1914 (reprinted 1987) Naval Dress & Badges 1909 (reprinted 1997) Old English Garden Flowers 2nd Series 1913 (reprinted 1994)	£7.50 £7.50 £7.50 £7.50 £7.50 £7.50 £7.50 £8.50 £8.50 £8.50

			VILLS (continued)	
Size	Print-	in s	mber	Complete
	ing	in s	iei	sei
В	C	40	Puppies by Lucy Dawson (unissued) (reprinted 1990)	. £12.50
A	C	50	Railway Engines 1924 (reprinted 1995)	£7.50
A	C	50	Kallway Engines 1936 (reprinted 1992)	£7.50
A	C	50	Railway Equipment 1939 (reprinted 1993)	f7 50
A	C	50	Railway Locomotives 1930 (reprinted 1993)	£7.50
A	C	12	Recruiting Posters 1915 (reprinted 1987)	£3.00
В	C	25	Rigs of Ships 1929 (reprinted 1987)	£7.50
A	C	50	Roses 1st series 1912 (reprinted 1994)	£7.50
A	C	50	Rugby Internationals 1929 (reprinted 1996)	£7.50
A	C	50	waterloo 1915 (reprinted 1987)	£10.00
A	C	50	Wild Flowers 1st series 1936 (reprinted 1993)	
A	C	25	World's Dreadnoughts 1910 (reprinted 1994)	£6.00
W.I). & I	н.о.	WILLS (Australia)	
A	C	50	Types of the British Army 1912 (reprinted 1995)	£7.50
A	C	50	War Incidents 2nd Series 1917 (reprinted 1995)	£7.50
W.F	I. & J	ı. w	OODS LTD-	
A	C	25	Types of Volunteers & Yeomanry 1902 (reprinted 1996)	. £6.00

NOTES

NOTES

ILLUSTRATIONS

- 1 Ogden, Fowls Pigeons & Dogs
- 2 Wills, Rugby Internationals
- 3 J. Sinclair, Well Known Footballers North Eastern Counties
- 4 Players, Cries of London 2nd Series
- 5 Players, Drum Banners & Cap Badges
- 6 Wills, Dogs 1937
- 7 Hignett, Zoo Studies
- 8 Rothman, Punch Jokes
- 9 Hill, Music Hall Celebrities
- 10 Players, Birds & Their Young 2nd Series (Unissued)
- 11 Wills, Merchant Ships of the World
- 12 Lambert & Butler, Third Rhodesian Series
- 13 British American Tobacco, Modern Beauties 2nd Series
- 14 Churchman, In Town To-night
- 15 Carreras, Footballers
- 16 Lambert & Butler, Winter Sports
- 17 R.J. Lea, Butterflies & Moths (Silks)
- 18 Players, Famous Beauties
- 19 Imperial Tobacco Company of Canada, Birds of Canada
- 20 Gallaher, The Navy
- 21 Boguslavsky, Mythological Gods and Goddesses
- 22 Wills, Pond & Aquarium 2nd Series
- 23 Players, Boy Scout & Girl Guide Patrol Signs & Emblems
- 24 Dominion, Old Ships 2nd Series
- 25 Mitchell, First Aid
- 26 Players, Aeroplanes (Civil)
- 27 Players, Natural History
- 28 Gallaher, Famous Film Scenes
- 29 United Kingdom Tobacco, Officers Full Dress
- 30 International Tobacco, International Code of Signals
- 31 Players, Aviary & Cage Birds
- 32 Gallaher, Film Partners
- 33 G. Phillips, Annuals
- 34 Lambert & Butler, Wireless Telegraphy
- 35 Murray, Bathing Belles
- 36 Hignett, How to Swim
- 37 Ching, Ships and Their Workings
- 38 Wills, Our King and Queen
- 39 Wills, Do You Know 3rd Series
- 40 American Tobacco Co, Songs C 1st Series
- 41 Mitchell, Stars of Screen & History
- 42 Ogden, Trick Billiards
- 43 Ardath, Cricket Tennis & Golf Celebrities
- 44 Murray, Types of Aeroplanes
- 45 Ogden, Racehorses
- 46 Mitchell, Empire Exhibition Scotland 1938

- 47 Lambert & Butler, Empire Air Routes
- 48 Wills Overseas, Units of the British Army and RAF
- 49 Carreras, Greyhound Racing Game
- 50 Westminster, New Zealand 2nd Series
- 51 Ogden, Sea Adventure
- 52 Notaras, Views of China
- 53 Scerries, Interesting Places of the World
- 54 Carreras, Types of London
- 55 Wills, Wonders of the Sea
- 56 Churchman, Kings of Speed
- 57 G. Phillips, Our Dogs
- 58 Drapkin, The Game of Sporting Snap
- 59 Abdulla, Old Favourites
- 60 R. Lloyd, Cinema Stars (Set of 25)
- 61 Players, Racing Caricatures
- 62 Rothman, Cinema Stars
- 63 Players Overseas, Ships Flags & Cap Badges
- 64 Ardath, Real Photographs Series G.P.2
- 65 Ogden, Owners Racing Colours & Jockeys (Series of 50)
- 66 Wills, Roses (1926 Issue)
- 67 Wills, Association Footballers (1935 Issue)
- 68 Cavanders, Cinema Stars
- 69 Franklyn Davey, Hunting
- 70 British American Tobacco, Aeroplanes of Today
- 71 Sarony, A Day on the Airway
- 72 Players, Wild Birds
- 73 Lambert & Butler, Famous British Airmen & Airwomen
- 74 Players, Straight Line Caricatures
- 75 Gallaher, Portraits of Famous Stars
- 76 Allen & Ginter, Birds of America
- 77 Gallaher, Famous Jockeys
- 78 Wills, Garden Flowers (1933 Issue)
- 79 Churchman, Wonderful Railway Travel
- 80 Carreras, Notable MPs
- 81 Co-operative Wholesale Society, African Types
- 82 Cope, Boxing Lessons
- 83 Morris, Horoscopes
- 84 Wills, Wild Flowers 2nd Series
- 85 Ardath, Real Photographs Series Ten
- 86 Ardath, Real Photographs Series Eleven
- 87 Rothman, Modern Inventions
- 88 Morris, Animals at the Zoo
- 89 Ogden, The Story of Sand
- 90 Morris, Wax Art Series
- 91 Players, Wild Animals' Heads
- 92 Ogden, Broadcasting
- 93 Duncan, Evolution of the Steamship
- 94 Morris, Measurement of Time
- 95 Ardath, Real Photographs 1st Series
- 96 Sarony, Links with the Past 2nd Series
- 97 Churchman, Eastern Proverbs 1st Series

- 98 J. Wix, Coronation Series
- 99 Wills, Lucky Charms
- 100 Wills Overseas, Lighthouses
- 101 United Tobacco Companies (South) Ltd, Our South African National Parks
- 102 Wills, Life in the Royal Navy
- 103 Wills, Garden Flowers New Varieties 2nd Series
- 104 A. & M. Wix, Cinema Cavalcade 2nd Series
- 105 Westminster Overseas, Famous Beauties
- 106 Mitchell, Wonderful Century 1837-1937
- 107 Dudgeon & Arnell, 1934 Australian Test Team
- 108 Players, Hidden Beauties
- 109 Ardath, Sports Champions
- 110 Wills, Overseas Dominions (Canada)
- 111 R.J. Lea, Fish
- 112 Players, Products of the World
- 113 Players, Modern Naval Craft
- 114 Hill, Views of Interest 4th Series
- 115 Players, Hints on Association Football
- 116 Players, Exploration of Space
- 117 Ching, Do You Know
- 118 G. Phillips, Soccer Stars
- 119 Millhoff, Art Treasures
- 120 Lambert & Butler Overseas, The World of Sport
- 121 J. Wix, Builders of Empire
- 122 Teofani, London Views
- 123 Morris, Treasure Island
- 124 Gallaher, Aesop's Fables
- 125 Ardath, Empire Personalities
- 126 Wills, Engineering Wonders
- 127 Ogden, By the Roadside
- 128 Hill, Famous Footballers (1939 Issue)
- 129 Carreras, Film Favourites
- 130 R. Lloyd, Tricks & Puzzles
- 131 Gallaher, Garden Flowers
- 132 Wills, Wonders of the Past
- 133 Gallaher, Dogs 1st Series of 48
- 134 Players, Curious Beaks
- 135 Ching, Jersey Past and Present 3rd Series
- 136 Churchman, Wings Over the Empire
- 137 Gallaher, Racing Scenes
- 138 Players, Famous MG Marques

5

PLAYER'S CIGARETTES.

GAP BADGE.

WILEST CIGARETTES

17th Lancers. (Duke of Cambridge's Own).

NIGNETT'S CIGARETTES

DISTRESSING SCENE OUTSIDE CENERAL MANAGERS OFFICE IN A PROVINCIAL TOWN THE DAY GEFORE THE CUP FINAL STREAMS OF FANALS.

10

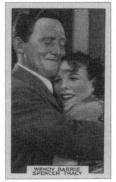

Quidens Eigareites

62 63 64

97 98 99 100

101 102 10

3

108 109

110

111

112

PLAYERE CIRANETTE

114 115 116

OGDEN'S CIGARETTES